RENOIR
IN THE 20TH CENTURY

RENOIR
IN THE 20TH CENTURY

With essays by
Roger Benjamin
Guy Cogeval
Claudia Einecke
Isabelle Gaëtan
Emmanuelle Héran
John House
Virginie Journiac
Martha Lucy
Laurence Madeline
Monique Nonne
Sylvie Patry

Los Angeles County Museum of Art
Philadelphia Museum of Art

HATJE CANTZ

Contents

This catalogue is published in conjunction with the exhibition

RENOIR
IN THE 20ᵀᴴ CENTURY

Renoir au XXe siècle
Paris, Galeries Nationales (Grand Palais, Champs-Élysées)
September 23, 2009 – January 4, 2010

Renoir in the 20th Century
Los Angeles, Los Angeles County Museum of Art
February 14 – May 9, 2010

Late Renoir
Philadelphia, Philadelphia Museum of Art
June 17 – September 6, 2010

This exhibition was organized by the Los Angeles County Museum of Art, the Réunion des Musées Nationaux, and the Musée d'Orsay in collaboration with the Philadelphia Museum of Art.

In Paris, the exhibition enjoyed the sponsorship of AXA Private Equity and its president, Dominique Senequier, as well as her entire staff.

The Los Angeles presentation is made possible by the Iris & B. Gerald Cantor Foundation.

In Philadelphia, the exhibition is supported by The Annenberg Foundation Fund for Major Exhibitions. Major foundation support is provided by The Pew Charitable Trusts and The Robert Lehman Foundation. Additional support is provided by The Women's Committee of the Philadelphia Museum of Art, generous contributors to the *Renoir Salon*, and other individual donors.

The exhibition is supported by an indemnity from the Federal Council on the Arts and the Humanities.

General Coordination and Organization

Paris

Réunion des Musées Nationaux

Thomas Grenon
Administrateur général

Jean-Marie Sani
Directeur du développement culturel

Marion Mangon
Chef du département des expositions

Barbara Kroher, Katia Cartacheff, Christelle Terrier
Chefs de projet au département des expositions

Isabelle Mancarella
Coordinatrice du mouvement des œuvres

Magali Sicsic
Administratrice des Galeries Nationales du Grand Palais

Pascale Sillard
Directrice de la communication, des relations publiques
et du mécénat

Cécile Vignot
Chef du service promotion et partenariats média

Florence Le Moing
Chef du service de presse

Alix de La Marandais
Chargée de mécénat

Musée d'Orsay

Guy Cogeval
Président de l'Établissement Public du Musée d'Orsay

Thierry Gausseron
Administrateur général du Musée d'Orsay

Olivier Simmat
Chef de cabinet du président
Mécénat et relations internationales

Philippe Thiébaut
Chef de la conservation

Hélène Flon
Chef des expositions

Amélie Hardiviller
Chef du service de la communication

Los Angeles

Michael Govan
Chief Executive Officer and Wallis Annenberg Director

Melody Kanschat
President and Chief Operating Officer

Nancy Thomas
Deputy Director for Art Administration and Collections

Irene Martin
Assistant Director for Exhibitions

Sarah Minnaert
Senior Exhibition Programs Coordinator

Nancy Russell
Head Registrar

Alexandra Moran
Senior Assistant Registrar for Exhibitions

Renee Montgomery
Assistant Director for Risk Management and Collections
Information

Philadelphia

Anne d'Harnoncourt †
The George D. Widener Director and Chief Executive Officer

Timothy Rub
The George D. Widener Director and Chief Executive Officer

Gail Harrity
President and Chief Operating Officer

Alice Beamesderfer
Associate Director for Collections

Suzanne F. Wells
Director of Exhibition Planning

Zoë Kahr
Assistant Director of Exhibition Planning

Irene Taurins
Senior Registrar

Tara Eckert
Registrar for Exhibitions

Honorary Committee

Marie-Christine Labourdette
Directrice des Musées de France

Jean-Paul Cluzel
Président du Conseil d'Administration de la Réunion des Musées Nationaux

Guy Cogeval
Président de l'Établissement Public du Musée d'Orsay

Thomas Grenon
Administrateur général de la Réunion des Musées Nationaux

Michael Govan
Chief Executive Officer and Wallis Annenberg Director, Los Angeles County Museum of Art

Timothy Rub
The George D. Widener Director and Chief Executive Officer, Philadelphia Museum of Art

Exhibition Committee

Paris
Sylvie Patry
Conservateur du patrimoine au Musée d'Orsay

Emmanuelle Héran
Conservateur du patrimoine, administratrice adjointe de la RMN en charge
de la politique scientifique
Commissaire pour la sculpture

Isabelle Gaëtan
Chargée d'études documentaires au Musée d'Orsay
Commissaire pour les dessins et les photographies

Los Angeles
Claudia Einecke
Associate Curator of European Painting and Sculpture, Los Angeles County
Museum of Art

J. Patrice Marandel
The Robert H. Ahmanson Chief Curator of European Art, Los Angeles County
Museum of Art

Philadelphia
Joseph J. Rishel
The Gisela and Dennis Alter Senior Curator of European Painting before 1900,
Senior Curator of the John G. Johnson Collection and the Rodin Museum, Philadelphia
Museum of Art

Jennifer A. Thompson
The Gloria and Jack Drosdick Associate Curator of European Painting and
Sculpture before 1900 and the Rodin Museum, Philadelphia Museum of Art

Acknowledgments

We would like to express our deepest gratitude to all the collectors who so willingly and generously loaned works for this exhibition:

France
Paris, Durand-Ruel
Paris, Archives photographiques Bernheim-Jeune
Private collection, courtesy of Galerie Bernheim-Jeune et Cie
Collection Daniel Brukarz
Collection Vaillant-Charbonnier
Brassaï Estate
Succession Richard Guino and Succession Renoir
Association des Amis de Louis Valtat

Germany
Roland Stark collection

Great Britain
London, Nahmad collection

Japan
Tokyo, Nippon Television Network Corporation

Spain
Carmen Thyssen-Bornemisza collection, on deposit at the
 Museo Thyssen-Bornemisza, Madrid

Switzerland
Basel, Galerie Beyeler
Private collection, courtesy of Galerie Kornfeld, Bern
Geneva, collection Marina Picasso c/o Galerie Krugier & Cie
Geneva, Stephan Chayto

United States
Baltimore, Dr. Morton and Tobia Mower collection
Los Angeles, Lynda and Stewart Resnick

and those who wish to remain anonymous. Works from private collections were entrusted to us as a result of the research and contacts made by Pascal Perrin, through the Renoir catalogue raisonné project at the Wildenstein Institute in Paris. We are particularly grateful for his generous and continued support. The teams at Christie's and Sotheby's in Europe, the United States, and Japan provided much assistance, for which we are extremely grateful.

We would also like to sincerely thank the directors of the following institutions for graciously sharing works from their collections:

Austria
Vienna, Albertina Museum
Vienna, Österreichische Galerie Belvedere

Brazil
São Paulo, Museu de Arte de São Paulo Assis Chateaubriand

Canada
Ottawa, National Gallery of Canada
Toronto, Art Gallery of Ontario

France
Bordeaux, Musée des Beaux-Arts
Cagnes-sur-Mer, Musée Renoir
Issy-les-Moulineaux, Archives Matisse
Lyon, Musée des Beaux-Arts
Paris, Musée d'Orsay
Paris, Musée National de l'Orangerie
Paris, Musée National Picasso
Paris, Petit Palais, Musée des Beaux-Arts de la Ville de Paris
Paris, Chancellerie des Universités de Paris, Bibliothèque
 Littéraire Jacques Doucet
Paris, Bibliothèque Centrale des Musées Nationaux
Paris, Bibliothèque Nationale de France, Département des
 Estampes et de la Photographie
Pont-Saint-Esprit, Musée d'Art Sacré du Gard

Germany
Karlsruhe, Staatliche Kunsthalle

Great Britain
London, The Courtauld Gallery
London, The National Gallery

Japan
Hiroshima, The Hiroshima Museum of Art
Kitashiobara-mura, Fukushima-ken, Morohashi Museum
 of Modern Art Foundation
Tokyo, Bridgestone Museum of Art, Ishibashi Foundation

Spain
Madrid, Museo Thyssen-Bornemisza

Sweden
Stockholm, Nationalmuseum

Switzerland
Geneva, Petit Palais, Association des Amis du Petit Palais
Zurich, Foundation Collection E. G. Bührle

United States
Austin, Photography Collection, Harry Ransom Humanities
 Research Center, The University of Texas
Baltimore, Baltimore Museum of Art
Bloomington, Indiana University Art Museum
Boston, Museum of Fine Arts
Brooklyn, The Brooklyn Museum
Buffalo, The Albright-Knox Art Gallery
Chicago, The Art Institute of Chicago
Cleveland, The Cleveland Museum of Art
Columbus, Columbus Museum of Art
Detroit, The Detroit Institute of Arts
Los Angeles, Los Angeles County Museum of Art
Los Angeles, UCLA, Art Library Special Collection
New Orleans, New Orleans Museum of Art
New York, The Metropolitan Museum of Art
Philadelphia, Philadelphia Museum of Art
Providence, Museum of Art, Rhode Island School of Design
Richmond, Virginia Museum of Fine Arts
San Francisco, Fine Arts Museums of San Francisco—
 Legion of Honor
Stanford, Iris & B. Gerald Cantor Center for the Visual Arts
 at Stanford University
Washington, DC, National Gallery of Art
Washington, DC, The Phillips Collection
Williamstown, MA, The Sterling and Francine Clark
 Art Institute

Organizers' Acknowledgments

For their unwavering support we extend our deepest thanks to the directors of our institutions: Serge Lemoine, under whom the Musée d'Orsay joined this project; Guy Cogeval; Thomas Grenon; Michael Govan; and the late Anne d'Harnoncourt, who was an enthusiastic advocate for the exhibition. Following Anne d'Harnoncourt's lead, Alice Beamesderfer, Gail Harrity, and Timothy Rub have supported the exhibition with equal vigor.

This ambitious project could not have been realized without the generous assistance and cooperation of our colleagues all over the world, to whom we express our sincere gratitude.

In the securing of loans and transportation of works, our very sincere thanks go to all of our staff for their efficiency and dependability.

For the architecture and graphic design of the Paris exhibition, we would like to thank Pascal Rodriguez and Marion Solvit for the talent and imagination they brought to their design and installation.

Marie-Claude Bianchini, Annie Dufour, and Pierre-Louis Hardy were invaluable in the making of the French catalogue. The English catalogue would have never been completed without the advice and attention of Hatje Cantz, in particular Angelika Hartmann, Anne O'Connor, and Tas Skorupa. We extend our gratitude to all involved.

We are grateful to Monique Nonne for her extensive and fruitful research in France, Switzerland, England, and the United States.

This exhibition and catalogue were made possible by friendly and enriching exchanges with Virginie Journiac, curator at the Musée Renoir in Cagnes-sur-Mer; John House, professor at the Courtauld Institute of Art; Martha Lucy, associate curator at the Barnes Foundation; and Christopher Riopelle, curator at the National Gallery in London. To them we extend our heartfelt gratitude.

Elsa Badie-Modiri at the Musée d'Orsay made an indispensable contribution to the realization of this project with her patient and methodical documentary research. We thank her for her valuable assistance.

Sylvie Patry would like to thank the team of the Sterling and Francine Clark Art Institute, where she worked as a fellow on this project: Michael Conforti, Michael Ann Holly, Mark Ledbury, as well as Richard Rand and Sarah Lees.

Many people helped us with the preparation of this exhibition and catalogue by offering assistance, advice, or active support, and we would like to extend our thanks to the following:

Matthew Affron, Sylvie Aubenas, Colin B. Bailey, Joseph C. Baillo, Barbara Beaucar, Florence Bobola, Sandra Boujot, Daniel and Fabien Boulakia, Emily Braun, Emmanuel Bréon, Caroline Bruyant, Augustin de Butler, Isabelle Cailleteau, Katia Cartacheff, Kathryn Calley Galitz, Mercedes Ceron, Jacques Chardeau, Olivier Chardeau, Liz Clark, Melanie Clore, Evelyne Cohen, Communauté du Chemin Neuf, Roland Constant, Alexandre Cornu, Laura Curler, Guy-Patrice Dauberville, Michel Dauberville, Cécile Debray and the members of the Comité Scientifique de Programmation at the Réunion des Musées Nationaux (Laurence des Cars, Yves Le Fur, Vincent Pomarède, Didier Ottinger, Rodolphe Rapetti, Élisabeth Taburet-Delahaye), Agnès Delannoy, Claire Denis, Paul Denis, Anne Distel, Javier Docampo, Judith F. Dolkart, Marina Ducrey, Denyse Durand-Ruel, Flavie Durand-Ruel, Paul-Louis Durand-Ruel, Christine Ekelhart, Marie El Caïdi, Marie-Christine Enshaian, Marina Ferretti-Bocquillon, Jenna Filia, Michael Findlay, Francis Fowle, Sylvie Fresnault, J. and M. Gaëtan, Monsieur de Galéa, Florence Gentner, Katja Gentrix, Anne Giani, Derek Gillman, Carmen Gimenez, Alain Girard, Lukas Gloor, Agnès de Gouvion Saint-Cyr, Elisabeth Gracy, Gloria Groom, Wanda de Guébriant, Pierre-Emmanuelle Guilleray, Amélie Guillet, Adelaïde Guino, Michel Guino, Laurence Guiot, Eva Hackney, Toshihiko Hatanaka, Catherine Haviland, Claire Herlic, Günter Herzog, Danielle Hodel, Michèle Hornn, Nadine Huntington, Catherine Imbert, Hervé Joubeaux, Michael Kelly, Nicole Kenning, Anabelle Kienle, Catherine Krahmer, Barbara Kroher, Rémi Labrusse, Geneviève Lacambre, Miranda Lash, Klervi Le Collen, Marc Le Coeur, Florence Le Moing, Cathie Lévy, Isabelle Loric, Sophie Maket, Isabelle Mancarella, Agnès Marandon, Michael Marrinan, Marie-Madeleine Massé, Véronique Mattiussi, Marie-Christine Maufus, Marc Mayer, Yuichiro Mizushima, Charles S. Moffett, Kazuto Morita, Kyoko Nanjo, Tsunetaka Narahara, Louis Nègre, Maureen O'Brien, Nykia Omphroy, Lynn Orr, Hadrien Paillocher, Robert McDonald Parker, Danièle Pelissier, Virginie Perdrisot, Bernard Pharisien, Marina Picasso, Hélène Pillu-Oblin, Christine Pinault, Anne Pingeot, Isabelle Pintus, Marie-Sophie Pottier, Alain Prevet and his team, Sophie Prieto, Jussi Pylkkänen, Rebecca Rabinow, Sophie Radix, Emily Rafferty, Aude Raimbault , Richard Rand, Jacques Renoir, Sophie Renoir, William Robinson, Béatrice Roche, Cora Rosevear, Julie Sasse, Thomas Schlesser, Lionel Schmitt, George T. M. Shackelford, Akemi Shiraha, Amélie Simier, Robert B. Simon, Guillermo Solana, Florence Sonier, Fabienne Stahl, Susan Alyson Stein, Louis Stern, Andrew Strauss, Jeanne Sudour, Cécile Tainturier, Akiya Takahashi, Marie-Dominique De Teneuille, Antoine Terrasse, Christelle Terrier, Gary Tinterow, Seiichiro Ujiie, Élise Vanhaecke, Julien Valtat, Christine Vayssié-Charbonnier, Isabelle Vazelle, Pierrette Vernon, Charles Villeneuve de Janti, Ada-Louise, Marthe, and Simon Voituriez, Marie-Claire Waille, Amy Walsh, Jacqueline Warren, Heinz Widauer, Guy Wildenstein, MaryAnn Wilkinson, Matthew Witkowsky, Céline Wormdal, Ayako Yoshida, and Michael Zimmermann.

At the Musée d'Orsay

We would like to thank our colleagues at the Musée d'Orsay who helped us with this exhibition, and the following in particular:

Patrice Schmidt and Sophie Boegly, for their work on the catalogue as well as the documentary rooms in the Paris venue; Laurent Stanich, for his good taste in framing and hanging the photographs in the documentary rooms in the Paris venue; and also: Saskia Bakhuys Vernet, Stéphane Bayard, Véronique Beauregard, Joëlle Bolloch, Martine Bozon, Myriam Bru, Evelyne Chatelus, Stéphanie De Brabander, Pascale Desriac, Denise Faïfe, Françoise Fur, Thomas Galifot, André Guttierez, Françoise Heilbrun, Nadège Horner, Isabelle Julia, Pierre Korzilius, Dominique Lobstein, Laurence Madeline, Laure de Margerie, Géraldine Masson, Caroline Mathieu, Nathalie Mengelle, Virginie Noubissié, Sylvie Patin, Héléna Patsiamanis, Delphine Peschard, Anne Pouchelon, Scarlett Reliquet, Michèle Rongus, Anne Roquebert, Marie-Pierre Salé, and Hubert Tayeb.

With a special thanks to: Élodie Voillot and Paul Perrin; as well as Lise Bréant, Anne Chapoutot, Gabrielle Cohen, Marie-Pierre Leduc, Lucile Ribeaudeau, Laure Sanchez, Tatjana Slyschak, and Adam Tanaka.

At the Los Angeles County Museum of Art

Among the great number of colleagues at LACMA who generously have supported this project and helped us realize it, we wish to thank, in particular: Victoria Behner, Laura Benites, Melissa Bomes, Marci Broiles, Annie Carone, Douglas Cordell, Shelly Cho, Eileen Dikdan, Thomas Frick, Jennifer MacNair, Amy McFarland, Nancy Meyer, Meghan Moran, Elaine Peterson, VanAn Tranchi, Diana Veach, and Daniel Young.

Very special thanks go to Melissa Pope, who applied her tremendous organizational talent to the proper management of checklists, correspondence, and a myriad of other crucial details. Our debt to her is immense.

At the Philadelphia Museum of Art

We would like to thank the many colleagues in Philadelphia who have offered vital support and assistance with the exhibition, in particular: Ruth Abrahams, Susan K. Anderson, Nancy Ash, Sherry Babbitt, Peter Barberie, Marcia L. Birbilis, Sarah Cantor, Ashley Carey, Conna Clark, Lindsey Crissman, Peter Dunn, Gretchen Dykstra, Elisabeth Flynn, Camille S. Focarino, Holly Frisbee, Sharon Hildebrand, Scott Homolka, John Ittmann, Norman Keyes, Shelley Langdale, Katie Leimbach, Teresa Lignelli, Sally Malenka, Kelly O'Brien, Suzanne P. Penn, Jack Schlechter, Shannon Schuler, Innis H. Shoemaker, Marla K. Shoemaker, Andrew Slavinskas, Mimi Stein, Michael R. Taylor, Mary Teeling, Evan Towle, Mark S. Tucker, Jennifer L. Vanim, Lindsay Warner, and Maia Wind.

Jennifer Thompson is especially appreciative of the research assistance provided by Alison Chang, Marie Dumas, and Antongiulio Sorgini.

This catalogue was coordinated by

Claudia Einecke and Sylvie Patry

with contributions by

Roger Benjamin
Research Professor in the History of Art,
The University of Sydney

Guy Cogeval
Président de l'Établissement Public du Musée d'Orsay

Flavie Durand-Ruel
Responsable des Archives Durand-Ruel, Durand-Ruel & Cie

Paul-Louis Durand-Ruel
Directeur, Durand-Ruel & Cie

Claudia Einecke
Associate Curator of European Painting and Sculpture,
Los Angeles County Museum of Art

Isabelle Gaëtan
Chargée d'études documentaires au Musée d'Orsay

Emmanuelle Héran
Conservateur du patrimoine, administratrice adjointe de la
RMN, en charge de la politique scientifique

John House
Walter H. Annenberg Professor, Courtauld Institute, London

Virginie Journiac
Conservatrice des Musées de Cagnes-sur-Mer

Martha Lucy
Associate Curator, The Barnes Foundation

Laurence Madeline
Conservateur du patrimoine au Musée d'Orsay

J. Patrice Marandel
The Robert H. Ahmanson Chief Curator of European Art,
Los Angeles County Museum of Art

Monique Nonne
Chargée d'études documentaires émérite

Sylvie Patry
Conservateur du patrimoine au Musée d'Orsay

Jennifer A. Thompson
The Gloria and Jack Drosdick Associate Curator of European
Painting and Sculpture before 1900 and the Rodin Museum,
Philadelphia Museum of Art

Élodie Voillot
Doctorante en histoire de l'art

General Notes

Abbreviations
Cat. (catalogue) designates works in the exhibition.
Fig. (figure) designates comparative illustrations of works
not in the exhibition.

References
Bibliographical references, exhibition catalogues (exh. cat.),
and sales catalogues cited by authors are abbreviated in the
notes (author or city, year). The complete reference can be
found in the bibliography.

Sponsors' Statements

The Iris & B. Gerald Cantor Foundation is honored to sponsor *Renoir in the 20th Century* at the Los Angeles County Museum of Art. We have long been committed to the recognition of significant accomplishments in the arts. The Foundation's avid involvement with Auguste Rodin and his sculpture gives us great understanding of those artists who were at times traditional, at other times innovative. Renoir stands out among these artists. Thus we are pleased to support this exhibition's insightful scholarship and its new perspective on perhaps the most controversial period of the career of one of France's most prolific artists.

The Iris & B. Gerald Cantor Foundation's involvement with *Renoir in the 20th Century* continues the relationship my late husband and I—and our Foundation—have had with LACMA for more than forty years. We have helped the museum add important works of art to its collections, we have supported the creation of gallery spaces and sculpture gardens, we have enabled the museum library to acquire scholarly reference materials, and we have funded enriching programs for the public.

What we have most enjoyed have been the opportunities we have had to sponsor important exhibitions, among them *Sargent and Italy, Treasures of the Holy Land: Ancient Art from the Israel Museum,* and *Gustave Caillebotte: Urban Impressionist.* It is exciting to see *Renoir in the 20th Century* come to the Los Angeles County Museum of Art. To all who have helped create it, I offer my sincerest thanks and admiration.

Iris Cantor
President and Chairman
Iris & B. Gerald Cantor Foundation

The Philadelphia Museum of Art is grateful for the support of
The Annenberg Foundation Fund for Major Exhibitions.

Major foundation support for the Philadelphia presentation was provided
by The Pew Charitable Trusts and The Robert Lehman Foundation.

Additional support was provided by The Women's Committee of the Philadelphia
Museum of Art, generous contributors to the *Renoir Salon*, and other individual
donors.

Preface

It has been twenty-five years since the Hayward Gallery in London presented its important retrospective on Pierre-Auguste Renoir, in conjunction with the Galeries Nationales du Grand Palais in Paris and the Museum of Fine Arts in Boston in 1985–86. Since that time, appreciative audiences have had the chance to see numerous exhibitions devoted to the artist. Among those that spring to mind let us mention the ones dedicated to his portraits (Ottawa, Chicago, and Fort Worth, 1997–98) and to his landscapes from 1865 to 1883 (London, Ottawa, and Philadelphia, 2007–08), two genres in which Renoir distinguished himself especially. Renoir is a painter loved by the public, no doubt about it—but is there not also a Renoir who is unappreciated, or even misunderstood?

The purpose of the present exhibition is to look into the artist's late years. Renoir's career was both long and prolific. Eugène Delacroix was still alive when the young painter made his way up from Limoges to Paris. When he died, in Cagnes in 1919, Pablo Picasso's *Les Demoiselles d'Avignon* was twelve years old, and Henri Matisse's *Interior with Aubergines*, seven. Renoir had long ago abandoned Impressionism. Like Camille Pissarro in his later years, like Edgar Degas, and like Claude Monet, Renoir had sought and found a new way of painting, of understanding reality differently, one that took account of the physical restrictions imposed by age. "Admirable tremor of time"—to use the extraordinary phrase with which Chateaubriand described the late style of Poussin, and which gave Gaëtan Picon the wonderful title for his book on artists' mature work—there is an element of this in the Renoir of the 1890s and the first years of the twentieth century. But late Renoir was also a master for whom tradition, if not academicism, took on a new meaning. In his twilight years, Renoir interpreted, by turns, Watteau and Velázquez and paid homage to Courbet; not least among the painter's many paradoxes were his efforts to seek out modernity through this reinterpretation of classical painting. While the young Impressionist Renoir had thrown down the gauntlet to the Academy, late Renoir's challenge was to invent a strictly modern idiom that he then used to treat classical subjects and compositions inspired by the Old Masters. The painters who were among the first to recognize the remarkable change of direction by the master from Cagnes were not mistaken: Matisse, who visited him and bought several sketches that were displayed on his studio walls in Nice; and Picasso, who more than anyone professed unparalleled admiration for Renoir, not only acquiring late works by the painter, but reinterpreting him in turn. Others made the pilgrimage to Les Collettes: not just the faithful Albert André and Aristide Maillol, but also Amedeo Modigliani and even Tsuguharu Foujita. The most seasoned collectors also admired Renoir, and his late works hung alongside recent creations by Picasso, Matisse, and Duchamp in the homes of the Arensbergs and Steins. At the home of Dr. Albert C. Barnes in Merion, PA, the brilliant collector—a friend and patron of Matisse—deliberately positioned Renoir's late paintings in counterpoint to contemporaneous works by Cézanne, as if to declare parity between the two painters in the formulation of a modern pictorial idiom; browsing through this famous collection, even the most doubtful viewer will be convinced of Renoir's profound originality and his forgotten place among the sources of the twentieth century. It is this forgetfulness that the present exhibition hopes to rectify.

We would like to thank all the lenders, private collectors, and those responsible for public collections who generously agreed to part with works that have a special place in their homes or in the affection of their audiences. If we may express any regret, it would be the impossibility to obtain the loans we would have liked from the Barnes Collection, whose statutes do not allow its works to be removed. We are aware that our project has suffered because of it, but the catalogue tries to make up for this absence.

This exhibition is the successful conclusion of many years of hard, dedicated work on the part of the curators and the fruit of their close and amicable collaboration. We would like to congratulate them and thank them for their commitment and determination in bringing together loaned works that were sometimes difficult to find, as well as introducing a catalogue that is the first publication on this subject. To all those who have made contributions from their own particular areas, we also extend our heartfelt thanks.

This exhibition presents the public with little-known, or even unknown, aspects of a famous artist. We hope that visitors' knowledge of Renoir will be all the richer as a result, and that Renoir will be recognized as a painter of a modernity that is as genuine as it is unexpected.

Thomas Grenon
Administrateur général de la Réunion des Musées Nationaux

Guy Cogeval
Président de l'Établissement Public du Musée d'Orsay

Michael Govan
Chief Executive Officer and Wallis Annenberg Director,
Los Angeles County Museum of Art

Timothy Rub
The George D. Widener Director and Chief Executive Officer,
Philadelphia Museum of Art

Expanding Flesh

Guy Cogeval

Peter Paul Rubens
*The Landing of Maria
de Medici at Marseilles,
November 3, 1600*
1622–25
Oil on canvas
155 x 116 1/4 in. (394 x 295 cm)
Paris, Musée du Louvre

Fig. i

"Renoir likes his women fat . . ." Short and to the point, this sounds a pretty trite verdict veiled in an aura of popular wisdom. But like any cliché, it carries a grain of truth. Caught by the demon of the twilight years, here, we are told, is Renoir indulging in female figures bloated completely out of shape, his painting the plaything of a dirty old man unambiguously and unhesitatingly projecting himself on the surface of the canvas. In his dotage, he listens to the recently awakened sirens of *la grande peinture*, painting mythological and allegorical themes, as if his innate way with private outdoor scenes were no longer good enough for him. As if he were ashamed at finding it comes so easily and naturally to him to empathize so completely with his models and subjects. Thus, in one of the earliest biographies of the artist, Gustave Coquiot expressed his amazement at seeing the old master "beside himself with all those bums, tits, and midriffs."[1]

The fact is that Renoir's "late" period seems to tear up the rulebook of good taste. Whether we call it "Rubenesque" or "baroque," Renoir, suffering from partial paralysis in his old age, appears to have been won over by the *body outrageous*, keeping it up with material of sometimes exhausting richness, the lowered intermediate tones (mauve and silver gray) highlighting the glorious contours. His nudes are more contorted than they should be. Like an artist with nothing left to lose, Renoir dares to be vulgar, and in so doing pulls off one of the dying Impressionist movement's finest seasons— or at any rate one of its most unexpected. Basically it is in poor taste, and we just lap it up!

On January 11, 1913, after visiting Renoir in the South of France, Mary Cassatt wrote to Louisine Havemeyer: "He is painting pictures or rather studies of huge red women with very small heads which are the most awful imaginable. Vollard convinces himself that it is beautiful. J.[oseph] Durand-Ruel has no illusions."[2] Here we have in a nutshell the question raised by the later nudes of a painter who had always considered the nude as the be-all and end-all of art, as it came under fire from good taste occupying the moral high ground. After his death, tongues started wagging and it became an open secret that the old man had lost his marbles. Just one clearcut example is enough to pinpoint what is at issue here. In January of 1920, referring to the post-1897 nudes, Pierre du Colombier noted the following: "It is the woman that, strictly speaking, is called the Renoir woman, a sturdy, slightly vulgar figure, a buxom wench dripping with raw animal sensuality. There are so many of these works (this may have been his most prolific period ever), and so many imitations: do they have to make the public forget the Renoir of 1875 or the Renoir of 1885? Definitely not; in our view, he looks over the hill."[3] This brief pick of objections to Renoir's eroticism could be brought right up-to-date, as feminism has given recent art history fresh arguments for dismissing out of hand a painter who treated his models like animals, a matter of size before inspiration. From old-fashioned Puritanism to the accepted, targeted iconoclasm of the new censors, nothing in this controversy over the painter has changed except more water under the bridge. Back in 1910 this was a retrograde, bourgeois, and conformist debate; in 2009 it has become hopelessly anachronistic. If it is quite a challenge to try to confront a whole set of established norms through this exhibition, then that strikes us as something we want—and need—to be doing.

1. Coquiot 1925, p. 217. **2.** Wadley 1989, pp. 257–258. **3.** Du Colombier 1920.

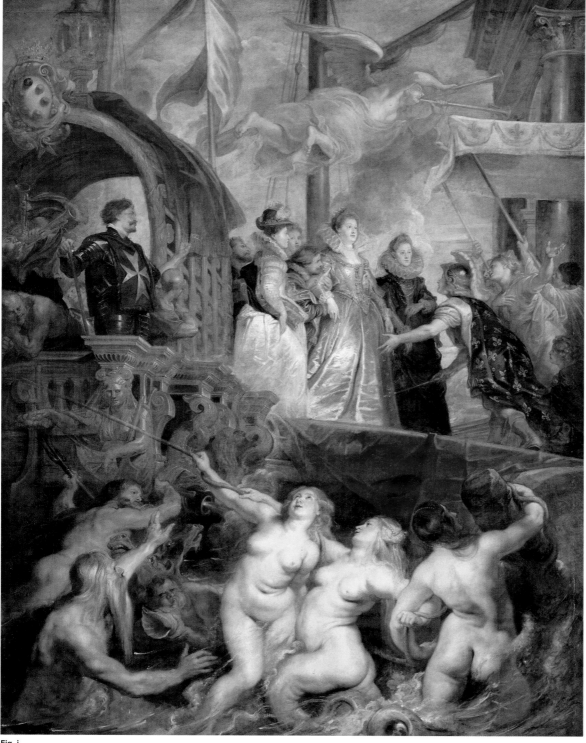

Fig. i

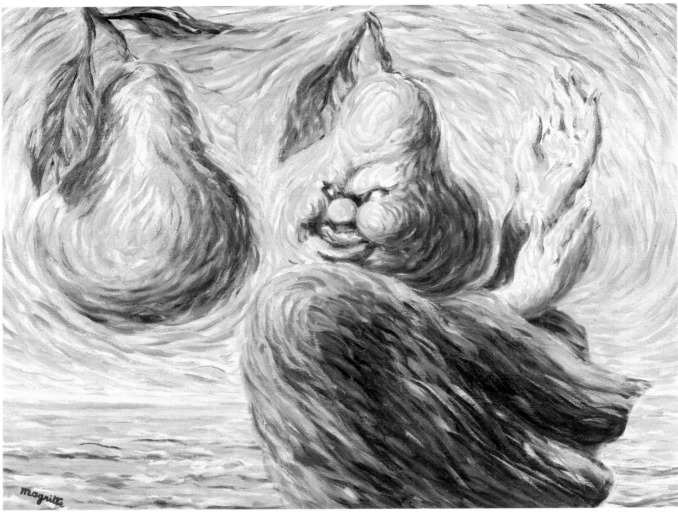

Fig. ii

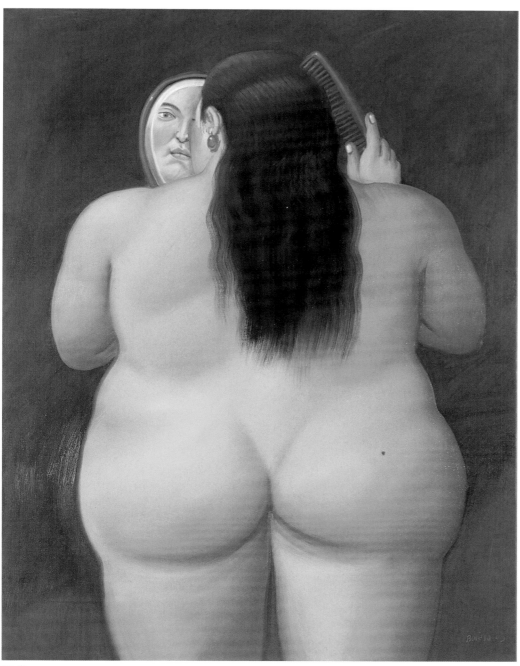

Fig. iii

René Magritte
Lyricism
1947
Oil on canvas
19⁷⁄₈ x 25⁵⁄₈ in. (50.5 x 65 cm)
Brussels, Musée Magritte

Fig. ii

Fernando Botero
The Toilette
Oil on canvas
39³⁄₄ x 30³⁄₈ in. (101 x 77.3 cm)
Private collection

Fig. iii

Pierre-Auguste Renoir
The Clown
1868
Oil on canvas
76³⁄₁₆ x 51³⁄₁₆ in. (193.5 x 130 cm)
Otterlo, Kröller-Müller Museum

Fig. iv

Pierre-Auguste Renoir
The Clown
1909

Cat. 43

Renoir makes no secret of his predilection for "strong women," which is usually taken to describe their forceful personalities but which we shall deliberately misconstrue as applying to his models' corpulent frames and to the insatiable vigor of his turn-ons. His son Jean used to say, in that unmistakable shrill and cocky voice of his: "A really good picture of a pretty woman is one where you want to pinch her bottom. . ." Just kidding, but it says it all. Art history, having a calling to idealize while being puritanical through sheer blindness, tends to shut its eyes to the sexual energy that has run through the destiny of forms ever since prehistoric times. We need to turn to others, like Sigmund Freud or Georges Bataille, to shed some light on our anatomical and erotic imaginary, the strange communion rite of art and desire, the artist and his public, East and West, yesterday and today—and also charm and animal beauty. The body, Barthes used to say, has a history, its own history. Looks, size, weight, magnetism, everything that defines its carnal and social reality is ruled by the relativity of the times. Its canon, to revert to the language of the Renaissance, is pliant stuff, coming in for endless revision, perversion, and projection. As Baudelaire and the Goncourt brothers wrote, art both reflects and determines this perpetually redefined body. Even in days when its representation came under tighter control, in the name of some mathematical ideal, the rules could be bent at will to achieve *de rigueur* visual seduction. Renoir knew this, having frequently looked at and quoted the Old Masters in the broad sense (Praxiteles and Raphael, Titian and Rubens, Watteau and Boucher, Ingres and Courbet)—secret pairings Baudelaire had spotted before him. Velázquez was another he occasionally came back to. The fine portrait of his son Claude (*Claude Renoir as Clown*, 1909 **Cat. 43**), who would only sit properly under a barrage of threats, received critical acclaim as an unexpected return to the terse, raw style of the master of *Las Meninas*. But the critics seem to have missed the extraordinary *Clown* of 1868 **Fig. iv**, an altogether more dangerous, risky alternative foray into Velázquez's territory.

Weighing his words, Renoir described himself as a "painter of figures." History painting, theoretically having seen the most embodiments, could be allowed to fade in this second half of the nineteenth century, with just more of the same classical and religious themes, while the task of the modernists was to revamp this threatened tradition by getting back to basics.

From late 1917 up until his death, Renoir had plenty of conversations with Matisse on the subject of Gustave Courbet. This great producer of flesh continued to have a seminal influence on the painter now based in Cagnes-sur-Mer. Talking with Matisse, they could only have harked back to the time of his early nudes, the painting turned down by the Salon of 1866, a variation on Courbet's incredible and essential (in the sense of "must-have") *Bathers* (Bruyas collection), *Diana the Huntress* of 1867 (Washington, DC, National Gallery of Art) or *Bather with Griffon* of 1870 (São Paulo, Museu de Arte), this last a variation on *Young Ladies on the Banks of the Seine* also by Courbet. For the new painting of the 1860s, including Édouard Manet and Frédéric Bazille, the master from Ornans had the overweening immodesty of the great masters and that typically French, basically rocaille tone, that they wanted to restore in a clean break with wayward academy painting. Later on, and despite an astonishing stylistic outburst of which this exhibition offers one assessment, Renoir constantly demonstrated his preoccupation with the sexual body, going so far as to bring our gaze right up close to those in his compositions. Who in 2009 is going to think that he *just happened* to tackle the Judgment of Paris theme? Or that he might have been so obviously inspired by the Medici gallery of Peter Paul Rubens in the Louvre, and especially by *The Landing of Maria de Medici at Marseilles* (1625), with those amazing plump-rumped sea nymphs that sent Delacroix and Cézanne into raptures in their day? And it will come as a surprise to no one that the painter's heirs had problems getting the last of the Orsay *Bathers* **Cat. 80** into the public collections. The cloud still hanging over late Renoir can be put down mostly to this over-indulgence in epicurean sensuality we find in his output of the 1900s, a prominent feature being the curves of Andrée Heuschling (whom his film director son Jean ended up marrying). As always, the painters did not wait for the historians' permission to acknowledge the value of the most controversial pictures on grounds of laughable good taste. Some paid their debt with a flash of humor: Picasso and Matisse, and Bonnard too, relishing to the full the Mediterranean and mythology post-1910 under the Bernheim brothers' influence; and likewise René Magritte during his "Vache" period **Fig. ii**; up to and including, closer to the present, the outrageous Botero **Fig. iii**.

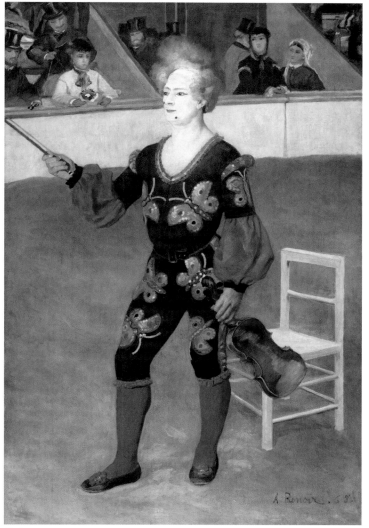

Fig. iv

Cat. 43

Giorgio de Chirico
*Still Life with the Apollo
Belvedere and Fruit*
Ca. 1930
Oil on canvas
18¹/₈ x 21³/₄ in. (46.1 x 55.2 cm)
Verona, Galleria dello Scudo

Fig. v

One of the most unlikely, or at least unfamiliar links is his secret understanding with the art of Giorgio de Chirico. Shortly after the Impressionist giant's demise, De Chirico published an article on "Augusto Renoir" in *Il Convegno*, a journal with a Renaissance title that sums up its rather classical outlook. In it, he draws a distinction between Renoir's style and the easygoing hedonism of the Impressionists: "*The Luncheon of the Boating Party* and *The Artist's Family* are works steeped in melancholy and dark *ennui,* this same world-weariness we find in the great novels of the best French authors. The boredom of the bourgeois family, the dreariness of Sunday afternoons and the country outing; the minor everyday tragedy set in the postures and features of its obscure protagonists . . . The same place is occupied by the female type Renoir has left us with: the lower middle-class woman, the housewife, the mother, the maid, the girl playing the piano, in the vegetable plot or the garden, but it is always the same slightly stuffy atmosphere. All these female figures who at home seem confined to rooms with low ceilings, or on going out meet up in the stifling heat of a still summer evening, or on one of those sultry afternoons in late spring, in which Flaubert kills off Madame Bovary's hapless husband, with all the solemn pathos of Greek tragedy. Renoir definitely belongs to the category of sincere, honest artists. For him, painting was something he just had to do, and while he kept changing styles, or coming under different influences, it was never out of self-interest; he always thought it would improve him, and doing things better was his obsession.[4]"

While De Chirico may have tended to see metaphysics wherever he looked, these comments do however point to this *latent time* in Renoir's late work. And throughout the 1920s and 1930s, De Chirico took many opportunities to paint still lifes **Fig. v** stylistically similar to the ones kept at the Orangerie and nudes that stand as so many tributes to the very late Renoir style.

Others, from Francis Bacon to Lucian Freud, may have combined a secret admiration with the muted violence of what looks like iconoclasm but is actually very much on the same wavelength as the old master's orgy of raw meat . . . The 1904 Salon d'Automne retrospective sponsored by Durand-Ruel and Bernheim-Jeune helped to attune the public to this "dream of happiness" toward which his later style seemed to be heading. It remains for us to weave our way through all the melancholy strands, all the breaks in tone to halftones that it comprises—as well as all those "gray areas" it opens up. This is what the current exhibition sets out to do.

4. De Chirico 1920, quoted in De Chirico 1985, pp. 151–152. Here translated from the French.

Fig. v

Essays

Renoir and the Art of the Past

John House

Pierre-Auguste Renoir's whole career can be seen as an attempt, or rather a sequence of attempts, to reconcile seeming opposites: the opposites of line vs. color; sharp contour vs. subtle gradation of tones; smooth surfaces vs. visible brushmarks; idealization vs. observation; subjects from the past vs. scenes from contemporary life. His sustained study of a wide range of art from the past played a crucial role in his explorations. From an early age he frequented the Louvre in Paris, and his first ambitious paintings in the 1860s demonstrated his acute awareness of many different facets of the art that he saw there. Even in the 1870s, when he was most fully committed to an aesthetic of modernity, his paintings continued to evoke memories of past art, and after 1880 he began overtly to model his own painterly practice on close study of particular painters among the Old Masters. The works that he studied were very diverse, ranging from antique sculpture to the *fêtes galantes* of Jean-Antoine Watteau, but all of them could be seen in the broadest terms as belonging within the category of classicism; he showed less interest in the domestic scenes of seventeenth-century Holland and little if any in the work of Caravaggio and his followers.

While working as a porcelain painter and a decorator of fans in the late 1850s, he developed his lifelong love for the art of the French eighteenth century, and in his old age he remembered studying the work of Watteau, Nicolas Lancret, François Boucher, and Jean-Honoré Fragonard, whose style and imagery clearly underpinned his own decorative designs.[1] At the same time, he reportedly spent his lunchtimes studying the antique sculpture in the Louvre;[2] it was then, we can assume, that he came to appreciate the more informal aspects of the arts of antiquity, so much in tune with the French artists of the eighteenth century.

In the later 1860s, although Renoir committed himself to the representation of contemporary subjects, his exhibition pictures synthesized direct observation with reminiscences of the past. His Salon exhibit in 1870, *Bather*, now known as *Bather with Griffon* (São Paulo, Museu de Arte), had no such direct thematic reference, but the pose of the young woman, undressed from her fashionable contemporary clothing, is clearly reminiscent of antique Venus statues such as the Cnidian Venus, with her hand modestly concealing her sex; she is thus presented as a modern goddess of love.

Even in the mid-1870s, the works that Renoir exhibited at the first three Impressionist group exhibitions retained some linkage with the past. Paintings such as *Ball at the Moulin de la Galette* **Fig. 2** and *The Swing* (Paris, Musée d'Orsay), scenes of recreation and flirtation, can be viewed as modern equivalents to the *fête galante*, comparable, as his close friend Georges Rivière felt, to Watteau's *Embarkation for the Island of Cythera* **Fig. 1** in the Louvre.[3]

Renoir's trip to Italy in the autumn of 1881 has long been seen as a turning point in his career. As he himself declared, he made the trip with the specific intention of seeing the work of Raphael in Rome;[4] the very fact that he planned such a trip indicates that

A related essay was published in Italian as "Il classicismo di Renoir" in exh. cat. Rome 2008.

1. Vollard 1919a, repr. in Vollard 1938, pp. 146–147. **2.** Ibid., p. 145; Renoir was given a permit to copy works in the Louvre in January 1860, before he entered formal training in the studio of Charles Gleyre. See exh. cat. London, Paris, and Boston 1985–86, p. 294 (p. 370 in French ed.). **3.** Rivière 1877, repr. in Riout 1989, pp. 196–197, and in Berson 1996, vol. 1, p. 186.

his interests and concerns were already changing before his departure. Signs of a renewed interest in modeling his figures and a clearer definition of form can also be seen in *Luncheon of the Boating Party* **Fig. 4** of 1880–81, the most ambitious work that he completed in the year before his departure for Italy. Indeed, this picture can be viewed as a tribute to a canvas in the Louvre that he admired throughout his career, Veronese's *Marriage Feast at Cana* **Fig. 3**, translating Veronese's biblical feast into the festive atmosphere of the terrace of the Fournaise restaurant beside the river Seine in summer.

Venice was his first port of call in Italy, but his visit seems to have offered him little of significance in artistic terms; the work of Veronese, he commented, could be better seen in the Louvre.[5] The situation was very different in Rome. Before his visit, he would have been aware of Raphael primarily as the painter of altarpieces and of the Vatican *Stanze,* which he would have known from reproductions; nothing had prepared him for the fresh and informal side of Raphael's art that he found in the decorations of the Villa Farnesina—the *Triumph of Galatea* **Fig. 5**, and the ceiling paintings in the Loggia depicting the *Banquet of the Gods* and, in the spandrels, the story of Cupid and Psyche. Many years later, remembering the impact of the Villa Farnesina on him, he remarked: "Raphael broke with the schools of his time, dedicated himself to the antique, to grandeur and eternal beauty."[6]

This comment shows how Renoir's experiences in Rome enabled him to view Raphael afresh; he recognized that this artist, for so long the paragon of the Academy and the "ancients," could be viewed as a painter who had responded directly to the world around him. He described his reactions to this discovery shortly after his return to France: "Raphael who did not work out of doors had still studied sunlight, for his frescoes are full of it. So, by studying out of doors I have ended up by only seeing the broad harmonies without any longer preoccupying myself with the small details that dim the sunlight rather than illuminating it."[7] Raphael, and especially, perhaps, the spandrel paintings at the Villa Farnesina, acted as the catalyst that led Renoir to simplify and monumentalize his forms, as seen most vividly in *Blonde Bather* **Fig. 6** painted during his Italian trip. Paintings such as this mark a decisive shift in his art, away from the specific details and attributes of contemporary life to an art that combined direct observation with a seemingly timeless vision of the human figure.

After Rome, Renoir moved on to Naples. Here, he found his new understanding of Raphael corroborated by the discovery of the mural paintings from Pompeii and Herculaneum, on display in the Museo Archeologico Nazionale.[8] These lively, informal scenes from classical mythology heightened his awareness of the possibilities of a synthesis between observation and classicism. He later compared them with the decorative arts of the French eighteenth century and with Camille Corot's landscapes peopled with mythological figures;[9] his son Jean remembered him talking about the way in which they suggested "an everyday eternity, revealed on the street corner."[10]

Renoir's great canvas of *Bathers* **Fig. 8** completed in 1887, is the summation of his Italian revelations, but reconceived in terms of French classicism of the late seventeenth and eighteenth centuries.[11] In composition and style, *The Large Bathers* is the clear descendent of the French mythological scenes of the *ancien régime.* Its subject is loosely derived from François Girardon's relief sculpture *Nymphs Bathing* of ca. 1670 in the park of the Château de Versailles, while the closest analogy for the figure group, in composition and in the treatment of the figures, is François Boucher's *Diana Leaving Her Bath* of 1742 **Fig. 83, p. 205** in the Louvre. Beyond these invocations of the informal, hedonistic classicism of French pre-revolutionary court culture, *The Large Bathers* presents a scene that wholly avoids any explicitly contemporary references; these bathing girls dwell in a seemingly timeless world, the province of nymphs and river goddesses rather than *parisiennes.*

Jean-Antoine Watteau
Embarkation for the Island of Cythera
1717
Oil on canvas
50³/4 × 76³/8 in. (129 × 194 cm)
Paris, Musée du Louvre

Fig. 1

Pierre-Auguste Renoir
Ball at the Moulin de la Galette
1876
Oil on canvas
51⁵/8 × 68⁷/8 in. (131 × 175 cm)
Paris, Musée d'Orsay

Fig. 2

Paolo Caliari, called Veronese
The Marriage Feast at Cana
1563
Oil on canvas
266¹/2 × 391¹/3 in. (677 × 994 cm)
Paris, Musée du Louvre

Fig. 3

Pierre-Auguste Renoir
Luncheon of the Boating Party
1881
Oil on canvas
51¹/8 × 68¹/8 in. (130 × 173 cm)
Washington, DC, Phillips Collection

Fig. 4

4. Letter from Renoir to Charles Deudon from Venice, autumn 1881, in Schneider 1945, p. 96, and in Renoir 2002, p. 117: "I want to see the Raphaels, yes sir, the Ra-, the pha-, the -els." **5.** Letter from Renoir to Mme Charpentier, autumn 1881, in Florisoone 1938, p. 36, and in Renoir 2002, p. 116. **6.** Blanche 1949, p. 435, partially repr. in Renoir 2002, p. 203. See also Blanche 1931, pp. 74–75. **7.** Letter from Renoir to Mme Charpentier, February 1882, in Florisoone 1938, p. 36, and in Renoir 2002, pp. 123–124. **8.** The museum in which the majority of the mural paintings discovered in Pompeii and Herculaneum before 1880 were housed. **9.** Vollard 1994, p. 199. **10.** J. Renoir 1962, p. 233. Although a number of paintings from the Pompeian excavations were already on display in the Louvre, it seems to have been his visit to Naples that made Renoir aware of their significance for his artistic project; later in his life, he spoke of his admiration for those that were in the Louvre. See Baudot 1949, p. 28; Alexandre 1930, p. 66; Bernheim-Jeune 1931, vol. 1, p. 11. **11.** See Riopelle 1990; House 1992.

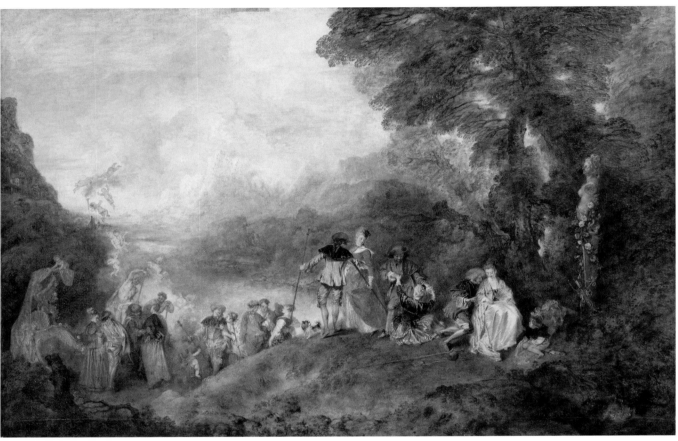

Fig. 1

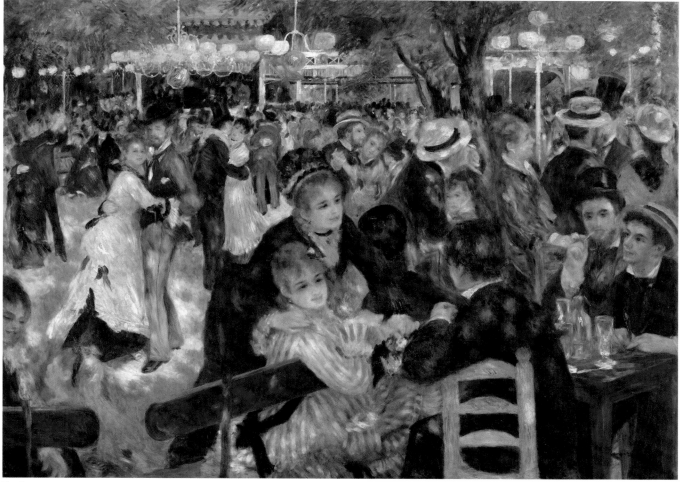

Fig. 2

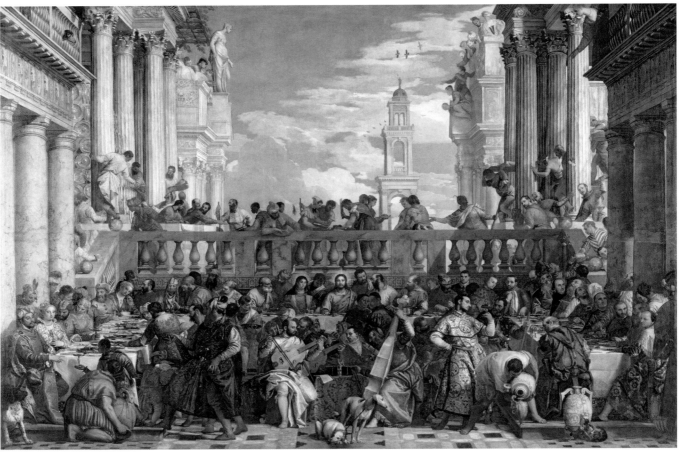

Fig. 3

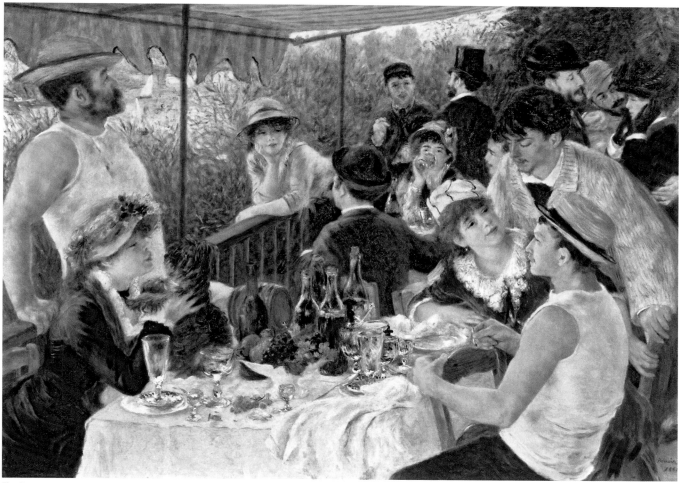

Fig. 4

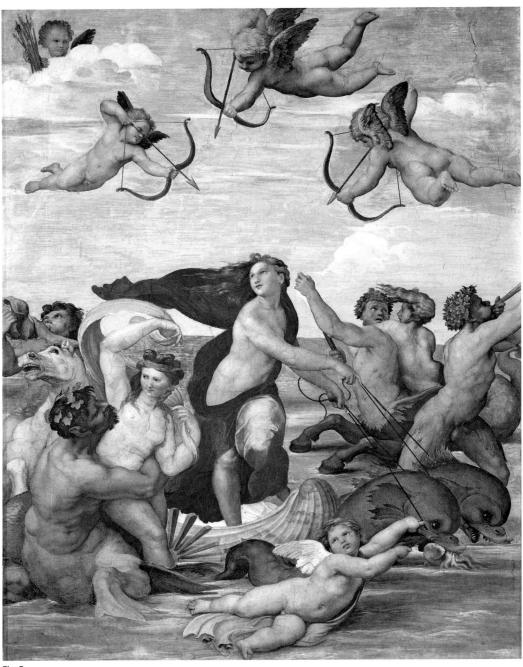

Fig. 5

Fig. 6

Raffaello Sanzio,
called **Raphael**
The Triumph of Galatea
1513–14
Fresco
116 x 88⅝ in. (295 x 225 cm)
Rome, Villa Farnesina

Fig. 5

Pierre-Auguste Renoir
Blonde Bather
1881
Oil on canvas
32¼ x 26 in. (82 x 66 cm)
Williamstown, MA, Sterling and
Francine Clark Art Institute

Fig. 6

Renoir's identification with eighteenth-century French art became still more explicit in the late 1880s and the 1890s, as he sought ways to move beyond the tight drafts-manship of *The Large Bathers* without losing the sense of form that he had reintroduced into his art. Describing his attempts to recapture a lightness of touch, he compared his latest work with the paintings of Fragonard: "It's nothing new, but it's a continuation of the paintings of the eighteenth century . . . Those fellows who give the impression of not painting nature knew more about it than we do."[12] It seems to have been the example of artists such as Fragonard that showed him how three-dimensional form could be suggested by free-flowing colored brushstrokes, as can be seen in a canvas such as *Bathers in the Forest* **Fig. 46, p. 111** of circa 1897, the most elaborate realization of this vision. Its theme is a reprise of *The Large Bathers* of 1887, and the figure-poses draw on studies that he had made for that picture and on the Girardon relief at Versailles. However, in contrast to the stiffness and stillness of the figures in the earlier canvas, the figures are far more animated and the softly brushed paint-handling gives the whole canvas a sense of movement and energy, more reminiscent of the ebullience of Fragonard's *Bathers* **Fig. 7** than of Boucher's more static *Diana Leaving Her Bath*

At the time of his major retrospective at Durand-Ruel's gallery in spring 1892 it became a commonplace to compare Renoir's art with the French eighteenth century,[13] and, in an interview later that year, he emphasized that it was French art that most aroused his enthusiasm, specifically mentioning the work of Watteau, Boucher, and Corot.[14] Reviewing the Renoir exhibition that Durand-Ruel mounted in 1896, Gustave Geffroy emphasized his roots: "he has his very solid link to the art of our French eighteenth century, he continues this lucid, flowery art which is very much ours and belongs to us."[15] Late in his life, he told René Gimpel: "I am of the eighteenth century. I humbly consider not only that my art descends from Watteau, Fragonard, Hubert Robert, but that I am one of them."[16]

Renoir's taste for the arts of the French eighteenth century was part of a wider revival of taste for the Rococo in late-nineteenth-century France. This taste has recently been discussed as one of the ingredients that contributed to Art Nouveau, and has been viewed primarily in terms of artificiality and elaboration, as reflected both in official public decorative commissions and in the private sphere in the *Maison d'un artiste* of Edmond de Goncourt.[17] However, Renoir's vision of the French eighteenth century was quite unlike this; the "penetrating charm and exquisite fantasy"[18] that he found in it was the expression of an unabashed delight in sensory pleasure and lively expression.

Although French eighteenth-century art seems to have been Renoir's primary model for his own practice during the 1890s, the memoirs of Jeanne Baudot, his pupil during these years, testify to his wide-ranging study of both painting and sculpture in the Louvre.[19] As well as long-standing favorites like Delacroix, Watteau, Fragonard, Boucher, and Veronese, he also paid close attention to Titian and Rubens—understandably, given his concern to model the human form with visible strokes of color. More surprising, perhaps, is the enthusiasm that he retained for artists whose treatment of form was pri-marily based on line; he paid close attention to both Ingres and Poussin, and, when instructing Baudot on what to copy as part of her studies, he chose a figure-group from Poussin's *Rape of the Sabines* and also the four dancers on the right of Andrea Mantegna's *Parnassus,* as "the means of submitting me to a discipline and deepening my knowledge of different techniques."[20]

His intense interest in the art of the past during the 1890s is also indicated by the journeys he made, to Madrid in 1892, to London in 1895, to Dresden in 1896 (after a visit to Bayreuth), and to The Hague and Amsterdam in 1898, at the time of a major Rembrandt exhibition. In various conversations, at the time and in his old age, Renoir commented on the art that he had most admired on these trips: at the Prado in Madrid the work of Velázquez and Titian, El Greco's portraits, the "little feet" in Goya's paint-ings of women and Poussin's "freshness";[21] the paintings by Claude Lorrain in London;[22]

12. Letter from Renoir to Paul Durand-Ruel, autumn 1888 [?], in exh. cat. London, Paris, and Boston 1985–86, p. 254 (p. 262 in French ed.), and in Renoir 2002, p. 139. **13.** See e.g. Alexandre 1892, esp. p. 13; Marx 1892, repr. in Marx 1914, pp. 279–282; Mauclair 1892. **14.** [Anon.] 1892. **15.** Geffroy 1896, repr. in Geffroy 1900, p. 191. **16.** Gimpel 1987, p. 21. **17.** See especially Silverman 1989, pp. 17–39. **18.** Renoir, "La société des irrégularistes," May 1884, ms. stored at the Louvre, published in Venturi 1939, vol. 1, pp. 127–129, reproduced in French and translated in the appendix of Herbert 2000, pp. 108–110, 203–204. **19.** Baudot 1949, pp. 28–30. **20.** Ibid., pp. 29–30. **21.** Vollard 1938, pp. 214 (Titian) and 220–221 (Velázquez); J. Renoir 1962, p. 231 (Velázquez); Manet 1979, p. 248, diary entry for August 7, 1899 (Velázquez); André 1928, p. 58 (El Greco and Goya); Denis 1957, vol. 1, p. 121 (Poussin). **22.** Vollard 1938, pp. 225–226.

Vermeer in Dresden[23] **Fig. 9**; and Vermeer, again, as well as Rembrandt, in Amsterdam.[24] The range of Renoir's tastes in these years testifies to the wide-ranging reassessment that he was making of his own artistic aims and methods, in the light of his scrutiny of the art of the past. More specifically, in conversation with Julie Manet he cited the example of Titian and Velázquez, as well as Manet, in discussing his reintroduction of black as a vital element in his palette—a color that he and his colleagues had abandoned as a matter of principle during the 1870s.[25] Renoir's interest in Vermeer at this point can be related to the interior scenes that he was painting in the late 1890s, such as *Christine Lerolle Embroidering* **Cat. 15** and *Breakfast at Berneval* **Fig. 10**, with their complex juxtaposition of foreground and background space.

During the last twenty years of his career, from the late 1890s onward, Renoir's art became more ambitious and his points of reference in the painting of the past changed. Instead of the French eighteenth century, his primary focus was now on Rubens and Titian—on the two painters who, more than any others, had created an ideal of fleshy female beauty and had modeled form with fluent strokes of color. Both artists were well represented in the Louvre—Rubens notably by the Marie de Médicis cycle—but his interests were intensified by the works that he saw on his travels. In 1903, Renoir spoke of his "quivers of joy" in front of Rubens's art,[26] but he felt that there was a depth in Titian that Rubens lacked; he praised Titian's *Venus and the Organist* **Fig. 11**, a canvas that he had seen on his visit to Madrid in 1892, in terms that are particularly relevant to his own late nudes: "The limpidity of that flesh, one wants to caress it. In front of this painting one feels all the joy that Titian had in painting it."[27] "That old Titian," he joked in his old age, "he even looks like me, and he's forever stealing my tricks."[28]

In his own painting, these interests are revealed both in his painting technique and in the greater monumentality of his female figures—a far cry from the adolescent girls in *Bathers in the Forest*. The beginnings of this change can be sensed in canvases such as *Woman Playing the Guitar* of 1897 **Cat. 13**; in *Bather and Maid* of 1900–01 **Fig. 114, p. 337**, the seated bather and her attendant, in a woodland glade, are transformed into a tautly structured pyramidal composition that carries generic echoes of Raphael, but the fullness of the nude figure's form is more reminiscent of Titian. In the long sequence of paintings of his last years representing the female nude, both seated and reclining, he overtly presented himself as the painter who had inherited and revived the lineage of European figure painting. As in the 1890s, these paintings wholly lack any visible signs of the contemporary world; the figures are set either in generic outdoor settings or lavish but inexplicit interiors.

In 1909–10, Renoir put his ideas on painting into words in a sequence of drafts of a preface for a new edition of the academic painter Victor Mottez's translation of Cennino Cennini's *Il Libro dell'arte* (The Craftsman's Handbook). In these texts, he presented his view of a timeless classicism, dating back to ancient Greece, that treated even the gods as a part of everyday life.[29] Renoir believed that these beliefs had been brought back to life in France by François I in the first half of the sixteenth century and had flourished until crushed by the false, imitative classicism that accompanied the French Revolution.[30]

Renoir himself wanted to recreate in paint this notion of a timeless world of love and beauty. Shortly before he died, Joachim Gasquet recorded, Renoir said: "What admirable beings the Greeks were. Their existence was so happy that they imagined that the gods came down to earth to find their paradise and to make love. Yes, the earth was the paradise of the gods . . . That is what I want to paint."[31] In part, this vision was grounded in Renoir's own direct experience of the South of France. Since the late 1890s, he had spent increasing amounts of time, through the winters, on the Mediterranean coast, and the combination of the climate and the visible traces of the region's classical past led him to view the South in idyllic terms: "In this marvelous country, it seems as if misfortune cannot befall one; one is cosseted by the atmosphere."[32] However, this idyllic vision also lay behind canvases with no such explicit subject—behind his scenes of women bathing, and behind the many small landscapes representing the surroundings of Renoir's home at Cagnes on the Mediterranean

Jean-Honoré Fragonard
The Bathers
1763–64
Oil on canvas
25 1/4 x 31 1/2 in. (64 x 80 cm)
Paris, Musée du Louvre

Fig. 7

Pierre-Auguste Renoir
Bathers, an Experiment in Decorative Painting, called *The Large Bathers*
1884–87
Oil on canvas
46 1/2 x 67 3/8 in. (118 x 171 cm)
Philadelphia, Philadelphia Museum of Art

Fig. 8

23. Ibid., p. 206; Baudot 1949, p. 77. **24.** Vollard 1938, pp. 226–227; André 1928, pp. 57–58. **25.** Manet 1979, p. 248, diary entry for August 7, 1899. **26.** Journal of Téodor de Wyzewa (diary entry for January 29, 1903), published (in French) in Duval 1961, p. 138. **27.** Vollard 1994, p. 218. **28.** Pach 1950, p. 21. **29.** Herbert 2000, pp. 165, 241. **30.** Ibid., pp. 172–173, 246–247. **31.** Gasquet 1921, p. 41. **32.** Renoir, as quoted in Rivière 1921, p. 250.

Fig. 7

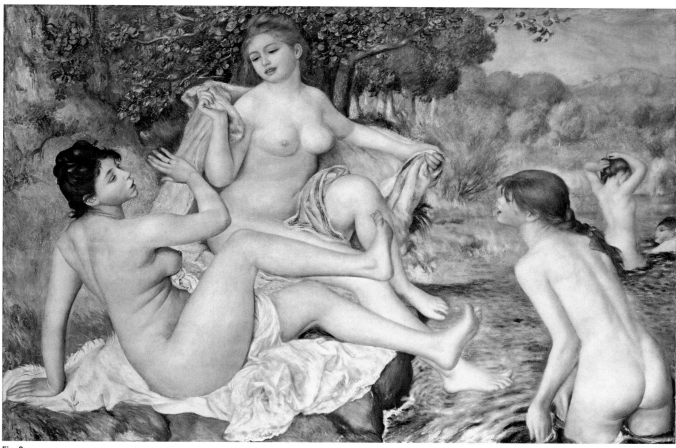

Fig. 8

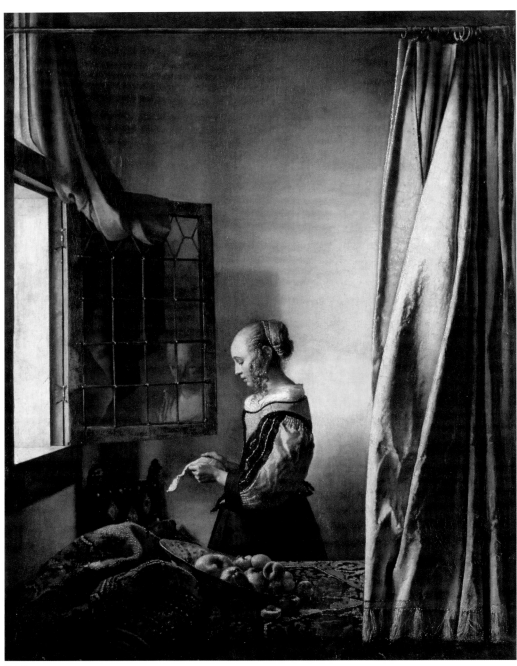

Fig. 9

Fig. 10

Johannes Vermeer
Young Girl Reading a Letter
1657
Oil on canvas
32⅝ x 25¼ in. (83 x 64 cm)
Dresden, Gemäldegalerie

Fig. 9

Pierre-Auguste Renoir
Breakfast at Berneval
1898
Oil on canvas
32¼ x 26 in. (82 x 66 cm)
Private collection

Fig. 10

Tiziano Vecellio, called **Titian**
*Venus with Cupid
and Organist*
Ca. 1550
Oil on canvas
54⅜ x 89⅜ in. (138 x 227 cm)
Madrid, Museo del Prado

Fig. 11

coast. But at the same time, his idea of the earthly paradise marked the extreme point of his wholesale rejection of modernity—of urban culture, of industry and mechanical manufacture, and of emerging socialist and feminist ideas; he was unashamed in his praise for the hierarchical society of the *ancien régime,* as well as for the art and craft practices that he associated with pre-revolutionary France.[33]

In a few works in the last decade of his life, he explicitly treated subjects from classical mythology, notably in his two canvases of the *Judgment of Paris* **Fig. 62, p. 154 & Cat. 65**. The first of these was evidently indebted to Rubens's *Judgment of Paris* in the Prado in Madrid; the central victorious figure in the second, turned toward the spectator, formed the basis of the monumental sculpture *Venus Victrix* **Cat. 70**, made by Richard Guino under Renoir's close supervision in 1914–16. It was when he was planning this that Renoir wrote to Albert André asking him to ascertain the proportions of the antique Venus of Arles and Medici Venus—but not, he said, of the Venus de Milo, "who is a great big gendarme."[34]

Throughout his career, Renoir tried to break down the barriers between the art of the past and his own direct visual experience of the world around him. The past painters whom he most admired were those whose work, as he saw it, revealed a belief in timeless notions of beauty, but at the same time was enlivened by direct observation. At no point in his career did he endorse the abstract and seemingly mechanical values of nineteenth-century academic classicism, though at times he did voice his admiration of paintings by Ingres, the chief mentor of this form of classicism. His most consistent admiration was directed toward the lineage of artists who created a celebratory vision of the world through freely brushed color—ranging from Rubens and Titian to Watteau and Fragonard. But the single moment that perhaps enabled him to reconcile fully the rival claims of past art and direct observation was his discovery in Rome in 1881 of the more informal side of Raphael's art in the Villa Farnesina, and his realization that "Raphael who did not work out of doors had still studied sunlight, for his frescoes are full of it." It was on this basis that he embarked on the exploration of the lessons of the art of the past that underpinned his painting through the last four decades of his career.

33. For further discussion, see House 1985a, and House 1985b. **34.** Letter from Renoir to Albert André, February 16, 1914, in exh. cat. Paris 1932, p. 14.

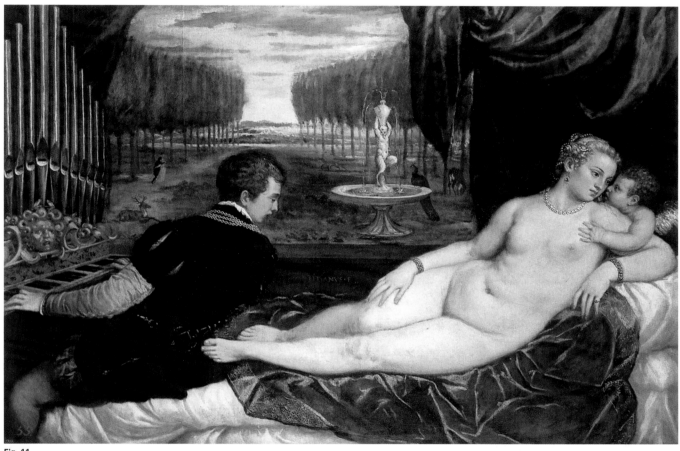

Fig. 11

Renoir and Decorative Art
"A Pleasure without Compare"*

Sylvie Patry

During a meeting with Ambroise Vollard, Renoir returned again to his admiration for François Boucher, saying: "though people have not hesitated to tell me that this was not what one should like, that Boucher 'was no more than a decorator.' A decorator, as if this were a flaw!"[1] It is difficult not to see in this comment an allusion to Renoir's own situation: his paintings are indeed regularly described as "decorative." As the artist suggests, then, the term is ambivalent: laudatory or pejorative by turn, depending on whether one views it as the affirmation of an artist capable of measuring up to a major genre and its large formats, where his desire to make pleasant paintings only serves to demonstrate his mastery of the craft—or, on the contrary, as the mark of a sensuous and superficial form of painting befitting a more minor genre. As often with Renoir, an anecdote or quip also conceals a deeper conception of art and of the artist's status. Renoir was a decorator himself, starting out as a painter of porcelain. And even after he had "crossed the Rubicon" between craftsmanship and great painting, he never ceased to identify himself as such.[2] At the very end of his life, he still had the dream "to do decoration again, like Boucher, and transform entire walls into Olympuses."[3] The alpha and omega of his career, decoration was, in Renoir's eyes, the foundation and function of all art: "Painting is intended to decorate walls, isn't it?"[4]

From this seemingly anodyne and irrefutable fact, one can surmise in Renoir a practice and an aesthetic directed against the "vulgarity" and "ugliness" of his time. Indeed, the only theoretical writings Renoir ever produced address the art of decoration[5] (painting, sculpture, architecture, and the decorative arts), even going so far that, in this field at least, theory seems to prevail over practice. At the current state of research, it is in fact impossible to estimate or define Renoir's decorative corpus precisely, whether with regard to the decorative arts in the strict sense of the term (ceramics, tapestry) or to mural painting: some works have disappeared; others have been removed from their architectural context; many remained in the planning stage. In the early twentieth century, rare were the private dwellings that boasted decorative works by Renoir,[6] and the artist received no commissions for public buildings. With the exception of certain chapters in Robert L. Herbert's *Nature's Workshop* (2000), there have been no specific studies of this question, and Renoir is rarely taken into account by specialists of the art of decoration.

And yet, in the decade between 1900 and 1910, Renoir experimented tirelessly and with renewed enthusiasm in fields as diverse as ceramics, tapestry, mural painting, furnishings, decorative carving, and framing, even though his illness sometimes impeded his execution. To his visitors he affirmed his passion for decoration in all its forms, insisting not without a certain pride on his early career as a craftsman, when they had come to celebrate the "master." Renoir's protestations need to be placed in the wider context of a redefinition of the notion of "decorative" in the early 1890s: the sense of

* Vollard 1994, p. 192.

1. Vollard 1994, p. 144. 2. J. Renoir 1962, p. 69. Jean Renoir's words reveal the gap that separated these two worlds.
3. Renoir, quoted in ibid., p. 98 4. Renoir, quoted by André 1919, translated in Wadley 1987, p. 263. 5. Spanning the period between 1877 and 1910, they were magnificently edited and studied by Robert L. Herbert in 2000, in the light of unpublished manuscripts. 6. For example, the apartment belonging to the Durand-Ruels and that of Maurice Gangnat (see Cat. 40 & 41).

the term was broadened to include works that were not necessarily conceived to form part of a décor but whose formal organization was decorative in itself. The question of "decoration" is therefore a crucial issue, a fresh approach, whether—to speak only of France—in regard to "historical" Impressionists (such as Claude Monet, Camille Pissarro, Mary Cassatt, or Berthe Morisot, in particular), to Post-Impressionist circles, or to artists who, like Pierre Puvis de Chavannes, were favored with public commissions at a time when the new public buildings of the Republic were being adorned at an unprecedented rate. As we can see from examples of ceramic ware and mural painting, Renoir contributed to this debate and forged a grammar of décor that also inspired his easel painting.

"Cheerful earthenware"

It was through the decorative arts that Renoir came into contact with the visual and creative arts[7] when, between 1854 and 1857, he decorated porcelain for the Lévy-Frères company in rue des Fossés-du-Temple.[8] One of the few ceramic pieces **Fig. 12** known to have been decorated by Renoir is emblematic of a type of bronze-mounted porcelain that imitated the sumptuous pieces of Sèvres and Limoges and pastiched the eighteenth century, then enjoying a return to fashion. The 1850s saw important industrial advances: mechanical printing replaced decoration by hand, and Renoir was obliged to abandon his first profession after having dreamed of joining the Sèvres porcelain manufacture, the guardian of manual expertise passed down from the eighteenth century.[9] Subsequently, Renoir appears to have worked with ceramics only on an occasional basis. The flowers filling his still life paintings are generally arranged in commercially acquired vases, such as the "vase that [Aline] had picked up for two sous at the market."[10] During the 1890s, Jeanne Baudot, a young pupil of Renoir's, remarked on the tiles decorated with "two nymphs in a landscape" that he had just produced for the dining room.[11] Like the ceramic plaques Pissarro produced in the 1880s,[12] these tiles were private, non-professional creations. Nevertheless, like the "enameled decorative plaques" executed around 1917,[13] they reveal an interest in an art enjoying a revival, whether in the form of mural ceramics (for example the "Osthaus triptych" that Henri Matisse peopled with nymphs and fauns, or the plaques by Ker-Xavier Roussel) or the development of art ceramics at the turn of the century. One often forgets that around 1906 Renoir played a part in this, however modest, just as the work produced at the Asnières studio around the ceramicist André Metthey is now identified with the birth of Fauve ceramics.[14] At that time Vollard and Metthey were looking for very different types of painters, such as Odilon Redon, Mary Cassatt, Maurice Denis, Pierre Bonnard, Jean Puy, Louis Valtat, and Maurice de Vlaminck, in order to revive an art "annihilated by mechanical printing."[15] Renoir produced simple decorations in a limited color range, applied with a free brush and bearing the hallmark of the traditional ornamental repertoire **Fig. 14**. Unlike some artists, such as Paul Gauguin between 1886 and 1895, or Pablo Picasso later, for whom the revival of ceramics also required the artist himself to fashion the piece, Renoir preferred to limit himself to the decoration of pre-existing forms. Although he may not have been a ceramicist in the sense understood around 1900, mastering the entire process from conception to production, he enthusiastically encouraged his younger sons, Jean and Claude, who were joined by his model Andrée Heuschling, to follow this route.

To support their vocation, in the fall of 1917 Renoir had a kiln built in his garden at Les Collettes. He took a personal interest in Claude's training: "a thrower came to give me lessons, and at the end of every afternoon my father . . . worked with me. He would have me design vases . . . My father . . . would fume about the infirmities that prevented him showing me his extraordinary qualities as a manual worker . . . To

Pierre-Auguste Renoir
Decorated candleholder
Late 1850s
White porcelain and bronze
11 3/4 x 4 1/8 in. (30 x 10.5 cm)
Paris, Musée des Arts Décoratifs, donated by Coco Chanel in 1941

Fig. 12

Jean Renoir (?)
Maleck André and Andrée Heuschling in the ceramics studio at Les Collettes
1920
Gelatin-silver print
Pont-Saint-Esprit, Musée d'Art Sacré du Gard

Fig. 13

Pierre-Auguste Renoir and André Metthey
Vase "Seated Woman"
Ca. 1906
Faience
21 5/8 x 15 3/4 in. (55 x 40 cm)
Paris, Musée des Beaux-Arts de la Ville de Paris, Petit Palais, Gift of Henry-Thomas, subject to life interest, 1986

Fig. 14

7. Although one tends to forget it, Renoir's older brother was an engraver, as was his brother-in-law; he came from a humble background, but one not completely devoid of artistic life, however modest. **8.** Studio founded in 1835 (*Documents sur la sculpture française* 1989, p. 201). The street name changed to rue Amelot (11th arr.) in 1868 (Hillairet 1963, p. 77). **10.** J. Renoir 1962, p. 272. **11.** This was at 13, rue Girardon, Paris. Renoir lived at this address between 1889 and 1901. He met Jeanne Baudot in 1893. "What has become of them [the nymphs]? Did Vollard take them when Renoir moved out?" (Baudot 1949, p. 14). There is a modest painted tile in the bathroom at Les Collettes: Dussaule 1992, p. 95; it is attributed to Claude Renoir. **12.** Shapiro and Lloyd 1980–81, nos. 213 and 214 b. There were two plaques by Pissarro in Mary Cassatt's collection. **13.** C. Renoir 1948, p. 10. **14.** Forest 1996. **15.** Metthey 1907, p. 749.

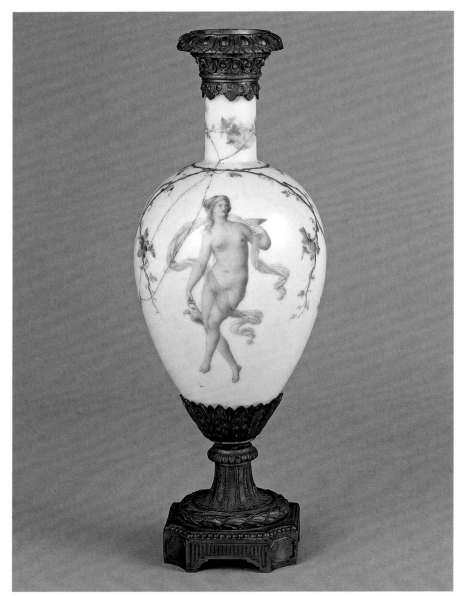

Fig. 12

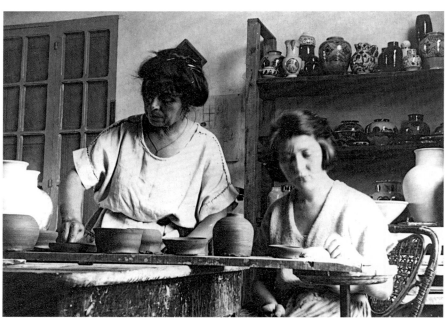

Fig. 13

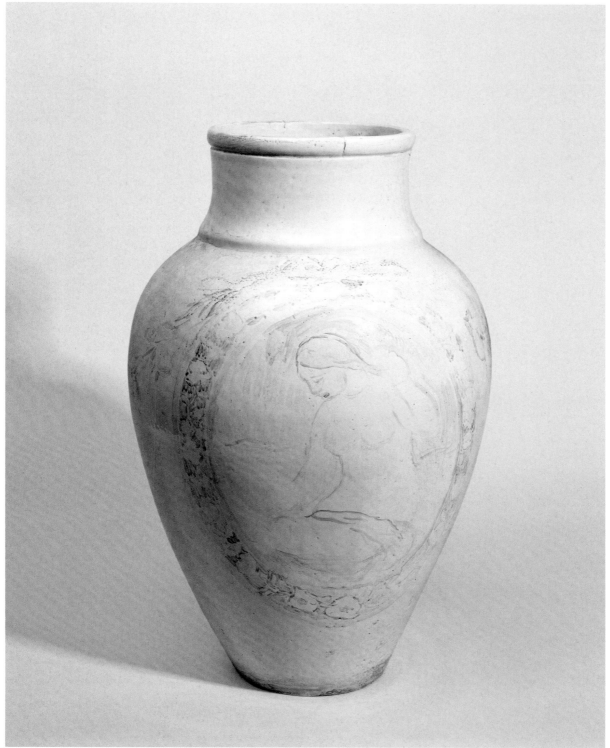

Fig. 14

underline my clumsiness, he painted and drew my vase designs."[16] After his father's death, Jean transformed Les Collettes into a studio-shop run by Andrée, now his wife, and Albert and Maleck André: "At Renoir's wish we did everything by hand. We got our clay out of fields . . . Our wheel was an old-fashioned one operated by a treadle. The baking was done in a wood-oven."[17] **Fig. 13** Truth and simplicity of material and motif, a direct link with nature, manual execution using traditional tools, direct sale to art lovers of the pieces produced: Renoir would certainly have approved this spirit of community, freedom, and craftsmanship that was very much in line with the principles he had expounded back in 1877 and which fulfilled his wishes even in the setting in which it bloomed: the unruly garden of Les Collettes. "We should therefore create reasonably priced inns, in lushly growing places, for decorators,"[18] Renoir once stated.

Although Renoir's ceramic production may have been occasional and modest, it established an aesthetic, moral, and social analysis that went beyond the decorative and fine arts. It is not insignificant that at the end of his life Renoir should have so insistently looked back to the years he spent with Lévy-Frères, a company characteristic of those Paris studios that ranked "far above the commonplace industry, though without seeking any higher title,"[19] and which were consistently honored at Universal Expositions between 1851 and 1876. Rather than the pieces themselves, typical of the historicist taste that Renoir rejected, it was the method of manufacture that was important here and the feeling of having kept alive a tradition of craftsmanship brutally interrupted by an industrial[20] "catastrophe."[21] In common with the revivalist movements in the decorative arts that had grown up in the second half of the nineteenth century—such as William Morris's Arts and Crafts Movement, some of whose work Renoir was familiar with[22]—Renoir indeed ascribed the ugliness of the objects and architecture of his time to mechanization. Not only did machinery produce repetitive, standardized forms, which he contrasted with "irregularity," a key concept of decorative art as far as Renoir was concerned, and one also shared by John Ruskin, it also divided up labor, denaturing the idea of collective production, depriving the worker of control and pleasure in the full process of execution. Renoir expressed nostalgia for the lost sense of community in which the artisan was the creator of his artifact and the artist a worker endowed with a "trade," rather than a theoretician of the avant-garde or an academician upholding institutional values. Up to the end of the eighteenth century, this now vanished cohesion had ensured that beauty reigned, from "doorknob" and "cheerful earthenware"[23] to great interior decoration.

"To put a little gaiety on the wall"[24]—Renoir and Mural Painting

If one were to return once more to Renoir's early years, one would also find an interest in mural painting: as a child Renoir demonstrated his talent by drawing on the wall in charcoal.[25] After giving up his career in porcelain painting, he painted "divinities and symbols on the walls of Paris cafés."[26] None of these twenty or so mural decorations has survived, so it is impossible to know whether they were the equal of the 1868 *The Clown*[27] **Fig. iv, p. 23** that he is thought to have painted for the café of the Cirque d'Hiver.[28] From the walls of cafés and the modest walls of Mère Antony's bar,[29] Renoir went on to create the interior decoration for Prince Georges Bibesco's private Paris residence, built between 1868 and 1872 by Charles Le Cœur, who was a friend of Renoir.[30] Destroyed in 1911, it was the largest décor Renoir produced although this unique example of Renoir's work for a modern dwelling appears to have been rather impersonal **Fig. 15**. In

16. C. Renoir 1948, pp. 8–9. See for example *Plate Design,* in the exh. cat. Chicago 1973, no. 82 (b/w reprod.). Working from canvas models, one hundred sets of thirty-six "Renoir" plates were issued in 1961 by the Urban Gallery with the collaboration of Claude Renoir. See the subscription bulletin, Musée d'Orsay documentation department. **17.** J. Renoir 1974, p. 48. Jean pursued this adventure in Paris in 1921, bringing in a potter from Cagnes named Baude and throwing pottery (Bertin 2005, p. 74). Some of these pieces joined paintings by his father in the collection of Dr. Barnes in Philadelphia. The Renoir Museum in Cagnes has a few. Pieces come up for sale regularly. **18.** Renoir, "Notes, 1883–1884" (Conversations on art in general, devoted to young artists, architects and painters), in Herbert 2000, Appendix E, p. 121. **19.** Quoted in *Documents sur la sculpture française* 1989, p. 201. **20.** "He did not speak of painting but talked passionately about the era of craftsmanship," Bonnard recalls (Bonnard 1941). **21.** If Vollard is to be trusted, this is the term used by Renoir (Vollard 1994, p. 144). **22.** The wallpaper seen in the painting of *Yvonne and Christine Lerolle at the Piano* Cat. 16 is a willow pattern design by William Morris. See Denis 1930, p. 93; Collins 2005, pp. 107–108; Herbert 2000, in particular "Renoir, Ruskin, Morris and the Arts and Crafts in France," pp. 25–40. **23.** Renoir, rough draft for the Cennini preface, 1910, in Herbert 2000, Appendix H, p. 159 (see note 34, below). **24.** J. Renoir 1962, p. 233. **25.** E. Renoir 1879, in Venturi 1939, vol. 2, p. 335. **26.** J. Renoir 1962, p. 99; Vollard 1994, p. 192. **27.** *The Clown [James Bollinger Mazutreek],* 1868, Otterlo, Rijksmuseum Kröller-Müller. **28.** Meier-Graefe 1911, p. 16, footnote. **29.** Renoir admired the decoration and contributed to it, displaying it in his painting *The Cabaret of Mère Antony* (Stockholm, Nationalmuseum): Vollard 1994, p. 156. **30.** See exh. cat. Paris 1996–97b, pp. 50–53, and Le Cœur 2002, pp. 209 and 211–213.

the late 1870s, thanks to commissions from new enthusiasts such as the publisher Georges Charpentier[31] and the banker Paul Berard, Renoir continued to design interiors but always in a private context and on a relatively modest scale. The only complete room design produced by Renoir still in place dates from this period, the dining room at the Berards' château at Wargemont **Fig. 16**: still lifes accompany the elegant eighteenth-century furniture that Renoir so much admired. This decorative production, made possible through a close connection with those who commissioned it (Renoir liked to describe himself as their "regular painter"), encouraged the artist in his conviction that the great tradition of interior decoration could only be restored through a fresh collaboration between the artist, his patron, but also the architect. In the 1890s, Paul Durand-Ruel, Paul Gallimard, and Maurice Gangnat followed the example of Charpentier and the Berards but, with the exception of the Bibesco ceilings, Renoir had no other opportunity to collaborate with an architect. However, as an antidote to the decadence of ornamental painting, in common with the supporters of the revival of decorative art, from the Arts and Crafts Movement to the Nabis, he never ceased to plead for the planned integration of all decorative arts.[32] Renoir went on to produce a number of decorative pendants created independently of any prior architectural context, no doubt encouraged by the success of the "Durand-Ruel Dances" of 1883 **Cat. 1 & 2**. Perhaps one should view this growing trend of the 1890s as a way of continuing to produce decorative pieces without commissions. The fact that Renoir repeated certain pairs **Cat. 6, 7, & 10** would appear to support what remains only a theory given the current state of information. The pendant nature of the compositions, the formats (often life size), the themes (such as nudes, springs, dances), and the technique (painting on frame-mounted canvas) allowed for ease of insertion into a pre-existing setting, whatever it might be.[33]

However, Renoir also continued to work in what remains both the ultimate expression of mural painting and an inaccessible ideal: fresco decoration. This inspired various experiments as well as a piece of writing on the subject in 1910.[34] Renoir wrote the preface to the new French edition of Cennino Cennini's *Il Libro dell'arte* (The Craftsman's Handbook), translated into French by the painter Victor Mottez in 1858,[35] who was one of the first to bring back the lost tradition of fresco. His most spectacular creation, for the church of Saint-Germain-l'Auxerrois (1846) was already in a state of ruin at the time Renoir wrote his preface, between 1908 and 1910, but René Piot or Paul Baudoüin, who later taught fresco classes at the École des Beaux-Arts, gave a new impetus to research.[36] "I have always been interested in fresco," Renoir stated.[37] In fact he was one of the very few artists to practice it in the 1880s under the guidance of a local mason (like Piot some twenty years later) in a church in Calabria while on his Italian tour of 1881 to 1882, during which he discovered the frescoes of Pompeii and those by Raphael. The story is perhaps too good to be true but it reveals a constant fascination for the art: if it had been completed, Renoir's final decorative piece, around 1917, would have been a vast fresco for his house at Les Collettes, making his son Claude regret not being able to "replace the 'consummate craftsman' who worked on the large fresco that was to decorate the staircase of the house."[38]

By the 1870s Renoir was looking for visual equivalents for a technique that was complex to carry out and unsuitable for the climate of northern Europe. Like the Neo-Impressionists and Gauguin, he experimented with media such as plaster and cement around 1877 and considered promoting the use of an English method of painting and sculpture on cement known as MacLean cement, which he used, for example, for the frame of a large mirror in the drawing room of the Charpentier house **Fig. 17**.[39] He also tried his hand at "producing frescoes with oil paints":[40] *Bathers, an Experiment in Decorative Painting,* called *The Large Bathers* (1883–87) **Fig. 8, p. 39** is the most radical example[41] of an effect that he also admired in the pastels of Degas.[42] Renoir's attempts came up against "this fundamental truth, that oil painting must be done with oils."[43]

Charles Le Cœur
Townhouse of Prince Georges Bibesco at 22, boulevard Latour-Maubourg: fireplace in the armory, cross section, and view of the gallery, 1868–72
Paris, Musée d'Orsay
The decoration painted by Renoir was located above the fireplace.

Fig. 15

Pierre-Auguste Renoir
Dining room at the Château de Wargemont with flower and game decoration by Renoir
Maurice Berard, "Renoir à Wargemont," *L'Amour de l'art,* October 1938

Fig. 16

31. Two panels for the staircase, ca. 1876, Hermitage Museum, St. Petersburg; panels of the seasons for the drawing room, 1879, catalogue, Charpentier sale, Paris, April 11, 1907, lot 69. **32.** Renoir 1877, repr. in Herbert 2000, p. 99, 198. **33.** For a more detailed analysis, see the catalogue entries. **34.** First published in *L'Occident* in December 1910, then in June 1911, Bibliothèque de l'Occident. The text and numerous drafts have been studied and published by Herbert, 2000, pp. 41–62 and 158–191. **35.** Cennini 1911. **36.** See Rapetti 1991, pp. 6–19. **37.** Vollard 1994, p. 156. **38.** J. Renoir 1962, p. 236 ; C. Renoir 1948, p. 10. **39.** Pissarro also tried his hand at this, see Pissarro 1989, vol. 1, pp. 117–119; Rivière 1921, pp. 35–36. Our thanks to Élodie Voillot for the information provided. **40.** Renoir, quoted in Vollard 1924, p. 62. **41.** See Riopelle 1990, pp. 367–368. **42.** Vollard 1924, p. 62. **43.** Renoir tried to reduce the oil that acts as the binder in pigments. Renoir, quoted in ibid., pp. 212–213.

HOTEL DU PRINCE GEORGES BIBESCO.

BOULEVARD DE LATOUR MAUBOURG Nº 22.

CHEMINEE · DE LA SALLE D'ARMES · COUPE TRANSVERSALE · VUE DE LA GALERIE

Fig. 15

Fig. 16

Fig. 17

His attraction to the matt quality of fresco work, shared by Puvis de Chavannes, Gauguin, and the Nabis, led Renoir to leave his paintings unvarnished and to think carefully about how they were hung. He was therefore delighted when the rehanging of the Rubens paintings from the Louvre allowed the Maria de Medici series of paintings to be hung "flat like frescoes."[44] Renoir's most ambitious project in this field remains the decorative work inspired by Pompeii in the late 1890s, and in particular the poorly documented series based around *Oedipus Rex* **Fig. 18** for one of the most important early twentieth-century collectors of his work, Paul Gallimard.

Renoir designed a series of panels inspired by Sophocles's play, performed by the actor Mounet-Sully[45] at the Comédie-Française in 1881. Due to a lack of information, we do not know whether it was Gallimard or Renoir who chose the subject. The play had strong reverberations at the turn of the century—from Paris to Athens via Vienna and Orange, it left its mark on figures as diverse as André Antoine, André Gide, Joséphin Péladan, and Sigmund Freud. The play was performed every year at the Comédie-Française,[46] and particularly so between 1894 and 1899,[47] the time when Renoir was working on this project. He must have had an opportunity to see it or find out a great deal about it from the press or from the faithful illustrations by Alexis Joseph Mazerolle published in 1890. It is difficult to imagine what Renoir's plan of action for this series might have been; it was intended to be placed in the Louis XVI wood paneling at Gallimard's house in Bénerville, near Dauville in Normandy,[48] which the artist visited regularly. He appears to have settled on two vertical panels (Sophocles and Jocasta) and two square, narrative panels showing the first and final scenes, which are also those that most impressed audiences. Renoir's interpretation is less an adaptation of a literary text than a recreation of one of the great moments in theater for a collector who was himself director of the Théâtre des Variétés in Paris and patron of the celebrated actress Mademoiselle Dieterlé. The antique décor based on the Willemin collections and the Louvre collections, the costumes vetted by professor Léon Heuzey, who taught drapery at the École des Beaux-Arts, and even the attitudes of the protagonists are what one would have seen at the Comédie-Française or in Mazerolle's book. Renoir's desire to rediscover antique fresco work was no doubt directly connected to one of the most resounding attempts to restore ancient drama. The Gallimard decoration is certainly not the only example found in the oeuvre of Renoir, for whom both performance in general and dance in particular presented undeniable decorative qualities **Cat. 40 & 41**. In his oil sketches (and without us knowing whether he intended to mount the canvases or paint directly onto Gallimard's wall), he makes full use of the tools of the trade to achieve the effect he desired: organizing panels and ornaments by mixing garlands and masks, creating a simplified composition developed as a border with colors reduced to a simple palette of earth tones and red, inspired by the frescoes of Pompeii that Renoir frequently admired at the Louvre.

The decoration was not realized, but Matisse and other visitors to Les Collettes saw the sketches pinned to the wall **Cat. 184, p. 138**, and Picasso had one in his collection **Cat. 76 & Fig. 194, p. 319**. Renoir's forays into decorative painting were only known to a small circle, with Thadée Natanson therefore able to state: "There is no interior decoration by Renoir to speak of."[49] The fact that this sense of a gap in Renoir's work was expressed by Natanson is all the more significant as he was one of the directors of the prestigious magazine *La Revue blanche,* a supporter of Renoir, and one of the most active promoters of the revival of decorative art in the late nineteenth century through the commissions he gave to Vuillard and Bonnard. It must be said that Renoir did not necessarily describe his decorative panels as such when he exhibited them. Furthermore, he never really attained what remained the holy grail of decorative art—monumental public painting—failing to participate in the building of the brand-new Hôtel de Ville in Paris, despite the writings he published as a call for monumental painting in 1877 and his approaches to Georges Lafenestre[50] and Léon Gambetta.[51] Also, Renoir's decorative painting, like that of Mary Cassatt and Berthe Morisot in the early 1890s, did not escape the reservations raised by Degas and Pissarro, for whom decoration "is an embellishment that

Pierre-Auguste Renoir
Mirror frame, surmounted by a medallion, for Mme Charpentier's drawing room
Ca. 1878–79
Painting on cement
Private collection

Fig. 17

44. Renoir, quoted in ibid., p. 224. **45.** Penesco 2005, pp. 181ff. **46.** There were 283 performances between 1881 and 1919 (Joannidès 1921, p. 54). **47.** Daily records from 1891 to 1899, Comédie-Française library, Paris. **48.** White 1984, p. 201. **49.** Natanson 1948, p. 21. **50.** See the undated letters [1882] from Renoir to Georges Charpentier, in Florisoone 1938, pp. 32–34. **51.** J. Renoir 1962, pp. 142–143. A meeting that can be dated to early 1882.

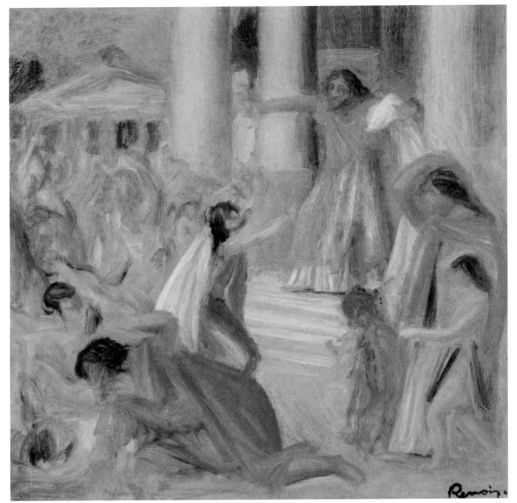

Fig. 18

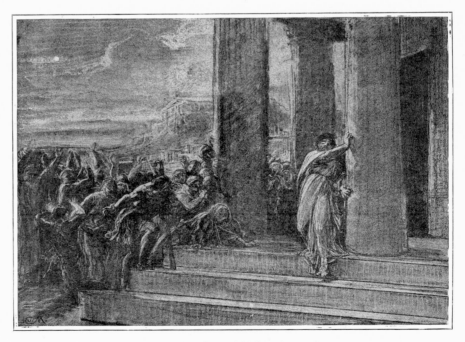

Où suis-je, malheureux ? Où s'égarent mes pas ?

Fig. 19

must be made to form part of a whole; one must therefore reach an understanding with the architect and the painters. The 'painting-decoration' is absurd."[52] Renoir, however, brought a different conclusion to these limitations, transposing his entirely personal concept of decoration to his easel painting.

"Since we are obliged to make easel paintings"[53]—Renoir and the "sense of decoration"[54]

Renoir became part of this movement in the 1890s. It was a movement in which "the decorative spirit would become the magic word in all attempts at renewal," as Pierre Francastel forcefully pointed out in 1937.[55] Renoir's engagement with decorative art, after being emphasized by great enthusiasts of his later work, such as Albert Barnes[56] and Julius Meier-Graefe,[57]—perhaps as a result of the more general attention being given to décor and embellishment by great art historians such as Aloïs Riegl at the turn of the century—was subsequently neglected, until the study by Robert L. Herbert. In addition to the technical experimentation mentioned above, Herbert describes the use of pastel tints, the rhythmic working of the later nudes and the invention of a new Arcadia as Renoir's principal contributions to the "modernist" decorative spirit of the early twentieth century.[58] Renoir differs in stepping aside from the path of synthesis (taken by Gauguin) and abstraction (followed by Monet), which no doubt was a factor in his relegation after 1945. Renoir chose to redefine the decorative according to what were often opposing polarities.

"What I call Grammar or basic notion of art, as you wish, can be explained in one word: irregularity."[59] This founding principle—to which Renoir wished to dedicate a "Society of Irregularists,"[60] endowed with a manifesto drawn up by him—expressed the artist's belief in the need to make nature an essential point of reference. In his eyes, this loss of proximity with nature was what had led to the decadence of nineteenth-century decoration in the West. Nature is evoked less here as the guarantor of truthful representation than as a celebration of an example of liberty, in a way similar to the garden at Les Collettes. For Renoir, nature was essentially "irregular," that is to say alien to the imperatives of order, repetition, and symmetry. Renoir did not, therefore, consider his principles as decorative qualities, differing in this respect from a dominant trend that included artists from Puvis de Chavannes to Georges Seurat and Maurice Denis. Renoir preferred enclosed, full forms to the repetition that suggests the possibility of a boundless continuation of the composition, as in the case of Puvis de Chavannes (whose pictures "seemed to him to be paintings one could pull out and lengthen at will.")[61]

This is why he valued carved, gilded frames, as opposed to the more sober modern borders specifically designed to underline the decorative quality of the painting by integrating it into the interior **Fig. 39, p. 101**. For Renoir, the decorative purpose of the painting did not require continuity to be established between the painting and its environment but the achievement of a harmonious coexistence: the frame must fulfill its function as a border, setting out the painting as a break in continuity and an opening. At a time when decoration was often expressed by a desire for simplification and synthesis, Renoir placed the "richness" of the frame, of color and composition at the heart of the decorative effect: "Painting is intended to decorate walls, isn't it? So we must make it as rich as possible."[62] As Albert André describes: "More and more, he likes compositions that fill the canvas 'to breaking point,' both in terms of surface and depth. He dislikes large, empty areas. He *furnishes* them and it does not feel like filling."[63] By the second decade of the twentieth century, this accumulation of motifs and colored brushstrokes no longer followed the rules of perspective, but, as with Bonnard and Vuillard at the same period, those of textile and tapestry art, fields of art for which Renoir executed cartoons during the same decade **Cat. 88**. This principle of decorative saturation of the painting did not conflict with the ideal of simplicity that Renoir concomitantly embraced. In this respect, the frescoes of Pompeii and the Raphael frescoes

Pierre-Auguste Renoir
Oedipus Rex, decoration project for Paul Gallimard
Late 1890s
Oil on canvas
13³/4 x 13³/4 in. (35 x 35 cm)
Private collection

Fig. 18

Alexis Joseph Mazerolle
"Where am I, miserable wretch, where do my steps wander?"
Engraving, illustration ("true to the performance") of *Oedipus Rex* by Sophocles, translated by Jules Lacroix, Société de Propagation des Livres d'Art, 1890, p. 145
Paris, Bibliothèque de la Comédie-Française

Fig. 19

52. Letter from Pissarro, October 2, 1892 (Pissarro 1989, p. 294). The following year Cassatt decorated the Women's Building at the World's Columbian Exposition in Chicago. **53.** Renoir, quoted in André 1919, translated in Wadley 1987, p. 263 **54.** Renoir, quoted in Pach 1912 and idem 1938, p. 110. **55.** Francastel 1974, p. 88 **56.** Barnes and De Mazia 1935, pp. 143–151 ("Formal Decorative Organization"). **57.** Meier-Graefe 1929, p.399ff. Meier-Graefe reproduced a view of the Renoir exhibition at the Flechtheim gallery in 1927 showing two decorative ensembles. **58.** Herbert 2000, pp. 72–87. **59.** Renoir, "Notes 1883–1884," repr. in Herbert 2000, p. 111. **60.** Renoir, "La Société des irrégularistes, May 1884," repr. in Herbert 2000, pp. 108–110, 203–204. Renoir finally abandoned the idea of publishing this text and founding this society. **61.** Manet 1987, p. 72, undated entry (between October 26 and November 14, 1895). **62.** Quoted in André 1919, cited in Wadley 1987, p. 263. **63.** André 1919, cited in Wadley 1987, p. 263. The emphasis is ours.

Suzuki Harunobu
The Mischievous Crab
1765–70
Woodblock print
Paris, Bibliothèque Nationale de
France, Département des
Estampes et de la Photographie

Fig. 20

Pierre-Auguste Renoir
Two Nudes
Preparatory study for
Bathers Playing with a Crab
Cat. 20
Ca. 1897
Pastel on paper
18³/₈ x 18 in. (46.7 x 45.7 cm)
Merion, PA, Barnes Foundation

Fig. 21

Henri Matisse
Study for the left panel of
Dance *in Merion*
Ca. 1932
Pencil on paper
10¹/₈ x 13¹/₈ in. (25.8 x 33.2 cm)
Nice, Musée Matisse

Fig. 22

at the Villa Farnesina remained a decorative ideal, encouraging a simple yet grand style of painting. For Renoir, simplicity was not synonymous with lack of ornamentation, but rather with the "necessary richness,"[64] that is to say the richness indispensable to the decorative effect, but without being either supererogatory or disharmonious.

Arabesque and distortion, whether in perspective or anatomical, play a part in maintaining this difficult equilibrium. Renoir agrees with Denis, for example, in defending distortion as an idiom essential to his decorative vocabulary. It is distortion that allows the artist to play with scale and format in order to monumentalize figures. Renoir's late nudes are good examples of this (see **Cat. 61, 62, & 80**). He foreshortens, juxtaposes, and amplifies to achieve an overall effect. In Renoir's work, arabesque, which was a key technique in late nineteenth-century decorative painting, also serves to amalgamate the parts with the whole, playing a central and often unrecognized role in his late oeuvre. *Bathers Playing with a Crab* **Cat. 20** could stand as the manifesto of "the writer of the perfect arabesque" celebrated by Natanson.[65] The theme and the composition are reminiscent of Japanese prints, an inspiration for all great nineteenth-century decorative revivals, and here more specifically Harunobu's *The Mischievous Crab* **Fig. 20**, also dominated by an interplay of undulating lines. *Bathers Playing with a Crab* can also be seen as an obsessional reformulation of the manifesto of the *Large Bathers* which by 1883–84 had carried the arabesque to the heart of this "Experiment in Decorative Painting." It is this line that connects the unbalanced bodies[66] and regulates the choreography of these open-air nudes, inspired by the traditional motif of the *lutte d'amour* or battle of love. It is not impossible that Matisse, when reflecting on his *Dance* for the Barnes Foundation (where he was able to view and admire a preparatory version of Renoir's *Bathers Playing with a Crab* **Fig. 21**), may have been a little influenced by the decorative suppleness and effectiveness of Renoir's use of arabesque **Fig. 22**.

Painting as an Armchair

In the end, Renoir invented a form of decorative painting that may well not have enjoyed the setting it deserved: in 1912, looking at the "Gangnat Dances" **Cat. 40 & 41**, Meier-Graefe asked himself: "But where is the architect capable of finding forms that can serve as a framework for this light magnificence, in such a way that room and painting might appear the work of a single hand, as in the eighteenth century and in earlier periods? . . . The joy that the viewer experiences in front of these decorations, which leave far behind them all the decorative efforts of our period, so besotted with style and yet so poor in style, is mingled with the regret that we no longer build palaces . . . But do the paintings have any less value for that? Do they not fulfill their lofty mission precisely for that reason?"[67] Renoir responds to these questions by focusing on the absolute necessity of thinking about and practicing the decorative arts and fine arts together, and by basing them on the principle of pleasure, of execution and perception. According to Renoir it is in this way that beauty will replace the pervading ugliness and that painting will be able to decorate walls and "bring them joy,"[68] producing its full effect and acting as "a cerebral sedative, something similar to a good armchair,"[69] continued Matisse in 1909 as he too reflected on an "art of balance, purity, and tranquility, free from disturbing or worrying subjects"—the mission of the "decorator" was indeed a lofty one!

64. To quote Gustave Moreau, who was also criticized for overfilling his canvases. **65.** Natanson 1896, p. 549. **66.** See the essay by Emmanuelle Héran in this volume, "Renoir, the Sculptor?" p. 70. **67.** Meier-Graefe 1911, p. 181. **68.** Vollard 1994, p. 222. **69.** Matisse 1908, repr. in idem 1972, p. 50.

Fig. 20

Fig. 21

Fig. 22

Dress-up and Costuming
Verfremdung in Renoir's Late Paintings

Claudia Einecke

Jean-Antoine Watteau
Pierrot, formerly called *Gilles*
Ca. 1718–19
Oil on canvas
72⁷/₈ x 59 in. (185 x 150 cm)
Paris, Musée du Louvre, Gift of
Louis La Caze, 1869

Fig. 23

Most analyses of Renoir's late work have focused on the monumental nudes and bathers that so spectacularly highlight his final years.[1] By contrast, little concerted attention has been paid to the remarkable costume fantasies Renoir developed in tandem with them, in the first two decades of the twentieth century. Yet these portraits and studio scenes, in which sitters and models wear fancy-dress costumes, are just as extraordinary as the nudes and, in a way, the flip side of the same coin. They, too, represent a critique of modernity and were Renoir's response to what he considered the many ills of modern urban existence: from mass production and professional specialization to feminism and grotesque fashions.[2] When the painter Suzanne Valadon, Renoir's one-time model and pupil, declared "he began his *Bathers* with a hatred for the ugly female attire of the period," she could have claimed the same for his use of costumes.[3]

Costumes as Markers of Artificiality

A common denominator in Renoir's late costume pictures, which links subjects and models dressed as clowns and hunters, bullfighters and shepherds, Spanish singers and odalisques, is a strategic misfit between fantasy costumes and real-world settings. Consider Renoir's portraits of his younger sons, Jean and Claude, dressed up as clowns in *The White Pierrot* **Cat. 42** and *The Clown* **Cat. 43**. The boys' traditional costumes elicit a range of possible associations: with the circus or stage (Pierrot is a figure from the *commedia dell'arte*), with art history (Renoir's solitary figures invoke Watteau's celebrated *Pierrot* **Fig. 23**), with children's masquerades. Yet none of these plausible situations are implied in the paintings. Rather, the costumed figures are set in neutral spaces: the white *Pierrot* casually perched on a plain, wooden chair; the red *Clown* halted in a columned foyer. In later years, Jean and Claude would distinctly recall the fiction of these and similar arrangements, in which they often participated unwillingly and impatiently; both remembered rebelling against uncomfortable, unloved costumes inflicted on them by their father's pictorial fantasies.[4] At the time, Albert André captured the mere studio-reality of Jean's Pierrot costume in his *Renoir Painting His Family* **Fig. 28**. He shows Renoir at the easel, in the process of painting baby Claude squirming on his nanny's knees, while his wife, in everyday dress, looks on, and Jean, garbed as Pierrot, awaits his turn as model.

The most startling of Renoir's studio constructs are surely the portraits of Alexander Thurneyssen as a *Young Shepherd in Repose* **Cat. 55** and that of the influential Parisian art dealer Ambroise Vollard in a toreador's suit **Cat. 51**. Many commentators have tried to explain away the implausibility of this outlandish costume for the respected Vollard

I wish to thank Michael Marrinan, whose insightful comments on an earlier version of this essay helped sharpen its focus and clarify my argument.

1. For example, Garb 1985; House 1985b; Pointon 1990, pp. 83–98. 2. See, for example, J. Renoir 1962, pp. 101, 381, 247 (industrialization and specialization), p. 88 (modern women), pp. 90, 273, 323 (unhealthy fashions); and exh. cat. Brisbane, Melbourne, and Sydney 1994–95, p. 22 (social decline signaled by the rise of feminism, prostitution, and disease among urban women). 3. Suzanne Valadon, quoted in Coquiot 1925, p. 95. 4. C. Renoir 1948, pp. 6–7, recounts Claude's stubborn refusal to wear the white stockings that were part of his clown suit. Baudot 1949, p. 66, describes how Jean, more than once infuriated his father with his inability to sit still. Jean Renoir, in turn, recalls his loathing for a "Little Lord

Fig. 23

Fig. 24

as an instance of irony and gentle mockery on the artist's part.[5] Yet it is unlikely that Vollard would have overlooked or tolerated even gentle mockery. Nor is it reasonable, as Jean Renoir pointed out, to think that his father would have "painted an enduring masterpiece just for the sake of a joke!"[6] Perhaps a clue to understanding this strange image lies in the painter's response to Vollard's suggestion that he shave off his beard for the portrait: "'Even clean shaven,' Renoir exclaimed, 'do you imagine that anyone would take you for a real toreador?'"[7] Clearly, Renoir did not think of his painting as a representation of reality, even an imaginary reality. Far from the *corrida,* he posed Vollard comfortably on a rattan *chaise-longue* in what seems to be his own studio, with the back of a large stretched canvas and an ornately carved architectural element for a backdrop. The startling incongruity between this everyday setting and Vollard's fancy-dress costume is a self-conscious reminder of Renoir's words: "It is the artist who makes the model."[8]

Costume portraits had been fashionable in the eighteenth century, where the purpose of dress-up was to associate the sitter with the virtues of a mythological or historical figure **Fig. 24**. Renoir's long-standing nostalgic admiration for eighteenth-century art and culture is well documented; he was thoroughly familiar with its traditions.[9] But we miss the point if we take his use of fancy dress to be merely anachronistic historicism. Renoir's sitters wear costumes that do not relate to their lives but, rather, register as a self-conscious artistic choice. The effect of combining egregious fancy dress with normal studio furniture is one of *Verfremdung* (to borrow a term from stagecraft)[10]— a jolt of disorienting alienation that undermines common expectations and reminds us that the work before us is not a representation of reality, but painted theater.

The Issue of Modern Dress

Renoir's decision to use costuming as a means of *Verfremdung* seems particularly apt considering the larger discourse about modern dress and modernist painting that defined the years of his artistic coming of age. The writer Charles Baudelaire addressed it in his 1863 essay *Le Peintre de la vie moderne* (The Painter of Modern Life), where he censured the historicizing use of costumes by academic artists and argued that, since every epoch naturally expressed itself in its fashion, modern art must embrace modern dress.[11] In his mind, costume portraits had been an appropriate mode of representation in the eighteenth century, because they reflected the period's penchant for role-playing inscribed in strict court etiquette and dress codes. By contrast, however, he warned that "[i]f for the necessary and inevitable costume of the age you substitute another, you will be guilty of a mistranslation only to be excused in the case of a masquerade prescribed by fashion."[12] In the end, for Baudelaire the plain black suit was an appropriate embodiment of the paradigm of equality and anonymity reigning in contemporary life.[13]

The critic Edmond Duranty strengthened the link between appearance and modernity in *La Nouvelle Peinture* (The New Painting), an essay occasioned by the second Impressionist exhibition, in 1876. He defined the "modern" portrait as one that rejects role-playing and psychological interpretation in favor of an objective, factual description intended to reveal "the special characteristics of the modern individual—in his clothing, in social situations . . . [S]urrounding . . . him are the furniture, fireplaces, curtains, and walls"—and, we might add, garments—"that indicate his financial position, class, and profession."[14] In fact, Renoir had created such "natural habitat" portraits, notably an earlier image of Ambroise Vollard dressed in a standard business suit **Fig. 25**: seated at a table upon which are also a porcelain figurine and a painted vase,

Jean-Marc Nattier
*Portrait of a Lady as
a Vestal Virgin*
1759
Oil on canvas
45^{1}/$_{2}$ x 53^{1}/$_{2}$ in. (114.3 x 135.9 cm)
Raleigh, North Carolina Museum
of Art, Purchased with funds
from the State of North Carolina

Fig. 24

Fauntleroy" suit his father made him wear for the painting *Child with a Hoop* (1898, repr. Florisoone 1937, p. 61), quoting his former nursemaid, Gabrielle Renard: "It's not how you usually looked! . . . We had to put the suit on you by force, and you kept kicking all the time." (J. Renoir 1962, pp. 396–397) **5.** Exh. cat. Tübingen 1996, p. 308; exh. cat. Rome 2008, p. 54. The exhibition catalogue Ottawa, Chicago, and Fort Worth 1997–98, the definitive study of Renoir's portraiture to date, gives a full account of the genesis of the Vollard portrait, pp. 262–263, 343. **6.** J. Renoir 1962, p. 400: "All our friends thought it was a joke. But it was nothing of the sort. Renoir had no intention of making fun of his model; and he painted the picture that is now so well known. Yet I still come across people who say to me, 'Did your father want to play a joke on Vollard?' As if one painted an enduring masterpiece just for the sake of a joke!" **7.** Vollard 1984, p. 245. **8.** J. Renoir 1962, p. 102. **9.** Fosca 1924, esp. pp. 20–22; exh. cat. London, Paris, and Boston 1985–86, p. 250 (p. 253 in French ed.); exh. cat. Brisbane, Melbourne, and Sydney 1994–95, p. 23; and Herbert 2000, p. 13. **10.** The concept was not invented, but raised to programmatic practice in the early twentieth century by Bertolt Brecht in his "Epic Theater." **11.** Baudelaire 1863, 1970, pp. 11–12. Some of the ideas were already formulated in Baudelaire's, " Salon de 1846" (see note 13, below). **12.** Baudelaire 1863, 1970, p. 13. **13.** Baudelaire 1846, 1965, p. 118.

he studies a small sculpture by Aristide Maillol, one of the young artists in his stable. Here, Vollard is represented in his proper milieu as a discerning connoisseur of modern art.

In Renoir's late costume portraits, however, this path is abandoned; these paintings turn their back on Impressionism and its claim to objective truth. Although we find markers of modern life in the studio settings, and costumes are donned for the occasion, neither the costumes nor the settings contribute to an understanding of the subject's reality or personality; they exist only as artistic fictions. Their fundamental incompatibility breaks the illusion of straight representation and forces us to read the paintings on their own terms: as artificial constructs.

Parallel with the fancy-dress portraits, Renoir employed this heuristic strategy also in two series of obviously staged studio scenes that featured models in Spanish and Oriental costumes. On one level, these compositions, which show women having tea or making music or otherwise whiling away their time, echo another series of pictures, in which female figures in modern dress busy themselves with such mundane domestic tasks as washing, sewing, and lace making **Cat. 15, 33–35**. On another level, however, they also self-consciously negate those realistic representations with fictive, exotic costumes and a mood of indulgent leisure.

Fantasies of Spain and the Orient

To nineteenth-century French minds, both Spain and the "Orient" (as the Middle East and North Africa were called) were exotic places—colorful, sensuous, alluring.[15] This notion formed the basis for an entire discipline of academic painting; it translated into exotic genre scenes in which an abundance of seemingly authentic ethnic details served to lend a convincing sense of realism to titillating "otherness." Part of the appeal of Orientalist paintings, and their Spanish variants, was a near-photographic delineation of costumes, furniture, and architecture to create the seamless illusion of a real (or at least potentially real) foreign world. Pictures of this type stage the fantasy of difference undisturbed by the viewer's awareness of their fictions **Fig. 26**.

When an avant-garde artist like Renoir painted foreign costumes, however, it was with a different mindset and with different results: in his canvases, incongruous settings undercut the associations—otherness, sensuality, eroticism—usually mobilized by exotic paraphernalia. In a half dozen or so pictures of Spanish guitar players Renoir painted around 1896–98, for example, the ethnic element is limited to the costumes—a ruffled white muslin dress trimmed with pink ribbons and bows, as worn in *Woman Playing the Guitar* **Cat. 13**, and a tight-fitting gold-embroidered toreador's suit, featured, for example, in *Young Spanish Woman with a Guitar* **Cat. 14**. These distinctive garments contrast intriguingly with a rather ordinary bourgeois French décor that includes flowered wallpaper, a patterned carpet, tasseled cushions, and a red velvet bedroom chair.

The same approach informs also a much later series of "Orientalist" studio scenes, painted in the 1910s, where—as in *The Concert* **Cat. 79** and in *Woman with a Mandolin* **Cat. 78**—the models wear a range of sensuous ethnic garments: a low-cut, embroidered tight vest with big round buttons; billowy harem pants; a loose diaphanous blouse with white stripes; silk scarves wound around the hips.[16] These costume elements would be at home in standard Orientalist fantasies of exotic and sensual "otherness." However, rather than reinforcing the illusion with matching props, Renoir set them amidst a studio environment that is distinctly French Rococo: witness the carved gilded oval gueridon, rose wallpaper, flower vases, and European tea sets. Our jolt of disorientation—Renoir's effect of *Verfremdung*—tells us that the colorful foreign costumes do not promise ethnographic veracity but, on the contrary, alert us to their existence as self-conscious pictorial devices.

Costumes, Models, and the Studio

Granted, Renoir addressed only indirectly the kind of alienation we are describing. In conversations with the painter Albert André, the confidant of his final years, Renoir

Pierre-Auguste Renoir
Ambroise Vollard
1908
Oil on canvas
32^{1}/$_{8}$ x 25^{5}/$_{8}$ in. (81.6 x 65.2 cm)
London, The Courtauld Gallery,
Gift of Samuel Courtauld, 1932

Fig. 25

14. Duranty 1876, 1996, pp. 43–44. **15.** The literature abut Orientalism and the perception of the Middle East and Northern Africa in the nineteenth century is vast and varied. For the French obsession with Spain, see exh. cat. Paris and New York 2002–03. **16.** Bernheim-Jeune 1931, illustrates more than a dozen Oriental costume pictures. Roger Benjamin offers a detailed, exhaustive study of Renoir's Orientalism, tracing it from the 1870s harem scenes inspired by Delacroix to Renoir's

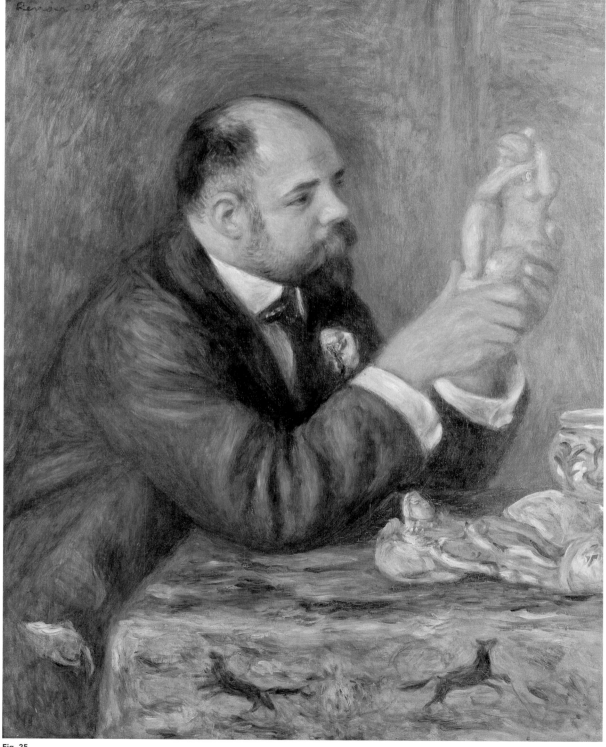

Fig. 25

Fig. 26

reflected on his art and on what he called the central issue of negotiating between objectivity and subjectivity: "How difficult it is in a picture to find the exact point at which to stop copying nature. The painting must not smell too strongly of the model, but at the same time, you must get the feeling of nature. A painting is not a verbatim record . . . Don't ask me whether a painting should be objective or subjective . . . The most important thing is for it to remain painting."[17] Renoir realized that the demands of objective representation and subjective interpretation were not an either-or proposition, but that the goal was to achieve a balance between the two—even if that did privilege the modernist notion of painting as such. To illustrate the practical side of this balancing-act, Renoir cited his recent outdoor nudes: "I battle with my figures until they are simply one with the landscape that serves as their background, and I want people to feel that they are not flat, and that neither are my trees."[18] The terms of his account pertain just as well to the contemporaneous "Oriental" scenes, for example *The Concert,* where overall patterning, close harmonies of color and tone, and a uniformity of facture and *ductus* across the entire canvas integrate figures, costumes, studio décor, and background into a visual one.[19]

A key to the visual unity and conceptual balance of Renoir's late paintings lies in the nuts-and-bolts of his studio practice. One element certainly was the painter's very calculated approach to the studio model who, in his words, "is only there to ignite me . . . to allow me to dare to do things that I would not have known how to invent without a model and to land on my feet if I get in too deep."[20] He stressed, "I couldn't manage without models. Even if I hardly look at them."[21] This simultaneous reliance upon and distancing from the model was a fine perversion of the Impressionist practice of objectively transcribing observed motifs. The physical set-up of Renoir's work area restated this mental attitude in material form. As described by André, and recorded in his 1916 painting *The Painter and His Model* **Fig. 27**, Renoir's studio featured "in the middle of the room, a sort of canopy made from four pieces of wood draped with fabric and serving to distribute the light on to the couch where the model was posing."[22] This stagelike construction, which could be transformed at will by a simple change of fabric hangings, produced a space that was both part of reality and set apart from it. Within this strictly demarcated space, Renoir choreographed a pictorial world in which his models might assume their various roles **Cat. 152, p. 294**.

Working with models upon a stage—with anchors in physical reality firmly fixed before his eyes—Renoir was able to break with reality, to create a world that could exist *only* in the studio and in his paintings. Paradoxically, it is precisely the material triggers of Renoir's late costume pictures—the real models, the real furniture, the real costumes—that sent his imagined world to another register, one that is neither pure reality nor pure imagination, but the hybrid he described as his goal. In their dual nature as both representation and construct, these paintings offer a world that is particular unto itself. A world that only belongs to art.

The categorical separation of painting from representation was perhaps the most pressing issue for early twentieth-century avant-garde artists, many of whom, like Matisse and Picasso, held Renoir in high esteem. Contrary to the widely accepted image of Renoir as a "natural" painter, who worked instinctively, unburdened by theory, and who was essentially solipsistic, André asserted: "He doesn't live in an ivory tower and has always been curious about what is going on in the world of painting."[23] And he quoted this maxim from the artist: "One must do the painting of one's time."[24]

Jean-Léon Gérôme
The Bath
Ca. 1880–85
Oil on canvas
28⁷/₈ x 23¹/₂ in. (73.3 x 59.7 cm)
San Francisco, Fine Arts
Museums of San Francisco,
Mildred Anna Williams Collection

Fig. 26

1881–82 trips to Algeria to its re-emergence in the twentieth century. The discussion of costume here is indebted to Roger Benjamin's description and identification of specific Algerian garments (Benjamin 2003, pp. 111, 113). The transparent gauzy blouse with white stripes or dots, which features in a number of Renoir's late "Oriental" and boudoir images, seems to be a direct quote from the central seated figure in Delacroix's *Women of Algiers in Their Apartment* (1834, Paris, Musée du Louvre). **17.** André 1919, 1923, pp. 34–35; also quoted in Wadley 1987, p. 273. J. Renoir 1962, p. 110, reiterates the point and calls "the contest between subjectivism and objectivism," the "central theme of [Renoir's] life." **18.** André 1923, p. 35. **19.** Our observations about Renoir's late costume pieces might also be usefully applied to reexamine his late nudes, which also often contain concrete remainders of the real world (discarded hats and dresses, the models' "Frenchness") that disrupt the illusion of the ideal, prelapsarian world they allegedly represent. **20.** André 1923, p. 38. **21.** Besson 1929, p. 4. For a comprehensive analysis of Renoir's all-important relationship to his studio models, see the study by Sylvie Patry in exh. cat. Paris 2005–06, pp. 27–37. **22.** André's description in Bernheim-Jeune 1931, vol. 1, p. 9. The stagelike structure is today reconstructed in the artist's large studio at Les Collettes (see Dussaule 1994, p. 58). Significantly, Matisse constructed just such a stage in the studio he rented in Nice from 1921, after he had visited Renoir several times in Cagnes. See exh. cat. Washington, DC, 1986–87, pp. 30–32, and the essay by Roger Benjamin in the present volume, p. 136. **23.** André 1923, p. 20. Colin Bailey cites Octave Mirbeau as the origin of this stereotype in 1913: see exh. cat. Ottawa, Chicago, and Fort Worth 1997–98, p. 44, note 13. **24.** André 1923, p. 49.

Undoubtedly, the stream of admiring young artists, who came to the South of France expressly to pay homage to the master in his old age, were a constant source for the latest ideas.[25] Certainly, Renoir's arresting late costume compositions, with their startling effects of *Verfremdung*, are best understood in relation to the modernist search for new modes of painting in the early twentieth century. Considering that Renoir, a generation older than the Fauves and the Cubists, had one foot in both centuries, it is not surprising that he hesitated to embrace a non-representational idiom. Navigating between an Impressionist realism that claimed objective truth and the illusionistic idealism of the academy, his late paintings chart a new course. By self-consciously mobilizing contradictory realities, Renoir proposed a modernity that was understood by many young avant-garde artists—from Matisse and Bonnard to Maillol and Picasso—who took their own cues from Renoir's work even if they did not, in the end, follow it.

Renoir in his Studio in Cagnes in 1916, after Albert André: The Painter and His Model
(1916, Cagnes-sur-Mer, Musée Renoir)
Reproduced in *L'Illustration*, December 13, 1919

Fig. 27

Albert André
Renoir Painting His Family
1901
Oil on canvas
18 1/8 x 19 5/8 in. (46 x 50 cm)
Pont Saint-Esprit, Musée d'Art Sacré du Gard

Fig. 28

25. See the essay by Virginie Journiac in the present volume, p. 88.

Auguste Renoir dans son atelier de Cagnes, en 1916, d'après le tableau de M. A. André : *le Peintre et le Modèle*.
Phot. Durand-Ruel et fils, éditeurs.

Fig. 27

Fig. 28

Renoir the Sculptor?

Emmanuelle Héran

The very few art historians who have tried to study the sculptures of Renoir have encountered some strange problems. Most of the sculptures were in fact created at the end of his life, at a time when the painter was crippled by illness and could hardly use his hands. So he worked with a young sculptor, Richard Guino, a collaboration that produced some twenty reliefs and sculptures in the round. However, Guino's name did not appear anywhere, neither on the works[1] nor in publications, and the sculptures were released and marketed under the name of Renoir alone. It was only much later and through recourse to the courts that Guino obtained recognition for his position as co-author and for his name to feature alongside that of the painter. An initial ruling was made by the Paris Superior Court on January 11, 1971. After an appeal by Renoir's estate, the judgment was confirmed on July 9, 1971, in a ruling by the Court of Appeals in Paris, then on November 13, 1973, by the Supreme Court of Appeals. In the interim, Guino died in early 1973, before he could hear this final decision.[2]

These legal issues have dissuaded researchers from looking into this aspect of Renoir's work and what is more, from studying the work of Guino. In the absence of any recent study, the book entitled *Renoir sculpteur*, published in 1947 by the Belgian writer Paul Haesaerts, has always been taken as the authoritative work.[3]

As a general rule, critics and art historians have shown very little regard for "Renoir's" sculpture, taking at face value an often-quoted letter from the painter to Albert André: "When Vollard talked to me about sculpture, I sent him packing to begin with. But on reflection I went along with it to have a pleasant companion for a few months. I don't know much about this art, but I have made rapid progess at dominos."[4] According to Georges Rivière, sculpture was no more than "a diversion, a pastime"[5] for Renoir, and as far as Paul Haesaerts was concerned, it was "a passing attempt, almost a bit of entertainment."[6] Indeed, too often have "Renoir's" sculptures scarcely been mentioned, or even left out completely from biographies and exhibitions, as was the case in the big retrospective in 1985. Underlying this lack of regard is the still deep-rooted conviction that sculpture is an art form inferior to painting, even more so when collaboration is involved.

"A hobbyhorse I couldn't shake off"

Now Renoir was deeply fond of this art. As far back as his childhood, he had admired the sculptures in the Louvre. "When I was little, I would often go into the Classical sculpture galleries, without really knowing why, but perhaps because . . . these halls were easy to get into, and no one was ever there. I stayed there for hours, daydreaming."[7] He was fascinated by the statuary in Chartres Cathedral and by Jean Goujon's *Fountain of the Innocents*. He was also interested in contemporary sculpture, pacing up and down the Musée du Luxembourg and visiting Auguste Rodin. "Sculpture had tempted him

1. Renoir was unable to sign neatly in clay. A wet clay stamp was used to replace this signature: Guino inserted it in a notch then smoothed it all over so that the signature formed an integral part of the work. Sometimes the signature only appears in the bronze editions as "Renoir" in block letters. **2.** We recommend the legal clarification of Aral 2008, who was the first to publish the reasons for the 1971 ruling. **3.** While Haesaerts was entirely serious about his work, he cited sources only very occasionally. **4.** Letter from Renoir to Albert André, April 28, 1914, Paris, Institut Néerlandais, Fondation Custodia. **5.** Rivière 1921, p. 252. **6.** Haesaerts 1947, p. 9. **7.** André 1923, p. 45.

all his life,"[8] according to Vollard. "No longer sculpting as a painter, but as a manipulator of authentic reliefs, Renoir would feel nostalgic for it throughout his life and go on to develop plans for it."[9] Jean Renoir talked of "a hobbyhorse [he] couldn't shake off."[10]

Attempts and Temptations

The painter began by carving, on his own, "a frame for a mirror with painted flowers, in the style of the eighteenth century, for Madame Charpentier's salon."[11] This cement frame featured an embedded medallion with the profile of a young woman. He redid only the medallion in bronze (Jacques Renoir collection)[12] though not the frame. Then Renoir tried his hand again at sculpture, modeling portraits in the form of medallions and then a portrait bust of his youngest son Claude, known as Coco **Cat. 89 & 90**—clumsy attempts that were also touchingly free from artifice.

His interest aroused by these few attempts, Vollard tried to persuade him to do more: "I had modeled a small medallion and a bust of my youngest son. Vollard then astutely asked if I would give some advice to a talented young sculptor who would be executing something from one of my paintings."[13] The date ascribed to these portraits varies between 1907 and 1908, but we do not know when this idea took root in Vollard's mind.[14] Barbara White is inclined to accept 1908, as she envisages the dealer tackling the painter about the matter when he was sitting for his portrait (London, Courtauld Institute Galleries), that is to say in the spring of that year, as Renoir wrote to him on May 7 when he was in Cagnes: "Come whenever you like. Now I'm all set to work."[15] There is no document available to vouch for these exchanges with any accuracy.

Richard Guino: Between Oblivion and Recognition

At the point when he met Renoir in 1913, Guino boasted a body of work and a style all his own. Born in Girona in Catalonia on May 26, 1890, and therefore Spanish in terms of nationality, Richard ("Ricard" in Catalan) Guino was twenty-three years old. The son of a cabinetmaker, he was educated at the fine arts school in the city of his birth, and then in the fine arts school in Barcelona.

It was at an exhibition in Girona that Aristide Maillol noticed him. The young Catalan artist joined him in Paris in 1910 and became his pupil and practitioner at l'Académie Ranson. He began to show his work in 1912 at the Société Nationale des Beaux-Arts, then at the Société des Artistes Décorateurs, and in various galleries.

When he worked for Renoir, Guino had to assimilate the style of the master and at the same time, he was continuing to create his own work; when this collaboration came to an end in January 1918, he tried his best to break away from Renoir's style. In 1919, he was fortunate enough to sign a contract with the Hébrard gallery, where he would have the advantage of solo exhibitions; the Sèvres factory ordered models from him from 1922 on; and finally the metal foundry Colin edited his works in bronze after 1924, followed by the Susse foundry in 1931. After World War II, Guino's art, which was unswervingly figurative, went out of fashion and suffered from the growing success of the "Renoir" bronzes. In 1964, he returned to Les Collettes and posed beside the large bronze of the *Venus Victrix* **Fig. 110, p. 314** acquired by the municipality of Cagnes. From the 1960s onward, he fought for recognition as the "co-author" of the "Renoir" sculptures.

Richard Guino died in Antony (Hauts-de-Seine, near Paris) in 1973. Although he was granted French citizenship, he enjoys greater recognition in Catalonia (where the museum in Girona exhibits his work) than in France, where he is barely represented at all in the public collections. His value remains low on the art market. We are still waiting for a serious academic study on his own works, which are preserved religiously by his descendants.

Vollard never cited Guino's name so that he could "lead people to believe that the works he held and sold were executed by Renoir alone."[16] Haesaerts was the first to take up this subject again in 1947. This thirty-year silence has to be set in the context

8. Vollard 1920, p. 200. **9.** Haesaerts 1947, p. 9. **10.** J. Renoir 1962, p. 345 (Fr. ed.). **11.** Rivière 1921, p. 250.
12. Bronze, Jacques Renoir collection. This work is not included in Haesaerts's catalogue, which simply cites it on p. 19 without illustration and dates it "around 1875." **13.** Renoir quoted by Albert André (André 1919, p. 41), repr. in Renoir 2002, pp. 29–30. **14.** Augustin de Butler (Renoir 2002, p. 36, note 55) is mistaken in making Vollard the instigator of the portraits of Coco: "As suggested by Vollard, Renoir completed a medallion and a bust of his son Claude in 1908." Renoir did not need his dealer to model personal effigies… **15.** White 1984, p. 241. **16.** Haesaerts 1947, p. 20.

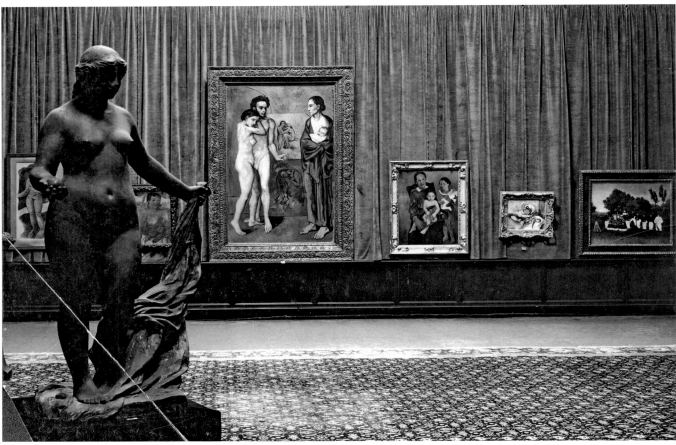

Fig. 29

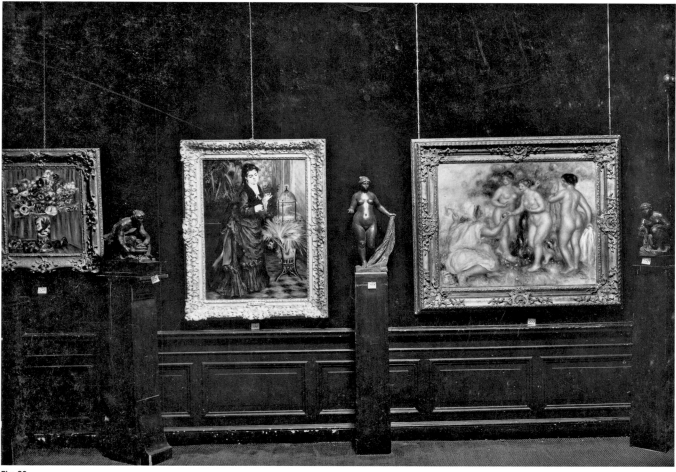

Fig. 30

of that period, when the name of a "practitioner" was never mentioned. When Rodin sold his works, he did not cite the people who helped him to model the clay or who carved the marble for him. When the bronzes with the "Renoir" signature multiplied and when Impressionism was the height of fashion, people took offense at the idea of "the authorship of Renoir's sculptural works being disputed."[17]

The terminology itself varies. In 1934, Pierre Renoir used the term "shared work" and for the transition from painting to sculpture, the verb "to translate." In 1937, Vollard talked about the "practitioner."[18] Rivière prefers the word "collaboration." In the catalogue for the exhibition in Les Collettes in 1969, the word used was "performer." Only in 1974 was the term "practitioner" taken up again in the book by Max-Pol Fouchet.[19] The appellate ruling of November 13, 1973, clearly played a part in this recognition: in 1976 Denis-Jean Clergue mentioned the judgment in the Cagnes exhibition catalogue and for the first time, referred to the special role of Guino, neither as "scribe," "contractor," "actor," nor "performer." Since then, it has been customary for art historians to use the word "practitioners" to describe sculptors' assistants in the nineteenth and early twentieth centuries, and to cite them systematically and study them.[20]

Now the role played by Guino went far beyond that of a simple practitioner or assistant. He modeled clay for an artist who was not a trained sculptor and who was no longer able to model because of the paralysis crippling his hands.[21] He helped to design the works, from both a theoretical and aesthetic perspective, even though Vollard initially informed Guino: "I have agreed it with Monsieur Renoir: he will not have anything to do with your work. You will arrange things with me."[22]

The Method

Guino worked according to the standard procedures of a sculptor in the early twentieth century: he modeled in clay, following a design provided by Renoir and from a live model **Fig. 31 & 33**. The clay was then cast in plaster **Fig. 32 & 34**. It would normally be a mold-maker who carried out this work, but we know that Guino took responsibility for this personally.[23] Occasionally, he would even retouch the plaster while it was still fresh.

The work was done in Essoyes, where a building at the bottom of the garden lent itself to modeling; in Cagnes especially, Renoir put the "gardener's small house"[24] at his disposal. For the enlargement of the *Venus,* the cellar of the main house proved to be more adaptable. As Guino pointed out, Renoir painted "on the first floor. And as for me, I would go down to the cellar and sculpt."[25] They also set up in the garden,[26] as "[u]nder this sun you have the desire to see marble or bronze Venuses among the foliage."[27] The painter always specified the subjects, and provided the sketches based on his paintings; Guino perfected a technique of long strokes in his modeling that create shimmering facets in the light.[28]

Vollard described the painter as holding "a long stick in his hand, dictating the volumes of his *Venus Victrix* to his practitioners," but also talks of a "cane."[30] This account has conveyed the image of a controlling and authoritarian Renoir and a Guino reduced to the level of pupil, in short of a schoolmaster rapping the fingers of a child with his stick. Guino, however, consistently denied this.

What is at stake in this argument about the stick is the degree of control exercised by Renoir on Guino's work. We know that the master continued to paint while in agony from his physical deterioration. Each of them worked in a studio appropriate to his work. Gradually Guino ended up creating well out of view, "alone for days." We stated above that Guino was not employed by Renoir but by Vollard. Some bills[31] provide evidence of the amounts the dealer paid to the young sculptor for his modeling and molding work. Transport receipts for completed works[32] show that Guino then went to the capital to receive the casts in his own studio in order to repair them before sending them to the metal founder.

17. Exh. cat. Marseille 1963, no page number, introduction to chapter on "Sculptures." **18.** Vollard 1937, pp. 281–282. **19.** Fouchet 1974, p. 172, no. 158. **20.** The first academic piece of research on Rodin's practitioners was submitted by Mme Jacqueline Guillot, Paris IV University, in 1989. For contemporary artists, they tend to be called "assistants." **21.** The image conveyed by an Archives Gaumont film in which we see Renoir modeling clay is clearly untrue, as is the image of Rodin carving marble in Sacha Guitry's film *Ceux de chez nous.* **22.** Letter from Vollard to Guino, undated, quoted in Haesaerts 1947, p. 17. **23.** Numerous bills for the purchase of sacks of plaster, but not clay, have been preserved. We therefore have to assume that Guino used local clay. **24.** Haesaerts 1947, p. 12. **25.** Jacques Ginepro, "Richard Guino (1890–1973). *Petite Maternité* (1915)," *L'Estampille,* fiche 163 C. **26.** Vollard 1920, p. 274; see also idem 1937, p. 81. **27.** J. Renoir 1962, p. 438 **28.** See Cat. 92–94. **29.** Vollard 1920, p. 274. **30.** Vollard 1937, p. 281. The term "cane" is also taken up by Perruchot 1964, p. 330. **31.** Private archives. **32.** Ibid.

We do not know who cast the first bronzes on behalf of Vollard. However, an unpublished letter provides the name of Florentin Godard: "Dear Monsieur Guino, I think there has been a mix-up with today's order on the part of Godard, as I have been at rue de Belleville and at your house to no avail. I wanted to tell you not to separate the pieces so that once they are put back in place, they do not give the impression of being something stuck on, in a word, that none of the reliefs [sic] are damaged but in this I know that I can rely on you. Yours, Vollard."[33] This same founder features in the Vollard–Maillol relationship in the context of similar procedures: the sculptor modeled and then took care of potential checks of the proofs; Renoir probably did not see all the proofs sold by Vollard; on the other hand it is possible, even probable, that Guino, the first-rate sculptor, validated them.

The Works

The dating of the sculptures created by Renoir and Guino was published by Haesaerts, from sources he does not cite and following a classification by year. We are proposing a refined form of dating, based on some unpublished archival documents: by season or period (six in total), by location, and by groupings.

From April 1913 until mid-June 1914, the two artists designed the works derived from the *Judgment of Paris*: the *Venus Victrix* in the round—initially the small version begun in Essoyes in the summer of 1913, followed by the large one, continued in Cagnes until spring of 1914 **Cat. 69 & 70**—and *The Judgment of Paris* in relief **Cat. 68** were the chance to compete with the great nudes of Western sculpture. One derivative, the rather more trivial bust of *Paris* (allegedly posed for by Gabrielle), with some alterations went on to become the personification of *La République*. At the same time, they fashioned a clock on an allegorical theme entitled *Hymn to Life* **Cat. 91**. The second, extremely rich, period took place in Cagnes from September/October 1914 until the death of Aline on June 27, 1915. Guino carried on what he had started, modeling medallions of artists, for the time being abandoning Greco-Roman mythology for portraits, both contemporary and retrospective: they represent Cézanne, Corot, Delacroix, Ingres, Monet, and Rodin,[34] among others. During a third period, between November 1, 1915 and June 1916 at the latest, the two artists returned to the nude, this time adopting an allegorical language, by designing a pair of statuettes on the theme of the elements: *Water*, in the form of a washerwoman, and *Fire*, symbolized by a blacksmith **Cat. 93 & 92**. A second version of the clock also dates to this period **Fig. 34**. Renoir also entrusted Guino with the retrospective bust of his wife for her burial place, along with a *Motherhood*. Guino worked on these at Essoyes and Paris from July[35] to September 1916. A fifth period of the Renoir-Guino collaboration took place in Cagnes from November 1916 till the beginning of July 1917. It was devoted to the enlargement of *Water* **Cat. 94**, as well as the continuation of the artists' portraits. The work started again in Cagnes from September to December 1917: the aim was to enlarge *Fire*. But Guino did not finish this work: in January 1918 Renoir dismissed him.[36]

Assessing the Renoir-Guino Collaboration

At the artistic level there can be no doubt that it was, on balance, a positive relationship: as early as 1920, Rivière concluded that "never has a collaboration produced a better outcome than that of Renoir and Guino."[37] Perruchot goes even farther: "The two men are perfectly in tune with each other,"[38] stressing the contrast between the rage of World War I and the pleasant harmony in which the two artists were working. Why and how did this shatter? George Besson reported what the artist had to say about it: "I no longer want to be the author of sculptures made in my absence, from my old sketches." Another concern being: "Vollard has the stamp of my signature. Will he use it, like a brand name, on all sorts of pieces, some of which may be successful but which I do not know about?"[39] More than anything, Renoir who only had a few

Male model posing in Renoir's studio at Les Collettes in Cagnes
Between 1913 and 1916
Photographs
Private archives

Fig. 31 & 33

Pierre-Auguste Renoir and Richard Guino
Fire
(1915–16, Plaster model)
Photograph
Paris, Musée d'Orsay, Vollard Archives

Fig. 32

33. Letter from Vollard to Guino, dated October 9, 1914, private archives. 34. The judges considered these medallions to be the work of Guino alone. 35. Letter from Renoir to Guino, July 23, 1916, in sales cat. Monaco 1994; exh. cat. Columbus 2005–06, p. 116. 36. Letter from Renoir to Vollard, January 7, 1918, sold Paris Drouot, June 6, 1975, no. 45. 37. Rivière 1921, p. 252. 38. Perruchot 1964, p. 330. 39. Quoted in ibid., p. 348, and Aral 2008, p. 101. A photocopy of this letter from Albert André to Guino, dated December 28, 1917, was donated by the Guino family to the archives of Château Grimaldi in Cagnes in 1977. 40. Letter from Renoir to Vollard, January 7, 1918, sold Paris Drouot, Bignou collection, June 6, 1975, no. 45, quoted in Aral 2008, note 105, with an incorrect reference to "Bignon."

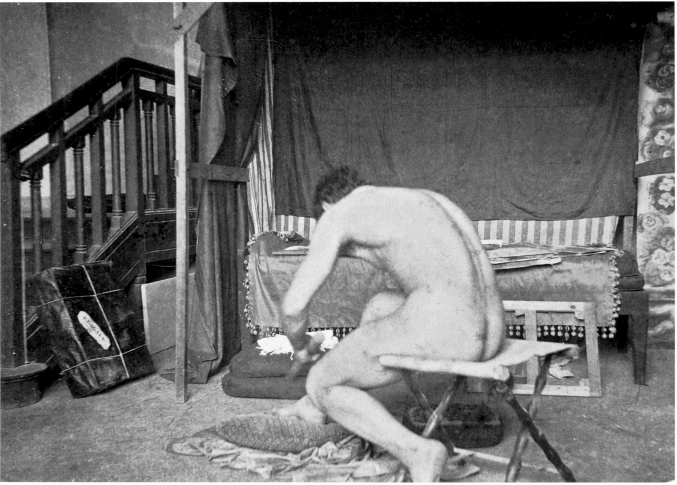

Fig. 31

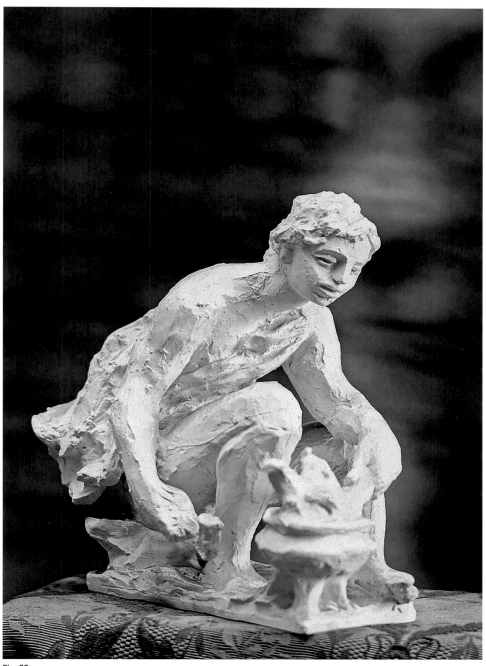

Fig. 32

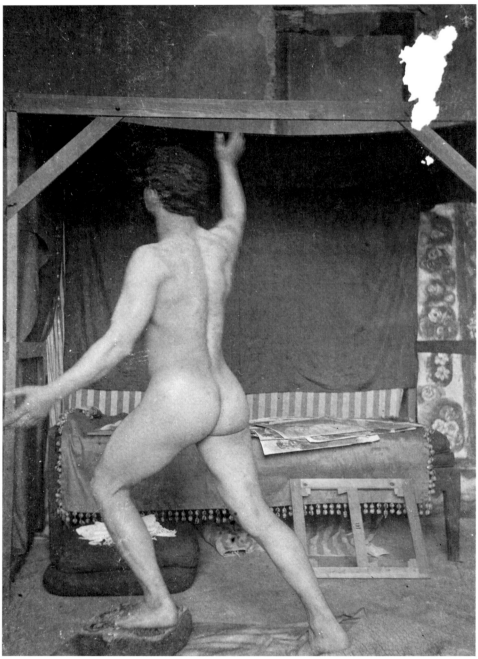

Fig. 33

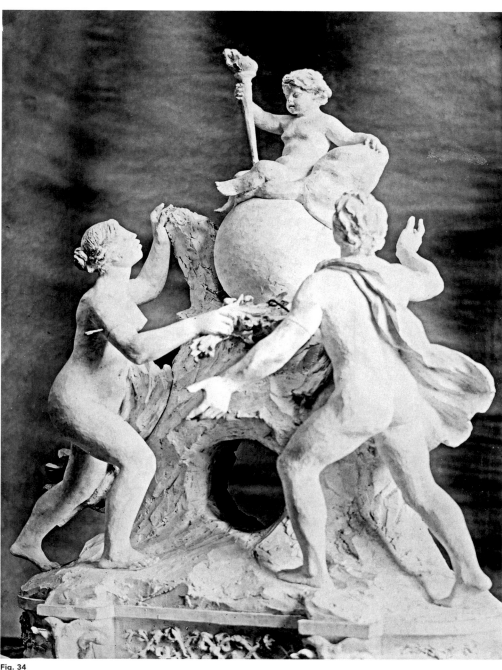

Fig. 34

months to live, declared that he was "extremely tired—very very tired; I would be quite pleased to have a few brief moments of respite."[40]

The first reason may have been the decisive one. Renoir was always forward-looking: going back to his old works held no interest for the old man, who wanted to use the little time he had left to pioneer new directions in painting. His pursuits were no longer the same as Guino's.

The second reason may have been just as influential. The fact that Vollard was selling these sculptures in large quantities exacerbated the unpleasant feeling Renoir had that this creative work was slipping away from him. According to Jean Renoir, he was not a fan of mass production. He needed to sense the hand of the worker, the craftsman, or the artist in the most trivial object. Is it possible that Renoir, when staying in Paris around mid-July 1917, could have seen the bronzes in Vollard's gallery and taken offense? Is there a link with the dealer's visit to Essoyes in August 1917?[41]

Yet the painter never had a bad word to say about Guino. Quite the contrary, when he decided to put an end to their collaboration, he endeavored to make arrangements for him. He recommended him to the sculptor Albert Bartholomé, praising his "incomparable . . . ability; [he was] a charming man whom I would not hurt for the world and who does his utmost to be nice to me."[42]

Last Partners: Louis Morel and Marcel Gimond

In September 1918 Renoir went into partnership with another sculptor, Louis Fernand Morel:[43] "If you happen to feel like coming to work with me, I can offer you hospitality and travel expenses. You will have everything here to make sculptures."[44] Quite independently of Vollard, Morel modeled three classical works—a *Dancer with Tambourine I,* a *Dancer with Tambourine II,* and a *Flute Player*[45] **Cat. 96–98**.

In November 1919 Renoir received a visit from Marcel Gimond. This young sculptor lived in Vence and wanted to do a portrait bust of him. They got along very well with each other. Renoir, who was still interested in sculpture and the decorative arts, "did projects with him, and asked him to collaborate with him for a fountain which they executed together, 'a nude child, with his arm around a swan's neck, underneath a dome supported by reinforced female caryatids,'"[46] and for a small structure which was to act as a case for the *Venus Victrix*. The painter sat four times for him, up to December 1, two days before his death.[47]

Reception and Distribution of the Sculptures of Guino and Renoir

The distribution of the sculptures of Guino and Renoir was slowed down by the war. Their reception was in no way comparable to that of the works shown in the official Salons. Save for the exhibition in spring 1916 of the large *Venus Victrix* and the large *Judgment of Paris* at the Triennial Exhibition, the distribution was a matter for the Parisian galleries, Vollard naturally, and then in the 1930s Étienne Bignou, Maurice Renou, and Pierre Colle, but also in Berlin for Alfred Flechtheim and in Munich, Heinrich Thannhauser **Fig. 29 & 30**, before reaching the United States. In 1934, the body of sculpted works was shown at the Galerie des Beaux-Arts,[48] which prompted Haesaerts to begin his research.[49]

Pierre-Auguste Renoir
and Richard Guino
Hymn to Life
(1913–14, Plaster model)
Photograph
Paris, Musée d'Orsay,
Vollard Archives

Fig. 34

41. Haesaerts also mentioned the quarrelsome temperament of Guino's wife, who is said to have annoyed Renoir. This is no more than a story. Eulalie Verdier died of Spanish flu in 1919, and Guino, who mourned her greatly, bought a burial plot for her in Cagnes cemetery on January 13, 1920. **42.** Letter quoted above from Renoir to Vollard, January 7, 1918. Besides, the correspondence preserved (in private archives) demonstrates a genuine fondness and cordial relations between Renoir's sons and Guino, who even did their portraits, exhibited in Cagnes. **43.** There has been no monograph devoted to Louis Morel. It is possible to consult the book written by a fervent amateur, Pharisien 1998, and the short biography edited by Sylvie Buisson in the exh. cat. Évian 2009, accessed on www.ville-evian.fr. Jacques Renoir made a fascinating documentary film about him. **44.** Letter of September 31, 1918, quoted in Haesaerts 1947, p. 31. **45.** Morel's name appears very late in publications on Renoir. Only in 1947 was he cited by Haesaerts; he was omitted from the exhibition catalogue in Lyon in 1950; Jean Renoir mentions him in 1962; he can be found a year later in the catalogue for the Marseille retrospective. **46.** *Bulletin de la vie artistique,* December 15, 1919, quoted in Perruchot 1964, p. 357. **47.** This bust in bronze was donated to Les Collettes by Mme Gimond. **48.** The Galerie des Beaux-Arts, located at 140, rue du Faubourg-Saint-Honoré, showed eighteen works, as well as engravings, watercolors, and drawings. The preface was written by Raymond Cogniat. **49.** Haesaerts corresponded with Guino as far back as 1941 (private archives). The study of the bronze editions is not the intention of this essay. Only a proper critical catalogue could allow us to disentangle the casts of the two artists when they were still alive from posthumous ones, the real from the fakes, the "original" high quality works from the mediocre, derived products.

Conquering Volume

The sculptures of Guino and Renoir have been interpreted by painting experts. Effectively, his painted works became a distorting prism, and the simple concepts of "sculpture by a painter" and of "painter sculptor"[50] avoid the need for any serious analysis. "Renoir's" sculpted works are certainly inseparable from his work as a painter. Each of them reveals one of his main priorities at the end of his life: "the conquest of volume."[51]

Such a pursuit is nothing new. Translating paintings, drawings, or engravings into sculptures is a time-honored tradition. We could cite the reliefs and sculptures in the round inspired by Dürer or Mantegna. In his book on *The Judgment of Paris,* Hubert Damisch talks of "interpretive sculpture," as one speaks of "interpretive engravings." According to him, "Renoir tried his hand at sculpture, as Raphael did with engraving: through an intermediary."[52] Damisch refers to the organization of Raphael's studio, notably his collaboration with the engraver Marcantonio Raimondi. While the former painted or drew, thus retaining the privilege of "creativity," the latter was only the "hand" that engraved. The signature is explicit: one "creates" and the other "makes."

In our opinion, the pursuit of Renoir and Guino goes far beyond this. It does not restrict itself to the transition from a painted or drawn motif to the third dimension. In this sense, it is significant that from the outset, Renoir wanted to make a statue from the *Judgment of Paris,* rather than a relief, and that the *Venus* in the round preceded the relief. For him, sculptural practice was the chance to conduct more in-depth studies of the monumental nude and its ongoing relationship to nature, and to resolve the tensions between line and contour, depth and volume, surface and light. It stems from a desire to occupy a major position in a rich and prestigious line. The undeniable success of the *Venus Victrix*—measured against no less than the great female nudes of antiquity—and of the *Large Washerwoman* proves that the sculpted works of Renoir and Guino were not, all things considered, an attempt that was of secondary importance to a painter close to death, but instead a lofty aspiration of two fledgling sculptors.

50. Haesaerts 1947 uses this term as early as page 1. See also pp. 33–34. **51.** Rewald, quoted in exh.cat. Monaco 1994, p. 36. We should bear in mind that Rewald was also an expert in sculpture. He is the author of an outstanding work on Maillol. **52.** Damisch 1997, p. 260.

"A painter who has never learned how to draw but who draws well—that is Renoir"*

Isabelle Gaëtan

Pierre-Auguste Renoir
The Coiffure, or *The Bather's Toilette*
Ca. 1900–01

Cat. 84

With these words Paul Gauguin clearly illustrates the ambiguity attached to Renoir's graphic production. Renoir himself, who had little to say on the subject, admitted that he had "never let a day go by without sketching something, even if it's only an apple on the page of a notebook. You lose the knack so quickly."[1] Albert André also refers to this in a text published for an exhibition of Renoir's drawings mounted in 1921 by the Galerie Durand-Ruel. Although Renoir almost always attacked the canvas directly with the brush, he explains, "he would turn out numerous studies in pencil, pen, pastel or red chalk, sometimes in watercolor."[2] Only a minute proportion of all this preparatory work survives[3] because, as Albert André tells us, Renoir "attached little importance to these scraps of paper and, unfortunately, many of them were burned lighting his stove."[4] A large number of drawings were also lost during the artist's many studio moves, as he had no hesitation in destroying his portfolios or even abandoning them to the hands of the concierge.[5]

"One of the rare and important exhibitions of Monsieur Renoir's drawings"
The lack of importance Renoir attached to his drawings—which he saw not as finished works but rather as necessary preludes to his paintings—appears to be confirmed by the fact that there were very few exhibitions of his drawings during his lifetime. The same is not true of his pastel work as, at that period, pastels enjoyed a certain status, similar to painting. Renoir therefore regularly showed his pastels in public, for example at the Salons, Impressionist exhibitions, and at his own personal exhibitions in France and abroad. Pastel was a technique that allowed Renoir to explore his talents as a colorist and occupied a special place in his oeuvre. He executed many pastels, including numerous portraits, which he considered to be finished pieces.[6] His work in pencil, pen, red chalk, charcoal, and watercolor was only shown selectively, for example in July 1879 when his "illustrations, ornamental and topical drawings"[7] were exhibited at the gallery La Vie Moderne in Paris. Some drawings may have been shown (but not included in the catalogue) at the major retrospective devoted to Renoir by the Galerie Durand-Ruel in 1892. A reference to this by Arsène Alexandre in the catalogue preface suggests that this was the case: "A careful study of his drawings, red chalk pieces, and pastels, some highly finished, some left as free sketches, would prove a useful complement to analysis and would also demonstrate his pursuit of the arabesque, just as his painting reveals his pursuit of contour, expression, and color. But one has to limit oneself." In 1896, however, it was a red chalk drawing (*Motherhood*, no. 368) that Renoir chose to

*Gauguin 1974, p. 254.
1. J. Renoir 1962, p. 74. **2.** André 1950, p. 5. In his catalogue *Renoir et Albert André, une amitié (1894–1919)* (exh. cat. Bagnols-sur-Cèze 2004), Alain Girard states that this text, written in 1921, was reprinted in the 1923 and 1928 editions of Albert André's work on Renoir, and was published again with additions in 1950 in his work on Renoir's drawings. The references to the text refer to the 1950 edition. **3.** The dispersal of the corpus has perhaps discouraged research as, with the exception of the pieces written for the 1921 exhibition, three works published between 1946 and 1958, and the facsimile edition, there is, to date, no study of Renoir's drawings. **4.** André 1950, p. 5. **5.** Daulte 1958, p. 7. **6.** Renoir showed two pastels (in the Drawings/Cartoons section) at the 1879 Salon, *Portrait of Paul C.* (no. 4476) and *Portrait of Théophile B.* (no. 4477); in 1880 he showed *Portrait of Lucien Daudet* (no. 5703) and *Portrait of Mademoiselle M. B.* (no. 5704); he showed a pastel entitled *Sketch* (no. 146) at the first Impressionist exhibition in 1874, and a *Portrait of M. H.* (no. 226) at the group's second exhibition in 1876. **7.** *La Vie moderne,* July 17, 1879, p. 239.

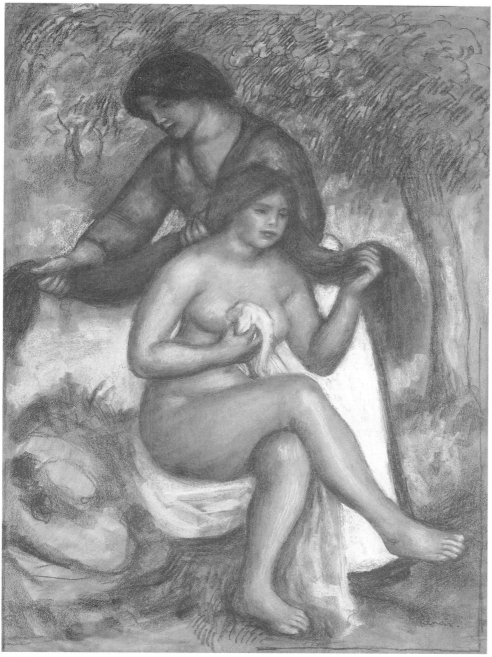

Cat. 84

show at the exhibition La Libre Esthétique in Brussels.[8] This "perfect Renoir drawing" was the only piece the artist exhibited and was singled out by *La Revue blanche* which stated that "this red chalk drawing is the highest expression of art at this exhibition."[9] In 1908, Renoir exhibited another four drawings at La Libre Esthétique as part of its jubilee event.[10] The first exhibition devoted solely to Renoir's drawings opened at the Galerie Vollard in the summer of 1912. The *Chronique des arts et de la curiosité*[11] reported it as being "one of the rare and important exhibitions of Monsieur Renoir's drawings; they date from different periods and all are worthy pieces." Louis Vauxcelles, in addition, recounts that there were "twenty large red chalk drawings . . . evoking all the celebrated works from *Young Woman Breastfeeding her Child* and the fine, large sketches of the *Bathers,* to the profile of *Coco Writing.*"[12]

"We make our way into the artist's studio, he opens his portfolios for us"

Although it was quite difficult to view Renoir's drawings during his lifetime, they very soon attracted keen interest after his death. In spring 1920 there was an affair concerning fake drawings which received copious coverage in *Le Bulletin de la vie artistique*.[13] No doubt hoping to profit from the fame of the recently deceased artist, a New York gallery put on sale a collection of works attributed to Renoir, including ninety-nine pastels.[14] According to the catalogue, these works had been given by Renoir to a female friend and valued by "a very well known artist, who had had dealings with Renoir and who was familiar with his work." As soon as the first piece was sold—in February—Renoir's oldest son, Pierre, protested against what he knew to be a pastiche.[15] The second sale went ahead nevertheless. As the painter Lucien Mignon explained shortly after, these were in fact works that he had painted himself but which had been attributed without his knowledge to Renoir.[16]

It is difficult to say whether it was this affair that prompted the Galerie Durand-Ruel to show Renoir's drawings to the general public. On April 4, 1921, the gallery mounted a large exhibition dedicated to the artist's watercolors, pastels, and drawings. The one hundred and forty-two works exhibited gave a complete overview of Renoir's graphic art, covering the whole of his career and illustrating the different techniques he used. "We make our way into the artist's studio, he opens his portfolios for us, hides nothing from us, from the most accomplished works to the faintest of notes," states François Fosca in one of the rare articles to cover the event.[17] The exhibition prompted the first two articles devoted to this aspect of Renoir's art, one by Fosca and another one by Albert André.[18] Various publications also decided to bring Renoir's drawings to a wider audience. In 1920, twenty-one of his drawings were published in the form of a facsimile, preceded by an introduction written by Élie Faure, one of the most ardent champions of Renoir's later work. The pencil drawings, pastels, and watercolors shown did not come from Renoir's studio but from private collections,[19] an indication that there was a market for this aspect of Renoir's work. A large number of them were also made available through Ambroise Vollard's 1919 work on Renoir, in which they served as illustrations. A number of color lithographs by Renoir were also published at the art dealer's initiative, Vollard having requested them from Renoir for his first album in 1896 on painter-engravers.[20]

"My drawing was accurate, but a little harsh"

It appears that Renoir began drawing at a very early age. His son Jean recounts, "It was after he had made his First Communion that he began to draw constantly. As paper was scarce, he would draw on the floor with chalk. My grandfather got annoyed when

8. *La Revue blanche* of March 15, 1896, p. 285. It appears that the drawing had "come from Durand-Ruel." Yet, in the catalogue, the red chalk drawing belongs to M. H. Adam. It was therefore perhaps the dealer who decided to send the work, rather than the artist. **9.** [Anonymous] 1896. **10.** The four drawings, the technique of which is not specified, were *Bathers* (no. 161), *Orange Seller* (no. 162), *Two Young Girls* (no. 163), and *Woman at her Toilette* (no. 164). **11.** *La Chronique des arts*, supplement of the *Gazette des Beaux-Arts*, no. 25 (July 13, 1912), p. 201. **12.** Vauxcelles 1912, pp. 218–219. The author mentions another exhibition at the Blot gallery which also appears to have been devoted to drawings. It may have been linked to the exhibition Vollard organized, as the two galleries were known to collaborate. However, we have found no mention of this exhibition or of any catalogue **13.** *Le Bulletin de la vie artistique*, no. 8 (March 15, 1920), pp. 225–226; no. 12 (May 15, 1920), pp. 334–337; no. 13 (June 1, 1920), pp. 361–363; no. 26 (December 15, 1920), pp. 739–740. **14.** Sales cat. New York, Anderson 1920a; idem 1920b. **15.** The letter of protest that Pierre Renoir sent to Durand-Ruel is reproduced in *Le Bulletin de la vie artistique* no. 8, March 15, 1920, pp. 225–226. **16.** The explanatory letter by Lucien Mignon is reproduced in *Le Bulletin de la vie artistique* no. 13, June 1, 1920, pp. 361–363. **17.** Fosca 1921, pp. 97–109. **18.** See above, note 2. **19.** *Facsimilés* 1920. **20.** Distel 2006–07, pp. 145, 189.

his tailor's chalk disappeared. But he thought the figures his son sketched all over the apartment floor were 'not at all bad.'"[21] His mother, who also seems to have been appreciative of her young son's talent, made him a gift of some pencils and exercise books in the margins of which he constantly scribbled. Jean Renoir believed that "this seems plausible, but Renoir never spoke to me of it."[22]

The earliest drawings to have survived date from the period when, as an apprentice porcelain painter with Lévy, Renoir also attended classes at the free drawing school. Besides pages of pencil drawings of porcelain decorations (1858, Viroflay, private collection[23]), there is an early notebook dating from 1857 (private collection[24]) that also reflects his studies as a young craftsman, particularly in the field of porcelain decoration. Along with "decorative" subjects (such as a couple in costume, nymphs, and floral motifs) in a highly simplified style, with an emphasis on the line defining the form, there are also some more detailed, more realistic animal studies, as well as a bust of his sister Lise in a more expressive style, that show that Renoir already "looked upon the world as a reservoir of subjects created just for him."[25]

It is worth noting that this sketchbook, and the one he brought back from his travels in Algeria and Italy in 1881–82, are the only ones known to us at present. As Albert André suggests in his introduction to the Algeria album, it was "perhaps the only one that he had ever carried in his pocket";[26] indeed everything would seem to suggest that Renoir was not in the habit of carrying a sketchbook about with him to jot things down. When, while still a craftsman, Renoir decided to become a painter, he was fully aware of the need to perfect his technique. "What Renoir wanted to learn especially was to draw figures."[27] By his own admission, his "drawing was accurate, but a little harsh."[28] A few rare studies illustrate this period of training during which Renoir, like any art student, applied himself to drawing from life,[29] from antiquity, from bas-reliefs with mythological subjects,[30] and plaster models.[31]

During his Impressionist period, Renoir appears to have done little pencil drawing, preferring to use pastel as this produced a result that was closer to painting. In 1879, however, the launch of the magazine *La Vie moderne* by his friends the Charpentiers in support of the Impressionists prompted him to devote more time to his work as a draftsman. Renoir was asked to provide illustrations and tried his hand once again at a type of drawing with which he had earlier experimented in 1877 for the journal *L'Impressionniste*. The young artist had produced mainly portraits.[32] Apparently, he found the task far from easy: "worst of all was that we were obliged to use a particular type of paper for our drawings . . . A scraper was needed to produce the whites: I could never manage it."[33]

"The rendering of form"

In the early 1880s, there occurred what Renoir himself described as a "break in my work," going so far as to say: "I did not know how to paint, nor how to draw."[34] Drawing, therefore, came to occupy a very special place in his work. Renoir's discovery of Raphael and Pompeii during his time in Italy—from October 1881 to January 1882—proved a revelation, encouraging him to work in the studio and produce highly developed preparatory drawings of his compositions. During this period of experimentation and research he produced numerous drawings, many admired by Berthe Morisot: "On a stand, a red pencil and chalk drawing of a young mother nursing her child, charming in subtlety and gracefulness. As I admired it, he showed me a whole series done from the same model and with about the same movement. He is a draftsman of the first order; it would be interesting to show all these preparatory studies or a painting, to the public, which generally imagines that the Impressionists work in a very casual way. I do not think it possible to go further in the rendering of form."[35] Executed mainly using

21. J. Renoir 1962, pp. 52–53. **22.** J. Renoir 1981, p. 61. **23.** Two pages are reproduced in Daulte 1973, pp. 12 and 13. **24.** This notebook was published in its entirety by Paul Renoir and Stefano Pirra in 1971. **25.** J. Renoir 1962, p. 53. **26.** André 1965, p. 10. The location of this notebook, which was in the Albert André collection, is now unknown. It was put up for sale at the Palais Galliera in December 1963 (no. 106). However, certain detached folios were offered framed. **27.** J. Renoir 1962, p. 102. **28.** Ibid, p. 102. **29.** *Young Man Standing and Studies of Heads*, charcoal on paper, private collection (sold at Sotheby's New York, October 10, 1996, no. 5). **30.** *Hector and Paris*, March 12, 1860, pencil (sold at Sotheby's New York, February 21, 1985, no. 152); *Homer*, January 11, 1860, pencil, private collection. These two drawings are reproduced in Daulte 1973, pp. 12, 13. **31.** *Studies of a Plaster Model*, charcoal, double face drawing, private collection (sold at Sotheby's London, March 11, 1998, no. 1998). **32.** Meier-Graefe 1911, p. 17, footnote. The author lists all of Renoir's drawings published in the journal. **33.** Renoir, quoted in Vollard 1995, pp. 268–269. **34.** Ibid., p. 209. **35.** Noted on January 11, 1886, in her private notebook. Morisot 1987, p. 145.

a finely sharpened black or sometimes red crayon, occasionally with white or red chalk highlights, these drawings reflect Renoir's stylistic evolution and are a testament to his marked return to line, similar to Ingres, whose work was familiar to him and for whom he always felt a keen admiration. Whether working on group studies or isolated figures, what Renoir sought above all else was a precision of line that would define volume and form. Indeed, be it in highly developed drawings or simple sketches, form for Renoir is contained within a rigorous, clear, and even stylized line. *The Large Bathers* **Fig. 8, p. 39** is without doubt the painting that inspired Renoir to produce the largest number of studies,[36] but it was far from the only one during this period.

At the same time, Renoir began to use what became one of his preferred media: red chalk, or sanguine. The particular characteristics of this rust-colored clay met several of Renoir's requirements. Firstly, it allowed him to introduce color into his drawing, and more specifically red, a color for which Renoir always expressed a preference and which dominates his late work. With a wide variety of tones, from brown to orange, and a texture that allows for *frottis* and light stumping, it is the ideal medium for an artist working with color **Cat. 40 & 41**. Renoir was an expert with this greasy, fungible material which, because of its tendency to flake, allowed him gradually to soften and develop his drawing **Cat. 85 & 86**. It was a technique that came to play a role in Renoir's creative process. As Albert André explains, once he had decided on his composition, Renoir preferred drawing to scale in red chalk, and then transferring this to canvas, rather than using the traditional squaring-up technique, no evidence of which can be found in his surviving oeuvre.[37] This process gave rise to drawings of the same dimension as that of the final paintings, no matter their size.[38] A great admirer of eighteenth-century art, Renoir was in fact developing a technique that he respected and which had acquired its respected status through artists such as Jean-Antoine Watteau, Jean-Honoré Fragonard, and François Boucher, to whose work he constantly referred. Like his predecessors, Renoir made this medium—so evocative of the charms of the flesh—his medium of choice for illustrating female beauty. In his studies of nudes in particular, he used the range of tones it allows to great effect in rendering flesh.

"It is not bas-relief, it is sculpture in the round"

During the 1890s, Renoir's drawing gradually freed itself from the precise, linear manner that he had developed in the mid-1880s. It gained in fluidity and roundness, the line becoming more curved and graceful. Very soon, he was no longer satisfied with the constraints of lead pencil, which shut form away within an enclosed space. He preferred to use charcoal or a softer black crayon, while continuing to work with red chalk **Cat. 87**. This meant that the line became thicker, giving the drawing more fullness and softness. By employing mainly chalks of a soft texture, Renoir was able to obtain a range of subtle modulations. He could flatten out the line, stump the contours, and shape the form. As John Rewald points out, line is no longer a limit that separates an object from its environment, on the contrary, it is a means of bringing them together.[39] As time went by, the form took on relief and spilled out onto the surrounding surface. This voluminous contouring, evocative of a new space on the page, is perfectly described by Albert André when he states: "it is not bas-relief, it is sculpture in the round."[40] This analogy with sculpture demonstrates the extent to which Renoir's late works are characterized by the pursuit of plasticity. For Renoir, painting, sculpture, and drawing were all ways of responding to this quest, as can be seen in the studies he produced for *The Judgment of Paris* **Cat. 65**, where he makes use of all three techniques. As with Rubens, the spontaneity with which Renoir throws down line—whether black or red—on to the page, renders form dynamic. The use of parallel repeated lines, veritable "radiations of form in space,"[41] accentuates the sense of life that emanates from these now vibrant contours, as can be seen in *Study for The Judgment of Paris* **Cat. 72**.

In drawing as in painting, it is the female form that dominates, both in the group studies and in those of isolated figures. Everything contrives to show off the female body

36. See Riopelle 1990. **37.** André 1950, p. 7. See the comments of Maurice Denis (1957, vol. 1, p. 121, Pentecost 1897). **38.** For example, the 1903 drawing *Reclining Nude with Rose*, paper mounted on canvas, 64 x 155 cm (sold in Paris, at the Palais Galliera, June 5, 1970, no. 61), which Renoir used for *Reclining Nude, Gabrielle*, 1903 (Musée de l'Orangerie, Paris, Walter-Guillaume collection), and *Reclining Nude*, 1903 (private collection). **39.** Rewald 1946, p. 14. **40.** André 1950, p. 8. **41.** Bazin 1930, p. 8.

in all its glowing splendor. The fullness of the form that radiates into the space shows that the model is now perceived as an object in movement, quivering with life, and no longer as a pretext for a simple arabesque. The effect of monumentality produced by what is often tight framing means that the figure, conceived as ample and sensual, saturates the page. The artist no longer seeks the precision of detail but simplifies form, with anatomical details such as the fingers and toes gradually disappearing. Germain Bazin claims that "the reason Renoir preferred the female form . . . is as much about plasticity as sensitivity. Only the female form offers both the voluminous relief that he sought (in human anatomy, the pectoral muscles are two rectangles; the breasts two spheres) and this fungible quality of the skin that he adores." The same is doubtless true of the young Maillol who, like Renoir, preferred to use women as his models. Often executed in red chalk, Maillol's drawings **Cat. 125, p. 413**, which show the same voluminous, rounded forms, suggest that the sculptor had seen those by Renoir, whom he visited regularly.

With the move to the South of France, the proximity of the Mediterranean brought antiquity to Renoir's mind. He gave his models—often simple servant girls (Gabrielle, Renée)—"the grace and nobility of the gods of Olympus."[42] While an artist like Degas preferred to show woman in the banality of her everyday life, Renoir gave her "the ample forms and fine, balanced movement of ancient statuary."[43]

Toward the end of his life, Renoir's graphic work became rarer. His ailing, deformed hands made it increasingly difficult for him to work with fragile, breakable media like charcoal and red chalk. However, to help his son Claude with his ceramic work, he turned once again to watercolor "of which he was very fond but had been forced to abandon long ago because of his infirmities and lack of help."[44] The *Study for Venus Victrix* **Cat. 73** shows that Renoir excelled at this technique, often using it for landscapes, particularly those executed during his repeated visits to the South of France.

"A great draftsman"

In 1921, Albert André acknowledged Renoir's mastery of drawing, stating that "it is now undeniable that Renoir is as great a draftsman as he is a painter. One may not like his form, but it cannot be denied. It is clear that it could not be other than it is, and that it fully expresses the idealism of sensuality that lay behind all his efforts."[45] Much earlier, Paul Gauguin too had recognized the full expressive power of his drawing: "In Renoir, nothing is in place: do not look for line, it does not exist; as if by magic, a pretty patch of color, a caressing light say all that is needed. On the cheeks as on a peach, a light bloom ripples, stirred by the breeze of love that whispers its music in the ear. One would like to bite the cherry that is the mouth, and through the laughter, a small, sharp, white tooth takes form. Beware, it has a cruel bite; it is a woman's tooth. Divine Renoir who cannot draw."[46]

The younger generation also recognized the paradoxical qualities of Renoir the painter-draftsman. "Bonnard speaks with unfeigned modesty . . . of Renoir's drawing, which he feels incapable of emulating."[47] As for Picasso, his admiration for Renoir led him to acquire *The Coiffure* **Cat. 84**, for his private collection, a masterful red-chalk drawing that is one of the high-points of Renoir's late graphic oeuvre.

42. Daulte 1985, [n. p.]. **43.** Ibid. **44.** C. Renoir 1948, p. 9. **45.** André 1950, pp. 6–7. **46.** Gauguin 1974, p. 254. **47.** Natanson 1951, p. 203. My thanks to Marie-Pierre Salé and Sylvie Patry for bringing this quotation to my attention and for their astute suggestions.

Renoir at Cagnes

Virginie Journiac

Konrad von Freyhold
*Orange blossom harvest
at Les Collettes in Cagnes*
May 1914

Cat. 168

Today as before, visitors to Les Collettes, Pierre-Auguste Renoir's house-museum at Cagnes-sur-Mer, can discover something of the painter's private life and a better understanding of his late period, now restored to favor by critics who once unjustly attributed these final works to "an old man with weak hands."[1] Robbed of the use of his fingers by severe rheumatoid arthritis, Renoir attempted the impossible and painted each day using various tricks and devices: he used an orthotic device to hold the paintbrush in his hand and had an easel on rollers so that the canvas could be adjusted to the height of his wheelchair.[2] Defiant of the constraints of his disabilities, Renoir launched himself into sculpture, with the assistance of the young Richard Guino. He even had plans to paint a monumental fresco on the walls of the house before his death on December 3, 1919, at Les Collettes.

The Move to Cagnes

When Renoir was diagnosed with rheumatoid arthritis in Montmartre in late 1897,[3] the doctors advised him to change climate and move to the South of France. After spending brief spells in Grasse in 1899, Magagnosc in 1900–01, then in Le Cannet from January to April 1902 and February to March 1903, Renoir eventually settled in Cagnes. Enchanted by the town—he had already stayed there in 1899 at the Hôtel Savournin—he rented an apartment at the Maison de la Poste from April 1903, and finally moved to Les Collettes at the end of 1908.

Ferdinand Deconchy played a significant role in Renoir's choice of Cagnes. It was he who encouraged Renoir to choose this protected resort, as Claude Renoir recalls: "he was quite simply my father's most loyal friend . . . It was he who, while still very young, long before he came to Cagnes, and with singular tact and modesty, had enabled my father, by far his elder, to realize certain dreams: to go painting in Italy and Algeria. And it was mainly he who brought my parents to Cagnes."[4] A Parisian by birth, in 1896 Deconchy married the daughter of the owners of the Hôtel Savournin. He was elected mayor of Cagnes in 1912, with the support of the town's intellectual and artistic circles. Trained as an architect, Deconchy enjoyed painting in the company of Renoir, who valued his artistic talent.[5]

Preserved from rampant urban development, Cagnes remained in many ways a very agricultural place. Even at the Maison de la Poste, right in the center of town, the landscapes Renoir sketched have a rural feel. It was a combination of circumstances that led the artist to decide on this final move. Building work associated with the setting up of a new school threatened the tranquility the family enjoyed. Around this time, Renoir was told that a property in Les Collettes was going to be cleared of its ancient olive trees. Renoir knew this large estate, several hectares in area, as he had already painted there in the past. He became owner of the property on June 28, 1907, saving the olive trees and thus opening a new chapter in his rich artistic life **Fig. 35**.

1. Besson 1932, p. 10. **2.** J. Renoir 1962, p. 454. **3.** Ibid., pp. 348–349. **4.** C. Renoir, in exh. cat. Cagnes-sur-Mer 1956–57. **5.** See exh. cat. Cagnes-sur-Mer 2008, pp. 71–77.

Cat. 168

Pierre-Auguste Renoir
Landscape at Les Collettes
Before 1912
Oil on canvas
8⅝ x 13 in. (22 x 33 cm)
Cagnes-sur-Mer, Musée Renoir,
on deposit from Musée d'Orsay

Fig. 35

Construction of the House

Renoir would have liked to live in the farmhouse on the estate and was particularly fond of it **Cat. 45**. However, Aline persuaded him to have a house built for themselves, like their friends the Deconchys who lived in a villa not far from Les Collettes. An architect was chosen: Jules Febvre.[6] This "bourgeois" house would be neo-Provençal in style, large, and functional, so that the family could receive their guests: dealers, friends, artists, visitors passing through, and models. Aline looked after the garden and planted a grove of orange trees **Cat. 168** (Renoir was particularly fond of the orange trees at the Maison de la Poste), along with vines, and a vegetable garden. At the artist's request, the majority of the estate remained wild, untouched by any gardeners. The family lived on its own produce, including olive oil, which it had pressed at the Le Béal oil mill. It was an agropastoral life and it suited Renoir, and his wife in particular.[7] However, he preferred the farmhouse to their new "bourgeois" home, which he would never paint. Aline organized their life around her husband so that he could devote himself entirely to his art and be as little affected as possible by his physical disabilities. Renoir had numerous work spaces: the main studio in the house (with a north-facing window), and the glass studio he had built in the garden, to which he added a third studio, set up in the new house at some unknown date.[8] There was also a studio area at garden level which appears to have been Richard Guino's preferred space for working on sculptures. An impressive team of cooks, maids, nurses, and models was organized so that Renoir could be transported daily from one space to another, from the house to the garden, with the aid of a chair with arms.

The Appeal of the South

Renoir had always been enchanted by picturesque scenes and figures, including while living at the Maison de la Poste, where he chose his models from among the local people. Men and women from Cagnes appear in many of his works, as do members of his family. His youngest son Claude, known as Coco, was a particular inspiration, as was Gabrielle, the children's governess. He also was in the habit of taking his models out to La Colle-sur-Loup or Villeneuve-Loubet, not far from Cagnes. When he remained working at Les Collettes, he would have them pose in the grounds while he painted them from inside his glass-walled studio. His vast estate remained the preferred site for his creations (his "follies," as he liked to call them), but Renoir was able to extend his artistic horizons by going out by car, driven by his chauffeur. He would return several times to the same spot and paint it from different angles.

At Cagnes, and along the Côte d'Azur, a tourist tradition not dissimilar to an artistic pilgrimage had grown up. Like Renoir, other great names in painting chose to enjoy the pleasant life to be had in the towns of the South of France at the end of the nineteenth century and in the first quarter of the twentieth century. Antibes became home to Claude Monet in 1888, Paul Signac and Henri-Edmond Cross in 1908, and Pierre Bonnard in 1917–18. André Derain lived in the Cagnes area from 1909 to 1910, Félix Vallotton between 1920 and 1925, and Chaim Soutine and Amedeo Modigliani in 1919. Cannes and Le Cannet were the haunt of Henri-Joseph Harpignies during the 1880s and 1890s, of Signac around 1915–20, Derain in 1905, Louis Valtat in the early years of the twentieth century, Charles Camoin between 1905 and the 1920s, Albert Marquet around 1905, Vallotton from 1905, and Bonnard from 1914. Félix Ziem, a forerunner of the painters who migrated to the South, lived in the area of Nice, Villefranche, and Beaulieu around 1850, Henri de Toulouse-Lautrec around 1880, Berthe Morisot during the 1880s, Edvard Munch in the early 1890s, Raoul Dufy between 1924 and 1928, Paul Signac in the 1920s, and Henri Matisse from 1917 until his death.

Renoir's Private Life

Nevertheless, the problems that accompany fame were soon felt in Renoir's Cagnes paradise where the artist appears to have aroused conflicting feelings. Construction of the new house was not yet complete when, in March 1908, he confided in a letter

6. Jules Febvre trained at the École des Beaux-Arts and was responsible for a number of buildings in Nice, including the façade of the port church, the Hôtel Majestic (1908), and various private houses. **7.** In a letter sent by Renoir to Julie Manet on March 20, 1908, he states: "We are busy planting, like La Fontaine's old man. A man was planting at fourscore . . . which doesn't amuse the old man himself but amuses my wife immensely." (Renoir 2002, p. 151). **8.** Butler 2008, p. 42.

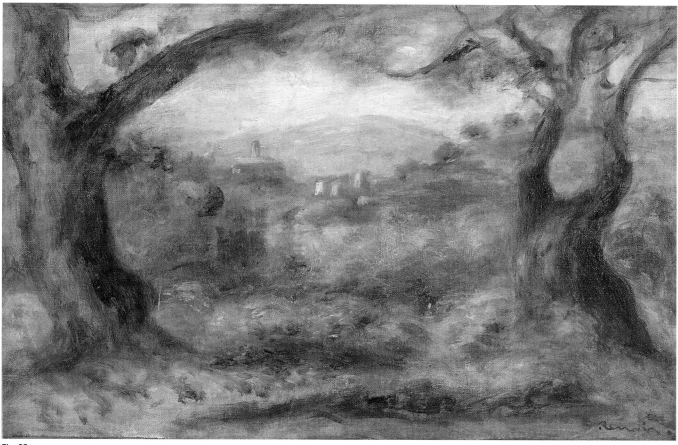

Fig. 35

Fig. 36

Fig. 37

to Julie Manet: "If the whole of Cagnes society had not become my friend because of my wealthy property, all would be well, but here I am now, a man of great regard in Cagnes, where last year I went unnoticed."[9] A few years later, on January 16, 1914, Renoir sent a letter from Nice to his friend Albert André. The tone is unmistakable: "I have been feeling quite at ease for a few days now . . . I really like it in this apartment in Nice. I feel less deserted than at Les Collettes, where it feels as if I'm in a monastery."[10] The Renoirs rented an apartment in Nice at 1, place de l'Église-du-Vœu, where Gabrielle often visited. In a letter to Durand-Ruel, the painter explains that this made life easier for him because "going up to my studio is becoming difficult."[11]

A martyr to ill health, Renoir looked on helplessly as Cagnes was transformed, meeting up with the western suburbs of Nice in 1914.[12] However, despite the progression of his illness, Renoir continued to work intensely. Visitors passing through were struck by his physical condition. Among those who describe it, the most striking account comes from the collector René Gimpel: "Before me was a shell of a man. . . . He was all unyielding angles, like the unhorsed knights in a set of tin soldiers. . . . Seated, he is a frightful spectacle, elbows clamped to his sides, forearms raised; he was shaking two sinister stumps dangling with threads and very narrow ribbons. . . . [h]e has his fingers—pressed in and spread against the palms of his hands…"[13] Paradoxically, this was Renoir's most productive period: over seven hundred and twenty canvases (published by Bernheim-Jeune in 1931) were inventoried in the studio after his death! And despite everything, the "painter of happiness" had never appeared so radiant.

Regular Visitors to Les Collettes

Renoir found an outlet for his suffering in work. Many people, from among his friends and models, describe the phenomenal energy that gripped him when he was creating. Renoir had various circles of acquaintances, the closest including some very diverse figures.

Like Ferdinand Deconchy, Albert André was considered by all to be Renoir's loyal friend, associate, and confidant. His friendship with Renoir began in 1894 at the Salon des Indépendants exhibition and continued for twenty-five years. He became a full-fledged member of the family—"my second father" is how Jean Renoir described him—and he became godfather to Claude. After the Renoir family had settled in Les Collettes, Albert André stayed there on numerous occasions (he had his own room in the house) and accompanied Renoir when he went painting outdoors in the garden. André wrote the only book devoted to Renoir to be published during his lifetime (in May 1919) that would receive the artist's full support.[14] It was also André who helped compile the inventory of the main studio at Cagnes after Renoir's death. And it was on Renoir's advice that he agreed to accept the position of curator of the Bagnols-sur-Cèze museum in 1917, the first provincial museum of contemporary painting.[15]

It is interesting to follow André's artistic career. He studied at the Académie Julian alongside future members of the Nabi group of artists (Pierre Bonnard, Maurice Denis, Édouard Vuillard) before becoming a eulogist of the art of Renoir, whom he observed assiduously. He left a quite extraordinary series of drawings of Renoir painting, along with some portraits of great truthfulness, which are now in the Musées Départementaux du Gard **Fig. 36**.

Another fortunate observer of Renoir was Richard Guino **Fig. 37**, a young Catalan sculptor who had worked with Aristide Maillol and was introduced to Renoir by Ambroise Vollard. He lived at the house in Les Collettes for four years, from 1914 to 1918. There was an extraordinary alchemy between the two artists, and their collaboration gave birth to around twenty works—three-dimensional transpositions of Renoir's pictorial experiments. The painter's spirit, manner, and style were totally assimilated by the sculptor who, some forty years later, obtained a court judgment recognizing him as co-author of these collaborative works.[16] One surprising anecdote recounts that Richard Guino's

Albert André
Renoir Painting
1919
Oil on canvas
16 3/8 x 20 1/4 in. (41.5 x 51.5 cm)
Cagnes-sur-Mer, Musée Renoir,
on deposit from Musée d'Orsay

Fig. 36

Richard Guino
Portrait of Renoir
1913
Lithograph signed in pencil
22 x 17 3/4 in. (56 x 45 cm)
Cagnes-sur-Mer, Musée Renoir,
gift of the artist in 1964

Fig. 37

9. Renoir 2002, p. 151. **10.** See exh. cat. Cagnes-sur-Mer 2008, p. 58. Fondation Custodia, Paris, no. 1979-A.385. **11.** Letter of January 12, 1912, published by C. Durand-Ruel Godfroy 1995, vol. 2, p. 88. **12.** Blanche 1919, pp. 234–235. **13.** Gimpel 1987, p. 12. **14.** George Besson includes this in the postscript to the facsimile edition of a book of Renoir sketches published by Éditions Daniel Jacomet in 1955. See exh. cat. Bagnols-sur-Cèze 2004, p. 79. However, the first monograph on Renoir to appear in 1911 was by the German art historian Julius Meier-Graefe who visited the artist in 1914; he published another monograph on Renoir in 1929 that included his later works up to 1919. **15.** Two exhibition catalogues document this meeting of artists: exh. cat. Bagnols-sur-Cèze 2004 and exh. cat. Cagnes-sur-Mer 2008. **16.** See Aral 2008.

companion, Eulalie Verdier, transposed Renoir's work into tapestry.[17] Guino left Les Collettes after Renoir expressed his wish that their collaboration should cease. He was succeeded by another sculptor, Louis Morel from Essoyes, whom Renoir guided in the creation of three bas-reliefs—two *Dancers with Tambourine* and a *Flute Player* **Cat. 96–98**—the power of which does not, however, compare with Guino's work. The collaboration with Morel was to be cut short.

Although Renoir's relationship with his sculptor assistants was sometimes strained, he became great friends with a young Japanese painter, Ryuzaburo Umehara, a student at the Académie Ranson in Paris, who displayed an unbounded admiration for Renoir's work throughout his life. Umehara visited Renoir in Cagnes in 1909 and returned there in 1920 to offer the family his condolences. On this occasion he had an opportunity to see the final works remaining in the main studio and offers this description in his memoirs: "He had pinned his last canvases, one on the other, on the three walls of his studio. There were three canvases entitled *The Judgment of Paris,* very similar in their composition. Countless paintings of female nudes, flowers, and landscapes, large and small, brilliant, almost moaning. I particularly admire the works of his old age."[18] Renoir displayed his modernity by choosing to support young artists, including Joseph Victor Roux-Champion, who gives one of the most moving accounts. In "The Private Life of Renoir at Les Collettes," which appeared in *Le Figaro littéraire* on July 9, 1955, he refers in particular to the friendship between Renoir and Albert André: "One of the finest torches to have illuminated the life of Albert André was extinguished the day that Renoir was laid to rest."

Other distinguished guests at the house included the family of the art dealer Paul Durand-Ruel and that of the collector Maurice Gangnat, whose names still adorn two bedrooms at the house. To this very close circle of friends can be added passing visitors to Les Collettes, each of whom left their account of Renoir.

Prestigious Visitors

Maurice Denis visited the Renoir family at the Maison de la Poste in February 1906, then at Les Collettes in March 1910 and February 1913.[19] It was through Jeanne Baudot that he met Renoir; Denis also had occasion to meet the young Umehara in Paris, at the Académie Ranson where he was teaching. They both give their recollections of Renoir.[20]

Claude Monet, Renoir's first comrade-at-arms, stayed at Les Collettes in December 1908,[21] and later in December 1910, when returning from a trip to Venice with his wife.[22]

Ambroise Vollard gives an account of Auguste Rodin's brief visit in March 1914.[23] Relations between Renoir and the art dealer were rather stormy. The artist often confided his thoughts on the subject of Vollard to those close to him, and Gabrielle Conrad-Slade condemned the way in which Vollard "embroidered" their relationship. It was during their lunch at Cagnes that Renoir executed a portrait of Rodin for the frontispiece of the monograph on the sculptor published by Bernheim-Jeune **Cat. 86**.[24]

In December 1917, one of Renoir's greatest admirers began visiting Les Collettes regularly: Henri Matisse **Cat. 184, p. 138**, newly resident in Nice. Matisse recorded his conversations with Renoir and his impressions in a large correspondence.[25] Initially puzzled by the "intrigues" he perceived among those close to Renoir, he became increasingly enthusiastic with each visit. Fascinated by the garden, Matisse was particularly inspired by the statue of *Venus Victrix* rising from the vegetation and executed several variations of the motif. Two oil paintings, one of which is kept at the Musée National des Beaux-Arts in Algiers, show the sculpture conceived by Renoir and Guino in a lush natural setting **Cat. 106 & Fig. 58**.[26]

Pierre Bonnard visited Renoir in the company of Matisse in April 1919.[27] He later published his *Memories of Renoir* in 1941, recalling this witty remark by Renoir: "One needs to embellish, isn't that so, Bonnard?"[28] Renoir's vivacity of mind and humor can

17. Death certificate no. 31, Register Office, Cagnes-sur-Mer. The information regarding Eulalie's embroidery talents come from the 1966–67 record of activities by the curator D. J. Clergue, Archives of the Musées de Cagnes-sur-Mer. **18.** See Shimada 2008. **19.** Jeanne Baudot reproduces a letter sent to her from Cagnes by Maurice Denis on February 1, 1913, in Baudot, 1949, p. 131. **20.** See Umehara's account in exh. cat. Cagnes-sur-Mer 2008, p. 126. **21.** Exh. cat. London, Paris, and Boston 1985–86, p. 311 (p. 395 in French ed.). **22.** Eluère 2006, p. 187. **23.** Vollard 2005, pp. 385–395. **24.** See also *Collection Vollard* 1999, no. 105, pp. 146–147. **25.** Butler 2008b. **26.** Potron 2002, pp. 122–125. **27.** Exh. cat. Cagnes-sur-Mer 2008, p. 113, letter from Matisse, April 27, 1919, regarding their joint visit to Renoir. **28.** Renoir 2002, p. 196 and note 98, p. 237.

also be seen in the account of his meeting with Amedeo Modigliani given by the Swedish painter Anders Osterlind.[29] Accompanied by his art dealer friend Leopold Zborowski and by Osterlind, with whom he was staying at the latter's villa "La Riante" in Les Collettes, Modigliani was introduced to Renoir in 1919. The meeting was cut short, not because of Renoir, although he was exhausted, but because of Modigliani himself, who reacted very badly, most probably out of envy, when he saw the old painter's nudes. Osterlind recounts that Renoir, in a gesture of generosity, sold a painting to Zborowoski at a low price in order to help out the young Italian artist, whose difficulties he had doubtless observed.

Renoir, who liked to support young artists (as we have already seen with Umehara and Roux-Champion), also forged a friendship with Louis Valtat. The latter, who was a close friend of Signac, visited the Renoir family on several occasions at Cagnes and painted alongside the master.[30] Paul Signac himself would later receive the Légion d'honneur from Renoir's hands in 1911.[31]

Louis Valtat and Albert André brought along a painter friend who, like them, had studied at the Académie Julian: this was Roussel-Masure. A friend of Alfred Sisley and Camille Pissarro, he also received guidance from Monet at Giverny and eventually settled in Cagnes in 1914. He kept a journal of his visits to Renoir, enthusiastically noting down the master's comments, notably this: "In order to paint well, one must paint quickly; this is the only way to bring life to the model, and one must avoid dwelling too much on detail."[32]

An Artists' Paradise Found

The Eden that was Les Collettes is often compared with Giverny, where Claude Monet spent the final years of his life. There are indeed many parallels, the first being the disabilities that affected both artists at the height of their career: Renoir suffered from arthritis and Monet from a cataract (which was operated on in 1923).[33] Both Renoir and Monet manufactured an ideal landscaped garden that would serve as their inspiration. On his property of over a hectare, with an extravagant water garden and a more orderly French-style garden, Monet translated his optical sensations to canvas. He became a passionate gardener—something that was not true of Renoir—recreating *in situ* an idealized form of nature. Renoir, on the other hand, worked from nature and reconstructed his ideal of nature directly on the canvas. Michel Georges-Michel recounts Renoir's comments about his friend, underlining the fundamental difference between them: "Monet painted 'hours' instead of painting each time 'an eternal hour.'"[34]

Another close friend of Renoir, Paul Cézanne also led this half-urban, half-rural lifestyle near Aix-en-Provence. In 1859, the artist's father had acquired a rural property of some fourteen hectares—Le Jas de Bouffan—with a country house and a farm. During the 1880s, a studio was built in the house for his son, then the estate was sold in September 1899. In late 1901, Cézanne in turn bought a small, seven-thousand square meter rural property on the hill at Les Lauves and built himself a studio there. Each day he would leave his apartment in rue Boulegon in Aix and go out into the countryside to work from nature. In 1888 Renoir stayed at Le Jas de Bouffan but cut short his visit "because of the black avarice" that reigned there. Relations between the two men would never be the same again.

The Renoir family enjoyed spending time with people, extending hospitality, and made the house at Les Collettes a wonderful place to visit. George Besson's description gives an eloquent account of the harmony in which Renoir lived and worked during the final years of his life: "Nothing could be less formal than life at Les Collettes. No barriers between master and servant, between kitchen and dining room, studio and living room—that large room that was never used but where Jean Renoir stood posing as a hunter **Cat. 56** or his younger brother Claude would project some films . . ."[35]

Despite some moments of solitude, especially after the death of his wife in 1915, and moments of extreme pain, which Matisse witnessed, Renoir told his visitor: "The pain passes, Matisse; but beauty remains. I am perfectly happy and I shall not die before completing my masterpiece."[36] **Cat. 80**

29. Exh. cat. Paris 1981, pp. 92–93; Dussaule 1995, p. 57. **30.** The visits Louis and Suzanne Valtat made to Cagnes are poorly documented. Potron 2002, p. 134. **31.** Ibid., p. 108. Paul Signac was awarded the Légion d'honneur on October 29, 1911 (Appointment decree, Archives of the Musée National de la Légion d'honneur, Paris). **32.** Bénézit 1999, vol. 12, p. 40. **33.** On the effect of polyarthritis on Renoir's art see: exh. cat. Cagnes-sur-Mer 2008, pp. 149–171. On the effects of Monet's cataract, see: exh. cat. Paris 2008. **34.** Georges-Michel 1954, p. 29. **35.** Besson, in *Arts de France*, no. 8, 1961, p. 8. **36.** In Fourcade 1976, no. 1, p. 97.

Renoir and His Early Twentieth-Century Patrons

Monique Nonne

By 1892, Renoir had reached the midpoint in a career that had begun with the 1864 Salon and would end with his death in 1919. Two events had placed him in the spotlight: the arrival at the Musée du Luxembourg of *Young Girls at the Piano* **Cat. 3** and a large solo exhibition organized by the Galerie Durand-Ruel. This was excellent publicity in commercial terms, but although Renoir's earlier works achieved sensational prices, his current production was less convincing. In 1897, his wife, Aline, thanked Vollard, who had sent 300 francs while waiting for better.[1] Twenty years later, Durand-Ruel recorded a credit of 35,438 francs, plus 75,000 francs for paintings recently purchased. Renoir's determination to paint according to his own lights had enabled him to connect with a new clientele.

New Collectors in France

At the start of the century, Renoir already knew most of the small number of art lovers who were interested in his work.[2]

A dentist by profession, Georges Viau bought work by the Impressionists and was also interested in the Nabis. In 1907 he put his collection, which included fifteen works by Renoir, up for sale, creating a stir among art dealers and collectors.[3] After this, Viau's interest in Renoir was less marked, and only six paintings were listed in the inventory of his collection drawn up by the Swiss art dealer and painter Carl Montag around 1914 with a view to another sale[4] **Fig. 40**.

An article published in September 1908 provides information on Paul Gallimard's collection.[5] At that time he owned sixteen paintings, but does not appear to have kept the portrait of his wife nor the decoration on the theme of Oedipus Rex he had commissioned from Renoir in the late 1890s.[6] In 1914, Gallimard parted with a number of works through the art dealer Eugène Druet. The Swiss art lover Georg Reinhart displayed an interest in a bouquet of peonies Renoir had painted around 1900, but the Muscovites Ivan Morozov and Sergei I. Shchukin were also in the running.[7]

In 1904, Gallimard introduced Renoir to his brother-in-law, Maurice Gangnat, who bought his first Renoir at the Berard sale in 1905.[8] A regular visitor to Renoir's studio, whether at Les Collettes, Essoyes, or in Paris, he had boundless admiration for the works the artist painted in his presence, and between 1905 and 1919 purchased around

I should like to thank Augustin de Butler, Marina Ducrey, Sandra Gianfreda, Lucas Gloor, Wanda de Guébriant, Ann Halpern, Günter Herzog, Harry Joelson, Kimberly Jones, Birgit Jordan, Catherine Krahmer, Ursula Perruchi, Eva-Maria Preiswerk, Emily Rafferty, Cora Rosevear, Gabrielle Schaad, Jennifer Thompson, Rudolf Velhagen, Jeff Werner, Céline Wormdal, Kyllikki Zacharias, Maria Zetterberg.

1. Letter from Aline Renoir to Vollard, Essoyes, September 4, 1897, Bibliothèque Centrale des Musées Nationaux, Paris, Vollard archives, MS 421 (2, 2) 318. **2.** Letter from Renoir to Paul Durand-Ruel, Cagnes, Saturday, April 18, 1903, *Correspondance Renoir-Durand-Ruel*, vol. 1, 1995, p. 184, and note 89, p. 280. **3.** Sales cat. Durand-Ruel, Paris, 1907. **4.** Schweizerisches Institut für Kunstwissenschaft / Institut suisse pour l'étude de l'art (SIK-ISEA), Zurich, Nachlass Montag, dossier 9, with estimates. The collection (two hundred and seven works) was purchased on February 14, 1918, by Wilhelm Hansen and Herman Heilbuth, from the firm Winkel & Magnussen in Copenhagen, Stiftung Langmatt archives, Baden, Viau dossier. **5.** Vauxcelles 1908, p. 24. **6.** For more on decoration, see the essay by Sylvie Patry in this volume. For the portrait of Mme Gallimard, see exh. cat. Ottawa, Chicago, and Forth Worth 1997–98, no. 52, pp. 217–219 and notes pp. 322–323. **7.** Letter from Carl Montag to Georg Reinhart, Paris, May 6, 1914, Winterthurer Bibliotheken, Winterthur, Sondersammlungen, Ms GR 19/97. **8.** See exh. cat. Ottawa, Chicago, and Forth Worth 1997–98, no. 52, p. 217, and note 18, p. 323; White 1984, p. 228 and note 54, p. 294.

Fig. 38

*Renoir painting the portrait
of Mathilde Adler, future
Mme Josse Bernheim-Jeune,
in Fontainebleau*
1901
Photograph
Paris, Archives Photographiques
Bernheim-Jeune

Cat. 142

one hundred and fifty of them.[9] The German art critic Julius Meier-Graefe recounts: "I only came to know the older Renoir when I stood in front of the hundred or so paintings in Gangnat's collection."[10] Gangnat helped attract the patronage of the dramatist Henry Bernstein, whose reputation earned him special consideration from Durand-Ruel; the dealer sold Bernstein four paintings: "I purposely offered him very reasonable prices, believing that it was in our common interest to see your paintings placed with someone as much in the public eye as he is."[11] Bernstein commissioned Renoir to paint his portrait, but two years later when Bernstein had to sell his paintings, Renoir found himself in good company, with Albert Marquet, Pierre Bonnard, Édouard Vuillard, and Henri Matisse.[12]

These collectors developed a personal relationship with the artist, but it was the art dealers who played the determining role in promoting Renoir's work.

Renoir and His Paris Art Dealers

For many years a solitary or almost solitary figure in the market he himself had created, Paul Durand-Ruel now faced some new blood and, although Renoir remained loyal to him, the artist nevertheless decided to retain his freedom: "As for me, I am a mediocre businessman, but don't imagine that I am going to sell my independence to just anyone."[13] Thanks to his regular purchases over the years, Durand-Ruel had built up a considerable stock that was the envy of his competitors, ever more numerous in a market in which the Impressionists were now well established. Renoir formed links with other art dealers, such as the Bernheim brothers **Cat. 142**. A committed anti-Dreyfusard, Renoir did not take to them at all at first, describing them as "horrible Jews."[14] However, by 1898 they were in business together, and their correspondence soon became friendly. In January 1900, the gallery devoted an exhibition to Renoir, and the following year the two brothers commissioned portraits of their fiancées.[15]

An astute businessman, Durand-Ruel had dealings with the Bernheims, who did not have a stock of Renoir's work. Already, "two or three years ago," he had let them have "a certain number at heavily reduced prices . . . At that time they pressed us to let them have another lot of forty or fifty paintings on the same terms."[16] Durand-Ruel also supplied paintings to Paul Rosenberg in Paris, Paul Cassirer in Berlin, and Hugo Miethke in Vienna because, although he may have feared a flood of work onto the market, he had to concede that "each painting sold creates a new enthusiast."[17]

Operating on the fringes of these art dealers with their prestigious galleries, Ambroise Vollard concluded his first transaction with Renoir on October 15, 1894. He would become an important figure in Renoir's life, gaining both his trust and his friendship. He purchased small pieces, at small prices, but large canvases, too, and encouraged Renoir to experiment with engraving and sculpture. Long conversations between the two men led to a monograph published in 1919.[18]

Renoir's Foreign Clientele

For all these art dealers, exhibitions formed an integral part of their business strategy, particularly in the case of foreign countries where there were no sales outlets. Durand-Ruel took few chances in Great Britain, where French painting did not yet enjoy any great popularity,[19] but did establish a presence in New York in 1888, where he championed the Impressionists. After showing Renoir with other artists, he went on to mount Renoir's first private exhibition in 1908, showing forty-one works.

One of Renoir's outstanding admirers in the United States at that time was Alfred Barnes; but there was also Leo Stein, who had been indifferent to Renoir until "one day one of the pictures clicked," leading him to purchase some of Renoir's work with his sister Gertrude.[20] However, few American art lovers were to experience this "click." Walter

9. Distel 1985–86, p. 25. For the decorative panels he commissioned from Renoir in 1909, see also the article by Sylvie Patry in this volume and Cat. 40 &41. **10.** Meier-Graefe 1911, p. 187. **11.** Letter from Georges Durand-Ruel to Renoir, Paris, February 16, 1909, *Correspondance Renoir-Durand-Ruel*, vol. 2, 1995, p. 42, and note 123, p. 251. **12.** Sales cat. Paris, Drouot, 1911. **13.** Letter from Renoir to Durand-Ruel, Cagnes, December 25, 1908, *Correspondance Renoir-Durand-Ruel*, vol. 2, 1995, p. 35. **14.** Letter from Renoir to Paul Berard, no date or location indicated, sales cat. Paris, Drouot Rive Gauche, 1979, no. 79. **15.** Mathilde (private collection) and Suzanne Adler (Musée d'Orsay, Paris) married Josse and Gaston. **16.** Letter from Georges Durand-Ruel to Renoir, February 16, 1909, *Correspondance Renoir-Durand-Ruel*, vol. 2, 1995, p. 42. **17.** Letter from Paul Durand-Ruel to Renoir, Paris, March 23, 1912, *Correspondance Renoir-Durand-Ruel*, vol. 2, 1995, p. 100. **18.** Vollard 1919a. See Distel 2006–07, pp. 142–149. **19.** Exh. cat London 1905, fifty-one Renoirs. See Distel 1989b, chap. 19, p. 231ff. See also Cooper 1954, pp. 60–70. **20.** Stein 1950, p. 204. See the essay by Martha Lucy in this volume, p. 110.

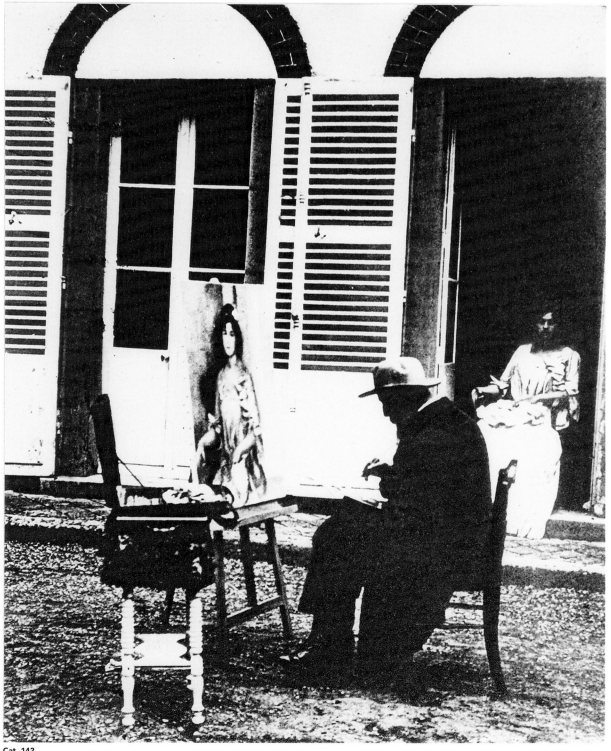

Cat. 142

Arensberg was one exception, purchasing a Renoir *Bather* **Cat. 77** dating from around 1917 for his New York apartment, where it hung alongside Marcel Duchamp's *Nude Descending a Staircase,* among others **Cat. 202, p. 322**.[21] Sterling Clark amassed a remarkable collection of Renoir's paintings, but declared that for him nothing measured up to the 1879–82 period.[22] Mary Cassatt enjoyed spending time in Renoir's company in the South of France but lacked enthusiasm for these "enormously fat red women with very small heads."[23] The writer Walter Pach, an ardent champion of Renoir, was still dismayed in 1937 when a retrospective mounted at the Metropolitan Museum of Art in New York included fifty-six paintings from the first half of the artist's career and only six from the second half.[24]

Germany and Switzerland proved to be more receptive to Renoir's recent work. In his effort to promote modern French painting, Meier-Graefe set aside a special place for Renoir and wrote the first important study of the artist, which became a reference work throughout Europe.[25]

Count Harry Kessler, a very early admirer of Impressionism, also played an important role **Fig. 39**. The writer Hélène von Nostitz often remembered with emotion "some bewitching and enchanting Renoirs"[26] in his Weimar apartment. He was in touch with Paul Cassirer, the Berlin art dealer, who gathered around him collectors and museum officials who were supporters of modern painting. Cassirer was a collector himself, and his wife Tilla Durieux described their elegant apartment in her memoirs, where Renoir's *Young Girls at the Piano* hung side by side with paintings by Édouard Manet and Paul Cézanne.[27]

Cassirer did business with Durand-Ruel from 1898 onwards[28] and exhibited his first Renoirs in April and then October 1901.[29] He continued to show Renoir regularly, alongside a very diverse range of artists, and in 1912 took over an important solo exhibition first shown in Munich.[30] His purchases and sales of Renoir's paintings grew as demand increased. He purchased one Renoir in 1904, six in 1909, and nine in 1912. The dealer met up with Renoir in Paris and in the South of France. He marveled at Renoir's easy manner with people, particularly with young artists, and was moved by the unaffectedness of this great man, whom he commissioned, in July 1914, to paint a portrait of Tilla Durieux **Fig. 38**.[31] War was nothing more than a passing interruption to business. In fact, the gallery sold twenty-one Renoir paintings in 1916 to collectors such as Christian Tetzen-Lund from Denmark, and to German colleagues such as Georg Caspari and Heinrich Thannhauser from Munich.[32]

Munich, like Berlin, was a thriving center for the arts. The art dealer Heinrich Thannhauser began collaborating with Cassirer in 1908. The following year he opened the Moderne Galerie with an exhibition that included numerous Impressionist works.[33] In January 1912, he devoted a first solo exhibition to Renoir and continued promoting him in the postwar period. However, Renoir's paintings of this period did not meet with unanimous enthusiasm among collectors. Carl and Thea Sternheim purchased Renoir's early *Clown* **Fig. iv, p. 23** from Vollard, alongside works by Van Gogh and Cézanne, but after seeing the exhibition of recent work at the Galerie Durand-Ruel in 1912, Thea spoke out saying: "Only paintings from recent years. Small beer. Not a single piece of any importance."[34]

By contrast, Dr. Fritz Thurneyssen was an admirer of Renoir and, with his family, visited the painter in the winter at Cagnes. Meier-Graefe, who felt that Thurneyssen's collection was only surpassed by that of Gangnat, mentions that it encompassed ten pieces from Renoir's recent period, no doubt purchased during his visit to Cagnes where, in 1908, Renoir painted a portrait of Mme Thurneyssen.[35] While staying with his

Anonymous
Dining room in the apartment of Harry Kessler, Cranachstrasse 15, Weimar
1903
Photograph
Marburg, Deutsches Dokumentationszentrum für Kunstgeschichte
Panel of a frieze by Maurice Denis (1895); on the right *The Apple Seller* by Renoir (1890)

Fig. 39

Carl Montag
Inventory of paintings in the salon of Georges Viau's apartment in Paris
Ca. 1914
Zurich, SIK-ISEA, Carl Montag estate

Fig. 40

Invoice of March 29, 1918, to Sydney Brown from Vollard for the purchase of two paintings by Renoir, *Landscape* and *Roses*

Fig. 41

"Exhibition of Paintings by Renoir"
New York, Durand-Ruel Galleries, February 7–21, 1918
Photograph
Paris, Durand-Ruel Archives

Fig. 42

21. The Philadelphia Museum of Art, Philadelphia, the Louise and Walter Arensberg collection, 1950. 22. Quoted in Kern 1996, p. 9. 23. Letter from Mary Cassatt to Louisine Havemeyer, Grasse, January 11, 1913, Cassatt 1984, pp. 308, 315. 24. Pach 1938, p. 228. 25. Meier-Graefe 1911; idem 1912; idem 1929. 26. Von Nostitz 1933, quoted in Van de Velde 1995, p. 133. 27. Durieux 1954, p. 110. See also Feilchenfeldt 2006, p. 29. 28. See *Correspondance Renoir-Durand-Ruel,* vol. 2, 1995, note 140, p. 253. 29. "III. Jahrgang" and "IV. Jahrgang der Kunst-Ausstellungen," Kunstsalon, Berlin, April and October–December 1901. Brühl 1991. 30. "Ausstellung Auguste Renoir. 41 Werke aus den Jahren 1873–1910," Moderne Galerie, Munich, Heinrich Thannhauser, mid-January to mid-February 1912. 31. Letter from Paul Cassirer to Max Slevogt, Berlin, September 2, 1914, Feilchenfeldt 2006, p. 374. Tilla Durieux devotes a chapter to Renoir in Durieux 1954, pp. 175–180. See also exh. cat. Ottawa, Chicago, and Fort Worth 1997–98, no. 68, pp. 259–261 and notes pp. 341–342. 32. Record of the Paul Cassirer gallery purchases and sales from 1904 to 1935, kindly provided by Walter Feilchenfeldt. 33. "Eröffnungs Austellung," November 1909 (seven Renoirs). 34. Quoted in Pophanken 1996, p. 426. 35. Meier-Graefe 1912, p. 183. See also exh. cat. Ottawa, Chicago, and Fort Worth 1997–98, nos. 66–67, pp. 254–258 and notes pp. 338–339. We do not know exactly which works he owned, but the Thannhauser archives (Buch

Fig. 39

Fig. 40

Fig. 41

Fig. 41 verso

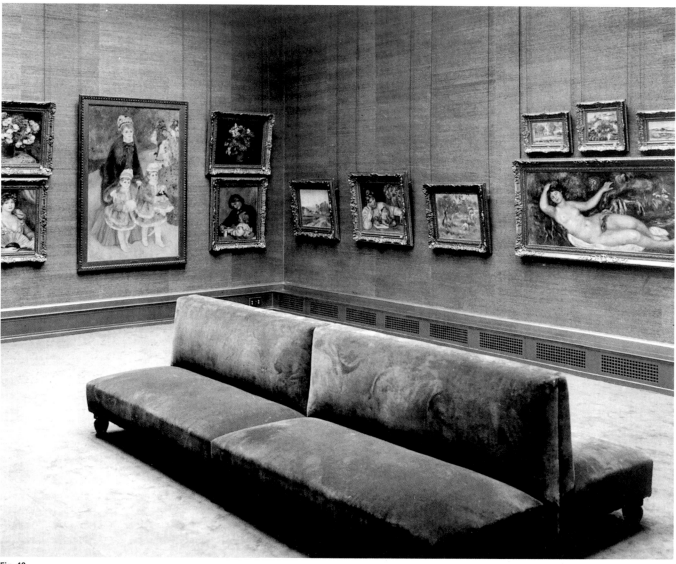

Fig. 42

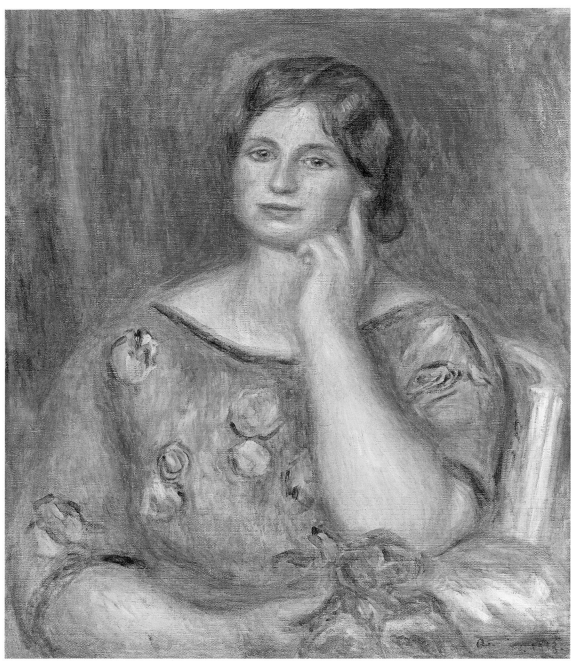

Fig. 43

family at Wessling-am-See in August 1910, Renoir painted another portrait of Mme Thurneyssen, with her daughter, and the following year, at Cagnes, one of Alexander, her son.

In 1901, the art collector and patron Karl Ernst Osthaus, who lived in Hagen, away from the major art centers, purchased Renoir's large painting *Lise* from Cassirer; this was the starting point of a unique collection of modern art that would "cast a few rays of light over our industrial area"[36] along the Ruhr. Osthaus preferred to deal directly with artists. It was his wife who made contact with Renoir, as Osthaus himself had some problems with the overly pink tones of the painter's recent works. In early winter 1912, while she was staying in Vence, Getrude Osthaus purchased five paintings that joined works by Van Gogh, Matisse, Signac, and Nolde in the new museum.[37] She returned to the South of France early the following year and had Renoir paint her portrait **Fig. 43**. Shortly after, Osthaus went to Cagnes and, captivated by the light, fell in love with Renoir's art, the artist becoming for him the equal of Ferdinand Hodler, one of the great masters: "Show me a contemporary painter greater than Renoir and Hodler, and I will turn my back on them."[38]

Switzerland, Munich, and Paris

In the early twentieth century, collectors from German-speaking Switzerland purchased their art in Munich—which was also the place where many painters went to study. One of these was Carl Montag, who then left for Paris in 1903 to complete his training, soon introducing modern French art to his native town of Winterthur. Dr. Viau acted as his guide in the world of collectors and art dealers, and it was not long before Albert André and Georges d'Espagnat took Montag to Renoir's studio.[39] Montag was to become a mentor to art lovers in Winterthur, many of whom were very active in the Kunstverein (arts society).

Two of the Kunstverein's most eminent members, Arthur and Hedy Hahnloser bought their first Renoir in Paris while on their honeymoon.[40] Some years later, on June 9, 1911, Félix Vallotton and his brother Paul purchased the Hahnlosers' first major Renoir, *The Fruit Bowl,* from the Drouot auction house. The young painter Henri Manguin, who played a crucial role in their choice of Renoir, exclaimed enthusiastically: "What a Renoir! It is very beautiful, a very pure piece."[41] Each year, in spring, the Hahnlosers made a trip to Paris. Their first contact with the Galerie Vollard concerned a "truly ravishing Renoir, a landscape." They soon formed an excellent relationship with the art dealer, who stayed with them on a visit in 1916.[42] They were also clients of Durand-Ruel and, in Lausanne, of the Bernheim gallery run by Paul Vallotton.[43] The Hahnlosers' admiration for Renoir was matched by their admiration for Bonnard, whom they saw as Renoir's heir.[44]

Among the other members of the Kunstverein, the Reinhart family counted as notable collectors. The father, Theodor Reinhart, bought mainly Swiss painters but, given Renoir's growing notoriety, commissioned the German painter Konrad von Freyhold to purchase two works from the painter during his stay in Cagnes.[45] In 1911, Georg Reinhart, his eldest son, purchased a Renoir *Bather* from Durand-Ruel and, the following year, a work from 1901, *Reclining Woman in a White Dress.* Then Montag sent Reinhart a small, back-view nude that Henri Manguin had admired. By 1920, these three works were joined by three still lifes and three other figure paintings. Renoir was the only French artist whose whole range of work Reinhart collected. In 1918, he sent Renoir a photograph of his garden with the large *Venus Victrix* and wrote: "My wife and I are great admirers of your art and . . . we are delighted to possess, in addition to seven of your paintings and a number of your lithographs, the bronzes of your little girl and your large *Eve,* as well as *The Judgment of Paris.*"[46]

Pierre-Auguste Renoir
Portrait of Gertrude Osthaus
Cagnes, 1913
21⁵/₈ x 18¹/₄ in. (55 x 46.4 cm)
Essen, Museum Folkwang

Fig. 43

2) show two sales: no. 1013, May 10, 1924, *Fruit Picking,* no dimensions; no. 1114, August 27, 1926, *Olive Grove,* 21⁷/₈ x 18¹/₄ in. (55.5 x 46.5 cm). Zentralarchiv des Internationalen Kunsthandels, Cologne, E. V. (Zadig). **36.** Letter from Osthaus to Renoir, January 20, 1913, in Heil and Sinzel 2000, p. 20. **37.** Freyer 1912, no. 164a: *Olive Garden;* no. 164b: *Landscape near Cagnes;* no. 164c: *Portrait of a Young Girl;* no. 164d: *Still Life;* no. 164e: *Gabrielle;* no. 604: *Head of a Young Girl* (lithograph). **38.** Letter from Osthaus to F. Hürsten, October 16, 1914, in Heil and Sinzel 2000, p. 37. Osthaus would later publish his memories of Renoir: Osthaus 1919–20, pp. 313–318, reproduced in Heil and Sinzel 2000, pp. 22–26, and in Osthaus 2002, pp. 173–175. **39.** See the chronology in exh. cat. Baden 1992, pp. 39–40. See also Preiswerk-Lösel 2001, p. 27. **40.** Hahnloser 1973, p. 21. **41.** Quoted ibid., pp. 24 and 29. **42.** Quoted ibid., p. 32. **43.** Purchases: September 1, 1916, *Head of a Young Girl;* November 6, 1916, *Young Woman Reading, La Toilette,* brush drawing, *Female Nude;* January 10, 1917, *Young Woman with Red Blouse in a Landscape.* Ledger of paintings sold, Lausanne, Paul Vallotton archives. **44.** Perruchi-Petri 1998, p. 148. **45.** Letter from Montag to Georg Reinhart, Paris, January 14, 1914, Winterthurer Bibliotheken, Winterthur, Sondersammlungen, Ms GR 19/97. **46.** Letter from Georg

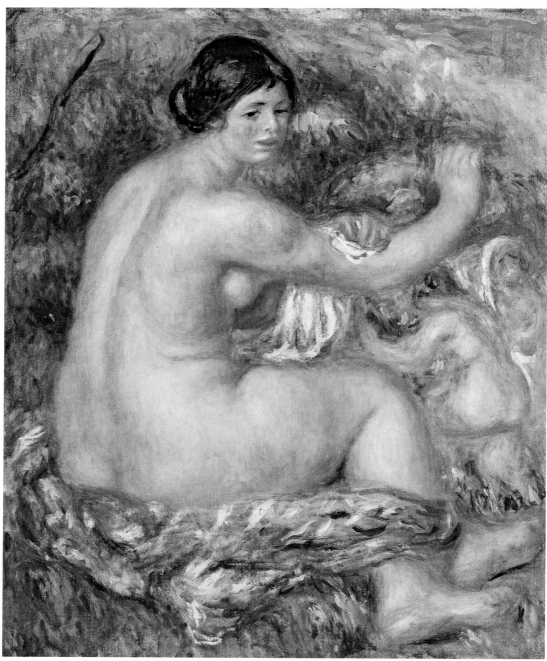

Fig. 44

Carl Montag was also an acquaintance of Jenny and Sydney Brown. In 1907, they attended the Viau sale in Paris and started buying Impressionist works in 1908. In 1909, they demonstrated great enthusiasm for a Renoir portrait being offered for sale by Montag.[47] Twice a year, in May and October, they went to Paris where Montag and Viau opened new doors to them. They hung the paintings they bought from Viau in their drawing room at Langmatt, their Baden residence, but "to avoid too much comment, we tell our friends that we have them on trial."[48] At the exhibition that Thannhauser organized in Munich in early 1912 they showed little enthusiasm for Renoir's recent works.[49] Shortly after, however, they bought three paintings from Vollard, including two recent ones, a landscape and a still life.[50] They owned a total of twenty-five paintings by Renoir who, along with Cézanne, was their favorite painter. Fourteen of these dated from after 1892.

Swiss art lovers also purchased from dealers such as Gottfried Tanner and Albin Neupert in Zurich, and from Paul Vallotton who ran a branch of Bernheim-Jeune in Lausanne. This opened in 1913 and the inaugural exhibition included a work by Renoir: *Woman Knitting*, "as iridescent as a butterfly wing,"[51] and, between December 1915 and late 1918, sold thirty-three paintings by Renoir.[52]

An Important Moment—Visiting the Master

These collectors and dealers willingly traveled to the South of France where Renoir spent the winter months. Paul Durand-Ruel, now elderly, went to Cagnes for his own pleasure but combined his efforts with those of his sons Georges and Joseph, now at the head of the gallery, in persuading Renoir to let them go off with some newly finished pieces. While on holiday in Monte Carlo, the Bernheims would make courtesy visits to Renoir and take the opportunity to peruse the latest works for sale. Gabrielle Renard observed these comings and goings: "Our most recent visitors are the Bernheims, who want to buy the entire studio . . . The whole of rue Laffitte and La Madeleine stops by Les Collettes. The Molines came last week," with the Durand-Ruels soon to follow.[53]

Vollard was as much at home at Les Collettes as he was at Essoyes. The photographic record he made of Renoir's work allowed Vollard to follow what Renoir was doing.[54] But he also went there to rest and spend time with the artist, particularly after the death of his wife, though this did not exclude business being conducted **Fig. 41**.

Some art patrons had the pleasure of meeting the artist whose works they collected, as we have seen with the Thurneyssens and Osthauses, who in turn introduced the painter Konrad von Freyhold.[55] Durand-Ruel was able to obtain this favor for certain clients, such as Arthur B. Emmons and his family: "He already has nine of your paintings and I think that we shall sell him more."[56] Renoir enjoyed having visitors and talking about painting, particularly with young artists. However, he was less pleased about the growing demand for paintings and, toward the end of his life, often refused to sell, or put off important collectors like the prince of Wagram, as Matisse recounted to the Norwegian art dealer Walther Halvorsen.[57] Matisse had settled in Nice in late 1917 and spent a lot of time with Renoir. He had first made contact with him in 1916 when he had been tasked with telling him that Halvorsen could not see him. The art dealer, grateful to Matisse for his help, explained his request: "I was able to do it knowing that we share the same interests [sic] the [sic] old man."[58] Matisse also acted as intermediary in a business matter. The art dealer Jos Hessel entrusted him with two Renoirs and a Cézanne for Halvorsen on condition that he should not hand them over to his friend

Pierre-Auguste Renoir
Bather, or *After the Bath*
Ca. 1910–12
Oil on canvas
26³/₈ x 20⁵/₈ in. (67 x 52.5 cm)
Winterthur, Kunstmuseum

Fig. 44

Reinhart to Renoir, Winterthur, May 21, 1918. Winterthur, Winterthurer Bibliotheken, Sondersammlungen, Ms GR 64/47. See also Schwarz 1998. For the collection catalogue, see exh. cat. Winterthur 1998, pp. 257–258. See also Paris, Bibliothèque Centrale des Musées Nationaux, Vollard archives, ms 421 (2,3), (4,1) and (4,13). **47.** February 19, 1909, *Portrait of Paul Meunier,* ca. 1877, see Preiswerk-Lösel 1992, p. 30 and note 12. **48.** See ibid., pp. 32–35. **49.** Letter from Sydney Brown to Carl Montag, February 6, 1912, SIK-ISEA, Zurich, Nachlass Montag, dossier 5C. **50.** Letter from Jenny Brown to Carl Montag, November 11, 1912, SIK-ISEA, Zurich, Nachlass Montag, dossier 5C. In 1912, the Browns purchased two paintings from Vollard: on May 7, *Fish,* 1911, 8000 francs, and *Landscape with Mountains,* ca. 1895, 5000 francs, and one on November 28, *Reclining Nude,* 1876, 15000 francs, Stiftung Langmatt archives, Baden and Bibliothèque Centrale des Musées Nationaux, Paris, Vollard archives, 421 (4, 13). Duplain 1992, p. 15. **51.** Ducrey 1988, p. 23. **52.** Ibid., pp. 21 and 36. "Journal" of paintings sold, Lausanne, Paul Vallotton archives. **53.** Letter from Gabrielle to Vollard, Cagnes, late March 1910, Paris, Bibliothèque Centrale des Musées Nationaux, Vollard archives, MS 412 (2, 2), 316, 317. **54.** Letter from Aline to Vollard, Essoyes, August 19, 1913, Bibliothèque Centrale des Musées Nationaux, Paris, Vollard archives, MS 421 (2, 2), 319, 320. **55.** Roland Stark archives. **56.** Letter from Georges Durand-Ruel to Renoir, Paris, November 15, 1912, *Correspondance Renoir-Durand-Ruel,* vol. 2, 1995, p. 119, and note 163, p. 257. **57.** Letter from Matisse to Halvorsen, Nice, April 17 (or 12), 1918, copy kindly provided by the Matisse archives. For the Prince of Wagram collection, see Distel 1985–86, pp. 25–27. See also Archives Nationales de France, Paris, AP / 173 bis / 429, 430, 431, 434. **58.** Letter from Halvorsen to Matisse, no date or location indicated, Matisse archives,

without payment.[59] Matisse and Halvorsen shared a keen admiration for Renoir, and Halvorsen was quick to let Matisse know when he came into possession of new works by the master.[60]

Matisse soon became a regular visitor at Les Collettes and introduced other painters to Renoir, as well as art enthusiasts and dealers. He went there with Halvorsen, who started buying directly from Renoir from as early as 1914.[61] In spring 1918, Renoir grudgingly let Halvorsen have a painting, and Matisse wrote to the collector: "after you left, perhaps your father-in-law told you, he was furious—because of the small torso— his nephew [?] told me that he only wanted to sell to Vollard and Durand because he does them a package and tells them that's the lot."[62] Matisse became a lot more cautious about bringing new art lovers, such as the Swede Conrad Pineus[63] to Les Collettes, and kept his distance from the Marseille collector friend of Camoin, Dr. Victor Audibert, who on several occasions pressed him to intervene with Renoir on his behalf.[64]

By this time, France had been at war for two years, but the passion of Renoir's admirers had not diminished, in fact quite the opposite.

World War I and the Neutral Countries

When war was declared on August 5, 1914, Renoir's German patrons and friends returned home. The paintings being held in Germany were immobilized, including, among the ninety-two works in Durand-Ruel's stock, twenty-six Renoirs.[65] To counter the effectiveness of German artistic propaganda in neutral countries, the minister for foreign affairs pressed art dealers in France to mount exhibitions, particularly in Switzerland, the Nordic countries and, to a lesser extent, in Spain and the Netherlands.[66] Durand-Ruel told Renoir that Paris art dealers were meeting to agree on some rules about their "relations . . . with the State for future exhibitions."[67]

Carl Montag was made responsible by the ministry of foreign affairs for "managing French artistic propaganda in Switzerland."[68] In 1916, he mounted an exhibition of French nineteenth- and twentieth-century art in Winterthur. Of the twenty-six Renoir paintings exhibited, the majority of which were recent works, twenty came from collections in Winterthur and Baden, the rest being sent by Durand-Ruel and Bernheim-Jeune. At the request of the propaganda department, Vollard also gave a lecture on Renoir.[69] Given the success of the exhibition, the newly opened museum decided to buy one of the Renoir canvases. The acquisitions committee, which met in special session in March 1917, wanted works for the museum that were representative of the great art movements. With advice from experts, including Montag, they decided upon a Renoir *Bather* sent by Vollard[70] **Fig. 44**.

Montag then mounted another exhibition of French art in Zurich, for which art dealers provided a large number of works.[71] Montag was delighted to have assembled so many masterpieces by Cézanne and Renoir.[72] Renoir was represented by sixty paintings and bronzes, including *Luncheon of the Boating Party* **Fig. 4, p. 33** and *The Theater Box*, on loan from Durand-Ruel. The collector Alphonse Kann, who was interested in selling certain paintings, offered five Renoirs.[73]

An exhibition including six Renoirs, all for sale, had already been mounted in Basel in 1917, the preface to the catalogue written by René Jean, who was in charge of French propaganda in Bern. In the spring of 1918, Carl Montag organized an exhibition in Geneva of the leading twentieth-century French painters that included works

000000a1. Matisse had not yet painted the portrait of Greta Prozor, Halvorsen's wife, dated late 1916. Centre Georges Pompidou, Musée National d'Art Moderne, Paris. **59.** Letter from Jos Hessel to Matisse, Paris, October 13, 1916, Matisse archives, Paris, 161013a1. Receipt from Matisse, Matisse archives, 161013a2. **60.** Letter from Halvorsen to Matisse, [1916], Matisse archives, Paris, 16000b2. **61.** *Villa in the South of France*, bought by Renoir in 1914, Zentralarchiv des Internationalen Kunsthandels, Cologne, E. V. (Zadig), Thannhauser archives, A77, XIX, 3, no. 1450. **62.** Letter from Matisse to Halvorsen, Nice, April 17 (or 12), 1918, kindly provided by the Matisse archives. **63.** Letter from Matisse to his wife, Nice, January 10, 1919, extracts kindly provided by the Matisse archives. **64.** Letter from Audibert to Matisse, November 26, 1916, Matisse archives, Paris, 181126a1. **65.** Letter from Joseph Durand-Ruel to Renoir, Paris, November 4, 1914, *Correspondance Renoir-Durand-Ruel*, vol. 2, 1995, pp. 150–151, and note 175, p. 259. **66.** Maignan 1979, pp. 126–137. See also Gloor 1992, pp. 19–26. **67.** Letter from Georges Durand-Ruel to Renoir, Paris, May 1, 1917, *Correspondance Renoir-Durand-Ruel*, vol. 2, 1995, p. 195. **68.** Duplain 1992, p. 13. **69.** Vollard 1984, pp. 354–355. The text is published in exh. cat. Baden and Vevey 2006, pp. 140–141. See also Koella 2006, pp. 116–137. **70.** Protokolle der Vorstandssitzungen des Kunstvereins, April 1915–July 1919, sessions of December 17, 1916, and March 8, 1917. Generalversammlungsprotokoll des Kunstvereins, November 4, 1889–March 12, 1917: meeting of March 12, 1917. Winterthur, Kunstmuseum archives. **71.** "Französische Kunst des XIX. und XX. Jahrhunderts," Zürcher Kunsthaus, Zurich, October 5–November 14, 1917. **72.** Letter from Montag to Richard Bühler, Paris, August 7, 1917, Winterthurer Bibliotheken, Winterthur, Sondersammlungen, Ms Sch 60/23 1276. **73.** The Phillips Collection, Washington, DC; The Courtauld Institute of Art,

from the Louvre and the Musée du Luxembourg. Léonce Bénédite, the influential curator of the Musée du Luxembourg, attended the private viewing.[74]

The outcome was a great success for French painting. Immediately after the war, Bernheim-Jeune seized an opportunity to take over the Gottfried Tanner gallery in Zurich, thus extending its area of influence.[75] Some magnificent collections began to take shape, including those of Oskar Reinhart in Winterthur, Emil G. Bürhle in Zurich, and Rudolf Staechlin in Basel, each of which included important Renoirs.

Walther Halvorsen was to the Nordic countries what Montag was to Switzerland. While living in Paris, he mounted a modern French art exhibition in Oslo in 1916, with the help of Matisse **Cat. 184, p. 138**. The following year he put together a second exhibition, conceived as an homage to Renoir whose "art . . . is more French than any other." The catalogue included a piece written by Matisse.[76] In his introduction, Halvorsen remarked that the war had favored the creation of great private collections in Copenhagen, Stockholm, and Christiania. He writes at length about his connections with Renoir: "'I am still searching,' Renoir, the master, told me when I was contemplating one of his recent works. This artist symbolizes the whole of France, the strength, the will to live and to continue his remarkable work despite everything. I wish, first and foremost, to dedicate this exhibition to him, because he is unknown in the Scandinavian countries . . . Few people, if any, in our country are familiar with the wonderful works he has produced in the last ten or fifteen years." Halvorsen had asked Renoir for his help with this exhibition and gathered together sixteen paintings, some owned by himself, such as the 1908 *Judgment of Paris*[77] **Fig. 62, p. 155**. On February 10, Halvorsen purchased a large bronze from Vollard for the Christiania museum.[78]

The Swedish art dealer Gösta Olson, who in 1917 opened the Svenks-franska Konstgalleriet in Stockholm, organized the Swedish leg of this exhibition. The French minister Thiébaut opened the exhibition but was outraged by the modernity of its content, which he described as sullying "our flag."[79] Three Renoirs were sold, including *Bathing Women,* which was acquired by Stockholm's Nationalmuseum **Cat. 46**. The museum's curator, Richard Bergh, had already purchased *Conversation* through Halvorsen.[80] In September, the exhibition was shown at the Göteborg museum which, in 1917, purchased Renoir's *The Turkish Jacket* from Paul Vallotton in Lausanne.[81]

It must be said that this dramatic conflict did indeed favor the fine arts. Durand-Ruel, who exhibited twenty-eight works by Renoir in New York in February 1918 **Fig. 42**, confided his thoughts to the painter: "Business is very poor for the moment in America; here, on the contrary, we are finding buyers; mainly from the neutral countries, buying either for themselves or for others."[82]

In these early years of the twentieth century, Renoir found his way into the collections that were most open to the new trends in the contemporary art market. Of course, his art dealers, who were also his friends, played a key part, but Renoir's own role is not to be underestimated. Surrounded as he was by highly regarded professionals, he was not the naïve character he claimed to be and succeeded in managing his career while retaining an independence that allowed him to renew his art with complete freedom.

London. SIK-ISEA, Zurich, Nachlass Montag, dossier 9. **74.** Ten paintings by Renoir. The exhibition took place from May 15 to June 16, 1918, at the Musée d'Art et d'Histoire. Archives de la Ville, Geneva, 340.C.5.10/18. **75.** Ducrey 1988, p. 43. **76.** "Den Franske Utstilling i Kunstnerforbundet," Kristiania, January–February 1918. **77.** Barnes and Reinhart saw *The Judgment of Paris* at his house. Zentralarchiv des Internationalen Kunsthandels, Cologne, E. V. (Zadig), Thannhauser archives, Halvorsen file, No. A077_078_0642. **78.** Bibliothèque Centrale des Musées Nationaux, Paris, Vollard archives, 421 (4,1), 307 and 311. **79.** Olson 1965, p. 59. **80.** *Bathers,* 16 x 20 1/8 in. (40.5 x 51 cm), inv. NM 2103; *Conversation,* 17 7/8 x 15 in. (45 x 38 cm), purchased in 1918. Another painting, *Young Parisian Woman,* 15 3/4 x 12 5/8 in. (40 x 32 cm), inv. NM 1757, was purchased in 1913. **81.** Ca. 1900, 22 x 18 1/8 in. (56 x 46 cm), purchased on February 16, 1917. Lausanne, Paul Vallotton archives. **82.** Letter from Joseph Durand-Ruel to Renoir, Paris, March 8, 1918, *Correspondance Renoir-Durand-Ruel,* vol. 2, 1995, p. 228.

Late Renoir in the Collections of Albert C. Barnes and Leo Stein

Martha Lucy

Pierre Matisse
Albert C. Barnes with Renoir's Bathers in the Forest *and* Leaving the Conservatory
1932
Photograph
Merion, PA, Barnes Foundation Archives

Fig. 45

Pierre-Auguste Renoir
Bathers in the Forest
Ca. 1897
Oil on canvas
29¼ x 39½ in. (74.3 x 100.3 cm)
Merion, PA, Barnes Foundation

Fig. 46

"I am convinced that I cannot get too many Renoirs," the American art collector Albert C. Barnes wrote to his friend Leo Stein in 1913.[1] Barnes was new to the business of collecting. He had made his first major purchases just the year before, but already he knew that he wanted his rapidly growing collection to center around the work of Renoir and Cézanne **Fig. 45**. Over the course of four decades, Barnes would go on to amass the largest collection of Renoirs in the world—one hundred and eighty-one in total—assigning each its place in his meticulously designed wall ensembles. What is remarkable about the Barnes Renoirs is not just the sheer number of them, but their character: most are late works. Roughly eighty-five percent were executed after 1890, and of this group nearly half were done in the last decade of Renoir's life, when he lived and worked at Les Collettes and gave himself over to obsessive study of the female nude. The walls of the Barnes Foundation, home to the Barnes collection, in Merion, Pennsylvania, are virtually brimming with paintings from this late period[2] **Fig. 47**.

In the early decades of the twentieth century, when Barnes was building his collection, Renoir was at the height of his popularity with American audiences. Between 1913 and 1940, there were nineteen Renoir solo exhibitions in the United States, and his paintings were fetching record prices from collectors like Barnes, Henry Frick, Sterling Clark, and Duncan Phillips.[3] This enthusiasm for Renoir, however, did not typically extend to the late paintings. The public wanted exhibitions of the Impressionist works, and many critics dismissed the late nudes as too fleshy and technically inferior—the product of a crippled old man who no longer had control of the brush.[4]

For Barnes, however, those fleshy, massive forms built of thin paint and arranged in decorative patterns represented artistic maturity. "Naturally as [Renoir] got older he got wiser and had better control of his means," Barnes wrote in a 1924 letter, "so perhaps his best work is that which dates from the '90s up to the time of his death. My large canvas, *Les Baigneuses*, represents the summation of his powers . . ."[5] Barnes's opinions on late Renoir were issued at great length in his 1935 *The Art of Renoir*. Written in the strict formalist language of the 1930s, the book moves through the whole of Renoir's career, dissecting individual paintings and tracing what Barnes sees as a continual stylistic evolution toward the "apotheosis" of the last few years. "In its continuity, its basically uninterrupted progress both in range and depth, Renoir's career is a superlative example of all the essential characteristics of the process of growth. Nothing is ever included in his mature paintings that he has not made genuinely his own, and

Research for this essay was funded by the Andrew W. Mellon Foundation. I owe an enormous debt of thanks to archivists Katy Rawdon, Barbara Beaucar, and Adrienne Pruitt, who guided my work in the Barnes Foundation archives; to Kate Butler, with whom I have had countless good conversations about Leo and Albert; to Richard Wattenmaker, who has so generously shared his knowledge of the Barnes collection and its history; and to John House, who has taught me much about Renoir.

1. Letter from Albert Barnes to Leo Stein, March 30, 1913. Yale Collection of American Literature, Beinecke Rare Book and Manuscript Library, Yale University. This letter is quoted in part in Wattenmaker 1993, p. 8. This catalogue, which also contains a text by Anne Distel (Distel 1993), is the only overall publication in French devoted to the Barnes Foundation. **2.** Albert C. Barnes chartered the Barnes Foundation in 1922 as an educational institution devoted to promoting the appreciation of fine art. The Foundation opened its doors to students in 1925. **3.** On the reception of Renoir in America, see exh. cat. San Diego and El Paso 2002–03. **4.** Among the critics defending Renoir's late work were Roger Fry (1921) and Walter Pach (1912). **5.** Letter from Barnes to the artist, critic, and industrial design theorist Harold Van Doren, September 18, 1924, Barnes Foundation archives.

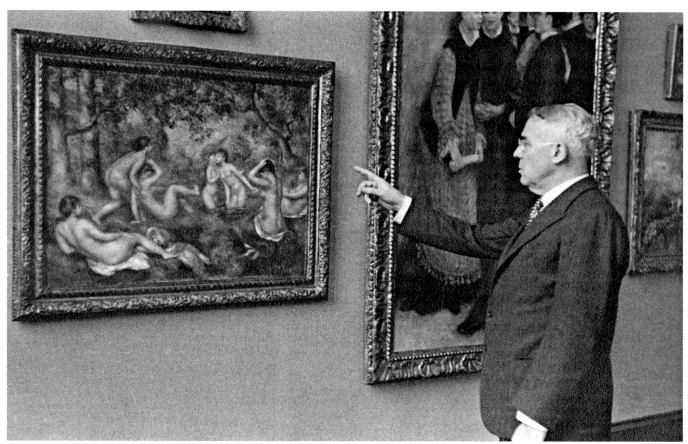

Fig. 45

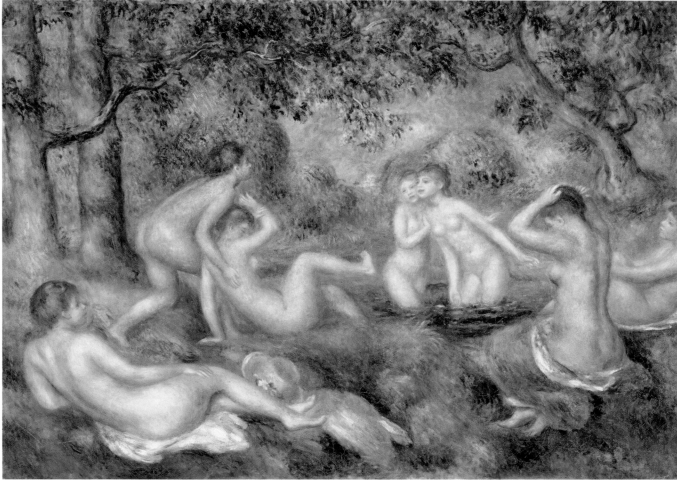

Fig. 46

Main Gallery, North Wall, at the Barnes Foundation in Merion, PA. This ensemble includes six late paintings by Renoir. Barnes's favorite, the 1916 *Bathers* (BF709), hangs in the bottom row, second from the right.

Fig. 47

George Besson
A corner of Renoir's studio in Cagnes
January 1918

Cat. 179

nothing, once assimilated, is lost."[6] Renoir, in other words, had always been working toward this final achievement.

How did Barnes arrive at this conviction about the superiority of the late works? A transformative experience was his 1921 visit to Renoir's studio in Cagnes **Cat. 179**, where he saw scores of canvases done in the last decade of the artist's life "with that loose juicy colorful richness that he alone could put in a painting. It almost broke my heart not to be able to get any of them but they are not for sale at present. It is quite evident that the old man knew what he was doing for he kept the best of his work for himself and did not sell it."[7] Much of his appreciation of these "juicy" late paintings, and of Renoir's work in general, came from intensive study—of books, of other collections, and of his own paintings. "I have read conscientiously practically every book on art that has been published during the last few years . . . I have lived with my own two hundred paintings as constant companions and objects of study from two o'clock every day until ten o'clock at night."[8]

Yet as much as his interest in late Renoir might read like a quirky personal obsession, Barnes was hardly alone in his thinking. The critical context in which his tastes developed is the subject of a recent essay by Colin Bailey, who notes that modernist critics like Roger Fry, Walter Pach, Clive Bell, and Willard Huntington Wright—all of whom Barnes had read and absorbed, if reluctantly at times—admired Renoir's later paintings and, like Barnes, preferred them to the more "formless" works of the Impressionist period.[9] Bailey also points to several people in Barnes's circle who guided his thinking on Renoir at this critical early juncture: the painters William Glackens and Alfred Maurer both made trips to Paris on Barnes's behalf, either purchasing works or reporting back on the latest offerings at the galleries.[10] However, the person who most encouraged Barnes's Renoir fixation was Leo Stein, the expatriate critic and collector.[11] While Barnes dwelled on late Renoir in Merion, Stein did the same in Paris; a look at the relationship between these two men gives us a sense not only of what the artist meant to each collector, but also of Renoir's crucial role in early twentieth-century modernism.

Barnes first met Leo and Gertrude Stein on December 9, 1912, in Paris, when Maurer brought him to their famous apartment at 27, rue de Fleurus. While Barnes and Leo would meet face to face on only a few occasions, their written correspondence spans four decades and is often deeply personal.[12] Especially in the years after their 1912 meeting, Barnes and Leo wrote frequently to one another, trading ideas—and sometimes arguing intensely—about psychoanalysis, aesthetics, art, and philosophy. Like so many of Barnes's relationships, his with Stein turned ugly at times; but for the most part, the two men had a strong friendship sustained by their similar philosophical positions about art—about its place in society, about what constitutes a great painting, and about the nature of the aesthetic experience, which they agreed should be rooted in reason. "We have had divergences," Stein wrote to Barnes in 1947, "but there has always been, I think, a mutual recognition that neither of us like twaddle about art instead of hard-headed commonsense."[13] Above all, the two friends shared a passion for the artists that formed the core of each of their collections—Matisse, Picasso, Cézanne, and especially Renoir.[14]

We do not tend to associate Leo Stein with Renoir. He and Gertrude are the mythic discoverers of Matisse and Picasso, the pioneering collectors of radical Fauve works like Matisse's *Woman with a Hat*[15] (bought straight out of the 1905 Salon d'Automne), intellectuals whose Saturday-night soirées and unmatched Cézanne collection drew people from all over the world. As the self-appointed expounder of "l'art moderne," Leo took it upon himself to articulate the merits of the new painting for a generation of artists, writers, critics, collectors, and dealers that assembled each week at 27, rue de Fleurus. "Our collection became in time one of the sights of Paris, for everyone who was curious to know modern art."[16] What is not often discussed is the fact that a good portion of what this generation saw in the Stein apartment—and thus what they would

6. Barnes and De Mazia 1935, p. 150. **7.** Letter from Barnes to the American artist Max Kuehne, July 26, 1921, Barnes Foundation archives. When the studio paintings were dispersed in the mid-1920s and 1930s, Barnes acquired forty-one of them. **8.** Letter from Barnes to Leo Stein, July 17, 1914, Barnes Foundation archives. **9.** Bailey 2008, pp. 534–543. **10.** Ibid., p. 537. **11.** Ibid., p. 542. See also Wattenmaker 1993, pp. 8–10, and Rewald 1989, p. 63. **12.** The Barnes Foundation archives preserves dozens of letters between Barnes and Stein, ranging in date from 1914 to 1947. **13.** Letter from Leo Stein to Barnes, July 8, 1947, Barnes Foundation archives. **14.** For a discussion of how Barnes came to arrive at these core artists, see Bailey 2008, Wattenmaker 1993. **15.** San Francisco Museum of Modern Art. **16.** Stein 1947, p. 158.

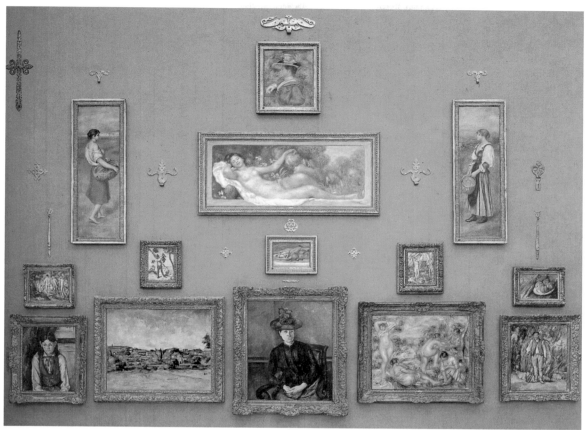

Fig. 47

Cat. 179

Fig. 48

Fig. 49

have understood as highly relevant to modernist developments—was Renoir's most recent work. Leo was a passionate devotee of Renoir, and it was he who pushed for his inclusion in the Stein collection. Admiring his use of color, his composition, and perhaps most of all, his sensuality, Leo anointed Renoir one of the "Big Four," the artists he felt most significantly affected the history of modern painting. When he began to lose faith in Picasso's new work around 1910, Leo turned even more intensely to Renoir. The late paintings especially, which seemed to issue from corporeal drives, were the antidote to the "contemptible" intellectualism of Picasso's Cubist turn.[17]

One of Leo Stein's most cherished Renoirs was the *Washerwoman and Child* **Fig. 49** from around 1887, which can be seen on the wall of the atelier in a photograph taken circa 1907 **Fig. 48**. Stein regarded the painting as "a marvel, and rare if not almost unique in Renoir's oeuvre," and remembered with near rapturous delight his first encounter with the painting in the window of a Parisian art dealer: "The picture . . . was brilliantly lighted. I looked and looked, and after a long while, I started toward home. But after a few hundred yards, I thought that the picture couldn't really be as beautiful as that— I must go back and look at it again. I did and stood a long time gazing at it."[18] Interestingly, it was not just Stein who marveled over this painting, but also the painters who gathered in his apartment. Stein notes that when *Washerwoman and Child* hung at 27, rue de Fleurus—probably from 1908, when he purchased it, to 1914—it "always enjoyed an unbounded popularity among the laity and in years gone by Picasso and Braque and Derain and Matisse and others were quite mad about it."[19] In fact, it was Picasso and Braque who first advised Stein to go see it in the gallery window; they "could talk about nothing except a Renoir they had seen in the window of the rue Royale."[20]

Stein's recollections remind us of Renoir's centrality for a generation of artists working in early twentieth-century Paris. While his remarks do not tell us exactly what it was that drew painters like Picasso and Braque to Renoir, we should note that what most stirred their excitement was a relatively *late* painting. Indeed, *Washerwoman and Child* is an emblem of anti-Impressionism, with its tight, controlled brushwork, its linear forms and geometry, its figures evoking more Renaissance stability than modern-life fleetingness. This was the modern Renoir that avant-garde artists circled around— perhaps for its embrace of the classical, perhaps for its graceful primitiveness, or perhaps because Renoir was an artist who dared break with a movement. In his works from the mid-1880s and after, Renoir—not just Cézanne—offered the new generation a path beyond Impressionism; and for those artists in the Stein circle around 1908, *Washerwoman and Child* perhaps represented that new direction more than any other.

For Barnes, who was just at the beginning of assembling one of the world's great collections of modern painting, the display of Renoir at the Steins must have made quite an impression: there, amidst the Matisses and Picassos, the artist was cast as one of the fathers of the modernist generation. Moreover, we know that Renoir's late work was part of the conversation during that 1912 visit, with Stein apparently laboring to convince Barnes of its value.[21] It is fascinating to compare Barnes's Renoir purchases immediately before and after that first meeting with Stein. Two days prior, on December 7, 1912, he had acquired a pair of important Impressionist-period Renoirs from the sale of the Hirsch collection at Hôtel Drouot—a loose, feathery painting from 1873 called *Two Women in the Grass* **Fig. 50**, and another called *Woman Crocheting*, ca. 1877. When he returned to Merion, his next purchase, from Durand-Ruel in February of 1913, was a group of seven Renoirs all painted between 1909 and 1912, which Durand-Ruel had gotten just months before, directly from the artist.

In the years that followed, Barnes continued to snap up Renoir's late works: of the twenty-seven Renoirs he purchased in 1914 and 1915, twenty-three were painted after 1890. Barnes continued to add late works through the 1920s and 1930s, getting several key pictures through Durand-Ruel, Étienne Bignou, and Paul Guillaume. Stein kept Barnes abreast of what was available at the Paris dealers—"I know most of the Renoirs that are lying about just now," he offered—and in turn, Barnes kept Leo up-

The studio of Leo and Gertrude Stein at 27, rue de Fleurus
Ca. 1907
Photograph
Berkeley, University of California, Bancroft Library, Annette Rosenshine Papers
Washerwoman and Child can be seen in the center, surrounded by several other Renoirs now at the Barnes Foundation. Top row, left: *Half-length Portrait* (BF222). Top row, right: *Landscape* (BF542). Bottom row, left to right: *Still Life* (BF49), *Landscape* (BF236) and *Nude Wading* (BF228).

Fig. 48

Pierre-Auguste Renoir
Washerwoman and Child
Ca. 1887
Oil on canvas
32 x 25³/₄ in. (81.3 x 65.4 cm)
Merion, PA, Barnes Foundation

Fig. 49

17. Leo Stein wrote frequently about his dislike of Picasso's Cubism. See ibid., p. 145. **18.** Stein 1950, pp. 18–19. Stein's statement that the painting is "a marvel" is from a letter from Stein to Barnes, December 24, 1920, Barnes Foundation archives. **19.** Letter from Leo Stein to Barnes, April 20, 1921, Barnes Foundation archives. **20.** Stein 1950, pp. 18–19. **21.** In a letter from 1914, Barnes writes of "the late works of Renoir which, two years ago, Leo Stein's eloquence had not enough effect to make me buy . . . [and] which I now consider to be the best of all Renoir's periods." Letter from Barnes to the American painter Guy Pène du Bois, September 1, 1914, Barnes Foundation archives.

to-date on his new purchases.[22] It was to Leo that Barnes confessed "I cannot get too many Renoirs"; and it was to Leo that Barnes wrote most candidly about what Renoir meant to him.[23] Decades later, in 1947, he reflected on their friendship: "Leo Stein died on Tuesday of last week and I'm in deep sorrow. Thirty-five years ago he put me on the right track to learn about paintings and we've been in close touch ever since."[24]

Leo Stein's Renoirs

While Barnes's Renoir collection is intact—all but one are on display in the galleries in Merion—Stein's Renoir holdings have become something of a mystery for historians. While Leo made occasional reference in his writings to specific paintings like *Washerwoman and Child,* he did not generally describe his Renoir purchases, nor did he leave any kind of inventory. Brenda Wineapple has estimated that Stein owned between twenty and thirty Renoirs, and a handful of these—including two paintings that are now at the Barnes Foundation—were identified in 1970 by Margaret Potter and Irene Gordon through careful study of photographs of the Stein atelier.[25] The identity of the rest, however, has remained elusive until now: letters and documents in the Barnes Foundation archives reveal that fourteen of Leo Stein's Renoirs have resided at the Foundation since 1921.[26] Ultimately, the story of Leo and Barnes and their passion for Renoir is about more than pure intellectual exchange.

The first Renoir to move from Stein to Barnes was a little painting called *Nude Wading* **Fig. 51**, in a deal made soon after Leo and Gertrude's bitter 1913 split; the siblings had decided to part ways and divide up the collection, with Gertrude taking most of the Picassos and Leo the Renoirs.[27] In early 1914, as Leo was preparing his move from 27, rue de Fleurus to a house in Settignano, outside of Florence, Barnes wrote to his friend : "I've just learned that you are disposing of some of your paintings, preparatory to a flight to Italy . . . If the two Renoirs—*Mother with Child,* + the little nude standing in water—are to be sold, you can probably do better with me than with the dealers."[28] Stein agreed to sell Barnes the "little nude standing in water," in March of 1914, but not without considerable anxiety, and the negotiation nearly failed. Stein later explained his hesitancy in a letter to Barnes: "I had a feeling very like sacrilege about selling a Renoir," and made clear that his decision to let the painting go was only to finance the purchase of another Renoir that was "much finer," the 1912 *Cup of Chocolate* **Fig. 53**, which Leo bought from Durand-Ruel in February.[29] In April, Stein left for Settignano "without a single Picasso, hardly any Matisses, only two Cézanne paintings & some aquarelles, and sixteen Renoirs."[30]

Years later, those sixteen Renoirs would figure prominently in Leo's dealings with Barnes. By January of 1920, Leo's financial situation was dire. Realizing he would have to sell his beloved Renoirs, he wrote to Barnes for an opinion on the American market, and Barnes encouraged him that "the prices will soar. . . . I feel pretty sure that you have in those sixteen Renoirs enough to enable you to live comfortably for the rest of your life."[31] Even with Barnes's promise of success, Stein was tentative; but by December of that year he resolved to sell the pictures and wrote to Barnes again with a more formal request for advice: "Apart from a painfully small property which has been enjoying some shrinks recently, my principal possession is my Renoirs. My own conviction in 1917–1918 was that I ought to have sold them, but I had too many resistances. Since then, Renoirs are constantly going up in price and the franc is going down. You know more about the Renoir market in America than anyone else I know, so I am asking you for some advice as to what I had better do. . . . I don't want to do anything foolish with those Renoirs."[32]

Pierre-Auguste Renoir
Two Women in the Grass
Ca. 1873
Oil on canvas
23 1/2 x 28 3/4 in. (59.7 x 73 cm)
Merion, PA, Barnes Foundation

Fig. 50

Pierre-Auguste Renoir
Nude Wading
Ca. 1890
Oil on canvas
16 1/4 x 13 1/4 in. (41.3 x 33.7 cm)
Merion, PA, Barnes Foundation

Fig. 51

22. Letter from Leo Stein to Barnes, April 7, 1914, Barnes Foundation archives. **23.** "Renoir has been to me the most all-satisfying of any man's work I know. . . . Perhaps the thing that most interests me in Renoir, that most strikes a personal response is, what seems to me, his joy in painting the real life of red-blooded people." Letter from Barnes to Leo Stein, July 17, 1914, Barnes Foundation archives. **24.** Letter from Barnes to Horace Stern, August 7, 1947, Barnes Foundation archives. **25.** See Wineapple 1996, p. 476, and exh. cat. New York 1970, p. 32, note 45, and pp. 89, 91. The two paintings identified in the Barnes collection are: *Girl in Gray-Blue Putting on Her Gloves* (inv. BF222) and a pastel called *Two Nudes* (inv. BF154). **26.** Many scholars had suspected that a clue to the current whereabouts of the Stein paintings might be found in the Barnes Foundation archives. Brenda Wineapple in 1996 calls the total reconstruction of the Stein collection a "daunting task" and laments how "the doors of the Barnes Foundation archives have remained so firmly closed," so that "a complete accounting of Barnes's Renoir purchases is impossible." Wineapple 1996, p. 454. Fortunately, the situation has changed: the Barnes Foundation archives are now open to scholarly inquiries on a limited basis. **27.** See Wineapple 1996. **28.** Letter from Barnes to Leo Stein, February 9, 1914, Yale University, Beinecke Rare Book and Manuscript Library. **29.** Letter from Leo Stein to Barnes, April 23, 1921, Barnes Foundation archives. Stein also reflected back on the sale of *Nude Wading* to Barnes in Stein 1947, pp. 53–54. **30.** Letter from Leo Stein to his friend Mabel Foote Weeks, April 2, 1914, Yale University, Beinecke Rare Book and Manuscript Library. **31.** Letter from Barnes to Leo Stein, January 20, 1920, Barnes Foundation archives. **32.** Letter from Leo Stein to Barnes, December 29, 1920, Barnes Foundation archives.

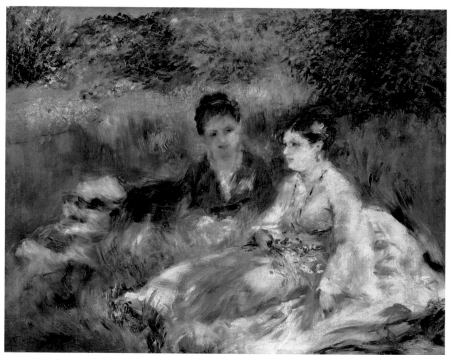

Fig. 50

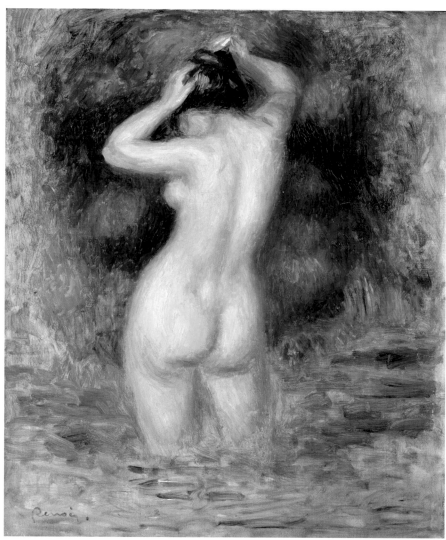

Fig. 51

Pierre-Auguste Renoir
Girl in Red
Ca. 1909
Oil on canvas
15 1/4 x 11 3/8 in. (38.7 x 28.9 cm)
Merion, PA, Barnes Foundation

Fig. 52

Barnes responded with a warm letter agreeing to help. He advised Leo to send the pictures to Durand-Ruel's New York gallery, where they would be appraised, photographed, and stored. Barnes would then shop them around to dealers and collectors, and he assured his friend once again that the pictures would bring high prices.[33] Thankful that the matter was finally being handled, Leo responded, perhaps too innocently: "I should be very grateful if you would look at the pictures and do about them whatever you think most advisable. I'm afraid that you think of them as more important than they are. Most of them are small and slight."[34]

In the early 1920s there were few Renoirs on the market. Neither Bernheim nor Durand-Ruel had much in their stock, and the hundreds of paintings left in Renoir's studio would not come up for sale for several years.[35] It must have occurred to the ever-savvy Barnes that Leo's crop of Renoirs could be had at a low price, especially given Leo's naïve insistence on their "small and slight" quality. After traveling to New York to reacquaint himself with the pictures he had last seen at 27, rue de Fleurus years before, Barnes wrote to Leo on April 7, 1921, with a complete reversal of his earlier assessment: "I had not seen your pictures since 1913 and I was very much surprised at the slight, unimportant character of nearly all of them."[36] These were not saleable pictures, Barnes continued, and among the dealers and collectors he had approached, he "could not find anybody willing to pay a fair price for any of the Renoirs." Barnes would, however, be willing to buy several of the pictures himself; Durand-Ruel might take a few others. To his letter Barnes appended a list of the paintings—the only known inventory of Stein's Renoir collection—numbering them 1 through 16, and marking the eight he wished to purchase with a "B." Stein agreed to the offer. In the weeks that followed, Barnes managed to procure five others on the list in a string of slightly underhanded maneuvers, so that he ended up with thirteen of the sixteen Renoirs that Stein had taken with him to Settignano; these he added to the *Nude Wading* purchased in 1914.[37]

Surveying these fourteen paintings at the Barnes Foundation, we begin to get a picture of Leo's elusive Renoir collection and therefore of what the many visitors to the Stein apartment would have seen. There is the beloved *Washerwoman and Child*, and the *Girl in Red* **Fig. 52**, which Leo called "one of my favorites among all."[38] There is a portrait, a pastel drawing of two nudes, a still life, and several landscapes, many of which are indeed "small and slight." There is also the 1912 *Cup of Chocolate* **Fig. 53**— the painting that Leo so desperately wanted in the winter of 1914, for which he had given up the *Nude Wading* and at least one of his Picassos.[39] Probably Leo's final purchase, *Cup of Chocolate* was the latest Renoir in his collection, and he described it as having "a weight and a kind of solemn power that is exceptional even in Renoir's later work."[40] For Leo, such weighty paintings represented the best possibility for modern art—a modern art that was rooted in classicism. "[H]istories of classic painting in the future will bear the title of Histories of Painting from the Beginning to Renoir, or perhaps Matisse."[41]

For Barnes, too, the best modern art was a continuation of the great achievements of the past rather than a wholesale jettisoning of tradition. On the walls of the Barnes Foundation, Renoir's late paintings are placed in careful dialogue with works by early twentieth-century artists—as they were at 27, rue de Fleurus—but also with Rubens, Tintoretto, and El Greco. Arranged by Barnes himself for educational purposes, these "ensembles" represent his ideals about a universal language of form: a grouping of

33. Letter from Barnes to Leo Stein, January 18, 1921, Barnes Foundation archives. **34.** Letter from Leo Stein to Barnes, March 8, 1921, Barnes Foundation archives. **35.** Leo Stein himself described the meager offerings at the galleries: "The stock of Renoirs to be found at the dealers in Paris is very poor. D-R [Durand-Ruel] has a number but not anything of much importance unless there are things that they have put aside and are not showing now. The Bernheims have also very little." Letter from Leo Stein to Barnes, April 2, 1920, Barnes Foundation archives. **36.** Letter from Barnes to Leo Stein, April 7, 1921, Barnes Foundation archives. **37.** The thirteen paintings are given here with the number and title from Barnes's April 7 list, and with the current inventory number in parentheses: no. 1 *Landscape* (BF236); no. 2 *Still-life* (BF49); no. 3 *Landscape* (BF536); no. 4 *Small head* (BF76); no. 5 *Landscape* (BF542); no. 8 *Landscape* (BF43); no. 9 *Figure, girl in red* (BF114); no. 10 *Pastel* (BF154); no. 12 *Spring landscape* (BF74); no. 13 *Half length portrait* (BF222); no. 14 *Cup of Chocolate* (BF14); no. 15 *Landscape (largest)* BF240); no. 16 *Mother and Child* (BF219). Within the Barnes collection these paintings were not easy to identify, due to the vague titles on the April 7 list. Thankfully, Durand-Ruel photographed the paintings at the time of the 1921 sale to Barnes. I am grateful to Paul-Louis Durand-Ruel for providing those photographs. **38.** Letter from Leo Stein to Barnes, April 23, 1921, Barnes Foundation archives. **39.** Leo Stein wrote, "When it happened that in order to buy a Renoir, I had to sell some of [Picasso's] pictures, I asked Gertrude to let him know at once of my intention. He took it nicely and said, 'If Leo sells pictures of mine to get a Renoir, I hope he'll get a good one.' After I had the picture, I once saw him coming in to see Gertrude and I said, 'Don't you want to see your Renoir?' He found it very good, and we had a pleasant talk," Stein 1947, pp. 187–188. **40.** Letter from Leo Stein to Barnes, December 24, 1920, Barnes Foundation archives. **41.** Letter from Leo Stein to Barnes, December 29, 1920, Barnes Foundation archives.

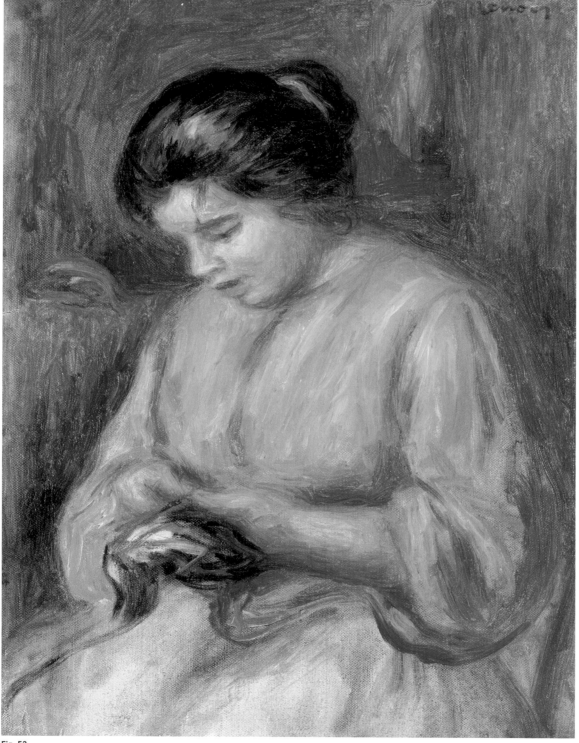

Fig. 52

Renoir next to Tintoretto next to a piece of eighteenth-century metalwork is meant to evoke sameness more than difference, to reveal the shared vocabularies for the basic human impulse toward self-expression. But the ensembles also stand as a historical document of Renoir's centrality to artistic developments in early twentieth-century Paris. Mixed together with Picasso, Braque, and Matisse, Renoir, with Cézanne, is presented as the father of early twentieth-century modernism, as the artist who led the way forward by looking backward.

Pierre-Auguste Renoir
Cup of Chocolate
Ca. 1912
Oil on canvas
21³/₈ x 25¹/₂ in. (54.3 x 64.8 cm)
Merion, PA, Barnes Foundation

Fig. 53

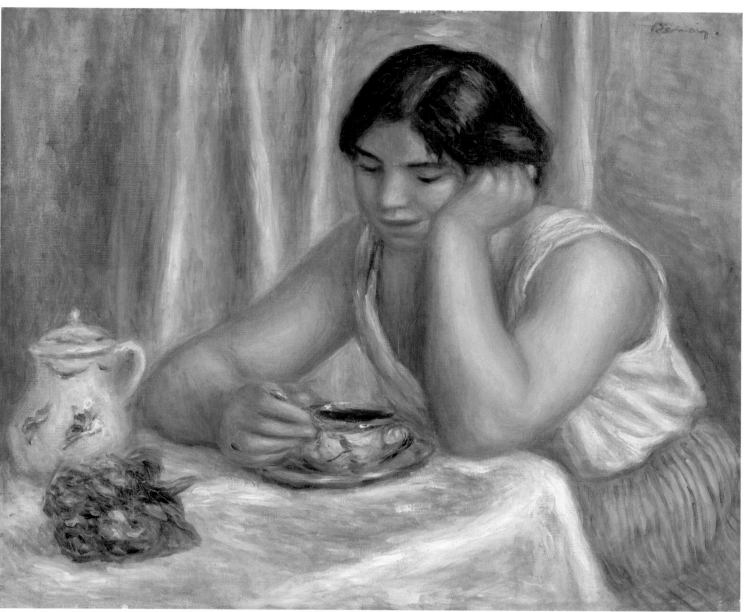

Fig. 53

Picasso 1917 to 1924: A "Renoirian" Crisis

Laurence Madeline

Renoir in his old age,
sitting in his studio
1912
Gelatin-silver print
11¹/₂ x 9¹/₄ in. (29.3 x 23.5 cm)
Paris, Musée National Picasso,
Archives Picasso

See Cat. 153

Pablo Picasso
Portrait of Auguste Renoir
(after a photograph)
1919–20

Cat. 99

On July 29, 1919, Pablo Picasso's dealer, Paul Rosenberg, wrote to the artist: "I saw Renoir, who will be in Paris on August 3, and spoke to him about you. It is too lengthy to go into it in this letter, but he wants to see you. He has been surprised by some things and even more so, shocked by others."[1] Surprised or shocked,[2] the elderly Renoir was making a gesture toward the younger man. Or could it have been Picasso himself who asked for this meeting, which in the end did not take place? Orchestrated by the person with the most interest in bringing together the points of view of the older and the younger man, this to-and-fro was like a relationship in which each of them was revealing an element of the other's search; a relationship in which even their life choices coincided.

Identifying with an Old Master

In 1919 Renoir was the survivor of a time past. Paul Cézanne had died in 1906, Paul Gauguin in 1903, and Edgar Degas had recently departed this earth; Claude Monet remained true and valiant, but he was of no interest to Picasso as he did not paint nudes. Renoir was not only still alive, but according to Guillaume Apollinaire, he was a "youthful" man who "uses his last days to paint these fabulous, voluptuous nudes which will be admired in years to come."[3] Renoir's advanced years and his desire and pleasure in painting despite the pain are described by his exegetes, all of whom tell of his tenaciousness, his combative approach to painting, and his constant battle with illness. He himself declared: "If I had not lived beyond seventy years of age, I would not even exist!"[4]

It is this extreme tension between willpower and physical helplessness that is captured in the photograph taken in Renoir's home in Les Collettes in 1913 and copied by Picasso, no doubt after the death of Renoir[5] **Cat. 99 & 153**. The painter is sitting up straight in the armchair he will never leave again. He looks toward the camera with an intelligent look in his eyes. He is thin and tense. His hands are gnarled. The photo shows both the body fading away, frustrating the artist and confining him to his armchair, and the persistence of the desire to paint. Copying the photograph, Picasso used the tip of his pencil to mark out the illness and the ravages of old age, emphasizing the two shapeless hands. It is the only portrait of a painter signed by Picasso. Seldom did he allow a feeling akin to empathy to emerge in this way, running counter to the crystal-sharp precision of his lines. In this copy, scholastic yet incantatory, we find, at last, the realization of the aborted meeting, as well as Picasso's fascination for an old age spent still at work, still searching, and for which he himself was to become the archetype following Renoir. Indeed, decades later, when he was almost ninety, Picasso was to declare: "I feel as if I am coming close to something. I am managing to say things in these canvases [the last Avignon canvases]. I have only just started."[6]

1. Picasso Archives, Paris, Musée National Picasso. **2.** Different accounts say that the shock must have been greater than assumed by Paul Rosenberg. Hence the view of Misia Sert: "The mere mention of Picasso made him jump into the air. He refused to listen to anything said about him, and flew into a real temper with those who took [Picasso] seriously" (Sert 1953, p. 83); and as Michel Georges-Michel writes: "I've got one of Picasso's latest canvases with me here. Look— 'Take that filth away!' cried Renoir." (Georges-Michel 1957, p. 26). **3.** Apollinaire (1918), quoted in Apollinaire 1993, p. 557. **4.** Renoir's comments reported by Fegdal 1927, quoted in Renoir 2002, p. 185. **5.** Pablo Picasso, *Portrait d'Auguste Renoir*, Paris, Musée National Picasso **Cat. 99**. **6.** Parmelin 1980, p. 15.

When Picasso briefly adopted the brushstroke of Vincent van Gogh, he effectively exorcized the suicide and dedicated himself body and soul, to painting; with his drawing of Renoir, he took possession of the artist's fertility in old age. The *Portrait of Old Man Seated* **Fig. 54**, painted in 1971 at a time when Picasso had reached a venerable age himself, confirms this hypothesis: here is an old man with wasted hands, stuck in an armchair. As if to counterbalance the sadness in these images, Picasso also made three copies from a photograph of a Renoir painting, *The Engaged Couple*.[8] Youth, insouciance, and the complicity of a young couple out walking perhaps echoed Picasso's life at that precise moment—a time when, freshly married and embarking on a new life, he launched an artistic dialogue with tradition that was entirely his own.

Identifying Circles

The collectors Gertrude and Leo Stein constituted the first circle frequented by Picasso from 1906 onward. At their house in rue de Fleurus, Renoir paintings were hung on the studio walls. Picasso subscribed to the Steins' taste and loved Renoir. A letter he wrote to them on November 23, 1907, reveals as much, and in it, he devised a strange combination: "My dear friends, all afternoon I have been thinking of your Toulouse-Lautrec. I had seen a Renoir drawing at the Galerie Vollard and was thinking that if the Lautrec belonged to me, I would have exchanged it with Vollard."[9] As Leo Stein reported, the works of Renoir were fetching significant prices at that point and Picasso, "who [sometimes] had no coal and no money to buy it, drew glowing pictures of Renoir's house with sacks of coal everywhere and some specially choice chunks on the mantelpiece."[10] A tribute to the painter recognized at last? First aspirations of the collector? Picasso had Renoir in his sights.

Renoir was always present throughout the Cubist years. His works were exhibited in 1912 and 1913: Apollinaire, champion of Cubism, Orphism, Futurism, as well as being a close friend of Picasso, paid homage to the "old Renoir, the greatest painter of the age and one of the great painters of all time."[11]

From 1918 on, Picasso moved in another circle equally in tune with the old painter. Ambroise Vollard, who championed Renoir's work, was never far from Picasso and supported him when he started out in Paris. In 1918 and 1920 he published three works on the life, recollections, paintings, and sculptures of Renoir.[12] Picasso's new dealer, Paul Rosenberg, who no doubt sold him *Seated Bather in a Landscape*, called *Eurydice*[13] **Cat. 22**, at that time owned sixty-six Renoir paintings[14] and met with the painter on a regular basis. The dealer Paul Guillaume, who was always around Picasso, was also part of the circle. He bought Renoir's paintings and collaborated with Apollinaire. Apollinaire quite rightly considered that, to the bohemian intellectual circle of the rue de Fleurus and to the select, refined group in the rue La Boétie, Renoir was a classical master— one who shed light on the traditional side in Picasso's work, providing a framework from which to understand his radical changes in style. Describing Picasso's apartment in rue La Boétie during his bourgeois years, Brassaï relates that, "Even his canvases from the Cubist period, now classics, were carefully framed and hung side by side on the wall with Cézannes, Renoirs, and Corots, as if they were in the house of a rich amateur rather than Picasso's."[15]

Visits to the Louvre

In 1947 Georges Salles invited Picasso to introduce the paintings he had just donated to the Musée National d'Art Moderne in the Grande Galerie of the Louvre. In the decade 1910–20, Renoir had been received in the Louvre exhibition halls by "Monsieur Guiffrey, curator of the painting department, [who] was the most agreeable of guides

7. See Madeline 2006. **8.** Pablo Picasso, *The Sisley Family, after The Engaged Couple by Renoir*, Paris, Musée National Picasso, inv. MP 868; Berlin, Museum Berggruen; and location unknown. The painting by Renoir, dated around 1868, is held in Cologne, Wallraf-Richartz Museum. **9.** *Correspondance Stein-Picasso* 2005, p. 48. **10.** Stein 1947, p. 187. It is worth noting that according to Pierre Cabanne, Picasso apparently said about this period: "Relationships between young and old painters are based on a sense of modesty. When I was young I wanted very much to meet Renoir, but I never dared to go and visit him. Anyway, he did not see the young ones . . ." (Cabanne 1992, p. 83). We should add, however, that Renoir was in fact happy to meet young painters: Bonnard and Matisse, for instance, to name but a few. **11.** Apollinaire (1912), quoted in Apollinaire 1993, p. 278. **12.** Vollard 1918; idem 1919; idem 1920. **13.** On the works of Renoir owned by Picasso, see Seckel-Klein 1998, pp. 202–211. **14.** Fitzgerald 1996, p. 108. **15.** Brassaï 1997, pp. 15– 16. On the subject of this collection, which Brassaï mentions in a footnote, we should note here that it broadly served to "draw" Picasso toward the art of the museums. His donation to the Louvre in 1973 helped to solidify his collection as a "little Louvre," underlining his link with the Old Masters—this should not, however, obscure Picasso's connection with the primitive and popular arts, etc., which informed quite a different, and equally large, part of his creative work.

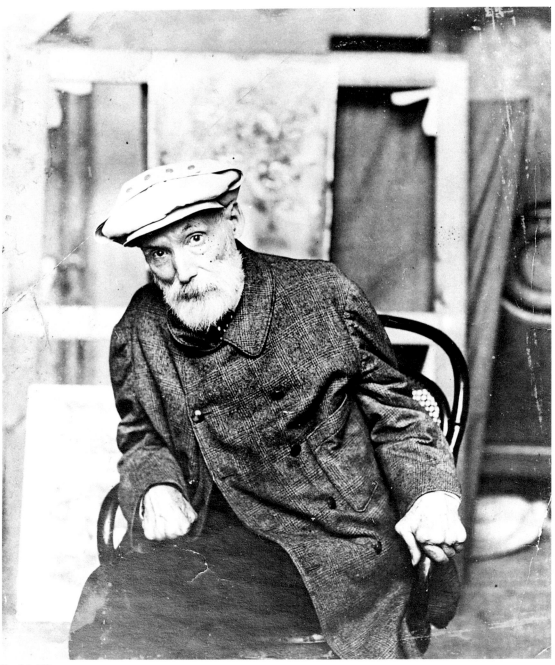

See Cat. 153

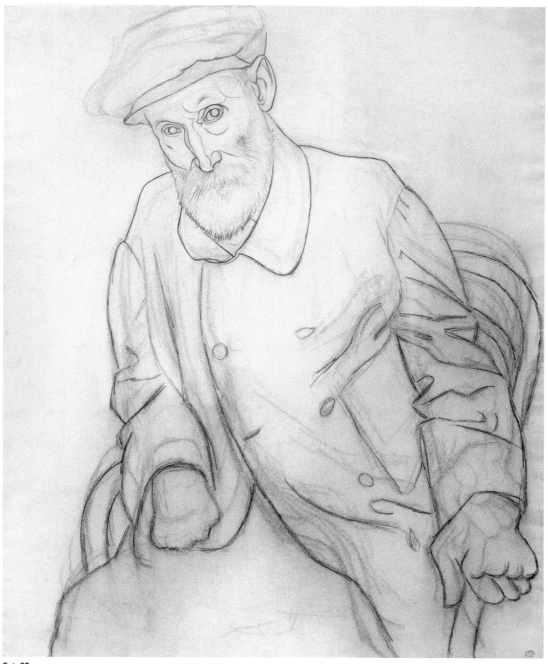

Cat. 99

Fig. 54

as far as he was concerned" and "he found the entire visit delightful."[16] For both artists, the museum had been a formative influence. Both admired the works of the Old Masters—often the same ones: an "Ingresque period" is attributed to each of them; in Picasso's case, it covered the years from 1917–24, overlapping with a "Renoir episode." Picasso copied Delacroix's *Women of Algiers,* of which Renoir had said, "when one has painted something like that, one can certainly rest on one's laurels,"[17] adding that he would have liked to copy it himself.[18] Picasso took inspiration from Corot and collected his works, just as Renoir loved Corot to the extent that "he did not stop referring to him until the day he died";[19] as for Raphael, Poussin, Titian, and Velázquez: in his work on *Las Meninas,* Picasso reworked the *Portrait of the Infante Marguerite* to which Renoir constantly "paid tribute"[20] as he walked up and down the corridors of the Louvre. There are many other connections, although there were some dislikes too, such as Rubens or Fragonard, who were important to Renoir, but meaningless as far as Picasso was concerned.[21] The essentially classical principle they share emerges from these common references.

The Mediterranean

The classical principle that propelled the two painters in succession into the halls of the Louvre is the same as that defining Aristide Maillol's *The Mediterranean,* presented at the Salon d'Automne in 1905. The Mediterranean—rightly claimed as the cradle of classicism since the late nineteenth century—represented the bastion of reason in the face of the irrational torments of Nordic countries. In the sun-kissed lands of their birth, Maillol,[22] Cézanne, and Renoir all reinvented a tradition that spread to Barcelona, where Picasso trained and where he stayed occasionally until 1917, and to Gosòl where he devised his first form of classicism in the summer of 1906.

Returning from Italy: The Shock of the Classical

Picasso's real "Renoirian crisis" (with attempts to meet him, purchases of his works, copying, et cetera) happened after his return from Italy where he stayed from February to April 1917. Enrico Prampolino sums up the significance of this stay: "Picasso's meeting 'with Rome' was like a bolt of lightning . . . when he found himself in the Vatican, face to face with works from the Classical period and the Renaissance, with Raphael and Michelangelo. This meeting was an event of crucial importance . . . as it affected his mind to the extent of pointing him in a direction that was to be among the most characteristic in his pictorial development."[23]

Renoir also undertook an Italian trip from November 1881 to January 1882. His itinerary included Venice, Florence, Rome, Naples, Pompeii, and Capri. Shaken, he wrote to Paul Durand-Ruel: "I am still starting out at the age of forty. I have been to see the Raphaels in Rome. This [work] is really beautiful and I should have seen it sooner. It is full of knowledge and wisdom."[24] And to Mme Charpentier, "I studied the Naples museum extensively, and the Pompeii paintings are extremely interesting from every point of view . . . I think I will have acquired this greatness and simplicity of the ancient painters."[25]

In both these artists from such different traditions, Italy provoked similar reactions: a classical awakening which, as well as introducing certain strictly Italian models, also referenced the French painters in love with Italy—Poussin, Corot, and Ingres—who, in turn, were a reminder of the whole classical French school. As Eugenio d'Ors points out about Picasso: "Rather than looking to his countrymen for an aesthetic affiliation, one should look to the masters of his adoptive land, in the traditions of Ingres or Poussin in the past; or even better, to the masters of these masters, among the Italians, artists of intellect like the Leonardos, the Raphaels, and the Mantegnas."[26]

The Classical Factor: The Color Red

Picasso's collection contains a small painting by Renoir, *Mythology, Figures from Ancient Tragedy* **Cat. 76**, which provides a vibrant recollection of Pompeii. Its fragmen-

Pablo Picasso
Seated Old Man
September 26, 1970–
November 14, 1971
Oil on canvas
57¼ x 44⅞ in. (145.5 x 114 cm)
Paris, Musée National Picasso

Fig. 54

16. Denis 1920, quoted in Renoir 2002, p. 182. **17.** Manet 1987, p. 119. **18.** André 1919, quoted in Renoir 2002, p. 31. **19.** Besson 1929, quoted in Renoir 2002, p. 185. **20.** Baudot 1949, p. 28, quoted in Renoir 2002, p. 201. **21.** "With Rubens on the other hand . . . It is not even painted. Everything is the same" (Kahnweiler 1952, quoted in Picasso 1998, p. 64). **22.** In Greece, Maillol thought he had "gone back to Banyuls. The mountains are the same shape, the colors the same" (Frère 1956, pp. 17–18). **23.** Prampolini 1953, quoted in Clair 1998, p. 316. **24.** Letter from Renoir to Paul Durand-Ruel, Naples, November 21, 1881, quoted in Renoir 2002, p. 117, also in White 1984, p. 115. **25.** Letter from Renoir to Mme Charpentier, L'Estaque, end January–beginning February, 1882, quoted in Renoir 2002, p. 123. **26.** Eugenio d'Ors (1930), quoted in Clair 1998, p. 316.

Pierre-Auguste Renoir
Mythology, Figures from
Ancient Tragedy, or Studies
of Figures from Antiquity
Ca. 1898

Cat. 76

Pablo Picasso
Studies
1920
Oil on canvas
39³/₈ x 31⁷/₈ in. (100 x 81 cm)
Paris, Musée National Picasso

Fig. 55

tary appearance and dominant red make the work stand out. Around 1900 Renoir heightened "the red tones aggressively, knowing that the patina would give them the desired color through time."[27] In doing so his intention was to avoid adding to the number of pale nymphs, whom he disliked. The increase in red is a response to the desire for a revitalized antiquity as he discovered it in Pompeii; it can be seen in the study Picasso owned as well as in finished compositions such as *Eurydice* and the *Judgments of Paris* **Fig. 62 & Cat. 65**, which he executed in 1908 and 1914, as if an explosion of red were flowing through the plump flesh of the three goddesses and the young shepherd.

Picasso's great classical figures are similarly tinted with this baked-clay red that comes from the Rose Period, in which his female nudes—in his first embrace of classicism—borrow as much from Ingres as from Renoir, who had studied Ingres himself (*Nude with Joined Hands*, summer 1906; *La Toilette*, summer 1906; *Seated Nude*, fall 1906). After 1917, and even with *Three Women at the Spring* (summer 1921), *Large Bather* **Cat. 100, p. 131**, *Harlequins* (1923), and *Flute Player* (summer 1923), Picasso's classical vision seems to undergo an overexposure to the sun. The appearance of sanguine in the drawings from 1922 (*Woman with Veil Standing* and *Two Men Seated*) is a response to the presence in Picasso's collection of Renoir's great drawing *The Coiffure*, or *The Bather's Toilette*[28] **Cat. 84, p. 83**. Pompeii Red, the classical essence of which is canonized on the gallery walls of museums, is the same one that enriches the figures of these two artists.

The Classical Factor: Forms and Deformities

Juxtaposing certain works reveals striking connections: Renoir's *Eurydice* **Cat. 22** with Picasso's *Seated Bather Drying Her Feet* **Fig. 85, p. 211**; or *Seated Bather* **Cat. 62** with *Seated Nude* (fall 1906) or *Large Bather* **Cat. 100, p. 131**; or even *Reclining Nude (Bather)* **Cat. 28** with *La Source* **Fig. 89, p. 228**. The use of red already cited and the pose—vaguely inspired by the sculpture *Spinario* **Fig. 84, p. 211** in Renoir's case and by the goddesses on the pediment of the Parthenon for Picasso[29]—point to antiquity. By way of a common reference, one might also cite the sculptures of Jean Goujon. More than anything else, however, the heaviness of the faces and bodies and their distortions are what create the parallels in the paintings, though in this instance it is the proximity of Picasso's work that highlights the liberties taken by Renoir. The latter, who claimed "it is because one knows how to draw that one is forced to deform,"[30] is on the face of it above suspicion, as the scene is so natural and idyllic ("No one, almost, distrusts Renoir"[31]). Yet the belly and shoulders are enormous, and the legs as swollen as those on Picasso's women; their crushing weight can hardly be ignored.

Ingres, the master common to both painters, had personally championed deformation as a way of reconstructing the classical ideal. And in the case of these bathers, it is all about reconstruction. From their respective periods, Renoir and Picasso give contrasting interpretations to the prototypes of antiquity they studied in Rome, Naples, and Pompeii, in the Louvre, the British Museum, and elsewhere. Even in the years 1910–19, Renoir's work is characterized by optimism: his gods are ready to come down to earth to find their Paradise there. In Picasso, it is a postwar apocalypse where man has been crushed on the road to complete ruin. There is pleasure in warm, happy flesh in the swollen figures of Renoir; in Picasso's figures, there is a direct dialogue with the remains of antiquity, marble statues bearing witness to lost civilizations.

A Few Moments of Happiness

Browsing through the chronologies of Renoir and Picasso, it becomes evident that the young Aline Charigot met up with Renoir in Naples in 1881, while Picasso made the most of what the same city had to offer with Olga Koklova in 1917. One also finds out that Renoir had his first son with Aline at the age of forty-four, and Picasso was forty when Paulo was born. Two rather mature men experiencing marriage and family life at a late stage: Renoir painted the mother, son, and both together. Picasso follows suit, and his paintings cry out "Renoir." Renoir is "master in the art of evoking joie de vivre, abundance, sensual pleasure, and youth."[32] He embodies the painting of happiness, of couples walking in a garden, dancers, women, and children. At the start of his career,

27. Dauberville 1967, quoted in Renoir 2002, p. 217. **28.** It is best to be cautious, however, as we do not know the date when Picasso acquired the work. **29.** This is the view of Elizabeth Cowling, who recalls Picasso visiting the British Museum on his trip to London in 1919 (Cowling 2003, p. 421). **30.** [Anonymous] 1920, quoted in Renoir 2002, p. 174. **31.** Gasquet 1921, p. 45. Gasquet adds: "It makes his influence even stronger and more permanent." **32.** George 1921, p. 56.

Cat. 76

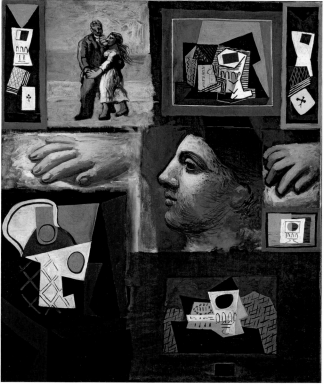

Fig. 55

Picasso contemplated these aspects of life (dancing, love, motherhood, and child-hood) either with a loud cry of excitement or in deep despair. In the early 1920s this all reemerged with a serenity and profusion redolent of the works of the older artist.

The Village Dance **Cat. 102** strangely echoes Renoir's work **Cat. 1**. Choosing the most perfect example of one particular definition of Renoir's painting—that of the 1880s—Picasso embraced it and transformed it into a work of paradox, both contemporary and timeless. Equally as close to the "Renoir" spirit is Child Eating (Paulo) **Cat. 103, p. 216**: a pink-toned painting of a baby with chubby cheeks and an inquisitive look. This intimate approach is exceptional. Picasso mostly introduces a certain distance with respect to his son in his paintings, for example in Paul as Pierrot **Fig. 100, p. 257** and Paul Drawing (1923). The portraits of his son are staged, conferring on him the importance and majesty of the kings and queens that populate the museums. Through him, Picasso makes his lifestyle choice official: marriage, bourgeois comfort, and family.[33] The influence of Renoir, who executed some portraits of children from middle-class families by transforming them into so many brothers or sisters of royal offspring in the Louvre, is obvious.

Embracing Tradition, Returning to the Museum

The Portrait of Madame Rosenberg and her Daughter (August, 1918) **Fig. 56** is without doubt the most extreme reflection on the work of Renoir undertaken by Picasso. This portrait, a commission marking the agreement the painter had just reached with his new dealer, as well as his venture beyond his bohemian world, represents his opportunity to cast a sideways look at the portraits executed by Renoir throughout his career. Above all, the Portrait of Madame Charpentier and Her Children (1878) **Fig. 57** and, similarly, the one of Madame Thurneyssen and her daughter, Mother and Child (1910) **Cat. 54**. In these two commissioned works, Renoir combines meticulous draftsmanship—he faithfully represents the features and posture of his models—with a sharpness of color drawn from his close study of nature. A deliberately discordant vision follows from this combination, and Picasso lingers over this to paint his own manifesto in the commissioned portrait. In August 1918, Picasso no longer adhered exclusively to Cubism, and though he willingly tagged along with his former masters, this portrait with its excessive draftsmanship showed a declared wish to change sides, to embark on the career of a successful painter, to abandon the infighting of the avant-garde. With this painting, Picasso seems to assert that, if Cubism—as theorized by the painters Bissière and Ozenfant—were to become classical, then he, Picasso, would establish his mastery elsewhere, with a classicism that was all the more authentically classical because of its extreme inventiveness.

This was a resolve not unlike the one that had guided Renoir: with his Portrait of Madame Charpentier, he was eliciting the support of a new circle of art patrons, confirming his return to the Salon, turning back toward the museums, yet also still doubting whether he knew how to paint or draw. Renoir's direction gave rise to a revealing comment from Pissarro, who was obsessed with money worries just as Renoir was beginning to see his way clear: "[Renoir] has been a great success at the Salon. I think he has made his mark. So much the better; poverty is so hard."[34]

The Mediterranean, trips to Italy and Naples, the same dealers, marriage, fatherhood, the quest for classicism, and a return to traditions and the museum: from 1917 to 1924, Picasso followed in Renoir's footsteps in a way that is disconcerting to say the least. His relationship to Renoir was the logical and rational one of an artist who feeds greedily and selectively on the art of his predecessors. But it is also the more surprising, more diffuse, and perhaps less conscious relationship of a painter who finds in the older man an alter ego that has gone back and forth in different directions, from deconstruction to reconstruction, from the street to museum, from nature to antiquity, from secessionist rebellion to the fervent adoption of a bourgeois outlook, from small-scale loyal collectors to wealthy society enthusiasts. Someone else who had coal to heat his rooms, houses, a wife, children and servants, studios, the Mediterranean sun—and boundless pleasure in painting.

33. Werner Spies stresses this social metamorphosis, quoting the testimony of Jaime Sabartès about Max Jacob, the archetypal bohemian-in-arms: "When Picasso became a father, Max went to visit him. When he left he said that he had not received the same warm welcome as before. 'The baby has gone to his head, he added.'" (Spies 1994, p. 64).
34. Letter from Camille Pissarro to Eugène Mürer, May 27, 1878, quoted in exh. cat. London, Paris, and Boston 1985–86, p. 214 (p. 156 in French ed.).

Pablo Picasso
Large Bather
1921

Cat. 100

Pablo Picasso
The Village Dance
1922

Cat. 102

Pierre-Auguste Renoir
Dance in the Country
1882

Cat. 1

Pierre-Auguste Renoir
Dance in the City
1882

Cat. 2

Pablo Picasso
*Portrait of Madame
Rosenberg and Her Daughter*
1918
Oil on canvas
51⅛ x 37⅜ in. (130 x 95 cm)
Paris, Musée National Picasso

Fig. 56

Pierre-Auguste Renoir
*Portrait of Madame
Charpentier and Her Children*
1878
Oil on canvas
60⅝ x 74¾ in. (154 x 190 cm)
New York, The Metropolitan
Museum of Art, Catharine
Lorillard Collection, Wolfe Fund,
1907

Fig. 57

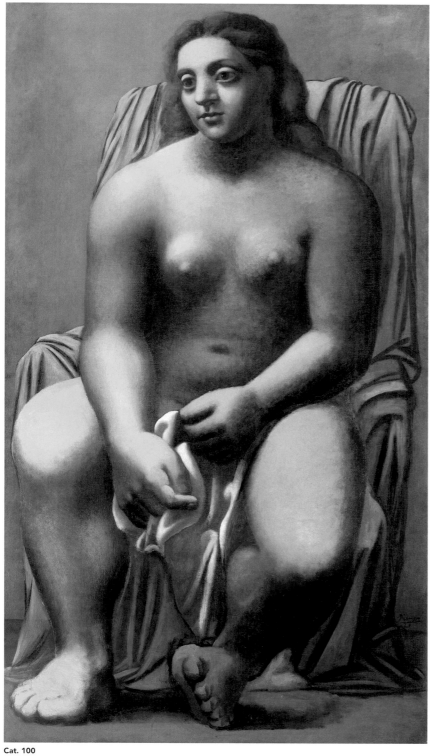

Cat. 100

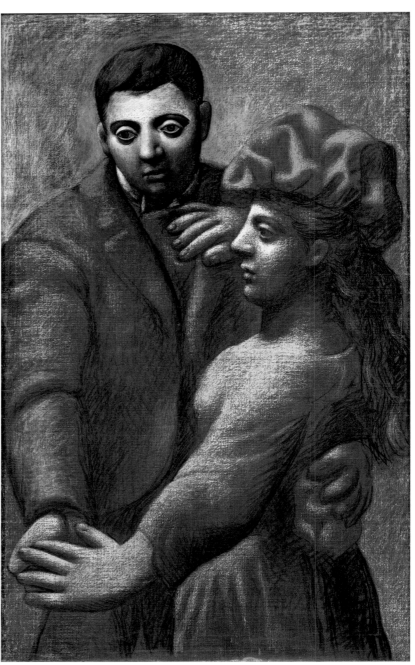

Cat. 102

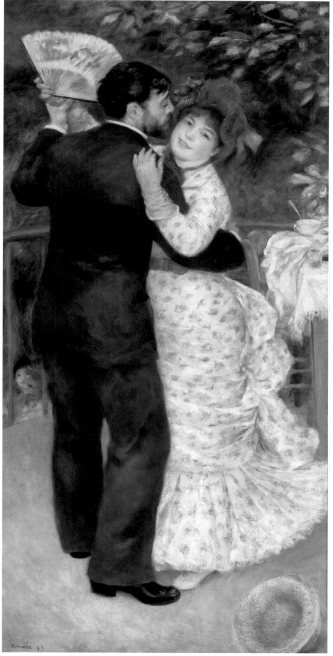

Cat. 1

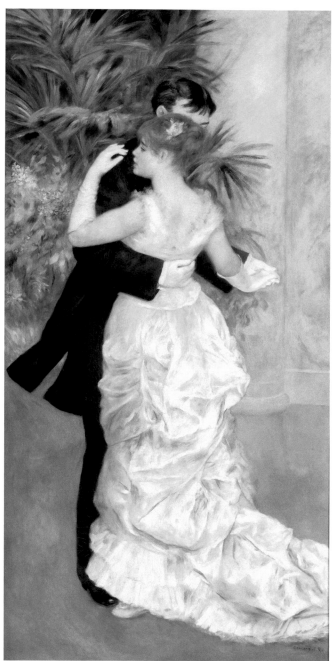

Cat. 2

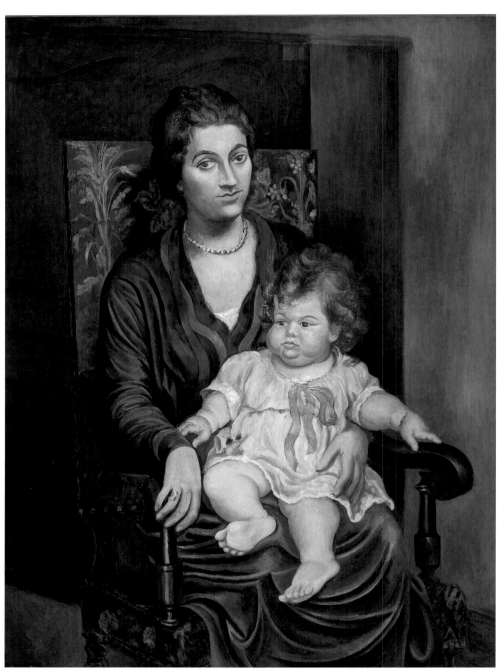

Fig. 56

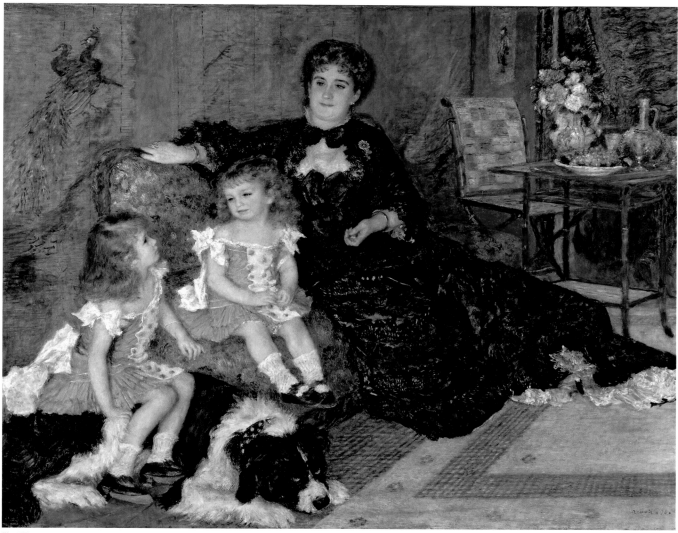

Fig. 57

Why Did Matisse Love Late Renoir?

Roger Benjamin

But his nudes... the loveliest nudes ever painted: no one has done better—no one. Often he would complete one in an afternoon; but he kept his last work [The Bathers **Cat. 80**] *by his side for over a year. It is his masterpiece, one of the most beautiful pictures ever painted... I've always felt,"* Matisse continued, with tears in his voice, *"that recorded time holds no nobler story, no more heroic, no more magnificent achievement than that of Renoir.*[1]

In order to love late Renoir as Matisse seems to have done, here is what you have to do:

Learn to love the indecisive in form. Away with specification, all sharp lines. Renoir's world is a cottony world. You know this is partly because of his hands, ruined by arthritis. So you accept with understanding, and you compensate. What exists in the picture enamors you because of the gracious pictorial form that it reveals. A Cubist critic of Matisse's day wrote: "Renoir's beautifully smooth curves are not spread out in measurable depth, but roll on top of one another, balanced and superimposed like luminous globes."[2]

To love his color you must accept red and pink as the principal colors that translate the world, with green and pale blues as the primary obverse. White and cream colors, pale yellow, burnt orange, lilac, wine colors, and tobacco colors make up the rest—wood, stone, flowers, hair, skin, and cloth. Light blue is for shadows, for water or sky; green—even dark green—is for foliage, but little else. All color is applied in thin veils of oil, and all substances are translucent.

To understand his landscape you have to accept that Renoir's was a life confined by illness. In it you are either inside—a theater of guéridons, curtains, upholstered chairs, and costume props—or you are outside, near the house: a world of gravel paths, old stone walls, clumps of foliage, gardens run to seed, sturdy old olive trees, and occasional vistas into distant but low-lying hills. There is no looking from inside to outside, no transition (as in Matisse), and no tramping out to the *motif* (as in Cézanne). All is stasis and the artful massing of cottony forms.

To love his women you have to forget the body we know from the media today, and intuit one based on the sensation of proximity, indeed intimacy: of flesh held close and dear, of warmth emanating from beneath light fabric, of perfumed skin that is delicate to the touch. Think not of the architecture of the limbs or the musculature of the body in motion, but of being plunged into a world of chiffon, the rotundities of breasts or stomachs sensed beneath the hand, the curvature of hips or bottoms. In short, a world of love and intimacy, of the caress, if not the sexual performance. A world of the lover's hug and murmur, of the child's clasping and desire to be held, safe and warm, in turn. It is a world of plenitude. Renoir's ideal is the young mother or the *nourrice*, she who nourishes directly from her body and her breast: she is young, strong, large, and devoted to her infant charge.

1. Matisse quoted in Harris 1923.　**2.** Lhote 1920, p. 308, trans. in Wadley 1987, pp. 286-287.

If you can perform these mental acts, you can begin to love late Renoir as Matisse might have done.

It seems impossible to separate Matisse's appreciation for Renoir from the moral and political crisis of the Great War. The work of the aged artist, still active through the Armistice and beyond, came to compensate for a world at war, the world of machines, of violent acts and wholesale death, of noise, speed, town and country under attack. The two men had an indisputable bond: both had young adult sons who were involved in the fighting. By the time that Matisse paid his first visit to Renoir at Les Collettes, on the last day of 1917, both Renoir's sons Pierre and Jean had been wounded (Jean by gunshot in 1915). Matisse's older son Jean had been an airforce mechanic since mid-1917, and the younger Pierre faced a call-up that came in August 1918; one month later he was demobilized due to Spanish Flu. Renoir suffered an anguish of worry for his sons; his nights of insomnia are documented. Matisse, nearly thirty years younger, had volunteered for service early in the war but had been rejected on physical grounds. He had to satisfy himself, as his politician friend Marcel Sembat put it, by "continuing to paint well" for the sake of his country, while his extended family in the far north was sequestered behind German lines.[3]

It is no mystery that Matisse should have sought Renoir out, once he had begun living on and off in the hotels of Nice in 1917 **Cat. 184**. Since the death of Cézanne in 1906, Renoir had become the doyen of all modern artists who painted on the Riviera. Although he'd had ample opportunity to visit Cézanne on his trips to St. Tropez and Collioure in 1904–06, Matisse, at the height of his Fauvist experimentalism, avoided that encounter.[4] His admiration for Renoir, whose post-1890 work had come to be seen as Post-Impressionist by informed artists and critics,[5] already seems sure. Renoir was given a retrospective at the 1904 Salon d'Automne, where Matisse was a key figure. He was familiar with the Renoir collection of his own patron Leo Stein, who wrote to Matisse early in 1907: "You may be interested to know we now possess a very fine Renoir which we didn't before."[6] By 1910 Matisse owned at least one small Renoir himself, as a Spanish writer noticed while visiting his Clamart studio with Matisse, who "cast a loving smile upon a small Renoir—'This nude is a gem: I wouldn't sell it for a fortune.'"[7]

Matisse began the famous pictorial *détente* that marked his "Nice period" at least a year before meeting Renoir. His personal *retour à l'ordre* began with the suite of portrait and figure studies of the model Lorette in Paris. Matisse was in a whirl of historicism, buying four Courbet paintings as well as the Renoir.[8] He now sought out his heroes: in January 1917 he first tried to visit Renoir, and visited Claude Monet at Giverny.[9] He later recalled: "except for Renoir—and he was by no means easy—I never sought the company of older painters. Renoir was interesting in other ways than for his painting."[10]

What did Matisse mean by this last phrase? In addition to the bittersweet comradeship they shared over their sons, I believe Matisse was drawn by the moral example the aged painter offered. The narrative of Renoir's gradual incapacity due to rheumatoid arthritis was well known to Parisian artists. Picasso, increasingly a friend of Matisse (the two exhibited together in Paris in January 1918), made his remarkable pencil drawing after the 1912 Durand-Ruel photograph—an homage to dogged spirit in the face of decrepitude[11] **Cat. 99, p. 125**. Yet neither this drawing nor Matisse's detailed descriptions grasp the horrible likelihood that the bone of each of Renoir's fingers was snapped in two below the main knuckle.[12]

It was perhaps to witness this great "man of sorrows" that Matisse took up the introduction offered by their mutual friend George Besson. A few years later he

3. Quoted in Silver 1989, p. 33. On this period in Matisse's life, see Spurling 2005, pp. 156–171, 189–196. **4.** "I often passed near Aix without ever having the idea of going to visit Cézanne" (letter from Matisse, no date, quoted in Matisse 1972, p. 310, according to Duthuit 1949). **5.** Anne Dawson has tracked this perception of Renoir's late work among the influential critics Camille Mauclair, Julius Meier-Graefe, and Anglophone tastemakers like Leo Stein; see exh. cat. San Diego and El Paso 2002–03, pp. 15–41. **6.** Leo Stein to Matisse, January 27, 1907. Archives Matisse, Paris. See *Correspondance Stein-Picasso* 2005, p. 33, note 2. See also the essay by Martha Lucy in this volume, p. 110. **7.** Sacs 1919, quoted in *Matisse on Art* 1995, p. 58; also cited by Butler 2008, p. 111. **8.** See Spurling 2005, p. 199, for details. **9.** Letter from Matisse to Paul Rosenberg, January 12, 1917, quoted in Butler 2008, p. 111. On Matisse and Monet see exh. cat. Washington, DC, 1986–87, p. 19, and Spurling 2005, p. 199. **10.** Letter from Matisse, no date (see above, note 4). **11.** See exh. cat. Brisbane 2008, p. 137. Picasso went on to acquire a major late nude by Renoir, *Seated Bather in a Landscape,* called *Eurydice* Cat. 22. **12.** See medical discussion and x-ray photos of a similar case in Gasc 2008, p. 168.

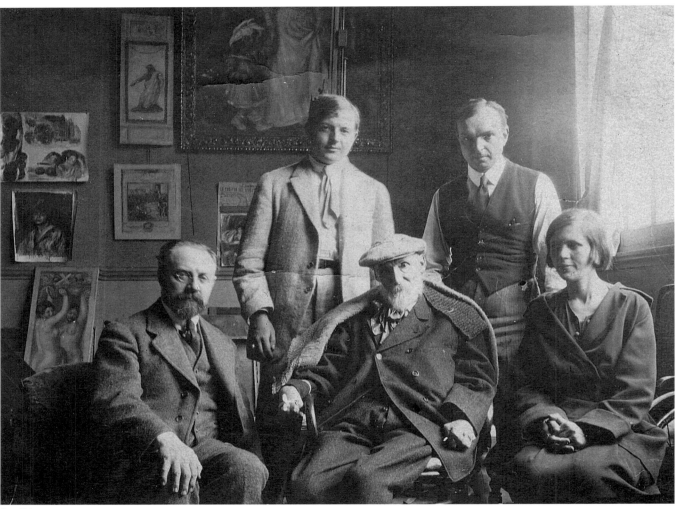

Cat. 184

recounted to Frank Harris: "His life was a long martyrdom: he suffered for twenty years from the worst form of rheumatism. The joints of his fingers were all immense, calloused, horribly distorted. . . . [And he still did] all his best work! . . . as his body dwindled, the soul in him seemed to grow stronger continually and to express itself with more radiant ease."[13]

This was a lesson Matisse never forgot: he reflected on it after his own life-threatening struggle with stomach cancer when he was Renoir's age, in 1943, remarking "I promised myself that when my turn came, I would not be a coward."[14]

Beyond that moral example, there was the flowering of a friendship. As Augustin de Butler has established by consulting extracts from the letters between Matisse and his wife, the younger painter visited Renoir far more often than previously thought, with at least sixteen documented visits between December 31, 1917, and Renoir's death on December 3, 1919.[15] The first visit was for Matisse a frustration in that he only met the artist after waiting two hours while he slept, and failed to gain access to his art. He blamed Renoir's artistic "minder" Albert André, who made a poor impression on Matisse.[16]

Hilary Spurling has painted a vivid picture of the warmth that developed between the two men, with Les Collettes becoming "the nearest [Matisse] got to a second home in his first unsettled years in Nice."[17] Matisse introduced his family, artist friends, and the collector Sergei Shchukin to Renoir, and importantly, found him a new model at the Nice art school. This was Andrée Heuschling, the aptness of whose "plump graceful figure, red hair, pearly skin, and wide catlike smile" Matisse recognized, apparently saying to her, "You're a Renoir."[18] The relationship was also formed around an admiration for one another's work. On January 13, 1918, Matisse wrote to his wife of seeing "stunning pictures" at Renoir's.[19] Some days later, at Renoir's invitation, Matisse submitted a number of his new canvases painted in Nice for the master's consideration. The reaction of Renoir to those first Matisses is well documented: he expressed a perplexed admiration for Matisse's successful use of black, a color which Renoir said he had long since banished from his palette.[20] However, in May, when Matisse showed several works he'd had sent down from Paris (notably his *Lorette on a Black Background, Green Dress,* 1916), Renoir was much less equivocal: "He really liked them, he found a frankness in them. It impressed him that my works carried so well from afar. He congratulated me, but as he said, not to indulge me. This did me a power of good."[21]

There was further reciprocation when later that year Matisse brought along his best Courbet, the *Sleeping Blonde* (1849), and the Renoirs he had collected over the last decade. The level of courtly address between the two is marked, as Renoir offered to exchange new paintings with Matisse, who declined, saying "I really am touched but I cannot accept, I am not worthy of it."[22]

After the master's death (detailed in a letter to his wife), Matisse continued to visit with the family and to study Renoir's paintings for several more years: "The visit I made last week to Renoir's, where I looked over his pictures in my own time," he wrote in 1920, "helped me a great deal."[23]

Matisse painted in the garden of Les Collettes from 1918 and certainly after Renoir's death. He commented in one letter that "Renoir's garden was looking sad and sorry to me."[24] Two small Matisse landscapes are painted as if pendants for one another: each shows the white plaster statue of Renoir's *Venus Victrix* from the front, and again from the rear. The frontal version is the more cheery in tone, with bright pink blossoms and a profusion of greenery rendered in the brushy, loose strokes of Matisse's "Nice" period **Cat. 106**. The second, showing the statue's rear, is rather grave in coloration and aspect, with browns and grey-greens in evidence **Fig. 58**. The impression that the works are painted as homages is increased when one notices the ivy growing up the statue's pedestal in the frontal version—the garden of Renoir is neglected now, its master is no more. Further, green leaves obscure the face of Venus, in what seems to be an invocation of French funerary sculpture tradition: in it, a veil is often drawn across the eyes of a mourning woman.

Henri Matisse at Les Collettes
March 1918
Left to right: Henri Matisse, art dealer Walther Halvorsen, Pierre-Auguste Renoir, Pierre Renoir, actress Greta Prozor (Halvorsen's wife)

Cat. 184

13. Harris 1923, p. 140. **14.** Matisse, as recounted by Louis Gillet, February 1943, in Matisse 1972, p. 290. **15.** Butler 2008b, pp. 111–116. **16.** Letter from Matisse to his wife, December 31, 1917, in Butler 2008b, p. 112. **17.** Spurling 2005, p. 218. **18.** Ibid., p. 217. **19.** Butler 2008b, p. 112. **20.** Gilot and Lake 2006. Jack Flam identifies the Matisse paintings in Flam 1986, pp. 468–469. **21.** Letter from Matisse to his wife, May 5, 1918, quoted in Butler 2008b, p. 113. **22.** Letter from Matisse to his wife, June 23, 1918, in ibid., p. 113. **23.** Letter from Matisse to his wife, March 7, 1920, in ibid., p. 114. **24.** Letter from Matisse to George Besson, December 27, 1919, in ibid., p. 114.

Cat. 106

Fig. 58

Henri Matisse
Renoir's Garden in Cagnes
1918–20?

Cat. 106

Henri Matisse
Renoir's Garden in Cagnes
1918–20?
Oil on canvas
14⁷/₈ x 18¹/₈ in. (37.8 x 46 cm)
Private collection

Fig. 58

The larger question, however, is the use Matisse made of Renoir's aesthetics. It would be unwise to disentangle his feelings about the man—which take on a highly emotive tone in Frank Harris's account—and his art. When Matisse expostulated that Renoir's late work included "the loveliest nudes ever painted: no one has done better—no one" and described the *The Bathers* **Cat. 80** as "his masterpiece, one of the most beautiful pictures ever painted," the modern viewer tends to be mystified. Led by the fashion industry since the 1950s, the catwalk, the market in celebrity, soft porn, and the rest, the "large" female has become a subject of fear, derision, abjection. The sin of late Renoir is to have proposed as aesthetically pleasing the very figure of the XXL woman.

The articulate arguments of feminist scholars like Tamar Garb call in question the cultural assumptions and sexual politics underpinning the late Renoir's vision. She calls the Musée d'Orsay *Bathers* "a fantasy of fecundity run riot," wherein Renoir's "psychically regressive fantasy of the elemental, earth-bound, natural Woman . . . produced an image so excessive in its scale and metaphorical language that it enters the realm of the absurd." She has no sympathy for the physical plight of the artist which Matisse found so inspiring, likening the *Bathers* to "billowing fleshy pillows, an image of soft, supine femininity [that] was to provide the final resting place for the weary imagination of the ailing artist."[25]

Even in his own day Renoir's supporters could see that the Renoir *type* was highly particular. His old friend and collaborator Albert André described the master's proclivities thus: "He has a taste for heavy hands and feet. The beautiful, robust girls who have served, almost exclusively, as his models during his last twenty years, have simply been his youngest children's nurse-maids. Almost all of his figures reveal this single type of feminine beauty that he favoured most. The mouth coming forward as if for a kiss . . . the long torsos with exaggerated hips; the slightly short legs, rounded but not particularly muscular; the feeling of bonelessness. This type becomes emphatic around 1880; he finds it all around him and imparts it, despite himself, to all of his figures."[26]

There is no evidence in Matisse's paintings that he subscribed to this vision. In this he differed from Picasso, who took on a delicious, almost absurdist parody of Renoir's massive women after his death. Matisse, in contrast, proposed a bodily norm much closer to modern tastes. Indeed, his Nice period figures, along with the elongated, suntanned nudes of Amedeo Modigliani, may have helped shape the taste of today. In Nice Matisse hired models whose physiques were svelte; his early favorite Antoinette Arnoux was an eighteen-year-old fashion model, while the athletic Henriette Darricarrère, who dominated his studio practice from 1921 to 1927, was a serious classical ballerina. Matisse knew anatomy more accurately than Renoir and, starting from the type established by his wife and chief model Amélie Matisse, from 1898 on insisted on a vision of the body where bone structure and musculature were studied in dynamic engagement with the rectangle of the picture. However, Jack Flam is surely right in claiming that the example of the late Renoir helped Matisse return to the figure and the nude after a long break, and licensed a fresh engagement with the erotic (last seen in the paintings around the *Le Bonheur de vivre* of 1906).[27]

Previously I have suggested Matisse took the broad idea of the Orientalist studio masquerade—for which the Nice paintings are celebrated—from the example of late Renoir.[28] As Matisse would have been aware, Renoir's Orientalism had three phases: his Parisian studio pieces, which centered on the brilliant 1870 *Odalisque,* the three dozen figures and landscapes he painted *in situ* in Algiers in 1880–81, and a return to the subject-matter in the last years (beginning with the two *Dancer* pendants painted in 1909 for Maurice Gangnat, *Dancing Girl with Tambourine* and *Dancing Girl with Castanets* **Cat. 40 & 41**). No doubt both men discussed their travels to the Maghreb (Matisse had been in Algeria in 1906 and Morocco in 1912–13). Both collected items of Maghrebin costume and used them as studio props—in Matisse's case, the collecting ran to furniture, ceramics, textile hangings, rugs, and screens.[29]

After his Moroccan paintings and drawings, the "eastern" subject next resurfaced in Matisse's loosely decorative images of Lorette in a turban, painted in 1917 in Paris.

25. Garb 1998, pp. 176–177. **26.** André 1919, quoted in Wadley 1987, p. 275. **27.** Flam 1986, p. 473. **28.** Benjamin 2003. **29.** See exh. cat. Le Cateau-Cambresis, London, and New York 2004–05, in particular, nos. 8, 17–18, 22–25, 28–29, 32–45, and 63.

Then came a set of fashionable "flappers" from 1917 with Marguerite Matisse and her friends. In Nice, Antoinette donned loose "Oriental" robes in the summer of 1919; however, it is not until the famous *Odalisque with Red Trousers* of 1921 **Fig. 59** that Matisse's series of Nice *Odalisques* began in earnest, running up to his departure for the United States and Tahiti in 1930.

Renoir's studio Orientalism had been intermittent since 1909, but consolidated in 1918–19 when his friendship with Matisse was most intense. His *The Concert* **Cat. 79** of that time best encapsulates the self-evident masquerade in which two fair European women wear the *ghlila* and the *sarouel*, yet one leans against an Empire tabouret heavy with roses and the other plays a small mandolin against a frieze of Italianate drapes. A similar hybrid scenography and coloristic conceit was soon adopted by Matisse. As he later remarked: "The *Odalisques* were the result of a joyful nostalgia, a beautiful living dream, and of an experience lived in a state of near ecstasy day and night, in a spellbinding climate."[30]

I would argue that the *Odalisque with Red Trousers* owes much to Renoir: the predominant red and pink palette, the splendor of exotic costume and translucent chiffon, and the fair-skinned torso of Henriette, rendered with an exacting touch quite close to Courbet, early Renoir, or indeed Ingres (another significant influence on Matisse in these years).[31] In dozens of less meticulous odalisques, Matisse took up the mantle of the deceased master of Les Collettes **Cat. 107**.

Over the next years in his residences at Nice, he revised and extended the project suggested by Renoir's final subjects. There has long been an argument that the détente of these years saw a falling-off of aesthetic quality in Matisse's work, which went from the taut experimentalism of the early years of World War I to an easeful decorativeness. Without judging that debate here, it seems true that late Renoir and Matisse's Nice period are all of a piece. If the project of reevaluating the former has succeeded, it must follow that the decade of Matisse's odalisques, with all its overripe beauty, is all the more representative of the best in the complex modernism of the postwar era.

Henri Matisse
*Odalisque with Red Trousers
(Henriette)*
1921
Oil on canvas
26³/₈ x 33¹/₈ in. (67 x 84 cm)
Paris, Musée National d'Art
Moderne

Fig. 59

Henri Matisse
Two Models Resting
1928

Cat. 107

30. As recounted in Verdet 1978, p. 128; idem 2001, p. 122. **31.** See Benjamin 2001.

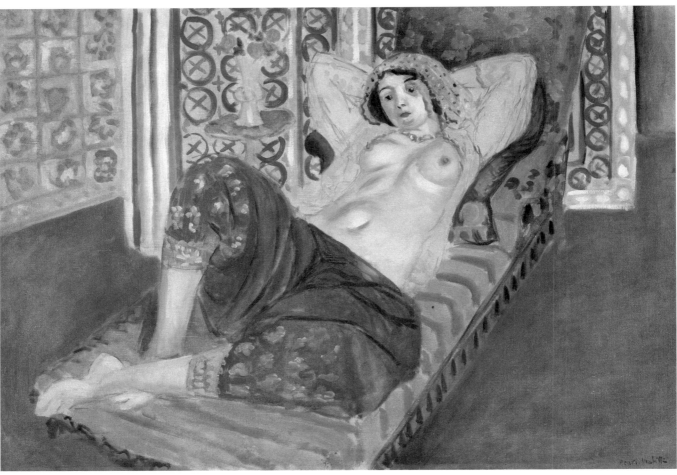

Fig. 59

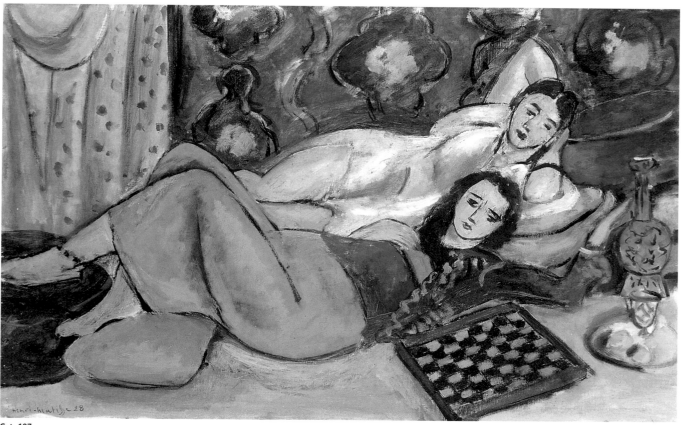

Cat. 107

Renoir and the Nabis

Sylvie Patry

Praising the works of Pierre-Auguste Renoir in his final years, Walter Pach added that "He also reaches forward to the painters of today, and his open-mindedness to new developments in painting . . . has been rewarded by the homage of the younger generation."[1] Among these, the Nabis (meaning "prophets" in Hebrew and Arabic)—a group formed at the end of 1888 around Paul Sérusier, Maurice Denis, Pierre Bonnard, Paul Ranson, Henri-Gabriel Ibels, Édouard Vuillard, Ker-Xavier Roussel, then Aristide Maillol and Félix Vallotton—entered into what was for some a fertile and enduring dialogue with Renoir. Yet even today there is a tendency to locate the emergence of the Nabis, and their followers, under the sign of Paul Gauguin alone, and then of Paul Cézanne, attaching more importance, as far as Renoir was concerned, to his direct and indirect links with the Fauves (Henri Matisse, Albert Marquet, Charles Camoin, Henri Manguin, and André Derain). It is true to say that during the 1890s the defenders of the "old"[2] Impressionists—while not unaware of the points of contact between the latter and Symbolism—set their fondness for nature and the motif against a Nabi aesthetic that was perceived, if not caricatured, as mystical.[3] Besides which, as they admitted themselves, the Nabis became directly acquainted with Impressionism only after the founding period in the late 1880s, and only by rejecting the incarnations they judged to be too realistic.[4] However, as early as 1892, Maurice Denis sent out the call "to reap the example and teaching of Renoir": the publication of his article in *La Revue blanche*[5] constituted the first meeting point between Renoir and the Nabis; then, during the second half of the 1890s, genuine relations developed and blossomed, which intensified around 1900, the date of the last joint exhibition of the group at the Galerie Bernheim-Jeune. It remains to be seen whether the link with Renoir took on meaning as an artistic orientation for the Nabis as a group, or whether individual connections should be sketched out, in which case, on account of the strength and longevity of their connection with Renoir, two key figures emerge—Bonnard and Denis.[6]

Artistic Networks, Critics, and Dealers

Renoir and the Nabis had numerous opportunities to get to know each other's work and come into contact with each other, as there were many crossovers between their artistic networks (Stéphane Mallarmé, Edgar Degas, Claude Monet, Paul Cézanne, Paul Signac, Henri Matisse, Albert André, Georges d'Espagnat, and Louis Valtat), critics (Octave Mirbeau, Gustave Geffroy, Georges Lecomte, Arsène Alexandre, Félix Fénéon, then George Besson, Élie Faure, François Fosca, and Léon Werth), and dealers (Ambroise Vollard, Paul Durand-Ruel, the Galerie Bernheim-Jeune). Their paintings often hung side by side in the same exhibitions and in the homes of the same collectors (Henry Lerolle, Jean Laroche, Georges Viau, Marcel Kapferer, the Bernheims, Jos Hessel, Arthur and Hedy Hahnloser, et cetera). Among these many constellations some favored the Nabis' connection with Renoir's recent output. In 1894 Renoir noticed the paintings of Albert André, who was close to the Nabis at that point after having become

1. Pach 1983, p. 44. **2.** Fénéon, "Le néo-impressionnisme," in Fénéon 1970, vol. 1, p. 75. Speaks of Pissarro, Sisley, Cézanne, Monet, etc., and Renoir in juxtaposition to the Neo-Impressionists. **3.** Lecomte 1892, pp. 22–23. **4.** Bouillon 2003, pp. 231–237. **5.** Denis 1892, p. 366. **6.** Maillol is a particular case. See the essay by Emmanuelle Héran in this volume, p. 156.

friends with them at the Académie Julian[7] in 1889. In the mid-1890s, thanks to Berthe Morisot,[8] Renoir often frequented the elegant salon of the painter and collector Henry Lerolle, an early supporter of the Nabis and of Denis in particular. In this way, through the Lerolle and Morisot circles, the relationships between the Nabis and Renoir developed against a background in which Impressionism and Symbolism intermingled throughout the 1890s; the key figure, both friendly and admired, was that of Stéphane Mallarmé.[9] After he had "found hideous" the first solo exhibition of the "Symbolist Bonnard" that had been organized in January 1896 at the Galerie Durand-Ruel,[10] in May/June of 1897 Renoir wrote to Bonnard to encourage him to "keep this art," and "all that is most exquisite" and "clearly your own,"[11] which could be seen in the illustrations for a novel by Peter Nansen, *Marie*. In this first display of admiration, the intermediaries were also key protagonists: the illustrations appeared in *La Revue blanche*, edited by the brothers Alexandre and Thadée Natanson. An early and loyal advocate of the Nabis, and a friend of Renoir and Bonnard,[12] Thadée strongly defended the painter's latest style in his journal in 1896 and 1900, even if Renoir, "admired above all," "is absent"[13] from his collection. His wife, the lovely Misia, would sit for Renoir, as she had done for Vallotton, Bonnard, and Vuillard **Cat. 26**. In passing, the letter from Renoir to Bonnard confirms that Renoir's earlier disrespectful attitude (he admitted stacking piles of *La Revue blanche* to prop up his models) revealed more than anything his obsession with refusing to seem like an intellectual artist at a time when journals were flourishing and disseminating the avant-garde's manifestoes and creative work.[14] We also know that he appreciated the laudatory article published by Thadée in his journal in 1896.[15] Another important player was Vollard, to whom Renoir had entrusted his letter to Bonnard: the dealer had paintings by the Nabis back in 1893[16] and several examples—modest to begin with in 1895—of Renoir's latest work.[17]

This intermediary role was noted by Bonnard **Cat. 110** and celebrated by Maurice Denis, whose *Homage to Cézanne* **Fig. 60** brought together the Nabis in the Galerie Vollard. The paintings represented in this work were a tribute to the guiding influence of the three masters—Cézanne, Gauguin, and Renoir.[18] Moreover, encouraging the artists to experiment in new areas, the dealer included Renoir and some of the Nabis in joint ventures such as ceramics[19] or the prints of *L'Album des peintres-graveurs* (1896).[20] Also present in the group portrayed by Denis is the critic André Mellerio, who was well acquainted with Renoir's works, about whom he published one of the very first monographic accounts in 1891.

It was to Mellerio that Denis revealed his intention of organizing a banquet in honor of the master—"the only way of showing an artist that he is respected and loved"[21]—following a ritual that was extremely widespread at the end of the century. In 1900 Mellerio lamented the absence of Impressionists from the Decennial Exhibition, an assessment of ten years of painting organized for the Universal Exposition, to which he wanted to give a counter response.[22] Regarding Renoir, Mellerio approached Denis: "I feel that they [the Impressionists] would need to be sounded out *separately* and *by writing to them* through their friends (e.g. Degas, through the Rouarts; Renoir, through you, etc.). We would suggest a separate exhibition in which *they themselves* would choose the canvases they would like to show."[23] Their exclusion from the Decennial actually amounted to a dismissal of their recent work, including some paintings of Renoir "with a strength of execution that sets them apart from the old ones; series such as the *Bathers*, and the *Women at the Piano*."[24] For the Nabis, in fact, the dialogue with

Pierre Bonnard
Vollard's Gallery: The Puppet Theater
Sketchbook, called "The Painter's Life," p. IV
Ca. 1910

Cat. 110

Maurice Denis
Homage to Cézanne
1900
Oil on canvas
70 7/8 x 94 1/2 in. (180 x 240 cm)
Paris, Musée d'Orsay,
gift of André Gide, 1928

Fig. 60

7 Exh. cat. Bagnols-sur-Cèze 2004, p. II. **8.** Letter from Renoir to Berthe Morisot, November 21, 1894, in Morisot 1987, p. 209. **9.** His funeral on September 11, 1898, brought together, among others, Bonnard and Renoir. See Cat. 132. **10.** First solo exhibition with fifty-six works. Letter from Camille Pissarro to Lucien, January 31, 1896, in Pissarro 1989, vol. 4, p. 159. "Bonnard was pleased and felt some pride in seeing his canvases in the place where he had come to look at the recent works of the Impressionists" (Natanson 1951, p. 73). **11.** Private collection, reprod. in exh. cat. Le Cannet 2005, pp. 74–75. Bonnard and Renoir did not know each other then: Bonnard 1941, quoted in Bouvet 1981, p. 194. From that point on, Renoir would admire Bonnard. Natanson cites Renoir as the first of the authoritative individuals who gave Bonnard's talent the stamp of approval (Natanson 1912, p. 540). Renoir announced to Besson: "I love the man, and I love the painter" (Renoir 2002, p. 216). **12.** Natanson 1951, pp. 11–12. **13.** "Even though Renoir is missing, he admires him above all others." Octave Mirbeau, introduction to sales cat. Paris, Bernheim-Jeune, 1908, p. IX. **14.** Vollard 1994, p. 138. **15.** Natanson in May 1896, quoted in idem 1948. **16.** Groom 2006–07, p. 83. **17.** Distel 2006–07, p. 145. **18.** A portrait of a woman by Renoir hangs on the wall. It does not reference a specific Renoir painting, but is probably a pastiche "in the manner of." **19.** See my essay on decorative art in this volume, p. 45 **20.** Painting movement from 1896 to the end of 1899: Paris, Bibliothèque Centrale des Musées Nationaux, Fonds Vollard, MS 421 (4,4); transactions relating to the engravings, f° 72. **21.** Unpublished letter from Mellerio to Maurice Denis, Paris, Sunday, no date, Saint-Germain-en-Laye, Maurice Denis regional museum, Maurice Denis archives, ms. **22.** Mellerio 1900, pp. 22–25. **23.** Unpublished letter from Mellerio to Maurice Denis, Paris, Sunday, no date, Saint-Germain-en-Laye, Maurice Denis regional museum, Maurice Denis archives, ms.12336. Mellerio's emphasis. **24.** Mellerio 1900, p. 18.

Cat. 110

Fig. 60

Renoir (as with Monet or Cézanne for that matter) did not begin solely on the basis of the emancipatory Impressionism[25] of the 1870s, but rather with his current creative works. They turned to their contemporary, a painter still searching, who had gone beyond Impressionism and had "developed and elevated his method toward synthesis and tradition,"[26] directions Renoir and the Nabis shared after 1900 around the issue of classicism.

Vallotton, Roussel, and Vuillard

The exchanges with Renoir varied from one artist to the next: they seem to have been secondary for Ranson[27] and Sérusier, and limited for Vallotton. The latter recommended a model to Renoir in 1906; he knew his paintings well (especially through his brother, the dealer Paul Vallotton, who was active in supplying the master's recent works in Switzerland); and between 1920 and 1924, according to him, he succumbed to the charms of Cagnes-sur-Mer, where he settled in 1924. But while his full-bodied bathers have sometimes been compared to Renoir's, one cannot talk of real artistic exchanges,[28] unlike those one can see with Vuillard and Roussel. The latter traveled to Cagnes with Denis in 1906: the visit confirmed and gave sustenance to his project of reviving classical mythology through the Arcadian celebration of nature and the nude. Similarly, Vuillard met the man he called "old Renoir"[29] on several occasions, and Misia Natanson recalled the friendship that bound them.[30] Vuillard saw Renoir's paintings frequently at the homes of the Bernheims, Durand-Ruel, Jos Hessel, and even Laroche, Viau, and Gangnat. The portraits he painted of some of his collectors occasionally contain direct references to these works in the form of paintings within the painting **Fig. 92, p. 231**.

Like Bonnard, Vuillard shared the same sitters as Renoir, including the Bernheims, the dealers they had in common from 1906 to 1912, and whose Renoirs "dazzled" him.[31] He painted the two brothers (Josse and Gaston) and their families between 1905 and 1912, then again in 1919–20 with Geneviève Bernheim,[32] ten years after the portrait of Geneviève by Renoir. *Claude Bernheim* (1905–06) by Vuillard and *Madame Josse Bernheim-Jeune and Her Son Henry* **Cat. 53** by Renoir differ in terms of the composition and framing (radically decentred in the case of Vuillard, who shifts the mother to the edge of the picture while Renoir places her in the center), but the Vuillard expresses a taste for the effects of paint and accumulation that breaks with the flat areas of color of the Nabi years. The Nabis' interest in Impressionism around 1900 and the example of Renoir are also relevant in this context: Renoir's great masterpieces of the 1870s, which were making their way into the museums with fanfare, such as the *Portrait of Madame Charpentier* **Fig. 57, p. 135**, constituted an enduring paradigm to the many portraits of "people at home"[33] which Vuillard was to paint until his death.[34] His late success as a high-society portraitist was sometimes compared to the career of Renoir. In both Renoir and Vuillard, the portraits from 1910–20 and the years that followed were shaped by a search for richness and accumulation on the canvas, for shimmers and adornments, for dense backgrounds in which the strokes of color are often vibrant and unexpected. Renoir showed the way to reconcile observation of the modern world with the tradition of the grand portrait of aristocratic pomp and ceremony. A shared taste for saturation—an implicit nod to the art of textiles and tapestry by the two artists, both dressmaker's sons—seems to act as an effective and decorative model for unifying the pictorial surface, going beyond the technical differences separating the two artists (transparency and smoothness of the oil in Renoir; mattness and decorative *guilloche* patterns in Vuillard's distemper paintings). The two painters, who each included Rubens in their pantheon, began to turn to the same reference point in the early 1910s: *Adam and Eve*, seen in the Prado, was transposed into a tapestry for the

25. "Impressionism has brought us freedom" (Bonnard, quoted in the excellent article by J. Munck 2006, p. 86). **26.** Denis 1993, p. 135. **27.** October 31, 1908, Ranson dined with Puy, Roussel, and Renoir among others at Vollard's house (Archives Vollard, notebooks, 421 [5,3], fº 178). **28.** I am grateful to Marina Ducrey for her assistance and information on Vallotton. **29.** Vuillard, *Journal*, October 25, 1911. My thanks to Guy Cogeval for permission to consult the transcriptions made by Mathias Chivot and Thomas Schlesser. **30.** Sert 1953, p. 83: "He was more and more interested with every year in the evolution of modern painting. Bonnard and Vuillard had become his friends." **31.** Vuillard, *Journal*, February 20, 1912: "dinner at the Bernheims—dazzled by the Renoirs." **32.** The two portraits, from 1910 and 1919–20, are now in the Musée d'Orsay thanks to a gift by M. and Mme Gaston Bernheim de Villers in 1951 (RF 1951-30 and RF 1977-389). **33.** Vuillard, *Journal*. **34.** The most direct tribute to this painting by Renoir, in our view, is *Madame Trarieux and Her Two Daughters* (1912, private collection; Salomon and Cogeval 2003, No. IX-197).

library of Princess Bassiano by Vuillard, and became a direct model for what was to be Renoir's most ambitious contribution to tapestry making—*The Saône Throwing Herself into the Arms of the Rhône* **Cat. 88**. Vuillard admired Renoir's capacity for blending the various components on the canvas (design, tonalities, and color) and, like many others, was interested in his technical skills, made all the more fascinating by the old master's illness.[36] But for Vuillard, "Renoir is [also] the opposite of what one thinks, of sophistication, elegance, etc." Around 1900 they were both ardent visitors to the Louvre, and they admired the paintings of Pompeii. While mythological scenes were the exception for Vuillard, his love of antiquity led him to admire them when directly reappropriated and given a natural look by Renoir—"which is the idea of antiquity, of the driving force of composition, the liberating rhythm set against the notion of knowledge."[37] In this sense, Vuillard admired the same qualities in Renoir as Roussel, and also Denis, who detected the "melancholy of antiquity" on the "beautiful faces"[39] painted by the master.

"The richness of the craft! The quiet persistence in the effort! And above all, the sensual pleasure! This is what Renoir teaches us."[40]

In Denis's opinion, too, Renoir was gifted with an ability to fit into the classical (but also profoundly French) tradition while at the same time rejuvenating it. Echoing Roussel's sentiment, Denis considered Renoir, like Cézanne, someone who had "lived under the Provençal sky": with their roots in the South, in "Latin soil," they were "the undisputed masters of youth"[41] at a time when French painting after 1905 was riddled with "classical sentiment."[42] The painter occupied a key position in Denis's very coherent theoretical framework, and his nudes in particular find an echo in Denis's paintings, especially the curves and flesh tints of his modern bathers; because for Denis, Renoir was a painter of the flesh. He was, however, interested in many aspects of Renoir's work, whom he met on numerous occasions in Paris and Cagnes.[43] In 1897, when Renoir first appeared in his diary,[44] Denis raved about the painter of the *Ball at the Moulin de la Galette* **Fig. 2, p. 31**, urging his friend, the collector Arthur Fontaine, to admire the masterpiece, which had just entered the Musée du Luxembourg;[45] yet it was as early as 1892 that Denis had become the first member of the Nabis to publish a testimonial of his interest in Renoir. From this date until 1920, when Denis prepared a beautiful funeral oration for Renoir,[46] his approach evolved and matured, but it continued to be dominated by the idea of Renoir as the painter who reconciled opposites: "Idealistic? Naturalistic? We like him however he is."[47] Already for Denis, Renoir had ceased to be an Impressionist tied to his motif, striving to record it in a perfect and immediate way, but was, as Bonnard would also later make clear, someone who showed the balance between the necessary reference to nature and its essential reinterpretation. In 1903 Denis wrote to his friend, the painter Jan Verkade: "But nothing has affected me more than the final canvases I saw in Renoir's house. Thanks to Renoir, I can glimpse a way of reconciling your ideas[48] and working from nature."[49] In saying this, Denis put his finger on what, in the eyes of Jean Renoir and contrary to the denials of the master, may be seen as the "real dilemma," the "central theme of his life—the contest between subjectivism and objectivism."[50] But in the context of Denis's text of 1920, this reading assumes a polemical value: Renoir protects us from the aridity of abstraction, whether derived from Cézanne's model—corrupted by Cubism and its followers—or from Matisse. It may not have been entirely innocent of Denis to apply Baudelaire's poetry (which provided the title for Matisse's painting *Luxe, calme et volupté*, reviewed by Denis

35. *La Bibliothèque*, Paris, Musée d'Orsay, RF 1977-368. **36.** Vuillard, *Journal*, March 17, 1915, "Renoir's gesture of rubbing his canvas all over with his stump, softening the whole canvas." Like Renoir, he juxtaposed painted sketches (women, flowers, portraits, etc.) with sketches for studies (Salomon and Cogeval 2003, No. VII-492.1 to 6). **37.** Vuillard, *Journal*, February 1, 1916. **38.** Ibid. **39.** Denis 1993, p. 193 ("La Mort de Renoir," *La Vie*, February 1, 1920, quoted in idem 1922, pp. 107–117). For convenience, we are quoting from the edition published by Jean-Paul Bouillon in 1993. **40.** Denis 1993, p. 199. **41.** For all the terms in quotation marks: ibid., p. 195. **42.** Rey 1921. **43** For the meetings between Denis and Renoir, the collections, and the portrait of his wife by Renoir, see below, Cat. 27. **44.** Denis 1957, "Pentecôte 1897 [copied]," vol. I, p. 121. **45.** Unpublished letter from Denis to Fontaine, dated 1897, Paris, Institut néerlandais, Fondation Custodia, Frits Lugt collection, 1973-A 210. My thanks to Isabelle Gaëtan for bringing this letter to my attention. **46.** "La Mort de Renoir," see above, note 39. **47.** Denis 1892, p. 366. **48.** From 1893 in Beuron Abbey, Verkade moved toward an art governed by strict geometric principles. In 1903, when he was painting the interior decoration for Father Lenz at Monte Cassino in Italy, he questioned its precision and, going through a crisis, tried to return to drawing from nature. **49.** Unpublished letter, August 25, 1903, documentation, Maurice Denis catalogue raisonné. **50.** J. Renoir 1962, p. 110. Renoir, quoted in André 1919, p. 34: "Don't ask me whether a painting should be objective or subjective, for I can assure you, I don't give a darn."

at the Salon des Indépendants exhibition in 1904)[51] also to Renoir's chaste and sensual "celebration of life." Like Matisse, Denis admired Renoir's mastery of color and his role as one of the architects of its liberation from imitative use; but, unlike Matisse, Denis also applauded Renoir's ability to combine order and sensual pleasure, without sinking into the excesses of the one (the lesson misunderstood by Cézanne) or the other (the subject freed from nature in Matisse). To these virtues, Denis added one of his main credos—the celebration of the *métier*, the "craft"—thus posing the question of the "reactionary"[52] nature of his view of Renoir. This is the line taken in his work with Renoir on the preface of Cennini's *Il Libro dell'arte* (The Craftsman's Handbook) when it was republished in French in 1908–10.[53] In spite of Renoir's serious interest in mural painting, which he had shared with the Nabis since the 1890s, he regarded the treatise as less commendable in terms of its technical methods (scarcely applicable in France since the beginning of the twentieth century) as for its tribute to the status of the artist and his practice. In Renoir's preface, in which Denis participated in the content and, perhaps, in the wording,[54] the main lesson drawn by Renoir (and Denis) is nostalgia for the crafsman-artist, master of a skill who can take his place in the collective production of a work. From this standpoint, using this model, both were reflecting on the education of future artists, and on the prime importance of craft for the formulation of fundamental principles. Thus it is not surprising that Denis inscribed Renoir in his pantheon of French art, on the Duthuit dome of the Petit Palais museum **Fig. 61**, in two forms: the artist at work at his easel, a widely used image of Renoir, but one that fits with the lesson one is meant to draw from his life and works, according to Denis; and linked to one of his most emblematic compositions, *The Spring* **Cat. 31**, a late nude where the female nude is reinterpreted in the light of Ingres and antiquity, and transfigured by Renoir's "lyricism" and the "plastic sense."[55] Celebration of craft and of the return to pleasure—this is the lesson that Bonnard, too, admired in the master: "Renoir, first and foremost, painted Renoirs. He often had models with a gray complexion, without a pearly shimmer, and he painted them with a pearly shimmer. He used the model for a movement or shape, but he did not copy: he never lost the idea of what he could do. I was walking with him one day, and he said to me, 'Bonnard, you have to embellish.' In his embellishing, he was expressing the very part that the artist should put in his painting first."[56]

"I regarded Renoir as a rather strict father" (Bonnard, October 18, 1941)

As Clive Bell[57] and Julius Meier-Graefe[58] noted, no one was nominated as the "true heir of Renoir"[59] more than Bonnard, to use Roger Marx's wording in his work on Renoir, which he dedicated to none other than Bonnard! This filiation is not always a matter of praise, as it has sometimes contributed to Bonnard being positioned on the fringe of modern art, on the pretext that he was the late "heir"[60] of the master,[61] ranking after him in the line of painters of happiness and "French charm"[62] behind Boucher, Fragonard, and Watteau, whom, incidentally, they both admired. The two artists frequented each other from the end of the 1890s on: Bonnard painted Renoir's portrait around 1916 and kept photographs of him and his son Jean. Bonnard and Renoir had in fact shared numerous commonalities since the 1890s, when the scenes of urban life by the young Nabi (like Renoir, using the figure of the young Parisian woman as the heroine) announced him as the sole inheritor of the "feeling for modern life" so characteristic of the painter of the *Ball at the Moulin de la Galette* **Fig. 2, p. 31**;[63] the craftsmanship of these scenes was similar to Renoir's young modern girls around 1900. The two artists chose their homes and set up their studios in Paris in the Clichy-Montmartre districts, which fascinated them and where they saw each other. The final years in the

Maurice Denis
The Spring and Renoir at His Easel
Detail of the Duthuit dome in the Musée du Petit Palais, "Contemporary Art" section
1925
Paris, Musée des Beaux-Arts de la Ville de Paris, Petit Palais

Fig. 61

Pierre Bonnard
Portrait of Renoir
Before 1916

Cat. 111

Pierre Bonnard
Portrait of Renoir
Ca. 1916

Cat. 112

51. Paris, Musée d'Orsay, on deposit from the Musée National d'Art Moderne: the "framework for a theory" according to Denis (1993, p. 95, note 57). **52.** In the sense of his response to modern art. We draw on Bouillon 1997, pp. 157–162: the study of Cézanne from the angle of his classicism seems in many respects to clarify the position of Renoir. Denis even manages to reconcile Renoir's lesson with the possibility of Christian painting, emphasizing the chastity of his nudes, even "pagan" ones, and their "sanctification through painting: good painting is devout in itself, as Michelangelo said." (Denis 1993, p. 194). **53.** See my essay on decorative art in the present volume, p. 49, note 35. **54.** See unpublished correspondence between Denis and Henry Mottez, son of Victor, the painter who had republished *Il Libro dell'arte*. Saint-Germain-en-Laye, Musée Maurice-Denis Le Prieuré, Maurice Denis archives, December 14, 1909, ms 8324: "I have received the two notes from Monsieur Chapon which you wrote about Cennini. I think it is very good this way. Renoir, to whom I have sent them, also approves and is going to put them in his preface letter." **55.** Denis 1993, p. 193. **56.** Bonnard 1947. **57.** Bell 1929, p. 152. **58.** Meier-Graefe 1938. **59.** Roger-Marx 1937, pp. 172–174. **60.** Francastel 1990, p. 322. **61.** See Roque 2006, "Le dernier des impressionnistes," pp. 27–35, and "Pas vraiment moderne," pp. 43–55. **62.** George 1933, p. 380. **63.** Denis, 1905, quoted in idem 1993, p. 93. Natanson (1900) compares the Renoir of around 1875 (street scenes especially) to Bonnard.

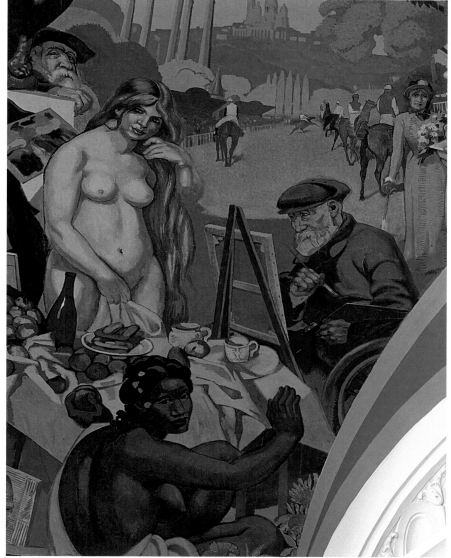

Fig. 61

Cat. 111

Cat. 112

Pierre Bonnard
The Peacock, or
The Three Graces
1908

Cat. 108

Pierre Auguste Renoir
The Judgment of Paris
1908
Oil on canvas
31⁷/₈ x 39³/₄ in. (81 x101 cm)
Private collection

Fig. 62

Pierre Bonnard
Dark Nude
1941
Oil on canvas
31⁷/₈ x 25⁵/₈ in. (81 x 65 cm)
Paris, Fondation Dina-Vierny—
Musée Maillol

Fig. 63

Pierre Auguste Renoir
Sleeping Woman
1900
Oil on canvas
26³/₈ x 21⁵/₈ in. (67 x 55 cm)
Private collection

Fig. 64

South of France provided more similarities: the painful solitude after the death of their wives; the last trip to Paris highlighted by a final, special visit to the Louvre just after the war;[64] but also the reservations raised by their last style, the feeling of a late achievement;[65] and above all, the withdrawal in the South to a direct contact with nature. Renoir visited and painted Le Cannet in 1902 and 1903, well before Bonnard settled there in 1925. The latter often visited Renoir in his house in Cagnes,[66] where he also went occasionally to paint, as did his friend Matisse, even after the master's death[67] **Cat. 198, p. 405**: "I would go to see him [Renoir] at the end of the day to avoid spoiling his session. He was found smoking a cigarette, screwing up his eyes as he looked at the canvas he was working on. He was happy to talk, but never about painting. He glorified the days of the craft industry."[68] Although furnished by their wives, their respective houses in the South of France showed a similar taste for sparseness:[69] Bonnard's simple dining room with its light-toned woodwork—like in Cagnes—had only three lithographs as decoration, two of which were by Renoir.[70] The studios, where their paintings were pinned up without frames,[71] opened out from a huge bay window onto a sumptuous garden, inspiring the two artists to paint lavish country scenes that throw into question the perspective structure in favor of a decorative saturation of space. After his first trip to the South in 1906, and even more so after the one in 1909, Bonnard became interested in Renoir as the apologist of a golden age populated with female nudes and of a reinvented Mediterranean. In this respect, after 1908, Bonnard's *The Three Graces* **Cat. 108** joins Renoir's *The Judgment of Paris* **Fig. 62**, painted the same year, in its treatment of the nude in the open air, the supple lines of the bodies, and the mythological inspiration. In this Arcadian spirit, Bonnard and Renoir were elaborating versions of the same models from the statuary of ancient art, starting with the *Spinario (Boy with Thorn)* **Fig. 84, p. 211**, the source for female bathers for both of them. Bonnard and Renoir were both obsessed with finding a good way to integrate figures into a landscape-tapestry: from Renoir's *Bathers* of 1919 **Cat. 80** to *Summer* by Bonnard,[72] or even *Earthly Paradise* **Fig. 113, p. 331**, one of the panels for the Bernheim-Jeune brothers.

The fact that the Bernheim-Jeune brothers acted as dealers for both artists, as well as for Vuillard, no doubt helped to facilitate exchanges: Bonnard and Renoir were able to see each other's work and were exhibited together in the gallery, as happened at the time of the important show on the nude organized in 1910. When executing commissioned portraits, they had the same sitters,[73] in a kind of playful game of tribute and rivalry: when Mathilde Adler provided both artists, who were fond of painting toiletries, with the same elegant dress from Callot-Sœur,[74] both painters—whose palettes tended almost exclusively to light colors after 1910—seized the opportunity to demonstrate their mastery of, and liking for, pure black **Cat. 52 & 109, p. 282**. In that light, it may not have been quite so innocent when Bonnard planned the reclining nude of *Earthly Paradise* for the entrance to a private townhouse in which the two salons were overflowing with late Renoir nudes.[75] Often eclipsed by Degas's example in the 1920s, these latter seemed to find a topical freshness in the nudes of Bonnard's last decade: monumentality reinforced by tight framing, but also warm vibrant colors mixed with gray—these features were reminders of the Renoiresque flesh of the late 1910s and defined, for instance, Bonnard's last nude **Fig. 63** posed by Dina Vierny, who liked to recall that in Maillol's eyes, she had the appeal of a living Renoir when she began to sit for the sculptor. Among the reproductions hanging on the wall of Bonnard's studio, the only painting was, after all, a Renoir nude presented and signed by the master,[76] the most admired piece[77] in his modest collection of Renoirs **Cat. 199, p. 374**.[78]

64. In October 1946, last visit to the Louvre by Bonnard accompanied by Georges Salles and Jean Leymarie. **65.** A confidence Bonnard shared a few years before he died sounds like a paraphrase of Renoir: "I sense that I am beginning to understand what painting is" (Giverny 1943, p. 59). **66.** Bonnard and Renoir also planned to meet up at Signac's, a plan which Renoir gave up on March 13, 1914. Letter from Renoir to Bonnard, private collection. My thanks to Marina Ferretti for her transcription. **67.** For example, *Oliviers à Cagnes*, 1922; Dauberville 1973, vol. 3, no. 1114. **68.** Bonnard 1941, see above, note 11. **69.** Natanson 1951, pp. 102–103, according to whom Bonnard did not like his house, just like Renoir. **70.** The third lithograph was by Bonnard (Joëts 1953, p. 8). *Young Girls Wearing Hats* by Renoir can be seen in the photograph taken by Henri Cartier-Bresson, *Bonnard in the Dining Room at Le Cannet,* 1944. **71.** Both Bonnard and Renoir cut their own canvases, thus avoiding standard sizes. Renoir sometimes, and Bonnard always, painted on unstretched canvases which were later mounted on frames (see Cat. 180). **72.** 1917, Saint-Paul, Fondation Marguerite and Aimé Maeght. **73.** Madame de Galéa also sat for Bonnard and Renoir. **74.** Dauberville 1967, p. 536. **75.** Newman 1984, p. 11. **76.** Joëts 1953: Bonnard is evoking the small nude which Renoir gave him and signed. **77.** Admiring the painting in the studio with the painter Jules Joëts, who had come to do his portrait: "How beautiful it is, how beautiful it is !" (Joëts 1953, p. 8). **78.** We know of at least two others: Sales cat. Paris, Charpentier, 1954, no. 20, *Still Life—Apples,* and no. 21, *Orange Trees against the Sea.*

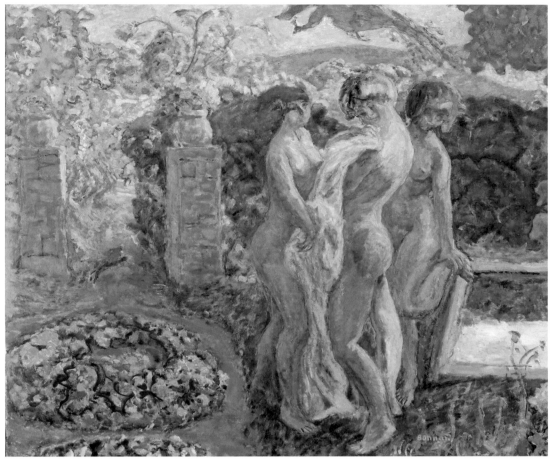

Cat. 108

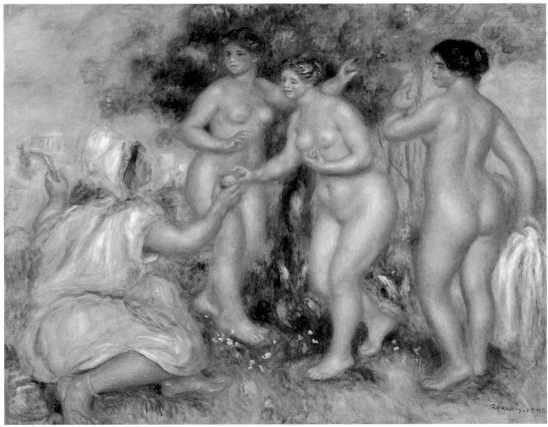

Fig. 62

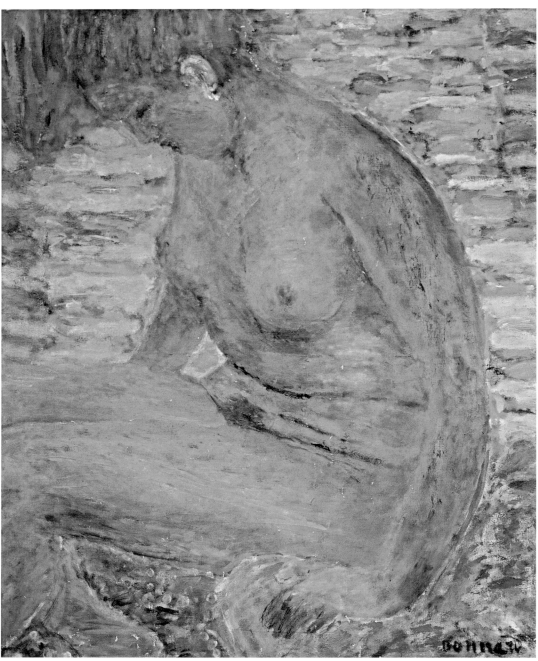

Fig. 63

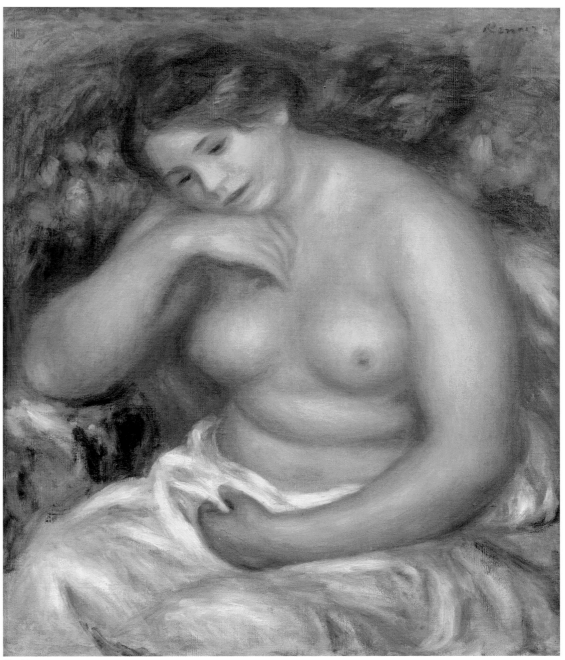

Fig. 64

Renoir and Maillol

Emmanuelle Héran

Twenty years separate Pierre-Auguste Renoir and Aristide Maillol, yet there are obvious similarities between them. They shared more than one taste and more than one way of life, starting with a kind of simplicity, or even a certain rustic approach and a refusal to intellectualize art. Maillol appreciated in Renoir the fact that he "is not burdened with theories."[1] They were also both from the Mediterranean region. The sculptor, at least, was firmly rooted in the land of his birth, Roussillon, and split his life between Marly-le-Roi and Banyuls, while the painter went back and forth between Paris, Essoyes, and Cagnes-sur-Mer, and spent the last part of his life in Provence. Each explored the South to find in it the roots of Western art. While Renoir traveled to Algeria, Italy, and Spain, Maillol discovered Greece thanks to his first patron, Count Harry Kessler, who took him there in 1908 and then on to Italy. Both collaborated with the sculptor Richard Guino, a Catalan by birth. Lastly, curiosity drove each of them to explore a range of techniques: they drew, and tried their hand at engraving and the decorative arts. Maillol started out as a painter and then ended up sculpting, so much so that he has gone down in history as a sculptor, even though he continued to paint; Renoir on the other hand came late to sculpture, with the help of Richard Guino, but so much so that he was also regarded as a sculptor.

The Maillol Exhibition at Galerie Vollard in 1902

Renoir and Maillol probably met around 1902. At least that is the first reliable date we have. In July of that year, in fact, the dealer Ambroise Vollard organized Maillol's first solo exhibition, in which Maillol displayed the full range of his talents, most notably in the decorative arts. There were three tapestries designed as commissions,[2] as well as objects useful in his everyday life: his son's crib and a mirror, both in wood; a door knocker in bronze depicting a *Washerwoman*; a clock entitled *The Two Sisters*; night lights; and an enameled clay fountain-cum-washbasin with female bathers.[3] Some of these objects had already been shown at the Société Nationale des Beaux-Arts in 1896, 1897, and 1899, and then at the Berthe Weil and Bernheim-Jeune galleries at the beginning of that year, 1902.

Maillol was acquainted with Renoir's painting, of course, even if he announced to the writer, Judith Cladel: "I was very late in understanding Renoir . . . Gauguin and Maurice Denis were the ones who began to open my eyes after I left art school."[4] Was this really so late, though? Yes, if the point of reference is Renoir's career, but the answer is "no" for someone following Maillol's development, even though in 1902 he was already over forty years old and had not yet fully embarked on his career as a sculptor. It is worth noting the similarity between Renoir's radical evolution after 1892 and Maillol's commitment to working with the Nabis in the early 1890s.

Among those who purchased Maillol's sculptures, which found great support in the Galerie Vollard, were Auguste Rodin and Octave Mirbeau.[5] Renoir visited the exhibi-

For Olivier and Bertrand Lorquin, in memory of Dina Vierny

1. Frère 1956, p. 133. **2.** *Music for a Bored Princess* (Copenhagen, Kunstindustrimuseet); *The Garden* (Paris, Musée Maillol); *The Book* (location unknown). **3.** Dina Vierny tried hard to reunite these objects in the Musée Maillol, which she set up in Paris. **4.** Cladel 1937, pp. 32–33. **5.** Rodin bought a *Bather Standing* (Paris, Musée Rodin) and Mirbeau a *Leda* (Winterthur, Oscar Reinhart collection). See Héran 2006a.

tion with his friend Jeanne Baudot[6] and set his heart on the indoor fountain.[7] We know this from a letter written from Maillol to his friend, the Hungarian painter József Rippl-Rónai: "My Vollard exhibition introduced me to many real artists . . . I made large earthenware fountains . . . Renoir bought one from me, which made me very happy indeed."[8]

Renoir continued to spend time in the dealer's shop, where the Maillol statuettes were prominently displayed. In Bonnard's sketchbook *The Painter's Life,* a drawing depicts this mythical place featuring Renoir, Camille Pissarro, Pierre Bonnard, and Edgar Degas **Cat. 110, p. 148**. One of Maillol's *Standing Bather* figures—the same as the one purchased by Rodin—can be made out in the background, standing on a piece of furniture. Maillol's painter friends were always keen to fill their pictures with his statuettes, and Renoir doubly so. In 1908 when he once again painted Vollard's portrait **Fig. 25, p. 65** he placed a Maillol statuette in white terracotta in the dealer's hands. It was the *Young Girl Crouching,* which is generally dated as 1900, though we know that Maillol sold it to Vollard in 1905, along with his copyright.[9] In 1910 Renoir went back to it again: in the portrait of Mme Josse Bernheim-Jeune and her son Henry **Cat. 53**, one of Maillol's statuettes, *Standing Bather Putting Up Her Hair,* can be seen on the table. These references not only bear witness to Renoir's admiration for Maillol's talent, they also pay homage to the decisive role played by the two dealers in rue Laffitte, Bernheim and Vollard, in Renoir's first steps as a sculptor and in disseminating his late works.

Vollard, Renoir, Maillol, and Guino: Portraits

If Maillol and Renoir spent time with each other, we do not know how frequently or on what terms. It seems to have been more of a three-way relationship in which the role of Vollard was always the decisive one. Jean Renoir remembers Maillol as one of the guests at Essoyes: the Renoirs and Rivières made up a group that would readily invite "some special guest, such as Vollard or my godfather, Georges Durand-Ruel, or the sculptor Maillol." The adults went for a ride in a brake, and the young ones followed on their bicycles. Among the latter were Renée Rivière, the youngest daughter of Georges Rivière and future wife of Paul Cézanne, the painter's son.[10] The memory of these pleasant summers is preserved in two busts sculpted by Maillol: one of Renoir in 1906 **Cat. 117, p. 274** and one of the pretty girl Renée in 1907 (terracotta, Paris, Musée d'Orsay).

It was Vollard who commissioned Maillol to produce the moving bust of Renoir. The story of this portrait is well known, thanks to Jean's account of it. The work was done during the summer of 1906 in Essoyes. "He was finishing a bust of my father. He worked on it in the studio while my father painted. He never asked Renoir to pose. He was so imbued with his subject that the likeness seemed to grow more and more apparent with every touch he put on his material. It was better than a physical resemblance: what he got into those few handfuls of clay was the very essence of Renoir's character. I was too young to understand then, but in later years my father often talked to me about this masterpiece."[11] And yet it was no easy task. "He was very ill, quite deformed, as the sculptor recalls in blunt terms. There was nothing there, apart from the nose . . . He did not have a mouth, only drooping lips. It was terrible."[12] On September 12, 1906, Renoir reassured Vollard: "My bust is coming along splendidly."[13] Then, when Renoir advised Maillol to reinforce the clay with a new wire, the sculptor carried on regardless. He paid a high price . . . "One morning we were all awakened by a frightful outcry. Maillol was tearing around the garden like a lunatic. He kept repeating at the top of his voice: 'Renoir's fallen down! Renoir's fallen down!' The rusty old wire had given way; the bust he was working on had fallen, and a shapeless little mass of clay lay on the studio floor. After a few days Maillol summoned up enough courage to start the piece all

6. Baudot 1949, p. 112. According to Haesaerts 1947, p. 15 (citing Vollard), Jeanne Baudot took Renoir to visit Maillol at Marly-le-Roi. They found him carving a statue of Venus directly from the stone. This is hardly plausible, for at the time, Maillol was only executing modest statuettes in wood and did not know how to carve in stone. This episode seems inaccurate and must have taken place later. **7.** This fountain later went into the collection of Count Kessler. It is now in the Musée Maillol. **8.** Wertheimer 1953. For information on this fountain, see below. **9.** The first known bronze of the young girl crouching, purchased by Vollard, is now held in the National Gallery in Berlin. See also the two other "Vollard bronzes" at the Karl Ernst Osthaus Museum in Hagen and the Hirshhorn Museum and Sculpture Garden, Washington, DC. For the portrait, see exh. cat. Ottawa, Chicago, and Fort Worth 1997–98, no. 60, pp. 238–240 and notes pp. 331–333. **10.** J. Renoir 1962, p. 353. **11.** Ibid., p. 364. **12.** Frère 1956, p. 238. **13.** Paris, Musée du Louvre, Prints and Drawings department, "Autographes", I.24.

Pierre-Auguste Renoir
The Large Bathers
1884–87
Detail of Fig. 8, p. 39

Aristide Maillol
Study for the Monument to Paul Cézanne
1912
Photograph
Paris, Réunion des Musées Nationaux, Druet-Vizzavona estate

Fig. 65

Aristide Maillol
Pomona
1910
Photograph

Fig. 66

Aristide Maillol
Summer
1911
Photograph
Paris, Réunion des Musées Nationaux, Druet-Vizzavona estate

Fig. 67

Pierre-Auguste Renoir
Venus Victrix
1913–15
Bronze
Height: 72 1/2 in. (184 cm)
Paris, Musée des Beaux-Arts de la Ville de Paris, Petit Palais

Fig. 68

Aristide Maillol
Venus
1818–1928
Bronze
Height: 68 7/8 in. (175 cm)
Paris, Jardin des Tuileries

Fig. 69

over again, but judging from what Renoir and Vollard said, I gather he did not succeed in recapturing his first inspiration."[14] A more detached account of Maillol tempers that of Jean Renoir: "[when] the bust collapsed . . . he was very upset . . . He was distressed."[15]

The date of this bust is uncertain: it varies, depending on the author, between 1906, 1907, and 1908. Maillol told Frère that he made the bust of Renée Rivière the same year, which is always given as 1907. But the letter from Renoir to Vollard is definitely dated 1906. In another letter to Vollard, Maillol declares: "I am going to give the Renoir bust to Gaudard [sic]."[16] The recent discovery of this letter has allowed us to establish that the dealer entrusted the cast to the metal founder Florentin Godard in 1908, but did not pay Godard his 2,000 francs until October 15, 1911.[17] Thus the portrait of Vollard holding the Maillol statuette, painted by Renoir in 1908, is a response to this bust two years after the fact. It is only too bad that Renoir, in return, never painted the portrait of the sculptor himself.

Bathers and Washerwomen

The most common parallel drawn between the respective works of Renoir and Maillol is of a thematic and formal kind: they liked the same physical type in women. Commenting on Maillol's women and adopting his words, critics very soon developed the theme of the Banyuls woman, with generous curves and typically Mediterranean. This cliché began with the title given to Maillol's sculpture *The Mediterranean* of 1905. We find it in Catalan from the pen of Eugenio d'Ors, who eulogized the "*ben plentada*"—the "robust" woman—in a novel in 1912. It was popularized in the works and monographs on Maillol published by John Rewald from 1939 onward.

On closer examination, Maillol used quite different models: while some are sturdy, starting with his wife, Clotilde, whose body was initially young and firm and then marked by motherhood, others are really slim, like the young girl recommended by Kessler, who commissioned the relief of *Desire* (Paris, Musée d'Orsay). Even now, however, the "large women" of Maillol and Renoir remain associated with the same conventional opinions and are victims of the same lack of understanding.

The theme of female bathers is one of the standard conventions in painting at the turn of the century. Maillol was fond of them when he started out in the 1890s. Every time he was asked about this period in his life, the point at which he believed himself destined to be a painter, he acknowledged his debt to Gauguin and, to qualify his comment, added Renoir's name: "If I had continued to paint, I would have been influenced by Renoir. I produced small paintings that were like his."[18] While it is accurate to say that the bathers of Maillol's Nabi period derive from Gauguin's, they share with Renoir's a tendency to tilting, unbalanced positions. Renoir's *Large Bathers* **Fig. 8, p. 39**, now in Philadelphia, acted as a paradigm, as much for Gauguin as for Maillol, especially the bather on the left, who is tilting over, with her right arm and left leg suspended in mid-air. Numerous studies in terracotta, modeled by the sculptor for monuments—the *Monument to Cézanne* from 1912 **Fig. 65**, and *The River* for the *Monument to Henri Barbusse* from 1938—are based on this pursuit of imbalance that mocks the inviolable laws of sculpture. Another obsession shared by Renoir and Maillol was that of the bather as she enters the water, standing submerged only to mid-thigh. In Maillol's work, this motif is notoriously linked to a kind of primal scene: the vision he had at a very early age of his sister Marie bathing at Banyuls. The comparison is disconcerting between the right-hand figure in Philadelphia's *Large Bathers* and one of Maillol's three-quarter-length clay figures called *Adolescent Girl* (photographed in 1914 by Druet); the latter is seen standing on a kind of black pedestal upon which the artist has drawn the waves created as she enters the water. Rarely would the ambiguity between sculpture and painting in Maillol's work be as striking.

Though less widespread, the theme of *Washerwomen* is nevertheless common to Émile Bernard, Maurice Denis, Louis Valtat, and many others. Mindful of the simple poetry of these everyday scenes from the Roussillon of his birth, Maillol developed them

14. J. Renoir 1962, p. 346. Rivière 1921, p. 247, dates these sittings and this episode during the summer of 1908. **15.** Frère 1956, pp. 237–238. **16.** Paris, Musée d'Orsay, Archives Vollard, MS 421 (2,2), fol. 176. It refers to the metal founder Florentin Godard. **17.** Vollard archives still in private hands. **18.** Frère 1956, p. 221. Zutter 1996, ill. p. 25 and 26. Haesaerts wanted to interview Maillol about his connections to Renoir, but the war made it impossible. He would have had to cross through Occupied France to meet him in Banyuls in the Free Zone.

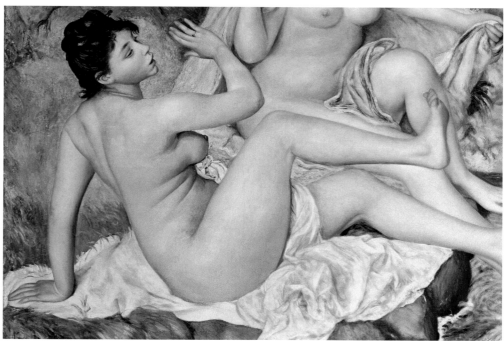

Detail of Fig. 8, p. 39

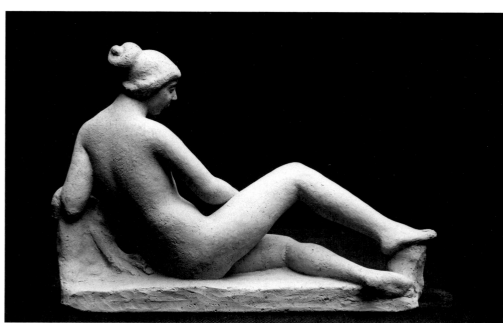

Fig. 65

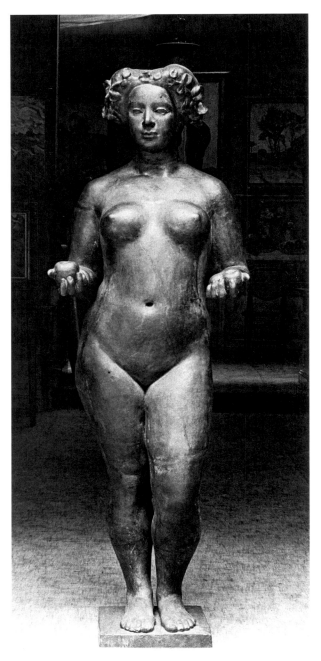

Fig. 66

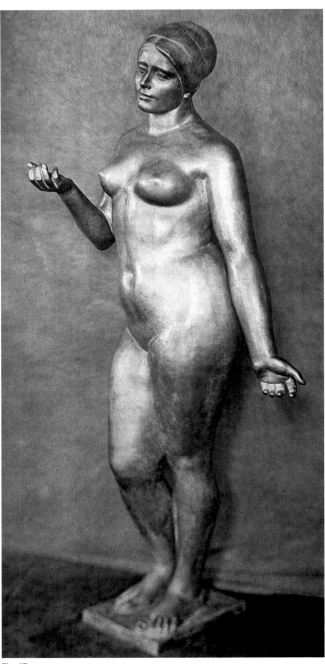

Fig. 67

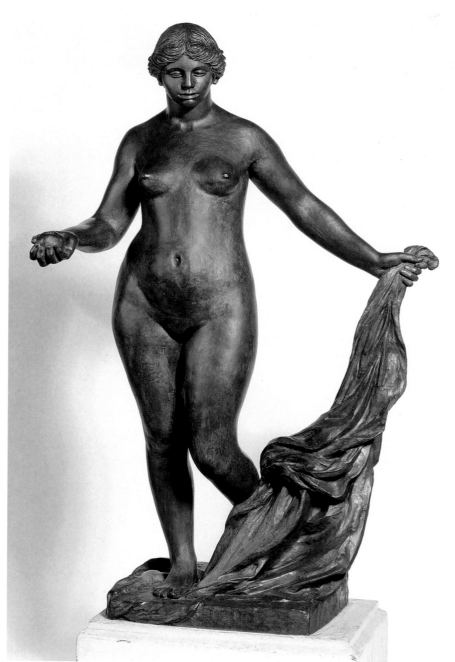

Fig. 68

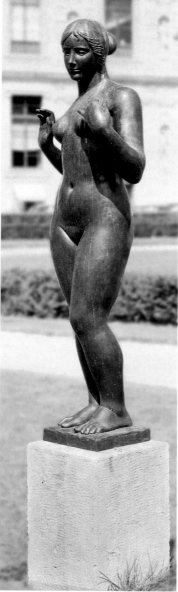

Fig. 69

Fig. 70

after 1895 in painting (Paris, Musée Maillol), engraving (a zincographic work in Frankfurt, Städel Museum and Municipal Gallery), and sculpture (door knocker in bronze, Musée Maillol). Renoir, too, dealt with this theme in *The Washerwomen* **Cat. 58**. He probably knew the works of Maillol; the fact that he, too, transposed the theme from painting to sculpture, with the help of Guino, supports this thesis **Cat. 94**.

In 1936 the trip to Italy marked a turning point for Maillol, who returned to painting and continued to draw without linking it directly to his work as a sculptor. He made use of a variety of drawing media, such as red chalk enhanced with a little white, or charcoal. There continued to be monumental nudes **Cat. 125, p. 413**.

Dina Vierny, a young model with a full figure who radiated exuberant energy, inspired him to create a series of paintings and drawings of impressive nudes who are like so many robust bathers carved into landscapes. He wrote this sentence to Dina, declaring his debt to Renoir: "Miss Vierny, I have been told that you resemble a Maillol or a Renoir; I would settle for a Renoir."[19] The kinship of these late nudes to Renoir's bathers stems without doubt from the flourishing canon of femininity, the deliberately complicated poses, the obligatory accessory of the white sheet contrasting with the matt skin, but especially from the tension between contour and relief, and the tight framing that allows the body to fill the whole picture space at the expense of the natural landscape. The draftsmanship is precise, however, and the palette realistic, in direct opposition to the free touch and arbitrary color of late Renoir. Maillol's explorations of the bather subject, that is, of "the relationship between the body and the landscape,"[20] thus echo the investigations Renoir pursued until his death, more than thirty years before.

A Mixture of Influences

Maillol is said to have given the following advice to the young sculptor, Louis Morel:[21] "Look at Renoir's nudes: that's sculpture. You need look no farther." Even so, he always denied that Renoir had influenced him in his work as a sculptor. He even reversed the direction of influence, from the younger to the older man. When Henri Frère asked him around 1939 about John Rewald's monograph, which was about to be published, he was told: "I made him correct some things . . . he said that it was seeing Renoir's sculptures that gave me the idea for my art, when in fact Renoir took the notion to make sculptures when he saw me working. When Renoir began to work in sculpture, half of my works had already been completed. Renoir was really interested in watching me make his bust. He would say to me: 'It becomes more alive with each stroke you apply.'"[22] So Rewald corrected his work, repeating the claim that Maillol was not essentially influenced by anyone, "[t]hough he copied Puvis de Chavannes and admired Gauguin, though he loved the work of Polycletus and was impressed by Renoir's magnificent sculptures, he only got to know these long after he had begun to work himself and drew inspiration solely from his own observations, from his wide knowledge, and from his material."[23] This alleged *tabula rasa* has now been seriously challenged, as the references that inspired his art have been disclosed.

In this case the link between the sculptures of Maillol, Guino, and Renoir is a tightly woven web. Their influence on each other was constant, mutual, and often came full circle. To begin with, Renoir became interested in Maillol's decorative works. His purchase of the indoor fountain at the Galerie Vollard in 1902 is revealing **Fig. 70**. It is hardly surprising that this former porcelain painter from Limoges set his heart on a ceramic. Above all, he is bound to have been struck by the nudes embellishing this fountain, especially at the bottom of the small bowl: three bathers in the center and one in each corner. Another decorative object designed by Maillol was the clock *The Two Sisters*, which Renoir had also seen at Vollard's in 1902. It must have served as a reference when Guino and Renoir in turn devised a clock in 1914 **Cat. 91**.

More than any other work, *Venus Victrix* **Cat. 70** reveals the depth of Renoir's influence. The part played by Guino was crucial: he followed Maillol's course at the Académie Ranson; he helped him to execute some sculptures; and he had a thorough knowledge of his work. When he and Renoir created a statuette, and then the statue, of Venus in the *Judgment of Paris*, they were responding to Maillol's *Pomona* **Fig. 66** exhibited at

Aristide Maillol
Fountain-washbasin in glazed clay
Before 1902
Purchased by Renoir in 1902, then by Count Harry Kessler; today in Paris, Fondation Dina-Vierny—Musée Maillol Paris, Réunion des Musées Nationaux, Druet-Vizzavona estate

Fig. 70

19. Dina Vierny Archives. 20. Haesaerts, cited in Lorquin 2001, p. 36. 21. See my essay on Renoir as sculptor in this volume. 22. Frère 1956, p. 78. 23. Rewald 1939, p. 8. The historian confuses Polycletus with Praxiteles.

Aristide Maillol
The Two Sisters (Clock)
Before 1902
Paris, Réunion des Musées
Nationaux, Druet-Vizzavona
estate

Fig. 71

the 1910 Salon d'Automne, and to *Summer* of 1911 **Fig. 67** which is derived from it. The position of the arms of *Venus* reworks the arm position in *Summer,* reversed from right to left. Did they thus adopt the suggestion of Meier-Graefe, an admirer of both Renoir and Maillol, who in 1912 observed about a bather painted by Renoir that she "would have made a superb Venus in stone"?[24] Maillol may have come across the *Venus* **Fig. 68** in 1916 at the Triennale, the "French art fair in aid of the Fraternité des Artistes" which took place at the Jeu de Paume from March 2 to April 15, 1916. In 1918 Maillol responded with a large figure he called *Venus* **Fig. 69**, which he was not to show until 1928 at the Salon d'Automne. This Venus does not hold an apple, but is instead raising her hands up to her throat to toy with her necklace. With this change the sculptor abandoned the iconography of the *Judgment of Paris*; he would return to it in 1930 with a *Nymph*, who would soon have two companions and go on to form the famous group of the *Three Graces,* completed in 1938.[25]

So although Maillol may have minimized Renoir's influence, his work—as much in painting and drawing as in sculpture—seems permeated by it. His art could not have evolved in the way it did without the research undertaken by Renoir in the previous generation. Maillol's last years show clear similarities with Renoir's old age in Cagnes: war had broken out once more and the South of France became the sole refuge far from the fighting that raged in the north. Each of them escaped the murderous madness of mankind, withdrawing into the solitude of creation.

24. Meier-Graefe 1911, p. 118. **25.** These sculptures were brought together in the Musée Maillol and Jardin des Tuileries in Paris.

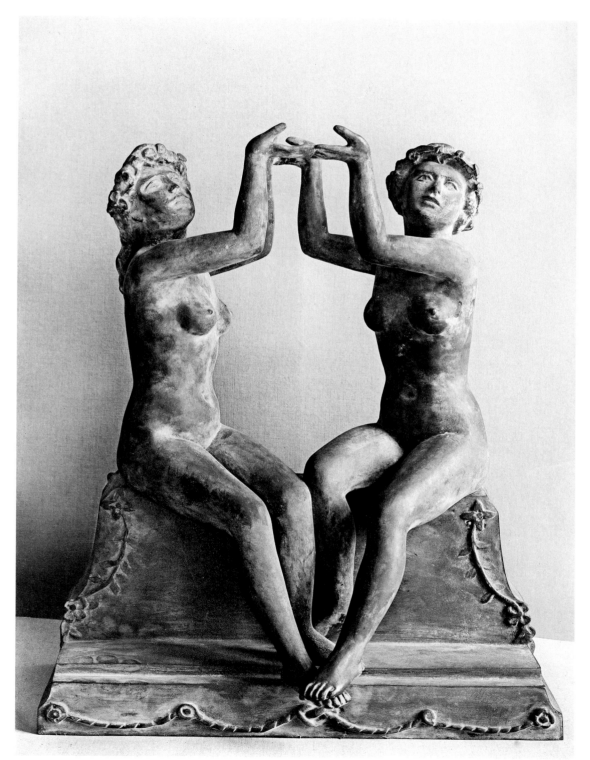

Fig. 71

Catalogue of Exhibited Works

Notice

This catalogue of exhibited works brings together the paintings, drawings, and sculptures Renoir produced between the early 1890s and his death in 1919. There are no text entries for *Dance in the Country* or *Dance in the City,* as both predate this period. Renoir's works are arranged approximately chronologically and according to the technique used (paintings, drawings, sculptures), with the exception of:
– *The Judgment of Paris* **Cat. 65**, where the sculptures and drawings derived from this work are considered within one joint entry;
– *Dancers with Tambourine I and II* and *Flute Player* **Cat. 96–98**, where the preparatory drawing **Cat. 95** for the relief of *Dancer with Tambourine* is included in the same entry.

Unless otherwise indicated, the works are exhibited in Paris, Los Angeles, and Philadelphia in the context of the present exhibition.

Titles of works
Wherever possible, the French titles given by the authors are those used in exhibitions and publications during the artist's lifetime. However, the titles of Renoir's works are often generic and were not necessarily chosen by him. In the absence of a catalogue raisonné for the period under consideration, the titles used are thus those attributed by the museums that hold them or by recent scholarly publications.

Date
At the current state of research, it remains difficult to date Renoir's paintings precisely if he did not date them himself, or where relevant documents or archival materials are lacking. Tentative dates have therefore been suggested for certain works:
Circa 1898: the exact date is uncertain.
1898?: the date is assumed.
1890–95: the work was executed between 1890 and 1895.

Dimensions
The dimensions are given in both inches and centimeters, with the height followed by the width and depth (the latter referring to sculptures).

Signatures, dates, and inscriptions
The signature, date, and other inscriptions are given.
Where this information does not appear, it is because the work is not signed or dated or does not carry any inscriptions.

Location and provenance
Information on how an institution acquired a work may be given after its location; further details of a work's provenance may be contained in the text entry, if it was deemed significant by the author.

Exhibitions and bibliography
These sections are selective. Particular attention has been given to exhibitions and publications during the artist's lifetime and to those between his death in 1919 and the 1940s.

Where works appear in the 1918a Vollard catalogue (or its 1989 reissue) or in the 1931 Bernheim-Jeune catalogue, this has been systematically indicated.
Major exhibitions, catalogues, and recent studies that, especially since the London, Paris, and Boston exhibition of 1985–86, have greatly enriched our knowledge of the artist, have been systematically consulted.

References in the text entries are abbreviated in the same way as in the rest of the catalogue. A complete reference list can be found in the bibliography at the end of this volume.

List of abbreviations
Cat.: Works included in the exhibition (with rare exceptions), for which an entry is provided with full reference information and, in most cases, a brief article.
Fig.: Works included in the catalogue for illustrative purposes.

Catalogue entries by:
F. and P.-L. D.-R.: Flavie and Paul-Louis Durand-Ruel
C. E.: Claudia Einecke
I. G.: Isabelle Gaëtan
E. H.: Emmanuelle Héran
V. J.: Virginie Journiac
M. L.: Martha Lucy
J. P. M.: J. Patrice Marandel
M. N.: Monique Nonne
S. P.: Sylvie Patry
J. A. T.: Jennifer A. Thompson
É. V.: Élodie Voillot

Cat. 1

Dance in the Country (Danse à la campagne)
1883
Oil on canvas
70⅞ x 35½ in. (180 x 90 cm)
Signed and dated bottom left: *Renoir 83*
Paris, Musée d'Orsay, acquired in 1979
RF 1979-64

Exhibited in Paris.

Cat. 2

Dance in the City (Danse à la ville)
1883
Oil on canvas
70⅞ x 35½ in. (180 x 90 cm)
Signed and dated bottom right: *Renoir 83*
Paris, Musée d'Orsay, acquired by gift in lieu of inheritance taxes in 1978
RF 1978-13

Exhibited in Paris.

These two works are illustrated on page 133.

Cat. 3

Young Girls at the Piano
(Jeunes filles au piano)

1892
Oil on canvas
45⅝ x 35½ in. (116 x 90 cm)
Signed bottom right: *renoir*
Paris, Musée d'Orsay, acquired from the artist by the state, 1892
RF 755

EXHIBITIONS
Paris 1892 (not in catalogue); London, Paris, and Boston 1985–86, no. 91 (no. 89 in French ed.); Paris 1993, no. 82; Taipei 1997, p. 139; Nancy 2006, no. 61.

BIBLIOGRAPHY
Alexandre 1892, pp. 30–31; *L'Éclair* 1892; Marx 1892; Bénédite 1896, no. 215; Mauclair 1902, pp. 222–223; Meier-Graefe 1904, p. 202; Meier-Graefe 1908, vol. 1, pp. 294–295; Meier-Graefe 1911, pp. 150, 152–153; Alexandre 1920, p. 6; Jamot 1923, p. 342; Fosca 1924, pp. 39–40; Meier-Graefe 1929, pp. 250–255; Barnes and De Mazia 1935, pp. 418–420, no. 203; Jeanès 1946, p. 30; Natanson 1948, p. 27; Lhote 1950, pp. 126–127; Pach 1950, p. 98; Gimpel 1966, p. 155; Daulte 1973, pp. 56–57; Mallarmé 1981, vol. 5, pp. 61–78, 149, 175; Gaunt 1982, no. 42; Hoog and Guicharnaud 1984, pp. 188–191; Gimpel 1987, p. 155; Dufour 1992; Kostenevich 1995, pp. 112–115; Eyerman 2002; Dauberville 2009, no. 993.

In late 1892, Renoir had the satisfaction of seeing his painting *Young Girls at the Piano* hanging from the picture rails of the Musée du Luxembourg in Paris. A propitious series of connected events had led to its acquisition by the French state. Henry Roujon, the politician, writer, and friend of Stéphane Mallarmé (a close associate of the Impressionists) had been appointed director of the Beaux-Arts on October 20, 1891. A short time later, following the death of Étienne Arago, his erstwhile assistant Léonce Bénédite became the curator of the Musée du Luxembourg, which was dedicated to the works of living artists recognized by the Beaux-Arts administration. Then, Roger Marx, a critic and Beaux-Arts functionary, joined forces with Mallarmé to organize a visit by Roujon to the studios of Monet and Renoir. The aim was to select a work for the Musée du Luxembourg, where the Impressionists were not represented. Reluctantly, Monet received the delegation in May, but there was no follow-up. With Renoir, it was quite the opposite; as soon as he was alerted, Renoir conceived a picture worthy of representing him in a museum: a large format with a modern subject—young girls at a piano in a bourgeois interior. Given the administration's procrastinations, he had time to paint two large sketches (Paris, Musée de l'Orangerie, and St. Petersburg, the State Hermitage Museum) as well as four final versions (private collections and New York, Metropolitan Museum of Art). He also did a large pastel (private collection). On April 4, Mallarmé wrote to Marx, his "dear accomplice," that he had not been able to arrange a new meeting with Roujon, and that "Renoir has benefited in this respect by redoing the same picture."[1] All of them were hoping, however, that the purchase would take place before the Renoir exhibition due to open at the Galerie Durand-Ruel in May. On April 15 the visit was imminent[2] and on April 25, Roujon gave instructions for the transfer of 4,000 francs to Renoir in payment for his painting.[3]

Renoir planned to "place [his] picture to see how it looks" among his other works presented at the Galerie Durand-Ruel, but he was worried about Roger Marx's reaction, and wanted to get permission from Roujon.[4] The director gave the go-ahead but Roger Marx was unhappy.[5] He asked the critic Théodore Duret to intercede with Renoir to make him withdraw his picture, fearing a reaction from those opposed to Impressionism.[6] The picture— "one of his perfect ones" to use Mallarmé's expression—was shown "separately and on an easel in a special room."[7] An article published in *L'Éclair* observed that it was so discreetly installed that many people did not see it at all, which explains why the newspapers gave no description of it. The still wet canvas would "mature" in time, and the author congratulated Roujon on his choice.[8]

However, when Bénédite presented the painting to the Musées Nationaux's advisory board—which included curators from dif-

ferent departments in the national museums—at its meeting on July 27, the problems began.[9] The Renoir had "created such an impression that I purely [and] simply withdrew my proposal" so that a negative response would not be recorded in the minutes, he explained to Roger Marx. Having been warned, Roujon feared that a fierce reaction would damage the other Impressionists and asked Marx and Bénédite to jointly approach Renoir and ask him to exchange *Young Girls at the Piano* for another picture "in a style more acceptable to the public," even if the price was higher.[10]

Among the canvases approved by the board members was John Singer Sargent's *La Carmencita* (Paris, Musée d'Orsay), freely executed but which stands out in high relief against a dark background: it did not meet with any objection. In Renoir's case by contrast, the colors (almost solid in terms of design) blend into each other in subtle transitions, and it was this decorative appearance that was disconcerting.

In the end the director of the Beaux-Arts mandated that Renoir's canvas be accepted. It was put into storage because the Musée du Luxembourg was to be reorganized in the fall by the new curator. It returned at the end of November and, in an article that

appeared on December 5, 1892, Roger Marx highlighted the presentation of works acquired in the previous few months for "the museum of contemporary art."[11] Very soon the merits of each of the finished versions were discussed, as they still are to this day. The 1985 retrospective presented three canvases and made a historic and aesthetic point in this matter. The fact remains that this painting marked the beginning of the Impressionists' entry into the museums, if one discounts the purchase by the state of a Sisley landscape four years earlier, a picture that was immediately deposited in the Agen museum.

M. N.

1. Mallarmé 1981, vol. 5, p. 62. **2.** Ibid., p. 68. **3.** Paris, Archives Nationales, F/21/2147. **4.** Letter from Renoir to Mallarmé, Monday [May 2?], sales cat. Librairie de l'Abbaye, Paris, 1980, no. 252. **5.** Letter from Renoir to Marx, May 6, Paris, library of the Institut National d'Histoire de l'Art, original manuscripts, box 117. **6.** Letter from Marx to Duret, library of the Institut National d'Histoire de l'Art, original manuscripts, box 115. **7.** Letter from Mallarmé to Roujon, [May 12], Mallarmé 1981, vol. 5, p. 77. **8.** *L'Éclair* 1892. **9.** Paris, Archives des Musées Nationaux, *1BB30. **10.** Letter from Bénédite to Marx, September 15, 1892, library of the Institut National d'Histoire de l'Art, original manuscripts, box 112. **11.** Marx 1892b.

Fig. 72

Fig. 73

Fig. 74

Henry Roujon (1853–1914)
Director of the Beaux-Arts
from 1891 to 1914
Engraving
Figures contemporaines from
Album Mariani, vol. 6, Paris,
Librairie Henri Floury, 1901

Fig. 72

Pierre-Auguste Renoir
Stéphane Mallarmé
(1852–1898)
1892
Oil on canvas
19³/₄ x 15³/₄ in. (50 × 40 cm)
Versailles, Musée National
des Châteaux de Versailles et
de Trianon

Fig. 73

Eugène Carrière (1849–1906)
Roger Marx (1859–1913)
1886
Oil on canvas
17³/₄ x 15¹/₈ in. (45 × 38.5 cm)
Paris, Musée d'Orsay

Fig. 74

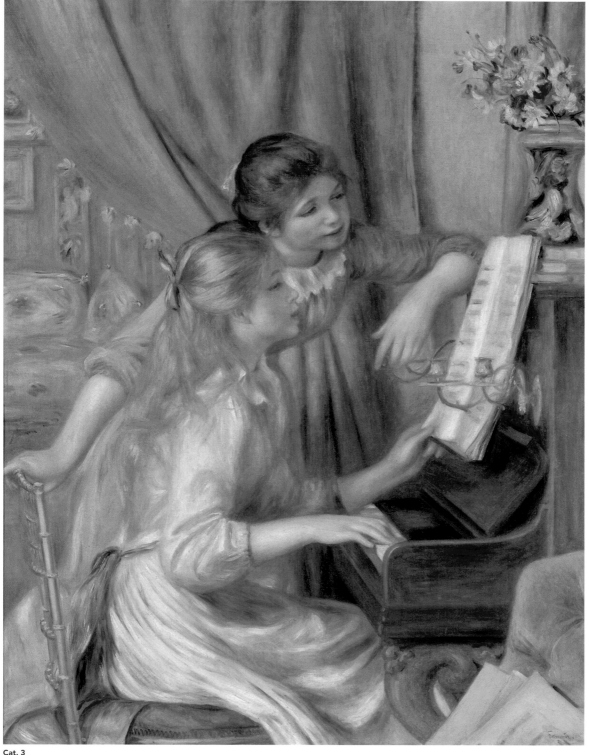

Cat. 3

Two Girls Reading (Jeunes filles lisant)

Circa 1890–91
Oil on canvas
22¼ x 19 in. (56.5 x 48.3 cm)
Signed bottom right: *Renoir*
Los Angeles, Los Angeles County Museum of Art, Frances and Armand
Hammer Purchase Fund, 1968
M.68.46.1

EXHIBITIONS
Zurich 1933; Haarlem 1936; Baltimore 1939; New York 1958, no. 53; New York
1959, no. 5; 1959–67, long-term loan, The Metropolitan Museum of Art, New
York; New York 1969, no. 77; Memphis 1969, no. 44; *Masterpieces from the
Armand Hammer Collection,* worldwide tour, 1969–82; Los Angeles 1991 (not
in catalogue); Tokyo, Kyoto, and Kasama 1993; Columbus 2005–06, no. 32.

BIBLIOGRAPHY
Baltimore Museum of Art Quarterly 1939, p. 8; Goldwater 1958, pp. 60;
Pictures on Exhibit 1958, p. 9; *Los Angeles County Museum of Art Annual
Report* 1968–69, p. 18; Werner 1969, p. 40; *Gazette des beaux-arts* 1970, p. 87;
Young 1972, pp. 447, 452; *The Armand Hammer Collection* 1975, no. 19;
The Armand Hammer Collection 1982, p. 82; *The Armand Hammer Collection*
1985, pp. 132, 239; Los Angeles County Museum of Art 1987, p. 84.

Young Girls Looking at an Album (Jeunes filles regardant un album)

Circa 1892
Oil on canvas
32 x 25⅜ in. (81.3 x 64.3 cm)
Signed bottom right: *Renoir*
Richmond, The Virginia Museum of Fine Art, The Adolph D. and
Wilkins C. Williams Museum Fund. Acquired 1953
53.7

EXHIBITIONS
Norfolk and Staunton 1958; Richmond 1958; New York 1969, no. 74; New York
1972; Chicago 1973, no. 61; Richmond 1978; Roanoke 1978; Roslyn Harbor
1984, no. 68; Montpellier and Grenoble 2007–08, pp. 116–117.

BIBLIOGRAPHY
Meier-Graefe 1911, p. 195, fig. 26; Meier-Graefe 1929, p. 317, fig. 268;
Florisoone 1937, p. 75; *Richmond Times-Dispatch* 1958, Section C, p. 13;
Virginia Museum of Fine Arts 1966, no. 73, p. 49; Daulte 1971, p. 80, no. 1891;
Near 1974, p. 108; Cruger 1990, p. 21, fig. 23; Dauberville 2009, no. 1010.

By 1890, through his association with the dealer Paul Durand-Ruel, Renoir was building a broadening market for his work. In fact, perhaps a little tired of having to please his buyers, he would report to Berthe Morisot—with noticeable irony—that he was once again working on a "genre painting (the kind that sells)."[1] Among his bestsellers at the time were pictures of pairs of young girls engaged in a shared activity. Playing the piano, picking flowers in a meadow, and reading were the most frequent themes, which Renoir developed in numerous variations and versions. Typically in such pictures, as in *Two Girls Reading* and *Young Girls Looking at an Album,* the young models are absorbed in their activity and seem to be unaware of being observed. In some cases, the themes and compositions evoke seventeenth-century Dutch and eighteenth-century French genre paintings; however, such historical associations are submerged by Renoir's emphasis on the modernity of the subject, signaled by the girls' everyday modern dresses, hairstyles, and prominent hats.

Renoir was much taken by hats and liked to explore their pictorial possibilities. Suzanne Valadon, who posed for Renoir in the 1870s, recalled that he would ask models to bring hats to sittings, or else have hats made for them;[2] at times he even seems to have fashioned them himself, as Julie Manet reported: "He showed us the portrait of a model with a ravishing hat of white chiffon with a rose on it (which he had made himself) and wearing a white dress with a green belt."[3] Favorites, such as the ribbon- and flower-trimmed straw boater and white lace cap in the present pictures, featured repeatedly. In paintings of the 1890s, hats are often given such prominence that they seem to be Renoir's primary subject, sometimes, as in *Two Girls Reading,* literally overshadowing the models who wear them. While Renoir took obvious pleasure in painting frothy lace and fluttering ribbons, Durand-Ruel discovered that his more elaborate and outlandish hats could be a commercial liability: they fell too quickly out of fashion and made some pictures difficult to sell. He felt compelled to ask Renoir to stop painting them.[4]

Two Girls Reading and *Young Girls Looking at an Album* illustrate Renoir's frequent practice of reworking a theme or motif in a series of variations connected by recurring elements—in this case the pair of hats, the theme of reading, and the two models. The girls are not individualized, as they would be in a portrait, and their closeness registers on a formal level rather than in terms of a psychological relationship. In the Los Angeles picture, the pictorial space is compressed, essentially blocked out by the two bodies turned at right angles to each other and close to the picture plane. In the Richmond picture the composition is more open: the structural tension between the geometric grid formed by shutters and album covers on the one hand, and the gentle arabesques that describe the girls' bodies on the other, gives the picture a taut lightness that seems to anticipate Matisse.

Although the two girls in these paintings may seem generic, they were favorite models of the artist who posed for him on numerous occasions, for example for *Young Girls at the Piano* **Cat. 3**. The girls' identity has been the subject of much speculation. One theory—that they were the daughters of Renoir's friend and patron Henri Lerolle—is contradicted by Renoir's later portraits of the two dark-haired sisters, who do not resemble the younger girls, even allowing for aging **Cat. 15, 16, & 17**. Similarly, Jean Renoir, the painter's son, rejected the idea that the dark-haired girl in the Los Angeles picture might be Julie Manet, whom Jean had known as a child and who also appears in several portraits by Renoir. The most plausible identification seems to be that attached to *Young Girls Looking at an Album* in a 1969 exhibition—that the girls were the daughters of the novelist and journalist Paul Alexis, the Renoir family's neighbor in Paris in the early 1890s.[5]

C. E.

1. Letter from Renoir to Berthe Morisot, fall 1891, in Morisot 1987, p. 186. **2.** Quoted in Coquiot 1925, p. 98. **3.** Manet 1987, p. 72, entry for November 17, 1895. **4.** Cf. Baudot 1949, p. 15. **5.** Exh. cat. New York 1969, no. 74.

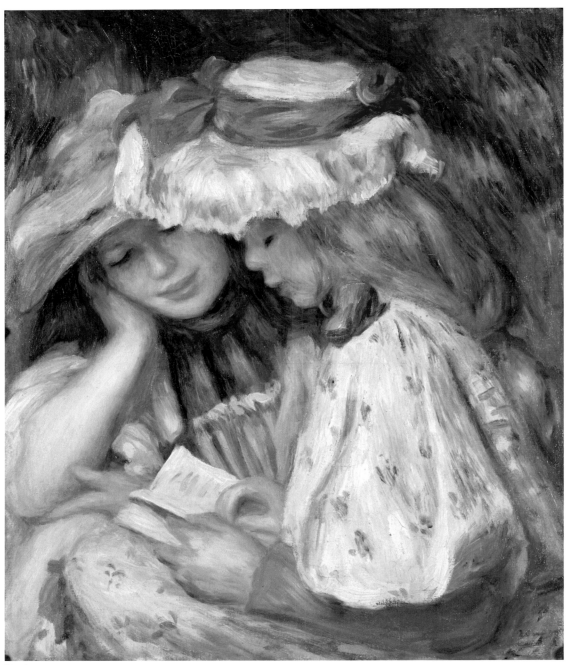

Cat. 4

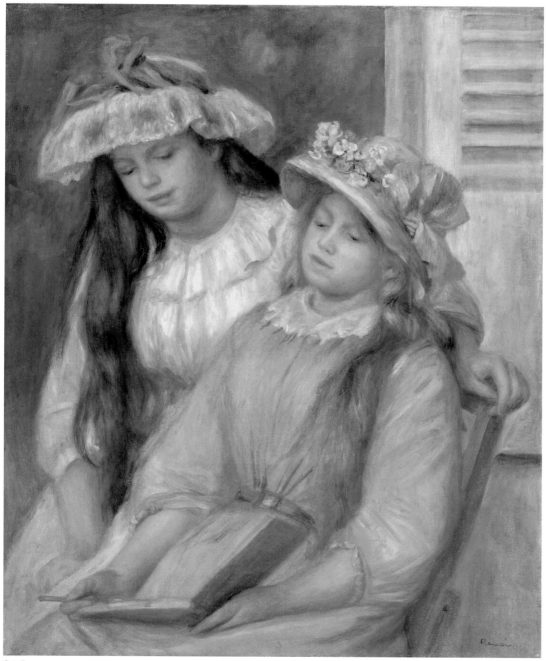

Cat. 5

Cat. 6

Girl with a Basket of Fish
(La Marchande de poissons)

1890–1891
Oil on canvas
51⁷⁄₁₆ x 16⁷⁄₁₆ in. (130.7 x 41.8 cm)
Signed bottom right: *Renoir*
Washington, DC, National Gallery of Art, Gift of William Robertson Coe, 1956
1956.4.1

Cat. 7

Girl with a Basket of Oranges
(La Marchande d'oranges)

1890–1891
Oil on canvas
50¹¹⁄₁₆ x 16⁷⁄₁₆ in. (128.8 x 41.8 cm)
Signed bottom right: *Renoir*
Washington, DC, National Gallery of Art, Gift of William Robertson Coe, 1956
1956.4.2

EXHIBITIONS FOR CAT. 6 & 7
Paris 1917 (not in catalogue) (Paris, Musée d'Orsay documentation, Rosenberg collection, pl. 598); New York 1921–22, nos. 16 and 25 (?); Paris, Orangerie, 1933, nos. 90 and 91; New York 1937, nos. 17 and 18; Rome 2008, nos. 27 and 28.

BIBLIOGRAPHY FOR CAT. 6 & 7
Comstock 1962, p. 65; Daulte 1971, nos. 567 and 568; Dauberville 2009, nos. 113 and 114.

These two pictures make up a decorative pair, painted for the salon doors of Paul Durand-Ruel's apartment at 35, rue de Rome in Paris. They were the first decorations that the dealer requested from one of his favorite painters. Aware of the decorative value of Impressionist painting, the dealer had actually approached Claude Monet for work between 1882 and 1885, who had executed a lovely series of fruit and flowers for the five doors in the dining room of the same apartment.[1]

Probably using the same model who is found elsewhere in his work (for example, *Woman Reading a Letter*, Paris, Musée de l'Orangerie) and whom he painted twice here, Renoir presents, as he liked to do, a pair based on a play of oppositions. Facing each other, the two young women suggest a series of contrasts: produce of the sea and fruits of the earth; one dark and one fair-haired; warm and cool colors; short, simple clothes set against an elaborate, full-length costume; the shores of the North (Normandy) and the South. While not serving as allegorical figures, they nonetheless celebrate the fertility of nature. The two Renoir paintings derive from the evocation of "trades," a traditional genre which Renoir liked to approach by way of, for instance, washerwomen. They also reflect the language of the picturesque (as shown by the orange seller's garments), which Renoir had been aware of while traveling in Algeria and Italy. He certainly did not create a realistic description of a peasant society, even though he painted his panels in La Rochelle and probably in Tamaris in the Var region.

In June 1890 he actually "get[s] down to your panels straight away to get them finished. I will do them in three, maybe four, installments and you will have them all by autumn," he wrote to Durand-Ruel.[2] Renoir took longer in fact, asking his sponsor "to be good enough to wait until the panels are dry. When I return, the next ones will be much better. I am infused with sunshine, and some of it will be left in my vision for the other panels."[3] Like this letter, the following exchanges lead us to assume that Renoir's first consignment was different from the present panels: "Do not be concerned about the decoration I have given you. I shall do

better from now on, and the nudes are only provisional. My plan is to make the people fully clothed! It was only to see roughly how it might look that I asked you to hang this door."[4] A few weeks later, still from Tamaris, Renoir again has doubts: "Tell me if the decorations work well or not, apart from the bottom one which I will redo with clothes on. I will make the others lighter. They must be a bit dark for the room."[5]

The vivid, sometimes acid, colors (very similar to those in *Young Girls at the Piano* **Cat. 3**) make the two "market girl" panels stand out in fact. This way, Renoir gave his sponsor what he wanted, as he was encouraging him to get rid of "once and for all, the gray which has haunted you for a while," adding "never be in a gloomy mood."[6] Renoir was also applying his idea of decoration, which was based on color: "The painted work in decoration is only of any use if it is polychrome; the more the harmony of tones is varied, the more decorative a painting will be," he wrote in 1877 in *L'Impressionniste*.[7] As much as the red and white contrast of the fisherwoman is typical of Renoir—to the extent that his son Jean later adopted it for the character of Nénette in *Le Déjeuner sur l'herbe*[8]—the combinations in the *Girl with a Basket of Oranges* are rather unexpected, especially if one considers the juxtapositions and variety of pure (and sometimes harsh) color in the long strokes of the skirt. Renoir also wanted the landscapes to be particularly sunny, the result of months of working in the open air which made him "make more progress than a year in the studio."[9] The figures, however, are not captured in an outdoor setting; the landscape is like a set in a theater or photographer's studio. Renoir has opted definitively for fantasy, a tribute to the figures he so admired by Camille Corot and Jean-Honoré Fragonard.

The panels, bought for 500 francs on April 19, 1891,[10] must have been installed during 1891, or even 1892 or 1893. When Lecomte edited his book on the Durand-Ruel collection, he described the "dining room [which] will soon be adorned with a decoration painted by Monsieur Renoir"[11] and recalls "Renoir's floral design" for the doors of the small salon on the occasion of a dinner which would have been in 1893.[12] The "market girl" panels were sold to Eugène Hirsh in 1909, then on to Bernheim-Jeune; they then came back to Durand-Ruel, only to be sold to the dealer Paul Rosenberg in 1917. In the meantime, Renoir had executed another version of this pair, now in the Barnes Foundation. Both versions, which have never been shown in France (except for the Washington pair, shown once in 1917 at the Rosenberg gallery), managed to arouse the interest of ardent connoisseurs of Renoir.

S. P.

1. Wildenstein 1996, nos. 919 to 954. **2.** *Correspondance Renoir-Durand-Ruel* 1995, vol. 1, p. 68. **3.** Letter from Renoir to Paul Durand-Ruel, Tamaris, [around February 7/8, 1891], ibid, p. 69. **4.** Letter from Renoir to Paul Durand-Ruel, Tamaris, [February 22, 1891], ibid, p. 70. **5.** Letter from Renoir to Paul Durand-Ruel, March 5, 1891, ibid, p. 71. **6.** Letter from Paul Durand-Ruel to Renoir, Paris, August 31, 1892, ibid., p. 82. **7.** Quoted in Herbert 2000, p. 196. **8.** Catherine Rouvel, quoted in exh. cat. Paris 2005–06, p. 182. **9.** Letter from Renoir to Paul Durand-Ruel, Tamaris, March 25, 1891, *Correspondance Renoir-Durand-Ruel* 1995, vol. 1, p. 75. **10.** Daulte 1971. **11.** Lecomte 1892, p. 199. **12.** Lecomte 1943.

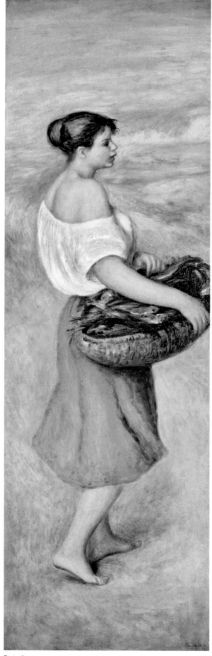

Cat. 6

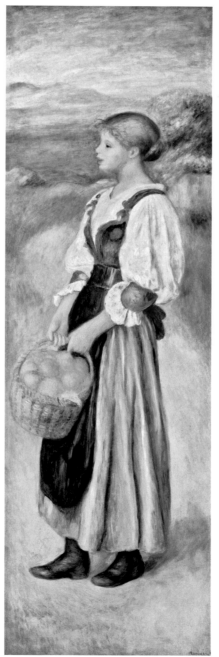

Cat. 7

Cat. 8

Bather Sitting on a Rock (Baigneuse)

1892
Oil on canvas
31¹/₂ x 25¹/₄ in. (80.5 x 64.5 cm)
Signed and dated bottom right: *Renoir. 92*
Paris, Private collection

EXHIBITIONS
Paris 1932, Durand-Ruel, no. 44; Paris, Orangerie, 1933, no. 94; New York 1935, no. 14; Paris 1958, no. 34; Munich 1958, p. 39, no. 28; Paris 1969, no. 30; Hamburg 1970–71, no. 42; Trent, Italy, 1982, fig. 14; London, Paris, and Boston 1985–86, no. 88 (no. 86 in French ed.).

BIBLIOGRAPHY
Duthuit 1923, p. 59; Régnier 1923, pl. 21; André 1923, pl. 21; Coquiot 1925, p. 120; Barnes and De Mazia 1935, p. 418, no. 199; *Art News* 1935, p. 15; Berr de Turique 1953, pl. 66; Rouart 1954, p. 75; Bünemann [1959], p. 105; Daulte 1971, no. 1106; Daulte 1974, p. 55, no. 4; Gaunt 1982, no. 41; Fezzi 1985, p. 115, no. 632; Dauberville 2009, no. 1319.

Following the polemic aroused by the exhibition of *The Large Bathers* **Fig. 8, p. 39** at the Georges Petit gallery in 1887, Renoir returned to this subject, his subject of choice in the early 1890s, but favoring the isolated figure over the group composition and adopting a new approach.

Here he shows a young girl in a landscape, her body and gaze turned toward the left. She is seated on a white sheet, her long, blonde hair tousled. *Bather Sitting on a Rock* is constructed on shades of yellow and pink, found both in the flesh tints and in the landscape. Renoir continues to work the values of his background in harmony with those of his figure's flesh and hair. Although this harmony of tones tends to unify the various elements, the composition conveys an impression of collage, of the figure being superimposed on a "photographic" background, to quote the term used by Claude Monet.[1] This incoherency had already attracted criticism in relation to the *Large Bathers* of 1884–87. The lack of spatial relationship between content and form in this painting may perhaps again be explained by the technique Renoir employs. This is not, as the Impressionist open-air tradition would wish, a nude painted outdoors from life, but, according to Renoir, one of his "outdoor pictures [painted] in the studio."[2] This appears to be confirmed by the fact that Renoir did not spend any time on the coast during the year preceding the sale of this painting to Durand-Ruel in June 1892. The method he uses fits perfectly with his wish at this time to relocate the (female) figure at the center of his art in the tradition of European figurative painting: "all the interest is focused on the figure; the landscape serves merely as an accompaniment . . . the landscape remains imprecise, so that all the attention is focused on the body, not only on its form, but on its flesh tones, because what matters is the radiance of the flesh in its living splendor."[3] Renoir took a strict, hierarchical approach to the elements of his composition: nude before landscape. Moreover, he wished to confirm the natural quality specific to feminine nudity. And yet, as Tamar Garb has pointed out, there is nothing natural about painting a nude woman in the open air.[4] In the new group of bathers that Renoir began in the early 1890s, he plays upon the ambiguity between artifice and nature, not hesitating to place his nudes in the open air, but with their hair styled in a bun and adorned with jewelry **Fig. 75**.

Renoir's fresh look at Rococo art in the late 1880s, and particularly at the bathers painted by François Boucher and Jean-Honoré Fragonard, does more to explain this decision than his Impressionist experience, even though this does resurface in his freedom of touch. We need only recall that Renoir's discovery of

Boucher's *Diana Leaving her Bath* (1742) **Fig. 83, p. 205** was one of his most powerful aesthetic experiences.

During this period, Renoir favored young girls as his models, their relaxed poses and blushing cheeks bringing to mind youth, innocence, and modesty. This sense of modesty is particularly felt in the *Bather Sitting on a Rock*, whose attitude and lowered gaze can be compared with the *Seated Bather* (1892) in the Lehman collection at the Metropolitan Museum of Art in New York.

Although many commentators have underlined the sense of timelessness Renoir's nudes seem to evoke, it is interesting to note that in 1892 the critic Roger Marx preferred to use the terms "modern" and "Parisian"[5] to describe the female type to which Renoir liked to return.

É. V.

1. Dauberville 1967, p. 202. **2.** Letter to Berthe Morisot, quoted in Morisot 1987, p. 183. **3.** Cogniat 1959. **4.** Garb 1998, p. 147. **5.** *Le Voltaire*, April 1892, quoted by Mirbeau 1913, p. 11.

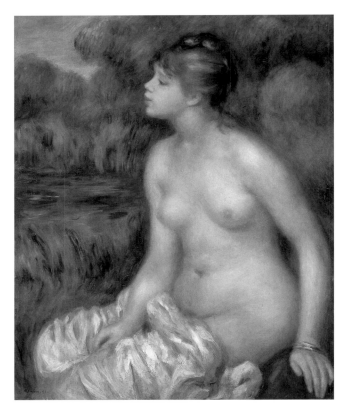

Fig. 75

Pierre-Auguste Renoir
Bather
1891
Oil on canvas
31⁷/₈ x 25⁷/₈ in. (80.9 × 65.6 cm)
Sakura, Kawamura Memorial
Museum of Art

Fig. 75

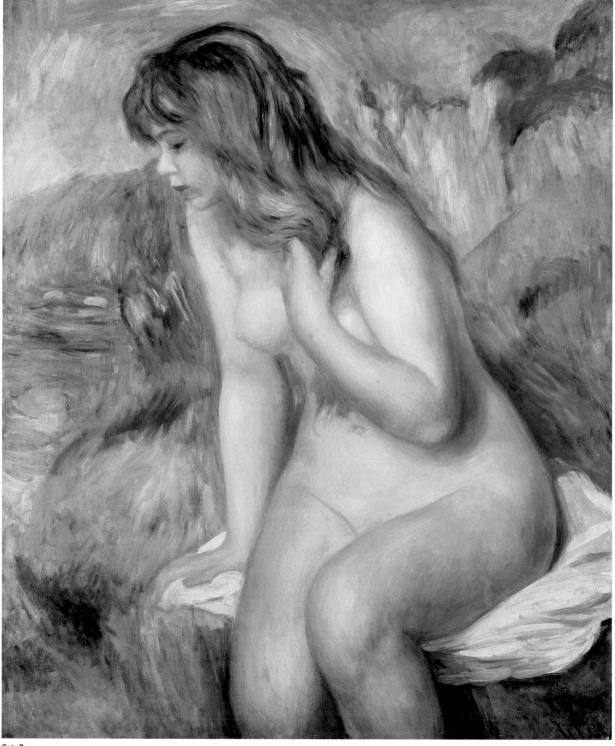

Cat. 8

Cat. 9

Bather with Long Hair
(Baigneuse aux cheveux longs)

Circa 1895–96
Oil on canvas
32 1/2 x 25 5/8 in. (82.5 x 65.2 cm)
Signed bottom right: *Renoir*
Paris, Musée National de l'Orangerie, Jean Walter and Paul Guillaume
Collection, acquired by the state with assistance from the Société des
Amis du Louvre, 1963
RF 1963–23

EXHIBITIONS
Paris 1899, no. 101 (?) (as *Baigneuse*); Dresden 1926, no. 142; Zurich 1932, no.
49; Paris 1945, no. 119 (as *Baigneuse blonde*); Paris 1966, no. 26; Athens 1980,
no. 32; Marcq-en-Barœul 1980–81, no. 34; Tbilisi and Leningrad 1981, no. 39;
Trento 1982, no. 5; London, Paris, and Boston 1985–86, no. 94 (no. 92 in French
ed.); Paris 1988, no number; Nagoya 1991, no. 25; Tokyo, Nagoya, Hiroshima,
Niigata, and Kyoto 1998–99, no. 23; Taipei and Kaohsiung 2000, no. 23;
Montreal and Fort Worth 2000–01, no. 8; Brisbane, Sydney, and Melbourne
2001, no. 8; Barcelona 2002, no. 9; Bergamo 2005, no. 5.

BIBLIOGRAPHY
Scheffler 1920, p. 181; Régnier 1923, n. p.; Dormoy 1926, pp. 341–342;
Grohmann 1926, p. 386; Waldmann 1927, pp. 94, 488; Meier-Graefe 1929,
p. 322, no. 276; *Oscar Schmitz Collection* 1936, no. 54; *Jours de France* 1959,
p. 46; Adhémar 1966, p. 21; Leymarie 1978, pl. 69; Haddad 1990, pp. 56, 187;
Hoog and Guicharnaud 1990, no. 87; Giraudon 1993, pp. 83–84; Cahn 1996,
p. 76; Cros 2003, pp. 134, 136–137.

"**T**hese natural surroundings, water flowing past... and rippling
foliage, become delightful gardens where these young bathers'
bodies breath, flourish, and are alive, these small creatures of

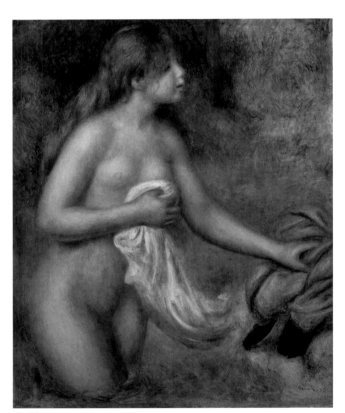

Fig. 76

Pierre-Auguste Renoir
Bather in a Stream
1895
Oil on canvas
31 1/2 x 26 in. (80 × 66 cm)
Merion, PA, The Barnes
Foundation
Fig. 76

instinct, children and women at the same time, to which Renoir
brings both steadfast love and impish observation. . . . Look at
these charming eyes like corollas, these mouths like luscious fruit,
their flesh happy, free, and opulent, their supple demeanor, and
those little lively movements: it is spontaneous life caught in the
truth of its manifestations, a veritable apotheosis of the present
moment, of youth, and of joyous sunlight." Published in *Le Journal*
of June 20, 1896, to mark a Renoir exhibition at the Galerie Durand-
Ruel, Gustave Geffroy's words beautifully evoke the atmosphere
of *Bather with Long Hair*. While we do not know for sure if the
work was part of the exhibition, it is nevertheless highly probable
that Renoir would have chosen this canvas to represent his recent
output, or else the first version, *Bather in a Stream*, executed the
previous year and now preserved in the Barnes Foundation **Fig. 76**.
Besides, Durand-Ruel bought this *Bather* not long after the exhi-
bition on November 18, and then sold it to Oscar Schmitz, a major
collector from Dresden on November 17, 1911.

In this picture, Renoir returns to a subject dear to him since
the early 1880s—the female bather in a landscape. He depicts a
young nude girl, in water up to knee level, facing left and looking
out beyond the canvas. While the pose is still reminiscent of the
chaste Venus found in ancient statuary, the posture is different. With
her right hand the young woman is drawing up to her chest the
white linen she has placed on the rock, where her left hand holds
in place the rest of what seem to be her clothes. These vary some-
what from one version to the next: in Dr. Barnes' version her clothes
are in fact far more conspicuous, because of both their greater
volume and their more sharply contrasting color.

The woodland setting in which the scene takes place is hard to
identify as it is only hinted at. The vague surroundings become a
simple backdrop, conferring a timeless quality onto the scene.
The only indication of its constituent elements is the tonal range
of the different areas: blue for water, brownish-green for foliage.
The diffuse light, softening the forms and giving unity to the whole,
gives the landscape a molten appearance, which is more pro-
nounced in the Paris version than the American one. Reduced to
muted shades, the palette reinforces this feeling of unity which is
only lifted by a few touches of color: the deep pink of the young
girl's cheeks and lips, which echoes the color of the cloth on the
right; the dark blue of her eyes picking up the shade of the water
in the foreground; and the orange-yellow color of her hair, which
echoes the tones of the rock.

Several works connected to this composition have been pre-
served. Two drawings executed in red chalk are preparatory studies
for *Bather with Long Hair*, as the hair in them covers the shoulder
and part of the young woman's arm, just as they do in this painting
but not the Barnes canvas. While the drawing in the Bührle col-
lection in Zurich (16 x 11 7/8 in. [40.5 x 30.2 cm]) is a simple figure
study, the second is the red chalk drawing that Renoir executed
in large format before tracing it onto the final canvas (*Young
Female Nude*, 29 1/2 x 21 1/4 in. [75 x 54 cm], sold by the Charpentier
gallery, November 30, 1954, lot no. 54). Two other works cannot
be linked with certainty to either of the two versions. In both cases,
these show a half-length portrait study of the bather. While one
of them was again done in red chalk (*Profile of a Young Woman*,
6 1/4 x 5 7/8 in. [15.9 x 15 cm], sold at Christie's London, April 1,
2004, lot no. 19), the other is one of the many small sketches the
painter liked to group on the same canvas. Vollard reproduced it
in the book he dedicated to the painter's works, unfortunately
without specifying the technique (Vollard 1989, no. 757).

I. G.

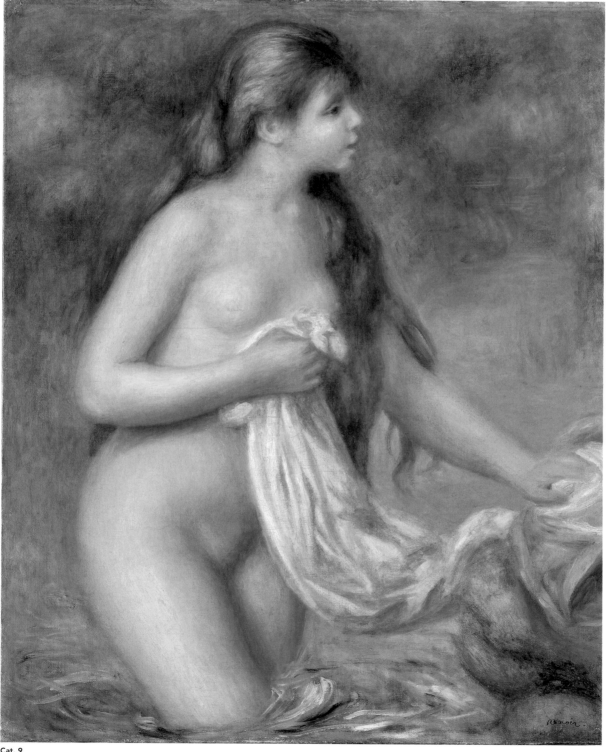

Cat. 9

Cat. 10

Caryatids (Cariatides)

Circa 1897
Oil on canvas
51¹⁄₈ x 16³⁄₄ in. (130 x 45 cm)
Signed bottom right: *Renoir*
Cagnes-sur-Mer, Musée Renoir, on deposit from Musée d'Orsay, 1995;
work rediscovered in Germany after World War II and placed in the
keeping of the Musées Nationaux, attached to the Musée du Louvre by
the Office des Biens et Intérêts Privés in 1950
MNR 198 Dépôt

EXHIBITIONS
Paris 1927, no. 50 ("M. Canonne"); Limoges 1952, no. 61 (dated 1909); Nice
1952, no. 23 (dated 1909); Paris 1954, no. 48 ("former Bernheim-Jeune
collections, Canonne"); numerous exhibitions on Impressionist paintings in
French public collections until 1985.

BIBLIOGRAPHY
Dussaule 1995, p. 46; Lesné and Roquebert 2004, p. 428; Dauberville 2009,
no. 1293.

Exhibited in Paris.

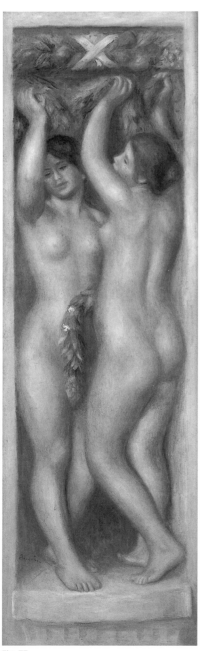

Fig. 77

This panel of *Caryatids* takes its place in the line of decorative pairs undertaken by Renoir from the beginning of the 1880s onward, together with *Dance in the City* and *Dance in the Country* **Cat. 1 & 2, p. 133,** which André Fermigier described as "modern caryatids." With this decorative panel, separated from its companion piece since at least 1927 **Fig. 77,** Renoir turned resolutely toward antiquity, picking up one of its architectural devices—the caryatid—along with the style of *trompe-l'œil* peculiar to decorative Roman frescoes. As he often did, Renoir mixes in other references: his caryatids are set in a niche which prevents them from fulfilling their original support function; like *canephorae* (basket-carrying maidens)—another theme of monumental sculpture—they are holding foliage garlands up to a vine arbor reminiscent of Raphael's Loggia of Psyche in the Villa Farnesina in Rome (1519) and Correggio's Camera de San Paulo in Parma, which combines vine arbors and sculptures in *trompe-l'œil* niches (1519–20). Similarly the proportions and smoothness of relief in Renoir's caryatids, as well as the sinuous line that connects the bodies, bringing them to life and giving them rhythm, are all features reminiscent of Correggio. Renoir also takes his place in the great tradition of French interior decoration, from the Château of Fontainebleau through to the eighteenth century.

In doing so, though with a very light touch rather than in a heavily theoretical way, Renoir is also making reference to the *paragone*, or comparison between the arts, especially between painting and sculpture, which was central to the aesthetic theories of the Renaissance and to the *Treatise on Painting* by Leonardo da Vinci, whose writings were being rediscovered from the 1880s on. Renoir freely gives his own interpretation of this comparison, which preoccupied him at a time when he was trying to give his painted nudes a sculptural quality in their rendering or by using poses inspired by classical works. But here, *trompe-l'œil* and *grisaille*, processes which were actually common in mural decoration, only compete with sculpture in a minor way, as the strong reds of the faces, hair, thighs, knees, and feet give painting its full due, breathing life into models in flesh tones rather than in stone. The color is all the more important in that it reestablishes once more the play of oppositions and associations produced by the contrast between the two models with brown and blonde hair, a contrast close to Renoir's heart throughout the 1890s.

The *Caryatids* shown here should probably be attributed to this period, if we accept as reliable a hitherto ignored note by Julie Manet, written by her after a visit to Renoir's studio on November 17, 1897: "He has also finished his two decorative panels of nude women supporting a very beautiful ornament containing fruit. They are magnificent, but I find '*décoration*' quite impossible to understand."[1] The style, treatment, and elongation of the bodies—differentiated in terms of the curves, which are looser and fuller than the versions in the Barnes collection (usually dated as 1909 but sometimes earlier, nearer to 1900)[2] **Fig. 78 & 79**—all seem to support Julie's account.

Pierre-Auguste Renoir
Caryatids
Ca. 1897
Oil on canvas
51⁵⁄₈ x 16¹⁄₄ in. (131 × 41.3 cm)
Asashi Beer Co. Ltd. (Japan)
Companion piece to
the *Caryatids*, Cat. 10

Fig. 77

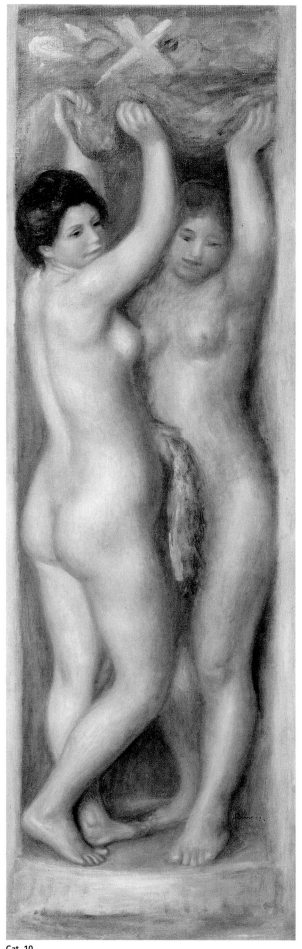

Cat. 10

We do not know the original destination of these *Caryatids,* or, for that matter, that of the Barnes Foundation panels, which remained in the painter's studio until they passed over to his son Jean's collection, and then on to Barnes. Until 1939[3] the present panel belonged to Henri Canonne, a pharmacist who invented the Valda throat lozenge and who assembled a fabulous collection of paintings by Renoir, Matisse, Vuillard, and Bonnard in his luxurious château in Saint-Germain-en-Laye, built in 1907. He did not, however, commission the *Caryatids,* first shown at the Galerie Bernheim-Jeune.[4] In a text on the Canonne collection, never before cited in relation to these *Caryatids,* Arsène Alexandre revealed that the panel was part of a far more extensive grouping: "Within the collection it is an example of a rather special series, and is worthy of notice and further explanation. Renoir had received a request from an art lover for a decoration. The nude, almost inevitably, was to spring to mind as the creative impetus of this work. He executed a whole series of them, arranged in the most subtle and delicate fashion . . . ; over-door panels, vertical panels, all moderately sized. I do not know if the decoration reached its destination, as nothing is more difficult than following Renoir's works around the world."[5] We find no trace of these studies in the catalogues of Vollard (1918) or Bernheim (1921); they should most probably be situated along with those undertaken for Paul Gallimard between 1892 and 1898 **Cat. 76.**

Besides the *grisaille* and *trompe-l'œil* effects, they share a similar decorative purpose and taste for ancient art as seen in Renoir's designs for *Oedipus Rex* **Fig. 18, p. 54.** Alexandre confirms this: "I was present for most of the elaboration [of the *Caryatids*] which involved a fairly large number of studies and reworking, and on this subject, I can provide a curious and unknown piece of information. At that time Renoir was paying a lot of visits to the Louvre to consult the ancient Greco-Roman paintings . . . But these were enough to fire his imagination and, completely enchanted, he made me admire the restraint and elegance in their amazing lightness of touch. We find proof of this enthusiasm in one of the vertical panels, which gives an entirely delightful impression—yet one tinged with regret—of the kind of decorative artist Renoir would have been, had the state dared to pursue the true mission of the Gobelins and repeat the experiences of the Bouchers and Fragonards with their genuine heirs. There is nothing more noble than these two figures juxtaposed naturally, living pilasters, at once vision and temptation, combining in their spiritually faded and lightly brushed colors the simple charm of ancient art, the sensual pleasure of the eighteenth century, and the delicate sensuality of Renoir."[6]

S. P.

1. Manet 1987, p. 117. **2.** Paris, Braun, 1932, nos. 6 and 7. **3.** Paris, Charpentier, 1939, no. 46. **4.** Paris 1954. **5.** Alexandre 1930b, p. 66. **6.** Ibid.

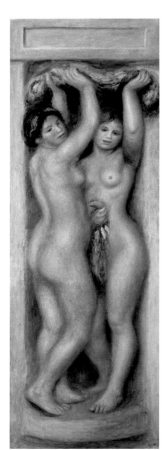
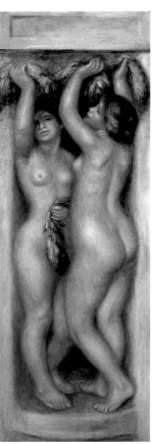

Fig. 78 **Fig. 79**

Pierre-Auguste Renoir
Caryatids
Ca. 1909–10
Oil on canvas
51¹/₂ × 18¹/₈ in. (130.8 × 46 cm)
Merion, PA, The Barnes Foundation

―――――
Fig. 78

Pierre-Auguste Renoir
Caryatids
Ca. 1910
Oil on canvas
51¹/₂ × 18¹/₈ in. (130.8 × 46 cm)
Merion, PA, The Barnes Foundation

―――――
Fig. 79

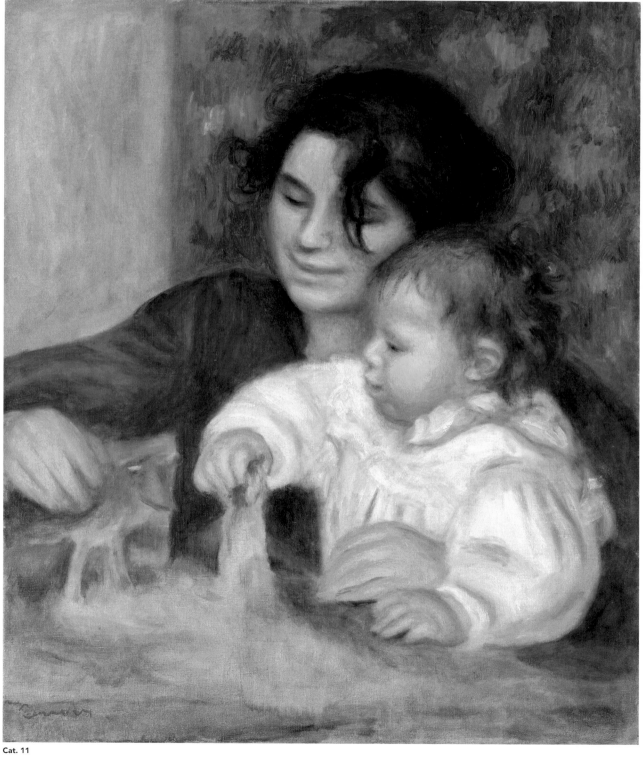

Cat. 11

Gabrielle and Jean (Gabrielle et Jean)

1895
Oil on canvas
25¹/4 x 21¹/4 in. (65 x 54 cm)
Signed bottom left: *Renoir*
Paris, Musée de l'Orangerie, Jean Walter and Paul Guillaume collection, acquired by the state with the assistance of the Société des Amis du Louvre, 1959
RF 1960-18

EXHIBITIONS
Paris 1896, no. 17 or 29; Paris 1944, no. 116; Paris 1966, no. 29; Paris 1967–68, no. 425; Paris 1969, no. 33; Marcq-en-Barœul 1980–81, no. 33; Paris, Palais de Tokyo, 1981, unnumbered; Brisbane, Melbourne, and Sydney 1994–95, no. 38; Ottawa, Chicago, and Fort Worth 1997–98, no. 54; Paris 2005–06, p. 28; Tokyo and Kyoto 2008, no. 8.

BIBLIOGRAPHY
Vollard 1918a, vol. 1, no. 104 and p. 26; Vollard 1919a, pl. 37, p. 184; Geffroy 1920, p. 158; Leymarie 1978, fig. 61; White 1984, p. 205; Wadley 1987, pl. 114, p. 328; Vollard 1989, no. 104, p. 26; Hoog and Guicharnaud 1990, pp. 196–199.

O f all modern artists, only Renoir and Picasso painted their offspring with such persistence and attention. Having come to family life relatively late, there were periods when they created what amounts to visual diaries of their children's young lives.

The birth in 1894 of Renoir's second son, Jean, provided the painter with a readily available, if not always willing, model. The boy's nanny was generally enlisted to keep him occupied while his father drew and painted. In later years, she would read him his favorite Andersen fairly tales, but in this early portrait, wooden toys capture the child's attention. Jean is seated on the lap of Gabrielle Renard, a distant cousin by marriage of Aline Renoir, who, as a sixteen-year-old, had moved from Essoyes to Paris the previous year to help with the new baby. Gabrielle's role in the household grew over the years, as she also became Renoir's favorite model: she sat for many portraits, studio scenes, and nudes. Her importance in the family was not entirely welcome to the irascible Mme Renoir, and after twenty years of service, Gabrielle was dismissed in 1914. However, she returned to help the ailing Renoir and his sons after Aline's death in 1915. In fact, her connection with the

Renoir family continued beyond the painter's lifetime. In particular, she became Jean's confidante and, upon his invitation, followed him to the United States in 1942. Settled in Hollywood with her husband, an American painter by the name of Conrad Hensler Slade, she helped Jean compose his memoirs, *Pierre-Auguste Renoir, My Father*. The book was first published in 1962, three years after Gabrielle's death.

The painting here is the first in a series of double portraits of Gabrielle and Jean executed between 1895 and 1896. In 1896 Renoir shared his enthusiasm for the project with a fellow painter, saying he was deeply embroiled with the subject, but that it was "not an easy thing":[1] a restless young model, prone to changing moods, did not allow him to work at his usual measured pace. In preparing this work, he took recourse to more sketches and drawings than for any other portrait—countless studies of the two figures, culminating in a drawing in the collection of the National Gallery of Canada **Cat. 83**, in which the final composition is essentially fully realized.

Although *Gabrielle and Jean* is a straightforward, observed portrait, its composition has antecedents in Venetian, Renaissance, or Dutch seventeenth-century art (one may think of Bellini, Cima da Conegliano, or Frans Hals). Despite the considerable work leading up to the final painting, it is executed in fluid strokes and brushed rather thinly, almost sketchily: Renoir left whole passages unarticulated, in particular the table, where the toys are hardly distinguishable; in later versions of the same subject (for example, Washington, DC, National Gallery of Art), the figures are depicted more solidly. However, the Orangerie canvas is not unfinished or incomplete. Rather, Renoir here plays with the contrast between thinly painted areas and slightly more built-up passages, such as the lock of hair falling unheeded over Gabrielle's forehead—a graceful, natural gesture that surely was part of what charmed Julie Manet when she saw the painting in 1895.[2]

J. P. M.

1. Letter quoted in exh. cat. Ottawa, Chicago, and Fort Worth 1997–98, p. 224. **2.** Manet 1979, p. 72, entry for November 17, 1895.

Cat. 12

Girl in a Red Ruff
(Femme à la collerette rouge)

Circa 1896
Oil on canvas
16¼ x 13⅛ in. (41.3 x 33.3 cm)
Signed top right: *Renoir*
Philadelphia, Philadelphia Museum of Art, Bequest of Charlotte Dorrance Wright, 1978
1978-1-28

EXHIBITIONS
San Francisco, 1965, no. 25; New York, 1969, no. 82; New York, 1974, no. 53.

Jean Renoir recalled, years later, that when he was not available—or willing—to pose for his father, Renoir would instead paint "a profile of Gabrielle." Gabrielle Renard, a distant cousin of Mme Renoir, joined the household in 1894 as Jean's nurse but soon became one of Renoir's favorite models. Done about 1896, the painting shows Gabrielle as a young woman wearing a frothy, red- and orange-edged ruff. Her face is fresh and luminous with softly modeled features that contrast with the more obvious brushwork and impasto of the ruff. The nearly shapeless gown with orange dashes on the sleeve appears in *Woman Playing the Guitar* **Cat. 13** of the same period, but the ruff was apparently not painted again until 1909 when Renoir portrayed his youngest son Claude dressed as a clown **Cat. 43**. Renoir seems to have had some trouble with Gabrielle's nose, readjusting it down and into a more vertical position.

In the early 1890s Renoir painted a series of bust and half-length depictions of young women, often in profile, wearing elaborate straw hats and fashionable gowns. Many of these fancy paintings were sold to Durand-Ruel and contributed to Renoir's commercial success in this decade. Unlike these costumed pieces, Gabrielle is hatless and dressed in an eclectic fashion. The ruff, which engulfs her neck, resembles the ruffled collar worn by the comic Pierrot, but its volume also recalls the stiff linen ruffs common in late sixteenth- and early seventeenth-century portraits by Peter Paul Rubens, Frans Hals, and others. Renoir visited London and Holland in the autumn of 1895 with Paul Gallimard, the collector and theater-owner, and he may have been playfully alluding to historical rather than contemporary fashion in this use of the ruff.

Although this small appealing work with its restrained palette of green, orange, and pink might have been made for the market, it was purchased from Renoir in 1897 by Paul Durand-Ruel and remained in the Durand-Ruel family collections until the 1960s, when a Philadelphia collector acquired it.

J. A. T.

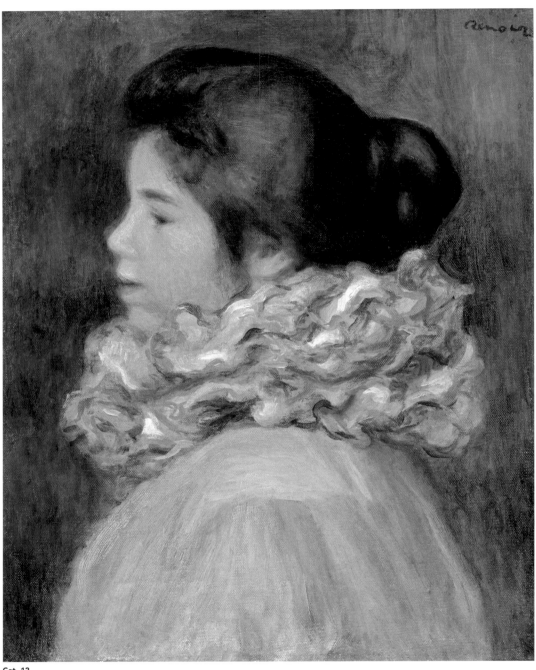

Cat. 12

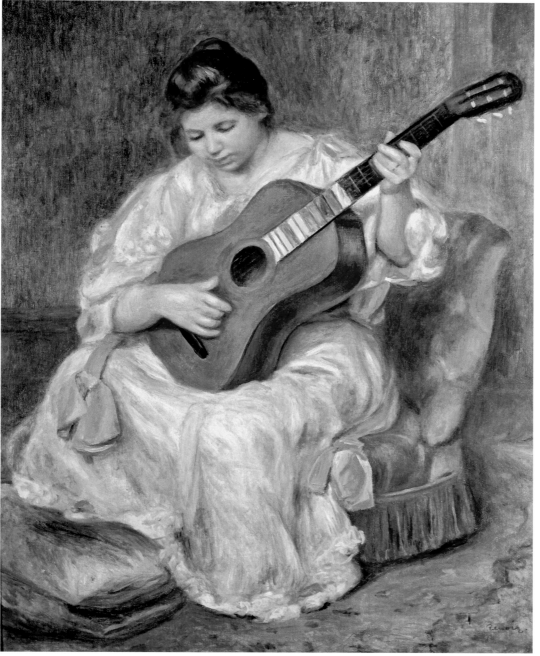

Cat. 13

Cat. 13

Woman Playing the Guitar (Femme jouant de la guitare)

1896–97
Oil on canvas
31⁷/₈ x 25⁵/₈ in. (81 x 65 cm)
Signed bottom right: *Renoir*
Lyon, Musée des Beaux-Arts, purchased 1901 (possibly directly from the artist)
B 624

EXHIBITIONS
Paris 1899, no. 108 (?); New York 1935, no. 10 (?) (as *La joueuse de guitare*, 1897, private collection, Paris); Venice 1948, p. 216, no. 56; Turin 1951, p. 18; Nice 1952, no. 17; Lyon 1952, no. 33; Arles 1952, no. 15; Marseille 1963, no. 43; London, Paris, and Boston 1985–86, no. 96 (no. 94 in French ed.); Lausanne 1989, no. 65; Tokyo and Kitakyushu 1989–90, no. 63; Atlanta, Seattle, and Denver 1999, no. 53; Lyon 2003; Hong Kong 2005, no. 19; Montpellier and Grenoble 2007–08, pp. 120, 121.

BIBLIOGRAPHY
Dissard 1912, p. 51, pl. 143; Coquiot 1925, p. 230 (?); Mauclair 1929, p. 90; Florisoone 1937, p. 77; Jullian 1938, p. 8; Venturi 1939, vol. 1, pp. 162–163, 167; Tapié 1952, p. 3, pl. 13; Vincent 1956, pp. 242–244; Fezzi and Henry 1985, no. 656; Manet 1987, p. 108; Durey 1988, p. 112; De Grada 1989, p. 7, ill. 63; Boyer and Champion 1993, pp. 442, 451; Brachlianoff et al. 1995, pp. 228–229; Brachlianoff et al. 1998, p. 230; Distel 2005, p. 112.

Cat. 13a

The Guitar Player, also called *The Guitar Lesson* (Joueuse de la guitare also called La Leçon de guitare)

1897
Oil on canvas
31⁷/₈ x 25⁵/₈ in. (81 x 65.5 cm)
Signed bottom right: *Renoir*
Private collection

BIBLIOGRAPHY
Meier-Graefe 1929, p. 273, pl. 260 (as *Guitarrenspielerin mit Kind*); Florisoone 1937, pp. 76, 166 (as The *Guitar Player*); Manet 1987, p. 108.

Exhibited in Philadelphia.

Around 1896–98 Renoir painted a series of pictures of women in Spanish dress playing the guitar. As Jeanne Baudot recalled, these works were inspired by the extraordinary popular success of Caroline Otéro—*La Belle Otéro*—a Spanish dancer and singer, who was performing to great acclaim at the Folies-Bergère. After seeing her on stage, so Baudot, Renoir immediately went out and bought props and Spanish costumes for his model Germaine.[1] In fact, the painter bought two complete, but very different costumes: a gold-embroidered form-fitting bullfighter's suit (see **Cat. 14**) and a full, white muslin dress trimmed with pink ribbons. Focusing on these outfits, he developed two composition schemes, quite different in their structure. Julie Manet saw examples of both picture types under way in Renoir's studio in early 1897 and described what must have been *Woman Playing the Guitar:* "He is working on some delightful guitar studies: a woman in a white chiffon dress which is held in position with pink bows leaning gracefully over the big yellow guitar, with her feet on a yellow cushion . . . The whole effect is colourful, mellow, delicious."[2]

As was his frequent practice, Renoir explored the same motif in several variants: for example in *The Guitar Player* (Melbourne, National Gallery of Victoria); *Woman with a Guitar* (location unknown, pictured in New York 2002–03, no. 23); and, more elaborate than the others, *The Guitar Player* (1897, private collection, **Cat. 13a**), which Julie Manet admired in January 1898 and described in her diary "We also saw pictures of a woman with a guitar with a little girl dressed in red listening to her, which is just delightful. Monsieur Renoir has painted the fabrics, cushions, and carpets in an extraordinary manner."[3]

It is difficult to see the connection between Renoir's guitar playing women and their purported inspiration. Otéro, the embodiment of "Spanish seduction," was notorious for her racy lifestyle, energetic performances, and revealing dresses designed to show off her famously voluptuous figure. In contrast, Renoir's quiet musicians display a demure inwardness that negates the cliché of Latin sensuality their Spanish dress might invoke. Conversely, this foreign dress strikes an unexpected exotic note in the ordinary bourgeois interior in which its wearers are posed. In *Woman Playing the*

Guitar and *The Guitar Player,* the furnishings of this room include a small armless boudoir chair upholstered in red velvet, tasseled yellow silk cushions, and a patterned rug in tones of ochre with red and green accents; in other versions, the room further features a flowered *paravent* or wallpaper and a cloth-covered table with a vase of flowers. Among all the variations of décor, changes of dress details, and different viewing angles, one constant remains: the costumed young woman absorbed in playing her instrument. To embody this figure, Renoir employed one of his regular models, Germaine, whose chestnut-red hair, soft round face, and pert up-turned nose represents the type of French prettiness Renoir liked best.

Renoir was ever open-minded and curious, and his work in the late 1890s and early 1900s was characteristically wide-ranging. Besides bathers and portraits, it also comprised realistic depictions of women in ordinary modern dress, busy with mundane domestic tasks, such as sewing and embroidering **Cat. 33–35**. In contrast to these, Renoir's "Spanish" pictures, with their unexplained costumes, register not as representations of reality, but as artful orchestrations of pictorial effects. In fact, they speak directly of the artistic traditions Renoir was especially drawn to at the time.

The pleasing palette and delicately layered paint used in *Woman Playing the Guitar* produce a particular elegance that is reminiscent of Jean-Antoine Watteau, whose *fêtes champêtres* often depict stylishly dressed women absorbed in music making. Renoir felt a special affinity with Watteau and studied his paintings during visits to the Louvre. At the same time, a second connection can be drawn to Camille Corot, also deeply admired by Renoir. Corot's costumed female figures with instruments, such as the one entitled *Haydée* (ca. 1870–72, Paris, Musée du Louvre) share with Renoir's guitar players a certain mysteriousness, their specific nature and meaning complicated by the unusual combination of setting, costume, and activity.

C. E.

1. Baudot 1949, p. 70. 2. Manet 1987, p. 108, entry for Monday, February 1, 1897. 3. Manet 1987, p. 126, entry for Saturday, January 22, 1898.

Cat. 13a

Cat. 14

Young Spanish Woman with a Guitar
(Jeune espagnole jouant de la guitare)

1898
Oil on canvas
21⁷/₈ x 25⁵/₈ in. (55.6 x 65.2 cm)
Signed and dated bottom right: *Renoir. 98*
Washington, DC, National Gallery of Art, Ailsa Mellon Bruce Collection
1970.17.76

EXHIBITIONS
Paris 1899, no. 112 (as *Jeune Espagnole jouant de la guitare*); Zurich 1917, no. 204; Paris 1905, no. 1325 (?) (as *Femme à la guitare*); Dallas 1937, no. 27; Washington, DC, 1966, no. 108; Leningrad and Moscow 1986, no. 32; Munich 1990, no. 50; Athens 1992–93, no. 51; Brisbane, Melbourne, and Sydney 1994–95, no. 40 (as *Young Woman with a Guitar*); Los Angeles 1999, no catalogue; Kyoto and Tokyo 1999, no. 35.

BIBLIOGRAPHY
Roger-Marx 1937, p. 25 (as *La Femme à la guitare*); Duret 1937, no. 13; Drucker 1944, no. 119 (as *Espagnole à la guitare*, with incorrect provenance); Goldwater 1966, p. 50; National Gallery of Art 1975, p. 302; Walker 1984, p. 417, no. 694; National Gallery of Art 1985, p. 347; Ford 1986, p. 10, no. 240; Quesada 1996, no. 288; Mittler and Ragans 1997, p. 186.

When Renoir began to paint a series of Spanish guitar players in 1896, he developed two distinctly different compositional types, based on two distinctly different costumes. By February 1897, Julie Manet, the daughter of Renoir's friend Berthe Morisot and niece of Édouard Manet, could see examples of both costumes in paintings under way in Renoir's studio. One was a woman's full white muslin dress with pink bows and ribbons, worn by the model in *Woman Playing the Guitar* and several related canvases **Cat. 13**. The other was a toreador's traditional "suit of lights," featuring a tight vest, short bolero jacket, and form-fitting knee-breeches, all richly embroidered with gold braid. This suit Julie Manet saw in a painting "of a man in Spanish costume who seems to be playing lively tunes on his instrument"[1]—probably *The Spanish Guitar Player* now in the collection of the Detroit Institute of Arts.

The two costumes held sufficient pictorial interest for Renoir to explore each in several canvases. After first trying the toreador's suit on a male model—a logical choice but rare in Renoir's oeuvre—he switched it to a female model. Apparently liking the effect, he produced at least two almost identical versions of *Young Spanish Woman with a Guitar* **Fig. 80** a bust-length picture of a young woman engrossed in her playing, half turned away from the viewer; her costumed head and torso are outlined against a warm-colored, featureless background. In a different take on the same motif—with the same model, the same costume—Renoir depicted the figure full-length, standing in a room empty except for a patterned rug. Significantly, this setting, as well as the young woman posing, are the same as in *Woman Playing the Guitar* and its variants **Cat. 13**. The fact that the woman's dress and the bullfighter's suit could function interchangeably in the same context suggests that, for Renoir, what counted was their generic effect as fancy-dress, rather than their specific cultural implications.

To the French mind in the nineteenth century, Spain represented an exotic world, colorful and exciting. By mid-century, Spanish dance troupes and singers performed regularly in Paris and became popular subjects in art. Among progressive painters, Édouard Manet's engagement with Spanish themes was to have an immediate and lasting effect. Shown at the Salon of 1861, his *Spanish Singer* (New York, The Metropolitan Museum of Art) instantly became an icon of the avant-garde, one that Renoir undoubtedly was conscious of when he selected the toreador's costume. In fact, his male *Spanish Guitar Player* seems to be a direct reworking (in reverse) of Manet's famous composition. *Young Spanish Woman with a Guitar* is a less literal descendant of the *Spanish Singer*, but makes a second allusion to Manet—his 1862 *Mademoiselle V… in the Costume of an Espada* (New York, The Metropolitan Museum of Art), which had strikingly featured a female model *en travestie*, clad in a bullfighter's suit. While wearing men's suits was not uncommon among popular performers,[2] both Manet and Renoir underscored that their paintings did not represent such a real circumstance, but were artificial studio constructs. What Manet indicated with the spatial disjunction between foreground figure and background scene, Renoir revealed by introducing subtle incongruities in the details: the classically French features of his Parisian model heightens the dress-up effect of her suit; and the ethnic specificity of the Spanish costume itself is compromised by the addition of a small black hat—not, as might appear at first glance, a matador's *montera*, but a contemporary woman's hat.

Renoir was to paint a Spanish toreador's costume again a decade later, in one of his most extravagant portraits—of Ambroise Vollard **Cat. 51**. Given that Vollard was a rather tall man, it is unlikely that the same suit was used on both occasions.

C. E.

1. Manet 1987, p. 108, entry for Monday, February 1, 1897. 2. Exh. cat. Brisbane, Melbourne, and Sydney 1994–95, p. 125.

Fig. 80

Pierre-Auguste Renoir
Woman with a Guitar
1897
Oil on canvas
21¹/₄ x 26 in. (54 x 66 cm)
Private collection

Fig. 80

Cat. 14

Yvonne and Christine Lerolle at the Piano
(Yvonne et Christine Lerolle au piano)

1897
Oil on canvas
28³/4 x 36¹/4 in. (73 x 92 cm)
Signed bottom right: *Renoir*
Paris, Musée de l'Orangerie, Jean Walter and Paul Guillaume collection, acquired by the state with the assistance of the Société des Amis du Louvre, 1960
RF 1960-19

EXHIBITIONS
New York, Durand-Ruel, 1939; San Francisco 1944, p. 36; Paris, Orangerie, 1966, no. 31; Paris, Palais de Tokyo, 1981, unnumbered; London, Paris, and Boston 1985–86, no. 97 (no. 95 in French ed.).

BIBLIOGRAPHY
Meier-Graefe 1929, p. 253; Bernheim-Jeune 1931, vol. 1, pl. 65, no. 201; *Cahiers d'Art* 1936, p. 276; Frankfurter 1939, p. 10; Baudot 1949, p. 67; Rouart 1954; Alexandrian 1974, p. 59; Manet 1979, pp. 138, 215; Hoog and Guicharnaud 1984, pp. 202–205; White 1984, p. 208; Tübingen 1996, p. 259; Ottawa, Chicago, and Fort Worth 1997–98, pp. 227, 328; Néret 2001, p. 288; Cros 2003, p. 148; Distel 2005, p. 103; Columbus 2005–06, p. 94.

Christine Lerolle Embroidering
(Christine Lerolle brodant)

1897
Oil on canvas
32¹/2 x 25⁷/8 in. (81.6 x 65.7 cm)
Signed bottom left: *Renoir*
Columbus Museum of Art, Gift of Howard D. and Babette L. Sirak, the Donors of the Campaign for Enduring Excellence, and the Derby Fund, 1991
91.1.57

EXHIBITIONS
Paris 1902, no. 20; Toronto 1934, no. 10 (as *Jeune femme brodant*); Paris 1969, no. 36; Chicago 1973, no. 65; Ottawa, Chicago, and Fort Worth 1997–98, no. 55; Columbus 2005–06, no. 65; Atlanta, Denver, and Seattle 2007–08, no. 87.

BIBLIOGRAPHY
Meier-Graefe 1929, p. 167; Bernheim-Jeune 1931, vol. 1, pl. 36, no. 101; Drucker 1944, p. 210; White 1984, pp. 208, 211; Columbus 1991–92; Tübingen 1996, pp. 259–260; Néret 2001, p. 223; Collins 2005.

Christine Lerolle

1897
Oil on canvas
26³/4 x 21⁵/8 in. (68.5 x 54.5 cm)
Signed and dedicated, top right: *au petit diable Christine / Renoir*
Collection Stephan Chayto

EXHIBITIONS
Sakura, Sendai, and Sapporo 1999, no. 48.

BIBLIOGRAPHY
Ottawa, Chicago, and Fort Worth 1997–98, pp. 227–228; Columbus 2005–06, pp. 63, 65.

Yvonne and Christine Lerolle were the daughters of Henri Lerolle, a now largely forgotten artist whose paintings—including large decorations for the Sorbonne and the Paris Hôtel de Ville—in their day enjoyed a modicum of success. Not a progressive artist himself, Lerolle admired the work of the Impressionists and distilled their style into his own less radical and more easily acceptable idiom.[1] Perhaps realizing his limitations, however, Lerolle gave up painting in the 1890s and is today better known as a collector of Impressionist and Post-Impressionist pictures. His collection notably focused on Degas but also, in later years, included works by Paul Gauguin and Maurice Denis. Having grown up in an artistic milieu, the Lerolle daughters married into another prominent Parisian family with many close ties to the Impressionist circles—the Rouarts. (Yvonne married Eugène Rouart; Christine, his brother Louis). Distant branches of the Rouart family tree included Édouard Manet and Berthe Morisot.[2]

Renoir was a close friend of the Lerolle family and painted the daughters on several occasions. Of three works he executed in 1897 alone, the portrait showing Christine in a pink dress with full white sleeves that strikingly sets off her dark eyes and hair, is the most conventional in form but also, because of the young woman's lively outward gaze, the most personally engaging. Indeed, Renoir dedicated the canvas "to the little devil Christine," a droll expression of the affectionate friendship that bound sitter and artist. In contrast, both *Christine Lerolle Embroidering* and *Yvonne and Christine Lerolle at the Piano* establish a sense of objective distance between viewer and self-absorbed subjects. Apparently, Renoir did not paint either of these portraits on commission. *Christine Lerolle* was a gift to the sitter, while the other two canvases remained in Renoir's possession until his death, without any indication that Henri Lerolle ever tried to purchase them.

The Lerolles presided over a lively musical salon that not only included the composer Ernest Chausson, Henri Lerolle's brother-in-law, but also Claude Debussy. The Lerolle daughters were accomplished musicians as well, and in portraying them at the piano Renoir returned to one of his favorite themes. After an early treatment in the Impressionist style (*Lady at the Piano*, 1876, Art Institute of Chicago), he had chosen the subject again for his first purchase by a French museum, *Young Girls at the Piano* (1892) **Cat. 3**. *Yvonne and Christine Lerolle at the Piano* differs from these other paintings in that it does not depict professional models but, instead, the daughters of his good friend Lerolle.

It is also the only treatment in a horizontal format, needed to replace the upright piano (that unsightly fixture of late nineteenth-century bourgeois interiors) with a more professional-looking grand piano. Perhaps suggesting that the elder was the more talented of the two sisters, Yvonne is shown playing while Christine assists by turning the score's pages.

The recurrence of young women playing piano in Renoir's oeuvre should not be interpreted as proof of a special interest in classical music on the part of the artist, who, in fact, preferred popular tunes. While in Munich in 1910 (see **Cat. 54 & 55**), he asked Renée, the daughter of his friend Georges Rivière, to bring her popular sheet music as relief from the high-brow music practiced in the Thurneyssen circle.[3] Rather, in the 1890s, his interest in the motif was primarily artistic: he explored it as a means to develop a new pictorial type that straddled the boundaries between portrait and genre scene. Renoir was increasingly ambivalent about portraiture—in 1913, he would tell Alice Merzbach, "I will not do a portrait of you, but I shall paint a picture you will be in" **Cat. 57**—and seems to have sought a solution by fusing the two traditional modes. He fully realized this in the Lerolle double-portrait: while it represents two named young women in their real home (identifiable by their father's collection of Degas paintings on the wall), the painting also has many of the characteristics of a seventeenth-century Dutch genre painting, notably the figures' absorption in a typical activity and the loving description of the domestic interior. Julie Manet, seeing the painting in Renoir's studio on the rue de la Rochefoucauld, seems to have perceived the unusual nature of the work, when she found Yvonne's likeness unconvincing but the paintings by Degas "painted with love."[4]

Renoir's admiration for some of the Dutch painters of the seventeenth century is well documented—according to Jeanne Baudot, he particularly enjoyed the sense of intimacy they evoked.[5] There are echoes of Vermeer's *Lacemaker*, one of Renoir's favorites, in *Christine Lerolle Embroidering*. Focusing on the warm domestic atmosphere that characterized the Lerolle household, the composition offers a double glimpse of gentile sociability: in the foreground, the young woman earnestly absorbed in her needlework, and in the background, two men—identified as Henri Lerolle, on the right, and the Belgian sculptor Louis-Henri Devillez, on the left—equally concentrated on their study of paintings. Like *Yvonne and Christine Lerolle at the Piano*, *Christine Lerolle Embroidering* blurs the distinction between portraiture and genre, combining contemporary reality with pictorial past. Renoir's tribute to the Dutch tradition, however, seems to have escaped Christine's aging grandfather, who took one look at the portrait and, unaware that the artist was within earshot, exclaimed derisively: "So, this is the modern style of painting!"[6]

J. P. M.

1. Loyrette 1991, p. 481. **2.** Exh. cat. Paris 2004, p. 189. **3.** Exh. cat. Ottawa, Chicago, and Fort Worth 1997–98, p. 252. **4.** Manet 1979, p. 138, entry for October 25, 1897. **5.** Baudot 1949, p. 29. **6.** Manet 1979, pp. 133–34, entry for Sunday, October 10, 1897.

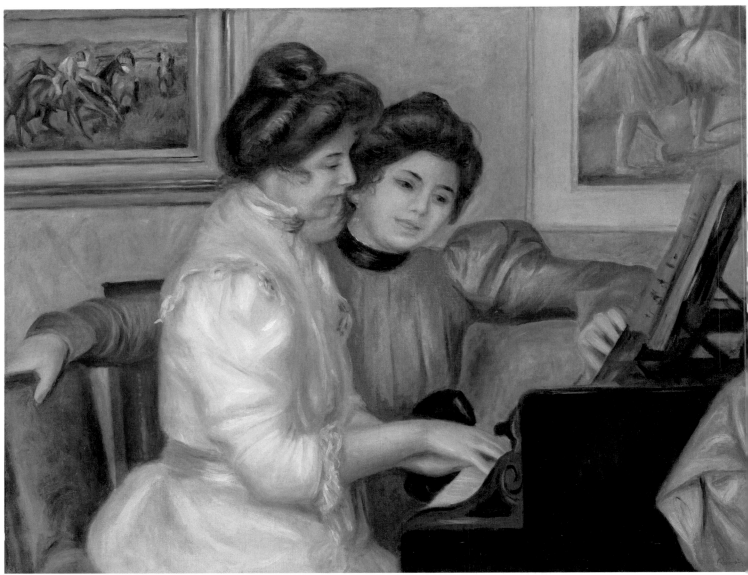

Cat. 15

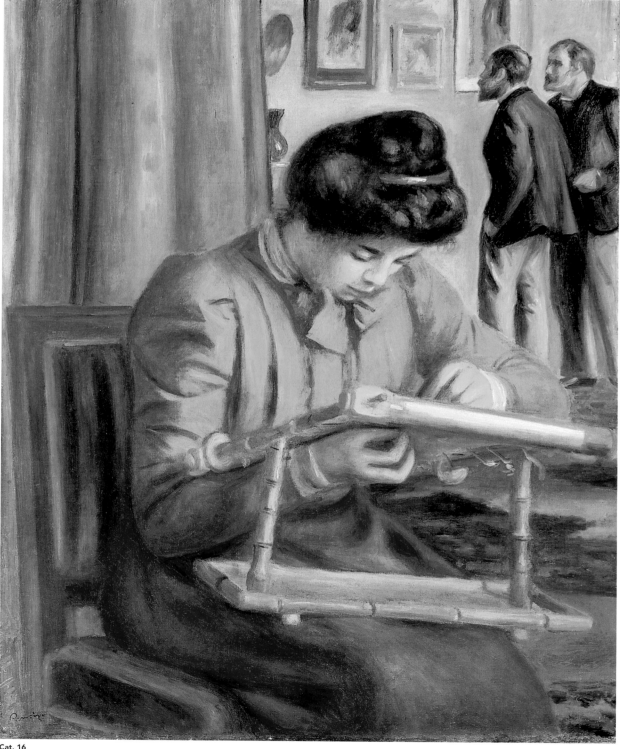

Cat. 16

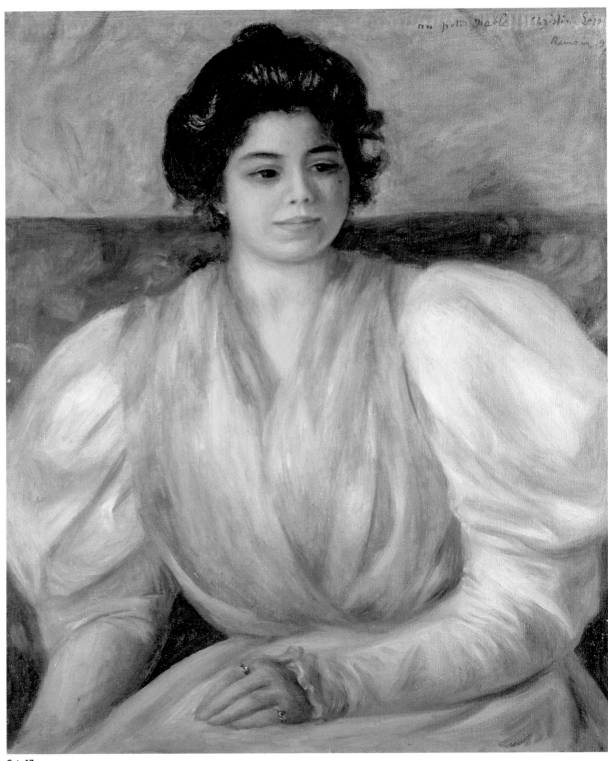

Cat. 17

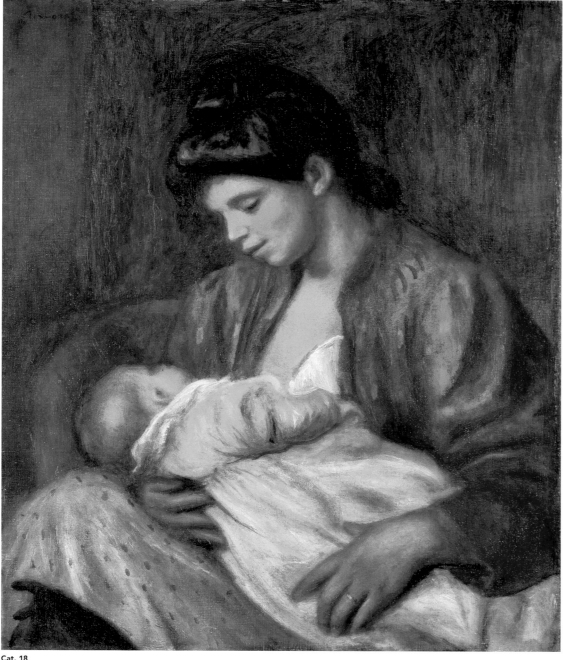

Cat. 18

The Young Mother (La Jeune Mère)

1898
Oil on canvas
22 x 18¹/₄ in. (56 x 46.5 cm)
Signed top left: *Renoir*
Baltimore, Dr. Morton and Tobia Mower

EXHIBITION
Bennington 2007.

Renoir's growing family may have provoked his return to maternal subjects in the late 1890s. An intimate, sentimental picture of a mother nursing her child, *The Young Mother* was probably created in the painter's studio rather than based on direct observation in the Renoir household.

An undated preparatory drawing shows the basic arrangement of the figures (whereabouts unknown, pictured in Schneider 1984, p. 57). The baby's features are undefined but the mother's profile and body are roughly worked out. While her left hand supports the baby's back in a higher position than in the painting, the dark

shape of her jacket is nearly identical. A related painting in the National Gallery of Scotland shows the same configuration of figures with variations in color and the framing of the composition **Fig. 81**. In the Edinburgh picture the mother wears a light blue jacket modeled with violet shadows and thick white highlights. Painted on a slightly smaller canvas, the scene is broader and includes the baby's feet and the silhouette of the mother's skirt. In contrast, the present picture is more tightly framed, cutting off the baby's legs and the mother's left arm. The closer cropping and stronger colors, particularly the mother's resonant red jacket, intensify the strong emotional bond between mother and child.

The model for the mother is Gabrielle, whose dark hair and distinctive facial features are recognizable, but the child, dressed in pink and seen from the back, is not identifiable. The painting is undated but was most likely done about 1898, the same year that the Edinburgh picture was sold to Durand-Ruel. *The Young Mother* likewise passed through Durand-Ruel and formed part of the collection of J. K. Newman of New York, whose sales catalogue (New York, Anderson Galleries, December 6, 1935, lot 37) firmly assigns the painting to 1898. Gabrielle's age would agree with this date, since she was sixteen in 1894 when she joined the Renoir household as Jean Renoir's nurse. One of the first paintings of her by Renoir, *Girl in a Red Ruff* **Cat. 12**, from 1896, shows her as a somewhat younger woman than in *The Young Mother*.

Renoir had conservative views on motherhood; he was a proponent of breast-feeding and abhorred the practice in wealthy families of hiring a wet nurse. In *Motherhood* (1885, Paris, Musée d'Orsay), he showed his wife, Aline, nursing their eldest son Pierre in Essoyes, with the baby's genitalia and Aline's breast exposed. A more chaste scene, *The Young Mother* focuses on a tender moment between a new mother and her child. A gold wedding ring appears on the mother's left hand, adding respectability and perhaps making the picture more attractive to potential customers.

J. A. T.

Fig. 81

Pierre Auguste Renoir
A Woman Nursing a Child
Ca. 1894
Oil on canvas
16¹/₄ x 12³/₄ in. (41.2 x 32.5 cm)
Edinburgh, National Galleries
of Scotland

Fig. 81

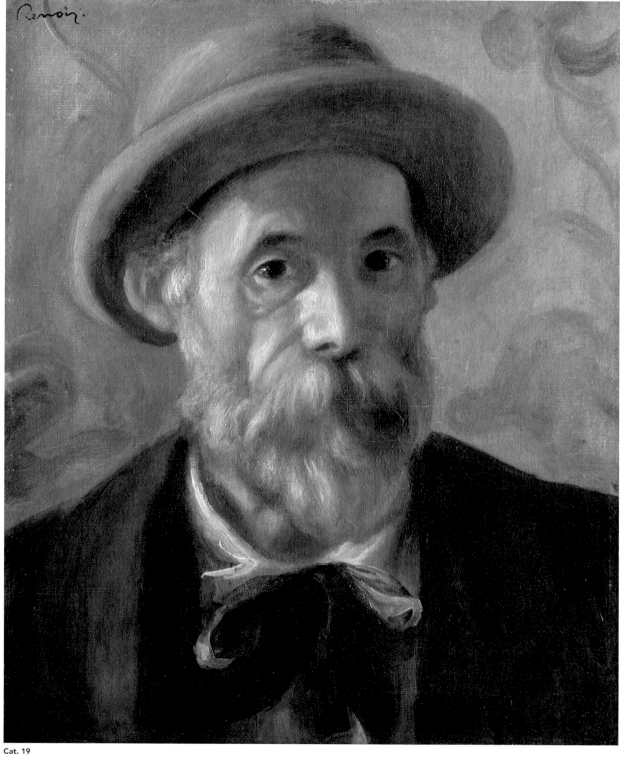

Cat. 19

Self-Portrait (Autoportrait)

1899
Oil on canvas
16 1/8 x 13 in. (41 x 33 cm)
Signed top left: *Renoir*
Williamstown, MA, Sterling and Francine Clark Art Institute, acquired by Sterling and Francine Clark from the Durand-Ruel Gallery, New York, April 10, 1937
1955.611

EXHIBITIONS
London 1935, no. 98 (Pierre Renoir collection); New York, Durand-Ruel, 1939, no. 15 (anonymous loan); London, Paris, and Boston, 1985–86, no. 99 (no. 97 in French ed.); Ottawa, Chicago, and Forth Worth 1997–98, no. 56.

BIBLIOGRAPHY
Bernheim-Jeune 1931, vol. 1, pl. 59, no. 182; White 1984, pp. 212–213; Manet 1987b, p. 180; Kern 1996, p. 58.

"In the studio too, the same [soft] hat adorned his small, lively, rather hirsute head. His tie loose—he liked to leave his neck free, using his nimble fingers to push his unstarched collar clear of it . . . Every part of him needed to move."[1] This description given in 1896 by Thadée Natanson, who was a close friend of Renoir at the time, resembles the self-portrait executed three years later. Along with the air of serenity, Renoir's features and the clothing he chooses to wear are testament to his rejection of rigid ceremonial and formal posing. Little inclined to confidence and introspection, and fundamentally modest, Renoir rarely made himself the subject of his art, with only five self-portraits spanning sixty-five years of painting: two from around 1875 and two more in 1910 showing an old man suffering from illness **Cat. 49**. The 1899 painting is therefore an isolated example at a period when Renoir's health was in decline. He completed this portrait in a rented house in Saint-Cloud after spending time in Cagnes in the early winter because of his rheumatism, and before leaving for treatment at a spa. According to Julie Manet, and as examination of the fine paint surface also suggests, the brushstrokes of the face have softened the signs of age. John House, who was the first to re-date the portrait, detects in it a desire to idealize.[2] However, if one is to believe Julie Manet, the result is, on the contrary, more true to life: Renoir "is finishing a very attractive portrait of himself; at first

he had made himself a little hard and too wrinkled; we demanded that he remove some of these lines, and now it is more like him."[3] In fact, in this self-portrait Renoir captures what fascinated all his contemporaries: the power of his gaze, the painter's true instrument of investigation, still seen strikingly in the film made by Sacha Guitry in 1915. "Renoir's eyes, these eyes that have enriched the world, their singular virtue a continual presence in his plans for change, his mockery, his gayest tricks, in his enthusiasm, and in the quickly extinguished passion of his little tempers . . . But it would also be difficult to imagine a different Renoir, before having seen him, all that gentleness, that gentleness and brightness in Renoir's eye, when his thinness began to betray him," Natanson continues.[4]

This self-portrait, one of Renoir's most accomplished—with its decorative background comparable to *Head of a Young Girl* **Cat. 37**, and also one of his strongest works, thanks to the tight framing that concentrates the viewer's eye on the face—was never exhibited during the artist's lifetime. It remained in his studio, then passed to his older son, Pierre, until it was placed with the Durand-Ruel Gallery in New York in 1936. It was acquired from the gallery by the great Renoir enthusiast Robert Sterling Clark, along with three other of Renoir's works, for twenty-four thousand dollars in 1937, the year of the major Renoir exhibition at New York's Metropolitan Museum of Art. This painting was one of four post–1890 works in Sterling Clark's thirty-eight strong collection of Renoir paintings and was joined two years later by a self-portrait of the artist executed around 1875 and shown at the Impressionist exhibition of 1876. Unlike his brother Stephen who, for example, owned the magnificent *Portrait of Tilla Durieux* **Fig. 38, p. 97** that he would later bequeath to the Metropolitan Museum of Art, Sterling Clark had little taste for Renoir's later period. This *Self-Portrait*, it must be said, with its gentleness and calm harmony, offers a happy compromise between the solidity and finish of the 1880s that Sterling Clark appreciated and the more sketchy manner adopted by Renoir after the turn of the century.

S. P.

1. Natanson 1948b, p. 15. 2. Exh. cat. London, Paris, and Boston 1985–86, p. 270 (p. 302 in French ed.). 3. Manet 1987b, p. 180, entry for Wednesday, August 9, 1899. 4. Natanson 1948b, p. 17.

Cat. 20

Bathers Playing with a Crab
(Trois baigneuses au crabe)

Circa 1897
Oil on canvas
21³/₁₆ x 25⁷/₈ in. (54.6 x 65.7 cm)
Signed bottom right: *Renoir*
Cleveland, Cleveland Museum of Art, Purchase from the J.H. Wade Fund, purchased 1939
1939.269

EXHIBITIONS
Cleveland 1921; Pittsburgh 1924, no. 38; Cleveland 1929; Philadelphia 1933–34; Cleveland 1936, no. 307; New York 1937, no. 56; New York, MoMA, 1939, no. 52; New York 1940, no. 331; Washington, DC, 1940, no. 2; New York 1941, no. 64; New York 1948, no. 24; Omaha 1951; Fort Wayne 1953; Cleveland 1956, no. 37; Minneapolis 1969, no. 71; Tübingen 1996, no. 86.

BIBLIOGRAPHY
Meier-Graefe 1929; Allen 1937, pp. 113–114; Francis 1940, pp. 17–18; Wilenski 1940, p. 344; Cheney 1941, p. 203; Jewell and Crane 1944, p. 122; Leclerc 1950, fig. 40; Pach 1950, p. 102; Rouart 1954, p. 88; Gauthier 1958; Schneider 1958, p. 21; Arnason 1968, p. 25; Daulte 1971, p. 81; White 1972, p. 179; Fouchet 1974, p. 33; Huyghe 1974, fig. 161; Wheldon 1975, p. 107, fig. 84; Pach 1976, pp. 145–146, fig. 63; Eichler 1984, p. 204; Monneret 1990, p. 155; Turner 1991, p. 154; Cleveland Museum of Art 1993, p. 195; Adriani 1999, no. 86; Cleveland Museum of Art 1999, pp. 532–534; Néret 2001, p. 332.

When Renoir exhibited his *Large Bathers* (1884–87) **Fig. 8, p. 39** at the Georges Petit gallery in 1887, it was poorly received, and the artist did not produce another group bathing scene for almost a full decade. *Bathers Playing with a Crab,* painted around 1897, marks his return to the subject and shows a female bather teasingly pushing a little crab toward one of her companions; this central action is offset by brilliant blue drapery. Though it is of much smaller scale, it recalls the seminal *Large Bathers* in fascinating ways. First, the theme of teasing is carried forward: the crab-wielder has replaced the splashing figure. Then, the composition is almost a perfect mirror image, in reverse, of the earlier painting, with a trio of large figures arranged in a triangle; smaller figures in the background; and a landscape that frames the wrestling figures and then opens up into the distance. Renoir seems to have "reissued" the 1887 painting a decade later, exchanging its dry paint and hard-edged figures for more fluid brushstrokes and softer forms.

Bathers Playing with a Crab is one of several paintings from the 1880s and 1890s that show nude female figures engaged in horseplay. In this group, which also includes *Bathers in the Forest* (ca.

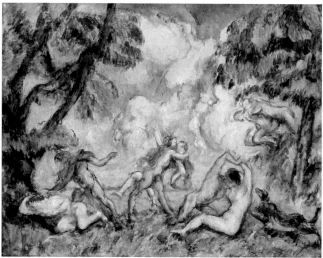

Fig. 82

Fig. 83

Paul Cézanne
The Battle of Love
Ca. 1880
Oil on canvas
14⁷/₈ x 18¹/₄ in. (37.8 x 46.2 cm)
Washington, DC,
National Gallery of Art

Fig. 82

François Boucher
Diana Leaving Her Bath
1742
Oil on canvas
(18³/₈ x 18 in.) 46.7 x 45.7 cm
Paris, Musée du Louvre

Fig. 83

1897, Merion, PA, Barnes Foundation) **Fig. 46, p. 111**, the bathers behave like real bodies in real space—moving, interacting, exchanging looks. These are not the primordial goddesses of Renoir's later bathing scenes, who are arranged in purely decorative patterns, almost floating in shallow space, their gestures ambiguous and unmotivated. Indeed, the Cleveland bathers inhabit their world in a very physical way, spreading out across the composition, with hats and dresses thrown on the bank, smaller figures trudging up from the water, and the taunting voice of the crab-wielder almost audible. Yet if there is a certain realism to *Bathers Playing with a Crab*, it is carefully controlled: the bodies of the wrestling figures mirror each other artfully, and pearly flesh is displayed from several angles for the viewer's visual delectation.

The erotic theme of nude horseplay perhaps derives from Paul Cézanne's *The Battle of Love* **Fig. 82**, a painting Renoir owned and which shows several pairs of figures on a grassy bank engaged in amorous wrestling, with sky and water behind them. Renoir seems to have based his wrestling figures on the duo to the right in Cézanne's painting. Yet *Bathers Playing with a Crab* has none of the turbulence of *The Battle of Love,* nor its violent undertones. The picture is light and amusing, its eroticism unthreatening, making it a direct—indeed, self-conscious—descendent of eighteenth-century paintings like François Boucher's *Diana Leaving*

Her Bath **Fig. 83**, which Renoir described as "the first picture that took my fancy, and I have clung to it all my life as one does to one's first love."[1] *Bathers Playing with a Crab* is perhaps even more closely related to Fragonard's *The Bathers* **Fig. 7, p. 38**, which shows a tangle of soft pink bodies, two of which are locked in a playful tussle.

Renoir made several studies for *Bathers Playing with a Crab,* including oil sketches, a highly worked chalk drawing, and a pastel focusing on the interaction between the two wrestling figures **Fig. 21, p. 58**. The large number of preparatory works suggests that this was an important canvas for him, which makes sense given his long hiatus from the group bather subject; but it also reflects the centrality of drawing in his artistic process during the 1890s. In later decades his approach to painting was more spontaneous. Writing in 1919, Albert André described how Renoir would begin, unsure of how exactly the composition was going to unfold: "he rapidly covers the canvas and you can see something vague and iridescent appearing, colours running into each other, something that enchants you, even before a sense of the image is intelligible."[2]

M. L.

1. Vollard 1925, p. 25. 2. André 1919, p. 32; repr. in Wadley 1987, p. 273.

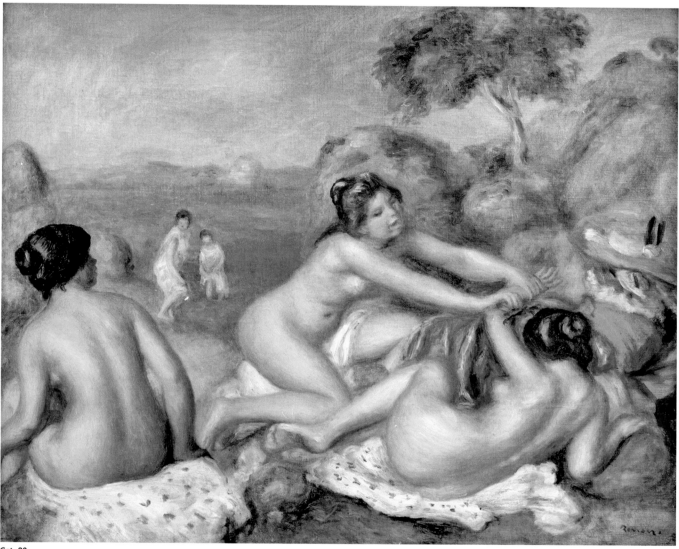

Cat. 20

Cat. 113

Cat. 21

Beaulieu Landscape (Paysage à Beaulieu)

1893?
Oil on canvas
25⁵/₈ x 31⁷/₈ in. (65.1 x 81 cm)
Signed and dated bottom right: *Renoir. 97*
San Francisco, Fine Arts Museums of San Francisco, Museum purchase,
Mildred Anna Williams Collection, 1944
19444.9

EXHIBITIONS
New York 1918, no. 23; San Francisco 1944, p. 61; New York 1965, no. 72;
Chicago 1973, no. 68; London, Paris and Boston 1985–1986, no. 92
(no. 90 in French ed.); Montpellier and Grenoble 2007–08, p. 144.

BIBLIOGRAPHY
Drucker 1944, p. 133; *Art Digest* 1944, p. 19; Saint Petersburg 1995, p. 126,
fig. 1; Potron 2000, p. 111.

Although Ambroise Vollard found little favor with Renoir—he "got on his nerves"[1] and "his semi-annual descents" often made him angry[2]—Paul Durand-Ruel, on the other hand, formed firm professional ties and a bond of friendship with the artist. It was to Durand-Ruel that Renoir sold this work in 1917, after placing it with him for three years. When dating the painting, Renoir mistakenly wrote "1897" on the canvas although he had only remained at Beaulieu until 1893.[3] For two months he had rented accommodations at the Villa Quincenet, 49, boulevard Félix-Faure.[4]

Although this work does not relate to Renoir's period in Cagnes, it still reveals elements that would come to characterize his late period. Organization is the order of the day: the low wall determines the foreground and opens on to the middle ground, where two silhouettes are seen. Durand-Ruel possessed another view of Beaulieu with a vista toward the sea (*Beaulieu Landscape*, St. Petersburg, State Hermitage Museum) in which the clear structuring of the fore-, middle-, and background is also apparent. It is an Eden-like view of nature that Renoir presents here, mixing aloes with clumps of colored vegetation made up of exotic plants. The artist may have been inspired by the magnificent gardens of houses in Beaulieu but, as in his later Cagnes compositions, these places have most certainly been idealized and recomposed.

Renoir often recalled the Old Masters, stating: "I am of the eighteenth century. I humbly consider not only that my art descends from Watteau, Fragonard, Hubert Robert, but even that I am one of them."[5] In this work Renoir indeed applies himself to demonstrating his "craft": the figures that provide scale form part of a calculated vanishing point; the foliage of the tree in the foreground draws the viewer into the painting. The overall effect is one of a double pursuit: the path stretching away and the opening on to the cloudy sky. The vegetation, which occupies three quarters of the painting, is fully balanced by the sky which, however, occupies only a quarter of the canvas. Touches of yellow, orange, and red subtly illuminate this dense, harmonious landscape.

V. J.

1. Gabrielle Conrad-Slade in *Nice-Matin*, December 15, 1951, p. 4. 2. Madeleine Bruno, in *Nice-Matin*, July 20, 1960, p. 7. 3. Letter to Gallimard, April 27, 1893, Dutch Institute, Paris, Custodia Foundation. 4. Potron 2000, p. 110. 5. Gimpel 1987, p. 21.

Pierre Bonnard
Sunlight
1923

Cat. 113, p. 208

Cat. 22

Seated Bather in a Landscape, called *Eurydice* (Baigneuse assise dans un paysage, called *Eurydice*)

Circa 1895–1900
Oil on canvas
45⅝ x 35 in. (116 x 89 cm)
Signed bottom left: *Renoir*
Paris, Musée National Picasso, Picasso gift, 1973–78
RF 1973-87

EXHIBITIONS
Paris 1916, no. 151 (as *Eurydice*); Paris 1917, no. 65 (as *Eurydice*); Paris, Louvre, 1978, no. 28; London 1990, no. 147; Tübingen 1996, no. 85; Munich 1998, no 66; New York, Chicago, and Paris 2006–07, no. 175 (no. 126 in French ed.).

BIBLIOGRAPHY
Vernay 1916, p. 28; Daulte 1971, no. 392; Parmelin 1974, pp. 6–9; Fitzgerald 1995, pp. 106–107; Seckel-Klein 1998, pp. 202–206; Adriani 1999, pp. 265–268; Néret 2001, p. 327; Cros 2003, pp. 140–144; Paris 2008–09, p. 146; London 2009, p. 77.

Exhibited in Paris.

Though the early provenance of this painting is not known, by 1916 it was in the collection of Ambroise Vollard. He lent it to the Exposition Triennale in Paris that year, and in 1917 to an exhibition at the Galerie Paul Rosenberg, and both times it was displayed with the title *Eurydice*. Indeed, a mythological setting is suggested by the small background figures decorating an ancient herm, a motif found also in *The Feast of Pan,* Renoir's 1879 painting for Paul Berard, and in the later *Ode to Flowers*. Yet it is unlikely that the composition represents anything so specific as the Eurydice story. With the exception of late works like *The Judgment of Paris* **Cat. 65**, Renoir generally avoided well-worn mythological narratives, preferring instead more general evocations of a classical past. The title *Eurydice* was probably assigned after the painting left Renoir's studio, perhaps by Vollard as a way of increasing the work's saleability. It was likely inspired by the bather's pose, which echoes the famous *Spinario* statue **Fig. 84**, and which fits the moment in the narrative when Eurydice is bitten in the foot by a snake. However, unlike the clearly injured bather in another *Spinario* composition by Renoir—the 1909 *Injured Woman* (location unknown, pictured in Meier-Graefe 1911, p. 175)—there is no evidence of a wound here.

Fig. 84

Spinario
(Boy with Thorn)
Bronze
Height: 28¾ in. (73 cm)
Rome, Palazzo dei Conservatori,
Musei di Capitolini

Fig. 84

Fig. 85

Pablo Picasso
Seated Bather Drying Her Feet
Summer 1921
Pastel on paper
26 x 20 in. (66 x 50.8 cm)
Berlin, Nationalgalerie Staatliche
Museen zu Berlin, Berggruen
collection

Fig. 85

For early-twentieth-century critics, Renoir's late nudes did not require a mythological narrative to conjure a remote past. They were seen as goddesses plucked from antiquity, their classical origins unequivocal. Yet if Renoir gave himself over to classicism, his deployment of its formal vocabularies is not so straightforward. With her small head and heavy legs, whose astonishing largeness struck the author André Malraux as almost arbitrary, a figure like *Eurydice* reinterprets the classical canon of ideal proportions.[1] Indeed, Renoir's classicism is not about the academic study of proportion but about nostalgic yearning. *Eurydice* presents a world impervious to the shifting social structures of modern life—to troubling class and gender ambiguities, and to the encroachment of industry on the landscape. The painting is a fantasy of the world in its nascent state, in which humans are uncomplicated, desiring beings—a fantasy made palpable by a luscious facture and distilled into the bather's contented expression.

If Renoir's classicism contributes to his uncertain place in the history of modernism, it was precisely this uncertainty that interested Pablo Picasso: he purchased *Eurydice* from Paul Rosenberg in 1919 or 1920, at a time when he was struggling with the problematic relationship of his own work to the art of the past. A painting like *Eurydice* would have appealed to Picasso for its negotiation between modernist and classical vocabularies, but also for the very sense of the past it evoked: a golden age rooted in bodily sensuality.

Picasso's interest in late Renoir owed partly to his relationship with Rosenberg. In the early 1920s, the dealer had a huge stock of late Renoirs, and Picasso, whose studio was next door to the gallery on the rue La Boétie in Paris, "could not have escaped these elephantine creations of Renoir's later years if he had tried."[2] In total, he bought seven Renoirs, all of them late paintings, making Renoir the second most represented artist in his collection.

Picasso's engagement with Renoir during the early 1920s had important repercussions in his own work. In his 1921 pastel, *Seated Bather Drying Her Feet* **Fig. 85**, for example, we see many echoes of *Eurydice*. Picasso's monumental bather takes up the whole of the pictorial space, in a pose almost identical to that of the Renoir figure. Like *Eurydice*, she is a purely corporeal creature who seems unconcerned with the things of the world: she gazes down in self-absorbed concentration, and her detachment is reiterated by the paring down of the background into three horizontal bands of sand, sea, and sky. Her gigantic arms are made heavier by the sculptural use of light and, in another apparent reference to a late Renoir painting, the *Seated Bather* of 1913 **Cat. 61**, her back bulges out past her shoulder. Yet her facial features are suprisingly delicate, her touch gentle, and it is perhaps in this contrast between anatomy and comportment that the picture's strangeness is located.

It is possible that Picasso knew *Eurydice* as early as 1916, when it was displayed at the Triennale and reproduced in the pages of *Les Arts*.[3] That same year Picasso designed a series of miniature drawings on matchbox covers imitating the styles of painters of the moment, one of which, as Sylvie Patry has observed, seems to be a "souvenir" of *Eurydice*.[4] Although the angle is different and a glimpse of the woman's sex is visible, the tilt of her head and the position of her legs are Eurydice's. Significantly, Picasso's *Bather Drying Her Leg* returns to the composition of the matchbox drawing. If the 1916 drawing was indeed a "souvenir" of *Eurydice*, it seems it later helped Picasso to translate Renoir's stunning painting into his own brand of corporeal classicism.

M. L.

1. Malraux 1974, pp. 20–21. **2.** Fitzgerald 1995, p. 106. **3.** Vernay 1916. **4.** Personal correspondence with the author; the matchbox is reproduced in sales cat. Christie's London, June 19, 2007, no. 166.

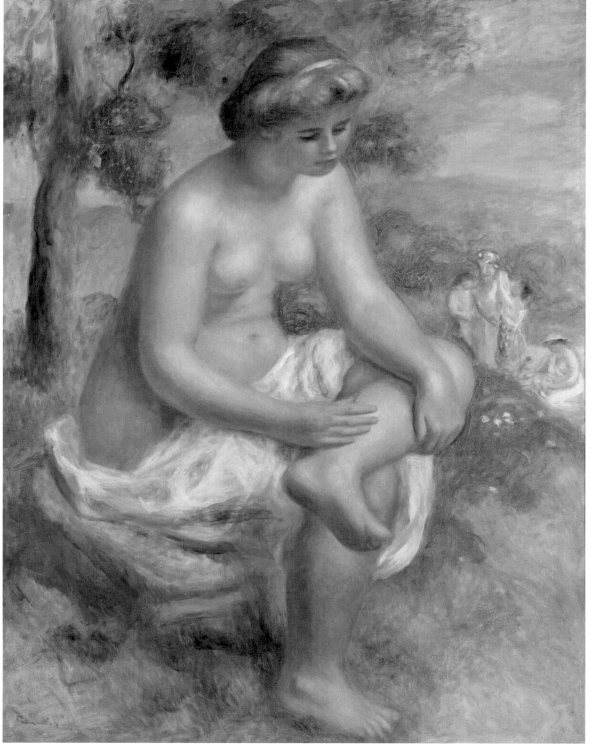

Cat. 22

Cat. 23

Gabrielle with a Rose *(La Sicilienne)* (Gabrielle à la rose [La Sicilienne])

Circa 1899
Oil on canvas
25³/₄ x 21³/₈ in. (65.3 x 54.2 cm)
Signed bottom left: *Renoir*
France, private collection

EXHIBITIONS
Paris 1913, no. 43 (as *Torse*, M. L. B[ernard] G[oudchaux] collection).
BIBLIOGRAPHY
Mirbeau 1913, pp. 48, 62; *Bulletin de la vie artistique* 1923, p. 492; Jamot 1929,
pp. 86, 97–98 (as *Gabrielle en buste*); Drucker 1944, pl. 130, pp. 211–212
(as *La Sicilienne*, J. P. Stang collection, Oslo); Daulte 1973, p. 81.

From the time she came into service in the Renoir family, Gabrielle featured as the children's nursemaid in paintings connected with Renoir's family life **Cat. 11**. However, very soon the status of "Ga" (as the three boys called her) changed, and she "began to do head poses, then she allowed a hint of shoulder to be seen, then a breast, and finally nothing was hidden from the painter's eye" according to Albert André.[1] Now a favorite model, "she featured everywhere in just about every canvas painted until 1914," when she left Les Collettes.[2] She is certainly the woman who posed for this *Female Torso* (the first title of the work at the Bernstein sale on June 8, 1911, lot no. 18), in spite of the title Drucker gave it in 1944, *La Sicilienne*.

Gabrielle with a Rose is apparently one of the first nudes to be inspired by the young woman. The painter decided on a three-quarter view of her, her head in profile to the left and her body from the waist up, which is very unusual for a Renoir nude. Here, the model is not caught unawares in what she is doing, as was normally the case **Cat. 9**, but instead she seems to be posing for the painter. Renoir is no longer representing a scene from everyday life, but rather a "portrait of a nude." Her noble pose has a look of Renaissance portraits about it. For instance, we find the same motif of the model from the waist up, with hands crossed on her

lap, in the famous *Mona Lisa* or even in the idiosyncratic transposition of it made by Camille Corot (*Woman with Pearl*, ca. 1868–70?, Paris, Musée du Louvre)—who was, for Renoir, "the greatest modern painter." Admittedly, in these two works the young women are fully clothed, their faces turned toward the spectator, but such differences are an indication of Renoir's taste for multiple references in the same canvas; the reference to antiquity—quite pronounced in his work at the turn of the century—is especially noticeable here. He was no doubt impressed by the Greek statues in the Louvre's antiquities collection, which he visited frequently at the time (see also **Cat. 10**), and which are echoed notably in the sculptural rendering of the young woman's bust, solid and firm, and the color of marble. If the chignon, with its strands falling over the nape of the neck, is reminiscent of the same hairstyles of classical Venuses, the head in profile seems to be taken from the figure of *Diana the Huntress* (Musée du Louvre).

Renoir reappropriated all of these references to turn his own canvas into a very personal work. The flower (white tinged with pink), which stands out from her black hair, was to become a frequent motif in his painting **Cat. 59**, while "the red hands and solid arms"[3] of which the painter was particularly fond and that are in evidence here, are repeated later, for example in *Bather with Brown Hair (Gabrielle Drying Herself)* **Cat. 47**.

Gabrielle with a Rose stands out against a landscape of dark foliage, which gives even greater emphasis to the paleness of the flesh tones and the sculptural appearance of the body. Barely defined, it becomes a simple backdrop, giving the scene a timeless quality, as is often the case with bathers painted by Renoir after the 1890s.

Gabrielle with a Rose was acquired on August 3, 1900, by Durand-Ruel, and exhibited, to our knowledge, only once, in 1913. It has belonged to several prestigious collections in France (Henry Bernstein, from April 1909 to June 1909; Bernheim-Jeune, June 1909; Bernard Goudchaux and Paul Guillaume) as well as abroad (J. P. Stang in Oslo).

I. G.

1. Exh. cat. Bagnols-sur-Cèze 2004, p. 62. 2. Ibid. 3. André, in ibid., p. 61.

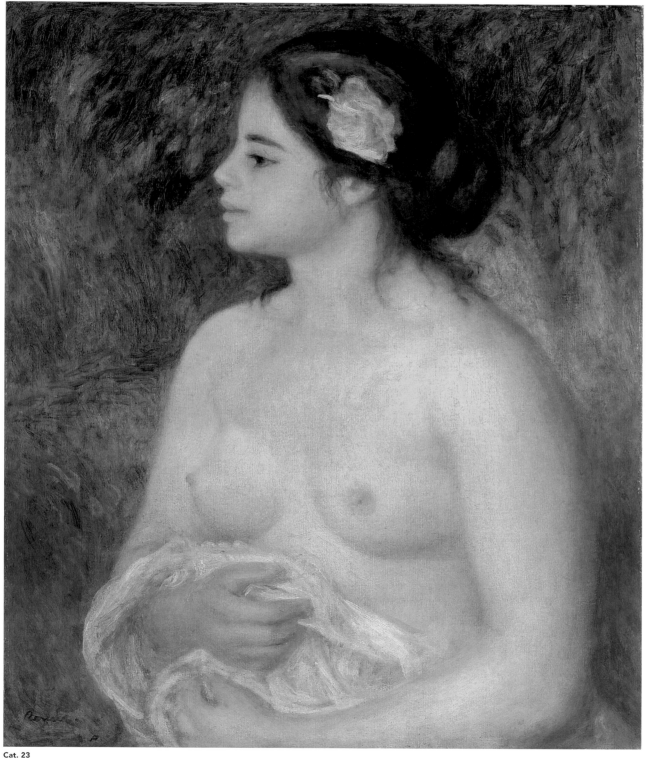

Cat. 23

Cat. 103

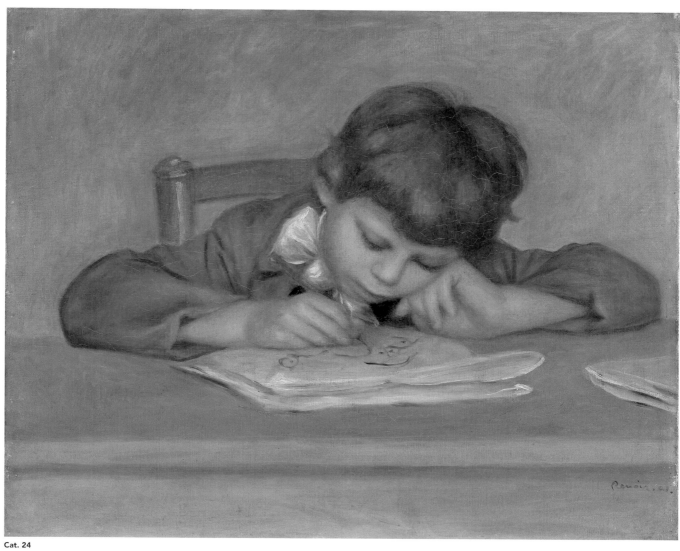

Cat. 24

Cat. 24

The Artist's Son, Jean, Drawing (Jean Renoir dessinant)

1901
Oil on canvas
17³/₄ x 21¹/₂ in. (45 x 54.5 cm)
Signed and dated bottom right: *Renoir. 01*
Richmond, Virginia Museum of Fine Arts, Collection of Mr. and Mrs. Paul Mellon, 1983
83.48

EXHIBITIONS
Paris 1912, no. 17; Edinburgh and London 1953, no. 46a; London 1956, no. 20; Washington, DC, 1966, no. 116; Nagoya, Hiroshima, and Nara 1988–89, no. 55; Ottawa, Chicago, and Fort Worth 1997–98, no. 57; Atlanta, Denver, and Seattle 2007–08, no. 88.

BIBLIOGRAPHY
Vollard 1918b, pp. 11, 183; Rivière 1921, p. 114 (dated 1888); André 1919, pl. 38; Bernheim-Jeune 1931, vol. 1, pl. 80, no. 260; Wilenski and Denvir 1954, vol. 2, pp. 3, 24; F. D. 1956, p. 65; White 1984, pp. 220, 223; Near 1985a, p. 458; Near 1985b, pp. 78–79; Howard 1991, p. 2; Joubert and Renard 1995, p. 12; Bragger and Rice 1996, p. 236; Rayfield 1998, p. 72; Bragger and Rice 2000, pp. 186–187; Nerét 2001, p. 378; Distel 2005, p. 106; Wax 2007, p. 27; Bret and Matsuda 2008, p. 6.

Posing for their father could be a chore for Renoir's sons, boring and difficult to sustain. To get around the boys' natural restlessness, the painter often waited until they were engrossed in a game

Fig. 86

Pablo Picasso
Claude Drawing
1951
Oil on canvas
18¹/₈ x 15 in. (46 x 38 cm)
Private collection

Fig. 86

Pablo Picasso
Child Eating (Paulo)
1922

Cat. 103, p. 216

or other enjoyable activity and had become oblivious of his presence. That is when he would sketch and paint them. Resulting pictures like *Gabrielle et Jean* **Cat. 11** and *The Artist's Son, Jean, Drawing* derive their characteristic air of intimacy and personal engagement from this practice. Fifty years after the fact, Jean Renoir remembered in detail the genesis of the latter portrait: "I was myself exactly seven when the painting was done. I had caught a cold and could not go to school, and my father took the opportunity to use me as a model. To keep me quiet, he suggested that a pencil and piece of paper should be given to me and he convinced me to draw figures of animals while he himself was drawing me."[1]

It was neither the first, nor the last time that Renoir painted one of his sons drawing. The oldest, Pierre, was thus portrayed in 1888 (private collection), and Claude, the youngest, in 1905 (Glens Falls, NY, The Hyde Collection).[2] In each instance, the composition focuses closely on the boy's head and hand, mirroring his absolute concentration on the task. In *The Artist's Son, Jean, Drawing* the view is widened somewhat to encompass more of the table top, chair, and paper on which the boy is working. Combined with the "honesty" and sobriety implied by the simple furniture and the restrained, warm color scheme, this perspective allows both sympathetic engagement and objective observation—traits that also characterized the genre paintings of Jean-Baptiste-Siméon Chardin. Renoir was an avowed admirer of Chardin, but there is a telling difference in their respective treatments of children absorbed in a task. Whereas in Chardin the activity itself generally carried a moralizing message—there were frivolous pursuits, such as blowing bubbles and the building of houses of cards, and there were useful activities, such as sewing (for girls) and studying books (for boys)—Renoir's candid studies of his sons avoid such subtexts.

Years later, these portraits in their turn became an inspiration for Picasso who, first in the early 1920s, and then again around 1950, painted series of pictures showing his own young children—first Paulo, later Claude and Paloma—at play, drawing, or eating **Cat. 103 & Fig. 86**. Stylistically unlike anything Renoir ever painted, these engaging scenes nonetheless reveal Picasso's knowledge and appreciation of Renoir's models in the way they represent the children's world with directness and simplicity, without recourse to implied narrative or comment. Picasso's portrait of Paulo eating **Cat. 103**, in particular, exploits the tight framing Renoir had devised to convey the spirit of the moment. The sense that the close pictorial focus enacts the child's absorption in his task is surely derived from Renoir's model.

The Artist's Son, Jean, Drawing marks a small milestone in the boy's young life. At the time it was customary that young children, boys as well as girls, wore their hair long, making the most of their pretty baby curls. Renoir, who loved to paint his sons' luxuriant locks adorned with ribbons and bows, made Jean keep this look longer than was usual. Suffering from taunts by other children, Jean "impatiently awaited the day when I was to enter the Collège de Sainte-Croix, where the regulations required a hairstyle more suited to middle-class ideals."[3] 1901 was the year this finally happened.

Like many of Renoir's portraits of his sons, which were painted for the artist's own pleasure, *The Artist's Son, Jean, Drawing* remained in the artist's collection until his death.

C. E.

1. Letter to John Roberts of Ganymede Press, 1952, quoted in exh. cat. Ottawa, Chicago, and Fort Worth 1997–98, p. 232. **2.** Both are illustrated in exh. cat. Ottawa, Chicago, and Fort Worth 1997–98, p. 330, figs. 282, 283. **3.** J. Renoir 1974, p. 20.

Cat. 25

Cat. 25

Claude and Renée (Claude et Renée)

1903
Oil on canvas
31 x 25 in. (78.7 x 63.5 cm)
Signature stamp, bottom right
Ottawa, National Gallery of Canada, Purchased 1949
4989

EXHIBITIONS
Paris, Bernheim-Jeune, 1938 (not in catalogue); Montreal 1948, no. 25 (dated 1904); Toronto 1949, no. 25 (dated 1904); Vancouver 1953, no. 79; Toronto, Ottawa, and Montreal 1954, no. 74; Los Angeles and San Francisco 1955, no. 64; Halifax, St. John's, Charlottetown, Fredericton, and Québec City 1971, no. 12; Chicago 1973, no. 73; London, Ontario, 1980, p. 24; Vancouver 1983, p. 58; Brisbane, Melbourne, and Sydney 1994–95, no. 41; Ottawa, Chicago, and Fort Worth 1997–98, no. 59; Vancouver, Regina, Windsor, Halifax, and Québec City 2000–02, p. 28; Columbus 2005–06, no. 73; Rome 2008, no. 38.

BIBLIOGRAPHY
Vollard 1920, p. 155; Rivière 1921, p. 213 (as *Enfant et sa bonne*); Vollard 1925, p. 154; Bernheim-Jeune 1931, vol. 1, no. 284, pl. 88; Terrasse 1941, pl. 37; *Canadian Art* 1950, p. 160; Hubbard 1959, pp. 44–45; Fosca 1961, pl. 184, p. 270; Hubbard 1962, p. 157, pl. 27, frontispiece; Boggs 1971, p. 41, fig. 56; White 1984, pp. 216, 222; Keller 1987, p. 140; Monneret 1990, p. 126; Washington, Paris, Tokyo, and Philadelphia 1993–94, p. 84; Nerét 2001, p. 379; Dauberville 2007, p. 103 (photograph of the 1938 Bernheim-Jeune exhibition).

Renoir's third son, Claude, was born in 1901. Nicknamed Coco, he rapidly became his father's new favorite infant subject. Once again, as with Jean some years before, the artists was captivated by pudgy baby cheeks, flouncy baby dresses and bonnets, and silky golden curls allowed to grow long and held with satin bows. In this portrait, he depicts Claude in the arms of Renée Jolivet, who, like Gabrielle Renard, had joined the Renoir household to help care for the children and assist with household chores. According to Jean Renoir, Renée was "a superb creature" who soon also doubled as a model for his father.[1] Renée's service with the Renoirs—or more precisely under the supervision of the irascible Madame Renoir—may have been difficult, since she did not remain with them for very long. She resigned in 1904 and—in Jean Renoir's sometimes fanciful memory—became an actress, traveled a great deal, and went to live in Egypt for some time.[2] More accurately, after leaving the Renoir household, Renée married Alphonse Cayat, a dramatic actor, and subsequently went to Turkey, not only to follow her husband on tour, but also to perform herself, using the stage name Renée Georges.[3] She later divorced Cayat, and remarried in 1934.[4]

While most of the portraits Renoir painted of his sons with their nursemaids are characterized by a feeling of warm intimacy between child and adult **Cat. 11**, *Claude and Renée* is marked by a strong sense of formality. Perhaps this reflects a certain emotional distance between the maid and her charge: unlike Gabrielle, Renée Jolivet did not became a surrogate mother to the Renoir children. At the same time, the hieratic composition may also be a deliberate allusion by Renoir to medieval Madonna-and-Child statues, with their combination of immobile gravitas and familial closeness.[5] Indeed, his figures have a clear sculptural quality made particularly palpable by the way they are set off against a plain, undifferentiated background, and by the use of an almost monochromatic palette dominated by earth tones. Their monumentality in many ways prefigures not only Picasso's "neo-classical" figures of the 1920s, but perhaps even Antoine Bourdelle's colossal *Virgin of Alsace* (1922, near Niederbruck, Haut-Rhin). Itself a modern reiteration of medieval sculpture, it was similarly based on family models—the sculptor's wife, Cléopatre, and their young daughter, Rhodia.

As was his habit, Renoir prepared the portrait of *Claude and Renée* with a series of study drawings, as well as with at least one painted "sketch" for the figure of Claude in his flamboyant bonnet.[6]

J. P. M.

1. J. Renoir 1962, p. 373. **2.** Ibid. **3.** We are grateful to M. Bernard Pharisien, who knew Renée Jolivet personally, for this information. **4.** Exh. cat. Ottawa, Chicago, and Fort Worth 1997–98, p. 236 **5.** Ibid. In fact, Renée Jolivet herself confirmed: "I modeled a Virgin and Child with Coco in my arms." (manuscript source, communicated by Bernard Pharisien). **6.** Reproduced in ibid., p. 331.

Cat. 26

Misia Sert

1904
Oil on canvas
36¹/₄ x 28³/₄ in. (92.1 x 73 cm)
Signed and dated top right: *Renoir 04*
London, The National Gallery, Bought 1960
NG 6306

EXHIBITIONS
Paris 1943, no. 167; Arles 1952, no. 28; Atlanta, Seattle, and Denver 1999, no. 54; Paris 2005–06, p. 72.

BIBLIOGRAPHY
Gold and Fizdale 1980, pp. 106–108 (portrait bought for 10,000 francs); White 1984, pp. 230, 233; Monneret 1990, p. 130.

Renoir knew Misia and met her often from the second half of the 1890s on. Born Misia Godebska in 1872, she was an accomplished pianist and, at the time, the beautiful young wife of Thadée Natanson, one of the two founders of *La Revue blanche*. Natanson was a fervent supporter and friend of Renoir, and he published a very nice portrait of him in the journal in 1896. Save for a brief estrangement connected with the Dreyfus affair (the Natansons were supporters of Dreyfus[1]), the connection between Renoir and the young woman (the muse of Vuillard, Bonnard, and Vallotton, who did numerous portraits of her in the late 1890s) came through the Symbolist and Nabi avant-garde circles associated with the journal, but also through Mallarmé, a mutual friend whose funeral Misia and Renoir attended together **Cat. 132 & 133**. From this time on, Misia valued the painter highly, and tried to buy two of his works from the Galerie Durand-Ruel, "*The Luncheon* and *The Balcony,* for which they were asking 4,000 francs. It turned out that I did not have enough money to buy them, so I begged a cousin of mine . . . to make the purchase. Alas! I came up against a refusal as ironic as it was contemptuous."[2] If the anecdote is true (the prices seem very low for pictures of this caliber), it may have been *Luncheon of the Boating Party* **Fig. 4**, sold by the dealer's sons in 1923 to the major American collector, Duncan Phillips, and *On the Terrace,* also sold by them, in 1925, for 100,000 dollars to Mrs. Lewis Coburn, an important collector from Chicago (1881, The Art Institute of Chicago). These two paintings, both of which featured in the Durand-Ruel inventory, were shown in the gallery in 1892 and 1899. The anecdote clearly shows Misia's taste for a style of painting that was just beginning to be accepted.

Yet Renoir only began to do portraits of Misia in 1904, either in February or the following autumn. He had become a sought-after painter, with the Salon d'Automne retrospective earning him a triumph that same year. Misia's situation also changed at that time. *La Revue blanche* had folded. Misia had divorced Thadée, now ruined, to live with Alfred Edwards, the fantastically wealthy press baron whom she married on February 24, 1905. Renoir, who got on well with Edwards,[3] was one of the few from the "*Revue blanche* years" (along with Bonnard) to remain close to Misia, and in 1911 she introduced him to the Ballets Russes, of which she was a keen patron. Like Bonnard, Renoir painted a portrait of Misia showing her new social status: it was a frivolous piece, far removed from the sensitive pianist of the 1890s shown in portraits or in quiet, intimate interior scenes by Toulouse-Lautrec, Vuillard, Vallotton, and Bonnard. Rich and confident, she posed in her new, luxury apartment in rue de Rivoli: "[I] settled down meekly in my pink dress, with a fringe on my forehead, to recapture my pose in the large arm-chair. In that little room, upholstered with green silk, the light was excellent, coming from two large windows overlooking the Tuileries . . . To the soft accompaniment of Gabrielle's advice and

criticism, which rippled on incessantly, Renoir spoke to me about the Commune. It was his favourite subject. . . . Then, suddenly interrupting his work, he would beg me to open my dress lower on the neck. During our sittings Renoir did not tolerate the slightest interruption. The amount of work he put into a portrait was very considerable. . . . a sitting lasted a whole day for him, for he stayed for luncheon, and when I returned towards the end of the day he was still there, profiting from the sun up to the last moment."[4]

According to Misia, Renoir painted seven or eight portraits of her; three are known today (Tel Aviv Museum of Art; Merion, PA, The Barnes Foundation). The one in the National Gallery was to be the second in a series that may have been halted by the divorce from Edwards in 1909. In July 1906 Renoir invited Misia to Essoyes: "I promise that I'll try to make you more beautiful than ever in your seventh portrait."[5] There followed another one executed in Nice, about which Bonnard reported, "They say the results are marvelous."[6] Renoir was measuring himself against the aristocratic portraits of Titian and Veronese, but also with Ingres, whose *Madame de Senonnes* he adored (Nantes, Musée des Beaux-Arts).[7] It also brings more directly to mind the portrait of *Madame Moitessier* **Fig. 87**, less well known then, but Renoir could have seen it in 1867 and 1883. Degas praised the painting for its classical nobility,[8] while Renoir borrowed the sitter's pose, itself derived from a fresco in Herculaneum (*Hercules and Telephos*, Naples, Museo Archeologico) that shows the traditional demeanor of melancholy.

At the end of the day Renoir delivered an ambitious portrait, in which the restraint and slightly cool ceremonial style contrast with the private nature of a painting that was apparently never exhibited in the days of Misia's prime. As Proust said, she had become a true "monument" of the literary, artistic, and musical glitterati in Paris. A close friend of Jean Cocteau, Coco Chanel, and Pierre Reverdy, she led an eventful life in which her marriage to, and then divorce from, the Spanish painter José Maria Sert left its mark. Nonetheless, throughout it all, Misia kept this portrait in her own possession.[9]

S. P.

1. Sert 1953, p. 46. **2.** Ibid., p. 56. **3.** J. Renoir 1962, p. 403. **4.** Sert 1953, pp. 82–83. **5.** Ibid., p. 83. **6.** Quoted in Gold and Fizdale 1980, p. 108. **7.** Vollard 1994, p. 379. **8.** Unpublished notes, in exh. cat. London, Washington, and New York 1999–2000, p. 441, note 14. **9.** Exh. cat. Atlanta, Seattle, and Denver 1999.

Jean Auguste Dominique Ingres
Madame Moitessier
1856
Oil on canvas
78³/₄ x 36¹/₄ in. (200 × 92.1 cm)
London, The National Gallery

Fig. 87

Fig. 87

Cat. 26

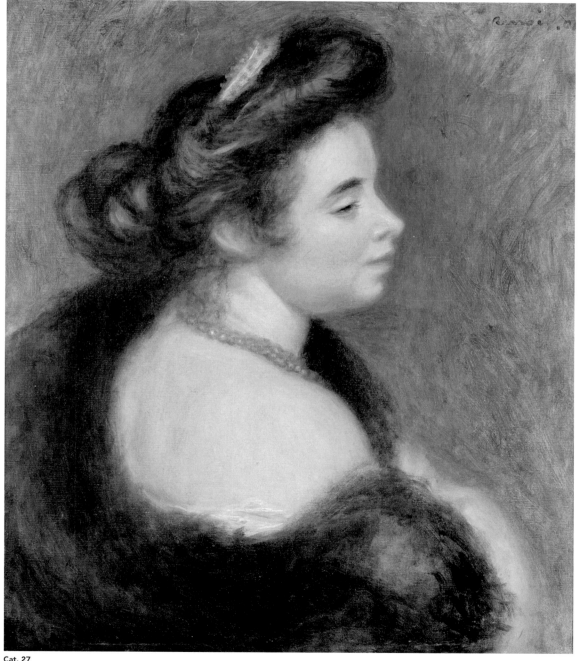

Cat. 27

Cat. 27

Portrait of Marthe Denis
(Portrait de Marthe Denis)

1904
Oil on canvas
21¼ x 17¾ in. (54 x 45 cm)
Signed and dated top right: *Renoir 1904*
Kitashiobara, Morohashi Museum of Modern Art

EXHIBITIONS
Paris, Galliera, 1953; Tokyo, Kumamoto, Ishikawa, Okayama, and Osaka
1983–84, no. 37; Saitama 2002, p. 155.

BIBLIOGRAPHY
Baudot 1949, p. 129; White 1984, p. 223, 226; Monneret 1990, p. 155.

Exhibited in Paris.

Maurice Denis was one of Renoir's early admirers, and he took the opportunity to praise, in *La Revue blanche*, the retrospective that the Galerie Durand-Ruel devoted to him in May 1892. As Jeanne Baudot (daughter of Renoir's physician and his student) recalled, it was most probably near the end of 1896 or the beginning of 1897 that, "at the time when I was working in Renoir's studio in 64, rue La Rochefoucauld [rented between October 1896 and 1901], Maurice Denis told me that he wanted to meet the master and I took on the task of interceding on his behalf. Renoir received him; he was pleased that the young generation appreciated his talent."

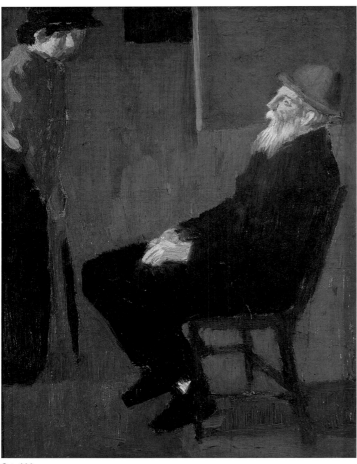

Cat. 114

Maurice Denis
*Portrait of Pierre-Auguste
Renoir with Jeanne Baudot*
Ca. 1906

Cat. 114

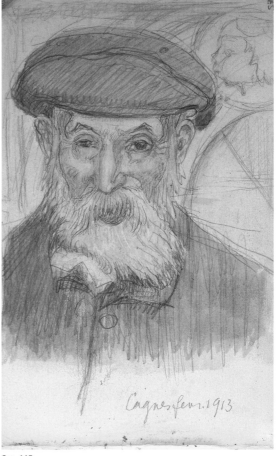

Cat. 115

Maurice Denis
*Portrait of
Pierre-Auguste Renoir*
February 1913

Cat. 115

In order to preserve the memory of this first encounter, Maurice Denis did a sketch from memory: Renoir is seated and I am standing in front of him, ready to leave"[1] **Cat. 114**. In fact Renoir appears for the first time in Denis's diary in spring 1897 and in correspondence.[2] Yet because of its style, its number in the Druet gallery inventory, and the likelihood that it was presented in the Bernheim gallery in 1907 ("Portrait de M. Renoir"), it is probably wise to date this sketch to 1906.[3] After 1897, Denis and Renoir saw each other frequently in Paris, as well as in Cagnes in 1906, 1910, and 1913 **Cat. 115**.

A first visit that took place in 1904 accompanied by his wife, Marthe, could have provided the opportunity for this portrait by Renoir, executed at Denis's request.[4] But this stay in Cagnes on the way back from Italy is not mentioned by Denis in his diary and does not really fit into his itinerary: he left Florence on April 24, was in Marseille on the 25th, and in Valence from the 26th to 29th, the date of his return to Saint-Germain-en-Laye.[5] Moreover, according to Jeanne Baudot's account, Marthe posed in the painter's Paris studio at 73, rue Caulaincourt. The Denises and Renoir were in Saint-Germain and Paris on July 14, when Renoir feared he would "have to delay this portrait project again," and on the 28th, when he left for Essoyes without having started it.[6] The fur worn by Marthe might suggest that the sittings occurred in the fall, but the picture does not give any futher clues, as Renoir uses a neutral, vibrant background in which to place and outline his model.

The composition's simplicity is underlined by a much reduced color range (black, play of warm tones varying from brown to golden, and the opposition of green and red complementaries). The almost square format—the same as for the portrait of Jeannie Valéry-Gobillard, another mutual acquaintance painted by Renoir in November 1904—and the arabesque drawn by the fur on the back also help to focus attention on Marthe's profile and shoulders and to enhance them. If we are to believe Jeanne Baudot, this was what Denis wanted: "'A pose studied in advance,' Renoir told me. I did not doubt it when I saw the picture: the bare shoulder emerging from the fur of a coat. Maurice Denis wanted Renoir to capture not only his wife's expression, but also the tone of her skin."[7] In the same year, Aristide Maillol adopted a similar approach for the first version of his portrait of Marthe: the pose was that of a young woman of thirty-three, elegant and sensuous, in a black dress with lowered straps, and it was this bust the collector Harry Kessler saw in Maillol's studio on August 21, 1904.[8]

These images of Marthe by Renoir and Maillol broke with the portraits her husband had done of her until then—from the "Symbolist Marthes" (to quote a title given by Denis himself) of the 1890s to the portraits of wife and mother dating from the turn of the century. Only in spring 1904, in Florence, in the course of a portrait series "in the style of the masters," had Denis represented

Marthe in a surprising light, her hair loose and shoulders bared (private collection). In commissioning two portraits of Marthe by Renoir and Maillol at the same time, Denis was thus comparing his unusually voluptuous image of Marthe, shapely and statuesque, with the idea of her provided by two artists whom he regarded as the heralds of a classical Mediterranean ideal that was both chaste and sensual. Thus the private memory of his beloved, who began to show the first signs of fatigue in 1904 (the prelude to the painful illness to which she succumbed in 1919), coincided with aesthetic concerns, just as Denis's third Italian visit forcefully confirmed the classical direction he had taken in 1898–99. Besides, in early 1904, Denis was also able to admire Renoir at the Libre Esthétique in Brussels where they managed to bring together thirteen of his "most outstanding works."[9] For Renoir, this portrait was an example of balance: between the bold decentering of a figure seen from the back and in profile like a sculpture, and the reassuring reproduction of her features, rendered with the requisite glorification of her beauty; between, too, the elegant tones of high society and the sense of closeness and intimacy in a portrait for a friend, itself the product of a dialogue between two artists inspired by the same model.

Denis kept this portrait all his life, in the salon of his house at the Prieuré in Saint-Germain-en-Laye, along with another Renoir, *Small Portrait of Young Girl*.[10] In 1961 the French national museums were asked to purchase Marthe's portrait, but they did not follow through.[11] The Morohashi Museum of Modern Art subsequently bought it at auction in 1997.[12]

S. P.

I am very grateful to Claire Denis for reading over this account and for the invaluable information she provided.

1. Baudot 1949, p. 129. **2.** Letter from Renoir to Denis, Saint-Germain-en-Laye, Musée Maurice Denis—Le Prieuré, Maurice Denis Archives, November 3, 1897, ms 13283. **3.** Dominique Denis and Anne Gruson, unpublished documentation, catalogue raisonné of Maurice Denis. **4.** According to White 1984, p. 223. **5.** Unpublished documentation, catalogue raisonné of Maurice Denis. **6.** Unpublished letters from Renoir to Denis, Saint-Germain-en-Laye, Musée Maurice Denis—Le Prieuré, Maurice Denis Archives, no inv. number and ms 13285. **7.** Baudot 1949, p. 129. **8.** Bouillon 1996, p. 129. **9.** Letter from Maurice Denis to Théo Van Rysselberghe, Saint-Germain-en-Laye, Musée Maurice Denis—Le Prieuré, March 12, 1904, pointed out by Claire Denis. **10.** Sotheby's London, May 24, 1898, no. 22; documentation, unpublished catalogue raisonné of Maurice Denis. **11.** Paris, Musée du Louvre, Archives des Musées Nationaux, unpublished note by Jean Cassou to Germain Bazin. **12.** Christie's London, June 23, 1997, lot no. 2.

Cat. 28

Reclining Nude (Bather), also called
The Spring (Nu allongé [Baigneuse],
also called La Source)

1902
Oil on canvas
26^1/$_2$ x 60^5/$_8$ in. (67.3 x 154 cm)
Signed bottom right: *Renoir*
Private collection
22.10.01

EXHIBITIONS
New York 1954, no. 2; Chicago 1973, no. 72; Basel 1989–90, no. 61; London, Tokyo, and Nagoya 1995–96, no. 55; Sapporo, Nagasaki, Kyoto, and Tokyo 1996, no. 2; Tübingen 1996, no. 88; Basel 1997, no. 59; Sakura, Sendai, and Sapporo 1999, no. 36; London and New York 2000, no. 39; Bologna 2004, no. 42; Krems 2005, p. 90; Riehen/Basel and Vienna 2006–07, p. 32; Wuppertal 2007–08, p. 156.

BIBLIOGRAPHY
Vollard 1918a, vol. 1, p. 46, no. 183; Meier-Graefe 1929, p. 259, no. 244; Pach 1950, p. 106; *Museum of Modern Art Bulletin* 1957, vol. 24, no. 4, p. 3; Pach 1958, p. 134; Barr 1977, p. 16; Museum of Modern Art 1988, p. 122; Adriani 1999, pp. 272–273.

This picture is one of several reclining nudes in horizontal formats that Renoir produced over roughly a dozen years, beginning in the late 1890s. The first, now at the Barnes Foundation, was executed as a decorative panel for the home of Renoir's patron Paul Gallimard. The others do not seem to have been commissioned, which suggests that Renoir painted them for the market. Early owners of the Basel picture include Ambroise Vollard and Paul Rosenberg. When Rosenberg gave the painting to the Museum of Modern Art in New York in 1956 it made headlines: "First Major Renoir Enters Museum of Modern Art," proclaimed the *New York Times* on June 24. One might argue that this rather late date of entry into the museum's hallowed halls—and its departure in 1989, when it was sold to Ernst Beyeler—attests to Renoir's troubled place in the modernist pantheon.

Indeed, in a painting like *Reclining Nude (Bather)*, Renoir not only challenges modernism's definitions but actively positions himself as a "traditionalist in the royal line that stretches back

Fig. 88

Jean Goujon
*Nymph and a Small Genie
on a Sea-Horse*
1549
Bas-relief from the *Fontaine
des Innocents*, Paris
Marble
29^1/$_8$ x 76^3/$_4$ x 4^7/$_8$ in.
(74 x 195 x 12.5 cm)
Paris, Musée du Louvre

Fig. 88

from the present to Ingres, Rubens, Raphael, and Giorgione."[1] The painting takes up the Renaissance theme of the nymph at the spring, which Renoir reissues as an erotic vision of woman as life's elemental source. With flushed cheeks and closed eyes, foliage brushing against her groin, Renoir's nude reclines in abandon while a spring flows over the rocks behind her. Her body is turned toward the viewer, and its forms are repeated throughout the landscape—mountains rhyme with the curve of hips and breasts, while long, chestnut strands of hair fuse with the grassy bank —so that nature itself becomes corporealized. Yet if woman is presented as unequivocally "natural," this vision is clearly achieved through the use of artifice. Her torso is impossibly long, her forms rendered with a decorativeness that critics admired: "This is not a study of the nude for the sake of representation primarily. It is more in the nature of lyric invention."[2] *Reclining Nude (Bather),* in other words, is not so much about faithfully representing nature as it is about fantasy—a fantasy of woman and of pure painting itself.

Several authors have observed that Renoir's reclining nudes derive from Jean Goujon's sixteenth-century reliefs for the *Fontaine des Innocents* **Fig. 88**. Renoir's debt is immediately apparent in the theme and in the contours of his figure but, moreover, the pictorial space of *Reclining Nude (Bather)* actually mimics the shallow plane of a bas-relief. Positioned in the extreme foreground, Renoir's figure seems to project forward; yet at the same time all angles are flattened, elbows and knees positioned in careful parallel with the surface of the canvas. The body is painted as if it were a piece of sculpture in an architectural niche, an idea that Renoir took even further in the version for Gallimard by surrounding the figure with a trompe l'oeil stone frame. This slippage between painting and sculpture occurs continually in Renoir's late work, reflecting a desire to engage the viewer's tactile sense.

When Picasso painted his own version entitled *La Source* in 1921 **Fig. 89**, he was undoubtedly thinking of Renoir's composition, which he probably knew through Rosenberg. In Picasso's painting a massive nude reclines in the foreground, her sculptural forms lining up parallel to the picture plane like those of Renoir's figure. There is something vaguely sarcastic about Picasso's take on the theme of woman as origin, as the figure sits in a strangely barren landscape with water pouring out of her lap/vase, the reference to her "source" amusingly obvious. Picasso seems to have drawn upon Renoir's reclining nude also when he designed the invitation for his 1921 "Exposition Picasso" at Rosenberg's gallery (reproduced in Doschka 1996). Here, the nude's torso stretches like elastic across the foreground, as if Picasso is playing on, as well as relishing, Renoir's artifice.

M. L.

1. *New York Times* 1956. 2. Pach 1950, p. 106.

Pablo Picasso
La Source
1921
Oil on canvas
25¹⁄₄ x 35³⁄₈ in. (64 x 90 cm)
Stockholm, Moderna Museet

Fig. 89

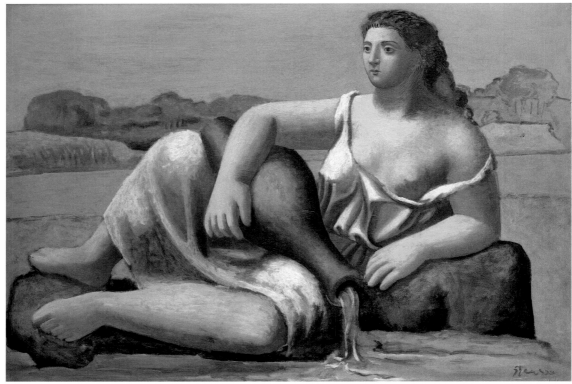

Fig. 89

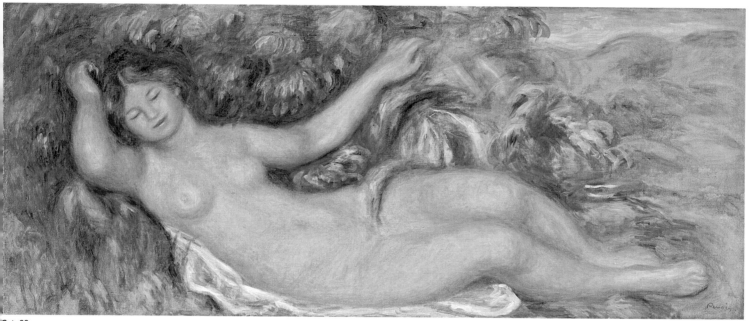

Cat. 28

Cat. 29

Bather (Baigneuse)

Circa 1903
Oil on canvas
36¼ x 28¾ in. (92.7 x73.4 cm)
Signed bottom right: *Renoir*
Vienna, Belvedere, purchased in 1923 from the Galerie Barbazanges with the assistance of the Verein der Museumsfreunde in Wien
2414

EXHIBITIONS
Paris 1913 (as *Nu à l'étoffe vert et jaune*) (?); Lyon 1952, no. 40 (as *Après le bain*, 1905); London, Paris, and Boston, 1985–86, no. 102 (no. 100 in French ed.).

BIBLIOGRAPHY
Mirbeau 1913; Rivière 1921, p.185 (as *Baigneuse à sa toilette*, 1903); Bernheim-Jeune 1931, pl. 83, no. 269 (as *Baigneuse assise, les cheveux épars*, 1902); Drucker 1944, pp. 102, 213, no. 147; Fouchet 1974, p.147; Wadley 1987, p. 286; Néret 2001, p. 337; Distel 2005, p. 110.

Exhibited in Paris.

Cat. 30

Large Bather (Baigneuse)

1905
Oil on canvas
38¼ x 28¾ in. (97 x 73 cm)
Signed and dated bottom right: *Renoir 05*
Philadelphia, Philadelphia Museum of Art, Gift of Mr. and Mrs. Rodolphe Meyer de Schauensee, 1978
1978-9-1

EXHIBITIONS
Zurich 1917, no. 214 (as *Torse de femme*); Paris, Bernheim-Jeune, 1938, no. 107 (as *La Grande Baigneuse*); New York 1950, no. 72; Los Angeles and San Francisco 1955, no. 67; New York 1958, no. 9; Chicago 1973, no. 74; London, Paris, and Boston 1985–86, no. 103 (no. 101 in French ed.).

BIBLIOGRAPHY
Rivière 1921, pl. 3 (as *Torse de femme*); René 1923, pp. 472–473; *L'Amour de l'art* 1926, p. 42; Meier-Graefe 1929, pp. 313, 334; George 1932, p. 272; Jedlicka 1947, no. 47; White 1984, p. 229.

From 1903 to 1905 Renoir painted several versions of a seated bather drying her leg and holding her hair out of her face. In one painting, at the Detroit Institute of Arts **Fig. 90**, her full-length figure fills the canvas, while in the Philadelphia and Vienna paintings, as well as in a third painted around 1904 **Fig. 91**, her legs are cropped just below the knee. Renoir had previously used the cross-legged pose in *Seated Bather in a Landscape*, called *Eurydice*, of about 1895 **Cat. 22**, but in the 1903–05 paintings the oblique angle of the figure creates a sinuous line that leads the eye along her massive thigh, up the torso to her red-cheeked face, and across a thick lock of hair that mirrors her leg. The arrangement of limbs and torso echoes François Boucher's *Diana Leaving Her Bath* of 1742 **Fig. 83, p. 205**. The sensuous open-air nude was a familiar theme in Rococo art, which abounded in mythological and allegorical narratives involving bathers. Renoir's adoption of the bather theme may reflect his admiration for Boucher, Antoine Watteau, and Jean-Honoré Fragonard, but Renoir's bathers are thoroughly modern in the lack of a narrative and in the monumental scale and cropping of the figures.

There are many precedents for the Vienna or Philadelphia bather in Renoir's work; she recalls the *Bather and Maid*, or *La Toilette* of about 1900 at the Barnes Foundation **Fig. 114, p. 337** in which a young woman sits with crossed legs while an attendant combs her long auburn hair. A pile of clothing and a wide-brimmed hat lie on the ground beside the bather who has a vulnerable expression and clutches a white cloth to her chest. The absence of the maid in the later versions concentrates all attention on the languid, self-absorbed nude who lacks an obvious purpose or setting. While the bather and her maid were situated beside a tree in a secluded grove, the bathers of 1903–05 are in an undefined location. The straw hat visible beside each figure suggests that she

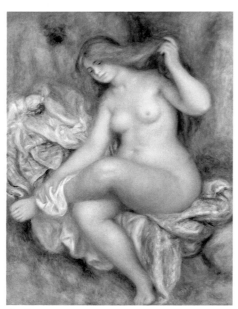

Fig. 90

Pierre-Auguste Renoir
Seated Bather
Ca. 1903–06
Oil on canvas
45¾ x 35 in. (116.2 x 88.9 cm)
Detroit, MI, Detroit Institute of Arts, Bequest of Robert H. Tannahill

Fig. 90

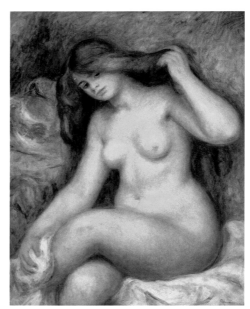

Fig. 91

Pierre-Auguste Renoir
Large Bather with Crossed Legs
Ca. 1904
Oil on canvas
36¼ x 28¾ in. (92.1 x 73 cm)
Private collection

Fig. 91

is outdoors, but foliage, rocks, and trees are not readily identifiable in the shallow patches of yellow, green, and brown around her.

Only the Philadelphia painting is dated, to 1905, but the other works can be placed around it if one assumes that Renoir was exploring the idea of a timeless nude and progressively shedding references to contemporary life. The Detroit version is probably the earliest, since it includes the most details of modern life, in the green and white patterned cloth on which the bather sits and the pink striped dress and beribboned hat that lie to her right **Fig. 90**. Gradually, in these pictures, the folds and patterning of the garments disappear into fluidly painted patches of color. In the Philadelphia *Bather* the dress has melted into a mass of red and pink paint that would be unrecognizable if one had not observed its decorative edgings in the Detroit or the Vienna paintings. Equally, the modeling of the figure grows softer, and she seems to lose bone and muscle-mass, becoming weightier and more bound to the earth. Subtle differences in the manner in which she holds her hair and inclines her head increase the sense that she is aware of the viewer.

The *Bather* is above all a painting of flesh—its suppleness, texture, and luminosity. Renoir reportedly delighted in ample, healthy models whose skin he praised for taking the light. Despite the overwhelmingly pink tones of the bather, the shadows and creases of her body are delicately modeled with yellow and brown and cooler tones like blue and gray. In their proportions and coloring, Renoir's nudes are often compared to the work of Rubens, whose grand canvases Renoir had long admired at the Louvre. Indeed, the critic Téodor de Wyzewa noted in his diary in January 1903 that Renoir was working on a large canvas, perhaps one of the bathers in this series, and that he spoke "of the genius of Rubens, of the quivers of joy one feels in front of his paintings."[1] In its focus on

anatomy and on eternal ideas of beauty, Renoir's *Bather* reflects his interest in and awareness of classical art. She is at once Venus, Diana, Eve, and Bathsheba, set in an Arcadian Mediterranean world. In fusing the bather with the past and with nature, Renoir was setting out his own ideals of female beauty and of pleasure. These ideals may have been at odds with contemporary feminist debates about women's role in society, but it was Renoir's paintings of nudes that most appealed to Picasso and other modern artists.

Renoir seems to have produced the 1903–05 bathers for his own pleasure, without an immediate goal of exhibiting or selling the canvases. The dated Philadelphia *Bather* was probably the one sold to Durand-Ruel in 1906. It was acquired by the Swiss collectors Emil and Alma Staub-Terlinden of Männedorf in 1916 and exhibited the following year in Zurich. The Vienna picture appears in Octave Mirbeau's publication accompanying the 1913 Bernheim-Jeune exhibition in which it may have been shown. If so, it did not sell since it was in Renoir's studio at his death and was later acquired by the Belvedere, the nineteenth-century painting gallery in Vienna. Another, *The Large Bather with Crossed Legs* **Fig. 91**, belonged to the Parisian banker and collector Jean Laroche who had his portrait painted by Édouard Vuillard in 1925–26 **Fig. 92**. In Vuillard's work Laroche is seated in his Paris salon, surrounded by tapestries, upholstered furniture, and two paintings by Renoir: *A Girl with a Fan* (ca. 1881, Williamstown, MA, Sterling and Francine Clark Art Institute) and *The Large Bather with Crossed Legs*, who hangs behind Laroche and echoes his own crossed-leg seated position.

J. A. T.

1. Duval 1961, p. 138.

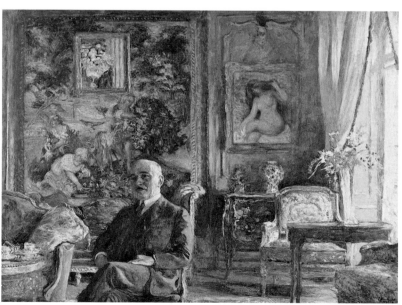

Fig. 92

Édouard Vuillard
Portrait of Jean Laroche
1926
Oil on canvas
35 x 45⅝ in. (89 x 116 cm)
Private collection

Fig. 92

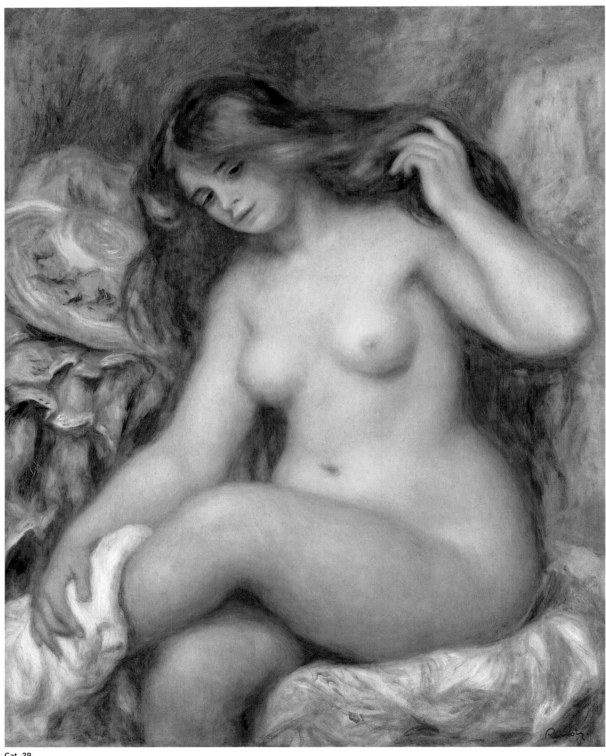

Cat. 29

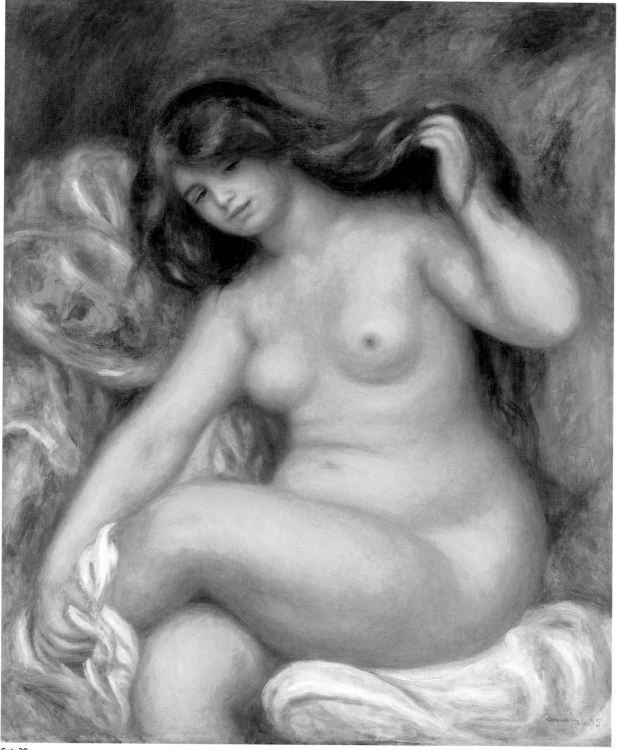

Cat. 30

Cat. 31

The Spring (La Source)

1906
Oil on canvas
36¼ x 28¾ in. (93 x 73 cm)
Signed bottom right: *Renoir*
Zurich, Stiftung Sammlung E. G. Bührle

EXHIBITIONS
Paris 1906, no. 1468 or 1469 (*as Femme nue*); London 1930; Amsterdam 1931, no. 45.

BIBLIOGRAPHY
Mauclair 1906, p. 144; Vauxcelles 1906; Meier-Graefe 1911, p. 177, 179 (as *Frauentorso*, Prince de Wagram collection, Paris); Vollard 1918a, vol. 2, no. 164; Rivière 1921, p. 249 (as *Baigneuse*); André 1923, fig. 39 (as *Torse de femme*); Régnier 1923, fig. 25; Meier-Graefe 1929, pl. 310 (as *Frauentorso*); Zervos 1934, p. 131; White 1984, pp. 228, 229 (as *Bather: The Source*); Gloor 2005, pp. 129, 152 (as *La Source*).

Exhibited in Paris.

"**S**ome primordial innocent madness, some ecstasy of gold, I don't know what it is! which she calls her hair, curves down with silken grace around a face lit up by the bloodstained nakedness of her lips. Instead of vain apparel, she has a body; and though her eyes are like precious gems, they cannot match the gaze that comes from her blissful flesh..."[1] The magnificent painting *The Spring* has everything of the "Woman of ancient times" celebrated by Mallarmé in his prose poem "Le Phénomène futur" in the anthology *Pages,* for which Renoir provided a decorative frontispiece in the form of a nude young woman with luxuriant hair and well-developed curves (Brussels, Edmond Deman, 1891). Renoir pursued one of his favorite themes with this painting, the personification of a spring: standing or reclining, they constitute a proper "family" among his nudes, and he exhibited two examples of them at the Salon d'Automne in 1904.

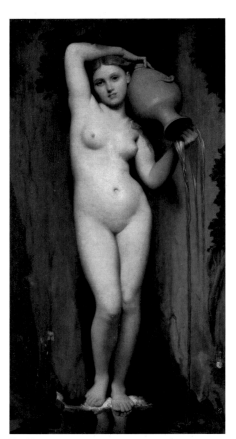

Fig. 93

Fig. 94

Jean Auguste Dominique
Ingres
The Spring
1856
Oil on canvas
163 × 80 cm
Paris, Musée d'Orsay, on deposit
from the Louvre, bequest
of Countess Duchâtel, 1878

Fig. 93

Alexander Liberman
The Studio of Georges Braque
From the book *The Artist in His Studio,* New York, Viking Press, 1960

Fig. 94

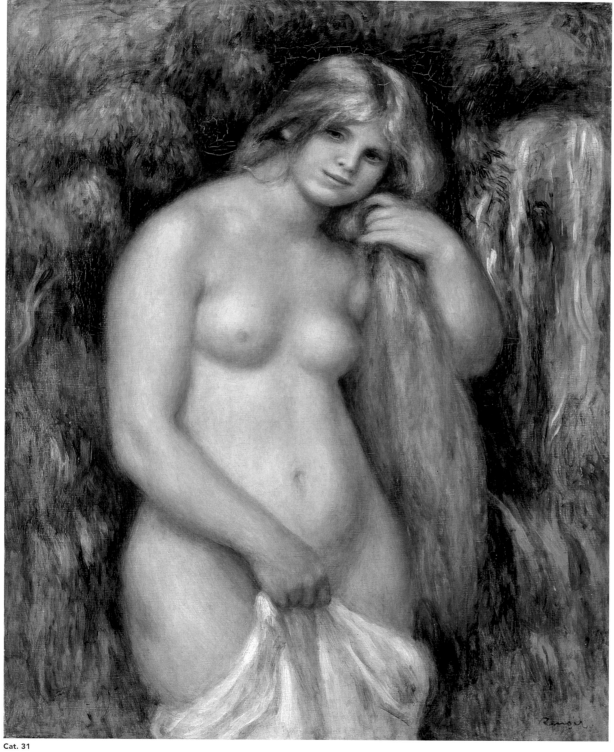

Cat. 31

The spring, symbolized by trickling water in pure white high-lights, allows the artist to associate woman with fertility, which is also suggested by the model's enlarged hips. As the source of life, woman is definitively placed by Renoir within the realm of nature, counter to the emancipatory trends at the turn of the twen-tieth century, as Garb (1985), House (1992), and Adler (1994) have rightly pointed out. This picture of nature—admittedly "con-structed" by a painter who was opposed to women's rights[2]—should in fact be interpreted in light of the social progress on which it turns its back, and from which it doubtless means to pro-vide an escape ("politics of escapism," according to John House). It is likewise a nature "of dreams," one offering not so much a social model as a golden age that only ever existed in art, as the painter well knew. In her pose, *The Spring* is a variation on the Medici Venus and the "Venus pudica" explored obsessively by the artist since the start of his career (*Bather with Terrier,* 1870, São Paulo, Museo de Arte). As was often the case, antiquity was only one of the many references with which Renoir competed: the "myriad" colors,[3] the smoothness of the model, and the "ecstasy of gold" of the hair hark back to Titian and to his very sensual penitent Mary Magdalenes, while the picture in its entirety is his most direct homage to *The Spring* by Ingres, referring to which he confessed that he "secretly took great delight [in her] pretty little belly" **Fig. 92**.[4] (His admiration should most probably be dated to the late 1870s rather than the 1850s, as he claimed, since *The Spring* could until 1863 only be seen in Ingres's studio.)

The clever layering of references does not interfere in any way with the primal energy that characterizes Renoir's late nudes and which has certainly contributed to their influence on subsequent generations. Besides revisiting Ingres—a veritable obsession shared by Picasso, Matisse, Denis, and Renoir around 1905—this "primitive" effect is created by the sculptural distortion and the enlargement and simplification of the body, which can be seen in Picasso's nudes of the 1920s but also in some from 1906–07. The painter owned a reproduction of the present *Spring* (Paris, Musée National Picasso, documentation), as did Braque, who had tacked it to his studio wall **Fig. 94**. It was also reproduced in the influential *Cahiers d'art,* edited by Christian Zervos in 1934, and it can be seen next to Renoir on the ceiling painting in the Petit Palais museum, created by Denis in 1925 **Fig. 61, p. 153**.

The Spring was shown at the Salon d'Automne in 1906, along-side four other paintings, forming a play of contrasts with another dark-haired nude (according to Louis Vauxcelles) and with *The Promenade* **Fig. 95, p. 240**; it constitutes a kind of companion piece to the latter, featuring the same model, only this time in modern dress and with her hair tied up. Two important critics commented on *The Spring,* which was positioned opposite ten Cézannes in the 1906 Salon d'Automne (of which Renoir was an honorary presi-dent): Vauxcelles hailed the two "luminous and warm" nudes, whose "youthfulness" surprised Camille Mauclair. *The Spring* then became part of the Prince de Wagram's collection, an eminent collector who also had a *Spring* from 1876. According to André Salmon, this painting, now in the Barnes Foundation like *The Bathers*—along with our *Spring* and the prince's whole collec-tion—was intended for the French state.[5] However, the prince's financial troubles and then death in 1918 put an end to this project.[6]

S. P.

1. Mallarmé 2003, p. 83. **2.** J. Renoir 1962, p. 88. **3.** Renoir, quoted in Pach 1912, p. 612. **4.** Renoir 2002, p. 31. **5.** Salmon 1956, p. 299. **6.** Exh. cat. London, Paris, and Boston 1985-86, pp. 25-27 (pp. 41–44 in French ed.).

Cat. 32

Terrace at Cagnes
(Terrasse à Cagnes)

Circa 1905–06
Oil on canvas
18¼ x 21⅝ in. (46.3 x 55 cm)
Signed bottom right: *Renoir*
Tokyo, Bridgestone Museum of Art, Ishibashi Foundation
Gaiyō 33

EXHIBITIONS
Osaka 1922, no. 33; Tokyo 1926, no. 9; Tokyo 1931, no. 88; Kamakura 1951, no. 8; Tokyo 1953, no. 50; Tokyo 1955, no. 44; Tokyo 1957a, no. 8; Tokyo 1957b, no. 33; Tokyo 1960, no. 114; Paris 1962, no. 40; Kurume 1963, no. 9; Tokyo 1968; Nagoya, Hiroshima, and Nara 1988–89, no. 57; Nashville 1990–91, no. 24; Brisbane, Melbourne, and Sydney 1994–95, no. 45; Sakura, Sendai, and Sapporo 1999.

BIBLIOGRAPHY
Gauthier 1958, p. 45; Fezzi 1972, no. 711; Fezzi 1985, no. 676; Bridgestone Museum of Art 1991, p. 68; Dussaule 1995, p. 13; *Ishibashi Collection* 1996, vol. 2, p. 29, no. 40, and p. 104, ill. 61.

From 1903 to 1907, before the purchase of Les Collettes, the Renoir family lived in an apartment in a building that housed the post office. From the windows, Renoir enjoyed a splendid view of the medieval town of Haut-de-Cagnes, as well as of a magnificent orange grove. The "Maison de la Poste" can be seen on the extreme right of the painting, surrounded by vegetation that no longer exists today. In the background are the houses of the old town built on the hillside. The white and ochre color harmonies of the façades complement the green and yellow tones of the exotic trees, bushes, and plants. The eye is drawn to a bright red spot of color that is the blouse of a woman seated sideways on the wall. She is accompanied by a man sitting a few steps away from her. The couple's presence breaks the fixity of the image and adds a "picturesque" note characteristic of Renoir's early twentieth-century landscapes. As here, these rural and semi-urban scenes are populated by workers, washerwomen, women reading, children playing, and young girls sewing or making up bunches of flowers.

Claude Renoir explains the logic that lay behind his father's decision to purchase Les Collettes and move from the Maison de la Poste: "A magnificent garden of beds of orange trees descended the hillside to the Vence road. The reason I mention these orange trees is because I am convinced that they are what lies behind the construction of the house at Les Collettes . . . In 1907, a decision was made to construct some new school buildings. One morning a team of laborers began pulling up the orange trees that formed the verdant foreground below our windows."[1] From this account, the decision to "save" the olive trees at Les Collettes, which were also slated for destruction, appears to have been just as important as that of planting an orange grove on the property, in memory of the orange terraces near the Maison de la Poste.

The painting, which was owned by Paul Durand-Ruel, migrated to Germany where it belonged to Paul Cassirer before becoming part of the collection of Japanese businessman Kōjirō Matsukata, who helped to bring Renoir to the attention of the Japanese through a major exhibition of his collection in Osaka in 1922.

V. J.

1. Dussaule 1995, p. 15.

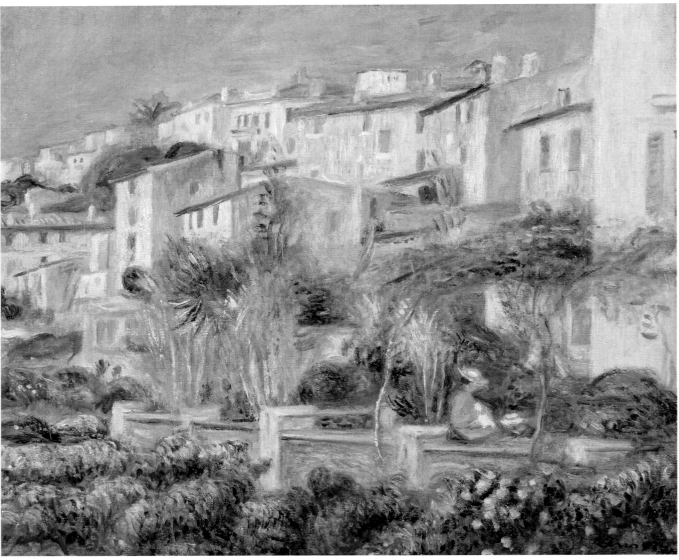

Cat. 32

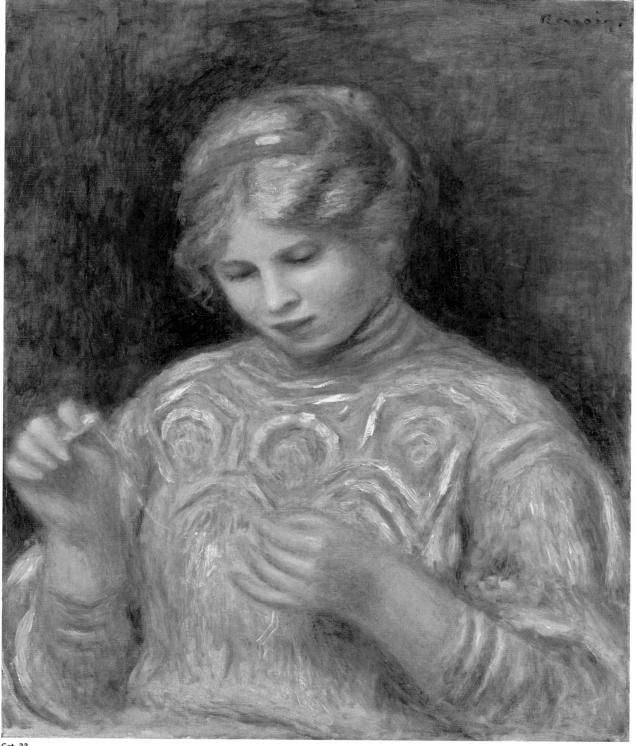

Cat. 33

Cat. 33

Girl Tatting (La Frivolité)

Circa 1906
Oil on canvas
22¼ x 18⅜ in. (56.5 x 46.7 cm)
Signed top right: *Renoir*
Philadelphia, Philadelphia Museum of Art, The Louis E. Stern Collection, 1963
1963-181-59

EXHIBITIONS
New York 1938–39, no. 18 (as *La Frivolité*); New York 1954, no. 4; Brooklyn 1962–63, no. 78.

BIBLIOGRAPHY
Rivière 1921, p. 239 (as *La Frivolité*); Meier-Graefe, 1925, p. 349 (as *Mädchenbildnis*); Wilenski 1940, p. 343 (as *La Frivolité*); Zahar 1948, pl. 77 (as *La Frivolité*); Philadelphia Museum of Art 1964, no. 136.

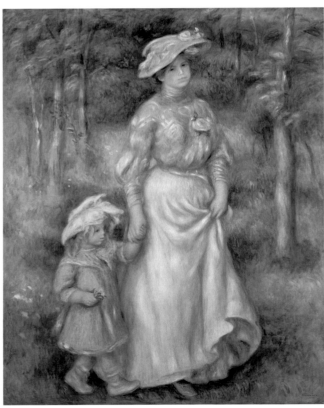

Fig. 95

Pierre-Auguste Renoir
The Promenade
Ca. 1906
Oil on canvas
65 x 50¾ in. (165 x 129 cm)
Merion, PA, Barnes Foundation

Fig. 95

Popularized by Thérèse de Dillmont's 1886 *Encyclopédie des ouvrages de dame* (Encyclopedia of Needlework), tatting, a form of lacemaking using a small shuttle and fine thread, became a fashionable women's pastime in the late nineteenth century. In Renoir's painting a young woman, wearing a blouse with embroidery that echoes the wheel-like patterns created in tatting, holds a tatting shuttle in her right hand and studies the lace in her left hand. An identical blouse is worn by a young woman in *The Promenade,* which was also painted in Essoyes in the summer of 1906 **Fig. 95**. Painted on an unusually fine canvas (Renoir generally preferred coarsely woven canvases), *Girl Tatting* has a lively surface; thick white impasto picks out the circular patterns on the gown while dabs of blue, green, pink, yellow, and white paint suggest the reflection of light on its surface. The cool green and blue tones behind the girl recall the backgrounds of Renoir's portraits of *Madame Paul Gallimard* (1892, private collection) and *Wilhelm Mühlfeld* (1910, private collection), but the painting lacks the specificity of a portrait or a genre scene.

Although Renoir painted many scenes of women embroidering or sewing, this is the only example of tatting in his oeuvre, and it is indebted to his love of seventeenth- and eighteenth-century painting. Johannes Vermeer's *The Lacemaker* (ca. 1669–70, Paris, Musée du Louvre), which Renoir admired, shows a young woman at a table making lace using a pillow and bobbins; her quiet concentration and studiousness is echoed in Renoir's picture. *Girl Tatting* equally acknowledges the eighteenth-century fashion for being portrayed while making lace. Sir Joshua Reynolds's *Portrait of Anne, Countess of Albemarle* (ca. 1760), which Renoir might have seen in London at the National Gallery in 1895, or Jean-Marc Nattier's *Portrait of Marie-Adelaïde of France* (1756, Versailles, Musée National du Château de Versailles) show noblewomen pausing between lacemaking knots. In both portraits the shuttle and thread feature prominently against the sitter's shawl or bodice, in the same manner that the elegant iridescent blouse of Renoir's young woman highlights her hands. The picture's uncertain relation to portrait and genre painting is echoed by the dual meaning of the title, *La Frivolité,* which is the term for this particular technique of lacemaking, as well as a noun meaning "trivial" or "lacking seriousness."

Girl Tatting first belonged to the industrialist Maurice Gangnat, who met Renoir in 1904 and purchased several canvases from the artist each year, in the process assembling one of the largest and most important collections of late work by Renoir.

J. A. T.

Gabrielle Mending (Gabrielle reprisant)

1908
Oil on canvas
25¹/₄ x 21¹/₄ in. (64 x 54 cm)
Signed top right: *Renoir*
Private collection

EXHIBITION
Tübingen 1996, no. 96.
BIBLIOGRAPHY
Werth 1925, p. 53; Alexandre 1930, p. 63.

Not exhibited.

Cat. 35

Seamstress at Window (Ravaudeuse à la fenêtre)

Circa 1908
Oil on canvas
25⁵/₈ x 21⁵/₈ in. (65 x 55 cm)
Signed bottom right: *Renoir*
New Orleans, New Orleans Museum of Art, Gift of Charles C. Henderson in memory of Margaret Henderson
No. 80.179

EXHIBITIONS
New Orleans 1959, no. 42; Orléans 1984, no. 26; Columbus 2005, fig. 20.
BIBLIOGRAPHY
New Orleans 1995, p. 70.

Renoir adored the theme of women sewing; it appealed to his love of domestic order and was a versatile subject that he returned to throughout his career. The solitary female figure engaged in handiwork has many precedents in Dutch and French genre painting and was also popular with Renoir's contemporaries Mary Cassatt, Berthe Morisot, Camille Pissarro, and Édouard Vuillard. For these painters it was an opportunity to paint modern life, clothing, and interiors, but in Renoir's hands it often became a study of tranquility and earnest concentration. Renoir frequently positioned the seamstress perpendicular to his easel so that he could paint her profile and show the fall of light on her face and clothing. It also provided him with the challenge of painting hands; he once exclaimed to Ambroise Vollard: "I can't understand a painter who doesn't like to paint hands!"[1] Scenes of women sewing may have held the added attraction of being readily observed and of requiring little effort from his models, who were frequently servants or members of his household.

Two paintings of about 1908 show Gabrielle stitching a piece of cloth. *Seamstress at Window* places her beside her source of light and suggests a comfortable, well-ordered household. A pot of flowers sitting on the sill obscures the view from the window, though a palm tree composed of a few rapid brushstrokes can be seen in the distance. The seamstress, wall, landscape, and flowers are all painted in the same warm yellows, oranges, reds, and greens, but a subtle use of shadows and tonal differences allows the solid form of the woman to emerge from her environment. The neat appearance of the seamstress lends a moral uprightness to the scene, while her profile view and voluminous sleeve create a sense of distance indicative of her meditative state.

Gabrielle Mending shows a sparse interior with only an upright chair and a green chair rail, yet the painting is strikingly colored. Gabrielle's red gown provides a vibrant field of color that thrusts her forward and balances her dark hair and eyes. Renoir adored red, but according to Vollard Gabrielle also loved to wear bright colors and to dress in a bohemian fashion. The square-necked gown is an informal one of a type that might have been worn around the house; there are several other paintings of Gabrielle in precisely this gown (*Gabrielle in a Red Dress,* 1908, Cambridge, MA, Fogg Art Museum). Its loose shape suggests a country setting far removed from Paris fashions.

The painting belonged to Maurice Gangnat in whose catalogue it is listed as having been painted in Cagnes in 1908; Renoir spent much of the year there and in the autumn moved into the new villa at Les Collettes. A red chalk drawing, also formerly in the Gangnat collection, is closely related to the painting and shows Gabrielle in profile with tendrils of hair falling around her face, driving a needle into a white cloth (*Gabrielle Sewing,* 1908, whereabouts unknown, pictured in Rivière 1921, p. 152).

Gabrielle mending was purchased directly from Renoir by Gangnat and was in his collection until 1925. Bernheim-Jeune later sold it to Henri Canonne, who owned an impressive collection of Impressionist paintings in the 1930s. *Seamstress at Window* was acquired by Durand-Ruel and belonged to Hunt Henderson of New Orleans who, beginning in 1905, formed one of the earliest collections of French Impressionist paintings in Louisiana.

J. A. T.

1. Vollard 1925, p. 198.

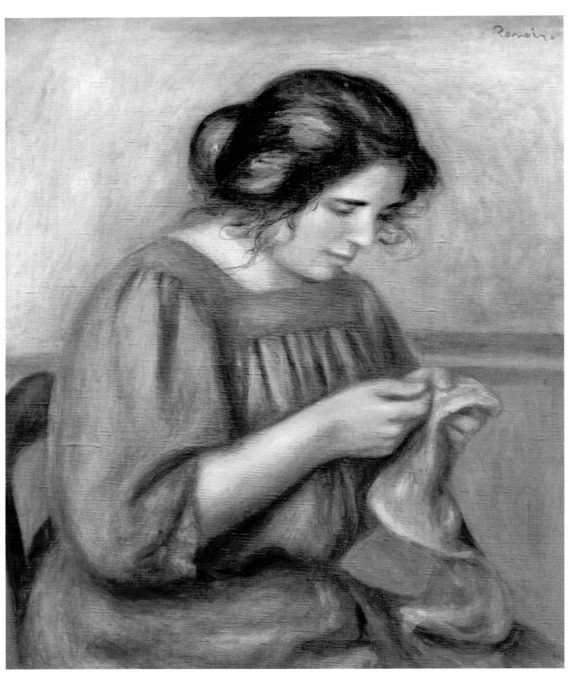

Cat. 34

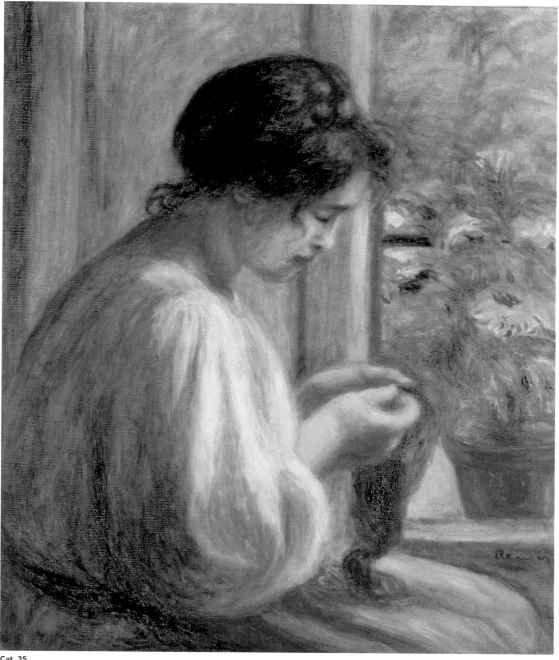

Cat. 35

Gabrielle Reading (Gabrielle lisant)

1906
Oil on canvas
21⁵/₈ x 18¹/₄ in. (55 x 46.5 cm)
Signed top right: *Renoir*
Karlsruhe, Staatliche Kunsthalle, purchased 1966
2550

EXHIBITIONS
Tübingen 1996, no. 95; Krems 2005, pp. 51, 105; Columbus 2005–06, p. 20.
BIBLIOGRAPHY
Lauts and Zimmermann 1971, vol. 1, p. 195, and vol. 2, p. 336; Keller 1987, no. 121, p. 145; Pharisien 1998; Voigt 2005, p. 89.

Renoir painted none of his models more often than Gabrielle Renard: she sat for him in portraits of Jean **Cat. 11**; in domestic genre scenes **Cat. 34**; for timeless nudes **Cat. 23**; and in costumed studio fantasies **Cat. 59**. Reading, the theme of this picture, was of long-standing interest to Renoir—for portraits (*Madame Monet*, 1872, Williamstown, MA, Sterling and Francine Clark Art Institute), as a shared activity linking figures psychologically **Cat. 5**, and as a motif in scenes of everyday life **Fig. 10, p. 41**.

Nonetheless, *Gabrielle Reading* differs from these readers, and others that we might cite, by its tight framing and emphasis on the figure at the expense of surrounding space and air. If Renoir usually situates his readers in more or less elaborated three-dimensional spaces, clearly detaches the figure from its background, and locates both behind the picture plane, in *Gabrielle Reading*, by contrast, he collapses space and focuses radically on the robust physicality of the model's body to produce a visual effect not unlike bas-relief sculpture. Her full arms and ample breasts swell forward; her oval head seems to tilt out of the picture plane; her chair and the drapery behind it (or is it alongside?) fuse into a single field of colors with such material density that the lines of body and furniture join in one plane without suggesting a shift across space. In short, foreground and background are no longer differentiated.

With this, *Gabrielle Reading* perhaps is best understood and appreciated alongside the bathers and studio compositions of Renoir's final years **Cat. 78 & 80**, in which the relationship of figure to ground was his great concern. Renoir believed these late paintings were the successful culmination of his ongoing struggle to find a proper balance between representation (what is observed) and painting (what happens on the canvas). "How difficult it is in a picture to find the exact point where the imitation of nature should end," he explained to Albert André, and went on to describe the method that made his late bather pictures a success: "I struggle with my figures until they are completely at one with the landscape that serves as their background."[1] In effect, this struggle also describes the unusual character and pictorial structure of *Gabrielle Reading*.

C. E.

1. André 1919, pp. 34, 35.

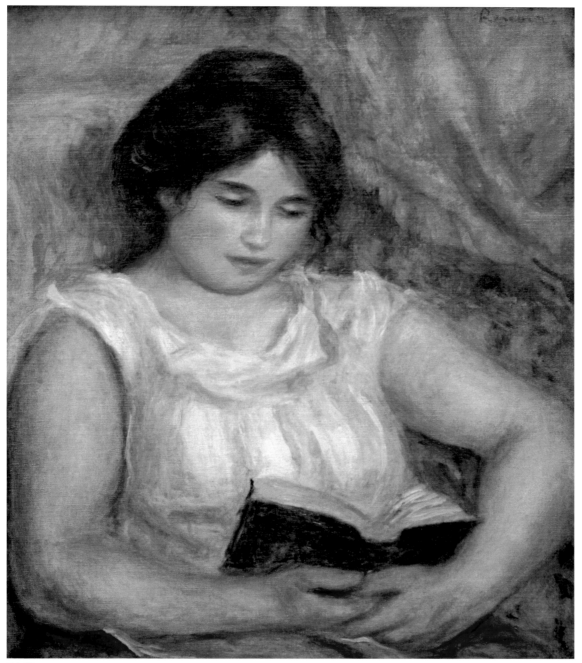

Cat. 36

Head of a Young Girl (Tête d'une jeune fille)

Circa 1890
Oil on canvas
16³/₄ x 13¹/₈ in. (42.6 x 33.3 cm)
Signed top right: *Renoir*
Washington, DC, National Gallery of Art, Gift of Vladimir Horowitz 1948
1948.18.1

EXHIBITIONS
Paris 1902, no. 3; New York 1924, no. 30.
BIBLIOGRAPHY
Dale 1929, no. 30; Washington, DC, 1965, p. 111, no. 1032; Washington, DC, 1968b, p. 101; Daulte 1971, vol. 1, no. 597; Washington, DC, 1975, p. 292; Washington, DC, 1985, p. 336..

La Toilette, Woman Combing Her Hair (La Toilette, femme se peignant)

Circa 1907–08
Oil on canvas
21⁵/₈ x 18¹/₄ in. (55 x 46.5 cm)
Signed top left: *Renoir*
Paris, Musée d'Orsay, bequest of Comte Isaac de Camondo, 1911
RF 2016

EXHIBITIONS
Marseille 1963, no. 51.
BIBLIOGRAPHY
Jamot 1914, p. 395–396; Vitry [undated], no. 198; Vitry 1914, p. 38; Vitry 1922, p. 42; Berr de Turique [1953], pl. 94; Bazin 1958, p. 296; Adhémar et al. 1959, p. 191, no. 375; Sterling and Adhémar 1958–61, vol. 4, no. 1610, pl. 631; Louvre 1972, p. 318; Fezzi 1985, p. 118, no. 705; Compin and Roquebert 1986, vol. 4, p. 173; Rosenblum 1989, p. 435; Compin, Lacambre, and Roquebert 1990, vol. 2, p. 392.

The studio figure, the artist's equivalent of a musician's scales, was an exercise to which Renoir turned consistently and with pleasure. Executed in 1890, *Head of a Young Girl* shows a half-figure dressed in a simple sleeveless white chemise, turned sideways toward the right. Her chestnut hair is gathered into a low bun. She stands out against the background of a plain band of orange placed alongside patterned wallpaper. The looser treatment and freer technique of the background allow the figure, with its clearly defined contours, to stand out sharply. Renoir fills the space fully yet without saturating it, achieving a subtle balance between the model and the decorative motifs, the content and the form. The roundness of the bun echoes the form of the petals, just as the body itself is constructed of a succession of curves. This fondness for cursive movement, and the use of an approach that creates both form and decorative motif in one and the same movement, is reminiscent of Jean-Honoré Fragonard, an artist in whom Renoir took an increasing interest in the late 1880s.

Almost twenty years later, Renoir turned his hand again to a very similar composition with *La Toilette, Woman Combing Her Hair*. However, rather than a studio exercise, Renoir preferred to show a woman in the everyday activity of styling her hair. Also dressed in a white chemise, this young woman is absorbed by the image she sees in the mirror, though it is partially concealed from the viewer. Her concentration counterbalances the apparent simplicity of her action. The theme of a woman styling her hair, and more broadly that of *la toilette,* is very common in the European art tradition. It features several times in Renoir's oeuvre from the mid-1870s, both as the subject of the painting, as in *Young Woman Braiding her Hair* (1876, Washington, DC, National Gallery of Art) and as an occupation for his women bathers. In Renoir's work, the hair plays a very important role as an emblem of femininity. However, this painting has more in common with *Young Girl with Arms Raised* at the Bremen Kunsthalle (undated), although its framing is far tighter and the model's right arm, bent toward the nape of her neck, entirely conceals her face.

The historical distance that separates the two works reflects the artist's evolution of style. The slightly grey-tinted flesh tones of *Head of a Young Girl* has given way to warmer colors. The general tonality of the piece is warmer, and the technique is looser. Furthermore, the importance given to the long, dark hair reflects the reestablishment of black as a key color in the painter's palette. In *La Toilette* Renoir creates a more complex and structured space, constructing his background in a similar manner and playing on the orientation of the constituent parts. The horizontal division of the background in *Head of a Young Girl* is replaced in the Musée d'Orsay painting by a vertical split. However, Renoir retains the principle of contrasting a plain band of color with a decorative pattern.

La Toilette, Woman Combing Her Hair was owned by the collector Isaac de Camondo, who donated his collection to the French state. This bequest, one of the most important ever made to the museum, ran counter to the customary rule by which artists were not accepted at the Louvre until ten years after their death. In addition to this work, Camondo also owned two other paintings by Renoir, *Young Girl with a Straw Hat* (ca. 1908, Paris, Musée d'Orsay) and *Young Girl Seated* (1909, Musée d'Orsay). This donation significantly enriched the public collections of Renoir's contemporary works, just as the earlier Caillebotte bequest had brought works from his Impressionist period to the Musée du Luxembourg.

The three paintings in the Camondo collection were purchased from Durand-Ruel in 1910,[1] as was the painting at the National Gallery in Washington, DC, which, after being sold by Renoir to the celebrated art dealer on June 26, 1900, was purchased in 1926 by Chester Dale. It later became part of the collection of Vladimir Horowitz, who gave it to the museum in 1948.

É. V.

1. *Young Girl with a Straw Hat,* purchased from Renoir on August 4, 1908, and *Young Girl Seated,* purchased from Renoir on July 27, 1909, were acquired by Camondo on April 29, 1910. *La Toilette, Woman Combing Her Hair,* purchased from Renoir on September 5, 1910, became part of the collection on November 15 the same year.

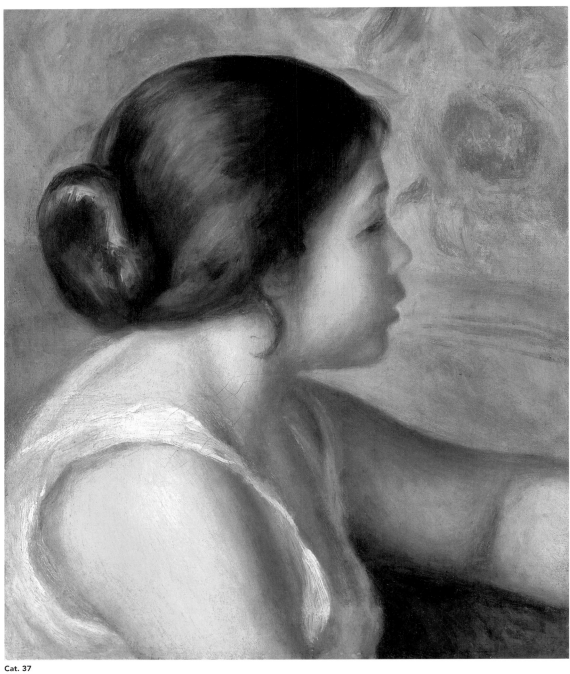

Cat. 37

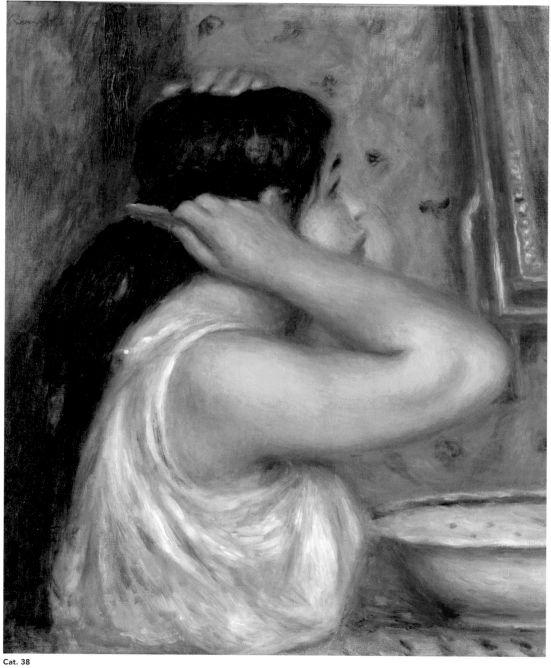

Cat. 38

Nude on Cushions, also called *Large Nude* (Nu sur les coussins, *also called* Grand nu)

1907
Oil on canvas
27 1/2 x 61 in. (70 x 155 cm)
Signed and dated center left: *Renoir 1907*
Paris, Musée d'Orsay, acquired by gift in lieu of inheritance taxes in 2000
RF 1975 18

EXHIBITIONS
Paris 1913, no. 48 (Amélie Dieterlé collection, as *Nu sur les coussins*); Paris, Durand-Ruel, 1920, no. 41; London 1932, no. 488 (as *Femme nue couchée*); Paris, Jeu de Paume, 1978; Paris 1980–81, no. 197; London, Paris, and Boston 1985–86, no. 106 (no. 104 in French ed.); Paris 1996–97, p. 165; Madrid 2001–02, p. 47, no. 8.

BIBLIOGRAPHY
Meier-Graefe 1911, p. 181 footnote; Meier-Graefe 1929, pp. 300–302; Vautheret 1933, no. 25; Adhémar 1976, p. 102–104; Distel 1989a, p. 240; Compin, Lacambre, and Roquebert 1990, pp. 510–511; Toutghalian 1995, p. 27.

Between 1903 and 1907, Renoir executed three important paintings, horizontal in format and showing nude female figures reclining on cushions: *Reclining Nude* (1903, private collection) **Fig. 97**, *Reclining Nude,* also called *Gabrielle* (ca. 1906, Paris, Musée de l'Orangerie) **Fig. 98**, and *Nude on Cushions,* also called *Large Nude.* Although Renoir tried his hand quite early on at open-air reclining nudes, as can be seen in *A Nymph by a Stream* (1868–69, London, National Gallery), it was primarily through the filter of the orientalizing odalisque and the languid Venus that he addressed the interior reclining nude.

In a room decorated with a green check wall covering, the model who, unlike in the other two paintings, is not Gabrielle, lies on a divan draped with a white sheet that covers her sex. Reclining against a large, round cushion, she raises her left arm toward her coppery hair, adorned with an open bloom, while her right arm rests naturally along her body. Though similar in composition, this painting differs significantly from the other two nudes. In this work, the last in a series of three, Renoir fully develops the sumptuous vision of color and décor that would come to characterize his late career. While he retains the traditional contours of the body, the style is far more supple, and the overall tonality warmer. The ideal simplicity of this classic theme becomes the pretext for chromatic

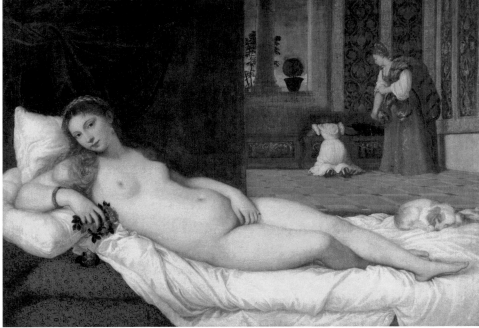

Fig. 96

Tiziano Vecellio,
called Titian
The Venus of Urbino
1538
Oil on canvas
47 x 65 in. (119 x 165 cm)
Florence, Galleria degli Uffizi

Fig. 96

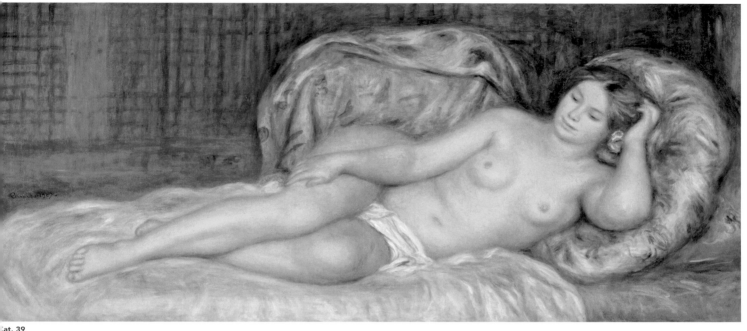

Cat. 39

experimentation and the celebration of color in the tradition of the great Venetian masters, under whom Renoir would have loved to have studied.

Renoir's late nudes are placed firmly within the mainstream of the European art tradition and evoke those of other great artists such as Titian, Rubens, and Goya, as well as Ingres and Manet. His debt to Titian is quite apparent: his *Nude on Cushions* evokes Titian's *Venus with Cupid and Organist* (1550, Madrid, Museo del Prado) **Fig. 11, p. 43** and especially the celebrated *Venus of Urbino* at the Uffizi Gallery in Florence (1538) **Fig. 96**, works that Renoir admired during his trips to Italy in 1881 and Spain in 1892 with Paul Gallimard. Like Ingres, Renoir dissolves the joints and makes use of physical distortion. These anatomical liberties are justified by the construction of the painting. In accentuating the volumes around the figure's pelvic area, Renoir is reconsidering the canon of femininity, just as he would do with the execution of his monumental sculpture *Venus Victrix* **Cat. 70**. This effect is rendered all the more impressive by the dimensions of the painting and the almost life-size presentation of the model. In fact, all three indoor nudes are distinguished by their large format. As Renoir's health deteriorated, their execution required great physical effort on his part and, although he often returned to this subject, it would always be in smaller formats, as in his *Reclining Nude, Seen from the Back,* also known as *After the Bath* (ca. 1909, Paris, Musée d'Orsay).

Unlike Édouard Manet's *Olympia* who keenly holds the viewer's gaze, Renoir's figure lowers her eyes, leaving us to our contemplation. It is interesting to note that in February 1907 Manet's painting, gifted to the French state by a group of subscribers that included Renoir, made its entry into the Louvre after spending seventeen years in the Musée du Luxembourg. Could it perhaps have been this flamboyant arrival on the walls of the Louvre that spurred Renoir to return to a composition developed a few years earlier?

Although Renoir's earlier *Reclining Nude* **Fig. 97** was shown at the 1905 Salon d'Automne (no. 32)—of which in fact Renoir was for the first time president—it was not until the exhibition mounted by the Galerie Bernheim-Jeune in 1913 (the preface to which, written by Octave Mirbeau, endorses the "simplicity" of Renoir's painting), that *Nude on Cushions* was revealed. Two years earlier, in a monograph devoted to Renoir, Meier-Graefe had rated it as a painting of prime importance.

The painting was purchased by the actress Amélie Dieterlé, Paul Gallimard's mistress, for her collection. Fernand Moch, an important collector from the 1920s and 1930s, bought the painting at public auction in 1933; later it belonged to the Kahn-Sriber collection, which also contained Vincent van Gogh's *Starry Night* (1888, Paris, Musée d'Orsay) and a drawing for *Olympia* by Manet (ca. 1862–63, Musée d'Orsay).

É. V.

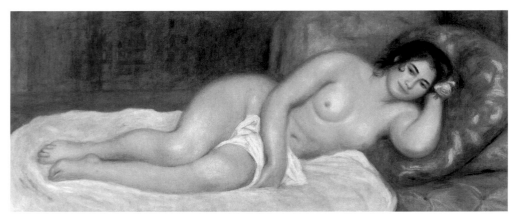

Fig. 97

Pierre-Auguste Renoir
Reclining Nude
1903
Oil on canvas
25⅝ x 61⅜ in. (65 x 156 cm)
Private collection

Fig. 97

Fig. 98

Pierre-Auguste Renoir
Reclining Nude (Gabrielle)
Ca. 1906
Oil on canvas
26⅜ x 63 in. (67 x 160 cm)
Paris, Musée de l'Orangerie, Jean Walter and Paul Guillaume collection

Fig. 98

Cat. 40

Dancing Girl with Tambourine
(Danseuse au tambourin)

1909
Oil on canvas
61 x 25¹/₂ in. (155 x 64.8 cm)
Signed and dated bottom left: *Renoir 09*
London, The National Gallery, Bought 1961
NG 6317

Cat. 41

Dancing Girl with Castanets
(Danseuse aux castagnettes)

1909
Oil on canvas
61 x 25¹/₂ in. (155 x 64.8 cm)
Signed and dated bottom left: *Renoir 09*
London, The National Gallery, Bought 1961
NG 6318

EXHIBITIONS CAT. 40 & 41
Paris 1931; Paris, Orangerie, 1933, nos. 118, 119, and pl. LVIII; London 1937, nos. 13, 14; 1937–54, long-term exhibition, Philadelphia Museum of Art; London 1998; Williamstown, Dallas, and Paris 2003–04, pp. 111–114, nos. 116, 117; Columbus 2005–06, figs. 50, 51, and p. 120; Rome 2008, no. 47.

BIBLIOGRAPHY CAT. 40 & 41
Meier-Graefe 1911, pp. 180–182; Jamot, December 1923, p. 329; Bouyer 1925, p. 250; sales cat. Paris, Drouot, 1925, nos. 138, 139; Meier-Graefe 1929, pp. 307–315; Alexandre 1931, p. 267; Bérenger 1931, p. 36; Drucker 1944, p. 145; Herbert 2000, p. 76.

On the eve of the dispersal of Maurice Gangnat's collection, the most significant ever assembled in France of Renoir's late-style paintings, the critic Charles Fegdal praised the "riot of color, magnificent use of light, a glorious feast of art. It contains one hundred and sixty Renoirs and four Cézannes."[1] The hundred and eighty or so paintings in total had been brought together lovingly and, as Renoir emphasized, with an "eye for it"[2] by the collector, who met the painter around 1904–05 through Paul Gallimard.[3] Gangnat bought directly from the painter, often during visits to Cagnes. *Dancing Girl with Tambourine* and *Dancing Girl with Castanets* fall into a different category, as they were commissions like some portraits, and were intended to be positioned on either side of a mirror in the dining room of the collector's apartment in Paris at 24, avenue de Friedland. In this way, Gangnat provided Renoir with one of his very rare opportunities to create a decoration for a specific architectural context. Yet, when he saw the *Dancing Girls* in situ, Meier-Graefe bemoaned the fact that Renoir had to be content with a bourgeois apartment, when it "should have been a fairy castle."[4] As far as the German critic was concerned, Renoir's panels managed nevertheless to make you "forget the narrow dining room, the mirror, and all the pettiness of our everyday lives."[5] Following the example of many decorative works in the nineteenth century, they lure us effectively into a daydream of someplace else.

Yet, as was usually the case, Renoir's models were drawn from the domestic sphere: Georgette Pigeot, Renoir's model from 1909–10, remembered posing for *Dancing Girl with Tambourine* and also taking over occasionally from Gabrielle, whose features were used for *Dancing Girl with Castanets*, when she had "a lot to do in the house."[6] The figures originally carried baskets of fruit, a fitting subject for the room which was to host the decoration.[7] In any case, when the painter and critic Jacques Félix Schnerb paid Renoir a visit in Paris in June 1909, the master showed him "two large sanguine sketches, two Oriental dancer figures . . . 'You see,

just by using tone, this has color.'"[8] Renoir was then following his standard practice of executing full-size red-chalk drawings which he later transposed onto canvas. Two of these can be identified today (each 55¹/₈ x 23⁵/₈ in. [140 x 60 cm]) but the poses and costumes in them are not the ones he retained in the final compositions. Renoir also designed parts separately, using drawings or painted sketches (*Woman Playing the Tambourine*, for instance, New York, Christie's, May 10, 2001, lot no. 110). He worked on the panels in tandem, depending on the models' availability; "when he was not satisfied," his model would pin up a "small piece of canvas . . . onto the large one, in a corner, and he would paint, nothing very precise, . . . he was looking for color tones."[9] This preparatory work and the length of time it took to develop reveal the importance Renoir attached to this ensemble, as does the format, which forced him to find a way of reaching all areas of the canvas in spite of his paralysis. Unable to remain upright for a long time, "he had his chair set up on trestles and painted the large dancing figures of the Gangnat collection high up," according to Albert André.[10] It may have been Monet's example (in June, Renoir had gone at the last minute and admired the exhibition of *Waterlilies* at the Galerie Durand-Ruel[11]) that inspired him in turn to rework his own vision of decoration in this ambitious diptych. Along with the Barnes Foundation's *Caryatids* **Fig. 78 & 79, p. 186**, these panels are in fact the last decorations to be completed by Renoir.

On this occasion, Renoir returns to a theme that has been important in his work since *Ball at the Moulin de la Galette* **Fig. 2, p. 31**. He had already successfully tested out the ornamental properties of dancing with *Dance in the City* and *Dance in the Country* **Cat. 1 & 2, p. 133**, a subject that was also central to the revival of decorative painting in the early twentieth century. Here, however, Renoir dispenses with any sociological description in favor of a rich work of fantasy filled with myriad references ranging from the shows of the Spanish dancer "La Belle Otéro"[12] to the Old Masters. Veronese immediately springs to mind—always admired in the Louvre and whose modern relevance was confirmed for Renoir during a trip to Venice (planned for fall of 1908 but postponed till June 1909)—but also the dancers from Mantegna's *Parnassus* (1497) in the Louvre, of which he had his student, Jeanne Baudot, make a copy.[13] More than anyone, one thinks of Eugène Delacroix—for example, the Louvre's *Jewish Wedding in Morocco* (see **Fig. 99**), from which Renoir pilfers the dancer as well as the tried and tested combination of the complementaries red and green. Indeed the Gangnat *Dancing Girls* represent the culmination of the rivalry and "vital dialogue" in which Renoir was engaged with the man whom he "valued above all others."[14] Renoir had been interested in Delacroix's Orientalism since the 1860s, especially that of *Jewish Wedding* and the *Women of Algiers in their Apartment* (1834, Paris, Musée du Louvre) to which he made repeated references. Renoir was also part of a more straightforwardly commercial form of Orientalism, in which the dancer with tambourine had become a colorful *topos*.[15] Renoir was aware of this aspect, using all sorts of fabrics and studio props that evoke Algeria at the turn of the century, mixed with Spanish castanets and boleros.[16] But if he let himself be carried away by the scent of the harem emanating from Delacroix's *Women of Algiers*,[17] Renoir was not attempting to reconstruct some "local color" or other. His admiration extended to the "Arabs, the only remotely interesting people with a free spirit, and beautiful" he wrote in 1883–84.[18] Renoir here is certainly experimenting with the decorative principles elaborated by Delacroix, especially in his late work in the Chapel of the Angels in the church of St. Sulpice in Paris (completed

1861): simplification, rich and powerful colors, arrested motion in order to give full monumentality to the figures which stand out like the maenads of classical reliefs. All of these were qualities to which the sculptor Henry Moore was sensitive, even in his own work, and which, in his view, justified the place of the *Dancing Girls* in a museum as prestigious as the National Gallery in London. These are the words he used in defense of their proposed acquisition: "Whoever doesn't like those girls doesn't understand what Renoir was trying to do. The two pictures must represent at least three or four months of continuous work at the best period of Renoir's life. . . . In these pictures he has learned to fit his forms into space. The shapes of these two girls are melted into the background; so that what you see and feel about them comes from inside the forms, not just from the outlines, as it did earlier, in his hard-edge paintings. And yet these rounded forms have a marvellous, supple rhythm, such as people are apt to associate only with outlines. What one likes about them is that, though they are so monumental, yet, if you compare them, for instance, with Maillol's sculp-tures, they have none of the stiffness which these are apt to have. They make me realise that Renoir was really a much greater sculptor than Maillol. . . . The pictures represent, I'm sure, a significant episode in Renoir's career, a special effort; that's why I think they are not just ordinary pictures for private collectors, why I believe they are the kind of pictures we should have in the National Gallery."[19]

S. P.

1. Fegdal 1927, pp. 177–178. 2. J. Renoir 1962, p. 450. 3. White 1984, p. 228; exh. cat. London, Paris, and Boston 1985–86, p. 288 (p. 358 in French ed.); exh. cat. Cagnes-sur-Mer 2008, pp. 93–95. 4. Meier-Graefe 1911, p. 181. 5. Ibid. 6. Letter from Georgette Pigeot to Cecil Gould, July 13, 1961, London, The National Gallery, documentation. 7. Ibid. 8. Schnerb 1983, p. 176. 9. Letter from Georgette Pigeot, July 13, 1961 (see note 6). 10. André 1923, p. 36. 11. Exh. cat. London, Paris, and Boston, p. 311 (p. 396 in French ed.). 12. Baudot 1949, p. 70. 13. Baudot 1949, p. 30. 14. Meier-Graefe 1911, p. 25. 15. See, for example, Léon François Comerre, *Young Woman with a Tambourine* (Paris, Hôtel Drouot, December 15–16, 2008, no. 81), but also Charles Landelle and Étienne Dinet. 16. Benjamin 2003, p. 114. 17. Baudot 1949, p. 28, cited in Renoir 2002, p. 201. 18. Renoir, quoted in Herbert 2000, p. 132. 19. Typed note, June 1963, London, The National Gallery, documentation, quoted in Wadley 1987, p. 359.

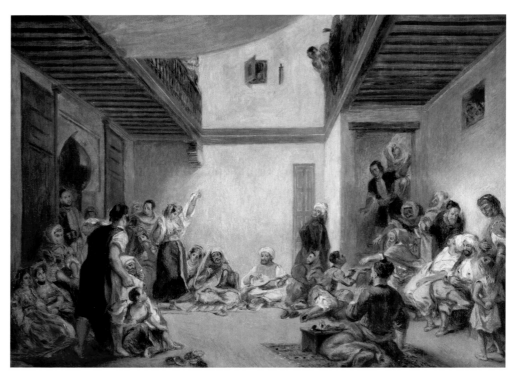

Fig. 99

Pierre-Auguste Renoir
The Jewish Wedding,
after Delacroix
1875
Oil on canvas
42³/₄ x 57 in. (108.7 × 144.9 cm)
Worcester, MA, Worcester Art Museum
Copy executed for the industrialist Jean Dollfus, an admirer of Delacroix

Fig. 99

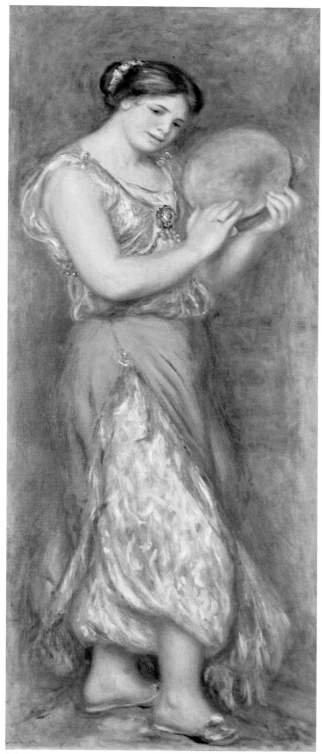

Cat. 40

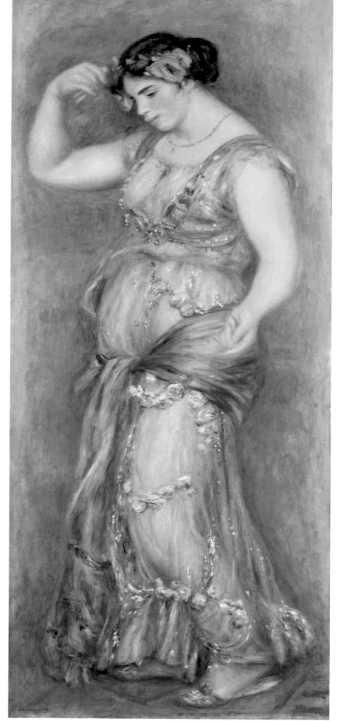

Cat. 41

The White Pierrot (Pierrot blanc)

1901–02
Oil on canvas
31 1/8 x 24 3/8 in. (79.1 x 61.9 cm)
Signed bottom right: *Renoir*
Detroit, The Detroit Institute of Arts, Bequest of Robert H. Tannahill, 1970
70.178

EXHIBITIONS
London 1932, no. 447; Paris, Orangerie, 1933, no. 99, pl. 50 (dated 1895; collection Paul Guillaume); Detroit 1970, p. 48; Tokyo, Kyoto, and Ibaraki 1989–90, no. 65; Ottawa, Chicago, and Fort Worth 1997–98, no. 58; Sakura, Sendai, and Sapporo 1999, no. 68; London and New York 2000, no. 104; Yokohama, Kitakyushu, Fukushima, and Fukui 2001, no. 12

BIBLIOGRAPHY
Art News 1930, p. 10; Bernheim-Jeune 1931, vol. 1, pl. 108, no. 342; *Fine Art* 1931, p. 28; *Les Arts à Paris* 1931, no. 18; *Formes* 1931, p. 193; *L'Art Vivant* 1932, cover; Gaunt 1952, pl. 85; Daulte 1964, p. 74; *Reader's Digest* 1971, p. 141; Nochlin 2008, pp. 39, 42.

Studio models played an indispensable and complex role in Renoir's creative process. On the one hand, they kept his paintings anchored in reality; on the other hand, they had to be familiar enough to him that their individuality did not get in the way of his painterly interpretation. Renoir's favorite models, therefore, were the members of his household and his own family. The artists younger sons, Jean and Claude, were the subjects of many charming, intimate paintings and drawings. However, they also posed for some of Renoir's more unusual, formal compositions,

such as *The White Pierrot*. Renoir's close friend, the painter Albert André, recorded the genesis of this painting in a series of lively pencil sketches of Jean posing **Cat. 126**, and a painting that shows Renoir at work in his Paris studio, in the circle of his family **Fig. 28, p. 69**. In the painting, the artist is seen seated at his easel, in the process of painting baby Claude sitting on his nanny's knees, while Jean and his mother, Aline, look on. Jean is wearing the distinctive Pierrot costume, although it is unclear if we see him before or after posing for his father, or perhaps during a break from the task. Sitting still for a long time while being painted was an ordeal for the boy, one that often led to a battle of wills between artist and model. Whatever the real mood in the studio that day (Jean looks rather sulky in André's drawings[1]), Renoir's painting itself shows none of it. In his splendid over-sized costume of white satin, a yellow conical hat, and red ruff collar, Jean is seated casually on a simple wooden chair, fresh-faced and relaxed. We do not know why Renoir chose to paint Jean in a Pierrot costume, but several observations can be made about it. First, there can be no doubt that Renoir intended his viewers to make a mental connection to another, *the* other, great Pierrot in the history of art: that painted by Jean-Antoine Watteau in 1718–19 **Fig. 23, p. 61**. Renoir was a great admirer of eighteenth-century French painting and, in fact, felt a deep personal connection with a tradition whose greatness he hoped to perpetuate in his own work. However, his *White Pierrot* does by no means copy or even quote Watteau directly. While

Cat. 126

Albert André
Study for *Renoir Painting His Family* **Fig. 28**, p. 69
1901

Cat. 126

Watteau represented Pierrot on stage, an actor in a role along with the other characters of the *commedia dell'arte,* Jean is posed in a neutral space with modern furniture that offers no plausible context for the boy's costume. Secondly, in their memoirs, both Jean and Claude recall occasions when they tried to escape the ordeal of posing in special costumes, and their hatred of clothes that were uncomfortable and had nothing to do with their normal lives.[2] Clearly, then, what here might look like the equivalent of a father's snapshot of his son playing dress-up, is in fact a carefully staged studio composition, set apart from reality by the costume.

By the late nineteenth century, the *commedia dell'arte,* originally a low-brow, populist kind of street theater, had become a high-culture subject, treated by academic and avant-garde artists alike. The stock character of Pierrot was a particular favorite. Usually cast as a melancholic, sad figure, he became a stand-in for the artist himself, embodying his outsider status and loneliness on the fringe of society. Obviously, however, this is not Renoir's interpretation in *The White Pierrot*: any metaphorical, universal meaning the costume might imply is negated by the neutral modern space in which the figure is posed and by the model's seemingly straightforward individuality. The painting subtly but effectively undercuts traditions and expectations. Years later, in the 1920s, Picasso, who admired Renoir and owned several paintings by him, would paint several pictures of his son, Paulo, in Pierrot and clown costumes that are very close in feel to Renoir's **Fig. 100**.

Like the other late costume "portraits" of his sons, Renoir painted *The White Pierrot* for himself. At his death, the canvas passed into the possession of Claude Renoir, who sold it to the Parisian art dealer Paul Guillaume around 1931, possibly together with *The Clown,* Renoir's portrait of Claude in a red clown costume **Cat. 43**.

C. E.

1. Pictured in exh. cat. Ottawa, Chicago, and Fort Worth 1997–98, p. 330. **2.** On the other hand, both also emphasize that, more often, for less formal pictures, Renoir let the boys simply busy themselves with some pleasant task, such as drawing, while he painted them Cat. 24.

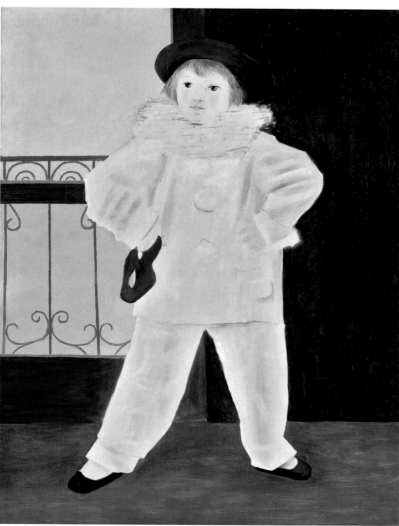

Fig. 100

Pablo Picasso
Paulo as Pierrot
1925
Oil on canvas
51⅛ x 38¼ in. (130 x 97 cm)
Paris, Musée National Picasso

Fig. 100

Pablo Picasso
Harlequin with a Mirror
1923

Cat. 105

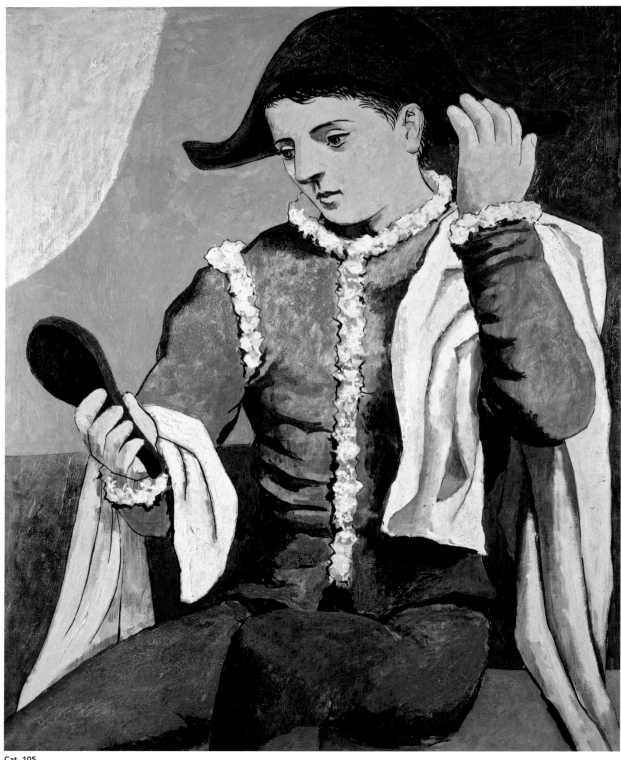

Cat. 105

Cat. 42

Claude Renoir as Clown, or *The Clown* (Claude Renoir en Clown, *or* Le Clown)

1909
Oil on canvas
47¼ x 30⅜ in. (120 x 77 cm)
Signed and dated bottom right: *Renoir. 09*
Paris, Musée de l'Orangerie, Jean Walter and Paul Guillaume collection, purchased by the state with the assistance of the Société des Amis du Louvre, 1959
RF 1960-17

EXHIBITIONS
Paris 1913, pp. 60, 63; Berlin 1928, no. 56; Paris, Bernheim-Jeune, 1938, no. 32; Paris 1966, no. 38; London, Paris, and Boston 1985–86, no. 110 (no. 108 in French ed.); Ottawa, Chicago, and Fort Worth 1997–98, no. 61; Tokyo, Nagoya, Hiroshima, Niigata, and Kyoto 1998–99, no. 32; Montreal and Fort Worth 2000–01, no. 15; Brisbane, Sydney, and Melbourne 2001, no. 15; Barcelona 2002, no. 16; Bergamo 2005.; Paris 2005–06, pp. 34, 36.

BIBLIOGRAPHY
Vollard 1918a, vol. 1, no. 584; Vollard 1920b, p. 111 (as *Portrait de Claude Renoir en robe rouge*); Rivière 1921, p. 241; Coquiot 1925, p. 232 (as *Le Clown [Claude Renoir]*, dated 1907); Bernheim-Jeune 1931, vol. 2, pl. 120, no. 374; C. Renoir 1948, pp. 6–7; *Jours de France* 1959, p. 46; Robida 1959, p. 44; George 1959, p. 1; Fosca 1962, pp. 211, 282 (as *Claude Renoir en robe rouge*); Daulte 1964, p. 81, pl. 27; Adhémar 1966, pp. 21–22; Pedrazzini 1966, p. 42; Alexandrian 1974, p. 61; Hamburg 1981–82; Hoog and Guicharnaud 1984, p. 218; Fezzi 1985, no. 698; Chikhani 1986; Martigny 1988, p. 158; Bade 1989, pp. 134–135; Feist 1993, p. 86; Joannides 2000, pp. 132–133; Néret 2001, p. 386; Cros 2003, pp. 158, 162; Weid 2006, p. 37; Nochlin 2008, pp. 39, 42.

As a father of three, Renoir knew all about children's restlessness. Most often he therefore painted his sons while they were absorbed in a quiet pastime, such as drawing **Cat. 24**. However, both Jean and Claude Renoir in later years vividly recalled the few times they were required to do the more difficult work of posing for formal, portrait-like compositions, such as *The Clown*: "I remember some dramatic moments which marked out the final sittings for my portrait dressed as a clown in red. I must have been about nine or ten years old; the costume was rounded off with white stockings which I stubbornly refused to put on. My father demanded the stockings so that he could complete the painting; it was no good—they were itchy. Then my mother

brought in silk stockings; they tickled me. There followed threats and then negotiations: I was promised in turn a spanking, an electric train set, boarding school, and a set of oil paints. Finally I agreed to put on some cotton stockings for a few moments; my father, on the verge of exploding with fury, finished the painting in spite of the acrobatics I was doing to scratch myself."[1]

Claude Renoir's memoir clearly establishes that the ambitiously scaled *Clown* did not capture a "real" moment in his life, but rather represented a scenario deliberately staged by his artist-father. The unloved billowing red clown outfit undoubtedly was among the costumes Renoir kept in a chest of drawers in his studio, to be pulled out as an occasion arose; the suit still exists and is preserved in the collection of the Musée Renoir in Cagnes-sur-Mer **Fig. 101**.[2]

In his later years, Renoir often spoke of his love and admiration for the paintings of Veronese, with whom he felt a special artistic and personal affinity. The Italian master's strong sensuous palette was an important source for the warm reddish harmonies that characterize Renoir's late works; the glowing orange-red that dominates *The Clown* was for some years his favorite color. However, Veronese is not the only Old Master Renoir revered and paid homage to in this painting. In Madrid in 1892, he had been deeply impressed by the paintings of Velázquez: the formal simplicity of the space in which Claude is posed—ennobled by a column and pilaster but otherwise spare and mysteriously indeterminate—evokes that master's great state portraits. The clown figure itself, dignified and impassive at the same time, inevitably brings to mind the famous *Pierrot* by Jean-Antoine Watteau, the eighteenth-century artist whose artistic heir Renoir felt himself to be. Watteau's *Pierrot* **Fig. 23, p. 61** had been part of the 1869 bequest of Louis La Caze to the Louvre—five hundred and eighty-three mainly seventeenth- and eighteenth-century paintings that became a touchstone for a whole generation of artists like Renoir.[3] Some years before painting *The Clown*, Renoir had chosen the classic white costume of Pierrot in a portrait of his older son, Jean **Cat. 42**. However, neither *The White Pierrot* nor *The Clown* directly quotes Watteau's masterpiece, although both pictures deliberately mobilize the viewer's knowledge of art history and the associations the costume may evoke. While *The Clown* was in safe-keeping with Renoir's dealer Durand-Ruel after 1914, it was entitled simply *Boy in a Red Dress* in a 1915 inventory[4]— a more generic appellation that drives home the point that the painting was indeed an artistic construct, rather than a representation of real life.

Like *The White Pierrot* and *Jean as a Huntsman* **Cat. 56**, *The Clown* remained in Renoir's possession until his death. Later, it entered the collection of the art dealer Paul Guillaume. It is not known if Guillaume acquired *The Clown* from Claude Renoir, who had inherited it, and who, in any event, sold *The White Pierrot* to Guillaume in the early 1930s.

C. E.

1. C. Renoir 1948, pp. 6–7. **2.** I am grateful to Isabelle Gaëtan for bringing it to my attention. Jean Renoir (J. Renoir 1962, p. 375) mentions a chest full of costumes in Renoir's Paris studio. No doubt, the painter kept similar stores in his other work spaces as well. **3.** Édouard Manet, for example, copied the La Caze pictures, studying especially Velázquez. See exh. cat. Paris, Pau, and London 2007–08. **4.** Hoog and Guicharnaud 1984, p. 218, cited in Ottawa, Chicago, and Fort Worth 1997–98, p. 241.

Fig. 101

Red clown costume
Cagnes-sur-Mer, Musée Renoir,
donated by M. and Mme Claude
Renoir, 1967

Fig. 101

Cat. 43

Cat. 44

The Vineyards at Cagnes
(Les Vignes à Cagnes)

Circa 1908
Oil on canvas
18¹/₄ x 21³/₄ in. (46.3 x 55.2 cm)
Signed bottom right: *Renoir*
New York, Brooklyn Museum, Gift of Colonel and Mrs. E. W. Garbisch, 1951
51.219

EXHIBITIONS
London, Paris, and Boston 1985–86, no. 109 (no. 107 in French ed.); Brisbane, Melbourne, and Sydney 1994–95, no. 46; Treviso 2003–04, no. 67.
BIBLIOGRAPHY
Néret 2001, pp. 393–394.

Cat. 45

The Farm at Les Collettes, Cagnes
(La Ferme des Collettes, Cagnes)

Circa 1914
Oil on canvas
21¹/₂ x 25³/₄ in. (54.6 x 65.4 cm)
Signed bottom right: *Renoir*
New York, The Metropolitan Museum of Art, Bequest of Charlotte Gina Abrams, in memory of her husband, Lucien Abrams, 1961
61.190

EXHIBITIONS
Little Rock 1963, unnumbered; Shizuoka and Kobe 1986, no. 16; Portland 1998, no. 63.
BIBLIOGRAPHY
Meier-Graefe 1929, pp. 291, 355, fig. 323; Bernheim-Jeune 1931, vol. 1, pl. 96, no. 309; Fosca 1962, p. 247; Fezzi 1985, no. 717.

Fig. 102

Pierre-Auguste Renoir
The Farm at Les Collettes
Ca. 1915
Oil on canvas
18¹/₈ x 20¹/₈ in. (46 x 51 cm)
Cagnes-sur-Mer, Musée Renoir

Fig.102

Maurice Gangnat, who regularly stayed at Les Collettes between 1908 and 1917, purchased around one hundred and eighty paintings from Renoir, including several landscapes of Cagnes. When he died, his family put one hundred and sixty paintings up for auction at Hôtel Drouot on June 24, 1925, including *The Vineyards at Cagnes,* which is listed as number 92. Gangnat was introduced to Renoir by Paul Gallimard and became a trusted friend. Renoir felt that Gangnat "has an eye for it" and that he understood his later work.[1] This landscape does not show the terraced fields of Les Collettes where Renoir's wife planted vines. While Aline exercised her horticultural talents on this fine agricultural property, Renoir would paint models in the open air, both at Les Collettes and in the surrounding area. Madeleine Bruno, one of his models, recounted these outdoor posing sessions, which sometimes required trips by car. Renoir "always finished his landscapes on site, returning two or three times to the same place."[2] In a somewhat surprising arrangement, Renoir would compose an "idealized" landscape outdoors, from life. Although *The Vineyards at Cagnes* is in the tradition of the classical landscapes—with a theatrical construction in the foreground framed by two trees and a model placed against one—the technique, speed of execution, and directional brushstrokes ally it more to Impressionism. There were plenty of rural activities at Les Collettes, and Renoir enjoyed capturing scenes of people at work (harvesting, for example), as in the painting *Les Collettes* (ca. 1908), at the Musée des Beaux-Arts, La Chaux-de-Fonds, which is constructed with the same poetic rigor.[3]

The painter's preferred subject on the estate was, without doubt, the farmhouse itself, which he depicted from various angles, favoring the south façade where a splendid linden tree created an interplay of light and shade. While *The Farm at Les Collettes* at the Metropolitan Museum of Art is shown in a wooded landscape, enlivened by figures and with an olive tree in the foreground breathing an extraordinary dynamic into the composition, *The Farm at Les Collettes* at the Musée Renoir **Fig. 102** is discovered through the foliage, almost "humanized," and comes across as a character in its own right. The façade is sprinkled with touches of yellow and rose ochre, evocative of skin tones. In this work Renoir gives rein to a sensuous, intimate approach to the building to which he was so deeply attached.

V. J.

1. J. Renoir 1962, p. 450. **2.** Madeleine Bruno, in *Nice-Matin*, July 20, 1960, p. 7.
3. Exh. cat. Marseille and Paris, p. 313.

Cat. 44

Cat. 45

Cat. 46

Bathing Women (Baigneuses)

Circa 1916
Oil on canvas
15³/4 x 20¹/8 in. (40 x 51 cm)
Signed bottom right: *Renoir*
Stockholm, Nationalmuseum, purchased 1918, with contributions from
Conrad Pineus and the Giesecke Fund
NM2103

EXHIBITION
Stockholm and Copenhagen 2002, p. 125, no. 186, and p. 127.

BIBLIOGRAPHY
Nationalmuseum 1928, p. 211; Nationalmuseum 1958, p. 16; Nationalmuseum 1990, p. 296; Hoppe 1936, p. 29; Osterman 1958, pp. 85–86; Olson 1965, pp. 56, 61; Abel 1996, pp. 88–89; Néret 2001, p. 338; Hedström and Grate 2006, pp. 219–220.

Renoir first painted a bathing group in a landscape during the mid-1880s—a monumental project to which he famously devoted several years (*The Large Bathers* **Fig. 8, p. 39**)—but did not return to the theme until 1897 with *Bathers Playing with a Crab* **Cat. 20** and *Bathers in the Forest* **Fig. 46, p. 111**. By the last five years of his life, however, bathing scenes like the Stockholm picture came to dominate his production. In them Renoir creates an idyllic universe inhabited by nude women lounging about in sun-dappled meadows, splashing in blue rivers, soaking up the Mediterranean sun. Cradled by the southern French landscape, his goddesslike creatures embody a fantasy of slow, timeless, natural subsistence; it is as if modern life, with its speeding trains and glittering department stores, did not exist.

If the elements in these late bathing scenes are generally the same—flesh, water, and foliage—Renoir experimented continually with their arrangement. Here, a river splits the composition in two, each half dominated by one of the large bathers in the foreground, while three tiny figures frolic on the distant banks. Surrounding vegetation is indicated by abstract zones of green and yellow, while the bright blue river seems to reach up toward the sky, merging with it, flattening out the pictorial space. The distant figures are barely discernible, their bodies composed of quick licks of paint, their size dwarfed by the head of the seated foreground figure. Nominally they are indicators of spatial recession, but their scale is so aggressively diminished that they actually render the overall space more ambiguous.

The two foreground bathers, by contrast, are painted with delicate strokes that evoke soft and luminous skin. While the standing figure is traditionally idealized, the seated figure bears markedly atavistic facial features, with a mouth that protrudes past the nose. She is hunched over, the lines of her thick, sculptural towel pulling the eye downward, while the more delicate body of the standing figure extends upward, to the very top of the canvas. Renoir used this type of emphatic play between the horizontal and the vertical frequently in his late figure groupings, for example, in two canvases entitled *Bathers* at the Barnes Foundation (see **Cat. 179, p. 113**), and in the *Judgment of Paris* **Cat. 65**. It is as if his figure pairs embodied two aspects of woman—an elevated, classical quality, as well as something more earthy and primordial, almost animalistic.

In his late bathing groups, Renoir drew from a cast of figures that he arranged and rearranged in varying compositions. The standing figure in *Bathing Women* evokes Venus from the *Judgment of Paris*, while the seated figure recalls or perhaps anticipates *The Pregnant Woman* at the Barnes Foundation. *Bathing Women* was probably painted around 1916. Its figures, with their rounded volumes that evoke touch, have a strong sculptural quality that may well reflect Renoir's engagement with sculpture in the years from 1914 to 1918. The seated bather, in particular, seems to be directly related to the small statue of *Washerwoman* **Cat. 93**, which would explain the heavy quality of the painted towel.

M. L.

Cat. 46

Cat. 47

Bather with Brown Hair (Gabrielle Drying Herself) (La Baigneuse brune [Gabrielle s'essuyant])

1909
Oil on canvas
36¹/4 x 28³/4 in. (92 x 73 cm)
Signed bottom left: *Renoir*
Private collection

EXHIBITIONS
Paris 1913, no. 47 (as *La Baigneuse brune*); Paris, Rosenberg, 1934, no. 1 (as *Baigneuse s'essuyant*, M. Josse Bernheim-Jeune collection); London 1934, no. 30.

BIBLIOGRAPHY
Mirbeau 1913, p. 63, p. 54; Fénéon 1919, vol. 2, pl. 128; J. Renoir 1962, ill. between pp. 374 and 375.

"**F**or art lovers today, Gabrielle, this essence of the female with the name of an archangel, represents the substance, the very essence, the soul of my father's nudes," Claude Renoir claimed some weeks after the death of Renoir's preferred model.[1] Once again, it is the beautiful Gabrielle who lends her body to the painter for the present *plein-air* nude. *Bather with Brown Hair* is the last canvas in a series of three showing Gabrielle drying her left leg, executed by Renoir between 1902 and 1909. Although the pose of the bather in this painting is virtually identical to that of the bather identified by Meier-Graefe[2] as being the first of the series, it differs somewhat from the version purchased by Dr. Barnes from Durand-Ruel in 1914 (Merion, PA, Barnes Foundation), in which Gabrielle's left hand is placed not on the garments to the right, but holds the cloth with which she is drying herself. This same pose is also found in a red chalk drawing dated 1905,[3] in which the figure is turning toward the right; current research has not yet connected this study with any painting. Although in the 1902 paintings the landscape is only suggested—as was often the case with Renoir's bathers from the early 1890s—it is less so in the 1909 painting. In fact, the different elements that make up its background, the tree and flowers on the left and the pool of water in the center, evoke the framing of the *Bather* paintings from 1895 **Cat. 9 & Fig. 76**. Moreover, the reuse in *Bather with Brown Hair* of the pink garments seen in the same position in the 1895 works shows that the landscape and accessories were most likely recomposed in the studio.

Although Renoir returns to the same subject here—a bather shown from the knee up in a wooded setting—he treats it in a very different manner: the innocent young nymph preparing to emerge from the water has been replaced by a fully grown woman drying herself on the grass. The simplicity of the bather's posture is reminiscent of Greek sculpture, which Renoir "described as divine" and impossible to surpass,[4] in particular the Louvre's *Crouching Aphrodite*, "all the folds and dimples of whose flesh he [was familiar with]"[5] and which he transposes here. The heavy contours of the young woman and the treatment of her skin and flesh tones show that once again Renoir was combining different sources. Already evident here, the memory "of the luminous flesh of Rubens's nudes"—which Renoir studied, seeking "to discover the process used by the Flemish master"[6]—were to become even more strongly expressed in his later nudes **Cat. 29 & 30**. As Walter Pach points out, "if the design of a canvas demanded some alteration of natural proportion; if the undulations of his linear rhythms demanded a displacement of some part of the body; if the flow and play of light and color demanded a relation of foreground and background elements which was not according to photographic vision; Renoir had little hesitation in giving the needs of his composition precedence over the materialism of fact."[7] The elongation of the limbs in his *Bather with Brown Hair* affirms the decorative significance of the painting, as does the bundle of pink fabric on the right, it being impossible to tell on what it might be resting; it matters little that the very balance of the figure seems so heavily compromised. Not only does its presence complement the tree trunk situated on the left, it also allows the painter to create a play between the white fabric of the cloth with which the young woman is drying herself and the pink fabric of the garments—an interplay already used in his 1895 *Bathers*.

The Galerie Durand-Ruel bought the painting from Renoir on July 27, 1909. It was later acquired by Bernheim-Jeune and was placed on sale at the Renoir exhibition the gallery owners organized in 1913. As the 1919 album devoted to their private collection shows, it then joined the impressive series of Renoir nudes owned by Josse and Gaston Bernheim-Jeune, which included numerous masterpieces **Fig. 103** and **Cat. 204, p. 421**.

I. G.

1. C. Renoir 1959, p. 30. **2.** Meier-Graefe 1929, no. 287, p. 332. **3.** Vollard 1989, no. 522. **4.** Baudot 1949, p. 29. **5.** André 1923, p. 45. **6.** Baudot 1949, p. 29. **7.** Pach 1950, p. 28.

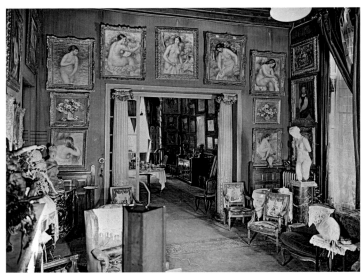

Fig. 103

View of the personal collection of the brothers Josse and Gaston Bernheim-Jeune in the salon of their residence at 107, avenue Henri-Martin, Paris
1924
Paris, Archives Photographiques Bernheim-Jeune

Fig. 103

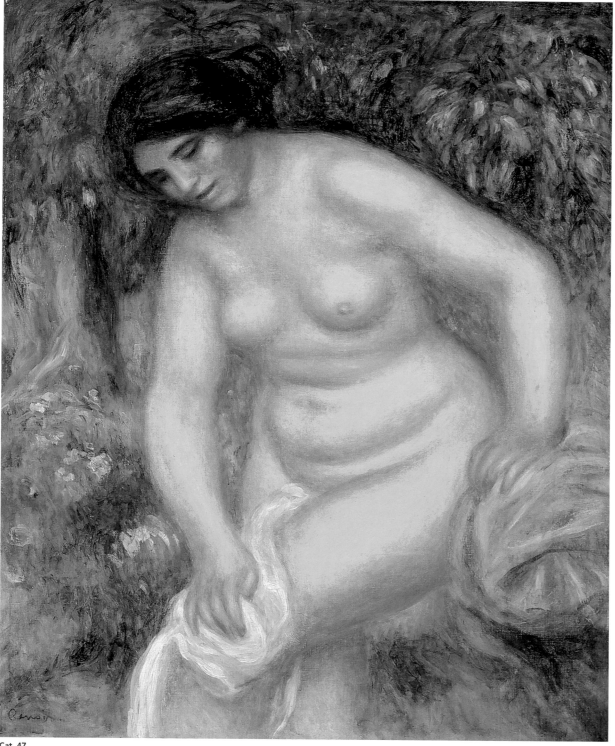

Cat. 47

Cat. 48

Coco (Claude Renoir)

1910
Oil on canvas
21⅝ x 18¼ in. (55 x 46.4 cm)
Stamped bottom left: *Renoir*
Boston, Museum of Fine Arts, Gift of Mrs. George Putnam, 1973
1973.513

EXHIBITIONS
Paris, Rosenberg, 1934, no. 7; Brisbane, Melbourne, and Sydney 1994–95, no. 44.

BIBLIOGRAPHY
Bernheim-Jeune 1931, vol. 2, no. 376, pl. 121; *Gazette des Beaux-Arts* 1974, p. 146.

Throughout his career, Renoir regularly and frequently enlisted friends, family, and other members of his immediate circle to pose for him in the studio. This practice may have grown out of economic considerations in Renoir's early years, but with time it became an artistic issue: Renoir disliked having to get used to new models and found it easier to paint familiar forms, faces, and bodies that he knew fit his painterly vision. It also was practical to have constant access to a model: Claude, the painter's youngest son, explained that he was often called on to pose when a scheduled model was suddenly unavailable, or when bad weather made planned land-scape studies impossible.[1] All told, Coco, as he was affectionately called, was the subject of some ninety paintings by Renoir.[2]

When he was very young, Claude did not enjoy modeling for his father, "because keeping still even for a few moments was an ordeal. I took advantage of every break, which were frequent, to disappear in the house or the garden, and when the sitting resumed, the whole household had to take part in the search to retrieve me . . . To secure a little stillness, my father chose poses that allowed me to play or get interested in something."[3]

Indeed, in most pictures of Claude, the boy is engrossed in a sedentary activity like reading or painting, making him forget that he is being painted. In contrast, the portrait here lacks such a nar-rative element. Claude sits on a plain wooden chair, patiently open to the artist's—and our—scrutiny. He is about nine years old, suf-

ficiently mature to curb his youthful restlessness and endure lengthy sittings. Gone are the long luxuriant curls of his baby years, which Renoir had painted so often with great pleasure, and which he made his sons wear, longer than was usual, until they entered school. Here, tousled and dressed in short pants and white shirt, Claude indeed is every inch a schoolboy of the time.

Unlike the "candid" pictures of Claude at play or reading, *Coco (Claude Renoir)* conforms to the conventions of formal portrai-ture, where the sitter's face and body are the center of attention: Claude's fresh-cheeked face and sturdy torso are set off neatly against an indeterminate green-brown background. Beyond this standard portrait device, however, the composition of the por-trait is highly unconventional. The figure is pushed to the front and squeezed into the lower right, the body abruptly truncated at the knees. While it has been argued that this "seems to suggest something of the gawkiness of the growing schoolboy, in con-trast to simple, carefully framed images of young childhood,"[4] it may be more profitable to consider Renoir's pictorial choice in relation to Edgar Degas, whose daring and unconventional crop-pings are a hallmark of his work. Renoir and Degas had been friends ever since their Impressionist days. As the two principal figure painters coming out of that movement, they would have remained particularly curious about each other's art.

Renoir stopped painting his sons almost entirely once they reached adolescence. Exceptions are the formal costume por-trait of *Jean as a Huntsman* **Cat. 56**, painted when Renoir's second son was sixteen years old; and the genre-scene-like *Breakfast at Berneval* **Fig. 10, p. 41**, which shows Pierre, the eldest brother, at age thirteen, reading in the foreground. Given Renoir's notions about the "naturalness" of women and children, he would have felt keenly the point at which his sons had passed the stage of natural childish innocence.

After his mother's death in 1915, Claude Renoir was his father's principal companion and caretaker. Staying on at the family estate while his brothers served in the war, he trained as a ceramicist. In later years, Claude Renoir had a second career as a film producer and cinema owner, at times collaborating with his famous film-maker brother, Jean.

C. E.

1. C. Renoir 1948, p. 6. **2.** Daulte 1964, p. 75, cited by Patry 2005–06, p. 26, note 2. **3.** C. Renoir 1948, p. 6. **4.** John House in exh. cat. Brisbane, Melbourne, and Sydney 1994–95, p. 129.

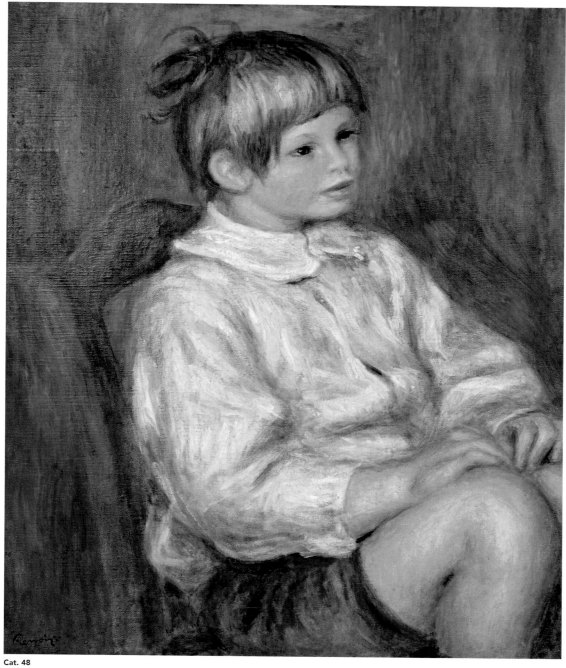

Cat. 48

Cat. 49

Self-Portrait in a White Hat (Autoportrait au chapeau blanc)

1910
Oil on canvas
16¹/₂ x 13 in. (42 x 33 cm)
Signed bottom left: *Renoir*
Collection Durand-Ruel

EXHIBITIONS
Paris, Durand-Ruel, 1920, no. 6; Paris, Orangerie, 1933, no. 120; Paris 1958, no. 54; New York 1969, no. 91; Paris 1969, no. 52; Chicago 1973, no. 77; Tübingen 1996, no. 103; Paris 2005–06, p. 63; Tokyo and Kyoto 2008, no. 12.

BIBLIOGRAPHY
André 1919, pl. 3; Rivière 1921, p. 245; Jamot 1923, p. 257; Duret 1924, no. 3; Meier-Graefe 1929, p. 379, pl. 355; Barnes and De Mazia 1935, p. 466, no. 253; New York 1941, frontispiece and p. 129; Lhote 1947, p. XII; Fox et al. 1950, p. 108; Pach 1951, 108; Gaunt 1952, pl. 93; Rouart 1954, p. 99; Gauthier 1958; Pach 1958, frontispiece; Schneider 1958, frontispiece; Bosman 1963, p. 77; Perruchot 1964, frontispiece; Daulte 1964, p. 81; Fezzi 1972, p. 122, no. 739; Daulte 1973, p. 61; Tokyo and Kyoto 1979; White 1984, p. 249; Rouart 1985, p. 112; Shimada 1985, pl. 60; London, Paris, and Boston 1985–86, p. 280 (p. 332 in French ed.); Monneret 1990, p. 136; Fell 1992, p. 5; Néret 2001, p. 243; Distel 2005, p. 120.

The last image Renoir left of himself is painted thinly, without impasto, metaphorically echoing the frailty of the artist in his later years. Yet, the sureness of its execution is astonishing: persuasively, Renoir captured his likeness without self-pity, showing physical decrepitude, but also the vitality of his glance. Although this was the artist's last self-portrait, at age sixty-nine, Renoir still had eight productive years ahead of him.

Renoir seldom represented himself. Beside two youthful portraits (1875, Williamstown, MA, Sterling and Francine Clark Art Institute; 1876, Cambridge, MA, Fogg Art Museum), only three other self-portraits are known, all belonging to his later years: one from 1899, also in Williamstown **Cat. 19**; one from 1910 (Buenos Aires, private collection[1]); and the picture presented here, also from 1910. This paucity suggests that Renoir was little interested in the kind of introspection that self-representation demands of an artist. Both the 1899 Clark portrait and the 1910 Buenos Aires picture show the artist rather elegantly attired, with opulent neck-wear and a stylish hat known as a *chapeau mou*. However, none of this elegance remains in the medal-like profile given in the present portrait. The smart *chapeau* is replaced by a simple canvas garden hat, a functional accessory designed to protect the artist from the sun's glare; like his working man's jacket (called a *vareuse*), it is hardly something to be worn outside one's home. The simplicity of this outfit contributes to the emotional impact of this small painting: it easily stands alongside other powerful probing and often disturbing images that many great painters—one thinks of Poussin, Rembrandt, or Titian—left of themselves at the end of their lives.

Self-portraits are usually painted from the artist's reflection in a mirror. The unusual, strict profile view here—not impossible, but difficult to achieve with mirrors—has led some commentators to suggest that the portrait may in fact have been painted from the bust Aristide Maillol sculpted of Renoir in 1906 or 1907 **Cat. 117**.

J. P. M.

1. Reproduced in exh. cat. Ottawa, Chicago, and Fort Worth 1997–98, p. 335, fig. 300.

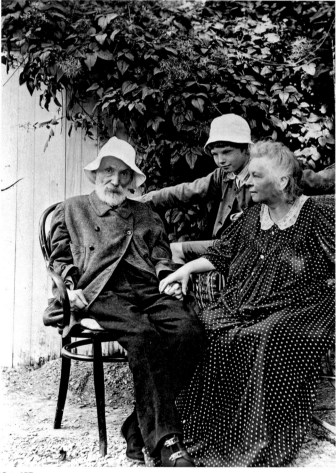

Renoir, Aline and Coco
1912

Cat. 157

Cat. 157

Aristide Maillol
Portrait de Pierre-Auguste Renoir
1906–07

Cat. 117, p. 274

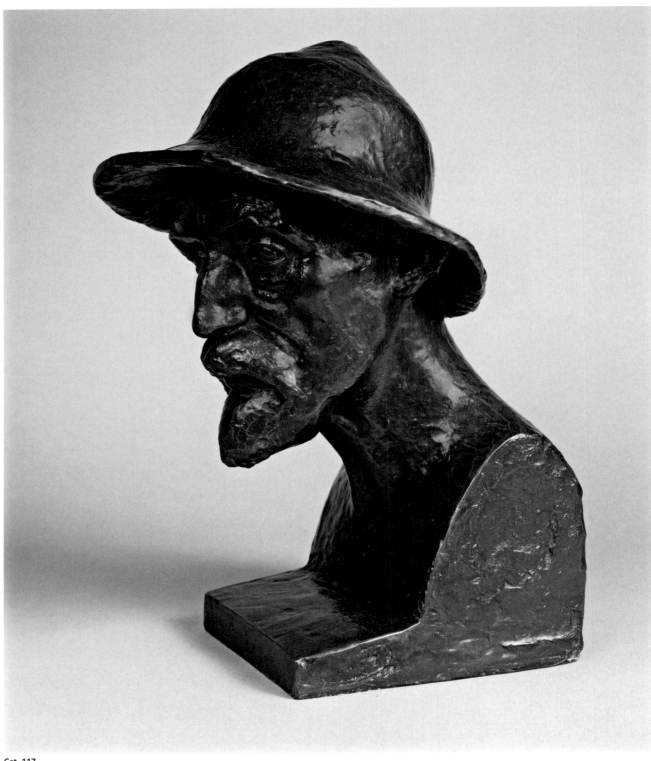

Cat. 117

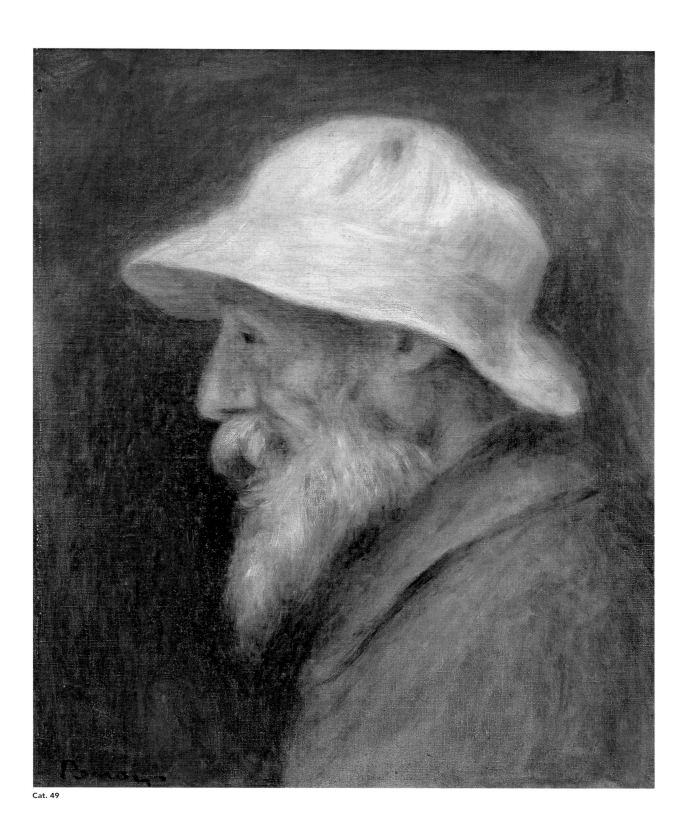

Cat. 49

Cat. 50

Portrait of Paul Durand-Ruel
(Portrait de Paul Durand-Ruel)

1910
Oil on canvas
25³/₄ x 21⁷/₁₆ in. (65.5 x 54.5 cm)
Signed and dated bottom left: *Renoir 1910*
Paris, Durand-Ruel

EXHIBITIONS
Berlin 1912, no. 41; Munich 1912, no. 41; Paris 1912b, no. 38; Paris, Rosenberg, 1934, no. 9; New York, Durand-Ruel, 1939, no. 21; New York 1943, no. 20; Paris 1958, no. 53; Paris 1969, no. 54; Hamburg 1970–71, no. 43; Chicago 1973, no. 78; Paris, Durand-Ruel, 1974, no. 56; Tübingen 1996, no. 102; Ottawa, Chicago, and Fort Worth 1997–98, no. 64; Paris 2005–06, p. 31; Tokyo and Kyoto 2008, no. 53.

BIBLIOGRAPHY
This painting is cited and reproduced in almost all works devoted to Impressionism or to Renoir's life, which is why we refer here only to the primary reference work, Rewald 1946b.

Fig. 104

Fig. 105

Paul Durand-Ruel purchased over a thousand works from Renoir, his earliest acquisitions dating from 1872. Between 1876 and 1888, the art dealer asked Renoir to paint portraits of his children: *Jeanne Durand-Ruel* (1876, Merion, PA, The Barnes Foundation); *Joseph Durand-Ruel* (1882); *Charles and Georges Durand-Ruel* (1882); *Marie Durand-Ruel Sewing* (1882, Williamstown, MA, Sterling and Francine Clark Art Institute); *The Daughters of Durand-Ruel (Marie and Jeanne)* (1882, Norfolk, Chrysler Museum); and *Marie Durand-Ruel* (1888). During this period, Paul Durand-Ruel, who had been a widower since 1871 and was heavily involved in his battle in support of Impressionism, did not feel the need to have a portrait of himself. It was not until 1910, when success was now assured, that he handed over his business affairs to his sons and asked his friend Renoir to paint his portrait. A short time later, in 1911, Renoir painted a portrait of *Madame Joseph Durand-Ruel,* the wife of Paul's eldest son.

In the letters that passed between the artist and his dealer, there is no reference to Paul Durand-Ruel's portrait. However, it appears that Renoir was in Paris between June 15 and October 22, 1910, and it seems likely that the portrait was painted during this visit. In the work, Renoir focuses mainly on the art dealer's face; contrary to his personal inclination, he does not seek to include any accessories or decorative elements. The face is treated with the greatest care and clearly reflects the friendship that existed between the two men after almost forty years of unbroken and mutual loyalty.

To quote just one example of this friendship: in 1885 Paul Durand-Ruel, who had been wrongly implicated in a matter involving counterfeit paintings, defended himself in a letter addressed to the journal *L'Événement,* in which he stated: "I come now to my great crime, that which dominates all others. For many years I have bought and held in the highest regard the works of some highly original and very learned painters, several of whom are men of genius, and I have tried to bring them to the attention of art lovers. I believe that the works of Degas, Puvis de Chavannes, Monet, Renoir, Pissarro, and Sisley are worthy of featuring in the finest collections." Renoir reacted by writing to his art dealer: "Do as they might, they will not destroy your true quality, the love of art and the championing of artists before their death. In the future, this will be your glory, because you alone have thought to do something so natural. My very, very best wishes, Renoir."[1]

P.-L. and F. D.-R.

1. Letter written from Wargemont in November 1885, quoted in Renoir 2002, p. 133.

Henri de Toulouse-Lautrec
Paul Durand-Ruel in
his Gallery, Rue Laffitte
Drawing with highlights in
colored pencils
7⁷/₈ x 4⁷/₈ in. (20 × 12.5 cm)
Private collection

Fig. 104

Paul Durand-Ruel
1910
Photo Lavieter (rights reserved)

Fig. 105

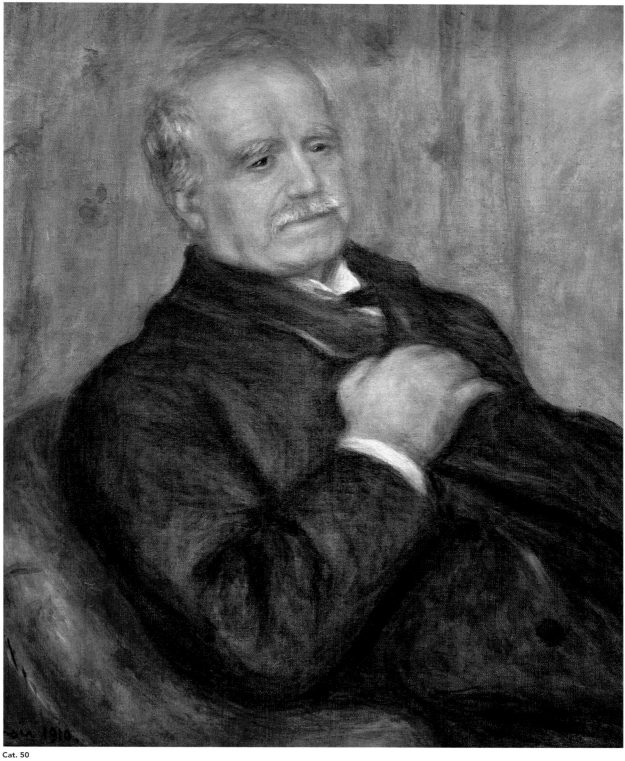

Cat. 50

Cat. 51

Ambroise Vollard in the Costume of a Toreador (Ambroise Vollard en toréador)

1917
Oil on canvas
40¼ x 32¾ in. (102.2 x 83.2 cm)
Tokyo, Nippon Television Network Corporation, acquired in 1964

EXHIBITIONS
Paris, Braun, 1932, no. 26; New York 1933, no. 40; Detroit 1933–34, no. 39; Paris 1936, no. 144; Venice 1938; Ottawa 1950, no. 17; Arles 1952, no. 23; Nice 1952, no. 31; Portland, Seattle, San Francisco, Los Angeles, Minneapolis, St. Louis, Kansas City, Detroit, and Boston 1956–57, no. 95; New York 1958, no. 68; New York 1972, no. 58; Chicago 1973, no. 86; Detroit 1976–77, no. 279; Tokyo and Kyoto 1979, no. 83; Tübingen 1996, no. 104; Ottawa, Chicago, and Fort Worth 1997–98, no. 69; Sakura, Sendai, and Sapporo 1999, no. 63; Paris 2005–06, p. 148; New York, Chicago, and Paris 2006–07, no. 177; Tokyo and Kyoto 2008, no. 23.

BIBLIOGRAPHY
Vollard 1918a, vol. 1, p. 98, fig. 391; Vollard 1919a, pp. 238–239; Rivière 1921, p. 225; Duret 1924, p. 73; Coquiot 1925, p. 234; Besson 1929, fig. 30; Meier-Graefe 1929, p. 327; Hopper 1933, pp. 542–543; *Art News* 1933, cover; Bulliet 1936, pl. 47; Vollard 1936, facing p. 221; Vollard 1937, pp. 244–245; Mauny 1940, p. 36; Drucker 1944, pp. 97, 191; Jedlicka 1947, no. 53; Chamson 1949, p. 53; Gaunt 1952, p. 103; Bernier 1955, p. 185; Pia 1955, p. 27; J. Renoir 1962, pp. 183, 399–400; Dauberville 1967, p. 209; Fezzi 1972, p. 123f, no. 763; White 1984, pp. 278, 280; Monneret 1990, p. 155; Néret 2001, p. 239.

Exhibited in Paris.

The fame of Ambroise Vollard's portrait as a toreador is matched only by the uncertainty surrounding its origin. Colin Bailey has masterfully summed up the various stories of the portrait's genesis provided by Jean Renoir, Ambroise Vollard, and René Gimpel.[1] In the end preferring the least fanciful of these accounts—that by Gimpel—Bailey nonetheless conveys the joyful, even chaotic, atmosphere of Renoir's studio at this late stage in his career. The presence of a toreador's suit in Renoir's *atelier,* whether brought from Spain by the artist or by Vollard, is peculiar enough in itself to fuel speculation about why Renoir might have painted his dealer this way.[2]

No stranger to costuming,[3] Renoir here develops the tradition of fancy-dress portraiture, practiced in the eighteenth-century by Pompeo Batoni or Joshua Reynolds, for example, whose sitters often donned pseudo-Spanish "Van Dyck costumes"; in the French context, he may have been inspired by Louis-Michel van Loo and his *Espagnolades,* or even more recent Spanish-inspired costume pieces, such as those by Édouard Manet. However, unlike van Loo's fictitious reconstructions, or Manet's austere contemporary Spanish subjects, Renoir deliberately placed his sitter among the props and in the space of his studio; he has him half reclining on a *chaise-longue* of bent bamboo, a popular piece of modern garden furniture. A photograph showing Vollard sitting for this portrait[4] illustrates how accurately Renoir represented his model; he made considerable changes, however, in the background, replacing the simple drapery with a more permanent-looking setting that includes an architectural motif and the back of a stretched canvas. These details unequivocally anchor the costumed sitter in the here and now of Renoir's studio, and what may have begun as a joke (when Renoir gave in to Vollard's repeated request for a portrait with the words "doll yourself up as a toreador and I'll do your mug,")[5] takes on an unexpected *gravitas.* The dealer and publisher comes to represent a larger concept—an allegory of the studio, in which the protector/patron becomes the docile model, subject to the artist's whims.

Renoir's relationship to Ambroise Vollard was more respectful than that of many other artists—for whom his name rhymed ominously with *voleur* (thief) or "dollar"—but this did not stop Renoir from teasing Vollard or from occasionally being annoyed by the tall and awkward man, whose clumsy attempts at humor often failed to amuse.

Years after Renoir's death, Picasso half-jokingly accused the older artist of having stolen "his stuff" when painting this portrait.[6] Picasso, who would have liked to claim a monopoly on Spanish themes, may also have felt challenged by Renoir's painting, whose remarkable modernity both engages tradition and subverts it, and differs tellingly from Picasso's own earlier, ambitious portrait of Vollard in the Cubist style (1909, Moscow, Pushkin Museum).

J. P. M.

1. Exh. cat. Ottawa, Chicago, and Fort Worth 1997–98, pp. 262–264, 343. **2.** A toreador costume preserved in the collection of the Musée Renoir in Cagnes-sur-Mer appears large enough to have fitted the powerful frame of Ambroise Vollard. We thank Virginie Journiac, curator at the museum, for this information, which seems to have been unknown to Colin Bailey in 1997. **3.** See the essay by Claudia Einecke in this volume, p. 60. **4.** Reproduced in exh. cat. Ottawa, Chicago, and Fort Worth 1997–98, p. 343, and in exh. cat. New York, Chicago, and Paris 2006–07, p. 19 (p. 277 in French ed). **5.** Dauberville 1967, p. 209. **6.** Gilot and Lake 1964, p. 49: "Renoir did him as a toreador, stealing *my stuff*, really," quoted also in exh. cat. Ottawa, Chicago, and Fort Worth 1997–98, p. 264.

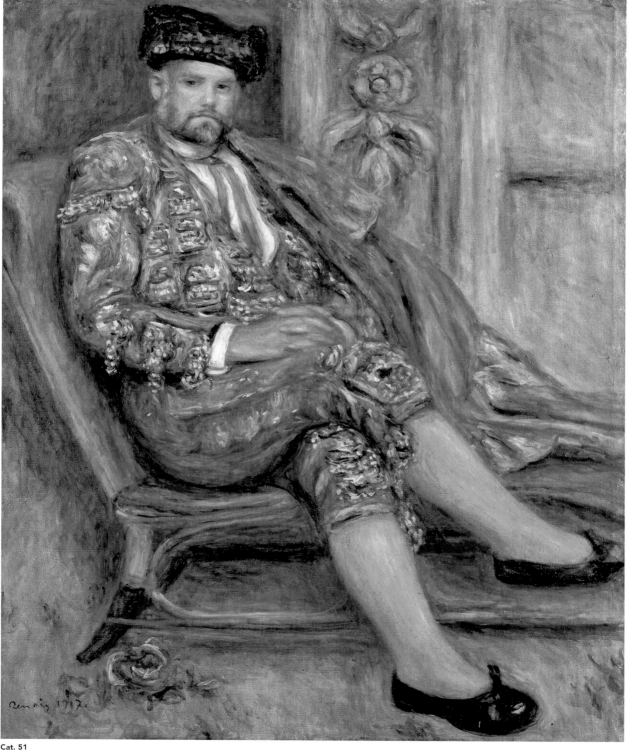

Cat. 51

Cat. 52

Monsieur and Madame Gaston Bernheim de Villers (Monsieur et Madame Gaston Bernheim de Villers)

1910
Oil on canvas
31⁷/₈ x 25³/₄ in. (81 x 65.5 cm)
Signed and dated top right: *Renoir. 10*
Paris, Musée d'Orsay, gift of M. and Mme Gaston Bernheim de Villers
on the occasion of their fiftieth wedding anniversary, 1951
RF 1951.28

EXHIBITIONS
Paris, Bernheim-Jeune, 1938; Lyon 1952, no. 50; Paris 1967–68, no. 427; Atlanta, Seattle, and Denver 1999, no. 56; Paris 2005–06, p. 35; Tokyo and Kyoto 2008, no. 56.
BIBLIOGRAPHY
Fénéon 1919, vol. 2, pl. 131; Adhémar et al. 1959, no. 374; Dauberville 1967, p. 219; Compin and Roquebert 1986, p. 177; Distel 1989b, p. 46; Rosenblum 1989, p. 433; Compin, Lacambre, and Roquebert 1990, vol. 2, p. 397.

Cat. 53

Madame Josse Bernheim-Jeune and Her Son Henry (Madame Josse Bernheim-Jeune et son fils Henry)

1910
Oil on canvas
36³/₈ x 28⁷/₈ in. (92.5 x 73.3 cm)
Signed and dated top left: *Renoir. 10*
Paris, Musée d'Orsay, acquired by gift in lieu of inheritance taxes, 1989
RF 1989.31

EXHIBITIONS
Paris, Bernheim-Jeune, 1938; Paris, Bernheim-Jeune, 1952, no. 55; New York 1969, no. 88; Paris, Forum des arts, 1978, no. 78; Paris 1990–91, p. 237.
BIBLIOGRAPHY
Fénéon 1919, vol. II, pl. 132; Distel 2005, p. 117.

Exhibited in Paris.

Gaston and Josse Bernheim were the sons of Alexandre Bernheim, a well-established dealer in the rue Laffitte, who was a friend of Gustave Courbet's and specialized in Barbizon painting. In the 1890s, the ambitious young men broke with their father over their wish to deal in more advanced art. They appended the epithet "Jeune" to their name to proclaim their independence and set up business on their own, offering Impressionist paintings at first, but soon adding Paul Cézanne, Georges Seurat, Édouard Vuillard, and Pierre Bonnard, among others. As much patrons of these artists as they were their dealers, the brothers Bernheim-Jeune soon assembled an impressive collection of modern art that included many paintings by Renoir.

In 1901, in a double wedding, Josse married Mathilde Adler while Gaston married her sister Suzanne, and the two couples went on to share a large townhouse on avenue Henri-Martin until 1929. Mathilde and Suzanne belonged to the Parisian bourgeoisie and were famous for their beauty and elegance: important artists like Vuillard and Bonnard painted their portraits, notably the latter's famous 1908 *The Loge* **Cat. 109**, which shows the sisters "bored and beautiful" in their opera box.[1] The same year, Renoir also portrayed them in the fashionable salon of their joint residence.

At this time, the ties between Gaston and Josse Bernheim-Jeune and Renoir grew stronger and stronger—thus the Bernheim brothers solicited a Viennese doctor to treat Renoir's rheumatic condition and, in 1910, commissioned further portraits of their wives and children.[2] One of these was a picture of Mathilde, Madame Josse Bernheim, with her son, Henry Dauberville. Madame was not

very pleased with the outcome, especially with the fleshiness of her arm. She complained about it to Rodin, hoping he would convince the painter to make a "correction" but, instead, Rodin opined that it was the best arm Renoir had ever done.[3] This anecdote, if true, is revealing in two ways: on the one hand, it illustrates the misgivings with which Renoir's late style was received even by his closest friends and most passionate defenders, such as the Bernheims. On the other hand, it clearly suggests that what Mathilde Bernheim-Jeune considered faulty drawing should be more properly understood as the particular kind of painterly effect Renoir was striving for in his late works.

The portrait surprises by its spatial distortions and an almost baroque eccentricity that owes less to a revival of past formulas than to a modern sensibility. Symbolically, Renoir has placed in the background a version of one of Maillol's *Bather* statuettes (*Bather Arranging Her Hair*), as a multiple allusion—to the modernity of his subject; to the role of the brothers Bernheim-Jeune in promoting that younger artist's work; and to Renoir's own interest in sculpture. In fact, the dealer Paul Durand-Ruel was to assert that "Renoir is the man who most influenced modern sculpture, much more than Rodin, . . . and he exerted that influence through his brush, by his form, masses, amplitude, and the sculptural nature of his figures."[4]

Monsieur and Madame Bernheim de Villers began as a single portrait of Suzanne Bernheim; the painting was well under way when Renoir decided to insert the figure of her husband, Gaston. Like her sister, the elegant Suzanne, dressed and bejeweled in high Parisian fashion, sat for Renoir in his studio at Les Collettes,[5] but the artist, drawing on imagination as much as on memories of visits, depicted both of them in settings more in keeping with their social status. In the portrait of Mathilde, a Louis XVI armchair and what looks like a red-draped grand piano in the background suffice to evoke the elegant surroundings of the Bernheim residence. In the double-portrait, the same effect is achieved even more economically with a settee (whose floral upholstery shows off Renoir's skill as a still-life painter) and a large-scale framed painting in the background, which perhaps is meant to allude to the various decorations that Bonnard, Vuillard, and Matisse painted for the Bernheims' summer residence in Villers-sur-Mer.

J. P. M.

1. Groom 1993, p. 191. **2.** Feliciano 1997, p. 78. **3.** Ibid. **4.** Gimpel 1987, p. 156. **5.** Denis 1957–59, vol. 2, p. 118.

Pierre Bonnard
The Loge
1908

Cat. 109, p. 282

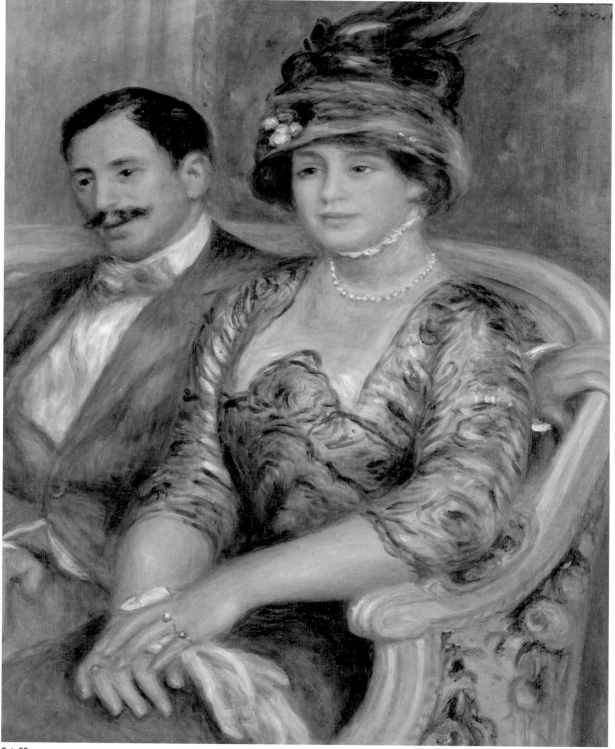

Cat. 52

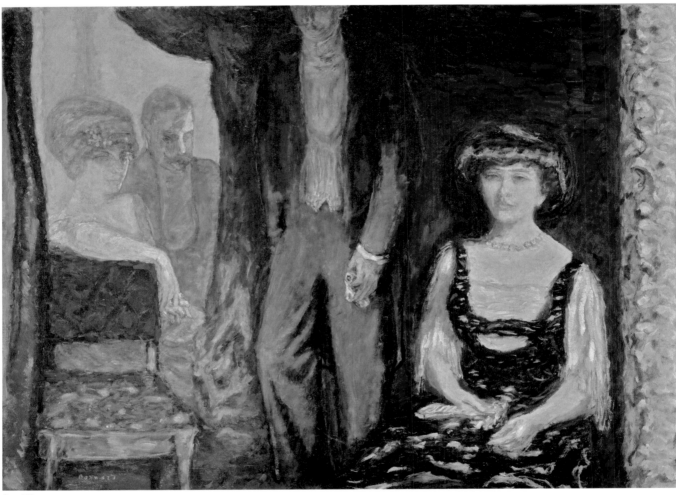

Cat. 109

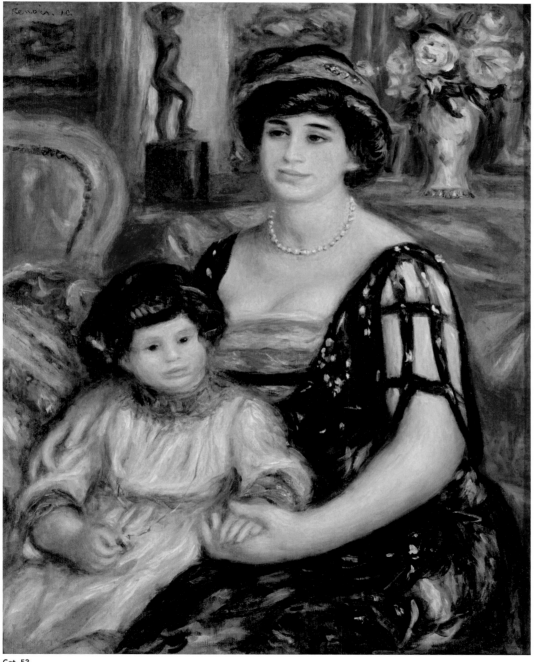

Cat. 53

Cat. 54

Mother and Child (Madame Thurneyssen and Her Daughter) (Mère à l'enfant [Madame Thurneyssen et sa fille])

1910
Oil on canvas
39³/₈ x 31¹/₂ in. (100 x 80 cm)
Signed and dated bottom left: *Renoir. 10*
Buffalo, Albright-Knox Art Gallery, General Purchase Funds, 1940
1940:6

EXHIBITIONS

London 1936, no. 41; Glasgow 1937, no. 53; Montreal 1938, no. 29; New York, Bignou Gallery, 1939, no. 13; New York 1942–43, no. 42; Seattle 1951; Omaha 1951; New York 1954, no. 7; Los Angeles and San Francisco 1955, no. 76; New Haven 1961, no. 64; Pittsburgh 1961; Washington, DC, 1968, p. 22; Buenos Aires 1969, no.13; Chicago 1973, no. 80; Fort Lauderdale 1986–87; Ottawa, Chicago, and Fort Worth 1997–98, no. 66; Tokyo, Nagoya, Hiroshima, and Ibaraki 1998; San Diego and El Paso 2002–03, no. 11; Paris 2005–06, p. 32; Atlanta, Denver, and Seattle 2007–08, no. 89.

BIBLIOGRAPHY

Meier-Graefe 1911, pp. 182–83 (as *Bildnis der Frau T. und ihres Sohnes*); Meier-Graefe 1929, pp. 316–318, 340; Duret 1937, p. 56; Brian 1939, pp. 9, 21, and cover; Washburn 1940, pp. 7–8; Buffalo Fine Arts Academy 1941; M. F. 1943, p. 17; Ritchie 1949, pp. 102–103, 196, no. 48; Pach 1958b, pp. 280, 281 (wrongly dated 1908); Munson-Williams-Proctor 1952, p. 3; Renoir 1962b, pp. 423–24; Wheldon 1975, pp. 94–95, pl. 94; Nash 1979, pp. 246–247; White 1984, pp. 245, 253; Berlin and Munich 1996–97, p. 429

Painting Mme Thurneyssen's majestic portrait was the main reason for the Renoir family's trip to Germany in the summer of 1910. The Thurneyssens had first met Renoir in Cagnes in 1908 and were to visit him again in 1911, in Paris, and 1912, in Nice. Although their identity has been firmly established,[1] much remains to be discovered about the couple from Munich whose patronage of the aging painter went beyond the commission of family portraits and the introduction of friends, like Wilhelm Mühlfeld, whom Renoir painted as well. Thus, Fritz Thurneyssen campaigned successfully for the gift of a work by Renoir to the Neue Pinakothek in Munich. As a matter of policy, the museum was not allowed to spend public funds on French art, and it was probably due to Thurneyssen's connections with Renoir that, in 1912, the dealer Durand-Ruel presented the Neue Pinakothek with Renoir's 1880 *Portrait of Monsieur Bernard.* In the early years of the twentieth century, the Thurneyssens' enthusiasm for Renoir and the modern French school was shared in Germany by an elite of art critics, curators, and collectors. Mostly, however, French modernism was accepted as the context that explained and legitimized Germany's own modern art movement. Important arbiters of taste like Hugo von Tschudi, director first of the Berlin, then of the Munich museums, who had done much to win aesthetic and political acceptance of French art after the Franco-Prussian War of 1870–71, vigorously built his museums' collections with works by the German avant-garde.

In this climate, the Thurneyssens may have faced a dilemma when they were casting about for an appropriately prestigious *Hausmaler* to immortalize their family. By 1910, the list of suitable German artists was short: Franz von Lenbach, long the leading portrait painter in Munich had died six years earlier; the once promising Munich Secession had collapsed and was but a memory. In Germany, only the aging Wilhelm Trübner might have been able to produce important portraits for a demanding patron, while in nearby Vienna, Oskar Kokoschka or Gustav Klimt could have offered the Thurneyssens an alternative to Renoir's fame. There is no indication, however, that any of these were ever considered.

Renoir's visit to Munich was a qualified success. Jean Renoir later remembered it as a particularly happy moment of his childhood and left a vivid description of the games he and his brother Pierre played with the Thurneyssen children and their friends.[2] Their father, however, grew bored and cut the visit short as soon as he had completed the portrait of his hostess with her younger child. As is well known, Renoir had admired the famous collection of paintings by Rubens in the Alte Pinakothek,[3] and it was, therefore, perhaps as an act of homage that he presented the mother-and-child pair as a modern-day vision of *Helena Fourment with her Eldest Son, Frans,* one of the Pinakothek's most celebrated pictures.

Colin Bailey has noted the "disturbing feature" of Mme Thurneyssen's exposed breast. In the presence of a child well past breast-feeding age, it can hardly be read as an allegorical allusion to maternity. Nor does it seem probable that Mme Thurneyssen's *négligé* was, as Ambroise Vollard would claim, the consequence of her husband's lustful request.[4] More likely, Fritz Thurneyssen wanted the painting he was commissioning from the famous Renoir—even if it was a portrait—to allude to the artist's celebrated mastery of the nude. The result, in any case, is far from erotic. Coupled with Barbara ("Betty") Thurneyssen's modest and melancholic downcast gaze, her quasi-heroic nudity rather evokes the *gravitas* of classical sculpture—an enduring model for Renoir, who a year later represented young Alexander Thurneyssen in the attitude of a Greek god **Cat. 55**.

More unexpected perhaps is the somber color scheme of *Madame Thurneyssen and Her Daughter;* it is unusual for Renoir, especially in his depictions of women and children. During his Impressionist years, Renoir had banished black from his palette, only to "rediscover" it in Italy as "the queen of colors."[5] It is liberally applied here, not only to render Mme Thurneyssen's opulent coiffure, but also in the folds of her *peignoir* and in the pattern of the background wallpaper. Colin Bailey has justly invoked the influence of late Titian—perhaps even more than Rubens—in this portrait, whose power resides precisely in its ambiguous atmosphere.

J. P. M.

1. See exh. cat. Ottawa, Chicago, and Fort Worth 1997–98, p. 254. **2.** J. Renoir 1962, pp. 423–424. **3.** Pach 1912, p. 613. Although, as Vollard reports, he also felt that the ones he knew from the Louvre were by no means inferior (Vollard 1925, pp. 138–139). **4.** See exh. cat. Ottawa, Chicago, and Fort Worth 1997–98, pp. 254–256. **5.** J. Renoir 1962, p. 386.

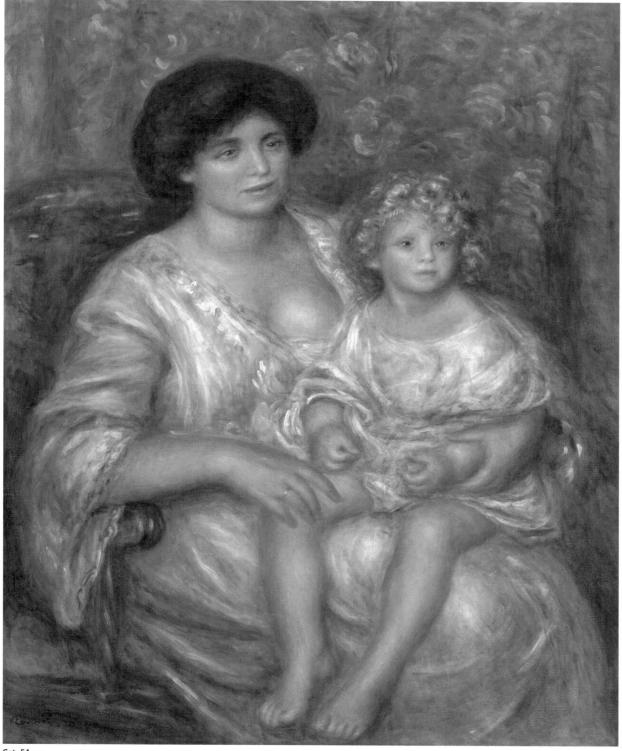

Cat. 54

Cat. 55

Young Shepherd in Repose
(Portrait of Alexander Thurneyssen)
(Jeune pâtre au repos
[Portrait d'Alexander Thurneyssen])

1911
Oil on canvas
29 1/2 x 36 5/8 in. (75 x 93 cm)
Signed and dated bottom right: *Renoir. 1911*
Providence, Museum of Art, Rhode Island School of Design,
Works of Art Fund
45.199

EXHIBITIONS
New York, Durand-Ruel, 1939, no. 23; New York 1941, no. 78 (as *Jeune Pâtre aux oiseaux*); New York 1942–43, p. 142; Portland 1944; Toronto 1944, no. 54; St. Louis 1947, no. 33; Worcester 1947; New York 1948, no. 27; Providence 1949, p. 31; Edinburgh and London 1953, no. 40; New York 1954, no. 9 (as *Young Shepherd with Birds*); Atlanta and Birmingham 1955, no. 23; Houston 1958; New York 1958, no. 64 (as *The Young Shepherd*); Wolfsburg 1961, no. 132, pl. 55; Cologne 1962, no. G161; Waltham and Providence 1967, no. 36; New York 1968, no. 68; New York, Wildenstein, 1970, no. 99; Chicago 1973, no. 81 (as *Alexander Thurneyssen as a Shepherd*); New York 1974, no. 58 (as *The Young Shepherd*); Williamstown 1974–76; Washington, DC, 1979; Roslyn Harbor 1984, p. 54; Winnipeg 1987, pp. 190–191; Nagoya, Hiroshima, and Nara 1988–89, no. 64; Brisbane, Melbourne, and Sydney 1994–95, no. 49; Ottawa, Chicago, and Fort Worth 1997–98, no. 67; San Diego and El Paso 2002–03, no. 12.

BIBLIOGRAPHY
Meier-Graefe 1911, p. 177; Meier-Graefe 1920, p. 156; Meier-Graefe 1929, pp. 320–321; Bernáth 1937, p. 163; Besson 1938, no. 44; Frankfurter 1939, pp. 7, 20; Venturi 1939, vol. 1, p. 106; Brian 1942, p. 23; Drucker 1944, pl. 154; Frost 1944, p. 36 (as *The Shepherd Resting*); Art News 1945, p. 10; Art Quarterly 1945, p. 244; Georges-Michel 1945, p. 97; Washburn 1945; *Worcester Telegram* 1947; *Providence* 1947; Laporte 1948, p. 179; Fox et al. 1950, p. 115 (as *Shepherd Boy*); Pach 1958b; *Bremer Nachrichten* 1961; J. Renoir 1962, p. 424; Pach 1964, p. 122, pl. 123; Fezzi 1972, no. 747, p. 123; Erwin 1980, pp. 26–27; White 1984, pp. 245, 250; De Grada 1989, p. 92, no. 68; Monneret 1990, p. 155, no. 19; Rosenfeld 1991, no. 61.

Renoir's last journey abroad took place in the summer of 1910. The Renoir family, accompanied by Renée Rivière and by Gabrielle, left France for Wessling am See, a small lakeside town on the Starnbergersee, not far from Munich. Their hosts were Fritz and Barbara, or Betty, Thurneyssen. Fritz Thurneyssen can best be described as a rich art lover, the author of a thesis on the history of Munich cabinetmakers.[1] He and his wife collected traditional academic paintings before embracing Renoir's late style, which they saw as the essence of modernity. They first met Renoir in 1908, during a stay in Cagnes, when he painted portraits of Betty (Switzerland, private collection) and of the Thurneyssens' son, Alexander, then aged ten (private collection). Two years later, Renoir executed a second portrait of Mme Thurneyssen with her young daughter on her lap **Cat. 54**, and a year after that, this second picture of Alexander in the guise of an Arcadian shepherd. By this time, Renoir was famously averse to commissions, so the number of his Thurneyssen portraits is a surprising exception.

One of Renoir's main reasons for accepting the Thurneyssens' invitation to Munich was the opportunity to see one of the world's largest collections of paintings by Rubens. While he did not think that the Munich Rubens were necessarily superior to those in the Louvre,[2] Renoir took away from the experience an important insight about the relationship between color and technique. "See the pictures by Rubens at Munich" he later told Walter Pach, "there is the most glorious fullness and the most beautiful color, and the layer of paint is very thin."[3] The realization that brilliant color did not need to equal thick paint is one of the cornerstones of Renoir's late style.

The portrait of Alexander Thurneyssen as a *Young Shepherd in Repose* was not painted during Renoir's Munich visit, but the following year. The boy traveled to sit for Renoir in the painter's Parisian studio on boulevard Rochechouart or, according to Meier-Graefe, at Les Collettes, but it is not entirely clear just how much of him we really see in the painting. While his regular, almost feminine, features and his extravagant bush of curly auburn hair are recognizable, Renoir may also (as he occasionally did) have called on Gabrielle to model the shepherd's body.[4]

Dressed in animal skins and a straw hat that, in the context, evokes a Greek *petasos* but probably was Gabrielle's everyday garden hat, the figure's pose is derived from one of the famous Parthenon sculptures, the so-called *Dionysus* from its east pediment. It is one of the rare instances in Renoir's late oeuvre where his taste for timelessness and classical monumentality is expressed in an overt reference to a specific ancient model. Subtly idealized and simplified, the figure has a sculptural quality and the classicism we also find in Renoir's statues and the figures of Aristide Maillol.

There are several ways to consider this painting's eccentricity and its uniqueness in the portrait tradition. On one level, it can simply be enjoyed as an amusing costume piece; but it also falls into the category of other turn-of-the-century decorative reinterpretations of classical Arcadian iconography (for example by Ker-Xavier Roussel); or it can be understood as the culmination of Renoir's obsession, in the early twentieth century, with the art of the past—a fusion perhaps of Phidias and Rubens. In any case, in Renoir's oeuvre the painting marks the resolution of a challenge he had taken up after his days as an Impressionist: the perfectly harmonious fusion of the figure with its background, indisputably achieved here with astonishing virtuosity.

J. P. M.

1. Exh. cat. Ottawa, Chicago, and Fort Worth 1997–98, p. 254. **2.** Vollard 1925, p. 138. **3.** Pach 1938, p. 109. **4.** Rosenfeld 1991, p. 155.

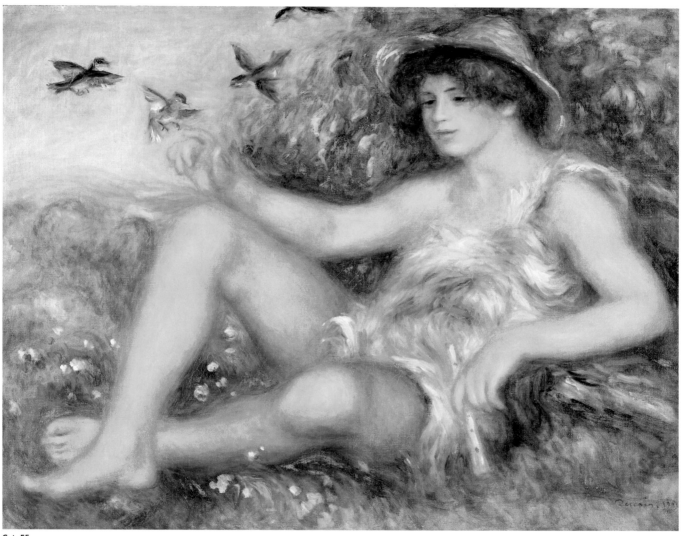

Cat. 55

Cat. 56

Jean as a Huntsman
(Jean Renoir en chasseur)

1910
Oil on canvas
68 x 35 in. (173 x 89 cm)
Signed and dated bottom right: *Renoir. 1910*
Los Angeles, Los Angeles County Museum of Art, Gift through the
Generosity of the late Mr. Jean Renoir and Madame Dido Renoir, 1979
M.79.40

EXHIBITIONS
Munich 1912, no. 37 (?) (collection of the artist); Chicago 1973, no. 76
(collection Jean Renoir); Los Angeles 1991 (not in catalogue); Ottawa, Chicago,
and Fort Worth 1997–98, no. 63; Paris 2005–06, p. 58; Atlanta, Denver, and
Seattle 2007–08, no. 110, p. 235; Tokyo and Kyoto 2008, no.11.

BIBLIOGRAPHY
André 1923, pl. 44; André 1928, pl. 72; Meier-Graefe 1929, p. 341; Bernheim-
Jeune 1931, vol. 2, pl. 125, no. 390; Los Angeles County Museum of Art 1987,
p. 84; Boudier 2005, pp. 40–45.

"**A**t Les Collettes, when I was fifteen years old, I wore a jacket that reminded my father of a hunter, so he had me pose with a gun and with Bob for a hunting dog. The gun was borrowed from one of our farmers, I shot it only once, killed a bird, and was horrified. The posing sessions, which were held in the big studio, went on for several months…"[1]

Jean Renoir's memoir confirms that this painting is not so much a specific individualized portrait as it is a studio scene contrived by an artist's fantasy. Its essential artificiality is underscored by the overt references the composition makes to celebrated works of past art: as Colin Bailey has pointed out,[2] Jean's pose is modeled on that of *Prince Baltasar Carlos as a Hunter* (ca. 1635–36, Madrid, Museo del Prado), one of the royal hunting portraits by Diego Velázquez, that Renoir had been able to admire during a visit to Madrid in 1892; the fluidly brushed, elegantly stylized landscape backdrop, furthermore, recalls paintings by Jean-Antoine Watteau, another of Renoir's favorites. The incongruity between the two levels of the picture—reality and art—gives the representation a certain solemn formality and raises it from the here-and-now of portraiture to the realm of timeless allegory. Although Jean himself did not hunt, the persona of a hunter—alert and poised—is nonetheless suitable for a fifteen- or sixteen-year-old adolescent, embodying the newly emerged physicality, confidence, and responsibility of the young adult. We might say, model and costume in this "portrait" combine to form an archetype.

This large, life-sized painting is a remarkable tour-de-force for an artist who was severely crippled by rheumatoid arthritis. Renoir was confined to a wheelchair from 1910 and had lost practically all mobility in his hands and wrists. His brushes were clamped between stiff fingers and—as is recorded in an astonishing bit of film footage shot by Sacha Guitry in 1915—Renoir used his whole upper body to apply paint in short, stabbing strokes. According to the painter Albert André, the elderly master's confidant in his final years, *Jean as a Huntsman* was one of several large vertical compositions Renoir undertook around 1910 out of defiance: "When one day somebody claimed that Renoir was completely crippled and unable to keep himself upright in front of his easel, and therefore no longer painted anything but reclining figures, using horizontal canvases, he had his chair installed on a trestle and painted, on vertical canvases, the tall dancing figures in the Gangnat collection **Cat. 40 & 41**, the portraits of his son Jean as a huntsman, and several other large canvases. Then he had an easel made where, on a sort of endless backing on rollers, he could attach large-scale canvases."[3] The painting, in effect, is a testament to Renoir's truly heroic determination in the face of terrible physical suffering, something the many visitors who came to pay homage to the old master in his late years invariably commented on.

In a 1979 conversation with Charles Millard, then curator at the Los Angeles County Museum of Art, Jean Renoir was to remember that his portrait was painted specifically to fit a magnificent carved and gilded Italian Baroque frame his father had seen in a Nice antique shop.[4] "He felt that a massive frame was necessary to set off the picture properly, 'especially in a drawing room in the Midi, where there is so much else to tempt the eye.'"[5] The painting remained in Renoir's possession until his death. It was inherited by Jean Renoir, who bequeathed it to the Los Angeles County Museum of Art in 1979, although it remained with Jean's widow, Dido Renoir, until her death in 1990.

C. E.

1. J. Renoir 1952, p. 98. **2.** Exh. cat. Ottawa, Chicago, and Fort Worth 1997–98, p. 246. **3.** André 1923, pp. 36–38. **4.** Note in curatorial file, LACMA. See also exh. cat. Ottawa, Chicago, and Fort Worth 1997–98, p. 246. **5.** J. Renoir 1962, p. 273.

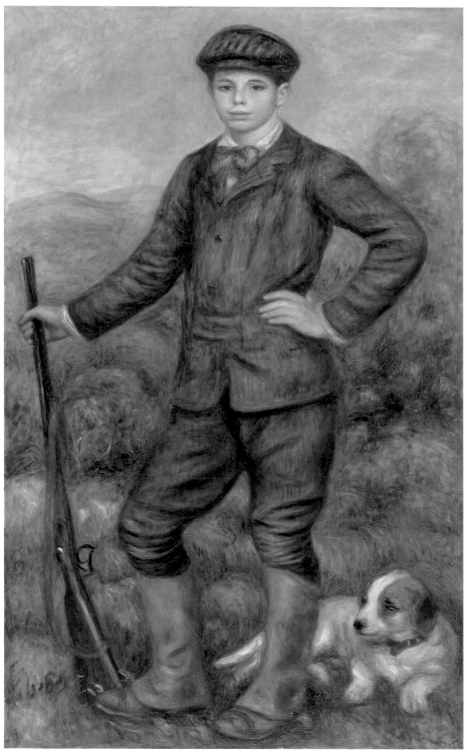

Cat. 56

Cat. 57

Portrait of the Poet Alice Vallières-Merzbach (Portrait de la poétesse Alice Vallières-Merzbach)

1913
Oil on canvas
36¹/₄ x 28³/₄ in. (92 x 73 cm)
Signed and dated bottom left: *Renoir 1913*
Geneva, Musée du Petit Palais, Association des Amis du Petit Palais, 1961
7895

EXHIBITIONS
Paris, Bernheim-Jeune, 1938; Turin 1964, no. 31; Tel Aviv 1964–65, no. 13; Geneva 1965, no. 21; Geneva 1974–75, no. 31; Geneva 1986, no. 35; Geneva 1998; Turin 2001, p. 162; Paris, Brescia, Rotterdam, and Québec, 2002–03, respectively no. 16, p. 49, p. 84, and no. 16 (each venue had a different catalogue edition); Lodève 2007, no. 8; Jena 2008–09, no. 60.

BIBLIOGRAPHY
Petit Palais 1968, no. 76; Ghez 1976. p. 216; Diehl and Ghez 1993; Mondial Collections 1995, p. 29; Palermo and Milan 2002, p. 65.

When she sat for Renoir, Alice Merzbach had not yet embarked on her career as a poet. Under the *nom de plume* Alice-George Vallières she would publish four volumes of poetry: *La Douloureuse Chanson* (1925); *Amours défuntes, amours vibrantes* (1928); *Crépuscule* (1952, illustrated by herself); and *À l'enseigne de l'Orme* (1956). Her poems, more reminiscent of the contemporaneous sentimental and popular poetry of Paul Géraldy than of the tempered symbolism of her obvious model, Anna de Noailles, have been largely forgotten. Vallières-Merzbach herself is an elusive character who has left no trace in the many accounts of Renoir's life, patrons, and models.

The painting was commissioned by Merzbach herself, who was then probably in her early thirties. Although, as is well known, Renoir professed an aversion to commissions, in some cases, as in the 1910 and 1911 Thurneyssen portraits **Cat. 54 & 55**, the paintings nonetheless reveal a relationship that goes beyond the basic contractual one. Not so, however, in the Merzbach portrait. Here,

Renoir has depicted his subject in the straightforward manner of the successful society portraitists of his day—Giovanni Boldini, Paul Helleu, or John Singer Sargent. As in their works, Renoir's portrait is short on capturing the sitter's personality; he seems to have been more attracted to his model's dress and jet black hair than to her face. Merzbach wrote an account of her encounter with Renoir, according to which she approached the artist—who was by then already severely crippled by arthritis—during one of her visits to the South of France. At first, Renoir showed no interest in painting her. "No, I no longer do portraits, I've had too much trouble with them," he said, but then, only moments later, ordered the young woman to remove her hat. "I obeyed this order," Merzbach continues, "and without further explanation, he told me 'come tomorrow morning, I will not make a portrait of you but I will paint a picture with you in it.'" The next day Merzbach arrived in Renoir's studio with a variety of gowns, but first put on a simple white satin dress. "When Renoir saw it," she recalls, "I thought he was losing his mind, that's how full of joy he was over this dress. 'I haven't painted white satin in twenty years—I don't want to see anything else . . . how happy I am.' And he began to paint." It took seventeen sessions for Renoir to complete the portrait; Merzbach was not allowed to see it until he finally said: "I have finished, you may look at it."[1]

According to the writer Charles Oulmont, who claims to have been present in Renoir's studio when the portrait was completed, the flowers were an afterthought, added by the artist at the suggestion of another visitor.[2]

Given that this portrait shows Renoir as a painter of fashionable society—a rarely considered aspect of his career—it may seem easy to dismiss it without reaching beyond its superficial banality. However, more profitably, it should rather be compared with some of Édouard Vuillard's commissioned portraits, which also may disconcert the viewer at first glance, but which, at further inspection, reveal equally rewarding pictorial qualities.

J. P. M.

1. Unpublished typescript in the archives of the Musée du Petit Palais. **2.** Note in the curatorial file of the painting.

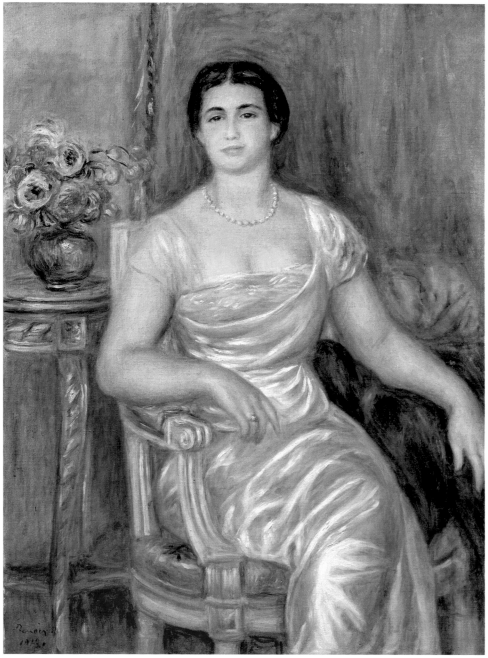

Cat. 57

Cat. 58

Washerwomen (Les Laveuses)

Circa 1912
Oil on canvas
25³/₄ x 21¹/₂ in. (65.5 x 54.5 cm)
Signed bottom right: *Renoir*
Private collection

EXHIBITIONS
Zurich, 1933, no. 70; New York, 1969, no. 83; London, Paris, and Boston 1985–86, no. 118 (not exhibited in Boston; no. 116 in French ed.).

BIBLIOGRAPHY
Meier-Graefe, 1929, no. 274, p. 275; Monneret 1990, pp. 142–143.

Exhibited in Paris.

Renoir initially painted the subject of country women washing clothes in a stream in December 1888 when he was working in Essoyes. Writing to Berthe Morisot and Eugène Manet in Paris, Renoir explained, "I am painting peasant women in Champagne so as to escape the expense of Paris models. I am doing laundresses, or rather washerwomen, on the banks of the river."[1] A work produced during that visit (*Washerwomen*, ca. 1888, Baltimore Museum of Art) shows three women and a young child beside a river, scouring linens in a lush country setting. Renoir returned to the theme nearly twenty-five years later in several canvases and a chalk sketch made in Cagnes. That this rural subject was equally part of the picturesque appeal of the Mediterranean is apparent in several turn-of-the-century postcards showing women washing cloth on the banks of the river Cagne **Fig. 106**.

In *Washerwomen* Renoir has reduced the composition to two colorfully dressed figures that appear monumental and heroic despite the relatively modest dimensions of the canvas. The women's rolled-up sleeves reveal strong, muscular arms while the close perspective and low vantage point enhance the intimacy of the scene. With its juxtaposition of women and landscape, *Washerwomen* has much in common with Renoir's paintings of bathers who are equally self-absorbed and at ease in nature. Renoir would combine these subjects in a sculpture of about 1917 **Cat. 94** in which a nude woman kneels, raising a wet cloth between her hands. These works stress the dignity and gracefulness of such

domestic activities rather than their arduous labor, an idea reinforced in *Washerwomen* by the idyllic landscape with its groves of trees, flowers, and bluish hills in the distance.

The painting is usually dated around 1912. John House has argued that the shimmery white highlights and the facial characteristics of the women, both most likely modeled by Gabrielle, are similar to those in *Gabrielle with a Rose* of 1911 **Cat. 59**.[2] Two related works were produced in the same period: a painting titled *Washerwomen in Cagnes* (ca. 1912, private collection) in which an expansive landscape is occupied by eleven women and two children washing, wringing, and drying cloth by a stream; and a chalk study for the two figures in *Washerwomen* **Fig. 107**. In the almost full-sized preparatory sketch, the solid forms of the women and their overlapping figures are worked in vibrant red tones that suggest the rich colors of the finished painting.

The early provenance of *Washerwomen* is unknown, but the painting was in Berlin by the late 1920s in the possession of Dr. Alfred Gold; it belonged briefly to the young collector and later gallery owner Estella Katzenellenbogen. In 1933 the picture was purchased by Salman Schocken, a Jewish publisher who formed a notable collection of Old Master and modern paintings that he kept in Israel and the United States.

J. A. T.

1. Quoted in Morisot 1987, p. 162. **2.** Exh. cat. London, Paris, and Boston 1985–86, p. 284 (p. 344 in French ed.).

Fig. 107

Pierre-Auguste Renoir
Washerwomen
Ca. 1912
Red, white, and black
chalk on paper
20⁵/₈ x 14⁵/₈ in. (52.5 x 37.2 cm)
Private collection

Fig. 107

127 – Côte d'Azur – **Cagnes-sur-Mer** – *Les bords de La Cagnes*

Fig. 106

The banks of the river Cagne
Postcard
Early 20th century
Cagnes-sur-Mer, Musée Renoir

Fig. 106

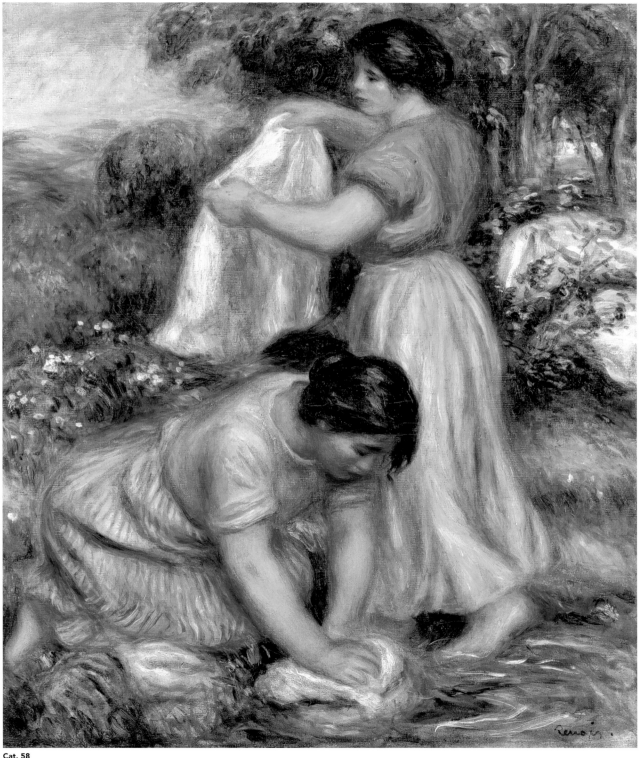

Cat. 58

Cat. 59

Gabrielle with a Rose
(Gabrielle à la rose)

1911
Oil on canvas
21⁷/₈ x 18¹/₂ in. (55.5 x 47 cm)
Signed top right: *Renoir*; on back of frame: *Cagnes 1911*
Paris, Musée d'Orsay, Gift of Philippe Gangnat in memory of his father,
Maurice, in 1925
RF 2491

EXHIBITIONS
Paris, Rosenberg, 1934, no. 12 (as *Gabrielle*); Cagnes-sur-Mer 1949, no cat.;
Lyon 1952, no. 46; Marseille 1955, no. 33; Limoges 1956, no. 25; Moscow 1956,
pp. 160–161; Cagnes-sur-Mer 1969, no. 1; Troyes 1969, no. 1; Taiwan 1997,
pp. 254–255, 328–329; Warsaw, Poznan, and Krakow 2001, pp. 146–147;
Budapest, Warsaw, and Bucharest 2004–05, no. 87; Paris 2005–06, pp. 117, 234;
Tokyo and Kyoto 2008, no. 29; Seoul 2009, pp. 82–83.

BIBLIOGRAPHY
Rivière 1921, p. 124; Beaux-Arts 1925, p. 207; Werth 1925, p. 51; Jamot and
Guiffrey 1929, pp. 83–84 and pl. 64; Meier-Graefe 1929, p. 393, ill. 371; Besson
1933, pp. 1, 8; Fox 1952, p. 6, no. 13; Adhémar, Sérullaz, and Beaulieu 1958,
no. 376; Fouchet 1974, pp. 152, 172; Gaunt 1982, no. 47; Compin, Lacambre,
and Roquebert 1990, vol. 2, p. 393; Minervino 2003, p. 216.

Gabrielle with a Rose belongs to a series of eight paintings exe-
cuted between 1907 and 1911 on one of Renoir's favorite themes—
the woman at her toilette. Gabrielle was the only model he used
for these works; she later became the painter's devoted assistant,
"attentive to his every move, preparing . . . his canvasses and
colors,"[1] and his strict nurse, surrounding "her master . . . with the
same care that she had once taken for the painter's young son."[2]
"Jealously guarding [Renoir's] rest and work time, she shooed out
intruders, shouting in a voice fit to break glass: 'the Master is
working . . . leave him alone!'"[3]

Against a neutral background, Gabrielle is represented in half-
length profile. She is wearing the same open white blouse over her
bare chest that is found in the other paintings in the series. The vari-
ations the painter introduces from one work to the next are min-
imal. Tightly framed to varying degrees, the young woman is often
leaning on a table, in the process of pinning a rose in her hair.
Sometimes, as is the case here, she wears a necklace. Renoir struc-
tured his painting on the opposition of colors: the pinkish reds of
the table and flowers tone in with the greens and yellows of the
background, while the black hair contrasts with the white of the
clothes. He establishes a network of connections between the

green of the necklace and that of the wall, or the red of the roses
and that of the young woman's cheeks. Green and red, comple-
mentary colors, mutually support each other; for many painters of
Renoir's generation, Eugène Delacroix was the first to demon-
strate the advantages that could be derived from this luminous and
colorful play of contrasts. A great admirer of his elder—"by nature,
of course, I have a preference for Delacroix"[4]—Renoir had in mind
The Women of Algiers in Their Apartment (1834, Paris, Musée du
Louvre). Indeed, for him "there isn't a finer picture in the world . . .
How really Oriental those women are—the one who has a little rose
in her hair, for instance!"[5]

The restricted color range in which warm tones predominate
is typical of the mature works of Renoir, along with the free-flowing
craftsmanship. The strokes are sometimes energetic—creating
luminous highlights on the blouse and face, for instance, or defining
certain contours with a single brushstroke, like the flowers or neck-
lace—and sometimes much lighter, allowing the painter to bring
the canvas to life while at the same time creating colored grada-
tions, as in the flesh tones.

While Renoir was always fond of associating women and
flowers—several of his Impressionist canvases depict young girls
in a garden—his preference seems to have been for roses after
1900. Indeed this flower, in full bloom, became a feature almost
equated with female beauty, which in his eyes consisted in plump-
ness and ample proportions: "I paint flowers with the color of
nudes, and I paint women in the same pink tones as the flowers,"[6]
and aside from that, Gabrielle sometimes put a cloth rose in her
hair when she posed **Cat. 152**.

It was probably during a visit to Cagnes, where he stayed each
spring in the Hotel Savournin, and later at Les Collettes,[7] that the
collector and close friend of the painter, Maurice Gangnat, noticed
the work. It joined his collection, which comprised no less than one
hundred and eighty paintings by Renoir, all executed after 1905.
As a tribute to his father, Philippe Gangnat decided to offer
Gabrielle with a Rose to the Louvre in 1925, when the collection
had to be broken up and sold at auction. It was also thanks to his
actions (Philippe was at the forefront of conserving Les Collettes)
that the painter's property became the Musée Renoir in 1960.

I. G.

1. C. Renoir 1959, p. 33. 2. Albert André in 1936, quoted in exh. cat. Bagnols-sur-Cèze
2004, p. 62. 3. C. Renoir 1959, p. 32. 4. Renoir, quoted in Vollard 1934, p. 202. 5.
Ibid. 6. Renoir quoted by Florent Fels in *Le Roman de l'art vivant de Monet à Buffet*,
1959, repr. in Renoir 2002, p. 212. 7. Pasteau and Journiac 2008, p. 93.

*Gabrielle modeling in the
studio of Les Collettes at
Cagnes*
Ca. 1911

Cat. 152

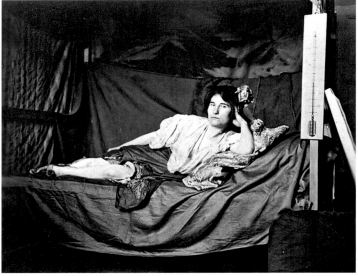

Cat. 152

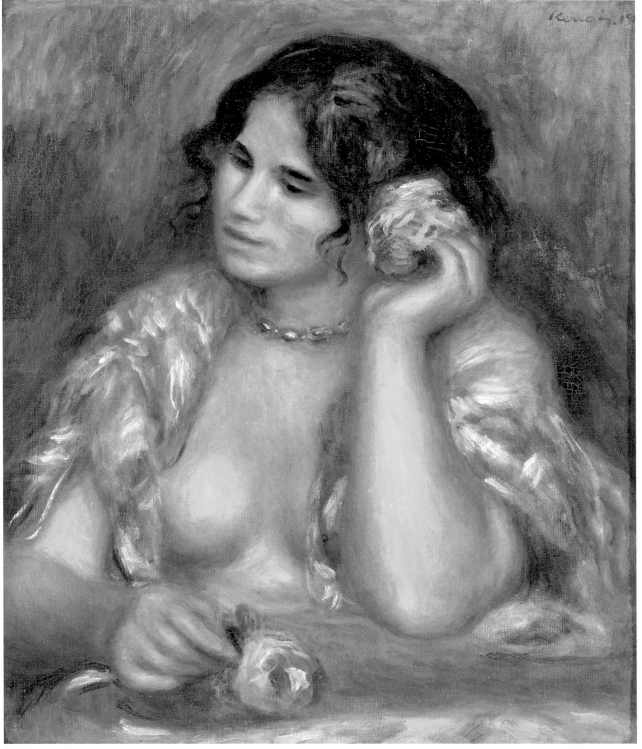

Cat. 59

Cat. 60

Bather Drying Her Leg
(Baigneuse s'essuyant la jambe)

Circa 1910
Oil on canvas
33$^1/_8$ x 25$^5/_8$ in. (84 x 65 cm)
Signed bottom left: *Renoir*
São Paulo, MASP Museu de Arte de São Paulo Assis Chateaubriand,
purchased from the Galerie Bernheim-Jeune, 1952
101

EXHIBITIONS
London 1954, no. 56; London, Paris, and Boston 1985–86, no. 111 (no. 109
in French ed.).
BIBLIOGRAPHY
Fénéon 1919, vol. 2, pl. 125; Rouart 1954, pp. 92–93.

Exhibited in Paris.

Cat. 61

Seated Bather (Baigneuse assise)

1913
Oil on canvas
32$^1/_4$ x 25$^7/_8$ in. (82 x 65.8 cm)
Signed and dated bottom left: *Renoir 1913*
Private collection, purchased in 2007

EXHIBITIONS
New York 1934, no. 27 ; New York 1935, no. 16.
BIBLIOGRAPHY
Coquiot 1925, p. 97; Roger-Marx 1937, p. 173; Frost 1944, p. 45 (dated 1914).

Not exhibited.

Cat. 62

Seated Bather (Baigneuse assise)

1914
Oil on canvas
32$^1/_8$ x 26$^5/_8$ in. (81.6 x 67.7 cm)
Signed bottom left: *Renoir 1914*
Chicago, The Art Institute of Chicago, Mr. and Mrs. Lewis Larned Coburn
Endowment; through prior bequest of the Mr. and Mrs. Lewis Larned
Coburn Collection; through prior acquisition of R. A. Waller Fund
1945.27

EXHIBITIONS
New York 1918, no. 16; New York 1934, no. 27; Washington, DC, 1937, no. 19;
Philadelphia 1938; Worcester 1941, no. 11; New York 1942, no. 10; Chicago
1946; Cincinnati 1951, no. 4; Pittsburgh 1951, no. 118; Paris and London 1952,
no. 93; Chicago 1973, no. 84; London, Paris, and Boston, 1985–86, no. 121
(no. 119 in French ed.).
BIBLIOGRAPHY
Coquiot 1925; *Art Digest* 1945, p. 6; *Art News* 1945b, pp. 18–19; Hope 1945,
pp. 97–102; Art Institute of Chicago 1961, p. 398; Druick 1997, pp. 77–78, pl. 26.

In these three works painted in the last decade of his life, Renoir presents the bather subject as a monumental figure who dominates the pictorial space. While the São Paulo bather **Cat. 60** is absorbed in the act of drying off, the two others **Cat. 61 & 62** gaze out serenely at the viewer, more posing than bathing. Yet despite their portraitlike bearing, these figures are hardly meant to conjure up an individual subjectivity. They are bodies first and foremost, wholly corporeal creatures. In works like these, an essential link between woman and the natural world is so self-evident that landscape can be signified, as it is in the São Paulo picture, by mere notations—abstract patches of green and yellow. There are also small hints at the world of artifice: an earring, a ring, and a striking emerald headband remind us that these bathers are not imagined, quasi-mythological characters, but red-blooded people of the modern world. They issue from a different mythology, perhaps, of ideal nineteenth-century womanhood.

In the 1890s and 1900s, Renoir repeatedly painted individual bathers in this kind of up-close format, both seated and standing, indoors and outdoors, their sensuous bodies always offset with fabric of some sort—discarded clothing, towels, curtains, or soft cushions (see, for example, **Cat. 9, 29, 30, & 31**). These pictures are almost always eroticized, with nude figures playfully pulling back long locks of hair, displaying themselves coquettishly, or concealing themselves as if surprised by an onlooker. In *Bather Arranging Her Hair* **Fig. 109**, for example, the garment slips off while strategically directing our eye to the woman's crotch, our desired touch displaced onto the fabric that mimics the shape of her pubis.

While the three present bathers seem generally to follow this model, their lack of overt sexuality suggests that Renoir is after something different here. Certainly these figures are still in the realm of the erotic—a nipple peeks out in the São Paulo picture, and in all three canvases the skin looks soft and inviting to the touch. However, in none of them does drapery slip suggestively off a body or suggest the act of unveiling; rather, cloth is either crumpled beneath legs or put to practical use. There is nothing coquettish about the women's poses, nor do they invite the sense of voyeurism elicited in so many of Renoir's bathing scenes. Even in the São Paulo picture, where the figure is seemingly unaware of our gaze, the voyeuristic element is diminished as there is simply no room for the viewer to enter the pictorial space. Here as elsewhere, Renoir's interest is more in exploring the body itself—its surface and its relationship to surrounding space—than in producing an erotically charged scene. Early critics like Maurice Denis emphasized the "classical serenity, free from perverseness," of Renoir's "beautiful nudes."[1]

What is striking about these late bathers is how close Renoir pulls in the focus. In the São Paulo composition the pyramid-shaped body stretches to the very edges of the canvas, while in

the Chicago picture **Cat. 62** the massive body pushes forward and sideways, into our space, so that the lower third of the composition is almost entirely flesh. Small figures crowd the background with even more flesh; drastically out of scale, they are barely contained within the frame. Even in the 1913 *Seated Bather* **Cat. 61**, in which the bather sits further back from the picture plane, Renoir takes measures to make her body fill the canvas. She is seated in profile, but the perspective is distorted so that the whole of her back is wrenched around into view.

This awkward relationship of the body to its pictorial space, so insistent in the Chicago picture especially, is what seems to have interested Picasso in works like his *Large Bather* of 1921 **Cat. 100, p. 131** or the *Large Nude with Drapery* **Cat. 104, p. 300**. Here, Picasso's figure is so close to the picture plane that there appears to be no room for her legs, one of which folds awkwardly under the chair. The shape of the body mimics the limits of the canvas, much like in the Chicago picture but to an even greater extent: Picasso's figure is more square than pyramidal, with blocky horizontal shoulders.

In all three Renoir canvases the distinction of figure from ground, and of the body's parts from each other, is achieved not through the use of contour but through subtle tonal shifts across the painted surface. In the Chicago bather, for example, the inner part of the figure's right arm distinguishes itself from her torso simply through the use of red. Darker areas of color in the neck and around the thighs give a sense of depth and hint at bone structure. In each of these pictures, massive forms are built up from layers of thin paint applied in short delicate strokes; Albert André described in 1919 how Renoir used "pure colors diluted with turpentine, as if he were working in watercolor."[2] In fact, the paint is so transparent that at times the white-primed canvas shows through it—an effect Renoir seems to have created deliberately. With regard to the Chicago bather, for instance, Douglas Druick has noted that in some areas of the background Renoir rubbed back the paint, possibly with his fingers, to reveal the crests of the canvas weave.[3] Renoir, it seems, made the canvas a part of his composition, using its white color and nubby texture, which diffuses and reflects light, to help him create a velvety-looking figure that seems to glow from within.

If Renoir's seated bathers are studies of massive volumes in space, they are also portraits of the body's surface, of its ripples and furrows, and of the way flesh absorbs and reflects light. For Renoir, in these late pictures, the canvas surface is a kind of surrogate for the body's surface, and there is a certain equation between paint and flesh. But if the body's surface is equal to paint, it is also equal to touch. These late bathers exist to evoke the tactile sense, in the velvety appearance of their skin and in the way it is always made to brush against soft white fabric. In the 1913 *Seated Bather*, the figure is not so much picking up the nearby cloth as just laying her hand on it, enacting "touch" for us.

M. L.

1. Denis 1920, in Denis 1993, p. 193. **2.** André 1919, p. 32, cited in Wadley 1987, p. 273. **3.** Druick 1997, p. 78.

Pierre-Auguste Renoir
Bather Arranging Her Hair
1893
Oil on canvas
36¼ x 29⅛ in. (92 x 74 cm)
Washington, DC, National Gallery
of Art, Chester Dale Colletion

Fig. 109

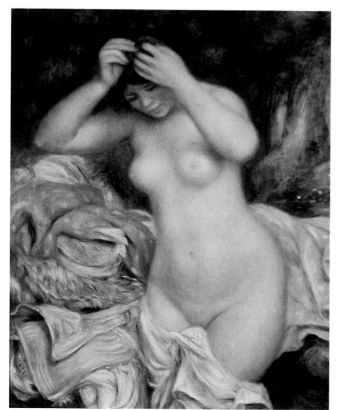

Fig. 109

Pablo Picasso
Large Nude with Drapery
1923

Cat. 104, p. 300

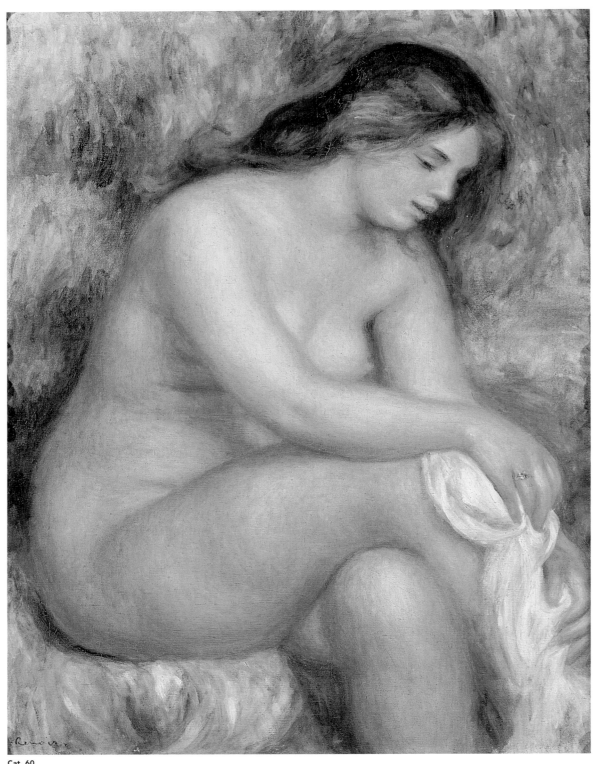

Cat. 60

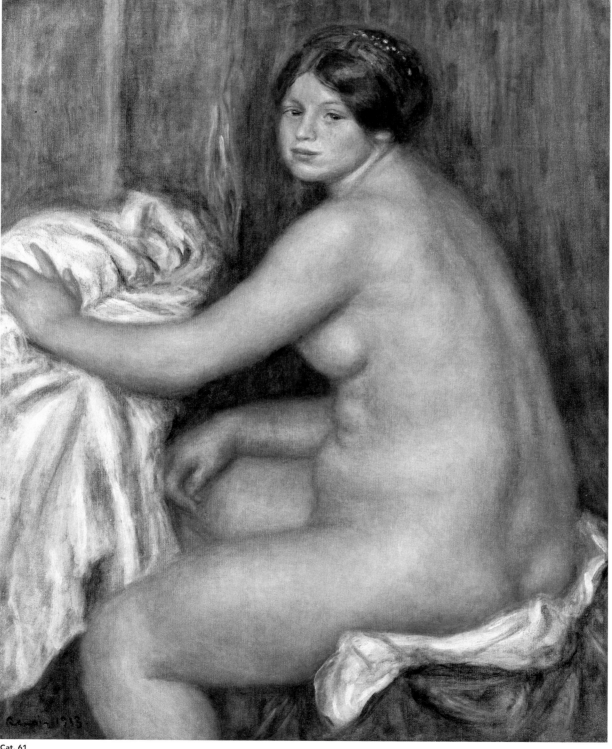

Cat. 61

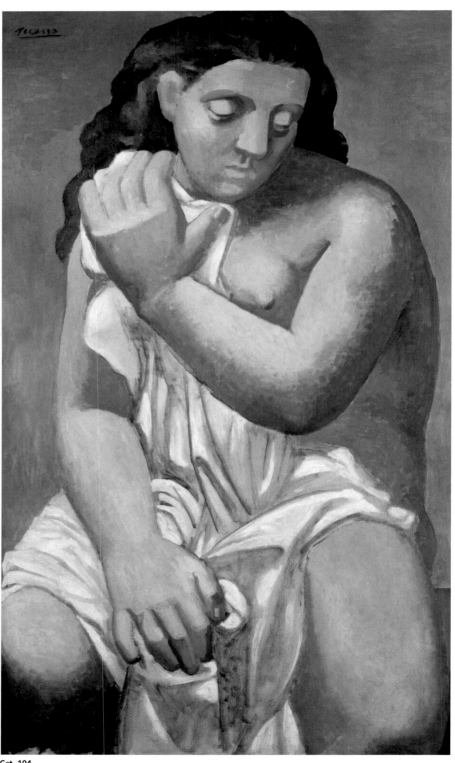

Cat. 104

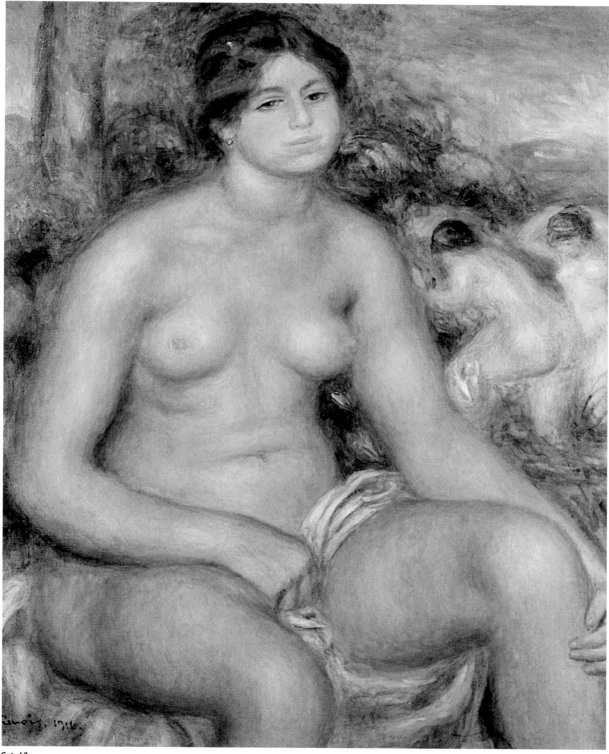

Cat. 62

Cat. 63

Landscape at Cagnes
(Paysage à Cagnes)

Circa 1915
Oil on canvas
15 1/8 x 19 3/4 in. (38.5 x 50 cm)
Signed bottom right: *Renoir*
Bordeaux, Musée des Beaux-Arts, on deposit from the Musée d'Orsay,
Marquet bequest, 1948
RF 1948-15 (Bx D 1962-2-15)

EXHIBITIONS
Nice 1952, no. 21; Paris 1960, no. 21; Tel Aviv 1964, no. 94; Bordeaux and Paris 1975–76, no. 183; Bordeaux 1983, no. 124; Fukuoka, Hiroshima, Tokyo, and Kanazawa 1983, no. 66; Barcelona 1984, p. 57; Mexico 1998, no. 27; Iwaki, Osaka, Shimane, and Fukuoka 2000, no. 31; Pescara 2003, unnumbered; Tokyo, Shimonoseki, Yawatahama, Hokkaido, and Yamagata 2003–04, no. 62 ; Salamanca and Lisbon 2005–06, no. 40; Montpellier and Grenoble 2007–08, pp. 146–147; Tokyo and Kyoto 2008, no. 44.

BIBLIOGRAPHY
Vergnet-Ruiz and Laclotte 1962, p. 249; Martin-Méry 1967, p. 46.

A property "rural in nature, ploughed, with olive trees, vines, orange and lemon trees, other fruit trees and uncultivated land on which there is a farmhouse, a paved area, and a water storage tank," was sold to the Renoirs on June 28, 1907, for 35,000 francs by the widow Mme Armand.[1] On May 2, 1908, the family acquired an additional plot of land from the painter Émile Wéry, in the area of Les Pas.[2] *Landscape at Cagnes* could be a view of Les Collettes or a neighboring property. There appears to be a water storage tank in the middle ground, to the side of the tree. The Renoirs' property extended beyond the road to Les Collettes, which is now a paved road leading to the museum. It was on this piece of land that Renoir had a kiln built for his son Claude to do his ceramics.[3]

This picture, painted around 1915, is technically similar to the painting *The Farm at Les Collettes* at the Musée Renoir in Cagnes-sur-Mer **Fig. 102, p. 262**; the broad, brightly colored, juxtaposed strokes (yellow, orange, and rose ochre with dashes of white on the vegetation), bring a play of light to the foliage and tall grasses. It is a wild and shimmering nature that Renoir enjoys depicting with what might be termed a divisionist brushstroke.

The painting formed part of the private collection of Albert Marquet. He may have acquired it on one of his two visits to Renoir, the first accompanied by Matisse in March 1918,[4] and the second by Bonnard in April 1919.[5] "Before leaving Nice, I saw Renoir, full of enthusiasm and in far better health than last year; what he is doing is ever more beautiful."[6] For Marquet, himself a keen follower of pure tone and expressive color, Renoir's final works compelled admiration.

V. J.

1. Alpes-Maritimes regional archives, Nice, entry 3 E 117 [40], no. 84. 2. Ibid., no. 88. 3. Dussaule 1995, p. 26. 4. Potron 2000, p. 130. 5. Letter from Matisse to Amélie, April 27, 1919, Matisse archives. 6. Letter from Marquet to Élie Faure, May 20, 1919, private collection, in *Correspondance Matisse-Marquet* 2008, p. 117, note 172.

Cat. 63

Cat. 64

Mediterranean Landscape, Cagnes (Paysage méditerranéen, Cagnes)

Between 1905 and 1910
Oil on canvas
6³/₄ x 7¹/₈ in. (17 x 18 cm)
Initialed bottom right: *R*
Paris, Musée Picasso, Picasso gift 1973-78
RF 1973–86

EXHIBITIONS
Munich 1998, p. 211; Rome 1999, p. 94; Barcelona 2007–08, p. 213;
Brisbane 2008, p. 128.

BIBLIOGRAPHY
Vollard 1918a, vol. 2, pl. 123; Fonds Ambroise Vollard, Musée d'Orsay, glass
plate, no. ODO 1996-56-1160; Béguin and Lemaistre 1978, p. 70, no. 29.

Exhibited in Paris.

This work of modest proportions is a fragment of a larger canvas that contained the same motif repeated three times. In 1918, the canvas had not yet been divided, as Vollard reproduced it in its entirety.[1] Gabrielle Conrad-Slade, née Renard, Renoir's model, recounts the treatment reserved for these sketches: "[Renoir] sometimes tried out colors in every corner of his canvas, and these experiments are sold today as paintings."[2]

This sketch is difficult to date, and the spot depicted is equally hard to identify since the countryside around Cagnes has changed a great deal, as have the resorts in the surrounding area. There are white buildings with pediment roofs in many of Renoir's paintings and—when blended into the landscape—they become difficult to identify.

Picasso began acquiring works by Renoir after World War I.[3] The Renoirs Picasso owned appear to be the result of exchanges with Ambroise Vollard and illustrate the great diversity of themes he collected: a landscape, a still life, two portraits, two bathers, and a sketch with mythological figures. Moreover, Picasso had no objection to the collector Leo Stein selling his paintings in order to acquire some by Renoir: "If Leo sells pictures of mine to get a Renoir, I hope he'll get a good one."[4]

Picasso's admiration for Renoir was patently not reciprocated. Michel Georges-Michel is quite clear on this subject, quoting Renoir as saying: "Take that filth away!"[5] It seems unlikely that the young Picasso got wind of these outbursts.

V. J.

1. Vollard 1918a, vol. 2, pl. 123. **2.** *Nice-Matin*, December 15, 1951, p. 4. **3.** Seckel-Klein 1998, p. 202–211. **4.** Stein 1947, p. 188. Stein sold one or more Picassos to purchase *Cup of Chocolate* **Fig. 53, p. 121** in 1914; see also the essay by Martha Lucy in this volume, p. 118, footnote 39. **5.** Georges-Michel 1957, p. 26; see also the essay by Laurence Madeline in this volume, p. 122, footnote 2.

Cat. 64

The Judgment of Paris
(Le Jugement de Pâris)

1913–14
Oil on canvas
28³/₄ x 36³/₈ in. (73 x 92.5 cm)
Signed bottom right: *Renoir*
Hiroshima, Hiroshima Museum of Art

EXHIBITIONS
New York, Duveen, 1914, no. 83; San Francisco 1962, no. 34; Philadelphia 1970, unnumbered; Chicago 1973, no. 75; Tokyo 1981, no. 13; London, Paris, and Boston 1985–86, no. 119 (no. 117 in French ed.); Yokohama and Kyoto 1986, no. 22; Nagoya, Hiroshima, and Nara 1988–89, no. 66.

BIBLIOGRAPHY
Vollard 1918, vol. 2, no. 90, pl. 357; Blanche 1919, p. 241; Bernheim-Jeune 1931, vol. 2, no. 405, pl. 131; Pach 1950, p. 118; J. Renoir 1962, pp. 355, 390; Daulte 1978, p. 50; Pach 1983, pp. 34, 35; White 1984, p. 255 and 261; Pezzi and Henry 1985, no. 718; Wadley 1987, p. 343; Nagoya, Hiroshima, and Nara 1988–89, pp. 166–167 and 250–251; Distel 2005, p. 126; Rome 2008, p. 34, fig. 6.

Exhibited in Los Angeles and Philadelphia.

The Judgment of Paris
(Le Jugement de Pâris)

Circa 1908
Red, black, and white chalk on paper
19¹/₄ x 24¹/₂ in. (48.9 x 62.2 cm)
Washington, DC, The Phillips Collection, Acquired 1940
1636

EXHIBITIONS
New York 1944, unnumbered; San Francisco 1947, unnumbered.

BIBLIOGRAPHY
Rewald 1946, no. 71; Daulte 1958, p. 26, pl. 30; Leymarie 1969, pp. 76, 80–81; White 1984, pp. 236, 241; Damisch 1997, pp. 254 (ill. as a "pastel"), 260.

Exhibited in Philadelphia.

Pierre Auguste Renoir
and Richard Guino
The Judgment of Paris (Le Jugement de Pâris), or *Study for One of the Versions of the Judgment of Paris* (Étude pour l'une des versions du Jugement de Pâris)

Circa 1914
Red chalk and white chalk on tracing paper prepared and glued on canvas
29¹/₂ x 40¹/₂ in. (75 x 103 cm)
Signed bottom right in black pencil: *Renoir*
Paris, Musée d'Orsay, kept by the Département des Arts Graphiques du Musée du Louvre; work rediscovered in Germany after World War II and placed in the keeping of the Musées Nationaux, attached to the Cabinet des Dessins du Musée du Louvre by the Office des Biens et Intérêts Privés in 1949
REC 57

EXHIBITIONS
Lausanne 1963; Paris 1964, no. 87; Paris 1983–84, p. 173; Paris 1994, no. 51.
BIBLIOGRAPHY
Vollard 1918, vol. 2, no. 75; Fouchet 1974, p. 86; Paris 1983–84, p. 173; Paris 1994, no. 51.

Exhibited in Paris.

Pierre Auguste Renoir
and Richard Guino
The Judgment of Paris
(Le Jugement de Pâris)

1913–14
Haut-relief, plaster, patinated terracotta
30 x 37¹/₄ x 4 in. (76.2 x 94.5 x 10 cm)
Signed and dated bottom right: *Renoir 1914*
Paris, Musée d'Orsay
RF 2745

EXHIBITIONS
Paris 1916, no. 153 (a bronze); Berlin 1927 (a bronze?); Paris, Orangerie, 1933, unnumbered, p. 48.
BIBLIOGRAPHY
Meier-Graefe 1929, pp. 365–371; Drucker 1944, pp. 114–115, pl. X, fig. 1 (bronze); Haesaerts 1947, no. 7 and p. 25, repr. pl. X to XIII; Perruchot 1964, p. 331; Okamoto 1965.; Inoue and Takashina 1972, p. 112, pl. IV; Clergue 1976, n. p.; Pach 1976, pp. 156–159; Pach 1983, p. 11 (bronze); Pingeot, Le Normand-Romain, and Margerie 1986, p. 228.

Exhibited in Paris.

1914
Haut-relief, bronze
29¹/₄ x 35¹/₂ x 6³/₄ in. (74.3 x 90.2 x 17.2 cm)
Signed and dated bottom right: *Renoir 1914*
Cleveland, The Cleveland Museum of Art, Purchase from the J.H. Wade Fund
1941.591

Exhibited in Los Angeles and Philadelphia.
Not illustrated.

In choosing this subject, Renoir was walking in the footsteps of great painters. Jean Renoir talks of the fact that many motifs are recurring themes in his father's oeuvre: "he regretted not having painted the same picture—he meant the same subject—all his life . . . I pointed out to him that that was what he had done with his 'Judgment of Paris.'"[1]

By tackling this theme, Renoir, like his predecessors, posed the eternal question of beauty. From Cranach, Raphael, and Rubens he borrowed the idea that the three goddesses, like the Three Graces, are simply one and the same woman, captured in three different postures. This approach allowed him to demonstrate that the competition is not to decide between three women, whose appearance here is undifferentiated, but between the three concepts the goddesses represent: beauty and love in the case of Venus; power in the case of Juno; and wisdom in the case of Pallas Athena. By selecting Venus, Paris is therefore choosing beauty, the goddess promising him the incarnation of this quality in the person of Helen of Troy. The composition has obvious direct sources. At the Prado in 1892, Renoir saw Rubens's final treatment of this theme; and he was familiar with the Marcantonio Raimondi engraving after a lost drawing by Raphael, the same one that inspired the left section of Édouard Manet's *Le Déjeuner sur l'herbe*. Richard Guino, the sculptor who collaborated with Renoir from 1913 to January 1918, also researched the subject. Two of his drawings (in a private collection) show *The Judgment of Paris*. One of them, a tondo, takes its inspiration from an engraving by Jean Mignon after Luca Penni.

In 1920, the Japanese painter Ryuzaburo Umehara visited the studio at Les Collettes and saw three versions of *The Judgment of Paris* on the wall. These were a painted sketch and two final paintings (done 1908 **Fig. 62, p. 155** and 1913–14 **Cat. 65**, respectively), each one linked to a series of drawings showing all or part of the scene. Several of them are large red chalk pieces that could not be borrowed for this exhibition, and it is difficult to know whether they are preparatory drawings for the paintings, the relief, the statuette, or the statue. The earliest sketch, signed and dated 1908 (31⁷/₈ x 39³/₄ in. [81 x 101 cm]), was exhibited for the first time in 1933 as part of the retrospective held at the Musée de l'Orangerie in Paris. It belonged to the American actor and filmmaker Charles Laughton and featured in the 1985 Renoir retrospective, but its more recent owner did not wish to lend it here. A second sketch (25⁵/₈ x 21¹/₄ in. [65 x 54 cm]), put up for auction at Christie's, New York, on May 5, 2004, forms a link with the second painting of *The Judgment* at the Hiroshima Museum. This composition, slightly reduced (28³/₄ x 36³/₈ in. [73 x 92.5 cm]) vis-à-vis the 1908 painting, was made into a lithograph (Delteil and Stella, no. 51); it is also often reproduced and occasionally lent to exhibitions. Finally, the drawing in the Phillips Collection **Cat. 66**, which is noticeably even smaller (18⁵/₈ x 24¹/₈ in. [47.3 x 61.3 cm]), is closer to the 1908 painting, of which the Louvre drawing (29¹/₂ x 40¹/₂ in. [75 x 103 cm]) **Cat. 67**, in turn, is a tracing.

There are notable changes from one version of the theme to the other. In Renoir's first composition the victorious goddess, Venus, is leaning over, her left arm bent forward, concealing her waist and part of her breasts. Her head is lower compared with those of her companions; in fact, she lacks a certain calm and majesty. On the other hand, the posture of her companion on the right is already established. In the second version, Venus is more static and more regal: supported on her right leg, her chest is pulled up, her left arm thrown backward, her hand not yet in possession of the apple. As so often, Renoir filled the space: Mercury flutters about in the sky above, and a small Greek temple can be glimpsed in the distance. With his long hair and generously proportioned posterior, Paris, who kneels on the ground with his left leg bent, appears sexually ambiguous. Jean Renoir recalls that at first his father had the actor Pierre Daltour pose for him. "But in spite of Daltour's fine athletic body, he finished the picture by using Gabrielle [Renard], [Marie Dupuis, known as] 'La Boulangère,' and [Georgette] Pigeot in turn as models for the shepherd."[2] The serene and triumphant beauty of Venus is inspired by the Latin account of the legend: in Ovid and Lucian, goddesses are nude, while in the Greek tradition—in the *Cyprian Songs, The Trojan Women,* and on vases—they are clothed. Renoir took his main inspiration from Rubens: the flying Mercury and the nudity evoke his *Judgment of Paris* in the Prado as well as the triad of goddesses in *The Education of Maria de Medici* at the Louvre.

It was for the socle of the sculpture in the round of *Venus Victrix* **Cat. 69 & 70** that Guino and Renoir decided to fashion a *Judgment of Paris*. Renoir wanted "a base decorated with a relief showing the entire scene of Paris's choice,"[3] a sort of historiated label. Initially, Guino began by modeling a modest relief in wax, adapted to fit the socle of a small Venus.[4] For the socle relief of the large Venus, Renoir decided to go back to the 1913–14 painting, using a simple trick: he made a tracing of the whole scene. He needed to do this because the painting was to be placed with Durand-Ruel. Renoir was happy to use the tracing for partial transfers, involving just a few elements of the composition. Here, because the tracing encompassed the entire scene, it could be translated into three dimensions and retain the same measurements as the original (30 x 37¹/₄ in. [76.2 x 94.5 cm]).

This tracing reveals some important details of how Renoir developed the work: numerous alterations, achieved by hatching, particularly on Venus's legs, indicate the solids and hollows, as if to help Guino transfer it into three dimensions. In the relief, too, Paris is femininized, to the point that Renoir went on to create a bust from it, renamed (in the beardless version) *La République*—no doubt on account of the figure's Phrygian cap! This relief received limited distribution. A bronze was exhibited with the Venus at the Paris Triennale of 1916. By the 1920s, a few castings were circulating in Europe, and the Thannhauser gallery organized a showing at the Berliner Künstlerhaus in January 1927. In 1928, the Hodebert gallery ordered five bronzes from the founder Valsuani.[5] There are, however, no recent casts of the relief as the French government has always refused to loan the precious original plaster in the collection of the Musée d'Orsay—purchased pre-emptively in 1954 at public auction, with the result that it could be used for the so-called Guino-Renoir edition authorized by the 1973 ruling.[6] Consequently, it is older bronzes that are found in the following museums: the Stedelijk Museum in Amsterdam, the Cleveland Museum of Art, the Minneapolis Museum of Art, the Saarlandmuseum in Saarbrücken, and the Kunsthaus Zürich.

E. H.

1. J. Renoir 1962, pp. 389–390. **2.** Ibid., p. 355. **3.** Haesaerts 1947. **4.** This statuette exists in a variety of executions: the wax, measuring 3¹⁵/₁₆ x 3³/₄ in. (10 x 12 cm); a plaster given by Guino to Les Collettes in 1964 (64.12.2); numerous bronzes, in two sizes, the largest measuring 11 x 13³/₄ in. (28 x 35 cm); and a few examples in silver. **5.** Paris, Musée d'Orsay, Barbazanges archives. **6.** For more on the Guino appeal, see my essay in this volume, p. 70.

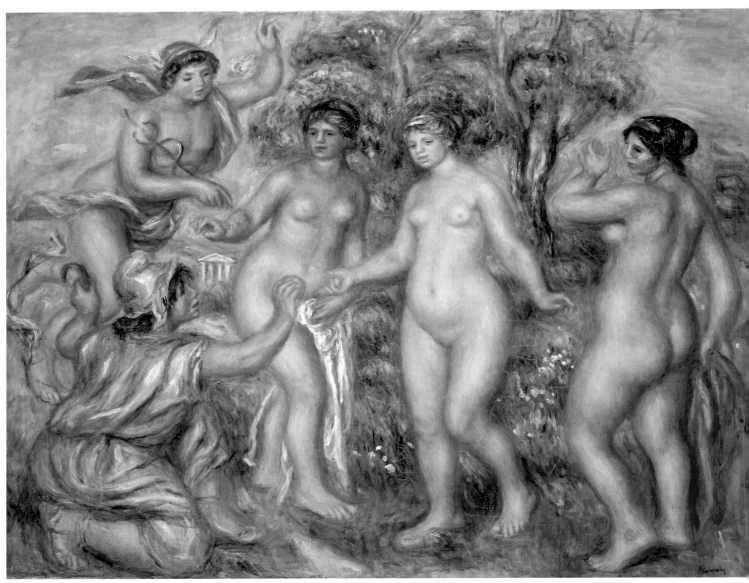

Cat. 65

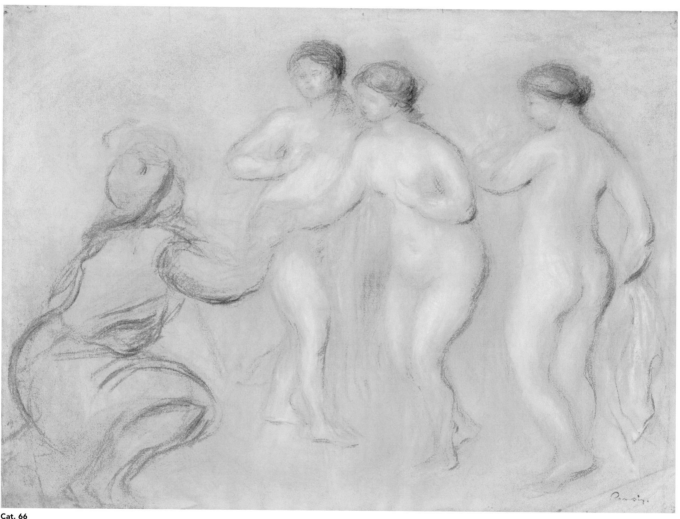

Cat. 66

Cat. 67

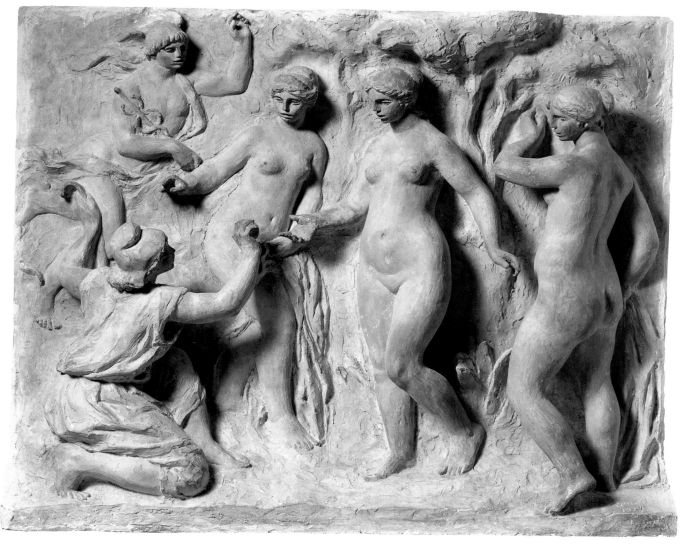

Cat. 68

Cat. 69

Richard Guino
and **Pierre-Auguste Renoir**
Venus Victrix (Venus Victorious), or
Small Venus Standing on a Socle
(Venus Victrix [Vénus victorieuse], or
Petite Vénus debout au socle)

1913–15
Bronze statuette on a socle, cast by Alexis Rudier
Statuette without socle: 23¹/₂ x 11³/₄ x 8¹/₈ in. (59.7 x 29.8 x 20.5 cm)
Socle: 9¹/₂ x 9⁵/₈ x 9¹/₂ in. (24.2 x 24.5 x 24 cm)
Signature inscribed on the upper side of the base: *Renoir*
Stanford, Iris & B. Gerald Cantor Center for Visual Arts at Stanford
University, Gift of Mr. and Mrs. Ben C. Deane
1978-230

EXHIBITION
New York 1941, no. 87 (first exhibition of the small Venus).

Cat. 70

Richard Guino
and **Pierre-Auguste Renoir**
Venus Victrix

1913–15
Patinated plaster
72¹/₂ x 44⁷/₈ x 29⁷/₈ in. (184 x 114 x 76 cm)
Signature inscribed on the upper side of the base: *Renoir*
Paris, private collection

EXHIBITION
Paris 1913, no. 152 ("second proof of 1st state" bronze).

Exhibited in Paris.

1913–15
Bronze, cast by Alexis Rudier
72¹/₂ x 44⁷/₈ x 29⁷/₈ in. (184 x 114 x 76 cm)
Signature inscribed on the upper side of the base: *Renoir*
Detroit, The Detroit Museum of Art, Gift of the Robert H. Tannahill
Foundation
76.82

BIBLIOGRAPHY
Detroit, Annual Report, 1976–77, p. 44, fig. 22.

Exhibited in Los Angeles and Philadelphia.
Not illustrated.

BIBLIOGRAPHY FOR ALL VERSIONS OF THE SCULPTURE *VENUS VICTRIX*
Apollinaire 1914; Vernay 1916, p. 27; Vollard 1919a, pp. 192, 260; Osthaus
1919–20, pp. 317–318; Vollard 1920, pp. 116, 148–149, 199–200, 232–233 and
274; Rivière 1921, p. 252; André 1923, pp. 42–43; Fosca 1924, pp. 55–56;
George 1924, pp. 332 and 339–340; André 1928, p. 51; Meier-Graefe 1929,
p. 351–365 and 404–405 (both versions); Paris, Braun, 1932, p. 14; Roger-Marx
1933, p. 87; Warnod 1934, p. 8; Paris, Beaux-Arts, 1934, n. p.; Vollard 1936,
p. 250; Vollard 1937, pp. 281–282; Besson 1938, p. 137; Venturi 1939, vol. 2,
p. 135 (large version); New York 1941, ill. 87, pp. 13–14 and 170; Drucker 1944,
pp. 114–115; Johnson 1944, pp. 132–135; Haesaerts 1947, no. 3 (small version),
repr. pl. V to VII, and no. 6 (large version), pl. XIV to XXI, pp. 21–26 and 33–40;
Roux-Champion 1955, p. 5; Alley 1959, no. 5934; Perruchot 1964, p. 330–331;
Okamoto 1965, pp. 158–160; Cagnes-sur-Mer 1969, n. p. (ill. of the large
bronze); Elsen 1974, p. 14ff; Fouchet 1974, p. 159; Clergue 1976, n. p.; Pach
1976, p. 57; New York, Toronto, Champaign, and Toledo 1977, p. 41 and 170;
Pach 1983, pp. 29, 43 (large version); White 1984, p. 258 (small version), p. 259
(large version), pp. 261, 264, 270; London, Paris, and Boston 1985–86, no. 127,
pp. 290–291 (fig. 55, p. 328, in French ed.) (large version); Renoir 2002, p. 165,
note 161; São Paulo 2002, pp. 12–13, 166–167 and 184–187; New York,
Chicago, and Paris 2006-07, pp. 399–400 (large version); Wuppertal 2007–08,
p. 152–153.

Cat. 71

Pomona (Pomone)

Charcoal on paper
17¹/₂ x 12³/₄ in. (44.4 x 32.5 cm)
Pont-Saint-Esprit, Musée d'Art Sacré du Gard,
Jacqueline Bret-André Bequest, 2008
CD.008.17.4

EXHIBITION
Paris 1930, no. 39 (First sketch for the statue of Venus).
BIBLIOGRAPHY
André 1919, pl. 37; André 1950, pl. 13.

Exhibited in Paris.

Cat. 72

Study for The Judgment of Paris
(Étude pour Le Jugement de Pâris)

Circa 1913–14
Red chalk on paper
24³/₄ x 18³/₈ in. (62.8 x 46.8 cm)
Private collection

Not exhibited. Not illustrated.

Cat. 73

Venus Victrix, or *Study for* Venus Victrix
(Vénus Victrix, or Étude pour *Vénus Victrix*)

Watercolor on paper
12¹/₄ x 9 in. (31 x 23 cm)
Signed bottom left; top left, diagonally, in Renoir's hand: *que le socle /
de la statue soit / au niveau de l'eau / avec des petits rochers / et
plantes aquatiques. / AR.* (the base / of the statue should be / at water
level / with some small rocks / and aquatic plants. / AR.)
Paris, Petit Palais, Musée des Beaux-Arts de la Ville de Paris
PPD02034

EXHIBITIONS
Vienna 1950; Lyon 1952, no. 71; Nice 1952, no. 49, p. 24; Paris 1953, no. 454;
Marseille 1963, no. 79.
BIBLIOGRAPHY
Haesaerts 1947, quoted in the entry for no. 3; Daulte 1958, p. 18, pl. 30;
White 1984, pp. 244, 261.

Exhibited in Paris.

Cat. 74

Reader with Venus
(Liseuse à la Vénus)

Circa 1913–15
Oil on canvas
20¹/₈ x 18¹/₂ in. (51 x 47 cm)
Private collection, by courtesy of Galerie Kornfeld

BIBLIOGRAPHY
Vollard 1989, no. 201.

Exhibited in Paris.

*V*enus Victrix is unquestionably a triumph. Its simplicity and honesty make it the incarnation of the "return to order" that occurred in sculpture in the early twentieth century. Although Renoir's *Venus* attracted little attention during his lifetime, by the late 1930s examples of it were being exhibited in New York at the Buchholz Gallery and Duveen Galleries. Many museums later acquired one, particularly the large version, including museums in Paris (Musée du Petit Palais), Cagnes-sur-Mer (Musée Renoir), Antwerp (Middelheim Park), Cologne (Wallraf-Richartz Museum), Detroit (Detroit Institute of Art), New Orleans (New Orleans Museum of Art), London (Tate Gallery), Rotterdam (Museum Boijmans Van Beuningen), São Paulo (Museo de Arte), and Williamstown, MA (The Sterling and Francine Clark Art Institute).

This figure of Venus is based on the image of the goddess in Renoir's *Judgment of Paris* **Cat. 65–68** who, lifted from the canvas, has been transformed into a sculpture in the round. From a letter written to Albert André on February 16, 1914, we learn that Renoir and Guino wished to emulate famous ancient statues such as the Medici Venus, the Venus de Milo, the Venus of Arles, and the Cnidian Venus. These are indeed what comes to mind when we look at this woman as she reveals herself, making us, like Paris, the judges of her unquestionable beauty.

Her dimensions are purposely larger than life. In fact she measures almost two meters in height, similar to the Cnidian Venus at 1.92 m, the Venus of Arles at 1.94 m, and the Venus de Milo at 2.02 m. Renoir in fact wrote to Albert André asking him "to find out the exact height from the heel to the top of the head of a Greek statue of a woman, . . . for example the Venus of Arles or the Medici or some other."[1]

Like many sculptors at this period, Renoir and Guino were intent on renewing the category of the mythologically based female nude. Renoir's ideas on this were radical: he did not like sculptures that were too animated or which had muscular bodies. He commented of Michelangelo that he had "studied anatomy too much, and for fear of omitting the smallest muscle, introduced some that can only interfere with his figures."[2] Renoir had no taste for either Mannerism or the Baroque. He left Rome tired of "too many draped figures, too many folds, too many muscles!"[3] After a visit to the Musée du Luxembourg he left with a "longing to flee, as if [he] dreaded being kicked or punched,"[4] deploring "these men and these women, so fraught as to be exhausting. They balance on one foot or else brandish a sword with all the might of their muscles. Such exertion cannot be sustained for the whole of eternity . . . One feels like telling these dying soldiers and these mothers howling with grief: Please, please, calm yourselves, get a chair and sit down . . . The statues at the Luxembourg are agitated for intellectual reasons, for literary reasons." Renoir even included Auguste Rodin in this assessment, preferring ancient art for its "simple attitudes."[5] The Pompeii frescoes offered relief from Michelangelo and Bernini. Nevertheless, and not without a certain ingenuousness, Renoir reassured himself by comparing "his" Venus with the figure of Aurora on the tomb of Giulio de Medici: "Michelangelo didn't trouble his mind a bit about having put an even bigger space between the two breasts."[6] For Renoir, "sculpture, being made of indestructible materials such as stone or bronze, must be just as eternal as these materials." This aesthetic cannot help but bring to mind the "noble simplicity" and the "calm grandeur" that had been advocated by Winckelmann and that had become Neoclassical dogma.

Yet the canon of the *Venus Victrix* is not antique, Neoclassical, or Realist: the goddess's profile with her gaping, fishlike mouth, her empty eyes, the chignon with its loose locks of hair, her youthful breasts as if molded in a bowl,[7] her thick waist, broadened pelvis, and full thighs—everything conspires to create a style that is unique and recognizable among all others.

As was customary at the time, the creative process began with a statuette, "then, suggestion by suggestion, the large statue was produced."[8] According to Vollard, Renoir, ensconced "under the olive trees in his garden" with Guino, produced some new drawings with a view to enlarging the piece. To our knowledge, no terracotta or plaster sketch has survived, although there is a small wax head that could be all that remains of the first modeling; unfortunately it could not be located in time for this study.

In order to bring off their joint work, Guino and Renoir needed to specify the exact position of the arms, which was not very clear in the painting. The right arm comes forward, while the left hand, clutching a flowing piece of drapery, is held slightly backward. The "singular richness of outlines"[9] thus achieved encourages the viewer to walk around the piece. An eloquent comparison can be made with the bronze cast by Primaticcio for Francis I of France (Fontainebleau, Musée National du Château): it is as if the modest Belvedere Venus had ceased concealing her sex with her hand.

Who acted as the model for this piece? A letter from Jean Renoir to Guino on October 27, 1917, states that it was "Renée who posed at Essoyes for the small Venus."[10] However, Renée Jolivet left the Renoir family in 1904. Barbara White cites Marie Dupuis, nicknamed "la Boulangère."[11] However, it seems more likely to us that it was Madeleine Bruno, who told Clergue in 1969: "I used to see Guino every day in the studio, at the time he was modeling the sculptures and the Venus in Renoir's presence." Yet on December 7, 1970, Gabrielle Renard also declared that she "had posed for the *Venus Victrix* executed by Monsieur Guino at Les Collettes under the guidance of his employer, Auguste Renoir, who told him what

Cat. 71

work needed to be done."[12] Now, Madeleine left the Renoir family in January 1914. If one considers her height (1.55 m) and in particular if one compares the statuette with the statue, one gets an idea of how much the sculptor had to elongate this figure. In a letter to Claude Renoir dated October 29, 1964, Guino recounts that the painter, who found her "too short," supplied some new drawings,[13] which is born out by a large, red chalk drawing (40 1/2 x 63 3/8 in. [103 x 161 cm], former Paul Renoir collection, location unknown, illustrated in exh. cat. Cagnes-sur-Mer 1970).

Modeling progressed quickly and by the spring of 1914 the statue was seen at Cagnes by Mary Cassatt and the German art collector Karl Ernst Osthaus. According to Apollinaire, a small maquette was exhibited at Galerie Vollard in June 1914. Completion of the large version, which was to be exhibited at the Salon d'Automne, was delayed by the war. Photographs from the Vollard archives (Paris, Musée d'Orsay) show the bronze at the Triennale Exhibition at the Jeu de Paume, which took place from March 1 to April 15, 1916. In June, Guino received the sum of 5,000 francs for "alterations to the statue of Venus and a plaster proof." Did he go back and work on the bronze? It is possible he did, because in addition to sculpting for Renoir, Guino was also charged by Vollard with producing multiple copies of all or part of the Venus right away. Guino submitted an invoice for 1,200 francs for "[a] proof in clay of the bust of the statue of Venus and a proof of the bust of Paris" and one for 800 francs for "[t]hree proofs in mortar of the head of the statue of Venus and fresco experiments." However, these experiments were unsatisfactory: the material cracked and turned an unpleasant

color. One important bill relates to a series of works carried out at Cagnes from November 1915, along with transport invoices that allow us to date the shipment of the works from Cagnes to Paris to between June 11 and 13, 1916.[14]

So, by 1916 Vollard was marketing busts, heads, and a small version of the Venus, either alone or standing on a socle, the front of which was decorated with a small Judgment of Paris that served as an illustrative panel, and on the sides had goats' heads—allusions to the fact that Paris was a goatherd. In 1934, the newspaper Le Figaro published a photograph of a master cast of the small Venus belonging to Vollard, as well as photographs taken by Brassaï of Vollard's private residence in rue de Martignac, in which one can see a small bronze of the Venus Victrix standing on the ground.

Vollard also set about selling a large bronze to the city of Paris to be installed in a garden, since it was made to be "in the open air, in front of a group of trees."[15] The fine blue and green watercolor at the Petit Palais reveals Renoir's intention: the inscription explains that the statue was to stand above a pool, "with small rocks and aquatic plants." Photographs from the Vollard archives **Fig. 110** show a bronze in this setting in an as yet unidentified garden. The watercolor suggests the thinking that accompanied the creation of this work. With "his" sculptures, Renoir continued to focus on a question that was fundamental to him: how to integrate the nude into the landscape. Vollard eventually made a gift of the bronze to the city in 1931.

In the garden at Les Collettes, the first work to be installed was a large, plaster Venus, as can be seen in the magnificent photographs by Maywald-Verve.[16] The large plaster sculpture—exhibited in Paris only—differs from this: patinated, retouched with shellac, and looking a little tired, it was used for a recent edition by Valsuani and then by Susse, which has been halted. This is the first time that this work is being shown to the public.

E. H.

1. Letter from Renoir to Albert André, February 16, 1914, cited in White 1984, p. 264. 2. Vollard 1920, p. 116. 3. J. Renoir 1962, p. 233. 4. Vollard 1920, p. 264. 5. André 1919, p. 45. 6. Renoir quoted in Pach 1983, p. 29. 7. According to Vollard, Renoir was not happy with the sculpture until Guino had raised the breasts. 8. André 1919, pp. 41-42. 9. George 1924. 10. Private archives. 11. White 1984, p. 240. 12. Private archives. 13. Ibid. 14. Ibid. 15. Fosca 1924, p. 56. 16. Drucker 1944, pl. IX.

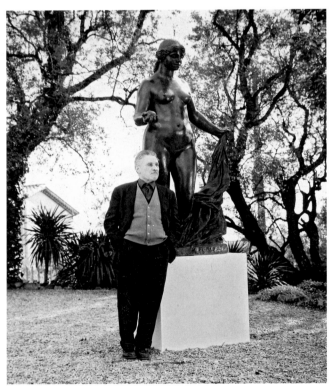

Fig. 110

Richard Guino at Les Collettes, posing at the foot of the Venus Victrix

Fig. 110

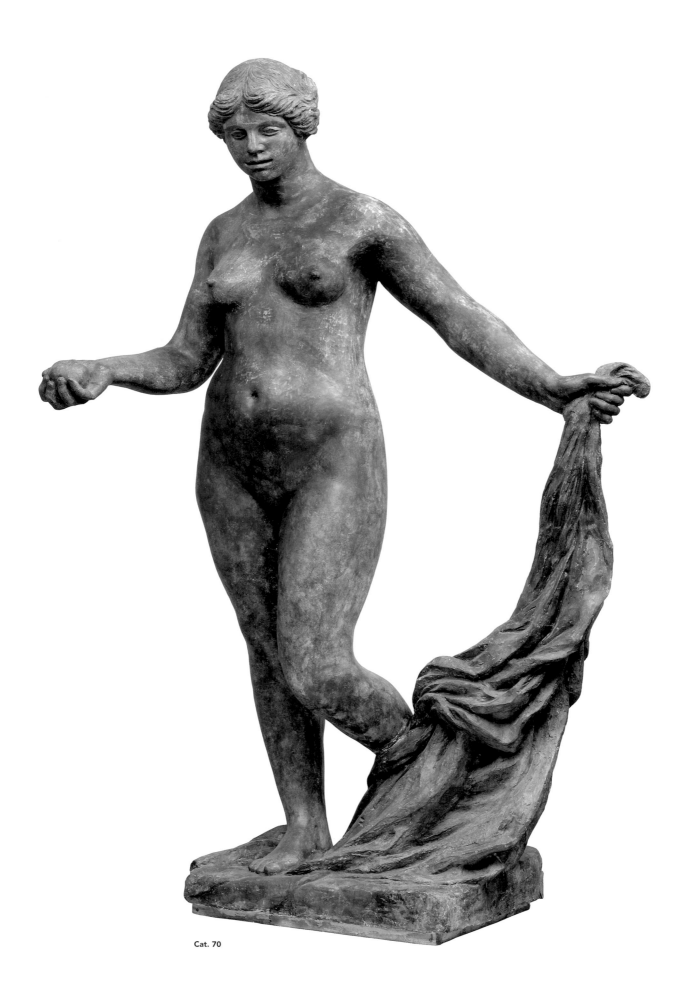

Cat. 70

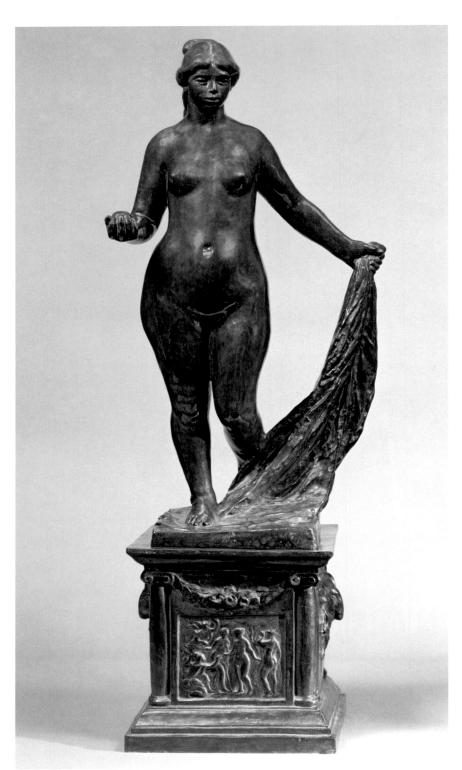

Cat. 69

Cat. 74

Cat. 73

Cat. 75

Portrait of a Model, Bust-Length (Portrait de modèle en buste)

1916
Oil on canvas
21⁷/₈ x 18¹/₈ in. (55.5 x 46 cm)
Signed and dated bottom left: *Renoir 1916*
Paris, Musée National Picasso, Picasso gift 1973–78
RF 1973–84

EXHIBITION
Paris, Louvre, 1978, n° 31; Munich 1998, n° 70; São Paulo 2002, p. 164; Turin 2003–04, p. 126; Vienna 2005–06; Barcelona 2007–08, p. 211; Brisbane 2008, p. 133 et 302.

BIBLIOGRAPHY
Musée Picasso 1985, no. T 67; Vollard 1989, no. 194; Seckel-Klein 1998, no. 70.

Exhibited in Paris.

Alexander Liberman
Picasso's bedroom in his Paris studio. On the wall: Studies of Figures from Antiquity *by Renoir Cat. 76;* Portrait of Marguerite *by Matisse; and a landscape by Corot*
1949

Cat. 194

Cat. 76

Mythology, Figures from Ancient Tragedy, or *Studies of Figures from Antiquity (Project for a Decoration on the Theme of Oedipus)* (Mythologie, personnages de tragédie antique, or Études de personnages antiques [Projet pour une décoration sur le thème d'Œdipe])

Circa 1895–98
Oil on canvas
16¹/₈ x 9⁵/₈ in. (41 x 24.5 cm)
Studio stamp bottom right: *Renoir*
Paris, Musée National Picasso, Picasso gift 1973–78
RF 1973–82

EXHIBITIONS
Paris, Louvre, 1978, no. 27; Munich 1998, no. 68; Rome 1999, p. 55; Turin 2003–04, p. 126; Barcelona 2007–08, p. 209; Brisbane 2008, pp. 126, 302.

BIBLIOGRAPHY
Bernheim-Jeune 1931, vol. 1, no. 115; Musée Picasso 1985, no. T 61; Seckel-Klein 1998, no. 68.

Exhibited in Paris.
Illustrated on p. 129.

Cat. 194

*P*ortrait of a Model, Bust-Length and *Studies of Figures from Antiquity* **Cat. 76, p. 129** were among the seven Renoirs—all of them from the master's late period—in Picasso's private collection. Among the seven, most were figure compositions, apart from a landscape **Cat. 64** and a still life with fish. While the dates and circumstances of the purchase of these two pictures are as yet unknown,[1] they figure on several photographs of various Picasso residences and seem to have been part of his everyday life, long after his "Renoirian crisis."[2] *Mythology,* which adorned the painter's bedroom on the rue des Grands-Augustins **Cat. 194, p. 319** in 1949, reappeared ten years later at Château de Vauvenargues **Cat. 197, p. 406**, while the *Portrait of a Model* found pride of place in the painter's studio in the villa La Californie in Cannes **Cat. 196, p. 407**.

Portrait of a Model, Bust-Length shows the studies Renoir was engaged in toward the end of his life. As he explained in his own words: "I battle with my figures until they are simply one with the landscape that serves as their background, and I want people to feel that they are not flat . . . The most important thing is for it to remain painting."[3] It is hard to say whether the young woman is located in a landscape or in an interior, so vague is the background. At the same time, the hair allows Renoir to blend the figure with the backdrop, as does the figure's right arm, as it tends to melt into the rest of the canvas. His search for volume and monumentality led him to simplify forms to the point of distortion, so the exposed breast becomes a simple sphere, and the left arm a rectangle.

In this portrait of an unidentified model, Renoir returns to a composition close to his heart. As he confided to Albert André: "Even today I still have to force myself, shake off my laziness, to create compositions and not allow myself to paint nothing but torsos and heads."[4] Clothed or nude, front view or profile, the half-length portrait of a young woman is clearly the most common motif in the master's work, whether in his finished paintings or, to an even greater extent, in the small studies he liked to combine on the same canvas, as in the *Studies of Figures from Antiquity.*

This medium-sized picture was one of Renoir's studies for an interior design for Paul Gallimard's country house at Bénerville. While we cannot establish the precise details of the commission,[5] it seems that the painter worked on the panels throughout 1898, as suggested by Julie Manet in an account in her diary of her visits to the master, first on July 1, 1898: "We went to M. Renoir's studio to see the panels of Grecian ladies painted to decorate doors. They're delicious—full of movement, with subtle draperies and luminous yellows;"[6] and again on November 9: "His decorations for Monsieur Gallimard's doors are gorgeous."[7] If Renoir chose to unite on a single canvas motifs that he had elsewhere treated individually, it was because "these sketches are what he likes best, and in which he invests all his being, indulging in all sorts of bold innovation"; he himself even claimed, "Were it not for the fact that I have to make pictures to deliver to the dealer and make a living, I would have been quite happy spending my life painting nothing but this."[8] The painter liked to mix together landscapes, figures, and still lifes in his sketches, which often ended up getting cut into separate small pictures. Nonetheless, in their original composite form, such sketches are echoed in the work of Picasso. The year after the master's death, Picasso, who regarded Renoir as the "Pope of painting," painted a picture entitled *Studies,* in which, like his predecessor, he juxtaposed several compositions on a single canvas **Fig. 55, p. 129**.

I. G.

1. Seckel-Klein 1998, p. 208. 2. See the essay by Laurence Madeline in this volume, p. 122. 3. André 1923, p. 35. 4. Ibid., p. 46. 5. Cf. the essay by Sylvie Patry in this volume, p. 53. 6. Manet 1987, p. 138. 7. Manet 1979, p. 204. 8. André 1923, p. 40.

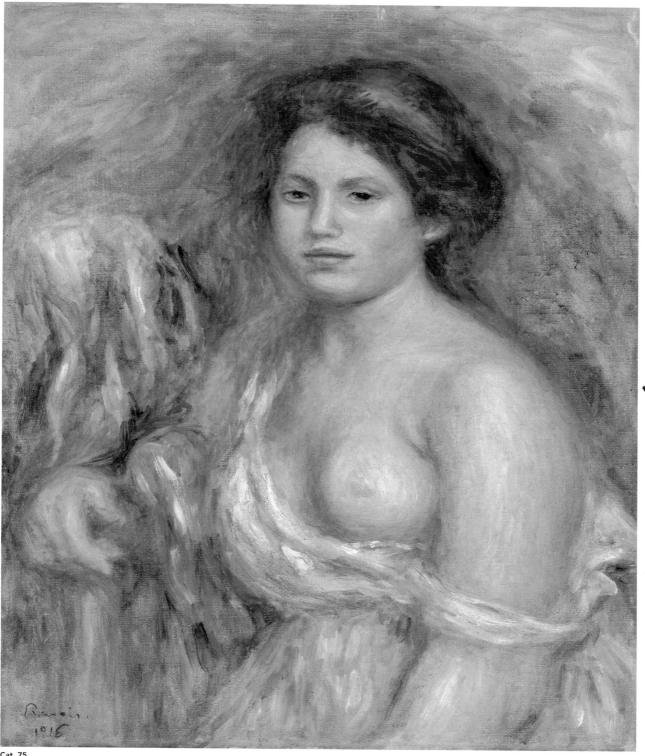

Cat. 75

Cat. 77

Bather (Baigneuse)

Circa 1917–18
Oil on canvas
20³/₄ x 13 in. (52.7 x 33 cm)
Signed bottom left: *Renoir*
Philadelphia, Philadelphia Museum of Art, The Louise and Walter
Arensberg Collection
1950-134-173

EXHIBITIONS
San Francisco, 1934, no. 145; San Diego, 1941; San Francisco, 1944; Chicago,
1949, no. 190.

BIBLIOGRAPHY
Arensberg Collection 1954, pl. 177; Canaday, 1959, pp. 220–222; Upjohn and
Sedgwick, 1963, p. 219.

The American artist and writer Walter Pach visited Renoir in Cagnes several times between 1908 and 1911 and recalled Renoir explaining: "I look at a nude; there are myriads of tiny tints. I must find the ones that will make the flesh on my canvas live and quiver."[1] Modeled in red, pink, and ochre with light touches of white, Renoir's standing nude is calmly fixed in the center of a dazzling verdant landscape. Closely resembling his sculpture of the triumphant *Venus Victrix* **Cat. 70**, the bather holds a piece of fruit in one hand while a white cloth spills from the other. The smooth brushstrokes of her rosy skin contrast the disjointed vertical dashes of bright yellow, green, and orange paint that describe the landscape and add vigor to the thinly painted canvas. The female nude in a landscape was an irresistible subject for Renoir, who returned to it in several small canvases made in the last years of his life. Although painted in small scale, they share the generous proportions, small heads, and heavy thighs of his monumental bathers.

Dated to 1917 or 1918, the canvas was acquired by Louise and Walter Arensberg of New York shortly after it was painted. Stimulated by the groundbreaking 1913 International Exhibition of Modern Art, known as the Armory Show, in New York, the Arensbergs became avid collectors of modern art and befriended Pach, who would occasionally act as their agent. A photograph of the Arensbergs' New York apartment about 1919 shows the living room in which they frequently hosted members of the artistic avant-garde including Pach, Marcel Duchamp, Francis Picabia, Alfred Stieglitz, and others **Cat. 202**. Renoir's *Bather* hangs in the center of the wall, directly below Duchamp's *Nude Descending a Staircase, No. 3* (1916, Philadelphia Museum of Art). Visitors to the apartment, including Duchamp, whose studio was in the same building, would not have missed the playful juxtaposition of nudes. Renoir was highly regarded in the early twentieth century by American artists, critics, and collectors, who appreciated his formal innovations and the lyrical, classical qualities of his painting.

J. A. T.

1. Pach 1912, p. 612.

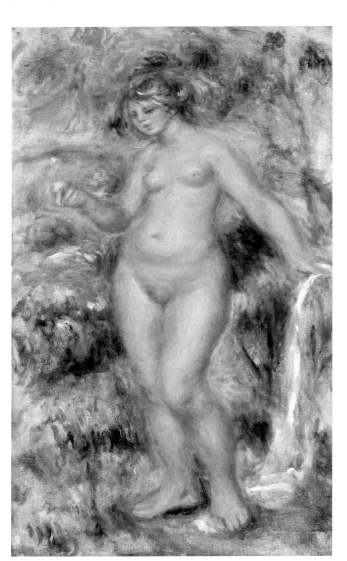

Cat. 77

Cat. 202

Charles Sheeler
*The apartment of Louise and
Walter Arensberg in New York*
Ca. 1918

Cat. 202 (detail)

Woman Tying Her Shoe (Femme nouant son lacet *also called* Femme faisant sa toilette)

Circa 1918
Oil on canvas
19⁷/₈ x 22¹/₄ in. (50.5 x 56.5 cm)
Signed bottom left: *Renoir*
London, The Courtauld Gallery, The Samuel Courtauld Trust
P.1932.SC.341

EXHIBITIONS

Paris 1922; London 1922; Norwich 1925, no. 62; London 1948, no. 61; Paris 1955–56, no. 44; London 1976, no. 39; Tokyo, Kyoto, Osaka, and Canberra 1984, no. 77; Cleveland, New York, Forth Worth, Chicago, and Kansas City 1987–88, p. 10 and no. 16; London 1994, no. 43, pp. 142–143; Brisbane, Melbourne, and Sydney 1994–95, no. 51

BIBLIOGRAPHY

Meier-Grafe 1929, p. 422; Wilenski 1931, pp. 261, 269, pl. 109b; Jamot and Turner 1934, no. 33; Home House Catalogue 1935, no. 13; Cooper 1954, no. 57; Thomas 1980, p. 24; Schneider 1984, pp. 86, 89; Wadley 1987, p. 274; Burnstock, Van den Berg, and House 2005, pp. 48, 49, 62–63.

Exhibited in Philadelphia.

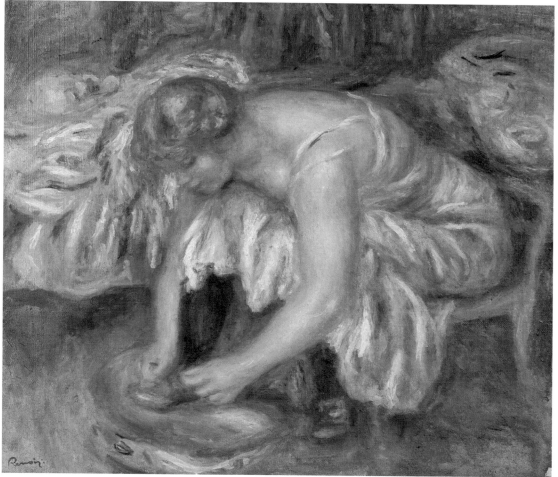

Cat. 77a

Woman with a Mandolin (Femme à la mandoline)

1919
Oil on canvas
22 x 22 in. (56 x 56 cm)
Stamp bottom right: *Renoir*
Private collection

EXHIBITIONS
Boston 1939, p. 22, no. 5; New York 1942, no. 3; Portland 1942–43; New York 1953–54 (The Metropolitan Museum of Art, on extended loan); New York 1954, no. 17; New York 1968, no. 70; New York and College Park 1980; Columbus, 2005–06, fig. 53, p. 71.

BIBLIOGRAPHY
Rivière 1921, p. 261; Bernheim-Jeune 1931, vol. 2, pl. 223, no. 704; Venturi 1942, p. 2; Pach 1950, pl. 126; *Museum of Modern Art Bulletin* 1953, p. 46, no. 1077; Pach 1983, p. 126; White 1984, pp. 280, 282; Bernheim-Jeune 1989, p. 246, no. 704, pl. 223 (as *Andrée en espagnole avec un turban jaune et une mandoline*); Braun 1994, p. 152, no. 56, p. 153.

Exhibited in Los Angeles and Philadelphia.

The Concert (Le Concert)

Circa 1919
Oil on canvas
29³/₄ x 36¹/₂ in. (75.6 x 92.7 cm)
Toronto, Art Gallery of Ontario, Gift of Reuben Wells Leonard Estate, 1954
53/27

EXHIBITIONS
Paris, Rosenberg, 1934, no. 49; Los Angeles 1952, no. 18; Los Angeles and San Francisco 1955, no. 88; Winnipeg 1955, no. 75; New York 1958, no. 69, p 83; Bordeaux 1962, no. 207, pl. 48; Hamilton 1964, no. 27; Vancouver 1966; Chicago 1973, no. 88, pl. 12; London, Paris, and Boston 1985–86, no. 126 (no. 124 in French ed.); Nashville 2001, no. 67; Ocala 2001; Williamstown, Dallas, and Paris 2003–04, fig. 130, p. 116; Columbus 2005–06, fig. 52, p. 70.

BIBLIOGRAPHY
Meier-Graefe 1929, pp. 417–419, 471, no. 402; Bernheim-Jeune 1931, vol. 2, pl. 216, no. 685; Besson 1938, pl. 52; Drucker 1944, p. 215, no. 163; *Art News Annual* 1952, p. 165; Coates 1958, p. 119; Goldwater 1958, p. 61; *Sele Arte* 1958, p. 21, fig. 48; Fezzi 1972, no. 770; Young 1973, p. 191; Art Gallery of Ontario 1974, p. 20; White 1984, p. 285; Art Gallery of Ontario 1990, pl. 147; Sion 1994, p. 62, p. 63; *Renoir Paints His Family* 1995; Minervino 2003, p. 219; Benjamin 2003, p. 116.

Renoir painted Orientalist scenes early in his career and again toward the end of his life. The early compositions, created between 1870 and 1872, paid homage to the much-admired North African pictures of Eugène Delacroix: these were *Woman of Algiers (Odalisque)* (Salon of 1870, Washington, DC, National Gallery of Art, Chester Dale Collection); *Madame Clémentine Valensi Stora (L'Algérienne)* (Salon of 1870, San Francisco, The Fine Arts Museums of San Francisco); and *Parisian Women in Algerian Costumes (The Harem)* (1872, Tokyo, The National Museum of Western Art). The later pictures, on the other hand—those painted between roughly 1915 and 1919—are expressions of Renoir's idiosyncratic aesthetic explorations at the end of his life.

In his final years, Renoir produced at least a dozen pictures of odalisques variously resting on divans or lounging on cushions, taking tea, and making music. These works appear as a cohesive project thanks to recurring studio settings and costume elements. A photo showing Renoir in his studio at Les Collettes with his favorite model at the time, Andrée Heuschling (nicknamed Dédée), documents the exotic garments he had on hand for this series **Cat. 185, p. 342**. Dressed for posing, the sixteen-year-old girl, who had recently joined the Renoir household to help care for the wheelchair-bound artist,[1] wears "several pieces of unmistakably Algerian costume . . . A long silk *ghlila* (vest) in floral brocade with fat lace buttons, a long silk scarf with bands of metallic thread . . . wrapped around her waist, and a chemise of white *broderie anglaise*."[2] Over the next few years, she would pose repeatedly in this outfit, or variations of it: she wears the whole ensemble (except for the shirt, which has been replaced by a loose transparent top with white spots) in *Woman with a Mandolin,* augmented by a yellow "turban"; in *The Concert*, she sports the turban but not the vest, which allows the flowing top to slide off her shoulder. Dédée's companion in *The Concert*, probably Madeleine Bruno, another of Renoir's regular models[3] **Cat. 80**, does feature a low-cut embroidered vest, but, rather than the Algerian *ghlila* we might expect, this is the tight vest of a traditional Spanish toreador's "suit of lights." Evidently, to Renoir's mind exotic costumes were essentially interchangeable: so, for example, in another painting, the real Algerian *ghlila* is designated as "espagnol"

(Spanish), while the transparent shirt is variously called "grec" (Greek), "espagnol," "oriental," and, simply, "chemise de tulle" (tulle blouse). Renoir's costumes were not meant to authenticate "real" ethnic scenes, but to create an artificial pictorial world that follows its own rules.

Woman with a Mandolin and *The Concert* were among the very last major subject paintings Renoir ever completed and, formally, they share much with *The Bathers* **Cat. 80**, the painting he considered the culmination of his long career. In all three pictures, a credible sense of space is sacrificed in favor of a unified surface design: overall patterning and a narrow chromatic scale fuses pictorial elements, figures and ground, into a single visual impression. In terms of liminal presence, the printed roses on the wallpaper background in *The Concert* register on the same level as the real flowers in the vase and in the model's hair. Living skin, clothing, wallpaper, three-dimensional objects—all lose their physical specificity in the translucent washes of paint that cover the canvas; only highlights have a different, opaque texture. Walter Pach astutely characterized this remarkable development in Renoir's late paintings with reference to *Woman with a Mandolin*: "Now the human being is the *occasion* of the painting and not its ultimate subject. The canvases are primarily an ordering of ruddy colors, pigment textures, swelling lines, and patterns. All of these components have been broadened out; the colors and shapes begin to be separated from the contexts. Further development in this direction—difficult as it is to imagine that Renoir could become so 'dehumanized'—would result in a coloristic abstract art. As it is, this canvas in some ways brings to mind Matisse's painting of the early twenties, although this picture is more directly sensuous."[4]

Woman with a Mandolin was a reworking, with a different model and costume, of *Girl with a Mandolin* (1918). Both paintings were reproduced and discussed by Walter Pach,[5] and probably shown together in 1942 by Durand-Ruel Galleries, New York.[6]

The Concert was owned by Claude Renoir. A slightly smaller version of it is in the collection of the McNay Art Museum in San Antonio, TX. More loosely painted, it may be a preparatory or intermediary sketch.

C. E.

1. Heuschling later married Renoir's second son, Jean, and, as Catherine Hessling, made a career as a film actress. **2.** Benjamin 2003, p. 111. **3.** Heuschling and Bruno are likely also the models for *The Bathers* Cat. 80, painted around the same time as *The Concert*. **4.** Pach 1983, p. 126. **5.** Ibid., p. 36. **6.** New York 1942, nos. 3 and 19.

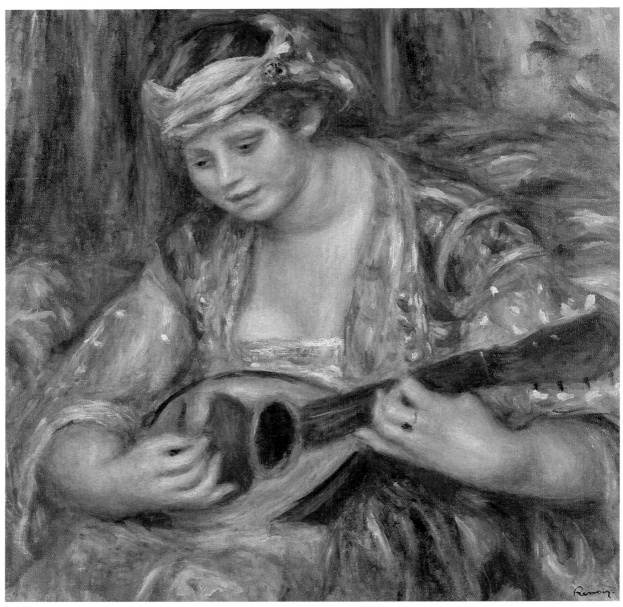

Cat. 78

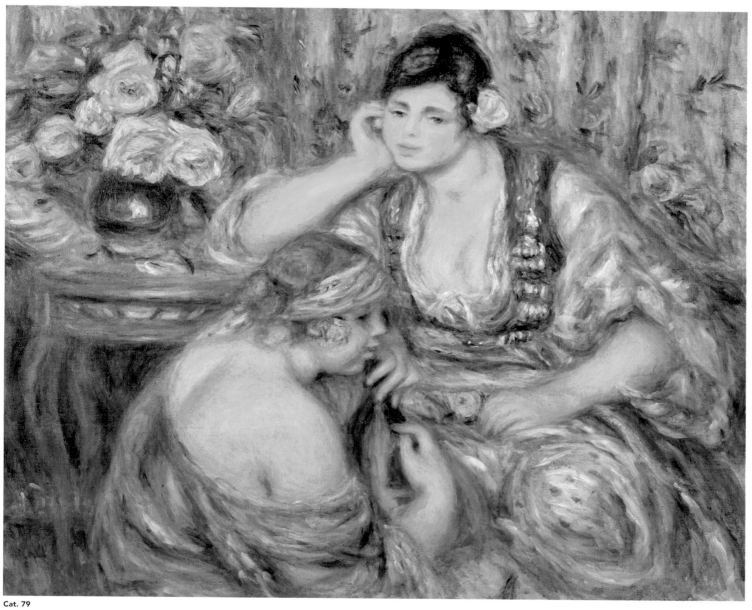

Cat. 79

The Bathers (Les Baigneuses)

1918–19
Oil on canvas
43¹/₄ x 63 in. (110 x 160 cm)
Paris, Musée d'Orsay, Gift of the artist's sons in 1923, transferred
from the Musée du Luxembourg to the Musée du Louvre in 1929
RF 2795

EXHIBITIONS
Paris, Salon d'Automne, 1920, no number; Copenhagen 1924–25 (label on
back); Paris 1927 (? label on back); London, French Gallery, 1930, no. 32; Paris,
Orangerie, 1933, no. 126 (as *Baigneuses [Les Nymphes]*), ill. LXII; Paris,
Rosenberg, 1934, no. 53; Venice 1948; Rome and Florence 1955, nos. 93 and
95; Chicago 1973, no. 87; London, Paris, and Boston 1985–86, no. 125 (no. 123
in French ed.); Paris 2005–06, p. 164.

BIBLIOGRAPHY
[Anonymous] 1923, p. 119; Jamot, December 1923, p. 344; Bénédite 1924, no.
501bis; Bernheim-Jeune 1931, vol. 2, cover and pp. 394–395; Rey 1931, p. 59;
Alexandre no date; Drucker 1944, pp. 106–108; Barnes and De Mazia 1959, pp.
143–144, 435 (as *Nymphs*); Perruchot 1964, pp. 351–354; House 1985b, p. 21;
White 1984, pp. 279, 280; Dussaule 1995, p. 87, Distel 2005, p. 127.

Renoir "paints, as a form of apotheosis, these two large nude bathers lying in a silken, dreamlike landscape. The sun disappears in a shroud of purple and gold," wrote Albert André in his preface to *L'Atelier de Renoir* with the lyricism that very often surrounds recollections of late Renoir.[1] Certainly, in the frequently quoted words of Jean Renoir, the painter saw this picture as a "culmination" and a "good springboard from which he could plunge into further researches."[2] The size of the work is an indication of his ambition: it is on a scale with the paintings that punctuated Renoir's career, as if the painter felt the need to confront each of his successive styles with the challenge of the large format (*The Cabaret of Mère Antony, Ball at the Moulin de la Galette, Luncheon of the Boating Party, The Large Bathers* of 1884–87, and *The Artist's Family* in 1896), the veritable yardstick in the eyes of this man whose first dream was decoration. With *The Bathers,* the stakes assumed special intensity, for Renoir was now an invalid, stuck in his wheelchair and crippled with arthritis: "Renoir is very worn out, a bit like these old silks that crackle all over when you give them a pull. In spite of that, he paints every day and has done a canvas measuring 200 by 100 cm with 2 large women, life-sized; it's wonderful," wrote Albert André on April 25, 1919.[3]

Everybody who witnessed it noted Renoir's courage in the face of pain, and his determination to see this work through successfully. To Matisse, who asked him "Why torture yourself?" Renoir replied: "Pain disappears, Matisse, but beauty lasts. I am perfectly happy and will not die until I have completed my masterpiece. Yesterday I thought it was finished, and I couldn't add another single brushstroke to it, but (and he winced, a reminder of his pain) then I slept on it . . . I will not die before giving the best of myself."[4] In an interview with Pierre Courthion, Matisse pointed out: "Renoir was having some difficulties managing the Bathing picture . . . as the picture was quite large, and Renoir had little movement in his hands; but it's only when I think of it now, in fact, that I can imagine Renoir might have had problems—one would never have guessed it seeing him in front of the canvas, as his mind was driving it all with such passion."[5] Albert André, Victor-Joseph Roux-Champion, and Jean Renoir have described the measures taken to make all parts of the composition accessible to Renoir's brush: an easel fitted with "two rollers, one of which rolled up the painted canvas while the other unrolled the section that was still white."[6] Matisse remembered that an assistant placed the picture at the correct height. As usual with Renoir, the canvas was not mounted on a stretcher: while the artist was painting, it was fixed to another support, as indicated by the presence of unoxi-

dized tack holes (meaning they had been used for only a short time) still visible on the back, as well as drips of paint on the lower flap of the canvas (5 cm wide). On his death Renoir's studio was filled with canvases painted without a stretcher, tacked to boards or to strips of wood put together into frames[7] **Cat. 180, p. 403**. Like Bonnard, Renoir decided on the final format of the work only after it was completed, readjusting it at the very end.

We do not know the extent of the preparatory work that culminated in such a well-thought-out painting: while Renoir seems to have drawn little at this time **Fig. 111**, instead setting out the main lines in oil on the canvas, he clearly tested the motif of the bust of Andrée Heuschling (the red-haired model) in autonomous pictures (Bernheim-Jeune 1931, vol. 2, no. 679; sales cat. London, Sotheby's, 1989, no. 38; Bernheim-Jeune, 1989, no. 706). The latter were executed indoors, perhaps in Nice in 1915 when Andrée began to pose for him. This process may be why Matisse remembered a time-span of three years, a long maturation period which until then only *The Large Bathers* of 1884-87 **Fig. 8, p. 39** had required.[8] In Jean Renoir's opinion, his father had, on the contrary, "executed the picture in a relatively short time, aided to a great extent by 'the simple and noble' way in which Andrée posed."[9] To the undeniable stimulation of an inspirational model ("Andrée was one of the vital elements which helped Renoir to interpret on his canvas the tremendous cry of love he uttered at the end of his life"[10]), perhaps we should also add that of history. Like the *Waterlilies* cycle by Renoir's friend Monet, *The Bathers* was inevitably associated with the joy at the Armistice on November 11, 1918.[11] Like Monet, in response to the end of the war and its suffering, Renoir chose a timeless, ahistorical theme that had been central to his work from the beginning: the nude in the open air, a "scene in which death had no place."[12] In doing so, he asserted definitively his view that painting remained dedicated to creating its own world, free from any obligation to bear witness.

Apart from the hat and colorful fabrics in the foreground, there is nothing that actually connects our five "nymphs" (as the painting was called for a long time) to any kind of context. The very setting in which they are situated is half-way between nature and an interior, a combination perhaps facilitated by the use of the glass studio in the garden of Les Collettes **Cat. 187, p. 403**. Previously used in *Nude on Cushions* **Cat. 39**, for instance, the cushion in the foreground smacks of the studio accessory and introduces an artificial note into the natural, vaguely Mediterranean-looking background. The space breaks off sharply at the picture's lower edge, as if a tapestry had come down after sheltering the bathers in the foreground. Renoir in fact introduced an abrupt change in scale between these two figures (posed by Andrée and Madeleine Bruno), the trees, and the three bathers in the background, intensifying the unreal and artificial character of the scene in order to give the whole the decorative unity he sought. In doing so, he followed the example of what he admired in *The Marriage Feast at Cana* **Fig. 3, p. 32**, which he went to see again on his last visit to the Louvre in August 1919: "If you observe the great painting by Veronese . . . you will find that the lines are not according to the rules of perspective, and he has made the figures in the different planes quite different from the proportionate size you would expect; but those people are in their place, everything has its true importance, and the picture is a great decoration. It is rare—that sense of great decoration. Rubens had it; Delacroix had it."[13] The elongated proportions and distortions applied to the female body derive from the same principle. There, too, Renoir had turned to the Old Masters as a source: "I have always loved Giorgione's

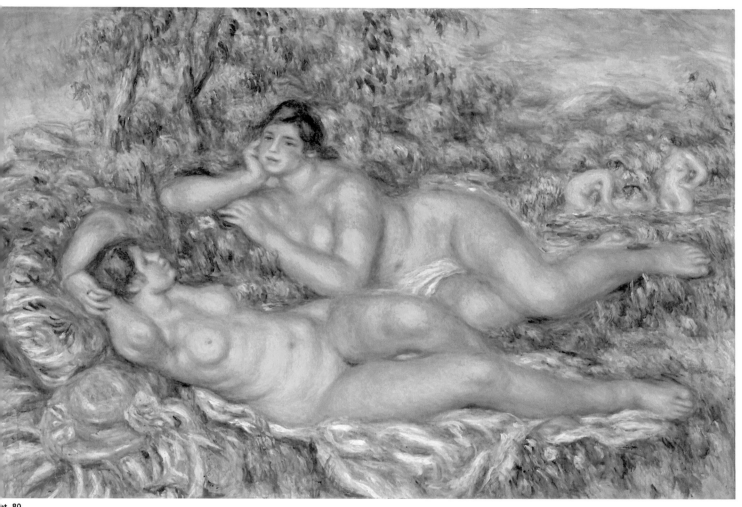

cat. 80

Concert Champêtre, in the Louvre.[14] Once, as I stood looking at it, someone said to me, 'That woman's arms are too short.' I had never thought of such a thing. But that is what the professor thinks of. He does not see how the work of the master is made up of good qualities and of defects, how every part of the picture should be as it is, for it is impossible to take one part and say, 'This produces the effect.'"[15] Renoir belongs to a long line of artists, from the Mannerists to Ingres, who used deformation for decorative ends: the body obeys the internal rules of the painting more than it reflects the reality of the model (certainly in the case of Andrée, who was not as plump as Renoir's figures). Ingres, for his part, elongated the back of the *Odalisque* in the Louvre and exaggerated, in defiance of all the laws of anatomy, the proportions of the nudes in his *Turkish Bath,* the shock of the 1905 Salon d'Automne (Paris, Musée du Louvre).

Whether it be Veronese, Rubens, Ingres, Delacroix, Titian, or the *Fountain of Diana* (Paris, Musée du Louvre)—then attributed to the sculptor Jean Goujon and revered by Renoir since his youth—*The Bathers* contains layer upon layer of quotations and tributes, not unlike Édouard Manet's "manifesto" painting, *Le Déjeuner sur l'herbe* (1862–63, Paris, Musée d'Orsay). In the dialectic between breaking with tradition on the one hand and integrating into the establishment on the other—which clearly was Renoir's own when he recalled the birth of Impressionism: "we only tried to show . . . painters that they had to enter the ranks," and entering the ranks meant, of course, relearning a craft that everyone had forgotten, with the exception of painters like Delacroix, Ingres, Courbet, and Corot, "who seemed to have come out of nowhere"[16]—*The Bathers* revisits two key works from the 1850s and 1860s, both of them "paintings of modern life" that had a seminal influence on his early work, and which have since taken their places in museums: Manet's *Déjeuner* and Gustave Courbet's *Young Ladies on the Banks of the Seine* (1856–57, Paris, Petit Palais) **Fig. 112.**

In 1907 *Le Déjeuner sur l'herbe* entered the Musée des Arts Décoratifs in Paris by bequest of Étienne Moreau-Nélaton. In addition to a reference to Giorgione's *Concert Champêtre,* Manet's painting (which was originally titled *The Bath*) shares the same subject as Renoir's *Bathers.* Both paintings have a similar composition, structured in successive layers (large figures in the foreground, cluster of trees in the middle ground), and down to the pose of the bather leaning over in the background. For that matter, the pose of the red-headed Andrée in the foreground also evokes Manet's *Olympia* (1863, Paris, Musée d'Orsay), which was hung in the Louvre in 1907, one year after Courbet's inflammatory *Young Ladies on the Banks of the Seine* had created a stir when it entered the Petit Palais in Paris. A key work for the young Renoir, who in 1870 derived his *Bather with Griffon* (São Paulo, Museu de Arte) from it, Courbet's painting, in the present *Bathers,* gave rise to a radical reinterpretation. Once more borrowing the pose of the model leaning on her elbows while reversing its composition, Renoir juxtaposed Courbet's candid evocation of ambiguous modern heroines, whose freedom comes at a price, with his own glorification of an innocent, abstract, and, in the end, asexual sensuousness, embodied by his nymphs. During the final years in Cagnes, the *Young Ladies* had become topical again thanks to Matisse's intervention (he had brought Renoir a preparatory study by Courbet for it from his own collection **Cat. 189, p. 406**). When Matisse asked Renoir what he thought his *Bathers* lacked in order to be complete, Renoir replied "'I feel it is not Courbet enough.' I did not ask for an explanation but thought that he meant his surface lacked the unity he desired and he liked in Courbet."[17]

Indeed, unity and harmony continued to be Renoir's primary concern: in their comparable format, the present *Bathers* follows a new version of *The Large Bathers* (1884–87, Philadelphia Museum of Art) **Fig. 8, p. 39** that Renoir did in 1903 at the instigation of Vollard (Cagnes-sur-Mer, Musée Renoir, on deposit from the Musée

Fig. 111

Pierre-Auguste Renoir
Two Reclining Nudes
Pencil on paper
11⁷/₈ x 17¹/₂ in. (30 x 44.5 cm)
Private collection
Formerly in the collection
of the sculptor Henry Moore

Fig. 111

Fig. 112

Gustave Courbet
*Young Ladies on the
Banks of the Seine*
Salon of 1857
Oil on canvas
68¹/₂ x 81¹/₈ in. (174 x 206 cm)
Paris, Musée des Beaux-Arts
de la Ville de Paris, Petit Palais,
gift of Étienne Baudry with the
assistance of Juliette Courbet,
1906

Fig. 112

d'Orsay). This sketchy painting leaves unresolved the issue that had dominated the reception of Renoir nudes since the presentation of the Philadelphia *Large Bathers* at the Georges Petit gallery—that is, the integration of the nude in the open air. The Philadelphia picture was exhibited again in 1913 at the Bernheim-Jeune gallery on the occasion of Renoir's last solo exhibition in France during his lifetime. The juxtaposition of the Philadelphia *Large Bathers* with more recent bathers and then, even more so, with those from 1918–19, highlights the changes that have taken place. In the 1918–19 *Bathers*, the thin, fluid paint (the pigment is so diluted that in places it looks like watercolor) gives the landscape a translucent texture; at the edges of the bodies, the brushstrokes and colors intermingle in order to create a smooth transition from flesh to nature. This paint preparation, which as so often with Renoir did not come straight from what was commercially available, provides the whole composition with an even luminosity, reinforced by dense highlights in white and pure colors. Using a technique that is very different from that of the 1884–87 *Large Bathers*, Renoir also obtained the characteristically fresh and matt look of fresco-painting, deftly resolving yet another of the challenges he had set himself throughout his artistic career.

For all these reasons, the painter's sons decided to offer the work to the Musées Nationaux in December 1922. In September 1919, two months before his death, when Renoir had started planning a donation with Paul Léon, the junior minister for fine arts, the painter was thinking of "giving the Luxembourg some landscapes and still lifes with which a modern Lacase [sic] gallery could gradually be set up, but they are wanting big things I think."[18] At this prospect, the Louvre curators envisaged buying the *Large Bathers* of 1884–87, then the property of Jacques-Émile Blanche, who was demanding 1,500,000 francs for it.[19] The picture was eventually bought by the painter Carroll S. Tyson in 1927 and transferred to the United States, a fate that nearly also happened to the 1918–19

Bathers, which Albert Barnes was eager to buy for over 800,000 francs.[20] The late *Bathers* were indeed "big things," and their entry into the museum unleashed a controversy that was publicized in the press thanks to Pierre Renoir's skillful handling. Referred to the Museum Board for a decision on March 5, 1923, the donation, while accepted, caused protests on the part of some members.[21] Alerted to the protests and aware of the comments of Jean Estournelles de Constant, then director of the Musées Nationaux, Pierre Renoir published a letter on March 30 declaring that the gift was being withdrawn in the face of the director's contempt for Renoir's late style and the reproach that it was a generosity deemed to be belated.[22] The whole "episode" gave free rein to complaints—quite familiar ever since the affair of the Caillebotte bequest in 1894—about the incompetence of the Board and the unrepentantly blinkered attitude of the curators.[23] Through a letter to the press on March 31, Paul Léon tried to appease the heirs,[24] and a compromise was eventually reached. The gift was accepted for the Musée du Luxembourg by the Advisory Committee on April 12, followed by a statement of acceptance on August 8. As is often the case with disputes between museums and the defenders of modern art, aesthetic reasons and administrative logic overlapped. A handwritten note, most certainly originating from Estournelles de Constant, summed it up: Renoir's painting, brought by the staff of the Galerie Barbazanges to the full Board meeting on March 6, had not been put on the agenda, nor presented to the Advisory Committee, as was required by Board statutes, all of which should already have invalidated the decision. But the final decisive factor was that the work of an artist who had been dead for less than ten years could not enter the Louvre. These undeniable legal and statutory arguments were coupled with a more basic reticence: "This painting, executed at a time when the master, who is a jewel of the French school, was in the final stages of the painful illness that had destroyed part of his capabilities, would do him a disservice when exhibited in the galleries of the Louvre."[25]

This note sums up the basis of the dispute that had been underway at least since the Renoir exhibition at the Salon d'Automne in 1920, where *The Bathers* had been shown for the first time. At that time, George Besson told Matisse, on October 28, 1920: "The 29 Renoirs in the Salon are a pretext for the most preposterous fight. Vauxcelles, Georges Lecomte, and Arsène Alexandre are running down the large nudes and beautiful landscapes we have seen him create. Poor Jean Renoir wanted to beat up the people who were guffawing in front of his father's works on the day of the private viewing."[26] Matisse regarded *The Bathers* as Renoir's masterpiece,[27] while Bonnard around 1916–20 carried on a dialogue, as it were, with Renoir on the subject of the *plein-air* nude and the "earthly paradise" in which *The Bathers* participated **Fig. 113**; a dialogue that was later taken up along different lines by Henry Moore, who owned a drawing **Fig. 111** connected to this painting—an inspiration, indeed!

<div style="text-align: right">S. P.</div>

Fig. 113

Pierre Bonnard
Earthly Paradise
1916–20
Oil on canvas
51 1/8 x 63 in. (130 x 160 cm)
Chicago, The Art Institute of Chicago, Estate of Joanne Toor Cummings; Bette and Neison Harris and Searle Family Trust endowments; through prior gifts of Mrs. Henry C. Woods

Fig. 113

1. Bernheim-Jeune, vol. 2, p. 12. **2.** J. Renoir 1962, p. 456. **3.** Unpublished letter, Durand-Ruel archives. **4.** Quoted in Fourcade 1976, p. 97; repr. in Renoir 2002, p. 218. **5.** Courthion 1941, p. 92; Matisse archives. **6.** Roux-Champion, quoted in Renoir 2002, p. 209. **7.** Besson 1932, p. 11. **8.** Courthion 1941, p. 92. **9.** J. Renoir 1962, p. 456. **10.** Ibid., p. 452 **11.** White 1984, p. 280. **12.** Matisse, quoted in Fourcade 1976, p. 97. **13.** Pach 1938, p. 110. **14.** The Louvre now attributes the painting to Titian. **15** Pach 1938, p. 110. **16.** Quoted in Vollard 1994, p. 170. **17.** Matisse, quoted in Renoir 2002, p. 218. **18.** Unpublished letter from Renoir to Vollard, Bibliothèque Centrale des Musées Nationaux, Archives Vollard, MS 421 [2, 2] 338, 339. The La Caze gallery in the Louvre showcased Louis La Caze's great bequest, in 1869, of 583 mainly seventeenth- and eighteenth-century paintings, including masterpieces by Chardin, Watteau, etc. **19.** Unpublished letter from Marcel Guérin to Jean Guiffrey, Archives of the Musées Nationaux, L 8. **20.** Valbelle 1923. **21.** Archives of the Musées Nationaux, *1BB39. **22.** March 29, 1923, Archives Nationales, F 21 4336; *L'Œuvre* 1923. **23.** Valbelle 1923. **24.** *L'Imagier* 1923. **25.** Documentation Musée d'Orsay. **26.** Unpublished letter, Matisse archive. **27.** Matisse, quoted in Fourcade 1976, p. 97.

Cat. 81

Nude Woman from the Back Drying Her Arm, and Sketches (Femme nue de dos s'essuyant le bras et esquisses)

Circa 1890–91
Pencil with black ink shading in the hair, on paper
12¼ x 7⅞ in. (31 x 19.9 cm)
Signed bottom right: *R*
Vienna, Albertina
24108

EXHIBITION
Paris, Orangerie, 1933, no. 147.

BIBLIOGRAPHY
Stix 1927, p. XVI, pl. 24; Rewald 1946, pl. 60; Huyghe and Jaccottet 1948, p. 110; Pach 1958, p. 23; Koschatzky 1977, pp. 372–373; Ekelhart 2007, no. 280; Dauberville 2009, no. 1607.

Exhibited in Paris.

The subject of this study, a nude seen from behind drying her shoulder, is one that often recurs in Renoir's graphic work of the early 1890s; in fact it features in no fewer than seven drawings, all executed in pencil. In some of these the figure is accompanied by a few sketches alongside. Executed with a much lighter line, these sketches were often reworkings of parts of the body, as is the case here: on the right, the painter has redrawn the young woman's head and shoulders and on the left, her hand.

Although this drawing of a nude is still consistent with Renoir's return to line and form in the early 1880s, it has, however, gained in suppleness. The artist does not hesitate to accentuate the contrapposto of the body, thus emphasizing the sinuosity of the line, in a way somewhat reminiscent of Ingres, for whom Renoir had utmost admiration. The use of repeated parallel lines also gives volume and rhythm to his drawing.

I. G.

Cat. 82

Nude Woman, *or* The Toilette (Femme nue assise, *or* La Toilette)

Circa 1890
Black, white, and red chalk, stump on cardboard
22 x 18⅛ in. (56 x 46 cm)
Signed and dedicated bottom left in black chalk: *A Roger Marx / bien amicalement / Renoir*
Paris, Musée d'Orsay, held in the Département des Arts Graphiques, Musée du Louvre, acquired by gift in lieu of inheritance taxes, 1978
RF 36726

EXHIBITIONS
Paris 1930, no. 34 (as *Femme nue assise*, Claude Roger-Marx collection); London, Burlington House, 1932, no. 974; Paris, Orangerie, 1933, no. 141 (as *Femme nue assise (La Toilette)*, Claude Roger-Marx collection); Paris, Charpentier, 1957, no. O; Paris 1969, no. 27 (as *La Toilette*).

BIBLIOGRAPHY
Fosca 1929, p. 322; London 1933, no. 913, pl. 201; Roger-Marx 1933, p. 77; *Seize aquarelles et sanguines* 1948, pl. 14; Roger-Marx 1964, p. 37; Leymarie 1953, no. 13, pl. 13; Daulte 1958, p. 14 and pl. 16; Leymarie 1969, p. 79

Exhibited in Paris and Los Angeles.

Roger Marx, assistant head of the fine arts section at the 1900 Universal Exposition, managed to persuade Renoir and his friends Claude Monet and Camille Pissarro to exhibit at the Exposition Centennale Française des Beaux-Arts (a "centennial" exhibition covering French art from 1789 to 1878), where a room was devoted to Impressionist painting. On July 11 of the same year, Renoir wrote to his friend Georges Viau: "as you have returned my jacket to me, I must indeed agree to accept this honor. In fact I do so wholeheartedly and ask you to thank Monsieur Roger Marx as he is the inventor."[1] Could it have been to thank Roger Marx for the honor of being made a Chevalier of the Legion of Honor, or perhaps for the invitation to take part in the centennial exhibition, as François Daulte suggests,[2] that Renoir gave him this *Nude Woman* and dedicated it to him? It is also possible that Renoir may have given the critic this drawing, dated around 1890, following the article Marx published on April 26, 1892, in *Le Voltaire* to mark the retrospective held at the Galerie Durand-Ruel. Whatever the case, Renoir chose to give this critic—who saw in him the successor of the great eighteenth-century masters—a work that evokes the *trois-crayons* technique ("three-chalks"—black, white, and red) so prized during that period.

In addition to this red chalk drawing, Roger Marx owned three paintings—*Arab Woman, Young Girl in Blue* and *Bust of a Woman*—and three engravings by Renoir. The artist had also been asked to contribute to *L'Estampe originale*, of which Marx was a founder. The present drawing appears to have passed into the collection of his son, Claude Roger-Marx, who kept it during his lifetime and did not include it among the drawings he donated to the Louvre in 1974. Claude, like his father a loyal champion of Renoir, devoted a book to him in 1933.

I. G.

1. Exh. cat. Paris, Louvre, 1980–81, no. 78–81. **2.** Daulte 1958, pl. 16.

Cat. 81

Cat. 82

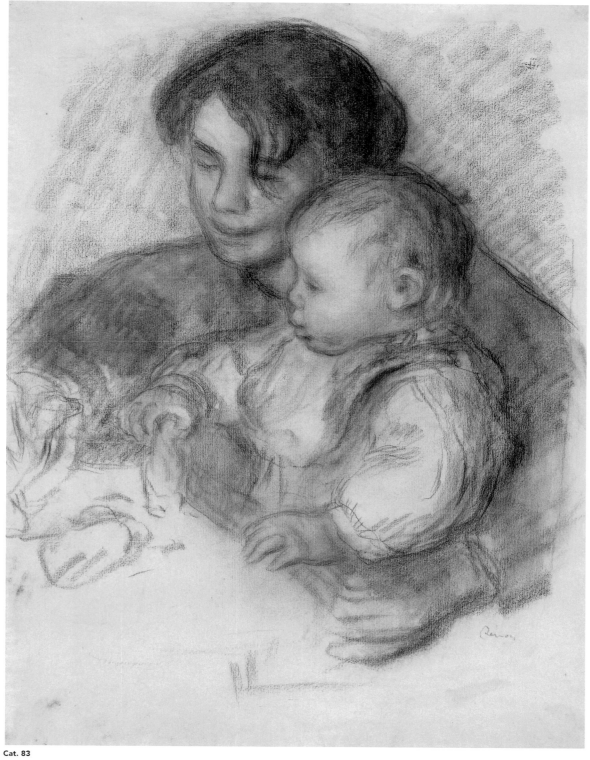

Cat. 83

Cat. 83

Gabrielle and Jean (Gabrielle and Jean)

Circa 1895
Charcoal on laid paper
24³/₈ x 18⁵/₈ in. (62 x 47.2 cm)
Signed bottom right: *Renoir*
Ottawa, National Gallery of Canada, Gift of Martin Fabiani, Paris,1956
7296

EXHIBITIONS
Toronto 1968, no. 60; Paris 1969–70, no. 63; Ottawa, Victoria, and
Alberta 2004–05, no. 67; Rome 2008, no. 76.

BIBLIOGRAPHY
Moskowitz 1962, no. 806; Fenwick 1964, p. 11, fig. 5; Popham-Fenwick 1965,
no. 276, pp. 186–189; Vollard 1989, no. 594.

Exhibited in Los Angeles and Philadelphia.

This is a preparatory drawing for the painting **Cat. 11**, dated 1895, depicting Jean playing on the lap of his nursemaid, Gabrielle. As the painter's son explained many years later, "When I was still very young—say at the age of three, four, or five—instead of deciding on the pose I was to take, [my father] would wait until I found something to occupy me and keep me quiet."[1] This would almost certainly have applied to this work as well, executed when he was still a baby.

The composition of this study is very close to the final painting, in which the position of Gabrielle's left hand is the only thing that has changed; instead of encircling the little boy, it is tucked under his arm. Jean's clothing has also been slightly altered, as Renoir has tied a scarf around the child's neck in the painted version. The size of the drawing is almost the same as that of the final work; Renoir liked to do studies to size, as he believed that a shape suitable for the size of a sheet of paper does not necessarily adapt to the different proportions of a canvas.[2] This is also why he preferred to trace full-sized red chalk drawings onto the canvas—as he did for *Gabrielle and Jean*[3]—rather than using the traditional method of making a grid to scale up the drawing.

The Ottawa drawing is the most detailed of the studies Renoir executed for his painting. In two others, the painter only sketched out the figures: in the first one, executed in red chalk, Gabrielle does not have a strand of hair falling over her left eye;[4] while in the second, done in chalk,[5] Jean is on Gabrielle's left, and her attention seems focused on the baby rather than the game. This may explain why John Rewald did not associate this work with the Orangerie painting, seeing it instead as a drawing of Gabrielle and Coco and dating it 1901.[6]

After the death in 1939 of Ambroise Vollard, who owned the drawing, ownership transferred to his brother, Lucien. With the help of the dealer Martin Fabiani, Lucien shipped it to the United States to be sold. Blocked by the British Navy, the drawing was deposited in the National Gallery of Canada until the end of the war; Fabiani presented it to the gallery in 1956.[7]

I. G.

1. J. Renoir 1962, p. 391. 2. André 1950, p. 7. 3. Sales cat. London, Sotheby's, 1986, no. 306. 4. Sales cat. London, Sotheby's, 2008, no. 180. 5. Location unknown; exh. cat. Ottawa, Chicago, and Fort Worth 1997–98, fig. 270, p. 326. 6. Rewald 1946, p. 23, pl. 77. 7. Assante 2007, p. 277.

The Coiffure, or *The Bather's Toilette* (La Coiffure, or La Toilette de la baigneuse)

Circa 1900–01
Red and white chalk on paper mounted on canvas
57 1/4 x 41 3/8 in. (145.5 x 105 cm)
Signed bottom right in red chalk: *Renoir*
Paris, Musée National Picasso, Picasso gift, 1973–78
RF 35793

EXHIBITIONS
Paris 1930, no. 22 (Vollard collection); Paris, Louvre, 1978, no. 51; Munich 1998, no. 67; Paris 2008–09, pp. 136, 363.

BIBLIOGRAPHY
Musée Picasso 1985, p. 63; Hoog and Guicharnaud 1984, p. 170; Vollard 1989, no. 71; Seckel-Klein 1998, no. 67; Barcelona 2007–08, p. 208.

Exhibited in Paris.
Illustrated on p. 83.

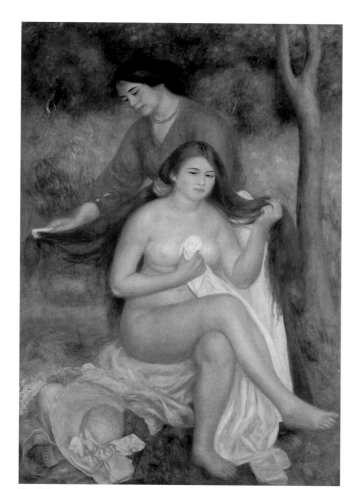

Fig. 114

Among the seven works by Renoir belonging to the Picasso collection, *La Coiffure* is the only drawing. This red chalk drawing is related to *La Toilette,* purchased by Albert C. Barnes from Étienne Bignou on December 10, 1935, even though some months earlier, in the monograph he devoted to the painter, the collector had expressed strong criticism of the painting, judging it to be "banal and academic," lamenting that "it lacks the spark of life."[1]

Slightly wider (the oil is 57 3/8 x 38 1/2 in.; the sanguine, 57 1/4 x 41 3/8 in.), the drawing differs in a number of ways from the final painting. In the latter, the bather faces front, while in the preparatory study, her face is in slight profile to the right; the tree is far less voluminous, as it has lost its foliage in favor of a simple, slender trunk; and the hat and clothes to the bottom left are both more prominent and more elaborate. The painter has also added some details, such as the comb used by the maidservant and the necklace she is wearing.

The date at which Picasso acquired this drawing is still a matter of speculation. Hélène Seckel's assumption[2] that the purchase may have been made on February 19, 1934, from Vollard has not been confirmed. However, a glass negative of the work (Paris, Musée d'Orsay, Vollard collection, ODO 1996-56-63) as well as a paper print of it (plate no. Vollard 93, Musée d'Orsay, Vollard archive, ODO 1996-56-63) were found in the gallery's photographic archive. On the other hand, when it was exhibited in 1930, *The Coiffure* belonged to the dealer.

When he paid a visit to Picasso on November 30, 1943, Brassaï observed: "A Renoir drawing has appeared on the easel in the entrance hall. He was offered a million and a half for it." However, the following Monday, on December 6, while he was photographing "some corners of the entrance hall . . . the portrait of Inès, Picasso's maid, had replaced Renoir's drawing on the easel."[3] Was this a new plan to acquire another Renoir drawing, or perhaps the present sanguine, put up for sale following Vollard's death in 1939? Whatever the case, the work appears in a photograph (photographer unknown) taken in the studio in rue La Boétie side by side with *Still Life with Apple,* which Picasso had painted in February 1937.

I. G.

1. Washington, Paris, Tokyo, and Philadelphia 1993–94, p. 80. **2.** Seckel-Klein 1998, p. 208. **3.** Brassaï 1986, pp. 115, 122.

Pierre-Auguste Renoir
Bather and Maid (La Toilette)
Ca. 1900
Oil on canvas
57 3/8 x 38 1/2 in. (145.7 x 97.8 cm)
Merion, PA, Barnes Foundation

Fig. 114

Cat. 85

Young Girl Seated (Jeune fille assise)

Circa 1908–09
Red chalk, stump, and white chalk, with black chalk details, brown pastel
on laid paper
35³/₈ x 27¹/₂ in. (90 x 70 cm)
Signed bottom right in chalk: *Renoir*
Paris, Musée d'Orsay, held in the Département des Arts Graphiques of
the Louvre; acquired by the state, 1915
RF 12832

EXHIBITIONS
Venice 1924, no. 1267; Paris, BN, 1933, unnumbered; Paris, Orangerie, 1933,
no. 148; Brussels 1936–37, no. 105; New York 1937, not in catalogue; Bogota
1938, no. 58 (as *Retrato de Gabriela*); Lyon 1938–39, no. 51 (as *Portrait de
Gabrielle*); Belgrade 1939, no. 150 (as *Portrait de Gabrielle*); Buenos Aires
1939, no. 266 (as *Retrato de Gabrielle*); Santiago 1940, no. 266; San Francisco
1941, no. 249; Limoges 1952, no. 59; Lyon 1952, no. 69; Nice 1952, no. 46 (as
Portrait de Gabrielle); New York, Cleveland, Washington, St Louis, and
Cambridge 1952–53, no. 161 (as *Young Woman Seated [Jeune femme assise]*);
Marseille 1963, no. 78; Vienna 1976–77, no. 59; Paris 1994, no. 40 (as *Jeune fille
assise sur une chaise*).

BIBLIOGRAPHY
Rewald 1946, p. 23 and pl. 87; Vollard 1989, no. 513.

Exhibited in Paris and Philadelphia.

Fig. 115

It was through the Galerie Vollard on August 18, 1915, that the
French state purchased the drawing of *Young Woman Seated*
from Renoir for the sum of 100 francs. Other than the pastel
depicting Théodore de Banville acquired in 1910 (Paris, Musée
d'Orsay, RF 12385), this was the only Renoir drawing to enter the
French national collections through purchase.

This red chalk drawing is a preparatory study for the painting
Young Girl Seated, which became part of the Louvre collection in
1911 by bequest from Count Isaac de Camondo **Fig. 115.** We also
know of a sketch very similar to the painting: a bust of a young
woman dressed in the same white blouse, against a neutral back-
ground (Sotheby's, New York, sale of May 7, 2003, no. 112).

Incorrectly identified for many years as Gabrielle Renard, the
model was in fact Mme Joseph Forestieri, whose maiden name was
Hélène Bellon. Born in Saint-Laurent-du-Var, she met Renoir in
1908 when the postman at Les Collettes, Garache (who would
later become her first husband), introduced his fiancée to Renoir.
The artist immediately expressed a desire to paint the young
woman. Although very reticent, she eventually posed for Renoir,
but only dressed in the white blouse seen here. According to
Robert Buson,[1] Hélène continued to pose for Renoir for four years.
The paintings in which she appears are still to be identified.

I. G.

1. Buson 1959.

Pierre-Auguste Renoir
Young Girl Seated
1909
Oil on canvas
25³/₄ x 21¹/₂ in. (65.5 × 54.5 cm)
Paris, Musée d'Orsay

Fig. 115

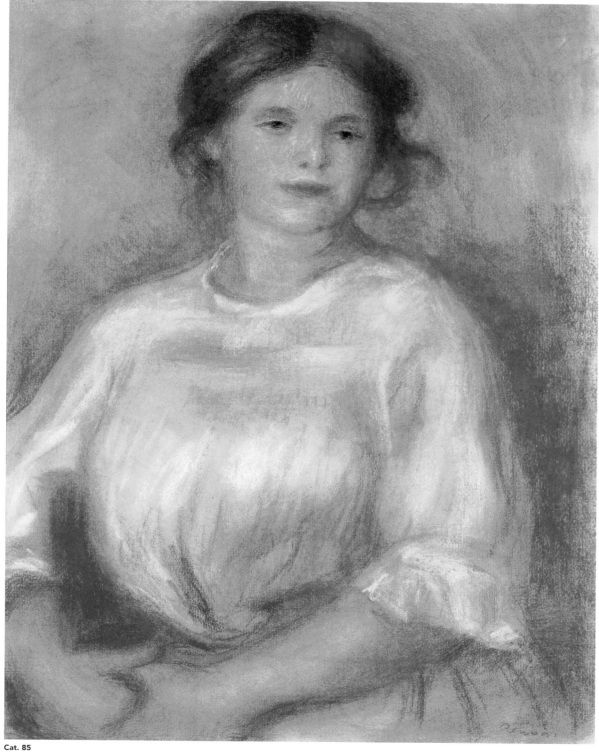

Cat. 85

Cat. 86

Portrait of Auguste Rodin
(Portrait d'Auguste Rodin)

March 1914
Red chalk on paper
21¼ x 17¾ in. (54 x 45 cm)
Signed and dated bottom left: *Renoir / 1914*
Private collection

EXHIBITIONS
Paris, Bernheim-Jeune, 1938, no. 38; Arles 1952, no. 34 (Mme Josse Bernheim coll.); Lyon 1952, no. 70 (Mme Josse Bernheim coll.); Nice 1952, no. 48 (Mme Josse Bernheim coll.); Paris, Bernheim-Jeune, 1952–53, no. 137; Paris 1953–54, no. 155 *bis*.

BIBLIOGRAPHY
Coquiot 1915, n. p.; Vollard 1919b, p. 242; Vollard 1920, pp. 232–233, 248–263; Duret 1924, p. 72 and pl. 34; Coquiot 1925, p. 130; Watt 1938, p. 35; Terrasse 1941, pl. 45; Sérullaz 1953, p. 70; Roger-Marx 1958, p. 31; Paris 1958–59, no. 83; Descharnes and Chabrun 1967, p. 258; White 1984, pp. 270, 286.

Exhibited in Paris.

When the Bernheim brothers were planning to publish an album on the works of Auguste Rodin, Gustave Coquiot, who wrote the preface, suggested they should ask Renoir to do a portrait of the sculptor for the frontispiece. The painter replied on November 12, 1913, that he would be "delighted to do a drawing of Rodin" for 1,000 francs.[1]

As early as November 17, 1913, Coquiot told Rodin that Renoir was expecting him in Nice.[2] In fact, the visit took place a few months later in Cagnes. On March 5, 1914, Coquiot announced to Rodin, who was traveling in the South of France: "Renoir and Madame Renoir are preparing a wonderful reception for you in Cagnes, where they are presently staying." Then he pressed the matter again on March 8: "Madame Renoir and Renoir are waiting for you, as is Madame Rodin. They have settled in well and all is in place to receive you. . . . Remember that Renoir is to do your portrait for our album for the Bernheim gallery."[3]

Apparently an initial meeting had been set for March 7, as Renoir sent a message to the sculptor that same day; he expressed the hope that the indisposition, which had prevented him from coming to see them, would be short-lived.[4] Vollard devoted several pages to this visit in the book he dedicated to the painter in 1919, reporting on the two masters' discussions on ancient art and their love of nature; the account would later be fiercely criticized by Coquiot.[5] Although Renoir confessed to his dealer a short while before the arrival of his model, "I will really have to concentrate on Rodin . . . [he] has quite a distinctive head," the red chalk drawing was nonetheless completed in under an hour. As the painter explained to Vollard, he had already executed two portrait drawings of the sculptor, which had no doubt helped with his work.[6] The first of these is probably the one mentioned by Vollard

in his letters to Rodin between October 11 and 15, 1905, and June 11, 1906,[7] and which is featured in the dealer's 1918 publication.[8] This correspondence mentions a plan for Renoir to do a portrait of the sculptor, but it is impossible to tell today if the drawing (executed in 1905) is just a preparatory study or the definitive work. The second drawing, done in pencil, was used to produce a lithograph published by Vollard in 1910.[9]

The two masters were full of mutual admiration. Rodin, "the greatest sculptor" in the painter's eyes,[10] is one of six great artists represented by Renoir in the medallion portraits he executed with Richard Guino in 1916. For Rodin—who did not do a portrait of the painter—his admiration was such that he acquired a nude from the artist, whom he described as the "divine Renoir." The work was a seated bather from 1880, which the sculptor compared to a Praxiteles;[11] although Rodin had coveted it since 1898,[12] it was not until June 2, 1910, that he acquired it from Bernheim-Jeune for 20,000 francs. However, it seems that already twenty years earlier, Rodin owned another of Renoir's paintings. Bought from Durand-Ruel on February 21, 1890, this painting has yet to be identified; the same is true of a *Female Nude*, the purchase of which, for 40,000 francs in July 1913, is recorded in the press (*La Vie*, July 19, 1913; *Paris Journal*, July 22, 1913). In the end, Renoir sent Rodin "a fabulous nude in case it might be of use."[13] Scribbled in pencil on a small card without any other details, these few words remain enigmatic, and the delivery has not been traced.

I. G.

1. Dauberville 2007, pp. 49, 54. **2.** Paris, Musée Rodin archives. **3.** Ibid. **4.** Ibid. **5.** Coquiot 1925, pp. 129–135. **6.** Vollard 1920, pp. 246–247. **7.** Paris, Musée Rodin archives. **8.** Vollard 1989, no. 276. **9.** Delteil 1923, no. 49; exh. cat. Paris 1958–59, no. 183. **10.** Letter from Renoir to Rodin, [1911], Paris, Musée Rodin archives. **11.** Revers 1911. **12.** Letters from Vollard to Rodin, June 1989 and May 19, 1910. **13.** Paris, Musée Rodin archives.

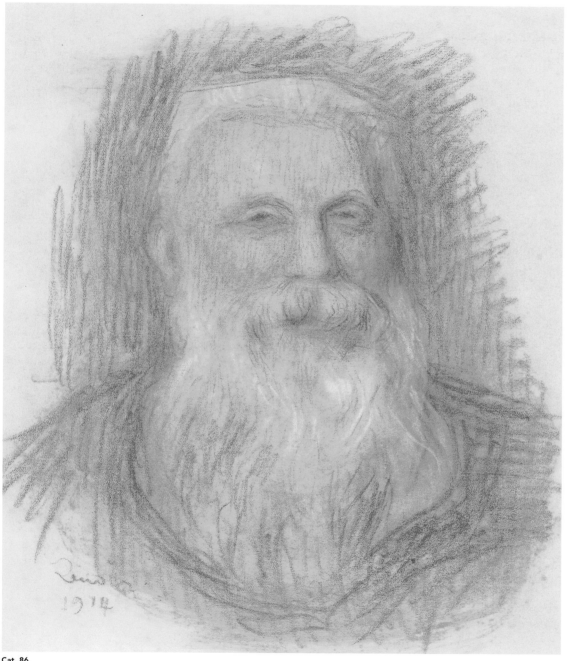

Cat. 86

Cat. 87

Seated Woman Leaning on her Elbow (Femme assise accoudée)

Circa 1910–17
Charcoal on paper
18 1/2 x 24 5/8 in. (47 x 62.4 cm)
Signed bottom right in black chalk: *Renoir*
Vienna, Albertina
24330

EXHIBITION
Paris, Orangerie, 1933, no. 149.

BIBLIOGRAPHY
Tietze 1925–26, p. 463; Stix 1927, p. XVI, pl. 26; Huyghe and Jaccottet 1948, p. 111; Koschatzky 1977, pp. 372–373; Vollard 1989 (p. IX); Ekelhart 2007, no. 283.

Exhibited in Paris.

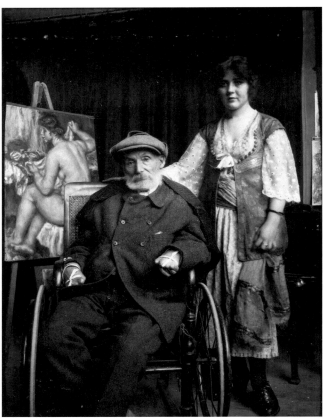

Cat. 185

Walther Halvorsen (?)
Renoir and Andrée in the studio at Les Collettes in Cagnes
March 11, 1918 (?)

Cat. 185

While Renoir's red chalk drawings (sanguines) are famous, his use of charcoal and black chalk is less well known. Thus, while he was gradually relinquishing pencil and his linear, precise style of the 1880s, the painter was using black as well as red chalk. As is seen in *Seated Woman Leaning on Her Elbow*, the line becomes thicker and softer, thanks to the delicate texture of the materials, and the drawing more voluminous and flowing. The highly shaded contours give fullness to the figure and throw it into high relief. As in his painted works, Renoir has no hesitation in distorting his model's arms and extending the curve of the line to satisfy the decorative demands of his drawing.

Though several of the painter's works feature a woman from the waist up, leaning on a table or pedestal table, our drawing can be more precisely compared to *Woman in a Greek Shirt, Leaning on Her Right Elbow*, dated 1917 (Bernheim-Jeune 1931, vol. 2, no. 620, 15 3/4 x 19 3/4 in. [40 x 50 cm]), which takes up the same motif as the one in this drawing. Slightly larger than the painted version, the study gives a tighter framing of the figure, accentuating its monumental appearance; some other differences can also be discerned, notably in the facial features and the absence of a bracelet.

As is often the case in the painter's late works, it is hard to identify the model he used for this drawing, as Renoir borrowed from several faces to create the ideal woman. Although the woman's position and face are similar to those of the young girl leaning on her elbow in *The Concert* **Cat. 79** or *Bathers* **Cat. 80**—posed for by the young Cagnes native Madeleine Bruno, who modeled for Renoir at the time—it was probably Andrée Heuschling, known as Dédée, who provided the features of the young woman in this picture. Comparing it to a photograph from that period supports this theory, right down to the costume, a blouse with flared sleeves **Cat. 185**. From her first meeting with Renoir (between 1915 and 1917 according to accounts), Andrée stood out among the regular visitors to Les Collettes, where she became the painter's favorite model. She married Jean Renoir in 1920, and four years later began a career as an actress under the name of Catherine Hessling, in one of the first films scripted by her husband. As Jean confirms in the book he dedicated to his father, Dédée seems to have brightened up the last years of the painter's life: "she was sixteen years old, red-haired, plump, and her skin 'took the light' better than any model that Renoir had ever had in his life. She . . . was gay, and cast over my father the revivifying spell of her joyous youth."[1]

I. G.

1. J. Renoir 1962, pp. 398–399.

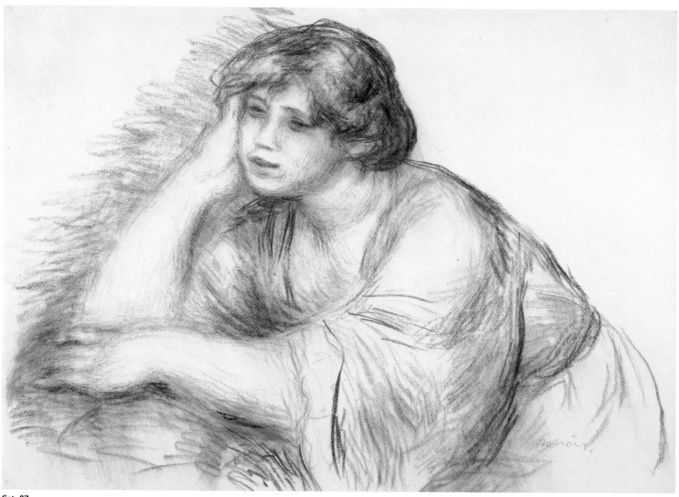

Cat. 87

Cat. 88

Sketch for The Saône Throwing Herself into the Arms of the Rhône
(Esquisse pour La Saône se jetant dans les bras du Rhône)

Circa 1912–13
Pen and ink on paper
6⁷/₈ x 4¹/₂ in. (17.5 x 11.5 cm)
Paris, Collection Daniel Brukarz

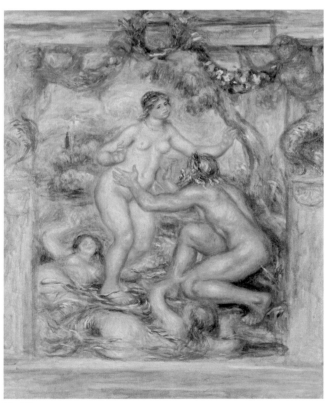

Fig. 116

Pierre-Auguste Renoir
The Saône Throwing Herself into the Arms of the Rhône
1915
Oil on canvas
40¹/₄ x 33³/₈ in. (102.3 × 84.8 cm)
Tokyo, Matsuoka Museum of Art

Fig. 116

This ink drawing seems to be the initial idea for a huge composition depicting *The Saône Throwing Herself into the Arms of the Rhône,* a commission given to Renoir by the City of Lyon. Here the painter uses a technique familiar to him—pen and ink. In fact, he used pen and ink for most of the illustrations from his Impressionist period, as well as numerous little sketches known today thanks to the work of Ambroise Vollard and Albert André.

Renoir executed several works related to this tapestry project which show that he established the broad lines of his composition from this very rough sketch. While the painter devoted himself first and foremost to the overall composition of the scene in most of his studies, there is one red chalk drawing in which he concentrates on the study of the two main figures (Rewald 1946, pl. 85), a motif he takes up again in two etchings entitled *The River Scamandre* (Delteil 1923, nos. 24 and 25). While the tapestry does not seem to have seen the light of day, Albert André is credited with executing the cartoon for it on the instructions of the master.[1] Many years later, in fact, Claude Renoir would recall his father's problems: "Alas! I had too little experience by a number of years to be useful to him, and I was supposed to assist, powerless, in his fruitless efforts to make the tapestry cartoon himself: *The Rhône and the Saône* requested by the City of Lyon.[2]"

If allegorical subjects are rare in Renoir's work, the presence of a male nude in his painting is exceptional. It is worth pointing out, however, that he painted a *River God* in 1885 (not located; Vollard 1989, no. 9), whose elongated horizontal format suggests that, as in this case, the work was destined for a decorative function.

It is in fact possible that *The Saône Throwing Herself into the Arms of the Rhône* was not the painter's first tapestry project—a *Landscape* dated around 1890 could well rob it of this position (Paris, Musée d'Orsay, RF 1945-5).

I. G.

1. Exh. cat. London, Paris, and Boston 1985–86, p. 278 (p. 328 in French ed.); exh. cat. Bagnols-sur-Cèze 2004, p. 31. **2.** C. Renoir 1948, p. 10.

Cat. 88

Cat. 89

Coco

Circa 1907–08
Lost-wax cast bronze medallion
8⅝ (diam.) x 1¾ in. (22 x 4.3 cm)
Inscribed signature: *Renoir*; on the edge: ¼
Paris, Musée d'Orsay
RF 1999

EXHIBITIONS
Lyon 1952, no. 82; São Paulo 2002, pp. 166–167.

Cat. 90

Coco

Circa 1907–08
Bronze bust, cast by Valsuani
14⅝ x 7⅞ x 7⅞ in. (37 x 20 x 20 cm)
Signed on the left of the base: *Renoir*; foundry stamp: *cire perdue / Valsuani / 21/30*
Paris, Petit Palais, Musée des Beaux-Arts de la Ville de Paris
PPS 3420

EXHIBITIONS
Bonn 1998, no. 95; São Paulo 2002, p. 166.

Exhibited in Paris.

Coco

Circa 1920
Bronze bust
10¾ x 7⅝ x 7½ in. (27.3 x 19.4 x 19.1 cm)
Signed at the front on the right: RENOIR; foundry stamp: *20/20 Cire perdue C. Valsuani*
Philadelphia, Philadelphia Museum of Art, Bequest of Lisa Norris Elkins, 1950
1950-92-47

Exhibited in Los Angeles and Philadelphia; not illustrated here.

BIBLIOGRAPHY FOR CAT. 89 & 90
Meier-Graefe 1911, pp. 118 (medallion and bust); Fosca 1924, p. 55; Meier-Graefe 1929, pp. 402–406 (bust); Haesaerts 1947, no. 1 and p. 19, pl. III (medallion), and no. 2 and p. 19, pl. IV and XXXVI (bust); Gaunt 1952, pp. 24–25; Robida 1959, p. 50; Perruchot 1964, p. 310; Cagnes-sur-Mer 1969, n. p.; Clergue 1976, n. p.; Gaunt 1982, pp. 24–25, reprod. of the Marmottan plaster; White 1984, pp. 235, 241 (medallion and bust); London, Paris, and Boston 1985–86, p. 278, (p. 328 in French ed.) (medallion); Pingeot, Le Normand-Romain, and Margerie 1986, p. 227 (medallion); Bonn 1998, p. 184; Palermo and Milan 2002, p. 22; São Paulo 2002, pp. 166–167; Dauberville 2007, p. 4 (medallion).

Claude, Renoir's youngest child, was the subject of the artist's first sculptures: first a bas-relief, then a bust, dated 1907 and 1908 respectively by Haesaerts, and both as 1908 by White. In fact, neither piece carries a date. If one assumes that the medallion was intended to decorate the mantlepiece in the dining room at Les Collettes **Cat. 158, p. 392**—where it still is mounted today—the work should be dated in reference to the construction of the house. However, it may just as well have been modeled for its own sake, prior to any building project. Furthermore, Coco's short, "page boy" (Haesaerts) hairstyle may coincide with the boy's entry into school, when the long ringlets that made him look like a little girl had to be cut. From his appearance on the medallion, Coco is almost certainly no more than six or seven years old, which would date the piece to 1907.

There actually are two versions of the medallion. The first, which is relatively unknown, is a plaster kept by the Tokyo National Museum of Western Art. Its surface is rough, the short hair is trimmed back on the nape of the neck and uncombed, and the forehead is covered by a fringe with a rebellious lock tumbling down. A second, different plaster, more finished and tidier, was

bequeathed by Michel Monet, son of the painter, to the Musée Marmottan, Paris: the surface is smoother, the hair longer and more even, and the forehead more exposed. It was this second plaster that was used as a model for the mantlepiece marble and for the bronze castings—thirty by Valsuani, this time signed "Renoir." There are also bronzes without the caster's name, as well as plaster editions such as the one sold at Cheverny in June 2008, which came from the art dealer Bignou.

Haesaerts comments on the "primitive appearance" of this relief, finding in it all manner of references to "Chaldean, Cretan, and Etruscan" art, as well as to "ancient Roman and Byzantine medals." Certainly it conveys a genuine freshness and a certain clumsy naïveté that is well suited to this intimate portrait; indeed it is an interesting experiment that the later collaboration between Guino and Renoir would never eclipse. It is unknown what material the medallion was originally made of. As to the bust, Haesaerts believes that it was first modeled in wax, although old photographs (Paris, Musée d'Orsay, donated by Paul Vitry and the Barbazanges archives) suggest a plaster that is yet to be located. Did Renoir model the plaster fresh, or was it cast from a wax or clay piece?

The bronzes of the bust were all cast after Renoir's death from this unlocated plaster piece, which carries certain telltale marks, in particular some notches on the lip, on the nose above the right nostril, and on the left cheek, close to the ear—Robida claims that Gabrielle Renard dropped it on the Nice tram! These bronzes are mounted either on a small socle, as can be seen in a number of photographs—in that case bringing the overall height to 16⅜ in. (41.5 cm), or else on a cubic pedestal of a patently recent style. In the case of the medallion, the lost-wax cast in the Musée d'Orsay is the fifth in a series of thirty made by Claude Valsuani, and was acquired from the Galerie Hodebert in 1930. Galerie Hodebert (formerly Barbazanges) also ordered nine busts from Valsuani in 1928 (Paris, Musée d'Orsay, Barbazanges archives), with the Galerie Renou et Poyet following suit. Haesaerts also mentions the Galerie Flechtheim in Berlin. Recent castings of the bust are lost-wax pieces by Valsuani, marketed by Renou et Poyet in, it would seem, an edition of thirty. The bust of Coco can be found in numerous museums including those of Cagnes-sur-Mer, Brussels (Musées Royaux des Beaux-Arts), Cologne (Wallraf-Richartz Museum), Malmö (Konstmuseum), San Francisco (Palace of the Legion of Honor), and Washington, DC (National Gallery of Art—which has two copies, including cast 9/30 of the Valsuani edition purchased by Chester Dale from the Galerie Barbazanges).

<div align="right">E. H.</div>

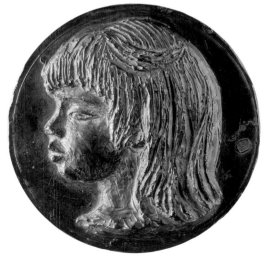

Cat. 89

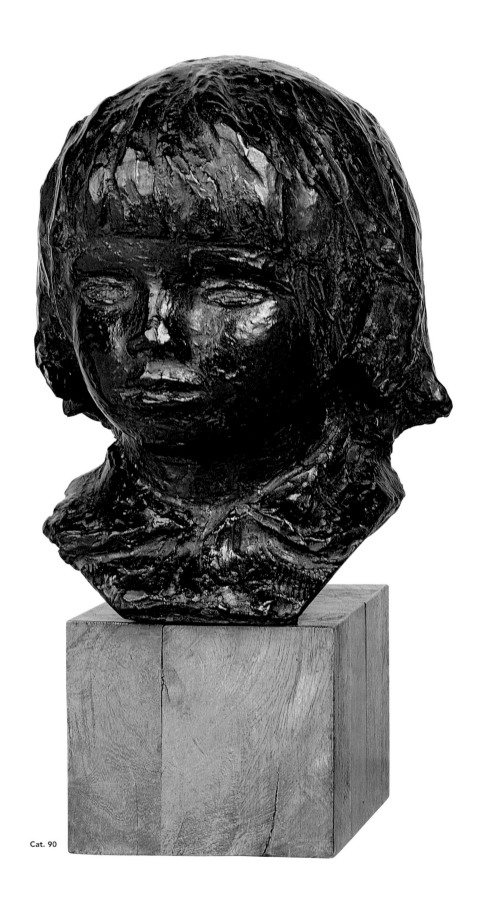

Cat. 90

Richard Guino
and Pierre-Auguste Renoir
Hymn to Life (Hymne à la vie)

Bronze clock, lost-wax casting
28 x 20 1/8 x 10 7/8 in. (71 x 51.2 x 27.5 cm)
Signed and dated at the back of the socle, level with the woman's left
foot: *Renoir 1914*; foundry stamp: *No 1 / cire perdue / Bisceglia / à Paris*;
other mark: *C. Alfred Daber Paris*
Paris, Musée d'Orsay, Gift of Alfred Daber
OAO 567

EXHIBITIONS
Marseille 1963, no. 71, ill. (this copy?); São Paulo 2002, pp. 168–169.
BIBLIOGRAPHY
Haesaerts 1947, no. 10 and p. 26, pl. XXII; White 1984, pp. 260, 264
(ill. of Dublin bronze).

The decision to produce a clock should not really surprise us. Renoir and Guino were convinced that no hierarchy existed between the major and minor arts, that all everyday objects should be made beautiful, and indeed that this was one of the artist's primary missions. Perhaps they were inspired by the example of Maillol **Fig. 71, p. 167**. Yet this clock is very different in terms of form— more heavily laden, more action-filled, and, with its Clodion-style figures, having more in common with eighteenth-century sculpture, or else with late nineteenth-century neo-Rococo sculpture like that of Jules Dalou. This effect is reinforced by the molded socle, decorated with goats' heads similar to those seen in the *Small Venus* **Cat. 69**. Moreover, although both Maillol's and this clock are characterized by an upward movement formed by two symmetrically arranged figures, in the Maillol the face of the clock is carried above, while in the Renoir it is located lower down, between the figures' knees, while a child resembling an angel perched on an orb—a symbol of life and of the future—crowns the top. This iconography turns its back on traditional representations of Time in the form of a bearded old man armed with a scythe.

The clock was not completed before the summer of 1914. We know this from a letter sent by Vollard to Guino and dated June 16, 1914:[1] "Dear Monsieur Guino, Renoir has arrived. Could you bring him the clock. If you can finish it at his house, all the better." But then, between November 1915 and June 1916, Guino proceeded to retouch the piece, as we know from an invoice that Vollard settled by paying 3,000 francs for work executed by Guino at Renoir's house in Cagnes during this period.[2] Haesaerts dates the clock's final completion to as late as 1917. In the course of this work, the male figure, on the left, underwent clear modifications. Renoir was keen to preserve its sexual ambiguity. On June 30, 1914, Vollard again wrote to Guino: "I have seen Monsieur Renoir who has told me what he wants for the man on the clock; he wants someone to find him a male model with feminine grace but at the same time something in his attitude that says: Look at me . . . Try to flush out this rare bird."[3] An unpublished photograph (private collection) shows a man posing nude for the clock in the lower studio at Les Collettes **Fig. 33 & 34, pp. 78–79**. His left foot rests on a small, thick cushion. However, another photograph shows the same model posing for *Fire* **Cat. 92**, see **Fig. 31 & 32, pp. 76–77**, which dates from 1916. This indicates that the clock was modified that year. Now, we know of two noticeably different versions of this group, that taken from the plaster model (Boston, Museum of Fine Arts) being the one most often reproduced. However, in the bronzes, the figure has shorter proportions. Could it be that a third model posed again at a later date? This would explain why Haesaerts dates the clock's completion to 1917. This laboriously created work failed to win admirers, and the bronzes rarely feature in public collections. The one at the Musée d'Orsay, still held in the reserve collection, belongs to a series of eight lost-wax castings by Mario Bisceglia and marketed by Alfred Daber, who donated it. Number five was acquired by the National Gallery of Ireland, Dublin, in 1966.

E. H.

1. Private archives. **2.** Ibid. **3.** Ibid.

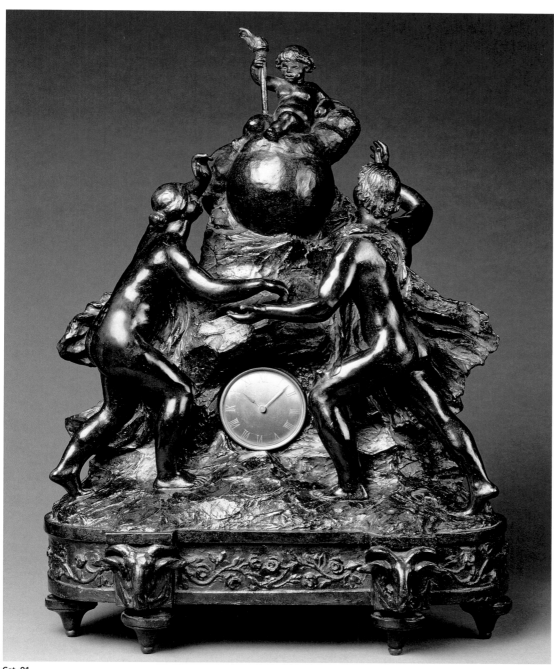

Cat. 91

Richard Guino
and Pierre-Auguste Renoir

Fire, or Small Blacksmith (Feu, *or* Petit Forgeron)

1914–16 to post-1916
Lost-wax cast bronze
12³/₄ x 8¹/₄ x 12⁵/₈ in. (32.5 x 21 x 32.3 cm)
Signed on the left of the socle: *Renoir;* foundry mark at the back: *cire perdue / C. Valsuani;* stamp of the Renoir estate
Paris, Musée d'Orsay
RF 2741

EXHIBITIONS
Paris 1934, no. 7 (this copy?); Antwerp 1958, unnumbered; Tokyo 1961–62, no. 123; Marseille 1963, no. 67; Lisbon 1965, no. 122; Leningrad and Moscow 1970–71, no. 107; Madrid 1971, no. 100; Paris 1973, no. 112; São Paulo 2002, pp. 168–169.

Exhibited in Paris.

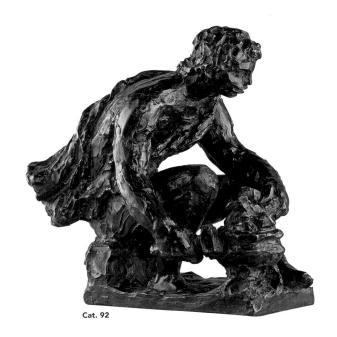

Cat. 92

Fire, or Small Blacksmith (Feu, *or* Petit Forgeron)

1914–16 to post-1916
Lost-wax cast bronze
12¹/₂ x 8 x 12¹/₂ in. (31.8 x 20.3 x 31.8 cm)
Signed on the socle, near the left foot: *RENOIR*
Philadelphia, Philadelphia Museum of Art, Gift of Mr. and Mrs. Bryant W. Langston, 1957
1957-43-1

EXHIBITIONS
Paris, Orangerie, 1933, no. 147; Cleveland 1929; Chicago 1933; Cleveland 1933; Cleveland 1936, no. 309; New York 1937, no. 66.

BIBLIOGRAPHY
Haesaerts 1947, no. 19 and p. 29, pl. XXVIII and XLIII.

Exhibited in Los Angeles and Philadelphia.
Not illustrated.

Water, or Small Washerwoman (Eau, *or* Petite Laveuse)

1916
Lost-wax cast bronze
13³/₈ x 7¹/₂ x 12¹/₄ in. (34 x 19 x 31 cm)
Signed on the socle, on the right: *Renoir*
Paris, Musée d'Orsay, work rediscovered in Germany after WW II and placed into the keeping of the National Museums, attached to the Louvre Museum by the Office des Biens et Intérêts privés in 1951
RFR 58

EXHIBITIONS
Limoges 1952, no. 65; Lyon 1952, no. 90; Tokyo, Fukuoka, and Kyoto 1954, no. 173; Antwerp 1955, no. 191; Marseille 1963, no. 66; Paris 1964, no. 108; Leningrad and Moscow 1970–71, no. 106; Madrid 1971, no. 101; Paris 1973, no. 112; São Paulo 2002, p. 168.

Exhibited in Paris.

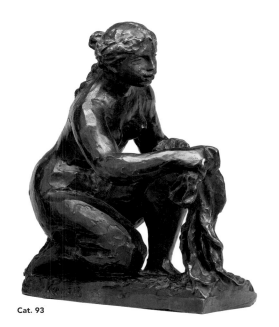

Cat. 93

Water, or Small Washerwoman (Eau, *or* Petite Laveuse)

1916
Lost-wax cast bronze
13¹/₄ x 7⁷/₈ x 12³/₈ in. (33.7 x 20 x 31.3 cm)
Signed on the socle, near the left leg: *RENOIR*
Philadelphia, Philadelphia Museum of Art, The Louis E. Stern Collection, 1963
1963-181-100

Exhibited in Los Angeles and Philadelphia.
Not illustrated.

BIBLIOGRAPHY FOR ALL CASTS OF CAT. 93 & 94
Drucker 1944, p. 114, pl. X, fig. 2; Haesaerts 1947, no. 20 and p. 29, pl. XXVIII and XLIII; Pach 1983, p. 39; Pingeot, Le Normand-Romain, and Margerie 1986, p. 227; Bade 1989, p. 36; Druick 1997, p. 76–77; Papet 2003.

Cat. 94

Water, *or* Large Washerwoman Crouching (Eau, *or* Grande Laveuse accroupie)

1917 ?
Bronze, cast by Alexis Rudier
48³/₈ x 27¹/₈ x 53¹/₈ in. (123 x 69 x 135 cm)
Signed on the upper side of the base, near the right knee: *Renoir 0*
Paris, Musée d'Orsay
RF 2703

EXHIBITIONS

Antwerp 1954, no. 52; Tokyo 1961–62, no. 122; Leningrad 1966, unnumbered; Paris 1967–68, no. 329; Paris 1973, no. 113; Paris 1974 (not in catalogue); Beijing and Shanghai 1985, no. 11; São Paulo 2002, p. 168.

Exhibited in Paris.

Large Washerwoman

Circa 1918
Bronze
48 x 50¹/₂ x 30 in. (121.9 x. 128.3 x 76.2 cm)
Signed on the base near the left knee: *RENOIR O*; dated on the base, on left: *1917*; stamp below the right foot: *Alexis Rudier Paris*
Philadelphia, Philadelphia Museum of Art, Purchased with the Diamond Jubilee Fund subscribed by Members and Friends of the Philadelphia Museum of Art, 1952
1952-84-1

EXHIBITION

Philadelphia, Chicago, and New York 1952–53, no. 94.

BIBLIOGRAPHY

Pictures on Exhibit 1952, pp. 57–58; Kimball 1953; *Pictures on Exhibit* 1953, p. 12.

Exhibited in Los Angeles and Philadelphia.
Not illustrated.

Fire and *Water* are a pair of crouching statuettes on the theme of the elements, but only *Water* was enlarged and given a more polished finish. The large-scale version of *Fire* was never made, and the small version is still rather sketchlike in nature.

Fire shows a young man, a simple artisan, busy poking a brazier, who personifies the element of fire, while *Water* is a ordinary servant girl absorbed in washing the laundry. Haesaerts sees here Renoir's taste for "the simple and everyday."

Two unpublished photographs **Cat. 31, p. 76** (private archives) show a nude male model posing for *Fire* in the lower studio at the house in Cagnes. He is seated on a folding stool, his back arched over. The *Washerwoman* is similar to a small painting that shows, in right profile, a washerwoman kneeling over her laundry, and to another small picture, the location of which is now unknown.

We are unaware of any clay sketch for *Fire*, but there was one for *Water*. It varies in the position of the hand, which now comes below the knee. In the larger statue, any anecdotal element is gone thanks to the inspired presence of the wet laundry which, now

held in both hands, forms two columns. Guino's modeling is to be admired, with its long planes that structure the form and catch the light. The plump posterior of the *Large Washerwoman* displays a joyful solidity.

It seems that Vollard immediately produced ten bronzes of *Fire*. Then, on behalf of the Galerie Renou et Poyet, Valsuani apparently cast a second series of ten bronzes, which included the one now kept at the Musée d'Orsay. However, this is not certain, as there are few of these bronzes in museums. We have located bronzes with the stamps of Rudier, Susse, and Godard. Vollard appears to have had *Water* cast by Alexis Rudier. There are also bronzes made from one or another version by various casters, including that given by Vollard to the Musée Léon-Dierx in Saint-Denis-de-la-Réunion. There are several examples of the large version of *Water* cast by Rudier, including the bronze at the Musée d'Orsay which has no stamp but was acquired from Rudier in 1950. Other examples can be found in Amsterdam, Berlin, London, New York, Philadelphia, São Paulo, Toledo, and Winterthur.

Only the Musée d'Orsay is in a position to exhibit all three of these works, although the small version of *Water* does not belong to the museum; it was recovered after World War II and placed in the care of the French national museums. The owner still remains unknown.

E. H.

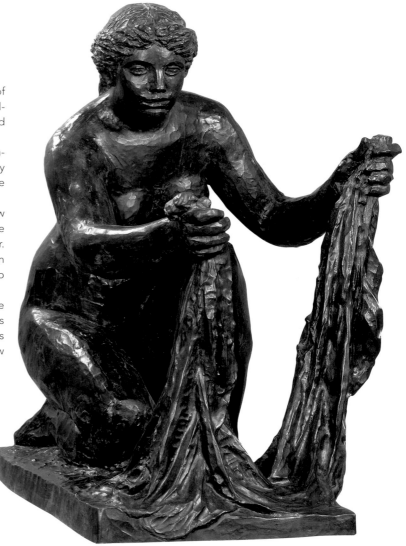

Cat. 94

Cat. 95

Study for Dancer with Tambourine
(Study for *Danseuse au tambourin*)

Circa 1912
Graphite on paper
16³⁄₈ x 11¹⁄₄ in. (41.6 x 28.6 cm)
Philadelphia, Philadelphia Museum of Art, Gift of Louis E. Stern, 1963
1963–181–171

EXHIBITIONS
Brooklyn 1962–63, no. 120; Philadelphia 1990a; Philadelphia 1990b.
BIBLIOGRAPHY
Rewald 1946, no. 70; Pach 1950, p. 16; *Life Magazine* 1963, p. 68 D;
Philadelphia Museum of Art 1964, no. 137, p. 194.

Cat. 96

Louis Morel and **Pierre-Auguste Renoir**
Dancer with Tambourine I, called *"with garland and extended arms"*
(Danseuse au tambourin I, called *"avec guirlande et les bras étendus"*)

Terracotta relief, edition of Renou and Colle, Paris
23¹⁄₄ x 16¹⁄₈ x 5¹⁄₈ in. (59 x 41 x 13 cm)
Inscribed signature bottom left, at the foot of the figure: *Renoir*
Cagnes-sur-Mer, Musée Renoir
51.16.1

Exhibited in Paris.

Cat. 97

Louis Morel and **Pierre-Auguste Renoir**
Dancer with Tambourine II, called *"without garland and arms together"*
(Danseuse au tambourin II, called *"sans guirlande et les bras rassemblés"*)

Terracotta relief, edition of Renou and Colle, Paris
22⁷⁄₈ x 16¹⁄₈ x 2³⁄₄ in. (58 x 41 x 7 cm)
Inscribed signature bottom right, level with the figure's feet: *Renoir*
Cagnes-sur-Mer, Musée Renoir
51.16.2

Exhibited in Paris.

Cat. 98

Louis Morel and **Pierre-Auguste Renoir**
Flute Player (Joueur de flûteau)

Terracotta relief, edition of Renou and Colle, Paris
22⁷⁄₈ x 16¹⁄₈ in. (58 x 41 cm)
Inscribed signature bottom left at the base of the tree trunk: *Renoir*
Cagnes-sur-Mer, Musée Renoir
51.16.3

EXHIBITIONS FOR CAT. 96–98
Lyon 1952, nos. 85, 86, and 87 (bronzes); Marseille 1963, nos. 69 and 70 (bronzes); Cagnes-sur-Mer 1969, no. 2 (bronze); Cagnes-sur-Mer 1970 (terracottas).
BIBLIOGRAPHY FOR CAT. 96–98
Haesaerts 1947, no. 21 and p. 30, pl. XXXVIII to XLII; Fouchet 1974, p. 86; Clergue 1976, n. p.; White 1984, pp. 277, 280; Herbert 2000, pp. 76–81.

Exhibited in Paris.

These joyous reliefs on the theme of dance and music are similar to the pair of paintings commissioned by Maurice Gangnat in 1909 for the dining room of his apartment at 24, avenue de Friedland, Paris **Cat. 40 & 41**, and even more so to a 1915 painting sold to Albert Barnes by the art dealer Hodebert (Merion, PA, Barnes Foundation), as well as to the various related drawings.

A number of drawings, including the one at the Philadelphia Museum of Art, were preparatory studies for these dancers, as were those in the former Maratier collection (published by Drucker) and the Durand-Ruel collection (reproduced by Pach). There is an obvious link between the choice of red chalk for the drawings and red clay for the terracotta editions.

The depth of the relief is slight, but the figure of *Dancer with Tambourine I* appears to want to escape the frame in which she finds herself: she points her foot and extends her right arm, which projects outward. She is prefigured like this in a drawing which shows her overly large and too dynamic for her narrow metope. She is also the only one to be placed against a background decorated with a garland.

It was the sculptor Louis Fernand Morel who assisted Renoir in the execution of this triad. The son of a winegrower from Essoyes, Morel trained at the École des Beaux-Arts in Paris and was awarded second place in the Grand Prix de Rome. He began exhibiting at the Salon des Artistes Français in 1905 and lived at La Ruche, the artists' studios set up in Montparnasse by the Aube-born sculptor Alfred Boucher. Morel remained there until his death in 1975. By the time of his association with Renoir, the sculptor already had a small scandal attached to his name: a stone *Female Nude* that decorated a tomb at Essoyes cemetery, to the great displeasure of local residents. Morel also created monuments to the fallen at Essoyes and Troyes (1920–26), and his work is featured in the town's fine-arts museum. However, Morel was, without doubt, a lesser talent than Guino.

According to Haesaerts, Morel worked in fresh plaster, not clay. All the castings of these reliefs, whether in terracotta or bronze, are posthumous. Vollard played no part in this trade, which remained under the control of Renoir's heirs. The castings first appeared in the early 1950s, in Paris at the Galerie Renou et Poyet at 164, rue du Faubourg-Saint-Honoré. Maurice Renou and Pierre Colle produced an unknown number of lost-wax bronzes during the 1950s; Valsuani later produced another twenty in all. These were widely disseminated by the Galerie Bignou, hence their success in the United States, as witnessed by their presence in the following museums: San Francisco Museum of Art, Philadelphia Museum of Art, and the Hirshhorn Museum and Sculpture Garden, Washington, DC—the latter being the only institution to own all three motifs. The present terracottas form part of another edition by Renou and Colle and were given to the Musée Renoir in Cagnes by Claude Renoir in 1951. At present, bronzes of questionable quality proliferate on the art market. Terracotta proofs (one of each relief) from Louis Morel's studio were put up for sale at Troyes on September 28, 2008.

There is a more polished version of the dancer, with long, flowing drapery and set off against a background decorated with a small temple with a triangular pediment (exhibited at the Slatkin Gallery, New York in 1958, location unknown) of which Haesaerts is unaware. It may be earlier than the others as it bears a greater resemblance to the Gangnat paintings. The universe of these reliefs is one of a joyous antiquity, in the same vein as the mural paintings Renoir had admired at Pompeii.

E. H.

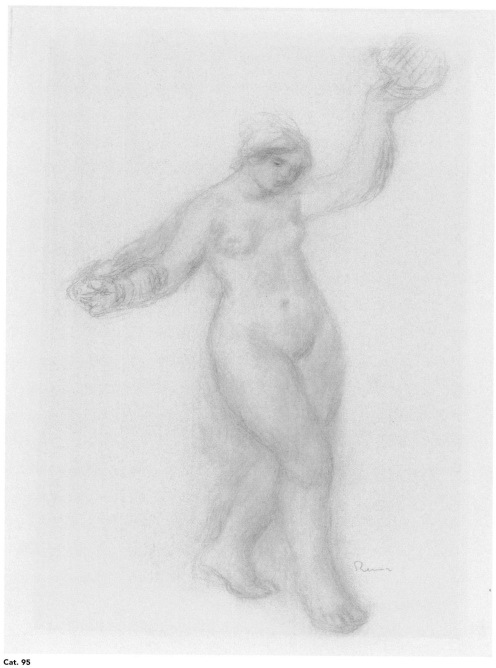

Cat. 95

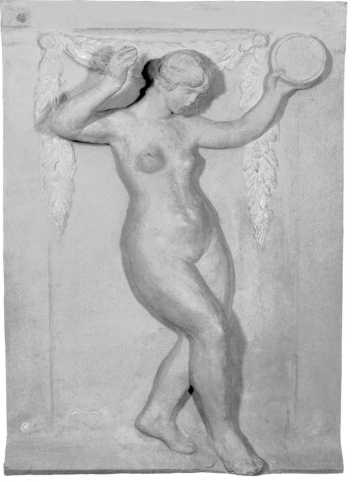

Cat. 96

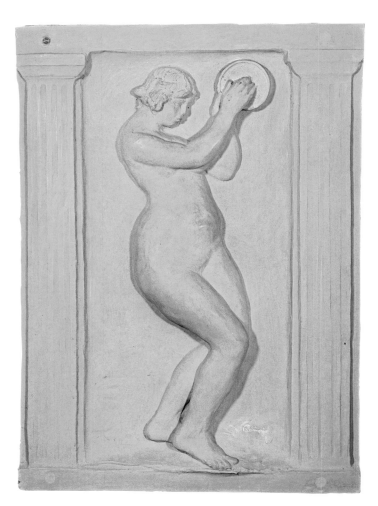

Cat. 97

Cat. 98

Renoir in His Time

"One must do the painting of one's time"*

Sylvie Patry

Tom Wesselmann
Great American Nude No. 44
1963
Acrylic, collage on board with
objects
81¹/₈ x 105¹/₂ in. (206 x 268 cm)
Private collection

Fig. 117

"At an age when most men have long since taken it easy, or are repeating themselves, Renoir finally triumphed, as master of a rather diaphanous, mottled palette that was quite amazing—and brand new."[1]

"Great (American) Nudes"

In one of the pictures in the series *Great American Nudes* **Fig. 117**, Tom Wesselmann introduced a reference to Renoir, in the form of a detail borrowed from one of the best known and iconic compositions in the painter's late works—*Gabrielle with a Rose* **Cat. 59**. Inserting it into the middle of a collage of mundane objects from everyday life, the American artist was inscribing himself within an artistic tradition: it was a reference to the habit artists have of pinning pictures they admire on their studio walls, as guides as it were, just as Pierre Bonnard and Georges Braque had done almost thirty years earlier with Renoir's nudes **Cat. 31**; **Cat. 199, p. 374**. Does this mean that this "Great Nude," inspired by Wesselmann's companion at the time, is a tribute to the master, painter of renown par excellence of the nude and of sensuality? A dialogue is created between *Gabrielle with a Rose* in the center of the picture and the nude silhouette of the young woman. More than anything, Wesselmann's response to Renoir has the air of a riposte. While Renoir was perhaps a point of departure, an obligatory intermediary with regard to the "Great Nude"—indeed, his authority had imprinted itself on a whole generation of American painters in the first half of the twentieth century—yet within the context of the 1960s, he also seems to represent a European tradition and the former hegemony of French Impressionism (emphasized by the carpet in the colors of the tricolore) on the art scene in the United States: against this, Wesselmann presents a monumental nude for the present day, anchored by its own references, such as the pin-up, within a context championed as specifically American.[2]

Wesselmann's Renoir quote is also significant in terms of what that artist represented at the time: Renoir was the epitome of a painter accessible to all, one who had himself incorporated popular culture in his art[3] to such an extent that the critic and artist Walter Robinson described him as the "father of Pop art, probably the greatest one."[4] Embracing Pop Art's reappropriation of popular culture, Wesselmann deliberately chose a master loved by a wide audience and increasingly despised in educated and enlightened circles, at any rate generally dismissed from among the "sources of the twentieth century"[5] since the 1940s. At the same time, this detail of *Gabrielle with a Rose* leads one to question the damage that popularization can inflict on art, especially in this age of mechanical reproduction—which in Renoir's case results in an inability to "stand the sight of him, as the chocolate and candy industries have overkilled the

For Ada-Louise, Simon, and Marthe

* Renoir, quoted in André 1923, p. 49.
1. Natanson 1900, p. 374. **2.** Even though the gesture of the arms crossed behind the head is the same as Andrée's in Renoir's *Bathers* Cat. 80. **3.** Cf. Greenberg 1993, vol. 3, p. 23: "Renoir, I believe, felt a certain affinity with popular art . . . [a]nd his notion of the picturesque seems to be taken . . . directly, albeit unconsciously, from popular art." **4.** "He is the father of Pop art, probably the greatest one. . . . His sunny scenes are prophetic of the modern postcard . . ." (Robinson 1985, p. 120). **5.** To pick up the title of the landmark exhibition by Jean Cassou; a vast, innovative panorama of the years 1884–1914 in which Renoir had his place (Paris 1960–61, nos. 586–590).

Fig. 117

mawkish, cottonlike flesh to such an extent."[6] Hence Renoir's presence in Wesselmann's work may be twofold: is it the painter who has been invited in, or the icon—whose immense popularity is put to the service of Pop Art? The Renoir painting is represented in a common, vulgar form: as a reproduction that truncates the original work, although this manipulation goes unacknowledged, given that the painting is shown framed and displayed the way it would be by collectors and museums. Reduced to a reflection of bad taste, Renoir is cast out into the realm of mass culture, of reproduction ad nauseam, and of the commercial market—basically, the culture of kitsch. Moreover, in its gold frame, the picture of Gabrielle becomes outmoded, at odds with the interior that accommodates it: in a process justified by the mutilation of the original, Wesselmann completes the noble gesture created by Renoir (a woman pinning a rose in her hair) by having her look toward the telephone, an everyday object both trivial and foreign to the atemporal world of Renoir, now made a focal point of the composition through Gabrielle's very gaze. Yet by the same token, Wesselmann also positions Renoir's painting at the start of a narrative that takes us from preparing for love all the way to full nudity, following a discourse that honors the powers of seduction in *Gabrielle with a Rose* and, in the end, its continued relevance for today. The way this *Great American Nude*—without the adjective, a Renoiresque title—invites the master into the heart of twentieth-century art could well sum up, beyond the obvious contextual differences, many of the assessments and questions that led to this exhibition.

"You see, I have arrived at modern painting"[7]

Appreciated by the general public and disparaged in cultural circles, such is the position of Renoir today and of "late Renoir" in particular, the Renoir who painted *Gabrielle with a Rose* used by Wesselmann in his picture. The vicissitudes of some of the works presented in this exhibition provide a striking summary of this situation. Two of them are now located in private collections after having been sold by the museums that owned them: *The Washerwomen* **Cat. 58**, formerly in the collection of the Metropolitan Museum of Art,[8] and *Reclining Nude (Bather)* **Cat. 28** previously in the Museum of Modern Art in New York. According to the practice of de-accessioning, which allows American museums to sell works in order to purchase others, in 1989, Renoir and some others (including Pablo Picasso, Piet Mondrian, and Claude Monet) made way at MoMA for Vincent van Gogh's *Portrait of Joseph Roulin*: the curator, Kirk Varnedoe, justified this decision on the twofold grounds that Renoir's painting "simply didn't belong to the history of modern art we are telling" and that the nude "a late and no-way ground-breaking painting by the artist, [did not] have an important place within the context of the Modern's collection."[9] In fact, all of the five Renoir works once belonging to MoMA have been de-accessioned, among them *Fog on Guernsey* of 1883, which came from the highly prestigious collection of Lillie P. Bliss, one of the museum's founders. By an ironic twist of fate, this landscape was bought back by the Durand-Ruel Galleries in New York, which at the time was trying to sell a late-style nude to MoMA—although without success: the nude instead went to the Art Institute of Chicago, which was "anxious to buy an important late Renoir"; it is now on show in this exhibition **Cat. 62**.[10]

But this late Renoir, the one who painted "enormously fat red women with very small heads" (in the words of Mary Cassatt[11])—women who were the contemporaries of Matisse's *Bonheur de vivre*[12] and *Blue Nude (Souvenir of Biskra)*,[13] as well as Picasso's *Demoiselles d'Avignon*[14]—has not always had the bad reputation he has today. In 1913, on the occasion of a show presenting the late nudes (Renoir's last solo exhibition in France), the poet, critic, and friend of Picasso, Guillaume Apollinaire, paid tribute to Renoir, "who is constantly growing. His latest paintings are always the most

6. Cécile Guilbert, in *Le Musée national* 2000. This reference was given by Augustin de Butler in "Le Rire de Renoir," published in 2001 online, *Ironie*, January 2001, no. 60; collection of quotes repeated in 2009 in l'Échoppe editions. As early as 1911, Meier-Graefe linked the dislike of late Renoir to the "inadequacy of reproductions" (Meier-Graefe 1911, p. 182). 7. Georges Duthuit ironically quoting a friend reading works on Renoir, in Duthuit 1923, p. 5. 8. Two other paintings have recently been sold by the Metropolitan: *Women Picking Fruit* and *Woman with a Basket of Fruit*, decorative panels dated 1895 and now in the Woodone Museum, Japan. 9. See Kimmelman 1989. 10. This information comes from partially unpublished notebooks of Sterling Clark (those dated January 7, 1943, September 30, 1943, and April 23, 1944), preserved in the Sterling and Francine Clark Art Institute. I am extremely grateful to Sarah Lees and Richard Rand for giving me permission to consult them. 11. Letter from Mary Cassatt to Louisine Havemeyer, January 11, 1913, following a visit to Cagnes (Cassatt 1984, p. 308, quoted in Wadley 1987, pp. 257–258). 12. See Cat. 200. 13. 1907, Baltimore, The Baltimore Museum of Art. 14. June–July 1907, New York, The Museum of Modern Art.

beautiful and also the youngest."[15] Renoir was also on view at the Armory Show, the gateway to modern art in the United States.[16] Renoir's importance there was such that one of his paintings, *Luncheon of the Boating Party* **Fig. 4, p. 33** (which later became the talk of the town by setting a new record sale price),[17] was reproduced as the frontispiece of the magazine *Arts and Decoration;* alongside it was an essay on the goals of the Armory Show,[18] an event with which dealers and critics like Alfred Stieglitz, Walter Pach,[19] Roger Fry, and Clive Bell were all associated. At that point they were all passionate defenders of late Renoir. In what was a striking parallel to Apollinaire's statement, Bell—the apostle of modernism in England, with links to the Bloomsbury group—also paid tribute to Renoir as the greatest living painter.[20] Roger Fry,[21] first curator and later advisor to the Metropolitan Museum of Art, in 1907 had been instrumental in the Met's spectacular purchase of the *Portrait of Madame Charpentier and Her Children* (1877) **Fig. 57** for the sum of 84,000 francs (then a record price for an Impressionist painting), in line with a trend that had seen Renoir's works enter the great European museums at the turn of the century.

Since 1904 and the retrospective devoted to Renoir in the Salon d'Automne in Paris, the aura surrounding the painter had continued to grow. In the United States the exhibition marked the starting point of what Anne Dawson has called the "idolization" of Renoir,[22] which saw him raised to hero status in American modernist circles, dethroning Monet, who would only regain this position after 1940, spurred on by a new generation of painters and critics such as Clement Greenberg. But between 1904 and 1940, it was Renoir who was held up as an example for American art by critics and artists like James Huneker, Henry McBride, Guy Pène du Bois, and William Glackens;[23] they were taking over from collectors such as Louise and Walter Arensberg, in whose New York apartment **Cat. 202, p. 322** avant-garde circles could admire the juxtaposition, on the same wall, of *Nude Descending a Staircase No. 3* by Marcel Duchamp, the darling of the Armory Show in 1913, and one of Renoir's *Bathers* **Cat. 77**. And what did they think of him?

First and foremost, they regarded Renoir as a figure painter, at a time when American artists were challenging the hegemony of the landscape and the celebration of vast spaces that had characterized the nation's pictorial tradition. They also noted his choice of subject matter, joyful and instantly accessible, but also his free use of color and detachment from reality, which allowed them to establish links between his painting and music. As a result of this reading, Renoir became a reference for the more abstract painting of the "synchromists."[24] Finally, the painter was a guiding light for a form of modernity that nonetheless preserved its links with tradition. Paradoxically and almost certainly, Renoir was accepted in the name of a "moderate" modernism, so much so that in 1945 an American museum sold a Picasso in order to purchase a Renoir painting. That year, the Rhode Island School of Design's Museum of Art parted with *Life* by Picasso (1903, now in the Cleveland Museum of Art)[25] so that they could acquire *Young Shepherd in Repose (Portrait of Alexander Thurneyssen)* **Cat. 55**. This latter painting is densely packed with late-Renoir features and, according to the museum's director at the time, equivalent to one of Beethoven's four last quartets.[26]

In the early years of the twentieth century, Renoir's prestige in the United States was based on whatever was going on in France, whether it was the publication in 1903 of Camille Mauclair's *L'Impressionnisme: son histoire, son esthétique, ses maîtres* (translated as *The French Impressionists*) or, that same year, the stir caused by the Renoir exhi-

15. Apollinaire, in *L'Intransigeant* 1913, reprinted in Apollinaire 1972, p. 278. **16.** New York 1913. Four of Renoir's paintings, dating mostly from the 1880s, were presented there: 502, *L'Ombrelle* [The Parasol]; 503, *Algérienne assise* [Algerian Woman, Seated]; 504, *Pivoines* (1882 [Peonies]); 505, *Dans le jardin* (1884, [In the Garden] lent by MM Durand-Ruel & Sons). **17.** The painting sold for 150,000 dollars in 1923, see exh. cat. Washington, DC, 1996–97, p. 234. **18.** This and other important documents related to the Armory Show, including the catalogues, are reprinted in: Association of American Painters and Sculptors (New York, NY), *The Armory Show: International Exhibition of Modern Art, 1913,* New York, Arno Press, [1972]. **19.** The American critic and painter Walter Pach, who had attended the Académie Matisse from 1908 to 1911, was one of the organizers of the French section. In 1912 he wrote: "If any modern painter seems a demigod to the world of today, it is Pierre-Auguste Renoir." (Pach 1938b, p. 104). **20.** "Renoir is the greatest painter alive." (Bell 1929, p. 66). **21.** See exh. cat. London 1999–2000, pp. 178–180. **22.** See exh. cat. San Diego and El Paso 2002–03, pp. 11–71. **23.** At the Philadelphia Museum of Art, the exhibition will be augmented by the presentation of several pictures by American painters influenced by Renoir, especially Glackens, the "American Renoir." **24.** Term coined by Morgan Russell, linking the notion of color and music (by associating the term with "symphony"): see exh. cat. San Diego and El Paso 2002–03, pp. 33–35. **25.** As a note of interest, Picasso's *Life* had been exhibited in Berlin in 1927 together with a Renoir sculpture, see Fig. 29, p. 72. **26.** Notes by Gordon Washburn, director of Museum of Art, Rhode Island School of Design, quoted in Dawson 1998, p. 184.

Apartment of Gertrude and Leo Stein at 27, rue de Fleurus, Paris. One can see Renoir's Brunette *and* Two Nudes *(ca. 1897, Merion, PA, Barnes Foundation Fig. 21, p. 58), amongst other paintings, including* Le Bonheur de vivre *by Matisse (1905–06, Barnes Foundation) and* Madame Cézanne with a Fan *by Cézanne (1878–1886–1888, Zurich, E. G. Bührle collection)*

Cat. 200

Albert Eugene Gallatin
Henri Matisse in his Nice apartment; on the walls Renoir's Nude with Raised Arm *and* Nude with Bath Towel
1932

Cat. 190

bition at the Salon d'Automne or, above all, the status given to Renoir by Gertrude Stein, and even more so by her brother Leo. As explained in Martha Lucy's essay in this volume **p. 110**, the role of these two great collectors was indeed crucial. In their apartment at 27, rue de Fleurus in Paris, Matisse, Braque, and Picasso saw their works hanging side by side with paintings by Renoir and Cézanne, sometimes intentionally as pendants (see *Woman with a Hat* by Matisse and *Girl in Gray-Blue Putting on her Gloves* by Renoir **Cat. 201, p. 365**). For the Steins, Renoir, Cézanne, Matisse, and Picasso represented the pantheon of the "Big Four" **Cat. 200 & 201**. Beside these artists, some of whom (such as Picasso and Matisse) are studied separately in this volume, Renoir found many admirers, from 1892 on, among the circles connected to Symbolism and the Nabis, who, following in the footsteps of Maurice Denis and Thadée Natanson in the journal *La Revue blanche,* defended his new style. They appreciated its monumentality, the "simplicity and grandeur" that Renoir (to use his own words) envied in Raphael and in the works of antiquity, and the balance he achieved between the reference to nature and interpretation—"that which the artist must put first and foremost into his painting," as Bonnard put it.[27]

Renoir seemed like a painter-poet, then, the creator of an autonomous world quite apart from reality. Stéphane Mallarmé, whose fauns and nymphs were compared to Renoir's nudes at the time, contributed to this reading of Impressionism and the artist's work, which was later taken up, in the context of Post-Impressionism, by Camille Mauclair and Téodor de Wyzewa, the poet and critic close to Renoir. Thus, at the turn of the century, Mauclair spread the idea of Renoir as "the most poetical of all the painters of his generation," someone who "conceives symphonies," and who "has painted according to his dream."[28] While it may be simplistic to address the many aspects of the reception of late Renoir in a few lines, especially when, for France, a study on the subject does not yet exist,[29] it does seem that, beyond all the movements and trends, Renoir more than any other showed independence, freedom, and the liberation of brush and color. The same can be said about Matisse and Bonnard, as well as Albert Marquet, Charles Camoin, André Derain, and Henri Manguin, who were all familiar with his work long before the visits some of them made to the master and the meetings recorded toward the end of the 1910s.[30] Matisse had already started to collect Renoirs (like Picasso and, to a lesser extent, Bonnard) before 1910: he owned a nude which he deemed to be a "gem,"[31] and like Renoir, he painted Arcadian nudes. Around the same time, in 1906 and then 1907, Picasso was painting more and more monumental nudes in intense reds, reminiscent of the Renoir nudes that were their contemporaries **Fig. 118 & Cat. 193, p. 369**.

At the height of his Fauvist phase in 1905, Camoin had declared his admiration for Renoir's mastery of strong and disconcerting colors.[32] As Monique Nonne points out in her essay in this volume **pp. 107–108**, both Manguin and Matisse promoted Renoir's work commercially. It seems unlikely, then, that the two younger painters looked to Renoir only in a period of "crisis," as is generally maintained in studies on them, or in reaction to contemporary currents, for example when Renoir was taken up by the anti-Cubists in the years 1910–20. For critics, artists, and collectors as diverse as Leo Stein, Matisse, Maurice Denis, Paul Guillaume,[33] and Albert C. Barnes, the embodiment and presence of the model in Renoir's painting—her very flesh—saved them from the soul-destroying abstraction of Cubism and from theoretical excess,[34] by reminding them of the physical aspect of painting. In identifying the artist with the craftsman, Renoir was also claiming his place within a wider movement, announcing a return to "craft" and laying claim to the figure of the worker-painter with skills and instinct, as embodied by Fernand Léger.[35] While this place is no less justified within what is conventionally

27. Bonnard 1947. See p. 151 above. **28.** Mauclair [1903], pp. 126, 124, 131. **29.** This work has yet to be done, even if Augustin de Butler presents aspects of this reception in one chapter ("L'indésirable," pp. 87–122) and the appendix ("L'infortune du dernier Renoir," pp. 424–464) of his thesis (*Revoir Renoir,* under the supervision of Pascal Bonafoux, Université Paris VIII, 2006). In an article due to be published, the result of graduate research at the École du Louvre (under my supervision), Paul Perrin was interested in the issue of Renoir's instances of participation in the Salon d'Automne and their reception. We would like to thank both authors for providing us with their unpublished work. **30.** See Virginie Journiac's essay in this volume, pp. 93–95. **31.** See Roger Benjamin's essay in this volume, in particular p. 136. **32.** "Fragonard and Renoir are the masters who most readily spring to mind" (in Morice 1905, p. 354, reissued in Dagen 1986, who stressed that while Camoin's "conversion" to Renoir dates mainly to 1918, Renoir had gradually turned him away from Cézanne before this date, p. 126, note 9). **33.** Georgel 2000, pp. 63–72. **34.** See Green 1987. **35.** Herbert 1994.

Cat. 200

Cat. 190

referred to as the "Return to Order"[36] and tradition, which included a nationalist component that celebrated Renoir as the French painter par excellence (for the same reasons as Paul Cézanne, Camille Corot, or Nicolas Poussin), it is all too often the only concession made to Renoir in accounts of the art of the twentieth century—when he features in them at all. All this, however, is a far broader topic, no doubt more complex, and warranting a more in-depth analysis than is possible in the scope of this exhibition. Here, we have effectively favored artists who (with the exception of Picasso) all knew and met the master, combining their admiration for him as a "great Mediterranean"[37] with affection for the old man in the context of the "rebirth of Classical sentiment"[38] in French art between 1910 and 1930. A full review of the influence of Renoir's works on the twentieth century would have demanded other choices, summoning the figures—other than as witnesses as we have done here—of Georges d'Espagnat, Louis Valtat, Maurice Denis, Ker-Xavier Roussel, and Édouard Vuillard,[39] as well as Camoin, Manguin, Marquet, Derain,[40] Braque,[41] and De Chirico,[42] even down to the members of the *Jeune Peinture Française* (Young French Painters), who elected Renoir and Bonnard as honorary presidents.[43] And that is just in the limited period under consideration here. This review would nevertheless come up against the paradox highlighted by Blanche in 1921: "Renoir's influence is not as visible as that of Cézanne on his many heirs.... Unfortunately, while this 'mature' younger generation admires Renoir unquestioningly, it [is more inspired] by Cézanne."[44]

"Renoir versus Renoir"[45]

This exhibition, then, arose out of the confusion created by the gulf between the discredit now surrounding late Renoir and the prestige he enjoyed at the start of the twentieth century among Post-Impressionist and avant-garde circles on both sides of the Atlantic. It also sprang from the many questions we had ourselves in the face of the many controversies that have marked the painter's late work. To repeat the term used by André Salmon in 1922 ("the triumph of Renoir"),[46] the period we are examining here effectively saw Renoir gaining fresh recognition and asserting himself as an example for younger generations. Yet there were also "serious reservations" at this time, on the part of Frantz Jourdain for instance, who in 1896 abandoned his "combative and age-old admiration for the artist."[47] From the early 1890s on, an enduring misunderstanding can be seen to take hold, rooted in the more general issue of Impressionism. Renoir's artistic career is in fact punctuated by breaks and about-turns. An artist who was constantly restless, the opposite of the image of the carefree painter that was later disseminated, he perplexed the connoisseurs of his work, and was conscious of it: Renoir was to say of Durand-Ruel, his loyal dealer since 1872, "not once did he accept the latest panel [I] took him without saying that he adored it—which was untrue, or not yet true."[48]

Since 1892, when the French National Museums acquired Renoir's works (*Young Girls at the Piano* **Cat. 3**), its new style was discussed in contrast to the old: "From the kind of people who relive every act of the play you have just seen, until you are sick of it, ... we have all too often heard them expressing their preference for the early Renoirs (which in turn have only been considered masterpieces since his entry into the museums), over the glorious late Renoirs. Mallarmé had the chance to convince a director of the Beaux-Arts, a civil servant and recent enthusiast all too inclined to choose a very old Renoir, to buy one of the artist's paintings for the nation—and had the wit to tell him that one was only justified to buy the most recent painting from a painter, still fresh on

Apartment of Gertrude and Leo Stein at 27, rue de Fleurus, Paris. One can see Renoir's Girl in Gray-Blue Putting on her Gloves *(ca. 1899, Merion, PA, Barnes Foundation), hung as a pendant to* Woman with a Hat *by Matisse (1905, San Francisco Museum of Modern Art). Above:* Portrait of Gertrude Stein *by Picasso (1906, New York, The Metropolitan Museum of Art)* Ca. 1907

Cat. 201

Exhibition of works from Renoir's last ten years (1909–19), Paris, Paul Rosenberg Gallery, January 16–February 24, 1934

Cat. 205

36. See Silver 1989. **37.** For instance, Renoir exhibited in *Interprétations du Midi*, Brussels, Libre Esthétique, March 8–April 13, 1913, nos. 198 to 201 (four landscapes). **38.** Rey 1931. **39.** For the last three, see my essay in this volume, "Renoir and the Nabis," p. 146. **40.** In the throes of "Cézannisme," Derain spent time painting in Cagnes in 1909 and 1910 (for example, *Landscape around Cagnes*, 1910, Chicago, The Art Institute). He appears in *La Fille de l'eau*, a film by Jean Renoir, as the café manager. **41.** Braque's admiration for *The Spring* by Renoir is reflected in the monumental *Canéphore* of 1922 (Paris, Musée National d'Art Moderne), for example, which can equally well be associated with the *Caryatids* Cat. 10 and other decorative panels by Renoir. In Braque's case, however, there is most probably a recollection of the Caryatids of the Treasury of Siphnos (Delphi), casts of which displayed in the Louvre were also drawn by Derain). **42.** For Morandi in Italy, "the first revelation of modern painting" was the Renoir room he admired at the Venice Biennale, according to Longhi, who considered Degas and Renoir to be the great names of the early twentieth century, on a par with Titian and Giorgione for their own century (Del Guercio 2003, p. 57). **43.** Terrasse 1927, p. 154. **44.** Blanche 1921, pp. 38 and 40. **45.** Salmon 1922, p. 84. **46.** Ibid., p. 83. **47.** On the occasion of the Renoir exhibition, Paris, Galerie Durand-Ruel, May 28–June 20, 1896, quoted from Baudot 1949, p. 43. **48.** Reported by Natanson 1948b, p. 32.

Cat. 201

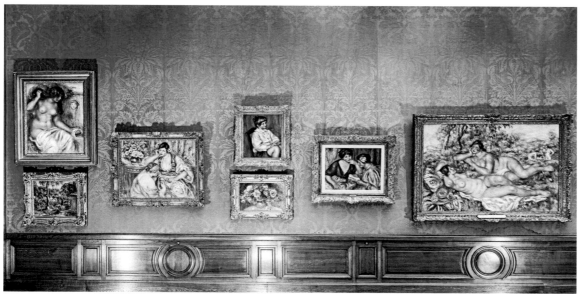

Cat. 205

the easel."[49] We can see more clearly the implications in Mallarmé's letter, who thanked Henry Roujon, the director of the Beaux-Arts, by telling him how pleased he was to see the entry of "this definitive canvas, so relaxed and free, a work of maturity."[50] On closer inspection, in fact, Renoir's record-breaking successes mainly pertained to the Renoir of Impressionism: the painter of the *Ball at the Moulin de la Galette* **Fig. 2, p. 31**, hailed as a major work (after plenty of problems, admittedly) in the Caillebotte bequest to the National Museums; the painter of *Portrait of Madame Charpentier and Her Children* **Fig. 57, p. 135**, and of *Luncheon of the Boating Party* **Fig. 4, p. 33**.

Thus in 1900, when the young Picasso was on the look-out for Parisian subjects, he thought of *Ball at the Moulin de la Galette*.[51] The prices reached by late Renoirs were nothing like those of the paintings from 1870–80. For the Salon d'Automne, where a retrospective was mounted for Renoir at the same time as Cézanne (in homage to the two painters, but also to the battles they had to fight in order to achieve such late recognition), it was the artist's old canvases that Durand-Ruel chose to represent him: "To be honest, I'm not the one exhibiting… personally, I would have preferred to exhibit new canvases."[52] The dealer acted the same with museums, which looked to him when acquiring Renoirs: which also explains the small proportion of late paintings purchased by public collections at the turn of the century.[53] In the context of Impressionism's gradual acceptance at that time, the Renoir who predominated was the painter of Montmartre, of ordinary, happy people and *grisettes* (young, coquettish working-class women); there can be no denying the element of nostalgia in all this, which was also captured later by Jean Renoir, the artist's second son, in his book about his father and in the film most closely associated with him, *French Cancan*.

Renoir's Impressionism became the key to enormous success, but it was the artist's capacity to go beyond Impressionism that made some critics and a generation of colleagues regard him as a contemporary, topical painter. Renoir showed the way for constant reinvention and, at every opportunity, his admirers would dish up the delicious paradox of the "imperishable youth"[54] of the old artist. For painters like Bonnard, Denis, as well as Roussel, Henri-Edmond Cross, and Matisse, Renoir was modern because he was "Classical"[55]: "[Like Cézanne], Renoir is a traditionalist.... [Cézanne] is a classicist like Rubens, Giotto, or even Renoir. Like them, he has always painted the same picture" while "an Impressionist is someone who paints a different picture every day," Matisse declared.[56] His views concur with a feeling and aspiration proclaimed by Renoir himself: when the idea took shape to give a Renoir painting to the Musée du Luxembourg in the form of a purchase at a token price, the painter dismissed the plan to donate a large nude on the grounds that he wanted "to give something I would be sure I would not rework; this is not the case with this large nude! I will start on ten more of them when I feel inclined."[57] A unity of subject matter to the point of obsession that was comparable to that of late Cézanne; a "compression of sensations"[58] stemming from a limited number of repeated themes borrowed from the narrowest tradition; but also a reconciliation between invention and tradition with a view to making the appropriation of that tradition look natural and direct—these elements form the basis of the "classical Renoir," Latin and anti-Impressionist and highly valued by the early twentieth century alongside the emergence of a "Baroque Renoir." At the 1905 Salon d'Automne, Denis paid tribute "first of all to the masters accepted as such by the young generation. Renoir, who incidentally no longer has anything Impressionist about him, triumphs there with his amazing late style—robust, copious nudes like the Raphael frescoes of the *Fire in the Borgo* and the Villa Farnesina: we should point out that his knowledge of the basics and of the model has in no way compromised his talent for freshnness nor his ingenuousness. Beside him, Cézanne is like a strict old master with a polished style, the Poussin of the still life and verdant landscape."[59] No labored, scholarly quotations in the Renoir nudes then, which are nevertheless conceived in reference and confessed rivalry to Titian, Raphael, and the statuary of antiquity, dis-

49. Ibid., p. 27. **50.** Mallarmé 1981, pp. 77–78. **51.** Picasso, *The Ball at La Galette*, fall 1900, New York, The Solomon R. Guggenheim Museum. **52.** Moncade 1904, quoted in Renoir 2002, p. 11. **53.** I am grateful to Monique Nonne for this information, which she also developed at a lecture at the Musée d'Orsay, "Renoir au musée," September 24, 2009. **54.** Natanson 1900, p. 375; see also Mirbeau in 1913: "To us he seems even younger and more necessary now than in 1875" (preface to the exhibition at the Galerie Bernheim-Jeune in 1913). **55.** See exh. cat. London 1990. Paul Fierens published an article entitled "Renoir classique" (Fierens 1933). **56.** Matisse 1952, reprinted in Fourcade 1976, p. 100. **57.** Account given by Rivière 1921, pp. 229–230. **58.** See Virginie Journiac's essay in this volume, p. 95. **59.** Denis 1993, p. 91.

playing what Jacques-Émile Blanche called "Panathenaic festivals of the flesh."[60] In this sense Renoir can be included among the anti-modern, reactionary forces returning to classicism, those championed by artists like Derain or André Lhote, for instance: like Cézanne he embodied a modernism that was classical, in other words anti-Impressionist, such as that Lhote set against Monet, the epitome of Impressionism in its purest form. From this perspective, Renoir's late painting assumes a new relevance: faced with a Renoir that was deceptively casual and spontaneous (features that initially seem like those of Impressionism), Lhote stressed the structured, planned nature of his painting and methods, "endless patience rewarded by freedom in execution, richness, and tranquility." Similarly to Cézanne, Renoir did not seek transitory fleeting effects, even in his rendering of light, but instead the "secret of the balance of nature."[61]

"Renoir as a whole?"

Since the 1900s, then, it has been a question of whether Renoir has to be taken "as a whole," as Vuillard[62] maintained on the occasion of the retrospective devoted to the master at the Orangerie in 1933. Such a project had been mentioned by Paul Léon and the artist at the end of his life but was never carried through. In order to show their father's last works to the public while waiting for this comprehensive event, Renoir's three sons sent thirty of Renoir's paintings completed between 1915 and 1919 to the 1920 Salon d'Automne. It was a posthumous consignment that unleashed battles and debates, especially around the *The Bathers* **Cat. 80** and the nudes—"pastoral butchery" that "reduce[s] humanity to all its glory and its animal functions," according to Georges Duthuit, Matisse's son-in-law,[63] echoing one of the most frequent criticisms of the late nudes from Charles Morice to Christian Zervos. The voluminous nudes, the strong reds, and the sketched nature of the final Renoirs had difficulty finding their audience: the reservations raised by the proposed gift of *The Bathers* in 1923 (initially to the Louvre) confirm this attitude.[64] Thus, the paintings of Renoir's final twenty years enjoyed only a fraction of exposure in 1933.[65] The critic Tériade denounced this "disappearing act" that deprived Renoir of the works in which he had truly expressed himself, as opposed to the earlier periods, in which critics had seen only a series of external influences. This is why he called his article "Renoir without Renoir."[66] By way of a retort, as a kind of codicil or addendum, an exhibition was dedicated to the painter's last ten years at the Galerie Rosenberg in Paris in 1934 **Cat. 205, p. 365**. Élie Faure, Walter Pach's friend and, like him, one of the most passionate defenders of late Renoir, wrote the following in the preface to the catalogue: "Those who only acknowledge the first forty years of Renoir's work... do not know Renoir"—a man, he went on, who achieved "the harmonious transposition of the concrete elements of the universe that have been slowly gathered in the deepest shadows of the subconscious and that are suddenly reassembled in a new logical order, becoming form itself."[67] Like Tériade, Faure was defending Renoir as "a painter through and through," the author of paintings "without a subject" who heralded the advent of a pure form of painting—in other words, modern painting, in the theoretical context of the times.[68] Hung densely and symmetrically, the exhibition brought together fifty-three paintings, some of which are now presented in our exhibition. Three years later, the big Renoir retrospective at the Metropolitan Museum of Art, which marked the high point of the painter's appreciation in the United States, suffered the same kind of imbalance as that in the Orangerie.[69]

60. In *La Pêche aux souvenirs*, 1949, quoted in Renoir 2002, p. 203. **61.** Lhote 1936, pp. 166 and 168. **62.** Unpublished diary of Jacques-Émile Blanche relating a conversation with Vuillard at the time of the Renoir retrospective in the Musée National de l'Orangerie in 1933 (Paris, Bibliothèque de l'Institut, Ms 4809, quoted in Collet 2006, pp. 360–361). Faced with Blanche's reservations about *The Daughters of Catulle Mendès*, Vuillard, who had gone to see the retrospective three times, came back delighted and announced: "The conclusion is 'You have to take Renoir as a whole.'" **63.** Duthuit 1923. **64.** Apart from the *Portrait of Colonna Romano*, no paintings dating after 1892 were bought by the French state. Hence the Musée d'Orsay collection of late Renoir is the result of gifts and legacies, in spite of a few missed opportunities: Renoir intended *The Artist's Family* (1896, Merion, PA, Barnes Foundation) for the Louvre (see exh. cat. Ottawa, Chicago, and Fort Worth 1997–98, p. 40, note 250). In the postwar period, at least two options were examined by curators: the purchase of the *Portrait of Marthe Denis* Cat. 27 and *Vollard in a Toreador's Costume* Cat. 51 (note from Germain Bazin to the director of the French national museums, July 25, 1951, Paris, Archives des musées nationaux). **65.** Twenty-four post-1900 paintings out of one hundred and twenty-one. **66.** Tériade 1933, reprinted in Tériade 1996, pp. 444–445. **67.** Faure 1934, n. p. **68.** Tériade 1996, p. 72. Immersed in this definition of a form of modernity widespread until the 1960s, Jean Renoir insisted on the absence of any iconographic issues in Renoir's paintings: "The question of the actual subject did not concern him at all. He told me one day that he regretted not having painted the same picture—he meant the same subject—all his life. In that way, he would have been able to devote himself entirely to what constituted creation in painting: the relation between form and color . . ." (J. Renoir 1962, pp. 398–390). **69.** This delighted Sterling Clark, who hailed the absence of the "sausage bloody Renoirs" of the late years (May 21, 1937, unpublished notebooks, quoted above, note 10).

Pablo Picasso
*Seated Female Nude
with Legs Crossed*
Fall/Winter 1906
Oil on canvas
59 1/2 x 39 3/8 in. (151 x 100 cm)
Prague, Narodni Galerie

Fig. 118

Cecil Beaton
Picasso in front of Renoir's
Seated Bather in a
Landscape, *called* Eurydice,
*in his apartment in the
rue La Boétie, Paris*
1932

Cat. 193

The 1934 exhibition did not really manage to win people over, any more than the one organized by the Philadelphia Museum of Art in 1938[70] (centered on a part of the Gangnat collection) or the show in the Durand-Ruel Galleries in New York in 1942.[71] The great admirer of Renoir Sterling Clark did not hide his reservations about an artist he had collected avidly, with the exception of works from his final years **Cat. 19**. Yet he picked up on the interesting fact that "two-thirds of visitors were from the younger generation, while if the exhibition had brought together the early Renoirs, the proportions would have been reversed."[72] From all these successes, setbacks, and controversies, it seems that even when his influence was most pronounced, from 1910 to the 1930s, late Renoir provoked very different reactions: unqualified disaffection on the one hand, disapproving of the woolly, formless brushwork, the "light red glaze," and the painter's "blotchy" nudes, to repeat the words heaped on by the critics from 1920–30;[73] on the other hand, unmitigated enthusiasm for a "riot of colors,"[74] the free and sensuous reappropriation of a timeless and classical genre, the female nude, appreciated by staunch supporters like the critic and collector George Besson, the painter Albert André, and even Vollard: Maurice de Vlaminck recalled how much the latter "was always trying to convince us that the late Renoirs, the ones he did at the end of his life, were the most beautiful. And he showed me his portrait dressed as a 'Toreador' **Cat. 51** . . . , then female nudes, bathers, and the 'lacquered pink' period."[75] By the same token, late Renoir had his own fervent collectors: from 1904–12, two enthusiasts put together two collections made up entirely of the painter's late works: Maurice Gangnat, whose collection was partially broken up in 1925, though another of his collections gave rise to exhibitions based on this period of the artist in Philadelphia, as has been seen, as well as in Paris and Düsseldorf;[76] and, on the other side of the Atlantic, Dr. Barnes was also accumulating almost one hundred and eighty Renoirs, nearly all of them painted between 1890 and 1919.[77] There, too, the contrast between passion, on the part of some, and the general disdain aroused confusion—to such an extent that each side could barely agree on the point when the last chapter of Renoir's work began.

Choosing a Date: 1892, an End and New Beginnings?

It is actually not so simple to define the scope of what is conveniently called "late Renoir" within a definitive chronology: it either oscillates between the beginning and the end of the 1890s, or, more radically, begins at the end of the 1900s, which limits "late Renoir" to the "final Renoir" of his last ten years, as was the case in the militant exhibition in the Rosenberg gallery in 1934. Somewhat paradoxically, we suggest starting Renoir's twentieth century ten years earlier, at the beginning of the 1890s. A time of transition rather than rupture, this period effectively crystallizes the events and developments that heralded new perspectives as much in the artist's career and life as in his work; it also seems to us to complete a preceding cycle, that of the 1880s and what is known as Renoir's "acid" or "Ingresque" period, marked by an "obsession with studies" and "hatred of Impressionism," to use the artist's own words.[78]

Renoir's confessions after the fact, as reported by his dealer Vollard, are well-known, and they were significantly reproduced in a special Renoir edition of *L'Amour de l'art* in 1921: "around 1883 a sort of rupture happened in my work. I had gone as far as I could with 'Impressionism' and I came to the realization that I did not know how to paint or draw."[79] This aesthetic "crisis" coincided with the break-up of the Impressionist group, worn out by their strategic, political, and artistic disputes. Renoir, who tended at the end of his life to downplay his commitment to both the Impressionist cause and to a position of independence, exhibited with any conviction alongside his friends for the last time in 1877; that is to say, he took part in three out of the eight Impressionst exhi-

70. Philadelphia 1938. The exhibition brought together sixty works executed between 1900 and 1917. Despite fierce criticism, several articles commented positively on the exhibition, but in a rather general way; the most complimentary appeared in *Art News*, celebrating the "Poetic Vision of the Late Renoir" (Davidson 1938). My thanks to Jennifer A. Thompson for this information. **71.** New York, Durand-Ruel, 1942. **72.** April 8 1942, unpublished notebooks, see reference above, note 10; see also Kern 1996, p. 9. **73.** Joachim Gasquet objected to this commonplace, citing instead the exhilaration created by "the deep wine color that intoxicates as if drunk straight from the crushed grape pulp. What terrific harvests these superb nudes are in the intense autumn of Renoir." (Quoted in Pinturrichio 1924, p. 8). **74.** Fegdal 1927, p. 178. **75.** Vlaminck 1943, p. 144. Vlaminck goes on to make it clear that he is very fond of Renoir, to whom he actually refers frequently in his book. **76.** Paris, Durand-Ruel, 1955; Düsseldorf 1956. **77.** See Martha Lucy's essay in this volume, p. 110. **78.** Vollard 1994, p. 213. **79.** Ibid., p. 209. Vollard 1921, pp. 47–52.

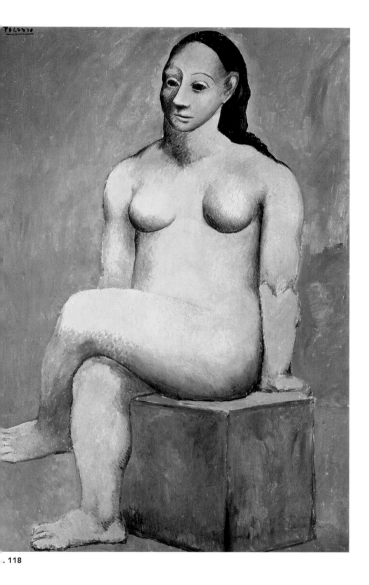

. 118

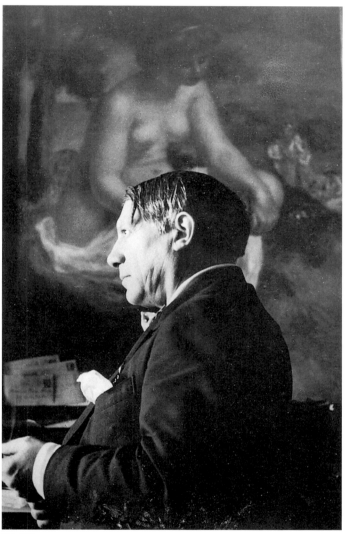

Cat. 193

bitions, not counting the submission to the 1882 show (the most important he ever agreed to) that was organized personally by Paul Durand-Ruel despite the artist's reservations. Renoir set out on a journey of self-discovery, renouncing the discipline of the 1880s that had been emphatically, exhaustively, and sharply opposed to the Impressionist style. At the end of the 1870s and the beginning of the 1880s, Renoir had by his own admission gone back to the school of the Old Masters, spending all his time in the Louvre, but also in Italy, to learn to "paint and draw" alongside classical as well as modern painters, foremost among whom was Raphael. The Philadelphia *Large Bathers* of 1884–87 **Fig. 8, p. 39** marked the high point of this radicalism in which the sparseness of design and brushwork seems to be in ongoing defiance of the *fa presto* and flickering luminosity mastered during Impressionism. The end result of numerous experiments (with design, color, and technique), the Philadelphia painting led in a sense to an impasse, and it had no successor in the Renoir corpus: still engaged in battle with the seduction and pitfalls of *plein-air* painting, Renoir opted here instead for a deliberate juxtaposition of bodies against a landscape treated like a backdrop, without the harmonious integration he had admired in the Villa Farnesina. He was roundly criticized for this lack of harmony when the painting was exhibited at the Galerie Petit in 1887. From this time on, Renoir abandoned this course. In the 1890s he went off in search of fresh solutions and came back to the female nude in the open air: he was to stay with it from then on, in the guise of the classical bather in a landscape **Cat. 9**. From this perspective, too, the early 1890s seemed like a fresh start.

For all that, Renoir did not completely renounce modern subjects, composing scenes of contemporary young girls engaged in such feminine activities as reading, conversation, or music. But he gave up once and for all the manifestos of modern life in which the evocation of contemporary pastimes were raised to the level of history paintings as in *Ball at the Moulin de la Galette* (1876) or *Luncheon of the Boating Party* (1881). His idea for a large composition inspired by the Lerolle girls, Julie Manet, and her cousins (elegant young girls of the Parisian bourgeoisie, with whom he had close links during the 1890s) was left at the planning stage. Renoir preferred genre scenes at that time, linking them to tradition (the eighteenth-century tradition of Fragonard and Watteau with their restrained descriptions of modern life) while also adapting them to suit the demands of the market. In this way he did more and more of this type of "genre painting (the kind that sells)"[80] as he called it. On the cusp of the 1890s, Renoir actually began to taste success. Though he never really lost his innate modesty, his attitude changed in the course of the 1890s: in May 1890 he refused an official honor, which won him Monet's admiration, for "true, it would have been useful, but he has to succeed without that. It's smarter that way."[81] Ten years later, it was a different matter. Renoir admitted to Monet that he had "agreed to be decorated... and whether I have done a stupid thing or not, I value your friendship."[82] This time, indeed, his friend disapproved: "What a very sad thing it is, really, to see a man of his talent, after fighting for so many years and having come through this battle in spite of the establishment, accepting an award at the age of sixty? How dismal it is to be human! It would have been so nice to remain free of all rewards."[83] While Renoir only became truly affluent around 1900, his paintings were reaching good prices and finding a client base. New enthusiasts and connoisseurs succeeded the collectors who had contributed to his initial, albeit fleeting, success in high society from the early 1880s on: after Charles Ephrussi, the Charpentiers, and the Berards, there followed Paul Gallimard, then the Prince de Wagram, Maurice Gangnat, and Albert C. Barnes in the early twentieth century.[84] The dealer who was with him from the very beginning, Paul Durand-Ruel, found himself competing with Ambroise Vollard after 1895, and then with the Bernheim-Jeune brothers. All followed Renoir's progress until he died, and then played a key role in the posthumous dissemination of his art.

From the 1890s on, Renoir relied heavily on his dealers, who were the key to his success and influence in his final years. In 1890 he exhibited at the Salon for the last time. Two years later, in 1892 and for the first time in nine years, the oldest and most loyal

80. Letter from Renoir to Berthe Morisot, fall 1891, in Morisot 1987, p. 186. **81.** Letter from Monet to Caillebotte, May 12, 1890, quoted in exh. cat. London, Paris, and Boston 1985–86, p. 304 (p. 385 in Fr. ed.) (reprinted in Berhaut 1978, p. 248). **82.** Letter of August 20, 1900, in Geffroy 1980, pp. 25–26. Renoir was made Chevalier de la Légion d'honneur on August 16 (Paris, Archives nationales, L H 2300/69). **83.** Letter from Monet to Gustave Geffroy, Giverny, August 23, 1900, reprinted in Wildenstein 1996, vol. IV, pp. 348 and 1565. **84.** Distel 1985–86, pp. 19-29.

among them, Paul Durand-Ruel, devoted a retrospective to him that was packed full with one hundred and ten items, compared to seventy in 1883. This impressive assembly of works—the pride and joy of the most prestigious museums today—was given a favorable reception, so much so that Arsène Alexandre, the painter's critic and friend who had written the preface for it, in 1894 hailed it as the "beginning of a triumph." Arsène Alexandre's lengthy text was also part of that first crop of monographic articles that helped to get the artist known, going back over his career and providing biographical details: Téodor de Wyzewa in *L'Art dans les deux mondes* (December 6, 1890) springs to mind, as does André Mellerio in 1891; equally, Georges Lecomte's substantial exposition in *L'Art impressionniste et la collection Durand-Ruel,* and Roger Marx's piece in *Le Voltaire* on April 26, 1892. While Renoir was not an isolated case (at a time when his friends Camille Pissarro, Alfred Sisley, and Berthe Morisot were enjoying the fruits of solo exhibitions supported by laudatory, authoritative articles), his gradual rise from the 1890s onward bears no comparison to that of Monet. At the same time, however, Monet, like Renoir, was being sidelined from public commissions[85] and had to wait until 1921 for the French government to buy one of his works.[86]

Renoir did, however, obtain this distinction in 1892, when the museums offered to buy *Young Girls at the Piano* **Cat. 3**: "The only recompense one should offer an artist is to buy or commission work from him," Renoir had announced in 1883–84.[87] For him, though, entry into the museum represented more than just official recognition, albeit late and hard-won: while *Young Girls* may have been a pleasant painting of the "kind that sells," it nonetheless needed the intervention of Mallarmé, among other supporters, in order to be accepted.[88] For Renoir, this acquisition was a crowning achievement, as museums were, in his view, the very source of art ("it's in the museum that one can get a taste for painting that nature alone cannot give you"[89]), as well as its most noble destination. What Renoir referred to as "entering the ranks"[90] when he summed up his ambitions, simply means finding his place in the museum among the admired masters of French painting. This position was strengthened by the Gustave Caillebotte bequest, thanks to which six of Renoir's paintings[91] were exhibited in 1897 alongside forty Impressionist works from Caillebotte's collection. It was "only" at the Musée du Luxembourg—then the museum of modern art—and not yet the Louvre, although Renoir was to be displayed there, too, during his lifetime, in 1914, thanks to the Isaac de Camondo bequest.[92] Along with the donor's brother, Martial Caillebotte, Renoir was the collector's executor, and in this capacity played a leading role. Thus, while it was around 1900 that he was rapidly gaining greater international recognition in the United States and Europe, the impetus that saw his paintings hung on museum walls had already been initiated in 1892 and then again from 1894–97. Similarly, the painter's own discovery of the European museums did not come until the early 1890s: before then, lacking means, he had not traveled much outside France. He had scarcely any knowledge of the great public collections, with the exception of his Italian voyage of 1881–82. But then, in 1892 he went to Spain for the first time and visited the Museo del Prado, returning full of admiration for Velázquez and Goya (including the decoration of the church of San Antonio de la Florida) and reinforced in his worship of Titian and Rubens. Thereafter followed his first trips to England (in 1895), Germany (Bayreuth and Dresden in 1896), Holland (The Hague and Amsterdam in 1898), then Munich in 1910. As John House discusses in his essay in this volume, Renoir's painting derived sustenance from these discoveries and encounters with masters he already knew well thanks to the Louvre and to photographic reproductions.[93]

85. Like Renoir, Monet tried to get a commission for one of the decorations of the new Hôtel de Ville in Paris (Wildenstein 1996, vol. 3, pp. 48–49). **86.** *Women in the Garden,* 1866–67, Paris, Musée d'Orsay, bought for 200,000 francs, transferred from the Musée du Luxembourg to the Louvre in 1928. But it would seem that the painter had passed up an earlier opportunity in 1892. See Cat. 3. **87.** Renoir in *Notes, 1883–84,* reprinted in Herbert 2000, p. 115. **88.** See Monique Nonne's catalogue entry in this volume, providing new information about the circumstances surrounding the purchase of *Young Girls at the Piano* Cat. 3 and the problems it encountered. **89.** Renoir quoted in André 1923, p. 49. **90.** Vollard 1994, p. 70. According to Meier-Graefe, Renoir's motto was "I remain in the ranks" (Meier-Graefe 1911, p. 23). **91.** One was *Ball at the Moulin de la Galette.* The other works still in the Musée d'Orsay today are *The Seine at Champrosay* (1876), *The Swing* (1876), *Study. Torso, Sunlight* (1876), *Woman Reading* (1874–76), and *The Railroad Bridge at Chatou* (1881). **92.** The bequest dates to 1911, although lengthy negotiations with the Beaux-Arts administration were required before the bequest of works, many or all of which were still frowned upon, was officially accepted. The Camondo rooms were opened in May 1914 and officially inaugurated in 1920. There were three of Renoir's works involved: *The Toilette* Cat. 38, *Young Girl in a Straw Hat* (ca. 1908) and *Young Girl Seated* Fig. 115, all kept at the Musée d'Orsay. **93.** It is often forgotten that Renoir made use of reproductions and acknowledged their educational value, for example in a draft for the Cennini preface (see Herbert 2000, p. 168).

The early 1890s also saw new turns in the artist's personal life. On the one hand, illness and pain crept into Renoir's existence: his face was paralyzed for the first time in 1889, then he had painful attacks of rheumatoid arthritis which became more frequent from 1896–97 and were followed around 1901–02 by a distressing deterioration that prevented him from walking once and for all in 1910. On the other hand, on April 14, 1890, he married Aline Charigot, whom he had met ten years earlier and with whom he had his first son in 1885, Pierre, the future actor. With the birth in 1894 of Jean, and then Claude (known as Coco) in 1901, the whole family became involved in his painting, augmented by servant girls and nursemaids such as "la Boulangère"[94] (more than likely in the Renoirs' service from 1894) and especially Gabrielle Renard, who is prominent in the painter's works for almost twenty years, from her arrival from Essoyes in August 1894 until she left around 1914. Models of choice and attentive helpers for Renoir as illness and old age overtook him, the members of his family and household provided him with a source of inspiration and constant support from the 1890s until 1915, in marked contrast to the more secretive attitude of the 1880s. Indeed, Renoir did not introduce Aline to Berthe Morisot until 1891. Five years before that, Morisot had admired the beautiful scene between mother and child presented by Aline nursing Pierre in Renoir's studio, without realizing its biographical dimension. The social differences between Aline and Berthe Morisot explain the discretion of the 1880s to a large extent, but in a moving turnaround of events, Berthe entrusted her own daughter, Julie Manet, to Renoir, who became her loving and caring guardian after Morisot's death.[95] From the 1890s on, then, Renoir not only mixed together the private sphere and artistic connections,[96] but also asserted himself as the painter of childhood and family bliss, lifting these subjects from the level of trivia to grant them the dignity they had in Velázquez, something Picasso would remember later on **Cat. 103, p. 216**.

In the course of the 1890s, a new geography marked itself out, delimited by Paris (more precisely Montmartre and its environs);[97] Essoyes, the village in the Aube region where Aline was born; and the South of France. Renoir most probably "discovered" Essoyes at the end of 1888,[98] and bought his first home there in 1896.[99] He visited the South of France periodically in the early 1880s, then returned there nearly every year during the 1890s, before basing himself in Cagnes through the winter months from 1903 on, first in the old post-office building, and then in the home he built at Les Collettes in 1907–08. Essentially a place of light and of countryside excursions with Cézanne first to L'Estaque then to Aix, and with Monet as far as Genoa in 1883, the South assumed a far wider dimension for Renoir at the turn of the 1890s, possibly under the impetus of the critic and Symbolist writer Téodor de Wyzewa, with whom he stayed in Tamaris in 1890. Associated with the Félibrige movement that defended Provençal and Mediterranean culture and was rooted in the Latin world, the heir to antiquity, Wyzewa may have introduced these ideas to Renoir,[100] for whom the appeal of the South had a profound influence on the development of his late works.

Finally, still in the early 1890s, an initial connection was made between Renoir and a new generation of artists, especially in the wake of the 1892 retrospective at the Galerie Durand-Ruel, which was an "apotheosis" for Frantz Jourdain,[101] future founder, in 1903, of the Salon d'Automne, and a revelation of "Renoir's lesson" for Maurice Denis.[102] During the summer he spent at Pont-Aven, Renoir saw the paintings of Gauguin and Meijer de Haan;[103] he met Armand Seguin there, as well as Émile Bernard, who co-opted him to his side in his quarrel with Gauguin for the paternity and leadership of the Cloisonnism style emerging in 1888. Renoir thus found himself dragged into Post-Impressionist issues: the reservations he expressed upon meeting Gauguin would be brandished as a warning by Bernard all his life. In 1893 Jeanne Baudot became Renoir's pupil: a modest painter, she was the one who connected Renoir with

94. Marie Dupuis, whose nickname came from her marriage to a baker's apprentice. Jean Renoir cites the date as 1899, but Renoir was a witness at Marie's marriage to Alexandre Berthomier in 1894. She divorced him in 1910 and married a painter-decorator, Raymond Dupuy, in 1915 (Gélineau 2007, p. 56). **95.** This is how Julie pursued her painting studies with Renoir. The young girl's diary is a mine of information on Renoir, whom she saw practically on a daily basis in the late 1890s. **96.** Thus, Renoir's second son, Jean, has Georges, one of Durand-Ruel's sons, for a godfather. **97.** See p. 377 of this volume for a list of Renoir's homes and studios, which were located in what are now the 9th and 18th arrondissements of Paris. **98.** *Correspondance Renoir-Durand-Ruel* 1995, vol. 1, p. 272, note 31. **99.** For 4,000 francs. The point about this issue is made in Pharisien 2009, p. 39ff. **100.** House 1985a, p. 18, note 76. **101.** Quoted by Perruchot 1964, p. 283. **102.** Denis 1892, p. 366. **103.** Vollard 1994, p. 225.

the "young generation" like Maurice Denis, or the group around Matisse they encountered in the Louvre.[104] Renoir visited exhibitions and salons with her, then with the painter Albert André, whom he met in 1894, and Valtat or d'Espagnat. All of them stressed Renoir's endless "curiosity"[105] and open-mindedness, anxious to at least "understand [the new trends]. I don't mean doing them. Let's not be too greedy."[106] As Albert André recalled, "You were sure to meet him at all the exhibitions where his young colleagues were on show. He was always one of the first visitors, the most attentive and the most benevolent."[107]

Late Style, "late vision"?[108]

Choosing the early 1890s, with 1892 as the pivotal year, to mark the beginning of Renoir's mature years is not to say that the years 1892–1919 constitute a monolithic whole. Renoir's life and situation evolved in the course of these thirty years: the 1890s differ from the period 1904–10, the years of apotheosis, the final journeys, and many encounters; the following years, from 1910–15, marked by the illness that restricted him to a wheelchair from 1910, culminated in a time of war, mourning (Aline died in 1915), and a degree of solitude in Cagnes between 1915 and 1919, despite regular exchanges— now well-known to the public—with Bonnard and Matisse. Throughout these thirty years Renoir's painting style was constantly changing. Neater and more restrained, his brushwork and colors blended together increasingly through the 1890s, only to loosen up, becoming more strident and more like a work in progress during the 1910s, offering up to the viewer the reworkings, artist's gestures, and streaky brushstrokes of a painting still in flux **Cat. 80**. While the pictures of the last thirty years do not present a homogeneous body of work, they seem to be striving toward a common goal, the conquest of the figure. Renoir felt as if he was always studying the same thing: "I may have painted the same three or four paintings in my whole life! What's certainly true is that since my trip to Italy, I have been laboring away at the same problems." This search may well be a unifying factor for the period covered by our project, but it is definitely not enough to define a "late style" for Renoir: we shall leave it to each individual to ascertain—following the wonderful works of Edward W. Said on this very subject[109]— whether it ends in the reconciliation hoped for by the artist in full possession of his faculties, or represents by contrast the poignant evidence of contradictions that remained forever unresolved. Contrary to thinking on late style that became established in the second half of the nineteenth century, running up to the works of A. E. Brinckmann in the 1920s[110] and then to the new research of the Frankfurt School around Theodor Adorno especially,[111] Renoir's "late vision" defies any contemplation of illness and death. For Renoir, the final works may have been truthful, but they refused to confront the negativity of the world or its finiteness, as Matisse pointed out.[112] Illness, mourning, and the war, which left the painter's two oldest sons seriously wounded and was the source of constant worry for him personally—none of these held any sway over his final paintings, defying a biographical reading of his late style. As historians of art, music, and literature investigating this issue have shown,[113] one of the main pitfalls in defining a "late style" as an independent, general category surely involves approaching the issue through too narrow a dependence on the life of the artist. In Renoir's case the risk is all the greater given that the suspicion surrounding his late paintings also stems from the artist's failing health and the disturbing deformation of his hands, incapable according to some of holding a brush.[114] Whether the myth serves a heroic vision or aims to discredit, it was invalidated during Renoir's lifetime by the many witnesses who were all impressed by the artist's dexterity, his technical mastery, and the physical transformation wrought in him by the very act of painting. Matisse, who also became ill, admitted to having been "very struck by the example of Renoir in his old age.... He

104. Baudot 1949, p. 30. Matisse, along with Marquet, Manguin, and Flandrin, congratulated her on being "guided by such a great artist." **105.** "The great benefit I derived from my visits to Renoir [in 1917–1918] was to observe that after a long working life, an artist's curiosity could not be exhausted." (Matisse, in Courthion 1941, quoted in Fourcade 1976, p. 102). **106.** Letter to Jeanne Baudot, March 6, 1904, quoted in Baudot 1949, p. 101. **107.** André 1923, p. 20. **108.** Faure 1934, n. p. **109.** Said 2006, pp. 12–13. **110.** Brinckmann 1925. **111.** Adorno 2002. **112.** Matisse recalled an art in which "death would have no place" (Fourcade 1976, p. 97). **113.** See among others Rosand 1987 and Painter and Crow 2002. See also the lecture series "Dernier Oeuvre, de la maturité en peinture," held at the Louvre from January 18 to February 8, 2007. **114.** Among numerous examples, see the poem dedicated to Renoir by André Salmon: "Renoir in the garden before the female nude,/paralysed,/ His brush tied to where the pulse beats" (Salmon 1920, p. 281).

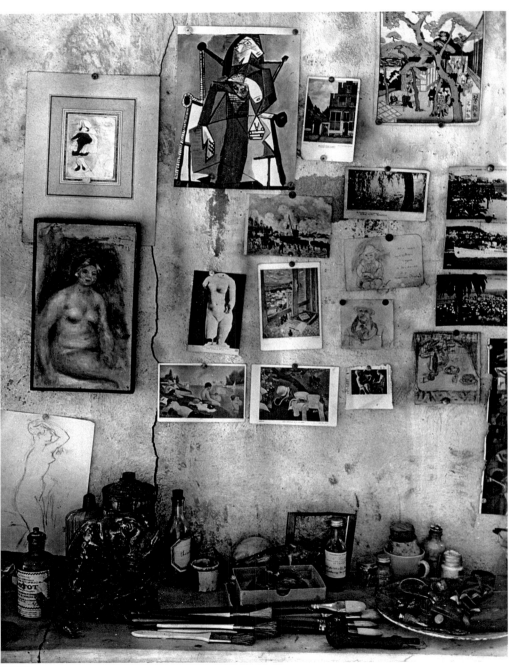

Cat. 199

was nothing but aches and pains… After half an hour, when he was busy [painting], it was as if he had been brought back from death: I have never seen such a happy man. And I swore to myself that when it was my turn, I would not be a coward."[115] The contrast between his illness and the vibrant tonality in Renoir's late style became to a great extent part of the fascination he held for young painters: the moral example of an undying faith in painting, just like the last paintings themselves, contributed to this "late vision" of the artist. Thus at a time when the history of art defined itself by an organic biological model that Renoir did not believe in—he rejected the concept of progress in art which would have located him in a superior position to the masters he admired just by virtue of chronology—he had the feeling of a late achievement, and constantly said to his visitors, "If I hadn't lived beyond seventy, I wouldn't have existed."[116]

"Renoir is a difficult painter"[117]

This exhibition builds on the belief that another reason why late Renoir is out of favor is due to a lack of knowledge: no recent event has been devoted to this side of the artist. While the last years of Monet, Degas, and Cézanne[118] have given rise to studies and exhibitions, the late paintings of Renoir are scarcely displayed in museums, except perhaps in Japan. There is no catalogue raisonné for the period in question: the first volume published by Daulte in 1971 ends in 1883, and the second volume published by the descendants of the Bernheim brothers, Michel and Guy-Patrice Dauberville, finishes in 1894, while the catalogue put together by the Wildenstein Institute is still underway. Anyone working on late Renoir should therefore rely on the first catalogue published by Vollard in 1918 and on the two-volume album of reproductions of the paintings which were found in the artist's studio after his death, published by the Galerie Bernheim in 1931. As far as documentary and archive sources are concerned, there is a similar degree of dispersal: following Nicholas Wadley, Augustin de Butler undertook an anthology that brought together comments made by and texts published about Renoir. He is currently working on an edition of Renoir's correspondence that will enrich our knowledge of the artist. Paradoxically, there are numerous statements and reported comments provided by Vollard, Albert André, Coquiot, Georges-Michel, and Jean Renoir, among others, but they are often anecdotal and contradictory. Even more so since Renoir loved to put up smokescreens: one recent discovery, which we owe to Jean-Claude Gélineau,[119] reveals that Renoir had a first daughter, Jeanne, by his former model, Lise Tréhot. He stayed in touch with this child throughout his life, sending her money through either Vollard or his models Gabrielle Renard or "la Boulangère." The existence of this child whom he kept hidden away undoubtedly makes us see with different eyes the family and maternal scenes that populate Renoir's work and are so closely identified with his art. In a wider sense this exhibition and catalogue have been designed to open up new fields of research and to put forward an alternate late Renoir: by favoring his figure paintings, the bathers and nudes, and the landscapes in the service of a new Arcadia, we propose to consider a Renoir who is fully aware of the debates surrounding art at the start of the twentieth century. Areas we cover include notions of decorative art, but also Primitivism, simplification, Hellenism, and Latinism, which run though the late works of the man who, along with Cézanne, at the time was considered one of the "two beacons"[120] of painting in the first part of the twentieth century, and not just one of the old monkeys Picabia ridiculed.[121] These trails are opened up by the choice of works assembled for this exhibition and by the writings in this catalogue. Hopefully our argument will convince the public that the time is now ripe to explore these works and "see Renoir in paint" (as Cécile Guilbert put it), for as in Meier-Graefe's view, "the paintings of [Renoir's] late period are like young wine: they need to settle."[122] Such is the ambition of this project that, upon programming it for the Philadelphia Museum of Art, Joe Rishel referred to it as "the most subversive show."

Brassaï
Wall in Pierre Bonnard's studio at Le Cannet, with Renoir's Seated Bather
1945

Cat. 199

115. "L'allongé—Une visite à Henri Matisse," *Candide* 1943, reprinted in Matisse 2005, p. 290. **116.** Quoted in Fegdal 1927, p. 178. **117.** André 1923, p. 12. **118.** Boston and London 1998–99 for Monet; Chicago and London 1996–97 for Degas; New York, Houston and Paris 1977–78 for Cézanne. **119.** Gélineau 2007. **120.** Blanche 1921, p. 40. **121.** *Tableau Dada,* 1920, work presumed destroyed, ill. in Green 2000, p. 26: a monkey in the center, with the inscriptions "Portrait of Cézanne / Portrait of Renoir / Still Life / Portrait of Rembrandt." We should note that Picabia painted nudes in Cagnes during the 1940s. **122.** Meier-Graefe 1911, p. 182.

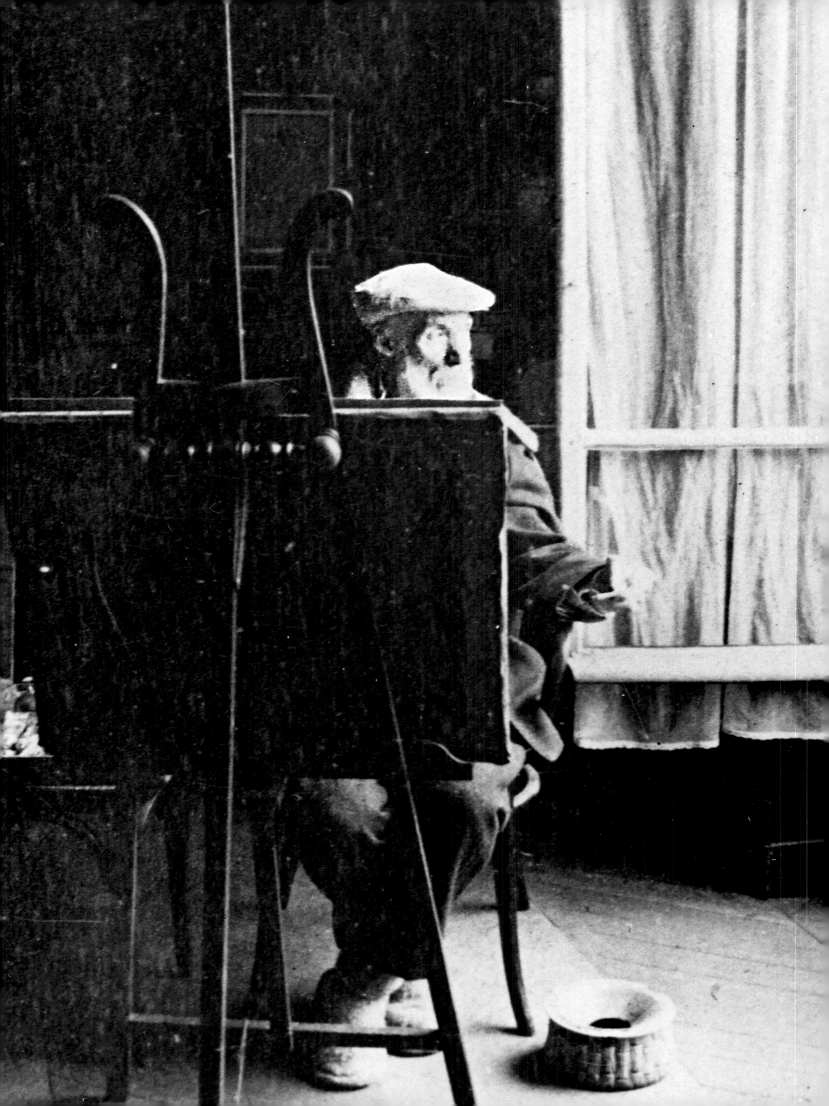

Chronology

Isabelle Gaëtan and Monique Nonne

Renoir was born on February 25, 1841, in Limoges. His family moved to Paris in 1844. Renoir worked as a porcelain painter from the mid-1850s, and in 1861 decided to enroll at Charles Gleyre's studio, where he met Frédéric Bazille, Alfred Sisley, and Claude Monet. He completed his training at the École des Beaux-Arts and the Musée du Louvre, going there regularly to copy works of art. He first exhibited at the Salon in 1864, where, subsequently, his paintings were accepted and rejected by turn.

In 1874, Renoir played an active part in preparing the first Impressionist exhibition, and presented seven works alongside those of his friends Monet, Camille Pissarro, Paul Cézanne, Sisley, and Berthe Morisot. However, despite some impressive contributions (*Ball at the Moulin de la Galette* in 1877 **Fig. 2, p. 31**), Renoir gradually distanced himself from the group.

The 1880s saw a change of strategy, as Renoir was calling his art into question; there was a return to the Salon, commissioned portraits, and, following his trips to Algeria and Italy, a return to drawing and the abandoning of the Impressionist technique. On April 14, 1890, he married Aline Charigot, whom he had first met ten years earlier and with whom he already had his first child, Pierre, born in March 1885.

Renoir's Paris residences and studios between 1890 and 1919

Studios

1890–92:	11, boulevard de Clichy
1890–95:	15, rue Hégésippe-Moreau
1894:	7, rue de Tourlaque
1896:	64, rue La Rochefoucauld
1901:	73, rue de Caulaincourt

Residences

1890–97:	13, rue Girardon, Château des Brouillards
1897:	33, rue La Rochefoucauld
1901:	43, rue de Caulaincourt
1912:	57 bis, boulevard de Rochechouart

Albert André?
Renoir at the easel, in his studio at 73, rue Caulaincourt, Paris
1901

Cat. 140

1892

April 25: Henri Roujon, director of the Beaux-Arts, gives instructions for the French state to purchase one of the versions of *Young Girls at the Piano* **Cat. 3**, for the sum of 4,000 francs.
May 7: Renoir retrospective at the Galerie Durand-Ruel with one hundred and ten items in the catalogue, prefaced by Arsène Alexandre.
June 15: Maurice Denis calls for "Renoir's example and teaching to be acknowledged."[1]
Late May–June: Renoir travels with Paul Gallimard in Spain. He pays special note to the Velázquez paintings in the Museo del Prado in Madrid.
Summer: Renoir spends time at Gallimard's house at Bénerville (Normandy), then with his family at Pornic (Vendée).
September–October: Renoir spends time at Pont-Aven (Finistère), where he sees Armand Séguin and Émile Bernard.

1893

Gallimard introduces Renoir to his cousin, Jeanne Baudot, who later becomes his pupil and a family friend.
April: The family moves to Beaulieu in the South of France **Cat. 21**.
July 9–10: Renoir is believed to have gone to Sainte-Marguerite (Orne) for the marriage of his daughter, Jeanne (whose mother was the model Lise Tréhot), to Louis Robinet.
July: Renoir spends time at Saint-Marcouf (Manche), then in August with his family at Pont-Aven.

1894

February 21: Death of Gustave Caillebotte, who bequeaths two works by Millet and sixty-five Impressionist paintings to the French state. Renoir is the executor of his friend's will. Forty paintings, including six by Renoir, are accepted in 1896 and exhibited at the Musée du Luxembourg in February 1897.
April: Renoir spends time at Saint-Chamas (Bouches-du-Rhône).
April–May: Renoir meets the painter Albert André, who becomes a close friend.
August: Renoir joins his wife and his son Pierre at Essoyes (Aube), the village where Aline Renoir was born.

September 15: Birth of Renoir's second son, Jean, in Paris. His godfather is Georges Durand-Ruel and his godmother is Jeanne Baudot. Aline's cousin by marriage, Gabrielle Renard, arrives in Essoyes to work for the family and regularly models for Renoir until she leaves in 1914 after meeting the American painter Conrad Slade.

October 15: Renoir carries out his first documented transaction with Ambroise Vollard, buying two watercolors by Manet. The following year, he entrusts the art dealer with some works on paper and several small-format pieces.

December: Conviction of Dreyfus. During the Dreyfus affair, Renoir is a convinced anti-Dreyfusard.

1895

January: Renoir accompanies Jeanne Baudot and her parents to Carry-le-Rouet (Bouches-du-Rhône).

March 2: Death of Berthe Morisot. Renoir, who has been an advisor to the family since the death of Morisot's husband, Eugène Manet, leaves the South of France and returns to Paris.

July 28: Now guardian to Julie Manet, Morisot's daughter, Renoir invites her and her cousins Paule and Jeannie Gobillard to join the family at Pont-Aven.

Renoir visits the Netherlands and London with Gallimard.

1896

March: With Monet and Degas, Renoir hangs works by Berthe Morisot for the retrospective held at the Galerie Durand-Ruel.

May 28–June 20: Renoir exhibition at the Galerie Durand-Ruel. Critics are divided.

July 15: Renoir leaves for Bayreuth with Martial Caillebotte and visits the Dresden museums.

September 5: Renoir purchases a "house, conveniences, and outbuildings in Essoyes."[2]

November 11: Renoir's mother, Marguerite Merlet, dies at Louveciennes.

1897

September: Renoir falls from a bicycle at Essoyes and breaks his arm. His friends and family later attribute the rheumatoid arthritis that would plague Renoir over the years to this accident. The spa treatments Renoir subsequently takes at Aix-les-Bains, Bourbonne, and Saint-Laurent-les-Bains bring no improvement. At his doctors' advice, Renoir spends the winter months in different spots in the South of France before finally settling in Cagnes.

September 21: The annual account statement sent by Durand-Ruel shows Renoir to have a credit of 6,680 francs.

December: Renoir returns to his painting lessons with Julie Manet and Paule and Jeannie Gobillard.

1898

February: Renoir is believed to have visited Cagnes for the first time.

August: Renoir stays with his family at Berneval-sur-Mer, near Dieppe, and plans to be in Essoyes in early September.

September 11: Renoir takes Julie Manet and Paule and Jeannie Gobillard to Stéphane Mallarmé's funeral at Valvins **Cat. 132–134, p. 385.**

October: Renoir visits museums in the Netherlands and the Rembrandt exhibition in Amsterdam in the company of Abel Faivre, Paul Berard, and Joseph Durand-Ruel.

December: Renoir sells Degas's *The Dance Lesson*, causing a rift between the two artists.

1899

February–March: Renoir stays at the Hôtel Savournin in Cagnes.

Summer: Renoir rents a house at Saint-Cloud.

Julie Manet and the Gobillard sisters visit Renoir frequently. Vollard and Téodor de Wyzewa also come to see him.

July 1, 3, and 4: The seven paintings by Renoir fetch good prices at the Widow Chocquet's sale.

August 3: Renoir starts his first two-week spa treatment at Aix-les-Bains (Savoie).

December 29: Renoir, who is staying in Grasse, gives a portrait of Jean to the museum in Limoges.

1900

January 13: Renoir and Aline move to the Villa Raynaud on the road to Magagnosc.

January 25–February 10: Renoir exhibition at the Galerie Bernheim-Jeune (sixty-eight paintings, pastels, and drawings).

May–June: Renoir exhibits eleven paintings at the Exposition Centennale de l'Art Français 1800–1889 (Centennial Exhibition of French Art 1800–1889).

August 16: Renoir is made *Chevalier* (knight) of the Legion of Honor by Paul Berard, who presents him with his insignia on June 17, 1901.

November–April 1901: Renoir stays at Magagnosc.

1901

January 28: Durand-Ruel sends *Woman Playing the Guitar* to the Musée des Beaux-Arts de Lyon **Cat. 13**, which has recently purchased it. There are now eight works by Renoir in French museums.

August 4: Birth of Renoir's third son, Claude, at Essoyes.

August 16: At Essoyes, Renoir exchanges a barn for a plot of land adjoining his property, enabling him to build a studio.

September 7: Renoir stays with the Adlers at Fontainebleau for some ten days. He paints portraits of Mathilde and Suzanne Adler, Josse and Gaston Bernheim's fiancées **Cat. 142, p. 99.**

October–December: Paul Cassirer, who had already exhibited works by Renoir in April at his Kunstsalon in Berlin, exhibits another twenty-three paintings by the artist.

1902

February 3: Albert André joins Renoir who has moved to Le Cannet in January. Aline, Jean, and Claude have arrived the day before.

May 23: The art collector Karl Ernst Osthaus buys *Lise with a Parasol* (1876) from Cassirer for 18,000 marks for his Museum Folkwang in Hagen.

1903

January: Renoir's health forces him to delay his departure for the South of France. In February he is finally in Le Cannet, leaving in April for Cagnes where he rents the Maison de la Poste.

August: Renoir joins his family at Essoyes, where he spends each summer.

November 13: In Marseille, Renoir learns of the death of Pissarro and returns to Paris for the funeral on November 15.

December: Renoir asks Albert André to accompany him and Durand-Ruel to view some dubious works purchased by Dr. Viau, one of his loyal admirers.

The Valtats visit Renoir in Cagnes.

1904

Gallimard introduces Renoir to his brother-in-law Maurice Gangnat who, after returning from Naples, has recently settled in Paris. Gangnat is to become the greatest collector of Renoir's work, and a close associate.

February 15: Renoir is in Paris for the Barthélemy affair: an art dealer at 52, rue Laffitte appears to be involved with some dubious or stolen artworks. Renoir does not file a complaint for fear of frightening away patrons.

October 15: The second Salon d'Automne mounts a successful retrospective devoted to Cézanne and Renoir (thirty-three paintings and two drawings). The following year, Renoir is made honorary president of the Salon, exhibiting there in 1905, 1906, 1910, and 1912.

1905

February: Georges d'Espagnat often comes to see Renoir in Cagnes in the late afternoon for a chat.

May 8–9: Sale of the Berard collection at the Galerie Georges Petit.

1906

Two Renoir paintings are donated to the Nationalgalerie in Berlin, under the directorship of Hugo von Tschudi.

January: Denis and Roussel visit Renoir in Cagnes.

September: Maillol models a bust of Renoir at Essoyes **Cat. 117, p. 274**.
November: Renoir returns to Cagnes for the winter, as he does every year.

1907

April 11: On the advice of Roger Fry, the Metropolitan Museum of Art acquires *Madame Charpentier and Her Children* **Fig. 57, p. 135** at the sale of the Charpentier collection, for the record price of 84,000 francs.
June 28: Purchase of the property at Les Collettes, Cagnes, for 35,000 francs. The construction of the house to plans drawn up by the architect Jules Febvre from Biot begins soon after. The estate will later be sold to the town of Cagnes on July 5 and 18, 1960.

1908

May: Vollard is in Cagnes. Renoir paints the third of five portraits he will execute of the art dealer. It is perhaps at this time that Vollard encourages Renoir to turn to sculpture (see p. 71).
May–June: Exhibition of landscapes by Monet and Renoir at the Galerie Durand-Ruel (thirty-seven works).
June 2: Walter Pach visits Renoir in Paris. Their conversations will continue over four years and are published in *Scribner's Magazine* in June 1912.
Saturday, July 25: Death of Louis Robinet, husband of Jeanne Tréhot. Renoir sends a letter of condolence from Bourbonne-les-Bains to his daughter and assists her financially in the future.
July 31: Vuillard buys a Renoir from the art dealer Dubourg.
November–December: "Exhibition of Paintings by Pierre-Auguste Renoir," New York, Durand-Ruel Galleries (forty-three paintings). Renoir's success prompts the dealer to exhibit his works more regularly, both in Paris and New York.
November: Renoir moves into his house at Les Collettes and receives visits from Durand-Ruel and Monet in December.

1909

Spring: Jacques-Émile Blanche visits Renoir in Cagnes.
December: Renoir refuses to organize a sale to raise money for a monument to Cézanne. He would have preferred to see a bust and a painting in the Musée d'Aix, because he believes that "a painter must be represented by his painting."[3]

1910

March 10: Denis visits Renoir in Cagnes.
April–October: Renoir retrospective at the ninth Venice Biennale (thirty-seven works).
May 10–mid-June: First version of Renoir's preface to the new edition of Cennino Cennini's treatise on art, *Il Libro dell'arte* (The Craftsman's Handbook), planned since July 1909 with Victor Mottez, who has translated the text (see p. 49)
June or July: In Paris, Renoir paints the portrait of Paul Durand-Ruel **Cat. 50**.
Summer: Trip to Bavaria with his family, Gabrielle, and Renée Rivière. Renoir is invited to Wessling am See near Munich by the Thurneyssens, whom he has met in 1908 in the South of France. Renoir paints a portrait of Mme Thurneyssen and her daughter **Cat. 54**. In Munich, Renoir admires works by Rubens at the Alte Pinakothek.

1911

Meier-Graefe publishes the first monograph on Renoir, which is translated into French the following year. The Thurneyssens are in the South of France and visit Renoir frequently. He paints a portrait of their son **Cat. 55**.
Mid-January: Mme Cézanne and her son, and later Paul Durand-Ruel, stay with the Renoir family at Cagnes.
June: With Misia Sert, Renoir attends a performance of the third season of the Ballets Russes at the Théâtre du Châtelet in Paris (June 6–17).
October: The Renoir family rents an apartment in Nice at 1, place de l'Église-du-Vœu.
October 25: Following surgery, Renoir spends time in Paris on his doctor's orders and is visited by Vuillard.
October 20: Renoir is made *Officier* of the Legion of Honor. Léon Dierx presents him with his insignia on November 12.

1912

Start of the year: Renoir is featured at the Centennial Exhibition of French Art in St. Petersburg, exhibiting twenty-four works.
February 15: Vuillard buys a painting from Renoir. On February 20, Vuillard dines with the Bernheims and is "dazzled by the Renoirs"[4] **Cat. 204, p. 421** and **Fig. 103, p. 268**.
June 11: Renoir's portrait exhibition at the Galerie Durand-Ruel is a great success. "Many visitors who up to now had not understood Monsieur Renoir's talent are beginning to appreciate it."[5]
Summer: Exhibition of Renoir's drawings at Vollard's (see p. 84).

1913

February: Denis lunches with Renoir in Cagnes and draws his portrait **Cat. 115, p. 224**.
February 17–March 15: Five paintings by Renoir are exhibited at the Armory Show (International Exhibition of Modern Art) in New York.
March 10–29: Renoir exhibition at the Galerie Bernheim-Jeune (fifty-two works). Octave Mirbeau writes the preface to the catalogue and also to the album published with this event.
August: Renoir works with the sculptor Richard Guino at Essoyes.
November 20: Konrad Ferdinand Edmund von Freyhold stays at the Hôtel Savournin in Cagnes. He pays a first visit to Renoir in his Nice apartment and becomes a friend of the Renoir family, seeing them regularly. His correspondence contains descriptions of the apartment in Nice, the estate at Les Collettes, and everyday life in the Renoir household. Freyhold takes numerous photographs, which the Renoir family are delighted about **Cat. 161–63**.

1914

May: Three paintings by Renoir are exhibited at the Louvre as part of the Camondo bequest (1911).
Early March: Rodin visits Cagnes. Renoir is commissioned by the Bernheims to draw his portrait **Cat. 86**.
March: Renoir works on a tapestry cartoon of *The Saône and the Rhône* for the Manufacture des Gobelins **Cat. 88**.
April 28: Renoir is in Cagnes. Aline visits Jean who has joined his regiment at Luçon.
May 23: Freyhold has been in Cagnes since April and spends the afternoon at the Renoir house, where there is an outdoor celebration to mark the end of the orange blossom harvest **Cat. 167–69**.
August 3: Germany declares war on France. Pierre and Jean are mobilized.
November 22: Alone at Cagnes, Renoir writes to Monet: "I often think of you and as I grow older, I begin to think of our youth. This helps me pass the time . . . My wife left three weeks ago to see the children."[6] Pierre and Jean Renoir are wounded and hospitalized in Carcassonne and Luçon.

1915

Renoir paints a new model, Andrée Heuschling, who is fifteen years old and known as Dédée. She will later marry Jean, in January 1920.
May (?): Aline goes to Gérardmer to see Jean, who has been seriously wounded in the leg. When she returns, she is confined to bed and dies in Nice on June 27.
August 3: Renoir is in Paris spending time with Jean as he convalesces.
Mid-December: Renoir asks Vollard and Durand-Ruel for their assistance in drawing up an inventory of his assets in Paris.

1916

June 15: Renoir gives the museum in Limoges a portrait of Colonna Romano.
July 23: Renoir asks for Guino's assistance in executing a monument in memory of his wife.
October–November: French painting exhibition at the Winterthur Kunstmuseum (twenty-six works). Vollard gives a talk on Renoir.

1917

In Cagnes, Renoir teaches pottery-making to his son Claude.
January: Albert and Maleck André stay at Les Collettes.

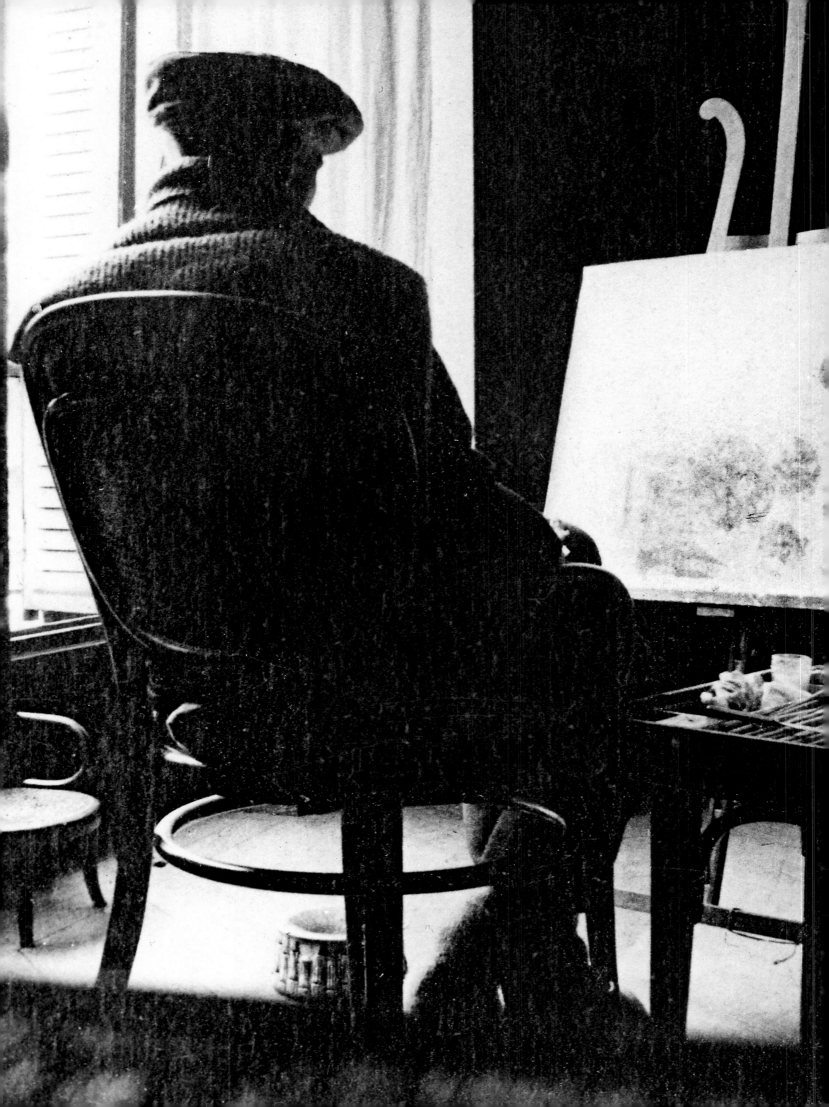

July: The National Gallery in London exhibits *The Umbrellas* (1881–85), part of the Hugh Lane bequest. English artists and art lovers write to Renoir: "From the moment your painting was hung amid the masterpieces of the past, we had the pleasure of observing that one of our contemporaries had immediately taken his rightful place among the great masters of the European tradition."[7]

October–November: Sixty works are shown at the exhibition of nineteenth- and twentieth-century French art at the Kunsthaus Zürich.

December 31: Matisse visits Renoir in Cagnes for the first time. "Not too happy with my visit. I saw Renoir but I didn't see his painting."[8]

1918

Early January: Renoir ends his collaboration with Guino (see p. 71).

January: The Andrés and Bessons visit Renoir in Cagnes.

January 13: Matisse visits Les Collettes again: "I've just returned from Renoir's house where I've seen some splendid paintings; everything has been sorted out in this respect."[9]

Early March: Renoir receives a visit from Vollard. Renoir is keeping well and has "made some masterpieces this winter."[10]

March 11: Visit by Marquet, Matisse, Greta Prozor, and Walther Halvorsen to Cagnes **Cat. 184, p. 138**. Marquet returns the next day.

March 18: Visit by Matisse and Victor Audibert, art lover from Marseille and friend of Charles Camoin.

March 30: The French state purchases the *Portrait of Colonna Romano* for the token sum of 100 francs to put on exhibition at the Musée du Luxembourg.

Spring: Concerned about the German advance, Renoir moves his paintings into safety. Pierre takes several large, rolled canvases to Nice.

June 22: Matisse, who visits Renoir frequently, shows him his Courbet painting **Cat. 189**, as well as his Renoir paintings. He expresses a desire to purchase a recent work.

September 3: Renoir invites the sculptor Louis Morel, originally from Essoyes, to join him in the South of France. Together they work on terracotta bas-reliefs **Cat. 96–98**.

1919

January 7, 10, and 18: Matisse visits Cagnes.

February 19: Renoir is made *Commandeur* of the Legion of Honor. On March 25, General Corbillet presents him with his insignia in Nice.

April 27: Matisse, Marquet, and Bonnard visit Renoir. Matisse believes that Renoir "has been doing marvelous things for a month."[11]

May: Renoir thanks Albert André for the book he has written on him: "you see me through a rose mist, but you see me."[12]

June 24–August 7: Renoir is at Essoyes.

July 29: Paul Rosenberg writes to Picasso in London: "I saw Renoir, who will be in Paris on August 3, and spoke to him about you… he wants to see you. He has been surprised by some things and even more so, shocked by others."[13]

Mid-August: Renoir is in Paris and visits the Louvre at the invitation of Paul Léon, director of the Beaux-Arts. His *Portrait of Madame Georges Charpentier* (1876–77, Musée d'Orsay, RF 2244) is exhibited among the recent acquisitions.

September: Paul Léon visits Renoir at Essoyes where "recently finished paintings, bought for vast sums of money by America, were being packed up." They talk about plans for a gift to the state.[14]

September 9: Plan for a Renoir exhibition for the reopening of the Musée du Luxembourg.

October 2: Renoir tells Léonce Bénédite of his wish to postpone the exhibition to the following spring.

December 3: Renoir dies in Cagnes from complications following lung congestion. He is buried on December 6 in Nice, near Aline.

Mid-December: Monet writes to Fénéon: "you can imagine how much the loss of Renoir pains me: he carried with him a part of my life. For the last three days I have been constantly reliving the years of our youth, of struggle and hope… It's hard to be left alone…"[15]

1920

October 15–December 12: The Salon d'Automne pays homage to Renoir with an exhibition of his late style (the catalogue lists thirty paintings).

1922

March 29: The Galerie Barbazanges and Renoir's sons sign a contract for the purchase of three hundred of the paintings remaining in Renoir's studio.[16]

June 7: Pierre-Auguste and Aline Renoir are re-buried in the cemetery at Essoyes.

1923

Renoir's sons donate *Bathers* **Cat. 80** to the French state.

1931

L'Atelier de Renoir is published by Bernheim-Jeune with prefaces by Albert André and Marc Elder. This two-volume publication includes reproductions of seven hundred and twenty works found in Renoir's studios at the time of his death.

1933

June 26–December 12: Renoir retrospective at the Musée de l'Orangerie. Paul Jamot writes the preface for the catalogue, which includes one hundred and forty-nine items.

1934

January 16–February 24: To complement the Orangerie exhibition, the Galerie Paul Rosenberg presents an exhibition of works produced by Renoir during the last ten years of his life, 1909–19.

The information given here is taken from a detailed chronology published in French in 2009 on the website of the exhibition *Renoir au XXe siècle:* http://www.rmn.fr/Renoir-au-XXe-siecle and the Musée d'Orsay website: http://www.musee-orsay.fr

1. Denis 1892, p. 366. **2.** Pharisien 2009, p. 44. **3.** Baudot 1949, p. 110–111. **4.** Vuillard, *Journal*, February 20, 1912. **5.** *Correspondance Renoir-Durand-Ruel* 1995, vol. 2, pp. 110–111. **6.** Bibliothèque Centrale des Musées Nationaux, Ms 0630 [06-08]. **7.** Albert André 1919, translated in Wadley 1987, p. 262. **8.** Letter to his wife, Matisse archives. **9.** Letter to his wife, Matisse archives. **10.** *Correspondance Renoir-Durand-Ruel* 1995, vol. 2, p. 229. **11.** Letter to his wife, Matisse archives. **12.** Custodia Foundation, 1979-A.399. **13.** Letter to Picasso, Picasso archives, AP. C5 896. **14.** Léon 1947, pp. 200–201. **15.** Wildenstein 1996, vol. 4, no. 2329, p. 403. **16.** Barbazanges archive, Musée d'Orsay.

Albert André?
Renoir from the back at his easel
1901

Cat. 141

Renoir: A Photographic Record

Isabelle Gaëtan

1892–1894

Renoir in his Paris studio
After 1892
Cat. 127

Martial Caillebotte
Renoir seated on the front steps of the Château des Brouillards in Montmartre
Late 1894
Cat. 128

Martial Caillebotte
Renoir in front of the Château des Brouillards, with the basilica of Sacré-Cœur under construction in the background
Late 1894
Cat. 129

Martial Caillebotte
Renoir, Aline, and Jean, born on September 15, 1894
Late 1894
Cat. 130

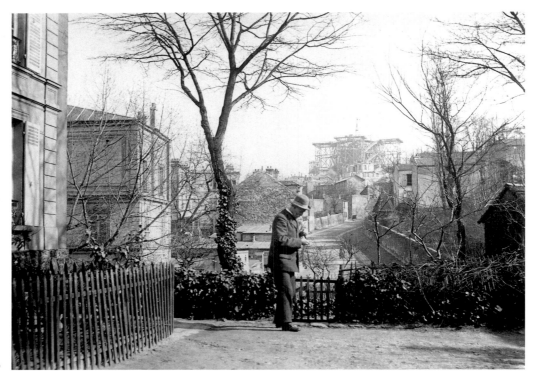

Cat. 129

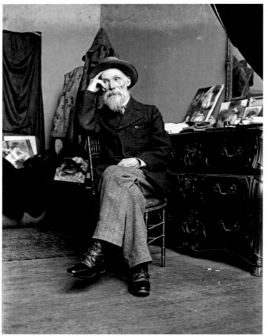

Cat. 127

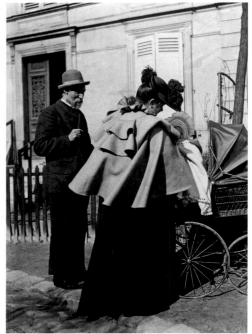

Cat. 130

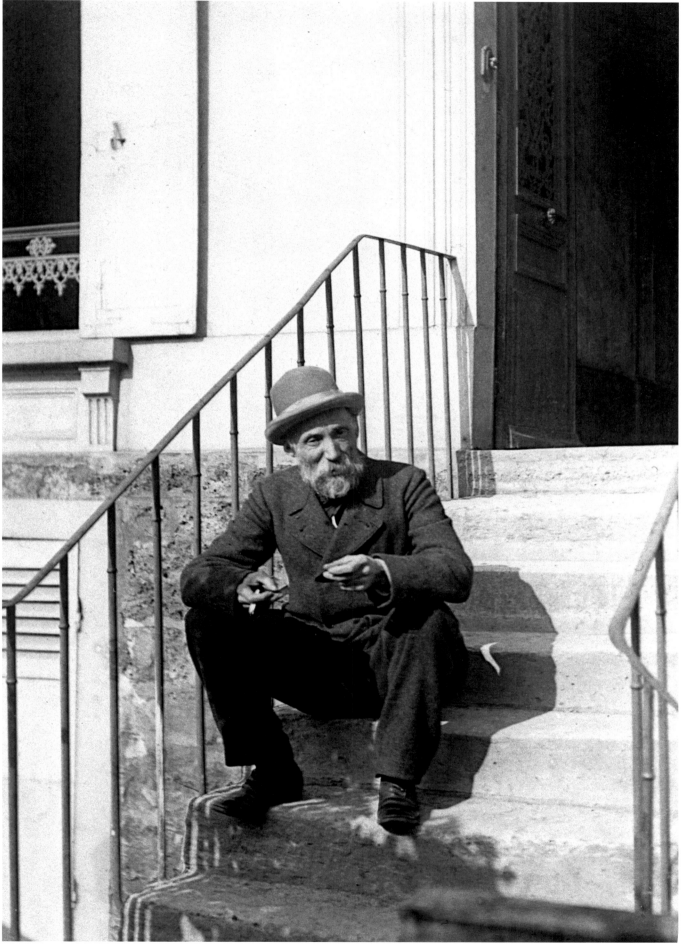

Cat. 128

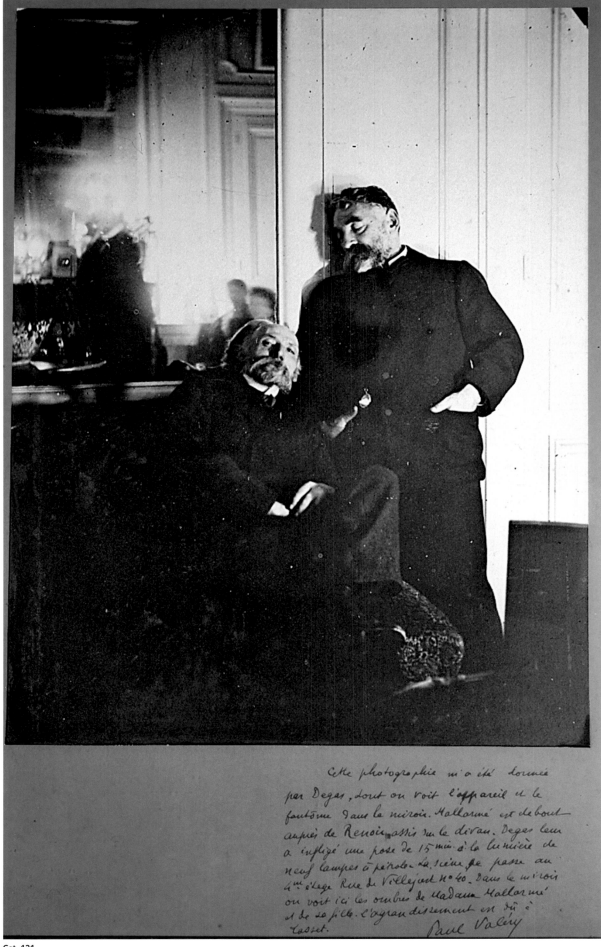

Cette photographie m'a été donnée
par Degas, dont on voit l'appareil et le
fantôme dans le miroir. Mallarmé est debout
auprès de Renoir assis sur le divan. Degas leur
a infligé une pose de 15 min. à la lumière de
neuf lampes à pétrole. La scène se passe au
4ᵐᵉ étage Rue de Villejust nº 40. Dans le miroir
on voit ici les ombres de Madame Mallarmé
et de sa fille. L'agrandissement est dû à
Tasset. Paul Valéry

Cat. 131

1895–1898

Edgar Degas
Renoir and Stéphane Mallarmé in the salon of Julie Manet at 40, rue de Villejust, Paris
December 16, 1895
Cat. 131

Alfred-Athis Natanson
Pierre Bonnard (from the back), Cipa and Ida Godebski, Thadée and Misia Natanson, and Renoir in Villeneuve-sur-Yonne on the evening of Mallarmé's funeral
Sunday, September 11, 1898
Cat. 132

Alfred-Athis Natanson
Renoir, Bonnard, and Misia at the Natansons in Villeneuve-sur-Yonne on the evening of Mallarmé's funeral
Sunday, September 11, 1898
Cat. 133

Alfred-Athis Natanson
Renoir, Bonnard, and Misia in the garden at the Natansons in Villeneuve-sur-Yonne on the evening of Mallarmé's funeral
Sunday, September 11, 1898
Cat. 134

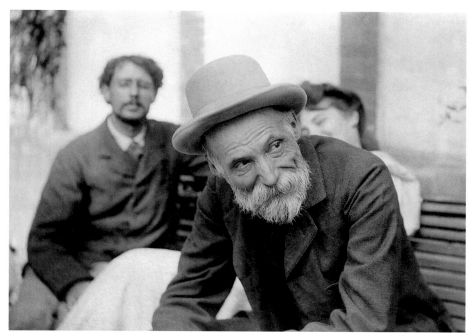

Cat. 133

Cat. 134

Cat. 132

1900–1904

Renoir, his son Pierre, and Alphonse Fournaise (Jr.) in a boat near Chatou
Circa 1900
Cat. 136

Louis Valtat, Georges d'Espagnat and Renoir, on a café terrace in Magagnosc
January–May 1900
Cat. 137

Georges d'Espagnat, Louis Valtat, and Renoir in Magagnosc
January–May 1900
Cat. 138

Renoir and Louis Valtat in Magagnosc
January–May 1900
Cat. 139

Paul Marsan, called Dornac
Auguste Renoir, Painter
October 18, 1904
from the series
Nos contemporains chez eux
(Our Contemporaries at Home)
Cat. 147

Cat. 137

Cat. 138

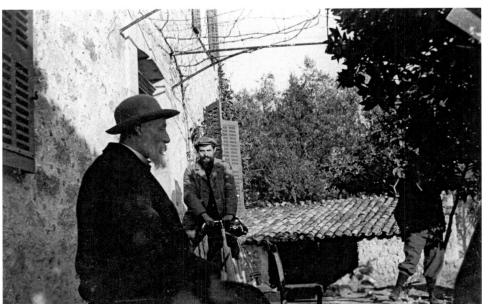

Cat. 139

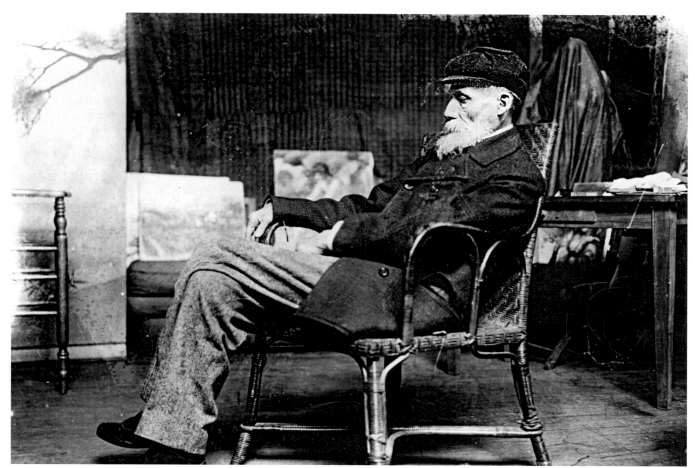

Cat. 147

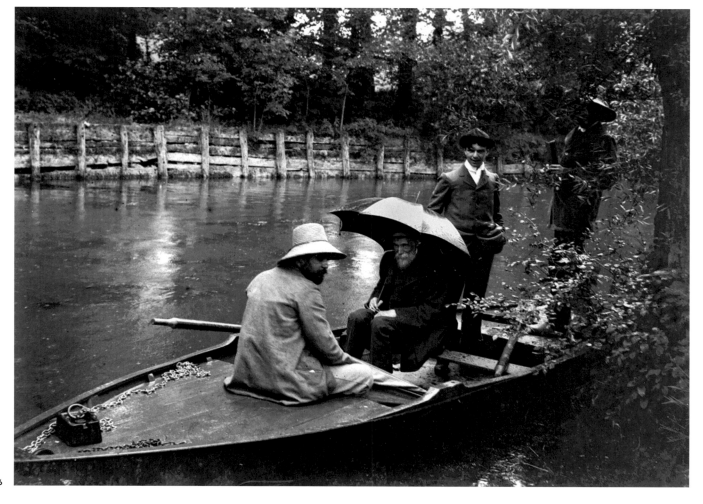

Cat. 136

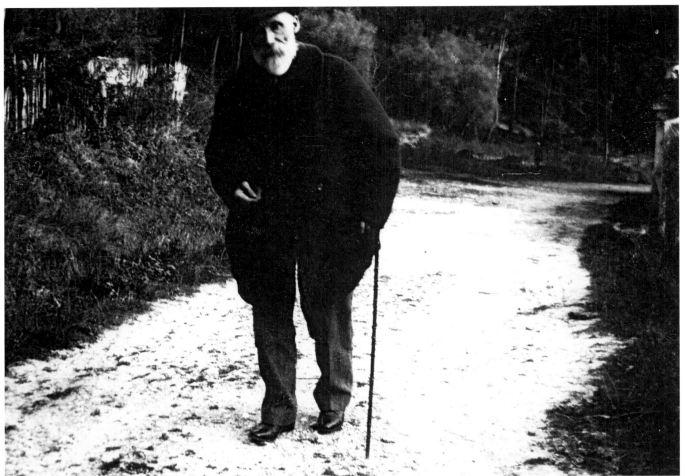

Cat. 143

Cat. 144

1902–1903

Albert André
Renoir taking a walk at Le Cannet
January–late April, 1902
Cat. 143

Albert André
Renoir, Aline, and Claude at Le Cannet
February–late April, 1902
Cat. 144

*The Renoir family in the painter's studio
at 73, rue Caulaincourt, Paris*
Circa 1902–03
Cat. 145

Cat. 145

1904–1906

Albert André
*Renoir painting in Albert André's
garden at Laudun*
1904
Cat. 148

Albert André
*Renoir and Gabrielle in
the Andrés' garden at Laudun*
1906
Cat. 149

Albert André
*Renoir, Maleck André, Gabrielle,
and Thérésine (the cook) at Laudun*
1906
Cat. 150

Albert André
Gabrielle in the Andrés' garden at Laudun
1906
Cat. 151

Cat. 149

Cat. 150

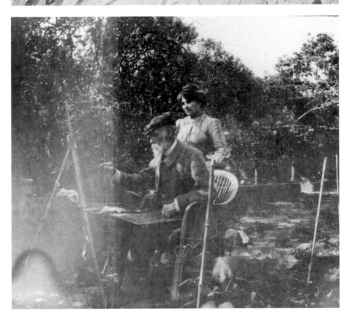

Cat. 148

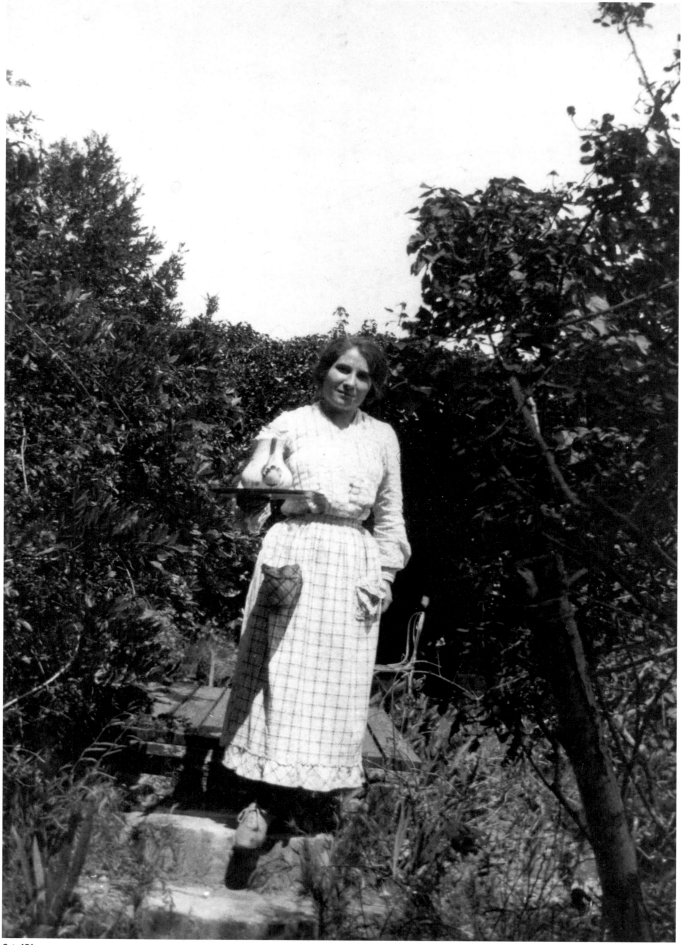

Cat. 151

1912–1913

Gabrielle in Renoir's studio at 38 bis, boulevard de Rochechouart in Paris
Circa 1912–13
Cat. 154

Renoir painting in front of the Maison de la Poste in Cagnes
1912–14
Cat. 156

Albert André
Renoir in the house of Les Collettes at Cagnes
1913
The mantelpiece is decorated with the medallion of Coco **Cat. 89**. Several "study canvases" combining different motifs are pinned to the door (see **Cat. 64 & 76**).
Cat. 158

Renoir and Gabrielle in front of the painting racks in the studio of Les Collettes at Cagnes
Cat. 159

Renoir and Mme de Galéa in the studio at Cagnes
January–February 1912
Cat. 160

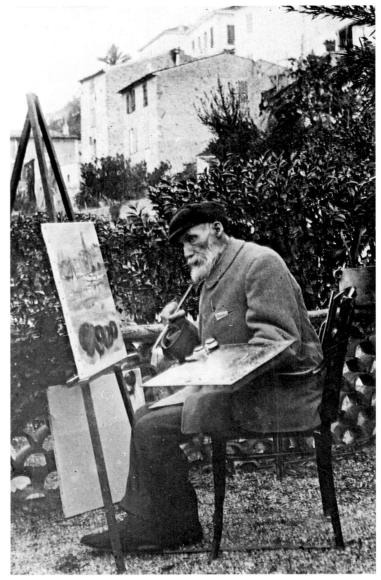

Cat. 156

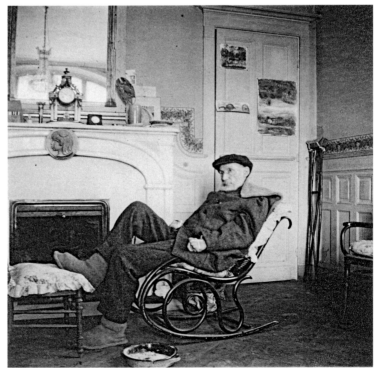

Cat. 158

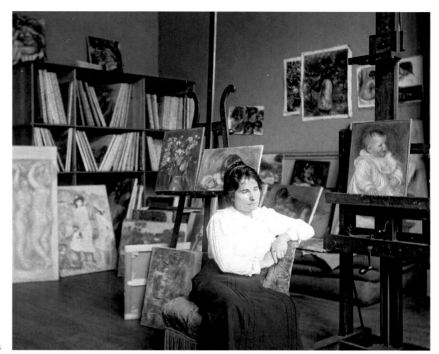

Cat. 154

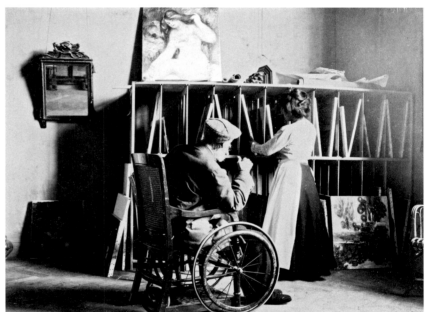

Cat. 159

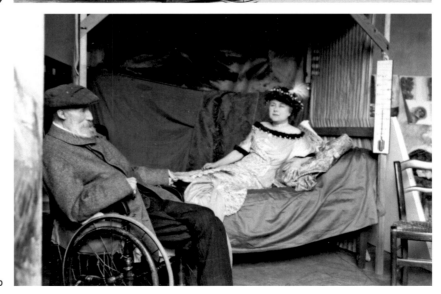

Cat. 160

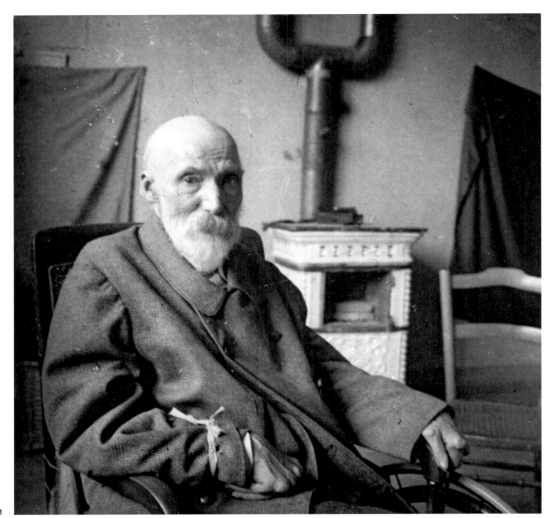

Cat. 161

Cat. 162

1913–1914

Konrad von Freyhold
*Renoir in the apartment he rented in
Nice at 1, place de l'Église-du-Vœu*
November–December 1913
Cat. 161

Konrad von Freyhold
Aline and Coco in the apartment in Nice
November–December 1913
Cat. 162

Konrad von Freyhold
*Renoir in the garden of Les Collettes
at Cagnes*
April–May 1914
Cat. 164

Cat. 164

Cat. 172

Cat. 167

1914

Konrad von Freyhold
Coco in front of an orange tree in the orchard of Les Collettes at Cagnes
April–May 1914
Cat. 165

Konrad von Freyhold
Madeleine Bruno, Renoir's model, in the garden of Les Collettes at Cagnes
April–May 1914
Cat. 166

Konrad von Freyhold
Orange-blossom harvest in the garden of Les Collettes at Cagnes
May 1914
Cat. 167

Konrad von Freyhold
A garden party organized by the Renoirs at Les Collettes in celebration of the end of the orange-blossom harvest
Saturday, May 23, 1914
Cat. 169

Konrad von Freyhold
Gabrielle and the American painter Conrad Slade (her future husband) at Cagnes
April–May 1914
Cat. 170

Konrad von Freyhold
View of the house of Les Collettes at Cagnes (east gable)
November–December 1913
or April–May 1914
Cat. 171

Konrad von Freyhold
An outbuilding on the estate of Les Collettes at Cagnes
November–December 1913
or April–May 1914
Cat. 172

Cat. 165

Cat. 166

Cat. 170

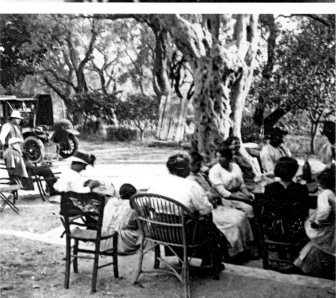

Cat. 169

Cat. 171

1914–1917

*Renoir and Aline in the studio
of Les Collettes at Cagnes*
Circa 1914
Cat. 173

*Renoir and Coco in the garden
of Les Collettes*
1914–15
Cat. 174

Claude Renoir
Renoir painting under a parasol
1916–17
Cat. 177

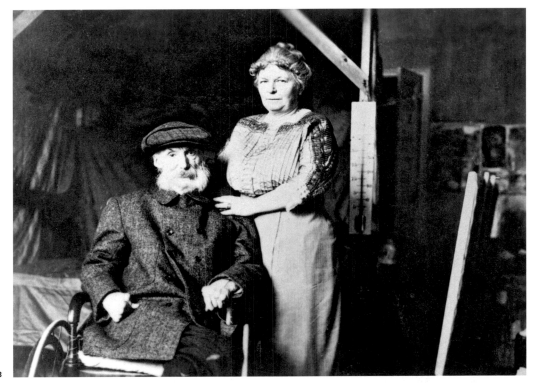

Cat. 173

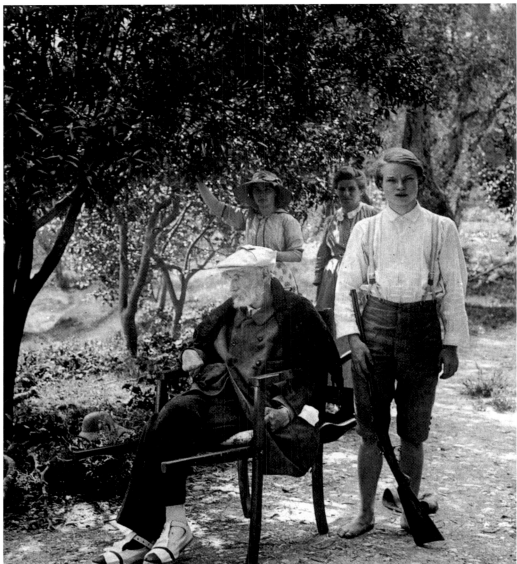

Cat. 174

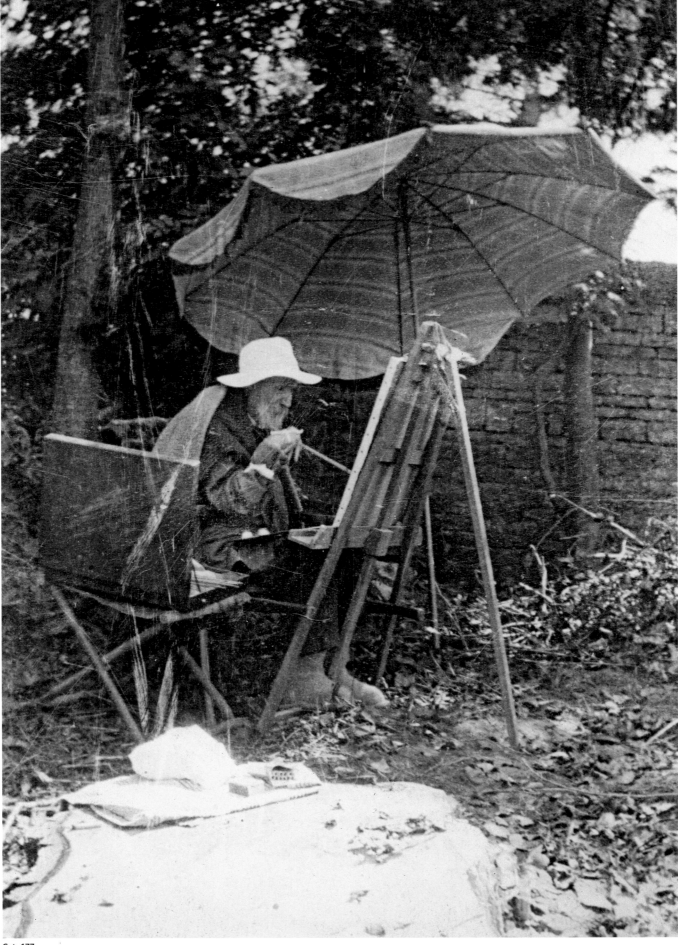

Cat. 177

1915–1916

Attributed to Pierre Bonnard
Pierre-Auguste Renoir and his son Jean
Circa 1916
Cat. 176

*Renoir and his son Pierre in their
apartment at 57 bis, boulevard de
Rochechouart, Paris*
1915–17
Cat. 178

Renoir
Circa 1915?
Renoir dedicated this photographic
portrait to Mme George Besson.
Cat. 181

Renoir
The photograph comes from an album
of artists' portraits put together by
Maurice Denis.
Cat. 182

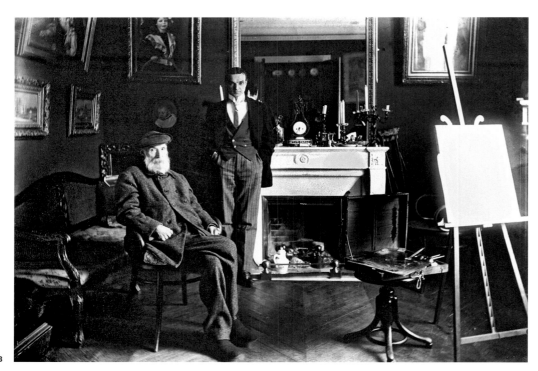

Cat. 178

Cat. 182

Cat. 181

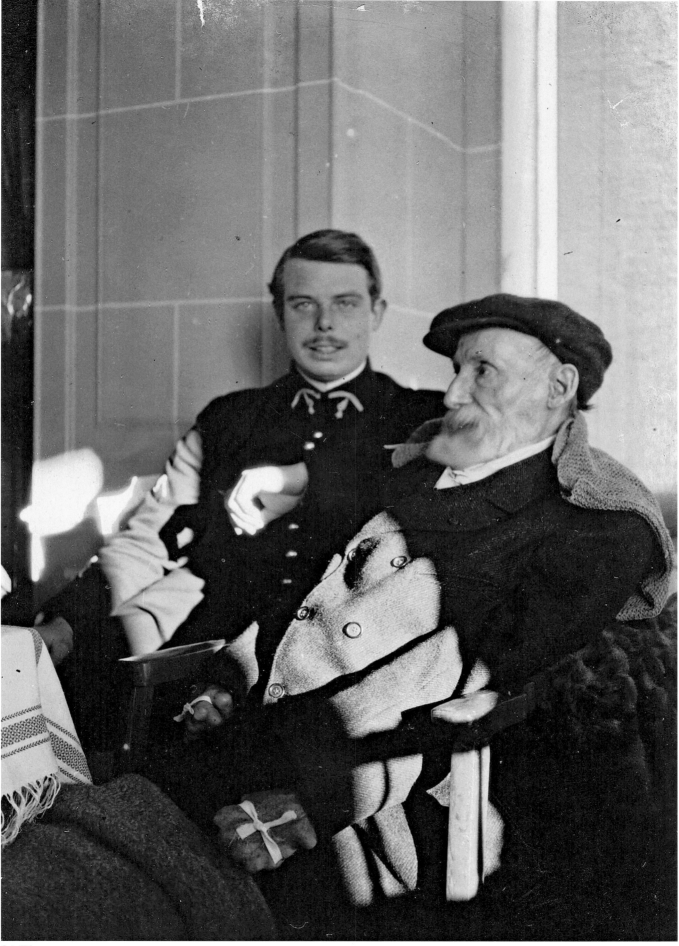

Cat. 176

1918–1930

George Besson
Renoir's studio at Cagnes
[January?] 1918
Andrée Heuschling, Renoir's favorite
model in his very last years, is recognizable
in several of the works seen here in the
painter's studio.
Cat. 180

Walther Halvorsen
*Renoir in his studio at Les Collettes
at Cagnes*
[March 11] 1918
Matisse owned a print of this photograph
that had been signed by Renoir.
Cat. 183

*Ambroise Vollard in front of Renoir's
Great Bathers, the version the dealer had
commissioned in 1903*
Circa 1920–30
Cat. 186

Denis-Jean Clergue
*Renoir's studio in the garden
of Les Collettes at Cagnes*
1947
Cat. 187

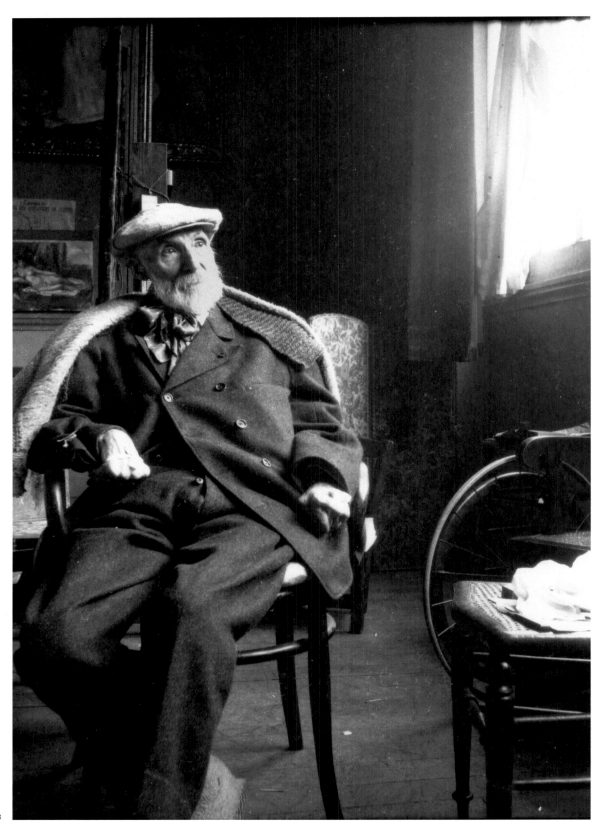

Cat. 183

Cat. 180

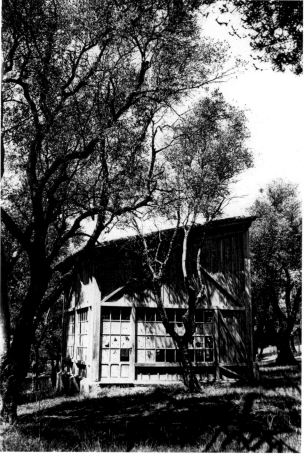

Cat. 187

Cat. 186

1939–1945

Albert André in his studio at Laudun
1939–45
Cat. 188

Comtesse Costa de Beauregard
*Pierre Bonnard and Claude Renoir in
the garden of Les Collettes at Cagnes*
1942–43
Cat. 198

Pierre Matisse
*Dr. Barnes in one of the galleries at his
foundation in front of* The Artist's Family
by Renoir (1896)
Late May 1933
Cat. 203

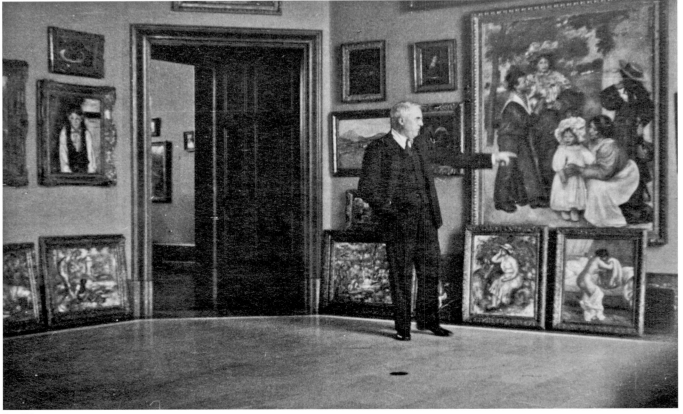

Cat. 203

Cat. 198

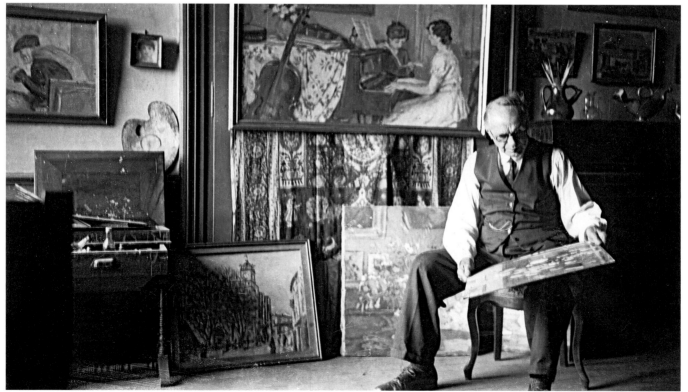

Cat. 188

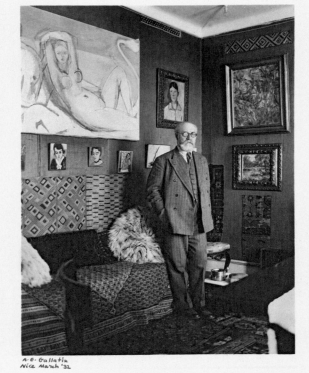

*A·E·Gallatin
Nice March '32*

*sympathiquement
Henri · Matisse*

Cat. 191

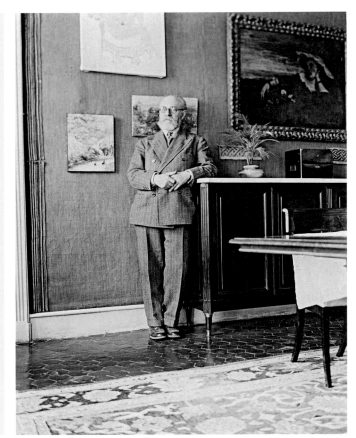

Cat. 189

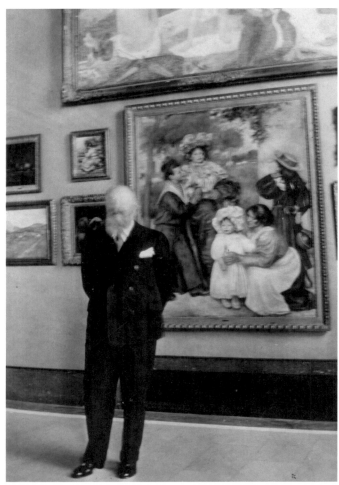

Cat. 192

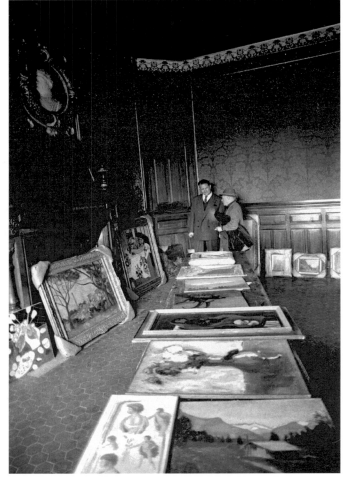

Cat. 197

1932–1959

Albert Eugène Gallatin
Henri Matisse in his Nice apartment, posing in front of Mediterranean Landscape by Renoir; on his left, Sketch for a Young Lady on the Banks of the Seine by Gustave Courbet (1856), which he showed to Renoir on June 22, 1918
1932
Cat. 189

Albert Eugène Gallatin
Henri Matisse in his Nice apartment. At left on the wall, a landscape by Renoir
1932
Cat. 191

Pierre Matisse
Henri Matisse at the Barnes Foundation in front of The Artist's Family *by Renoir (1896)*
Late May 1933
Cat. 192

André Ostier
Picasso in his studio in his villa La Californie (Cannes) with, placed on a piece of furniture, Portrait of a Model, Bust-Length *by Renoir* Cat. 75
September 1958
Cat. 196

David Douglas Duncan
Picasso at the Château de Vauvenargues with his collection of paintings. In the foreground, Renoir's Studies of Figures from Antiquity Cat. 76
1959
Cat. 197

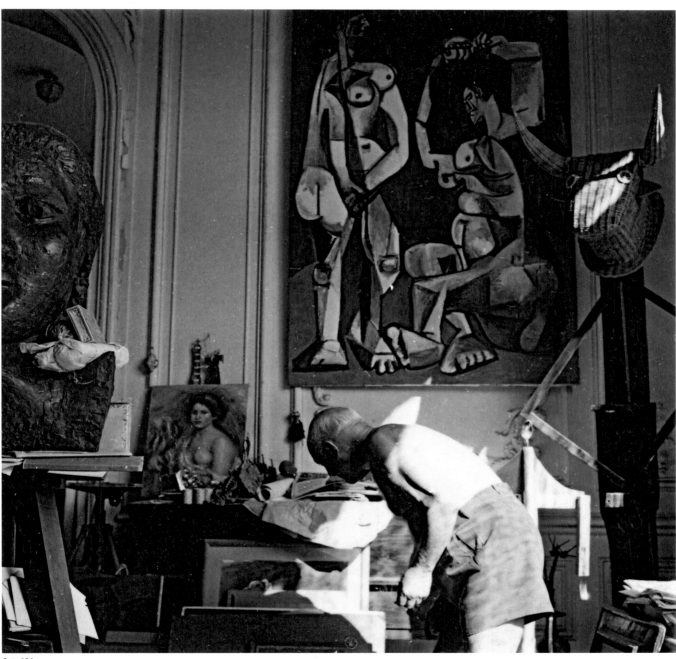

Cat. 196

Appendices

List of Exhibited Works by Picasso, Matisse, Bonnard, Denis, Maillol, and Albert André

Isabelle Gaëtan

Cat. 99

Pablo Picasso (1881–1973)
Portrait of Pierre-Auguste Renoir (after a photograph)
1919–20
Pencil on a charcoal drawing on vellum
24 x 19³⁄₈ in. (61 x 49.3 cm)
Paris, Musée National Picasso, acquired by gift in lieu of inheritance taxes, 1979
M.P.913
Exhibited in Paris, illustrated on p. 125

Cat. 100

Pablo Picasso
Large Bather
1921
Signed and dated lower right: Picasso / 21
Oil on canvas
71⁵⁄₈ x 40 in. (182 x 101.5 cm)
Paris, Musée National de l'Orangerie, collection of Jean Walter and Paul Guillaume, purchased by the French state with the support of the Société des Amis du Louvre, 1963
RF 1963-77
Exhibited in Paris, illustrated on p. 131

Cat. 101

Pablo Picasso
Woman with a White Hat
1921
Signed bottom right: Picasso
Oil on canvas
46¹⁄₂ x 35⁷⁄₈ in. (118 x 91 cm)
Paris, Musée National de l'Orangerie, collection of Jean Walter and Paul Guillaume, purchased by the French state with the support of the Société des Amis du Louvre, 1963
RF 1963-72
Exhibited in Los Angeles and Philadelphia, illustrated on p. 411

Cat. 102

Pablo Picasso
The Village Dance
1922
Fixed pastel and oil on canvas
54⁷⁄₈ x 33⁵⁄₈ in. (139.5 x 85.5 cm)
Paris, Musée National Picasso, acquired by gift in lieu of inheritance taxes, 1979
M.P.73
Exhibited in Paris, illustrated on p. 132

Cat. 103

Pablo Picasso
Child Eating (Paulo)
1922
Oil on canvas
13³⁄₄ x 12¹⁄₄ in. (35 x 31 cm)
Collection Marina Picasso
Illustrated on p. 216

Cat. 104

Pablo Picasso
Large Nude with Drapery
1923
Oil on canvas
63 x 37³⁄₈ in. (160 x 95 cm)
Paris, Musée National de l'Orangerie, collection of Jean Walter and Paul Guillaume, purchased by the French state with the support of the Société des Amis du Louvre, 1959
RF 1960-3
Not exhibited, illustrated on p. 300

Cat. 105

Pablo Picasso
Harlequin with a Mirror
1923
Oil on canvas
39³⁄₈ x 31⁷⁄₈ in. (100 x 81 cm)
Signed and dated top right: Picasso/1923
Madrid, Museo Thyssen-Bornesmisza
Exhibited in Paris, illustrated on p. 258

Cat. 106

Henri Matisse (1869–1954)
Renoir's Garden in Cagnes
1917
Signed lower right: Henri Matisse
Oil on cradled wood
14⁵⁄₈ x 17³⁄₄ in. (37 x 45 cm)
Algiers, Musée des Beaux-Arts d'Alger
Not exhibited, illustrated on p. 140

Cat. 107

Henri Matisse
Two Models Resting
1928
Oil on canvas
18¹⁄₂ x 28⁷⁄₈ in. (47 x 73.3 cm)
Philadelphia Museum of Art, gift of Mrs. Frank Abercrombie Elliott, 1964
1964-107-1
Illustrated on p. 145

Cat. 108

Pierre Bonnard (1867–1947)
The Peacock, or The Three Graces
1908
Oil on canvas
42¹⁄₂ x 49¹⁄₄ in. (108 x 125 cm)
Signed lower right: Bonnard
Private collection, Courtesy of Galerie Bernheim et Cie, Paris
Exhibited in Paris, illustrated on p. 155

Cat. 109

Pierre Bonnard
The Loge
1908
Oil on canvas
35⁷⁄₈ x 47¹⁄₄ in. (91 x 120 cm)
Signed lower left: Bonnard
Paris, Musée d'Orsay, acquired by gift in lieu of inheritance taxes, 1989
RF 1989-32
Exhibited in Paris, illustrated on p. 282

Cat. 110

Pierre Bonnard
Sketchbook called *The Painter's Life: The Galerie of Ambroise Vollard, 6 rue Laffitte in Paris.* Upper section, from left: Pierre-Auguste Renoir, Camille Pissarro (seated), Ambroise Vollard (holding a painting), Pierre Bonnard, and Edgar Degas (seated); lower section: *The Puppet Theater*
Circa 1910
Traces of sketches in pencil, pen and brown and black ink, gray-blue wash
12³⁄₈ x 9¹⁄₂ in. (31.5 x 24 cm)
Paris, Musée d'Orsay, kept at the Département des Arts Graphiques, Musée du Louvre, acquired in 2003
RF 52756, fo 4 ro
Exhibited in Paris, illustrated on p. 148

Cat. 110a

Pierre Bonnard
Morning Toilette, or *Nude Near the Window*
1912
Oil on canvas
49⁵⁄₈ x 26¹⁄₂ in. (126.5 x 67.3 cm)
Private collection
Exhibited in Los Angeles, illustrated on p. 412

Cat. 111

Pierre Bonnard
Portrait of Pierre-Auguste Renoir
Before 1916
Pen and India ink
12¹⁄₄ x 7⁷⁄₈ in. (31 x 20 cm)
Private collection
Exhibited in Paris, illustrated on p. 153

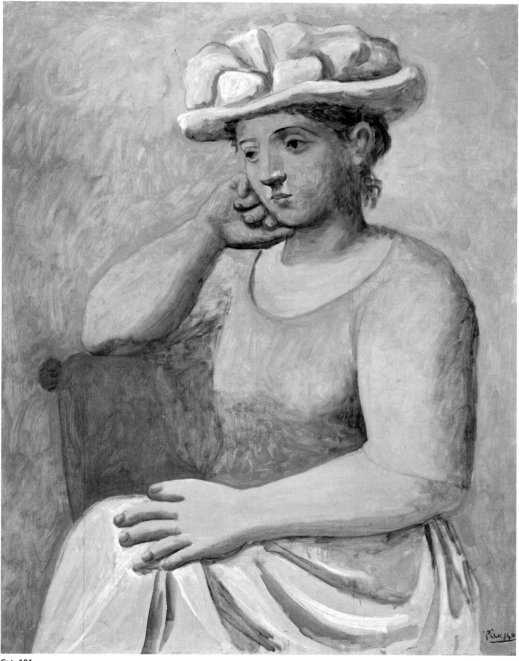

Cat. 101

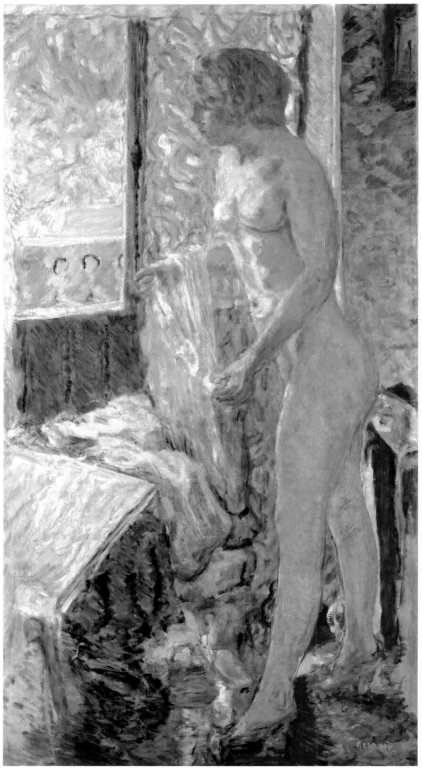

Cat. 110a

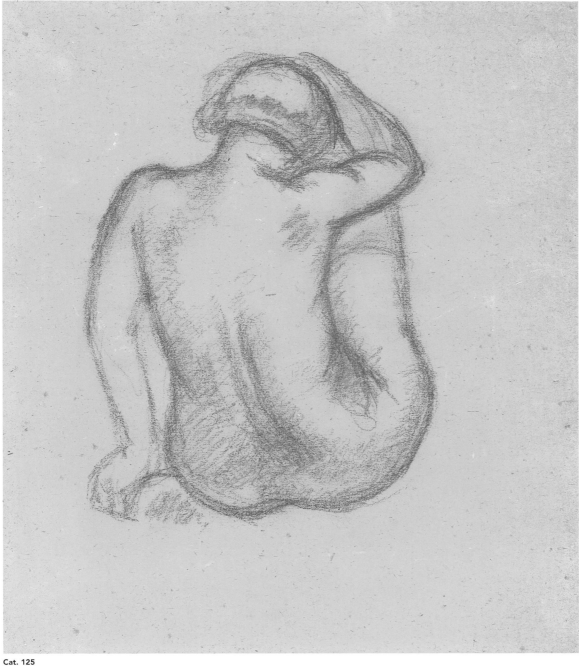

Cat. 125

Cat. 112

Pierre Bonnard
Portrait of Pierre-Auguste Renoir
Before 1916
Etching
10⁵/₈ x 7⁷/₈ in. (27 x 20 cm)
Paris, Bibliothèque Nationale de France, Département des Estampes et de la Photographie
Exhibited in Paris, illustrated on p. 153

Cat. 113

Pierre Bonnard
Sunlight
1923
Oil on canvas
24⁷/₈ x 24¹/₂ in. (63.2 x 62.2 cm)
Madrid, Carmen Thyssen-Bornemisza Collection, on loan at the Thyssen-Bornemisza Museum
Illustrated on p. 208

Cat. 114

Maurice Denis (1870–1943)
Portrait of Pierre-Auguste Renoir with Jeanne Baudot
Circa 1906
Oil on board
10³/₄ x 8¹/₈ in. (27.2 × 20.5 cm)
Paris, private collection
Exhibited in Paris, illustrated on p. 224

Cat. 115

Maurice Denis
Portrait of Pierre-Auguste Renoir
February 1913
Dated lower right: Cagnes fevr 1913
Watercolor and black pencil on paper
7 x 4¹/₄ in. (17.7 x 10.7 cm)
Private collection, carnet no. 41, fol. 57
Exhibited in Paris, illustrated on p. 224

Cat. 116

Aristide Maillol (1861–1944)
Torso of L'Action enchainée
Circa 1906
Bronze
47 x 32 x 29 in. (119.4 x 81.3 x 73.7 cm)
Collection of Lynda and Stewart Resnick
Exhibited in Los Angeles, not illustrated

Cat. 117

Aristide Maillol
Portrait of Pierre-Auguste Renoir
1906–1907
Bronze
15⁷/₈ x 9¹/₂ in. (40.3 x 24.1 cm)
New York, The Metropolitan Museum of Art, Edith Perry Chapman Fund, 1951; acquired from The Museum of Modern Art, gift of Mrs. Cornelius J. Sullivan, in memory of Cornelius J. Sullivan
53.140.8
Illustrated on p. 274

Cat. 118

Aristide Maillol
Pomona
1937
Bronze
66³/₄ x 22¹/₄ x 15¹/₂ in. (169.5 x 56.5 x 39.4 cm)
Philadelphia, Philadelphia Museum of Art, Gift of R. Sturgis et Marion B. F. Ingersoll, 1959
1959-150-1
Exhibited in Los Angeles and Philadelphia, see p. 162

Cat. 119

Aristide Maillol
Reclining Female Nude (Study for Monument to Cézanne)
Circa 1912
Charcoal on paper
6¹/₂ x 9¹/₈ in. (16.5 x 23.2 cm)
San Francisco, Fine Arts Museums of San Francisco, Gift of Arthur Sambone, 1925
1925.131
Exhibited in Los Angeles and Philadelphia, not illustrated

Cat. 120

Aristide Maillol
Study of Two Female Nudes
Circa 1910–25
Graphite on wove paper
8¹/₂ x 10³/₄ in. (21.6 x 27.3 cm)
San Francisco, Fine Arts Museums of San Francisco, Gift of Manug K. Terzian, 1956
1956.71
Exhibited in Los Angeles and Philadelphia, not illustrated

Cat. 121

Aristide Maillol
Seated Nude
Red chalk on paper
14¹/₄ x 9³/₈ in. (36.2 x 23.8 cm)
Monogrammed (M in a circle) lower right in red chalk
Philadelphia, Philadelphia Museum of Art, Louis E. Stern Collection, 1963
1963-181-160
Not illustrated

Cat. 122

Aristide Maillol
Nude Woman Standing
Red chalk on paper
11³/₄ x 7¹/₄ in. (29.8 x 18.4 cm)
Monogrammed (M in a circle) lower center
Cleveland, The Cleveland Museum of Art, Gift of The Print Club of Cleveland, 1926
1926.544
Exhibited in Los Angeles, not illustrated

Cat. 123

Aristide Maillol
Female Nude from the Back
Graphite pencil on paper
8⁷/₈ x 7¹/₄ in. (22.5 x 18.5 cm)
Studio stamp (L. 1852b) at lower right
Paris, Musée d'Orsay, kept at the Département des Arts Graphiques, Musée du Louvre, Berthellemy Bequest, 1930
RF 39696
Exhibited in Paris, not illustrated

Cat. 124

Aristide Maillol
Seated Female Nude
Red chalk on laid paper
9⁷/₈ x 7¹/₄ in. (25.2 x 18.3 cm)
Monogrammed (M in a circle) lower left side
Los Angeles County Museum of Art, Gift of the Austin and Irene Young Trust, 1994
AC 1994.87.30
Exhibited in Los Angeles and Philadelphia, not illustrated

Cat. 125

Aristide Maillol
Seated Nude
Red chalk on paper
14⁵/₈ x 9¹¹/₁₆ in. (37.1 x 24.6 cm)
Bloomington, Indiana University Art Museum, James S. Adams Collection, Elizabeth G. Adams Bequest, 1981
81.31.10
Exhibited in Los Angeles and Philadelphia, illustrated on p. 413

Cat. 126

Albert André (1869–1954)
Study for Renoir Painting His Family
1901
Pencil on paper
9⁷/₈ x 12³/₄ in. (25 x 32.5 cm)
Pont-Saint-Esprit, Musée d'Art Sacré du Gard, Jacqueline Bret-André Bequest, 2008
CD.008.17.201
Exhibited in Paris, illustrated on p. 256

List of Photographs Exhibited in Paris

Isabelle Gaëtan

Note
Unless otherwise indicated
– all photographs are vintage prints
– all dates refer to the original shot
– all dimensions refer to the originals

Cat. 127

Renoir seated in his Paris studio, most likely the one at 15, rue Hégésippe-Moreau
After 1892
Modern print made by Patrice Schmidt from a glass negative
4³/₄ x 3¹/₂ in. (12 x 9 cm)
Paris, Musée d'Orsay, Archives Vollard
ODO 1996-56-1979
Illustrated on p. 382

Cat. 128

Martial Caillebotte (1853–1910)
Renoir seated on the front steps of the Château des Brouillards on Montmartre
Late 1894 [after Jean's birth on September 15]
7¹/₄ x 5¹/₈ in. (18.3 x 13 cm) (modern print)
After an original print in a private collection
The painter lived in this building at 13, rue Girardon starting in late 1890.
Illustrated on p. 383

Cat. 129

Martial Caillebotte
Renoir in front of the Château des Brouillards, with the basilica of Sacré-Cœur under construction in the background
Late 1894 [after Jean's birth on September 15]
5¹/₈ x 6³/₄ in. (13 x 17.2 cm) (modern print)
After an original print in a private collection
Illustrated on p. 382

Cat. 130

Martial Caillebotte
Renoir, Aline, and baby Jean, in front of the Château des Brouillards
Late 1894 [after Jean's birth on September 15]
7⁷/₈ x 5³/₄ in. (20 x 14.5 cm) (modern print)
After an original print in a private collection
Illustrated on p. 382

Cat. 131

Edgar Degas (1834–1917)
Renoir and Stéphane Mallarmé in the salon of Julie Manet, Paule and Jeannie Gobillard, at number 40, rue de Villejust, Paris; reflected in the mirror, Degas with his camera, as well as the wife and daughter of Mallarmé
December 16, 1895
Enlargement and print by Delphine or Guillaume Tasset, mounted on cardboard
15¹/₈ x 11¹/₂ in. (38.5 x 29.2 cm)
Paul Valéry's commentary on the cardboard mount: "This photograph was given to me by Degas, whose camera and phantom can be seen in the mirror. Mallarmé is standing next to Renoir, seated on the divan; Degas made them pose for 15 minutes, lit by nine petroleum lamps. The scene took place on the 4th floor of rue de Villejust, no. 40. In the mirror you can see the shadows of Madame Mallarmé and her daughter. The enlargement was done by Tasset. Paul Valéry."
Paris, Chancellerie des Universités, Bibliothèque Littéraire Jacques-Doucet
79
Illustrated on p. 384

Cat. 132

Louis-Alfred, known as **Alfred-Athis Natanson** (1873–1932)
Pierre Bonnard (from the back), Cipa and Ida Godebski, Thadée and Misia Natanson, and Renoir, in the garden of Les Relais, the Natansons' estate at Villeneuve-sur-Yonne, on the evening of Mallarmé's funeral
Sunday, September 11, 1898
Gelatin-silver print
5¹/₈ x 7¹/₈ in. (13 x 18 cm)
Vaillant-Charbonnier collection
Illustrated on p. 385

Cat. 133

Louis-Alfred, known as Alfred-Athis Natanson
Renoir, Bonnard, and Misia Natanson on the evening of Mallarmé's funeral at the Natansons' at Villeneuve-sur-Yonne
Sunday, September 11, 1898
5¹/₈ x 7¹/₈ in. (13 x 18 cm)
Vaillant-Charbonnier collection
Illustrated on p. 385

Cat. 134

Louis-Alfred, known as Alfred-Athis Natanson
Renoir, Pierre Bonnard, and Misia Natanson on the evening of Mallarmé's funeral, in the garden of Les Relais, the Natansons' estate at Villeneuve-sur-Yonne
Sunday, September 11, 1898
5¹/₈ x 7¹/₈ in. (13 x 18 cm)
Vaillant-Charbonnier collection
Illustrated on p. 385

Cat. 135

Louis-Alfred, known as Alfred-Athis Natanson
Renoir on the evening of Mallarmé's funeral, at the Natansons' at Villeneuve-sur-Yonne
Sunday, September 11, 1898
Gelatin-silver print
5¹/₈ x 7¹/₈ in. (13 x 18 cm)
Vaillant-Charbonnier collection
Not illustrated

Cat. 136

Renoir, his son Pierre, and Alphone Fournaise (Jr.) in a boat near Chatou
Circa 1900
Modern print made by Patrice Schmidt from a glass negative
2³/₈ x 3¹/₂ in. (6 x 9 cm)
Paris, Musée d'Orsay, Archives Vollard
ODO 1996-56-1981
Illustrated on p. 387

Cat. 137

Louis Valtat, Georges d'Espagnat and Renoir on a café terrace in Magagnosc
January–May 1900
4¹/₈ x 5⁷/₈ in. (10.4 x 15 cm) (modern print)
Archives de l'Association Les Amis de Louis Valtat
Illustrated on p. 386

Cat. 138

Georges d'Espagnat, Louis Valtat, and Renoir in Magagnosc
January–May 1900
4 x 5⁷/₈ in. (10.2 x 15 cm) (modern print)
Archives de l'Association Les Amis de Louis Valtat
The three painters are most likely standing in front of the Villa Raynaud in Magagnosc.
Illustrated on p. 386

Cat. 139

Renoir and Louis Valtat in Magagnosc
January–May 1900
4 x 5⁷/₈ in. (10.2 x 15 cm) (modern print)
Archives de l'Association Les Amis de Louis Valtat
At the time, Renoir was renting the Villa Raynaud, on the road to Magagnosc, near Grasse.
Illustrated on p. 386

Cat. 140

Albert André? (1869–1954)
Renoir at the easel, in his studio at 73, rue Caulaincourt, Paris
1901
6¹/₈ x 4¹/₈ in. (15.5 x 10.4 cm)
Pont-Saint-Esprit, Musée d'Art Sacré du Gard, Jacqueline Bret-André Bequest, 2008
CD.008.17.260
Illustrated on p. 376

Cat. 141

Albert André?
Renoir from the back in front of his easel, in his studio, at 73, rue Caulaincourt
1901
6⁷/₈ x 4¹/₂ in. (17.3 x 11.5 cm)
Pont-Saint-Esprit, Musée d'Art Sacré du Gard, Jacqueline Bret-André Bequest, 2008
CD.008.17.261
Illustrated on p. 380

Cat. 142

Renoir painting the portrait of Mathilde Adler, the future Mrs. Josse-Bernheim-Dauberville, at the Bellune Pavilion at Fontainebleau
September 1901
Paris, Archives photographiques Bernheim-Jeune
Illustrated on p. 99

Cat. 143

Albert André
Renoir taking a walk at Le Cannet
January–late April 1902
4⁵/₈ x 7 in. (11.6 x 17.7 cm)
Pont-Saint-Esprit, Musée d'Art Sacré du Gard, Jacqueline Bret-André Bequest, 2008
CD.008.17.259
Illustrated on p. 388

Cat. 144

Albert André
Renoir, Aline, and Claude at Le Cannet
February–late April 1902
5 x 6¹/₈ in. (12.6 x 15.6 cm)
Pont-Saint-Esprit, Musée d'Art Sacré du Gard, Jacqueline Bret-André Bequest, 2008
CD.08.17.257
Illustrated on p. 388

Cat. 145

The Renoir family in the painter's studio at 73, rue Caulaincourt, Paris
Circa 1902–03
Modern print made by Patrice Schmidt from a glass negative
3¹/₂ x 2³/₈ in. (9 x 6 cm)
Paris, Musée d'Orsay, Archives Vollard
ODO 1996-56-1977
Aline holds Claude (born in 1901) on her lap. Jean (born in 1894) stands next to her, while Pierre, the eldest son (born in 1885), stands next to his father at the right.
Illustrated on p. 389

Cat. 146

Dornac (also called Paul Marsan, pseudonym of Paul Cardon [1858–1941])
Auguste Renoir, Painter
October 18, 1904
Print on citrate paper mounted on cardboard
4⁵/₈ x 6³/₄ in. (11.6 x 17 cm)
Album-card from the series *Nos contemporains chez eux* (Our Contemporaries at Home)
Paris, Bibliothèque Nationale de France, Département des Estampes et de la Photographie
Not illustrated

Cat. 147

Dornac (also called Paul Marsan, pseudonym of Paul Cardon)
Auguste Renoir, Painter
October 18, 1904
Print on citrate paper mounted on cardboard
4⁵/₈ x 6³/₄ in. (11.6 x 17 cm)
Album-card from the series *Nos contemporains chez eux* (Our Contemporaries at Home)
Paris, Bibliothèque Nationale de France, Département des Estampes et de la Photographie
Illustrated on p. 387

Cat. 148

Albert André
Renoir painting in Albert André's garden at Laudun, in the Gard Region
1904
Gelatin-silver print
3³/₈ x 3⁵/₈ in. (8.5 x 9.2 cm)
Pont-Saint-Esprit, Musée d'Art Sacré du Gard, Jacqueline Bret-André Bequest, 2008
CD 008.17.258
Illustrated on p. 390

Cat. 149

Albert André
Renoir and Gabrielle in the Andrés' garden at Laudun
1906
3¹/₄ x 3⁵/₈ in. (8.4 x 9.1 cm)
Pont-Saint-Esprit, Musée d'Art Sacré du Gard, Jacqueline Bret-André Bequest, 2008
CD.008.17.255
Illustrated on p. 390

Cat. 150

Albert André
Renoir, Maleck André, Gabrielle, and Thérésine Héliogabale (the Andrés' cook) in the garden of Laudun
1906
4³/₄ x 3¹/₂ in. (12 x 9 cm)
Pont-Saint-Esprit, Musée d'Art Sacré du Gard, Jacqueline Bret-André Bequest, 2008
CD.08.17.254
Illustrated on p. 390

Cat. 151

Albert André
Gabrielle in the Andrés' garden at Laudun
1906
6³/₄ x 5 in. (17.2 x 12.6 cm)
Pont-Saint-Esprit, Musée d'Art Sacré du Gard, Jacqueline Bret-André Bequest, 2008
CD.008.17.256
Illustrated on p. 391

Cat. 152

Gabrielle modeling in the studio of Les Collettes at Cagnes
Circa 1911
5¹/₈ x 7¹/₈ in. (13 x 18 cm)
Los Angeles, University of California, Art Library Special Collection, Jean Renoir collection
Illustrated on p. 294

Cat. 153

Renoir seated in one of his studios
1912
Modern print made by Patrice Schmidt from a glass negative
4³/₄ x 3¹/₂ in. (12 x 9 cm)
Paris, Musée d'Orsay, Archives Vollard
ODO 1996-56-1975
See the print belonging to Picasso, reproduced on p. 124
Picasso drew a portrait of the painter from this photograph after Renoir's death
Cat. 99, p. 125

Cat. 154

Gabrielle in Renoir's studio at 38 bis, boulevard de Rochechouart, Paris
Circa 1912–13
Modern print made by Patrice Schmidt from a glass negative
7¹/₈ x 9¹/₂ in. (18 x 24 cm)
Paris, Musée d'Orsay, Archives Vollard
ODO 1996-56-1692
Paintings visible in the photograph, above the painting racks:
Nude Drying Herself (1912, Toledo, Toledo Museum of Art), *Seated Bather Asleep*
(1912, sales cat., Paris, Piasa, 2003, no. 17);
leaning against the racks: *Caryatids* (ca. 1909–12, Merion, PA, Barnes Foundation),
Children on the Beach at Guernsey (ca. 1883, Boston, Museum of Fine Arts);
on the easel to Gabrielle's right: *Bouquet of Tulips* (1905, Paris, Musée National de
l'Orangerie), *Claude Renoir Writing* (1905–06; Bernheim-Jeune 1931, no. 296);
at the foot of the easel: *Woman Writing a Letter* (ca. 1890–95, Musée National de
l'Orangerie), *Landscape* (1905; Vollard 1989, no. 334);
on the easel to Gabrielle's left: *Child with a Spoon* (1905; Bernheim-Jeune 1931,
no. 274);
on the wall, from left to right: *Woman with a Basket* (Vollard 1989, no. 438),
Claude Renoir Writing (1905, Cagnes-sur-Mer, Musée Renoir, on deposit Musée
d'Orsay, MNR 1004);
on the sofa: *Léontine and Coco* (1909; sales cat. New York, Sotheby's, 1990).

Cat. 155

Gabrielle in Renoir's studio at 38 bis, boulevard de Rochechouart, Paris
Circa 1912–13
Modern print made by Patrice Schmidt from a glass negative
7¹/₈ x 9¹/₂ in. (18 x 24 cm)
Paris, Musée d'Orsay, Archives Vollard
ODO 1996-56-1694
Work visible in addition to those in cat. 154: *The Farm at Les Collettes* (1912, Mexico,
Museo Soumaya)
Not illustrated

Cat. 156

Renoir painting in front of the Maison de la Poste in Cagnes
1912–14
Modern print made by Patrice Schmidt from a glass negative
9¹/₂ x 7¹/₈ in. (24 x 18 cm)
Paris, Musée d'Orsay, Archives Vollard
ODO 1996-56-1246
The painting the artist is working on could be *Pomegranates, Bananas and
View of the Port at Cagnes* (1912–14; Bernheim-Jeune 1931, no. 432).
Illustrated on p. 392

Cat. 157

Renoir, Aline, and Coco
1912
7¹/₈ x 5¹/₈ in. (18 x 13 cm)
Los Angeles, University of California, Art Library Special Collection, Jean Renoir
collection
Illustrated on p. 273

Cat. 158

Albert André
Renoir in the house of Les Collettes at Cagnes
1913
Gelatin-silver print mounted on cardboard
10.5 x 11 cm (4¹/₈ x 4³/₈ in.)
Pont-Saint-Esprit, Musée d'Art Sacré du Gard, Jacqueline Bret-André Bequest, 2008
CD.008.17.252
Illustrated on p. 392

Cat. 159

*Renoir and Gabrielle in front of the painting racks in the studio
of Les Collettes at Cagnes*
3¹/₈ x 4¹/₂ in. (8 x 11.5 cm) (mount: 3¹/₂ x 4³/₄ in. [8.8 x 11.9 cm])
Embossed stamp top right: SIR [ex Sirot collection]
Silver print mounted on gray-blue cardboard
Paris, Bibliothèque Nationale de France, Département des Estampes et de la
Photographie
Above the storage compartments is a version of *Seated Bather* **Cat. 29 & 30**.
Illustrated on p. 393

Cat. 160

Renoir and Mme de Galéa in the studio at Cagnes
January–February 1912
Modern print from negative
3³/₈ x 4¹/₄ in. (8.5 x 10.9 cm)
Paris, Musée d'Orsay, Archives Vollard
ODO 1996-56-1687
Illustrated on p. 393

Cat. 161

Konrad Ferdinand Edmund von Freyhold (1878–1944)
Renoir in the apartment in Nice (1, place de l'Église-du-Vœu)
November–December 1913
Gelatin-silver print
3¹/₈ x 3¹/₄ in. (8 x 8.2 cm)
Collection Roland Stark
Illustrated on p. 394

Cat. 162

Konrad Ferdinand Edmund von Freyhold
Aline and Coco in the apartment in Nice
November–December 1913
Gelatin-silver print
4¹/₈ x 3³/₈ in. (10.5 x 8.5 cm)
Collection Roland Stark
Illustrated on p. 394

Cat. 163

Konrad Ferdinand Edmund von Freyhold
The Renoir family in the apartment in Nice
November–December 1913
Modern prints from eleven stereoscopic vues
1⁷/₈ x 4¹/₈ in. (4.9 x 10.5 cm)
Paris, Bibliothèque Nationale de France, Département des Estampes et de la
Photographie
Not illustrated

Cat. 164

Konrad Ferdinand Edmund von Freyhold
Renoir in the garden of Les Collettes at Cagnes
April–May 1914
Gelatin-silver print
3¹/₂ x 3¹/₂ in. (9 x 9 cm)
Collection Roland Stark
Illustrated on p. 395

Cat. 165

Konrad Ferdinand Edmund von Freyhold
*Coco in front of an orange tree in the orchard of Les Collettes
at Cagnes*
April–May 1914
Gelatin-silver print
3³/₈ x 3¹/₄ in. (8.5 x 8.4 cm)
Collection Roland Stark
Illustrated on p. 397

Cat. 166

Konrad Ferdinand Edmund von Freyhold
*Madeleine Bruno, Renoir's model, in the garden of Les Collettes
at Cagnes*
April–May 1914
Gelatin-silver print
3¹/₂ x 3³/₈ in. (9 x 8.5 cm)
Collection Roland Stark
Illustrated on p. 397

Cat. 167

Konrad Ferdinand Edmund von Freyhold
Orange-blossom harvest in the garden of Les Collettes at Cagnes
May 1914
Gelatin-silver print
4 x 3³/₈ in. (10.2 x 8.5 cm)
Collection Roland Stark
Illustrated on p. 396

Cat. 168

Konrad Ferdinand Edmund von Freyhold
Orange-blossom harvest at Les Collettes at Cagnes
May 1914
Gelatin-silver print
3³/₈ x 3¹/₄ in. (8.5 x 8.2 cm)
Collection Roland Stark
Illustrated on p. 89

Cat. 169

Konrad Ferdinand Edmund von Freyhold
A garden party organized at the Renoirs' at Les Collettes at Cagnes in celebration of the end of the orange-blossom harvest
Saturday, May 23, 1914
Gelatin-silver print
3³/₈ x 3¹/₈ in. (8.5 x 8 cm)
Collection Roland Stark
Illustrated on p. 397

Cat. 170

Konrad Ferdinand Edmund von Freyhold
Gabrielle and the American painter Conrad Slade (her future husband) at Cagnes
April–May 1914
Gelatin-silver print
4¹/₈ x 3³/₈ in. (10.5 x 8.5 cm)
Collection Roland Stark
Illustrated on p. 397

Cat. 171

Konrad Ferdinand Edmund von Freyhold
View of the house of Les Collettes at Cagnes (east gable)
November–December 1913 or April–May 1914
Gelatin-silver print
3³/₈ x 3¹/₄ in. (8.5 x 8.3 cm)
Collection Roland Stark
Illustrated on p. 397

Cat. 172

Konrad Ferdinand Edmund von Freyhold
An outbuilding on the estate of Les Collettes at Cagnes
November–December 1913 or April–May 1914
Gelatin-silver print
4¹/₈ x 3³/₈ in. (10.5 x 8.5 cm)
Collection Roland Stark
Illustrated on p. 396

Cat. 173

Renoir and Aline in the studio of Les Collettes at Cagnes
Circa 1914
3¹/₈ x 4¹/₄ in. (8 x 10.7 cm)
Los Angeles, University of California, Art Library Special Collection, Jean Renoir collection
Illustrated on p. 398

Cat. 174

Renoir and Coco in the garden of Les Collettes
1914–15
3 x 3⁵/₈ in. (7.6 x 9.2 cm)
Los Angeles, University of California, Art Library Special Collection, Jean Renoir collection
Illustrated on p. 398

Cat. 175

Attributed to **Pierre Bonnard** (1867–1947)
Pierre-Auguste Renoir
Before 1916
Proof on albumen paper from a negative on flexible gelatin-silver bromide film
4 x 3 in. (10.2 x 7.6 cm)
Paris, Musée d'Orsay, gift of Antoine Terrasse subject to life interest in his name and on behalf of his brothers and sister, 1992
PHO 1987-31-61
Not illustrated

Cat. 176

Attributed to **Pierre Bonnard**
Pierre-Auguste Renoir and his son Jean
Before 1916
Proof on albumen paper from a negative on flexible gelatine-silver bromide film
4 x 3 in. (10.2 x 7.6 cm)
Paris, Musée d'Orsay, gift of Antoine Terrasse subject to life interest in his name and on behalf of his brothers and sister, 1992
PHO 1987-31-62
Illustrated on p. 401

Cat. 177

Claude Renoir (1901–1969)
Renoir painting under a parasol
1916–17
6³/₄ x 4⁷/₈ in. (17.2 x 12.4 cm)
Pont-Saint-Esprit, Musée d'Art Sacré du Gard, Jacqueline Bret-André Bequest, 2008
CD.008.17.250
Illustrated on p. 399

Cat. 178

Renoir and his son Pierre in their apartment at 57 bis, boulevard de Rochechouart, Paris
1915–17
7¹/₈ x 9¹/₄ in. (18 x 23.4 cm)
Los Angeles, University of California, Art Library Special Collection, Jean Renoir collection
Illustrated on p. 400

Cat. 179

George Besson (1882–1971)
A corner in Renoir's studio at Cagnes
[January?] 1918
5¹/₈ x 6⁷/₈ in. (13 x 17.6 cm)
Issy-les-Moulineaux, Archives Matisse
Illustrated on p. 113
Works visible in the photograph:
on the ground: *Group of Bathers* (1916, Merion, PA, Barnes Foundation);
on the wall from top to bottom, left to right: *Andrée Seated on a Grecian Chair* (1917; Bernheim-Jeune 1931, no. 625), *Reading, Two Women with Red and Pink Corsages* (1918; ibid., no. 644), *Rose, Sugarbowl, and Head* (1914–19; ibid., no. 507), *Bathers* (ca. 1918, Merion, PA, Barnes Foundation).

Cat. 180

George Besson
Renoir's studio at Cagnes
[January?] 1918
5¹/₈ x 6⁷/₈ in. (13 x 17.6 cm)
Issy-les-Moulineaux, Archives Matisse
Works visible in the photograph:
on the ground: *Blonde with a Rose* (1917–18, Paris, Musée National de l'Orangerie), *Woman with a Mirror* (Rouen, Musée des Beaux-Arts), *Reader with Roses* (ca. 1917–18; Bernheim-Jeune 1931, no. 582), *Seated Nude* (1917, Merion, PA, Barnes Foundation);
on the left wall from top to bottom: *Profile of Andrée in Pink on a Blue Background* (1917–18; Bernheim-Jeune 1931, no. 642), *Madeleine: Head Studies* (1912–14; ibid., no. 414), Marie Lestringuez (1912; sales cat. New York, Sotheby's, 2002, no. 126), *Female Nude from the Back and in Profile* (1915; Bernheim-Jeune 1931, no. 500), *Female Nude on the Couch in Nice* (1910; ibid., no. 386);
on the radiator: *Nude with a Hat* (1915, Basel, Galerie Beyeler)
Illustrated on p. 403

Cat. 181

Renoir
Dedication: *à Madame Besson/son très affectueux/Renoir*
Circa 1915?
Gelatin-silver print mounted on stiff paper
9³/₈ x 7¹/₈ in. (23.8 x 18 cm)
Pont-Saint-Esprit, Musée d'Art Sacré du Gard, Jacqueline Bret-André Bequest, 2008
CD.007.18.253
Illustrated on p. 400

Cat. 182

Album formerly belonging to Maurice Denis, with two photographs of Renoir
Album: 15¹/₈ x 12⁵/₈ in. (38.5 x 32 cm)
Photograph: 3¹/₈ x 4¹/₈ in. (8 x 10.6 cm)
Private collection
Illustrated on p. 400

Cat. 183

Walther Halvorsen (1887–1972)
Renoir in his studio at Les Collettes at Cagnes
[March 11?] 1918
4³/₈ x 3¹/₈ in. (11 x 8 cm)
Private collection
A print of this portrait, signed by Renoir, was given to Matisse by Halvorsen (Archives Matisse)
Illustrated on p. 402

Cat. 184

Renoir, his son Pierre, Walther Halvorsen, Greta Prozor, and Henri Matisse in the studio of Les Collettes at Cagnes
March 11, 1918 [?]
3 x 3³/₄ in. (7.5 x 9.5 cm)
Issy-les-Moulineaux, Archives Matisse
Illustrated on p. 138

Cat. 185

Walther Halvorsen (?)
Renoir and Andrée Heuschling in the studio of Les Collettes at Cagnes
March 11, 1918 (?)
4³/₈ x 3¹/₈ in. (11 x 8 cm)
Private collection
Nude (1915, Japan, private collection) is on the easel.
Illustrated on p. 342

Cat. 186

Ambroise Vollard on front of Renoir's Great Bathers, the version the dealer had commissioned in 1903 (1903–05, Cagnes-sur-Mer, Musée Renoir, on deposit at the Musée d'Orsay, MNR 878)
Circa 1920–30
6¹/₂ x 4³/₈ in. (16.5 x 11 cm)
Paris, Bibliothèque Centrale des Musées Nationaux, Archives Vollard
Ms 421–3,9, fo 11
Illustrated on p. 403

Cat. 187

Denis-Jean Clergue
Renoir's Studio
1947
Gelatin-silver print
9¹/₈ x 5¹/₂ in. (23.3 x 13.9 cm)
Cagnes-sur-Mer, Archives du Musée Renoir
C.M. (08)
Illustrated on p. 403

Cat. 188

Albert André in his studio at Laudun, in the Gard Region
1939–45
7 x 9³/₈ in. (17.9 x 23.8 cm)
Pont-Saint-Esprit, Musée d'Art Sacré du Gard, Jacqueline Bret-André Bequest, 2008
CD.008.17.251
Illustrated on p. 405

Cat. 189

Albert Eugene Gallatin (1881–1952)
Henri Matisse in his Nice apartment, posing in front of Mediterranean Landscape *by Renoir; on his left,* Sketch for a Young Woman on the Banks of the Seine *by Gustave Courbet (1856, private collection), which he showed to Renoir on June 22, 1918*
1932
Gelatin-silver print
4 x 3 in. (10.2 x 7.6 cm)
Philadelphia, Philadelphia Museum of Art, A. E. Gallatin Collection, 1952
PDP-313
Illustrated on p. 406

Cat. 190

Albert Eugene Gallatin
Henri Matisse in his Nice apartment, on the walls two small paintings of nudes by Renoir: Nude with Raised Arm *(9⁷/₈ x 5¹/₈ in., 25.2 x 13.1 cm; sales cat. Christie's New York, May 10, 2007, no. 246) and* Nude with Bath Towel *(ca. 1900, 10³/₄ x 6³/₄ in., 27.3 x 17.1 cm; sales cat. Christie's New York, May 7, 2008, no. 302)*
1932
Gelatin-silver print
7 x 5 in. (17.9 x 12.7 cm)
Philadelphia, Philadelphia Museum of Art, A. E. Gallatin Collection, 1952
PDP-316
Illustrated on p. 363

Cat. 191

Albert Eugene Gallatin
Henri Matisse in his Nice apartment. At left on the wall, a landscape by Renoir can be discerned
1932
Gelatin-silver print
9¹/₂ x 7¹/₈ in. (24.1 x 18.1 cm)
Philadelphia, Philadelphia Museum of Art, A. E. Gallatin Collection, 1952
1952-61-130
Illustrated on p. 406

Cat. 192

Pierre Matisse (1900–1989)
Henri Matisse at the Barnes Foundation in front of The Artist's Family *by Renoir (1896) and* Models *by Georges Seurat (1886–88)*
Late May 1933
5¹/₂ x 2³/₄ in. (14.1 x 7 cm)
Issy-les-Moulineaux, Archives Matisse
Illustrated on p. 406

Cat. 193

Cecil Beaton (1904–1980)
Picasso in front of Renoir's Seated Bather in a Landscape, *called* Eurydice, *in his apartment in the rue La Boétie, Paris*
1932
9¹/₂ x 7¹/₈ in. (24 x 18 cm)
Paris, Musée National Picasso, Archives Picasso
M.P. Ph 356
Illustrated on p. 369

Cat. 194

Alexander Liberman (1912–1999)
Picasso's bedroom in his Paris studio in the rue des Grands-Augustins. On the wall: Studies of Figures from Antiquity *by Renoir* cat. 76; Portrait of Marguerite *by Matisse; and a landscape by Corot*
1949
5¹/₈ x 7¹/₈ in. (13 x 18 cm)
Paris, Musée National Picasso, Archives Picasso
M.P. Ph 2400
Illustrated on p. 319

Cat. 195

André Gomès (1913–1997)
Picasso's studio in his villa La Californie at Cannes, with Renoir's
Portrait of a Child *(1910–12) and* Still Life with Fish *(1916)*
1958
5¹/₈ x 5¹/₈ in. (13 x 13 cm)
Paris, Musée National Picasso, Archives Picasso
M.P. Ph. 3469
Not illustrated

Cat. 196

André Ostier (1906–1994)
Picasso in his studio in his villa La Californie (Cannes) with, placed on
a piece of furniture, Portrait of a Model, Bust-Length *by Renoir* **Cat. 75**
September 1958
5¹/₈ x 5¹/₈ in. (13 x 13 cm)
Paris, Musée National Picasso, Archives Picasso
M.P. Ph 1518/b
Illustrated on p. 407

Cat. 197

David Douglas Duncan (born 1916)
Picasso at the Château de Vauvenargues with his collection of
paintings. In the foreground, Renoir's Studies of Figures from
Antiquity **Cat. 76**
1959
Austin, The University of Texas, Harry Ransom Humanities Research Center,
Duncan Archives, 1996
Illustrated on p. 406

Cat. 198

Comtesse Costa de Beauregard
Pierre Bonnard and Claude Renoir in the garden of Les Collettes at
Cagnes
1942–43
4³/₄ x 6⁵/₈ in. (12 x 16.8 cm)
Private collection
Illustrated on p. 405

Cat. 199

Brassaï (1899–1984)
Wall in Pierre Bonnard's studio at Le Cannet, with Renoir's Seated
Bather
1945
Silver-chloride artist's proof
19⁷/₈ x 7⁵/₈ in. (27.5 x 19.5 cm)
Paris, Estate Brassaï
A352
Illustrated on p. 374

Cat. 200

Apartment of Gertrude and Leo Stein at 27, rue de Fleurus, Paris.
One can see Renoir's Brunette *and* Two Nudes *(ca. 1897, Merion, PA,*
Barnes Foundation [Fig. 21]), amongst other paintings, including
Le Bonheur de vivre *by Matisse (1905–06, Barnes Foundation) and*
Madame Cézanne with a Fan *by Cézanne (1878–1886–1888, Zurich,*
E. G. Bührle collection
Gelatin-silver print
4⁷/₈ x 6⁷/₈ in. (12.4 x 17.3 cm)
Baltimore, The Baltimore Museum of Art, Archives and Manuscript Collections,
Dr. Claribel and Miss Etta Cone Papers
SFH.22
Illustrated on p. 363

Cat. 201

Apartment of Gertrude and Leo Stein at 27, rue de Fleurus, Paris.
One can see Renoir's Girl in Gray-Blue Putting on her Gloves *(ca.*
1899, Merion, PA, Barnes Foundation), hung as a pendant to Woman
with a Hat *by Matisse (1905, San Francisco Museum of Modern Art).*
Above: Portrait of Gertrude Stein *by Picasso (1906, New York,*
The Metropolitan Museum of Art)
Circa 1907
Gelatin-silver print
4⁵/₈ x 6³/₄ in. (11.7 x 17.1 cm)
Baltimore, The Baltimore Museum of Art, Archives and Manuscript Collections,
Dr. Claribel and Miss Etta Cone Papers
SFH.21
Illustrated on p. 365

Cat. 202

Charles Sheeler (1883–1965)
Interior of the apartment of Louise and Walter Arensberg in New York.
Renoir's Bather **Cat. 77** *hangs in the center of the wall, below* Nude
Descending the Staircase No. 3 *by Marcel Duchamp (1916,*
Philadelphia Museum of Art), with two paintings by Picasso on either
side: Violin and Guitar *(1913) and* Female Nude *(1910–11,*
Philadelphia Museum of Art)
Circa 1918
Casein silver print
7⁵/₈ x 9³/₄ in. (19.4 x 24.9 cm)
Philadelphia, Philadelphia Museum of Art
1950-134-990
Illustrated on p. 322

Cat. 203

Pierre Matisse
Dr. Barnes in one of the galleries at his foundation in front of three
paintings by Renoir: on the wall: The Artist's Family *(1896); on the*
floor: Woman Resting near a Tree *(ca. 1915–17) and* Gabrielle Arising
(1909)
Late May 1933
2⁷/₈ x 4¹/₂ in. (7.3 x 11.5 cm)
Issy-les-Moulineaux, Archives Matisse
Illustrated on p. 404

Cat. 204

View of the personal collection of the brothers Josse and
Gaston Bernheim-Jeune in the salon of their residence at 107,
avenue Henri-Martin, Paris
1924
Modern print made by Patrice Schmidt from a glass negative
Paris, Archives photographiques Bernheim-Jeune
Works seen in the photograph:
back wall, starting at upper left: Dreaming Girl (Fénéon 1919, pl. 104), Large Bouquet
of Wildflowers (ca. 1870; Dauberville 2007, no. 24), Young Girl with a Braid (Fénéon
1919, pl. 114), Study for Gabrielle and Jean and a Little Girl (1895–96, pastel; Fénéon
1919, pl. 117), Bather and Maid (La Toilette) (1900–01, Merion, PA, Barnes Foundation,
Fig. 114), Portrait of Two Little Girls (1890–92, Paris, Musée National de l'Orangerie),
Gabrielle with a Mirror (1910; Fénéon 1919, pl. 136), The Shepherd Girl (1902–03; ibid.,
pl. 129), Woman's Head (Portrait of Margot) (1877, private collection), Woman with
Lilacs (Fénéon 1919, pl. 106), The Theater Box (1874; sales cat. London, Sotheby's,
2008, no. 37), Reading, or Young Girl Reading, Lying in Grass (1897, Nagano, Kitano
Construction Corporation), The Bohemian Girl (1879, Canada, private collection).
Illustrated on p. 421

Cat. 205

Exhibition of works from Renoir's last ten years (1909–19),
Paris, Paul Rosenberg Gallery, January 16–February 24, 1934
Modern prints made by Patrice Schmidt from a glass negative
9³/₈ x 11⁷/₈ in. (23.7 x 30 cm)
Paris, Musée d'Orsay, Fonds Rosenberg
ODO 1996-34
Illustrated on p. 365

Cat. 206

Sacha Guitry
Ceux de chez nous (Those of Our Land)
Paris, Théâtre des Variétés, November 23, 1915,
with kind assistance from the Succession Sacha Guitry
Not illustrated

Cat. 204

Bibliography

The bibliography lists all the references cited in shortened form in the essays and catalogue entries.

Publications

Abel 1996
Ulf Abel. "Auguste Renoir (1841–1919). Badende kvinnor." In Görel Cavalli-Björkman, dir. *Fröken Gieseckes kärlek till konsten.* Stockholm: Statens Konstmuseer (Årsbok för Statens Konstmuseer, 42), 1996.

Adhémar 1966
Hélène Adhémar. "La collection Jean Walter et Paul Guillaume." *Médecine de France,* no. 173 (1966), pp. 17–32.

Adhémar 1976
Hélène Adhémar. "La donation Kahn-Sriber." *La Revue du Louvre et des musées de France,* no. 2 (1976).

Adhémar, Sérullaz, and Beaulieu 1958
Hélène Adhémar, Maurice Sérullaz, and Michèle Beaulieu. *Musée national du Louvre: catalogue des peintures, pastels, sculptures impressionnistes.* With a preface by Germain Bazin. Paris: Éditions des Musées Nationaux, 1958.

Adhémar et al. 1959
Musée national du Louvre: catalogue des peintures, pastels, sculptures impressionnistes. Prepared by Hélène Adhémar, Madeleine Dreyfus-Bruhl (paintings), Maurice Sérullaz (pastels), and Michèle Beaulieu (sculptures), with a preface-letter by Germain Bazin. New ed. Paris: Éditions des Musées Nationaux, 1959.

Adler 1994
Kathleen Adler. "Renoir: the Matter of Gender." In exh. cat. Brisbane, Melbourne, and Sydney 1994–95, pp. 29–39.

Adorno 2002
Theodor W. Adorno. "Le style tardif de Beethoven." *Moments musicaux.* Geneva: Contrechamps, 2002.

Adriani 1999
Götz Adriani. *Renoir.* Cologne: DuMont, 1999.

Alcouffe 1988
Daniel Alcouffe [Entry on Isaac de Camondo]. "Répertoire des donateurs." *Les Donateurs du Louvre.* Paris: Réunion des Musées Nationaux, 1998, p. 163.

Alexandre n. d.
Arsène Alexandre. "Propos inédits de et sur Renoir." *Les Nouvelles.* [n. d.].

Alexandre 1892
Arsène Alexandre. "Renoir." In exh. cat. Paris 1892.

Alexandre 1920
Arsène Alexandre. "Renoir sans phrases." *Les Arts,* March 1920.

Alexandre 1930
Arsène Alexandre. *La Collection Canonne: une histoire en action de l'impressionnisme et de ses suites.* Paris: Bernheim-Jeune et Renaissance de l'art, 1930.

Alexandre 1931
Arsène Alexandre. "Au musée des colonies." *La Renaissance de l'art français et des industries de luxe,* no. 9, September 1931, pp. 265–272.

Alexandrian 1974
Sarane Alexandrian. *Le Monde des grands musées.* Fasc. 5. "La peinture impressionniste de A à Z." January–February 1974.

Allen 1937
Josephine L. Allen. "Paintings by Renoir." *Bulletin of the Metropolitan Museum of Art* 32 (May 1937), pp. 113–114.

Alley 1959
Ronald Alley. *Tate Gallery Catalogue: The Foreign Paintings, Drawings and Sculptures.* London: Tate Gallery, 1959.

André 1919, 1923, 1928
Albert André. *Renoir.* Paris: G. Crès et Cie, 1919. Reprint, 1923 and 1928.

André 1950
Albert André. *Renoir: dessins.* Paris: Braun et Cie, 1950.

André 1965
Albert André [Preface]. *Renoir en Italie et en Algérie (1881–1882).* Paris: Daniel Jacomet, 1965.

Annual Report 1968–69
Los Angeles County Museum of Art Annual Report. Annual report for the fiscal year 1968–69.

Apollinaire [1912]
Guillaume Apollinaire. "Chroniques d'art: Les Futuristes." *Le Petit Bleu.* Paris, February 9 [1912].

Apollinaire 1914
Guillaume Apollinaire. "Une statue de Renoir." *Paris-Journal,* June 2, 1914. Reprinted in *Œuvres en prose complètes,* Paris, Gallimard (Bibliothèque de la Pléiade), vol. 2, p. 746.

Apollinaire [1918]
Guillaume Apollinaire. *L'Europe nouvelle.* [September 14, 1918].

Apollinaire 1960, 1993
Guillaume Apollinaire. *Chroniques d'art: 1902–1918.* Edited by L. C. Breunig. Paris: Gallimard, 1960. Reprint, Paris: Gallimard (Folio), 1993.

Apollinaire 1972
Guillaume Apollinaire. *Apollinaire on Art: Essays and Reviews, 1902–1918.* Edited by Leroy C. Breunig. Translated by Susan Suleiman. New York: Viking Press, 1972.

Aral 2008
Guillaume Aral. "Renoir-Guino: duo-duel." In exh. cat. Cagnes-sur-Mer 2008, pp. 97–105.

Arensberg Collection 1954
Philadelphia Museum of Art. *The Louise and Walter Arensberg Collection: 20th Century Section.* Philadelphia: Beck, 1954.

Armand Hammer Collection 1975
The Armand Hammer Collection. Los Angeles: Armand Hammer Foundation, n. d. [1975].

Armand Hammer Collection 1982
The Armand Hammer Collection. Los Angeles: Armand Hammer Foundation, 1982.

Armand Hammer Collection 1985
The Armand Hammer Collection. Los Angeles: Armand Hammer Foundation, 1985.

Arnason 1968
H. Harvard Arnason. *History of Modern Art.* New York: Harry N. Abrams, 1968.

Art Digest 1944
"Renoir Landscape Finds California Home." *Art Digest,* December 1, 1944.

Art Digest 1945
"Famous Renoir Nude Goes to Chicago." *Art Digest,* December 15, 1945.

Art Gallery of Ontario 1974
Art Gallery of Ontario. *Handbook/Catalogue illustré.* With a preface by William J. Withrow and an introduction by Richard J. Wattenmaker. Toronto: Art Gallery of Ontario, 1974.

Art Gallery of Ontario 1990
Art Gallery of Ontario. *Art Gallery of Ontario: Selected Works.* Toronto: The Gallery, 1990.

Art Institute of Chicago 1961
Paintings in the Art Institute of Chicago: A Catalogue of the Picture Collection. Chicago: Art Institute of Chicago, 1961.

Art News 1930
Art News 29, no. 2 (October 11, 1930).

Art News 1933
Art News 32, no. 5 (November 4, 1933).

Art News 1935
Art News 33, no. 25 (March 23, 1935).

Art News 1945
"Providence Renoir." *Art News* 44, no. 12 (October 1–14, 1945), pp. 10–11.

Art News 1945b
"Chicago Perfects its Renoir Group." *Art News* 44 (December 1, 1945), pp. 18–19.

Art News Annual 1952
Art News Annual 20 (1952).

Art Quarterly 1945
"The Young Shepherd by Renoir." *Art Quarterly* 8, no. 3 (Summer 1945), pp. 244–246.

Arts de France 1961
Arts de France 8 (1961).

Asahi Graph Magazine 1988
Asahi Graph Magazine. Special issue "Renoir." 1988.

Assante 2007
Maryline Assante di Panzillo. "The Dispersal of the Vollard Collection." In exh. cat. New York, Chicago, and Paris 2006–07, pp. 258–262 (pp. 275–279 in French ed.).

Bade 1989
Patrick Bade. *Renoir.* Translated by Nicole Tisserand. Paris: Hazan, 1989.

Bailey 2008
Colin B. Bailey. "The Origins of the Barnes Collection, 1912–1915." *Burlington Magazine* 150 (August 2008), pp. 534–543.

Baltimore Museum of Art Quarterly 1939
Baltimore Museum of Art Quarterly, July 1, 1939.

Barnes and De Mazia 1935, 1959
Albert C. Barnes and Violette De Mazia. *The Art of Renoir.* New York: Minton, Balch & Co. (1935), 1959.

Barr 1977
Alfred Barr. *Painting and Sculpture in the Museum of Modern Art: 1929–1967.* New York: Museum of Modern Art, 1977.

Baudelaire 1846, 1965
Charles Baudelaire. *Salon de 1846.* Paris, Michel Lévy, 1846. English from *Art in Paris 1845–1862: Salons and other exhibitions reviewed by Charles Baudelaire.* Edited and translated by Jonathan Mayne. London, Phaidon Press, 1965, pp. 41–120.

Baudelaire 1863, 1970
Charles Baudelaire. "Le peintre de la vie moderne." *Le Figaro.* November 8, November 26, December 3, 1863. English from *The Painter of Modern Life, and Other Essays.* Edited and translated by Jonathan Mayne. London, New York: Phaidon Press, 1970, pp. 1–40.

Baudelaire 1980
Charles Baudelaire. *Œuvres completes.* With a preface by Claude Roy and notes by Michel Jamet. Paris: Robert Laffont, 1980.

Baudot 1949
Jeanne Baudot. *Renoir, ses amis, ses modèles.* Paris: Éditions littéraires de France, 1949.

Bazin 1930
Germain Bazin. "Les sanguines de Renoir." *Formes,* no. 5 (May 1930), pp. 7–10.

Bazin 1958
Germain Bazin. *Trésors de l'impressionnisme au musée du Louvre.* Paris: Somogy, 1958.

Beaux–Arts 1925
"Bulletin des musées." *Beaux-Arts, revue d'information artistique,* no. 13 (July 1, 1925), p. 207.

Béguin and Lemaistre 1978
Sylvie Béguin and Isabelle Lemaistre. *Donation Picasso: collection personnelle de Picasso.* Paris: Réunion des Musées Nationaux, 1978.

Bell 1929
Clive Bell. *Since Cézanne.* London: Chatto & Windus, 1929.

Bénédite 1896
Léonce Bénédite. *Le Musée national du Luxembourg: catalogue raisonné et illustré des peintures, sculptures, dessins… des écoles contemporaines réunies,* 1896. Paris: Librairies-Imprimeries réunies, 1896.

Bénédite 1924
Léonce Bénédite. *Le Musée du Luxembourg: peintures, école française.* Paris, 1924.

Bénézit 1999
Emmanuel Bénézit. *Dictionnaire critique et documentaire des peintres, sculpteurs, dessinateurs et graveurs.* New edition under the direction of Jacques Busse. Paris: Gründ, 1999.

Benjamin 2001
Roger Benjamin. "Ingres chez les Fauves." In *Fingering Ingres*. Edited by Adrian Rifkin and Susan Siegfried. Oxford: Blackwell, 2001, pp. 93–121.

Benjamin 2003
Roger Benjamin. "Afterimages: Algerian Echoes in Renoir's Late Work." In exh. cat. Williamstown, Dallas, and Paris 2003–04, pp. 109–117.

Bérenger 1931
Henry Bérenger [Preface]. *Exposition coloniale internationale de Paris, mai–novembre 1931*. Paris: Beaux-Arts, May–December 1931.

Berhaut 1978
Marie Berhaut. *Gustave Caillebotte*. Introduction by Daniel Wildenstein. Paris: La Bibliothèque des arts, 1978.

Bernáth 1937
Aurel Bernáth. "Composition in Modern Painting." *Magyar Müvészet* 12 (1937).

Bernheim-Jeune 1931
Bernheim-Jeune. *L'Atelier de Renoir*. Prefaces by Albert André (vol. 1) and Marc Elder (vol. 2). Paris, 1931, 2 volumes.

Bernheim-Jeune 1989
J. and G. Bernheim-Jeune. *L'Atelier de Renoir*. San Francisco: A. Wofsy Fine Arts, 1989.

Bernier 1955
Georges and Rosamond Bernier. *The Selective Eye*. New York: Random House, 1955.

Berr de Turique 1953
Marcelle Berr de Turique. *Renoir*. Paris: Phaidon [1953].

Berson 1996
The New Painting: Impressionism 1874–1886. Documentation. Edited by Ruth Berson. San Francisco: Fine Arts Museums of San Francisco; Seattle: University of Washington Press, 1996, 2 vols.

Bertin 1986, 2005
Célia Bertin. *Jean Renoir: biographie*. Paris: Perrin, 1986. New edition, Paris: Éditions du Rocher, 2005.

Besson 1929
George Besson. *Renoir*. Paris: G. Crès, 1929. Reprint, Paris: G. Crès et Cie, 1932.

Besson 1933
George Besson. "Renoir à Cagnes." *Beaux-Arts*, no. 24 (1933).

Besson 1938
George Besson. *Auguste Renoir*. Paris: Braun, 1938.

Blanche 1919
Jacques-Émile Blanche. *Propos de peintre. I: De David à Degas*. Paris: Émile-Paul Frères, 1919.

Blanche 1931
Jacques-Émile Blanche. *Les Arts plastiques*. Paris: Éditions de France, 1931.

Blanche 1949
Jacques-Émile Blanche. *La Pêche aux souvenirs*. Paris: Flammarion, 1949.

Boggs 1971
Jean Sutherland Boggs. *The National Gallery of Canada*. London: Thames & Hudson, 1971.

Bonnard 1941
Pierre Bonnard. "Sur Renoir." *Comoedia*. October 18, 1941.

Bonnard 1947
"Le bouquet de roses." Interview with Pierre Bonnard conducted in 1943 by Angèle Lamotte. *Verve* V, nos. 17 and 18. Paris, 1947.

Bosman 1963
Anthony Bosman. *Pierre-Auguste Renoir*. Translated by Correy van Alpen. New York: Barnes & Noble, 1963.

Boudier 2005
Laurent Boudier. "Champs contre champs." *Télérama*. Special issue, September 2005, pp. 40–45.

Bouillon 1996
Jean-Paul Bouillon, "Maillol et Denis: 'fraternité artistique' et moment historique." In exh. cat. Berlin, Lausanne, Bremen, and Mannheim 1996–97.

Bouillon 1997
Jean-Paul Bouillon. "Le modèle cézannien de Maurice Denis." *Cézanne aujourd'hui*. Conference, Paris, Musée d'Orsay, November 29–30, 1995. Edited by Françoise Cachin, Henri Loyrette, and Stéphane Guégan. Paris: Réunion des Musées Nationaux and Musée d'Orsay, 1997, pp. 145–164.

Bouillon 2003
Jean-Paul Bouillon. "Maurice Denis et la réaction à l'impressionnisme de Monet." *Monet*. Conference, Treviso, Casa dei Carraresi, January 16–17, 2002. Edited by Rodolphe Rapetti, MaryAnne Stevens, Michael Zimmermann, and Marco Goldin. Conegliano: Linea d'Ombra, 2003, pp. 230–241.

Bouvet 1981
Francis Bouvet. *Bonnard: l'œuvre gravé, catalogue complet*. Preface by Antoine Terrasse. Paris: Flammarion, 1981.

Bouyer 1925
Raymond Bouyer. "Les 'Renoir' de la collection Gangnat." *Gazette des Beaux-Arts*. April 1925, pp. 246–250.

Boyer and Champion 1993
Guy Boyer and Jean-Loup Champion, eds. *Mille peintures des musées de France*. Paris: Gallimard et Beaux-Arts, 1993.

Brachlianoff et al. 1995
Dominique Brachlianoff et al. *Guide des collections: musée des Beaux-Arts de Lyon*. Paris: Réunion des Musées Nationaux, 1995.

Brachlianoff et al. 1998
Dominique Brachlianoff et al. *Guide des collections: musée des Beaux-Arts de Lyon*. Paris: Réunion des Musées Nationaux, 1998.

Bragger and Rice 1996, 2000
Jeannette D. Bragger and Donald B. Rice. *Quant à moi: témoignages des Français et des francophones: manuel de classe*. Boston: Heinle & Heinle, 1996. Reprint, 2000.

Brassaï 1964, 1986, 1997
Brassaï. *Conversations avec Picasso*. Paris: Gallimard, 1964. Reprint, 1986 and 1997.

Braun 1994
Emily Braun. *Manet to Matisse: The Hillman Family Collection*. New York: Alex Hillman Family Foundation, Seattle, in association with University of Washington Press, 1994.

Bremer Nachrichten 1961
Bremer Nachrichten. April 8, 1961.

Bret and Matsuda 2008
Corinne Bret and Hiromi Matsuda. *Une famille d'art et d'amour*. Tokyo, Nippon Television Network Corporation, 2008.

Brian 1939
Doris Brian. "Milestones in French Painting," *Art News* 37 (February 25, 1939), p. 9.

Brian 1942
Doris Brian. "This Century's Share of Renoir." *Art News* 41, no. 4 (April 1–14, 1942), pp. 22–23 and 32–33.

Bridgestone Museum of Art 1991
Bridgestone Museum of Art, Ishibashi Foundation: Masterpieces from the Collection. Tokyo: Bridgestone Museum of Art, 1991.

Brinckmann 1925
A. E. Brinckmann. *Spätwerke grosser Meister*. Frankfurt: Frankfurter Verlagsanstalt, 1925.

Brühl 1991
Georg Brühl. "Die Ausstellungen des Kunstsalons Cassirer." *Die Cassirers: Streiter für den Impressionismus*. Leipzig: Leipzig Verlag, 1991, p. 154ff.

Buffalo Fine Arts Academy 1941
Buffalo Fine Arts Academy, Albright-Knox Art Gallery. "Newcomers." *Gallery Notes*. May 1941.

Bulletin de la vie artistique **1920**
"Quelques pensées de Renoir." *Bulletin de la vie artistique*, no. 3, January 1, 1920.

Bulletin de la vie artistique **1920b**
Bulletin de la vie artistique, no. 8, March 15, 1920.

Bulletin de la vie artistique **1920c**
Bulletin de la vie artistique, no. 12, May 15, 1920.

Bulletin de la vie artistique **1920d**
Bulletin de la vie artistique, no. 13, June 1, 1920.

Bulletin de la vie artistique **1920e**
Bulletin de la vie artistique, no. 26, December 15, 1920.

Bulletin de la vie artistique **1923**
Bulletin de la vie artistique, no. 23, December 1, 1923.

Bulletin des musées **1923**
"Musée du Luxembourg." *Bulletin des musées*. March 1923.

Bulletin des musées **1925**
Bulletin des musées, no. 53, July 1, 1925, p. 207.

Bulletin of the Detroit Institute of Arts **1977–78**
Bulletin of the Detroit Institute of Arts 56, no. 1 (1977–78).

Bulliet 1936
Clarence J. Bulliet. *The Significant Moderns and Their Pictures*. New York: Covici, 1936.

Bünemann [1959]
Hermann Bünemann. *Renoir*. Ettal: Buch-Kunstverlag, [1959].

Burnstock, Van den Berg, and House 2005
Aviva Burnstock, Klaas Jan van den Berg, and John House. "Painting techniques of Pierre-Auguste Renoir: 1868–1919." *Art Matters: Netherlands Technical Studies in Art*, vol. 3, 2005, pp. 47–65.

Buson 1959
Robert Buson. "Hélène Bellon est décédée hier à Cagnes." *Nice-Matin*, Thursday, January 22 1959.

Butler 2008
Augustin de Butler. "Renoir aux Collettes: L'atelier du jardin." *Revue de l'Art*, no. 161, 2008, 3, pp. 41–48.

Butler 2008b
Augustin de Butler. "Matisse aux Collettes." In exh. cat. Cagnes-sur-Mer 2008, pp. 111–116.

Cabanne 1975, 1992
Pierre Cabanne. *Le Siècle de Picasso*. Paris: Denoël, 1975. Reprint, Paris: Gallimard (Folio), 1992.

Cahiers d'Art **1936**
"Les Ventes." *Cahiers d'Art*, nos. 8–10, 1936, p. 276.

Cahn 1996
Isabelle Cahn. *Les Nus de Renoir*. Paris: Assouline, 1996.

Canaday 1959
John Canaday. *Mainstreams of Modern Art*. New York: Simon & Schuster, 1959.

Canadian Art **1950**
"Important Acquisitions by Canadian Galleries." *Canadian Art* 7 (1950).

Candide **1943**
"L'allongé—Une visite à Henri Matisse." *Candide*, February 24, 1943.

Cassatt 1984
Cassatt and Her Circle: Selected Letters. Edited by Nancy Mowll Mathews. New York: Abbeville Press, 1984.

Cennini 1911
Cennino Cennini. *Le Livre de l'art, ou Traité de la peinture*. Translated into French by Victor Mottez. Edited by Henry Mottez. Preface by Pierre-Auguste Renoir. Paris: Bibliothèque de l'Occident, 1911.

Chamson 1949
André et Lucie Chamson. *Renoir*. Lausanne: J. Marguerat, 1949.

Cheney 1941
Sheldon Cheney. *The Story of Modern Art*. New York: Viking Press, 1941.

Chikhani 1986
Marie-Thérèse Chikhani. "La collection Jean Walter et Paul Guillaume au musée de l'Orangerie." *L'Orient—Le Jour*, August 27, 1986.

De Chirico 1920
Giorgio de Chirico. "Augusto Renoir." *Il Convegno*, 1920.

De Chirico 1985
Giorgio de Chirico. *Il Meccanismo del pensiero: critica, polemica, autobiografia 1911–1943*. Edited by Maurizio Fagiolo. Turin: Einaudi, 1985.

Cladel 1937
Judith Cladel. *Aristide Maillol: sa vie, son œuvre, ses idées*. Paris: Bernard Grasset, 1937.

Clair 1998
Jean Clair, ed. *Picasso: 1917–1924*. Paris: Gallimard, 1998.

Clergue 1976
D. J. Clergue, ed. *La Maison de Renoir: musée Renoir du souvenir*. Cagnes-sur-Mer: Les Collettes, 1976.

Cleveland Museum of Art 1921
French Paintings of the Later XIXth Century. Cleveland: Cleveland Museum of Art, 1921.

Cleveland Museum of Art 1993
European and American Painting in the Cleveland Museum of Art: A Summary Catalogue. Edited by Alan Chong. Cleveland: Cleveland Museum of Art, 1993.

Cleveland Museum of Art 1999
European Paintings of the 19th Century. Edited by Louise d'Argencourt and Roger Diederen. Cleveland: Cleveland Museum of Art, 1999, 2 vols.

Coates 1958
Robert M. Coates. "The Art Galleries." *The New Yorker*, April 19, 1958, pp. 127–128.

Cogniat 1959
Raymond Cogniat. *Renoir: nus*. Paris: Fernand Hazan, 1959.

Collection Vollard 1999
La Collection Vollard du musée Léon-Dierx: les donations de 1912 et 1947. Paris: Somogy, 1999.

Collet 2006
Georges-Paul Collet. *Jacques-Émile Blanche: le peintre-écrivain*. Paris: Bartillat, 2006.

Collins 2005
John Collins. "Christine Lerolle Embroidering: Between Genre Painting and Portraiture." In exh. cat. Columbus 2005–06, pp. 86–111.

Compin, Lacambre, and Roquebert 1990
Isabelle Compin, Geneviève Lacambre, and Anne Roquebert. *Catalogue sommaire illustré des peintures du musée d'Orsay*. Paris: Réunion des Musées Nationaux, 1990.

Compin and Roquebert 1986
Isabelle Compin and Anne Roquebert. *Catalogue sommaire illustré des peintures du musée du Louvre et du musée d'Orsay. IV: École française*. With contributions from Jacques Foucart and Élisabeth Foucart-Walter. Paris: Réunion des Musées Nationaux, 1986.

Comstock 1962
Helen Comstock. "The Connoisseur in America." *The Connoisseur*, January 1962, pp. 64–68.

Cooper 1954
Douglas Cooper. *The Courtauld Collection: A Catalogue and Introduction*. London: University of London, 1954.

Coquiot 1915
Gustave Coquiot. *Rodin: cinquante-sept statues*. Paris: Bernheim-Jeune, 1915.

Coquiot 1925
Gustave Coquiot. *Renoir*. Paris: Albin Michel, 1925.

Correspondance Matisse-Marquet 2008
Matisse-Marquet: correspondance 1898–1947. Edited by Claudine Grammont. Lausanne: La Bibliothèque des arts, 2008.

Correspondance Renoir-Durand-Ruel 1995
Correspondance de Renoir et Durand-Ruel. I: 1881–1906; II: 1907–1919. Edited by Caroline Durand-Ruel Godfroy. Lausanne: La Bibliothèque des arts, 1995, 2 vols.

Correspondance Stein-Picasso 2005
Gertrude Stein Pablo Picasso: correspondence. Edited by Laurence Madeline. Paris: Gallimard (Art et Artistes), 2005.

Courthion 1926
Pierre Courthion. "L'art français dans les collections privées en Suisse." *L'Amour de l'art*, 1926.

Courthion 1941
Pierre Courthion. "Entretiens avec Henri Matisse" (1941). Excerpts reprinted in Fourcade 1976, pp. 101–103.

Cowling 2003
Elizabeth Cowling. *Picasso: Style and Meaning*. London: Phaidon, 2003.

Cros 2003
Philippe Cros. *Pierre Auguste Renoir*. Paris: Finest S. S. et Pierre Terrail, 2003.

Cruger 1990
George Cruger. "Enduring Legacy: The Personal Patronage of Adolph D. and Wilkins C. Williams." *Arts in Virginia* 29, no. 2–3 (1990), pp. 7–21.

Dagen 1986
Philippe Dagen. *La Peinture en 1905: l' "Enquête sur les tendances actuelles des arts plastiques"*

de Charles Morice. Paris: Lettres modernes, 1986.

Dale 1929
Maud Dale. *Before Manet to Modigliani: from the Chester Dale Collection*. New York: A. A. Knopf, 1929.

Damisch 1997
Hubert Damisch. *Le Jugement de Pâris*. Paris: Flammarion. Reprint, 1997.

Dauberville 1967
Henry Dauberville. *La Bataille de l'impressionnisme*. Paris: J. et H. Bernheim-Jeune, 1967.

Dauberville 1965–74
Jean and Henry Dauberville. *Bonnard: catalogue raisonné de l'œuvre peint*. Paris: Bernheim-Jeune, 1965–1974, 4 vols.

Dauberville 2007 et 2009
Guy-Patrice and Michel Dauberville, in collaboration with Camille Fremontier-Murphy. *Renoir: catalogue raisonné des tableaux, pastels, dessins et aquarelles. I (1858–1881); II, (1882–1894)*. Paris: Bernheim-Jeune, 2007 and 2009, 2 vols.

Daulte 1958
François Daulte. *Pierre Auguste Renoir: aquarelles, pastels et dessins en couleurs*. Basel: Phoebus, 1958.

Daulte 1964
François Daulte. "Renoir, son œuvre regardé sous l'angle d'un album de famille." *Connaissance des arts*, no. 153, November 1964, pp. 75–81.

Daulte 1971
François Daulte. *Auguste Renoir: catalogue raisonné de l'œuvre peint*. Lausanne: Durand-Ruel, 1971.

Daulte 1973
François Daulte. *Renoir*. London: Thames & Hudson, 1973.

Daulte 1974
François Daulte. *Auguste Renoir*. Milan: Fratelli Fabbri, 1974.

Daulte 1978
François Daulte. "Hiroshima Museum of Art." *L'Œil*, December 1978, p. 50.

Daulte 1985
François Daulte [Preface]. *Dessins et aquarelles de Renoir*. Exh. cat. [Paris, Galerie Hopkins-Thomas, April 25–June 30, 1985; Monte Carlo, Artis Monte-Carlo, July 18–September 14, 1985], Paris, 1985.

Davidson 1938
Martha Davidson. "Poetic Vision of the Late Renoir." *Art News*, April 30, 1938.

Dawson 1998
Anne E. Dawson. "The Renoir acquired in 1945 by the Rhode Island School of Design Museum: a significant choice." *Gazette des Beaux-Arts*, April 1998, pp. 183–198.

Delteil 1923
Loÿs Delteil. *Le Peintre-graveur illustré (XIXe et XXe siècles). XVII: Camille Pissarro, Alfred Sisley*. Paris: L. Delteil, 1923.

Denis 1892, 1968
Maurice Denis [Pierre L. Maud]. "Notes d'art et d'esthétique, le Salon du Champ-de-Mars, l'exposition Renoir." *La Revue blanche*, no. 9, June 25, 1892, pp. 360–366. Reprint, Geneva: Slatkine Reprints, 1968.

Denis 1905
Maurice Denis. "La peinture." *L'Ermitage*, no. 11, November 15, 1905.

Denis 1920
Maurice Denis. "La mort de Renoir." *La Vie*, February 1, 1920.

Denis 1922
Maurice Denis. *Nouvelles Théories*. Paris: Rouart et Watelin, 1922.

Denis 1930
Maurice Denis. "Henry Lerolle et ses amis." *La Revue de Paris*, November 1, 1930.

Denis 1957–59
Maurice Denis. *Journal 1884–1904*. Paris: La Colombe, 1957–1959, 3 vols.

Denis 1993
Maurice Denis. *Le Ciel et l'Arcadie*. Edited by Jean-Paul Bouillon. Paris: Hermann, 1993.

Descharnes and Chabrun 1967
Robert Descharnes and Jean-François Chabrun. *Rodin*. Lausanne: Edita; Paris: Vlo, 1967.

Diehl and Ghez 1993
Gaston Diehl and Oscar Ghez. *De l'impressionnisme à l'école de Paris*. Geneva: Musée du Petit Palais, 1993.

Dissard 1912
Paul Dissard. *Le Musée de Lyon: les peintures*. Paris: Renouard, 1912.

Distel 1985–86
Anne Distel. "Renoir's Collectors: the Pâtissier, the Priest and the Prince." In exh. cat. London, Paris, and Boston 1985–86, pp. 19–29.

Distel 1989a
Anne Distel [Entry on Kahn-Sriber]. "Répertoire des donateurs." *Les Donateurs du Louvre*. Paris: Réunion des Musées Nationaux, 1989, p. 240.

Distel 1989b
Anne Distel. *Les Collectionneurs des impressionnistes: amateurs et marchands*. Düdingen: Trio et Franz Stadelmann, 1989.

Distel 1993a
Anne Distel. "Dr. Barnes in Paris." In exh. cat. Washington, Paris, Tokyo, and Philadelphia 1993–94, pp. 29–43.

Distel 1993b
Anne Distel. *Renoir: "Il faut embellir."* Paris: Gallimard (Découvertes) and Réunion des Musées Nationaux, 1993.

Distel 2005
Anne Distel. *Renoir: A Sensuous Vision*. Translated by Lory Frankel. London: Thames & Hudson, 2005.

Distel 2006–07
Anne Distel. "Vollard and the Impressionists: The Case of Renoir." In exh. cat. New York, Chicago, and Paris 2006–07, pp. 142–149.

Documents sur la sculpture française 1989
Documents sur la sculpture française et répertoire des fondeurs au XIXe siècle. Paris: Société d'histoire de l'art français (Archives de l'art français, XXX), 1989.

Dormoy 1926
Marie Dormoy. "La collection Schmitz à Dresde." *L'Amour de l'art* VIII, no. 1 (January 1926), pp. 339–343.

Doschka 1996
Roland Doschka. *L'éternel féminin: from Renoir to Picasso*. Munich & New York: Prestel, 1996.

Drucker 1944
Michel Drucker. *Renoir*. Preface by Germain Bazin. Paris: Pierre Tisné (Bibliothèque des arts), 1944.

Druick 1997
Douglas W. Druick. *Renoir*. Chicago: The Art Institute of Chicago, 1997.

Du Colombier 1920
Pierre Du Colombier. "Renoir." *La Revue critique des idées et des livres*, January 25, 1920, pp. 159–160.

Ducrey 1988
Marina Ducrey and Guy Ducrey. *La Galerie Paul Vallotton depuis 1913*. Lausanne: Galerie Vallotton, 1988.

Dufour 1992
Hélène Dufour. "Mallarmé modèle et portraitiste." *Regards d'écrivains au musée d'Orsay*. Paris: Réunion des Musées Nationaux, 1992, p. 234.

Duplain 1992
Georges Duplain. "Charles Montag, peintre, trait d'union entre créateurs et amateurs." In exh. cat. Baden 1992.

Duranty 1876, 1986
Edmond Duranty. *La Nouvelle Peinture: à propos du groupe d'artistes qui expose dans les galeries Durand-Ruel*. Paris: E. Dentu, 1876. Reprint, Caen: L'Échoppe, 1988. English from Edmond Duranty. "The New Painting: Concerning the Group of Artists Exhibiting at the Durand-Ruel Galleries." In exh. cat. Washington and San Francisco 1986, pp. 37–47.

Duret 1924 (1926)
Théodore Duret. *Renoir*. Paris: Bernheim-Jeune, 1924 (published in 1926).

Duret 1937
Théodore Duret. *Renoir*. Translated by Madeleine Boyd. New York: Crown Publishers, 1937.

Durey 1988
Philippe Durey. *Le Musée des Beaux-Arts de Lyon*. Paris: Albin Michel, 1988.

Durieux 1954
Tilla Durieux. *Eine Tür steht offen: Erinnerungen*. Berlin: F. A. Herbig, 1954.

Dussaule 1992
Georges Dussaule. *Renoir à Cagnes et aux Collettes*. Cagnes: Musée Renoir et Ville de Cagnes-sur-Mer, 1992.

Dussaule 1995
Georges Dussaule. *Renoir à Cagnes et aux Collettes*. Cagnes-sur-Mer: Ville de Cagnes-sur-Mer, 1995.

Duthuit 1923
Georges Duthuit. *Renoir*. Paris: Stock, 1923.

Duthuit 1949, 2006
Georges Duthuit. *Les Fauves*. Geneva: Trois Collines, 1949. Reprint, Paris: Michalon, 2006.

Duval 1961
Elga Liverman Duval. *Téodor de Wyzewa: Critic Without a Country*. Geneva: Droz, and Paris: Minard, 1961.

Eichler 1984
Richard W. Eichler. *Die Wiederkehr des Schönen*. Tübingen: Grabert, 1984.

Ekelhart 2007
Christine Ekelhart. *Die französischen Zeichnungen und Aquarelle des 19. und 20. Jahrhunderts der Albertina*. Vienna, Cologne, and Weimar: Böhlau, 2007.

Elsen 1974
Albert Edward Elsen. *Origins of Modern Sculpture*. New York: George Braziller, 1974.

Eluère 2006
Christiane Eluère. *Monet et la Riviera.* Paris: Citadelles et Mazenod, 2006.

Erwin 1980
Joan Hammond Smith Erwin. *Renoir and Pompeian Wall Painting.* Masters' dissertation, Brown University, 1980 (unpubl.).

Eyerman 2002
Charlotte N. Eyerman. "Playing the Market: Renoir's *Young Girls at the Piano* Series of 1892." In *Music and Modern Art.* Edited by James Leggio. New York: Routledge, 2002, pp. 38–58.

F. D. 1956
F. D. [Review of Wilenski and Denvir 1954, vol. 2]. *Connoisseur* 88, no. 555 (September 1956), p. 65.

Facsimilés 1920
Renoir: facsimilés d'après 21 dessins, aquarelles et pastels de toutes les époques. Introduction by Élie Faure. Paris: Ganymède and Georges Crès et Cie, 1920.

Faure 1934
Élie Faure. "Préface." *Exposition d'œuvres des dix dernières années (1909–1919) de Renoir,* Exh. cat. [Paris, Galerie Paul Rosenberg, January 16–February 24, 1934]. Paris, 1934, preface unpaginated.

Fegdal 1927
Charles Fegdal. *Essais critiques sur l'art moderne.* Paris: Stock, Delamain, Boutelleau et Cie, 1927.

Feilchenfeldt 2006a
Konrad Feilchenfeldt. "Briefe von Paul Cassirer und seinem Team." In *Ein Fest der Künste: Paul Cassirer der Kunsthändler als Verleger.* Edited by Rahel E. Feilchenfeldt et Thomas Raff. Munich: C. H. Beck, 2006.

Feilchenfeldt 2006b
Rahel Feilchenfeldt. "Paul Cassirer—ein Mosaik." In *Ein Fest der Künste: Paul Cassirer der Kunsthändler als Verleger.* Edited by Rahel E. Feilchenfeldt et Thomas Raff. Munich: C. H. Beck, 2006.

Feist 1993
Peter H. Feist. *Pierre Auguste Renoir 1841–1919: un rêve d'harmonie.* Cologne: Taschen, 1993.

Feliciano 1997
Hector Feliciano. *The Lost Museum: The Nazi Conspiracy to Steal the World's Greatest Works of Art.* New York: Basic Books, 1997.

Fell 1992
Derek Fell. *Le Jardin de Renoir.* Translated from the English by Sylvie Cohen. Preface by Jacques Renoir. Paris: Robert Laffont, 1992.

Fénéon 1919
L'Art moderne et quelques aspects de l'art d'autrefois: cent soixante-treize planches d'après la collection privée de MM. J. et G. Bernheim-Jeune. Presented by Félix Fénéon. Paris: Bernheim-Jeune, 1919, 2 vols.

Fénéon 1970
Félix Fénéon. *Œuvres plus que completes.* Edited by Joan U. Halperin. Geneva and Paris: Droz, 1970, 2 vols.

Fenwick 1964
Kathleen M. Fenwick. "The Collection of Drawings." *National Gallery of Canada Bulletin* 2, no. 2 (1964).

Fezzi 1972
Elda Fezzi. *L'Opera completa di Renoir nel periodo impressionista: 1869–1883.* Milan: Rizzoli, 1972.

Fezzi 1985
Elda Fezzi. *Tout l'œuvre peint de Renoir: période impressionniste, 1869–1883.* French edition edited and revised by Jacqueline Henry. Paris: Flammarion, 1985.

Fierens 1933
Paul Fierens. "Renoir classique." *L'Art vivant,* July 1933, p. 286.

Figaro littéraire 1953
Figaro littéraire, December 12, 1953.

Fine Art 1931
Fine Art, January 1931.

Fitzgerald 1995, 1996
Michael Fitzgerald. *Making Modernism: Picasso and the Creation of the Market for Twentieth-Century Art.* New York: Farrar, Straus & Giroux, 1995. Reprint, Berkeley: University of California Press, 1996.

Flam 1986
Jack D. Flam. *Matisse: The Man and His Art, 1869–1918.* Ithaca: Cornell University Press, 1986.

Florisoone 1937
Michel Florisoone. *Renoir.* Paris: Hypérion, 1937.

Florisoone 1938
Michel Florisoone. "Renoir et la famille Charpentier, lettres inédites." *L'Amour de l'art,* no. 1, February 1938, pp. 31–40.

Ford 1986
Terence Ford, ed. *RIDI/RCMI (Répertoire international d'iconographie musicale/International Repertory of Musical Iconography), Inventory of Music Iconography.* no. 1. Washington, DC: National Gallery of Art, 1986.

Forest 1996
Dominique Forest. "Les peintres et la céramique au tournant du siècle." In exh. cat. Nice and Bruges 1996, pp. 12–23.

Formes 1931
Formes, no. 21, December 1931.

Fosca 1921
François Fosca. "Les Dessins de Renoir." *Art et decoration,* July 1921.

Fosca 1924
François Fosca. *Renoir.* Translated by Hubert Wellington. New York: Dodd, Mead, and Company, 1924.

Fosca 1929
François Fosca. "La collection Claude Roger-Marx." *L'Amour de l'art,* no. 9, September 1929.

Fosca 1961, 1962
François Fosca. *Renoir: His Life and Work.* Translated by Mary I. Martin. London: Thames and Hudson, 1961. Published in the United States by Prentice-Hall (Englewood Cliffs, NY), 1962.

Fouchet 1974
Max-Pol Fouchet. *Les Nus de Renoir.* Lausanne: La Guilde du livre, 1974.

Fourcade 1976
Dominique Fourcade. "Autres propos de Matisse." *Macula,* no. 1, 1976, pp. 92–115.

Fox 1952
Milton S. Fox. *A Gallery of Portraits by Renoir (1841–1919).* [New York], Harry N. Abrams, 1952.

Fox et al. 1950
Milton S. Fox et al. *Renoir.* New York: Harry N. Abrams, 1950.

Francastel 1937, 1974
Pierre Francastel. *L'Impressionnisme.* Paris: Les Belles-Lettres, 1937. New edition, Paris: Denoël et Gonthier, 1974.

Francastel 1990
Pierre Francastel. *Histoire de la peinture française.* Paris and Brussels: Elsevier, 1955. Reprint, Paris: Denoël, 1990.

Francis 1940
Henry Francis. "Renoir's Three Bathers." *Cleveland Museum of Art Bulletin* 27 (1940), pp. 14 and 17–18.

Frankfurter 1939
Alfred M. Frankfurter. "The Portraiture of Renoir." *Art News* 37, no. 26 (March 25, 1939), pp. 6–12 and 20.

Frère 1956
Henri Frère. *Conversations de Maillol.* Geneva: Pierre Cailler, 1956.

Freyer 1912
Kurt Freyer. *Museum Folkwang. I: Moderne Kunst.* Hagen: Museum Folkwang, 1912.

Friedenthal 1965
Richard Friedenthal. *Lettres des Grands Maîtres. II: De Blake à Picasso.* Paris and Brussels: Séquoia, 1965.

Frost 1944
Rosamund Frost. *Pierre-Auguste Renoir.* New York: Hyperion Press, 1944.

Fry 1921
Roger Fry. "The Last Works of Renoir." *Arts and Decoration* 14 (January 1921), pp. 246–247.

Garb 1985
Tamar Garb. "Renoir and the Natural Woman." *Oxford Art Journal* 8, no. 2 (1985), pp. 3–15.

Garb 1998
Tamar Garb. *Bodies of Modernity: Figure and Flesh in Fin-de-siècle France.* New York: Thames & Hudson, 1998.

Gasc 2008
Michel Gasc. "Pierre Auguste Renoir et sa polyarthrite rhumatoïde." In exh. cat. Cagnes-sur-Mer 2008.

Gasquet 1921
Joachim Gasquet. "Les Paradis de Renoir." *L'Amour de l'art,* February 1921.

Gauguin 1974
Paul Gauguin. *Oviri: écrits d'un sauvage.* Edited by Daniel Guérin. Paris: Gallimard (Idées), 1974.

Gaunt 1952
William Gaunt. *Renoir.* London: Phaidon Press, 1952.

Gaunt 1982
William Gaunt. *Renoir.* With notes by Kathleen Adler. Oxford: Phaidon, 1982.

Gauthier 1958
Maximilien Gauthier. *Renoir.* Paris: Flammarion, 1958.

Gazette des Beaux-Arts 1970
"La chronique des arts." *Gazette des Beaux-Arts,* 6th series, vol. 75, supplement, February 1970.

Gazette des Beaux-Arts 1974
"La chronique des arts." *Gazette des Beaux-Arts,* 6th series, vol. 83, no. 1260, supplement, January 1974.

Geffroy 1896
Gustave Geffroy. "Auguste Renoir." *Le Journal,* June 20, 1896.

Geffroy 1900
Gustave Geffroy. *La Vie artistique.* 6th series. Paris: E. Dentu (H. Floury), 1900.

Geffroy 1920
Gustave Geffroy. "Renoir, peintre de la femme." *L'Art et les artistes,* no. 4, 1920, pp. 151–162.

Geffroy 1924
Gustave Geffroy. *Claude Monet: sa vie, son œuvre.* Paris: Crès, 1924. New edition edited by Claudie Judrin. Paris: Macula, 1980.

Gélineau 2007
Jean-Claude Gélineau. *Jeanne Tréhot, la fille cachée de Pierre-Auguste Renoir.* Essoyes: Éditions du Cadratin, 2007.

George 1921
Waldemar George. "Renoir et Cézanne." *L'Amour de l'art.* February 1921.

George 1924
Waldemar George. "L'œuvre sculpté de Renoir." *L'Amour de l'art,* 1924, pp. 332–340.

George 1932
Waldemar George. "The Staub Collection at Maennendorf." *Formes,* Eng. ed., vol. 25, May 1932.

George 1933
Waldemar George. "Bonnard et la douceur de vivre, à propos de l'exposition chez Bernheim-Jeune." *Formes,* no. 33, 1933, pp. 380–381.

George 1959
Waldemar George. "La donation Walter est indispensable au Louvre." *Arts,* no. 708, February 4, 1959.

Georgel 2000
Pierre Georgel. "La collection Jean Walter et Paul Guillaume: histoire et propos." In exh. cat. Montreal and Fort Worth 2000–01, pp. 15–86, and in particular: "Ancien ou moderne?" pp. 63–72.

Georges-Michel 1945
Michel Georges-Michel. *Les Grandes Époques de la peinture "moderne" de Delacroix à nos jours.* New York and Paris: Brentano's, 1945.

Georges-Michel 1954
Michel Georges-Michel. *De Renoir à Picasso: les peintres que j'ai connus.* Paris: Arthème Fayard, 1954.

Georges-Michel 1957
Michel Georges-Michel. *From Renoir to Picasso, Artists in Action.* Translated by Dorothy and Randolph Weaver. Boston: Houghton Mifflin, 1957.

Ghez 1976
Oscar Ghez. "Impressionism and After: The Petit Palais, Geneva." *Connoisseur* 158, no. 773 (July 1976), pp. 216–223.

Gilot 1965
Françoise Gilot. *Vivre avec Picasso.* Paris: Calmann-Lévy, 1965.

Gilot and Lake 1964
Françoise Gilot and Carlton Lake. *Life with Picasso.* New York: McGraw Hill, 1964.

Gimpel 1966, 1987
René Gimpel. *Diary of an Art Dealer, 1918–1939.* Translated by John Rosenberg. New York: Farrar, Straus & Giroux, 1966. Reprint: New York: Universe Books, 1987.

Giraudon 1993
Colette Giraudon. *Paul Guillaume et les peintres du XXe siècle: de l'art nègre à l'avant-garde.* Paris: La Bibliothèque des arts, 1993.

Giverny 1943
André Giverny. "Bonnard." *La France libre.* May 15, 1943, pp. 57–61.

Gloor 1992
Lukas Gloor. "Kunst als Propaganda im ersten Weltkrieg." In exh. cat. Baden 1992.

Gloor 2005
Lukas Gloor, ed. *Foundation E. G. Bührle Collection, Zürich: Catalogue.* Conegliano and Zurich: Linea d'Ombra, 2005, 2 vols.

Gold and Fizdale 1980
Arthur Gold and Robert Fizdale. *Misia: The Life of Misia Sert.* New York: Knopf, 1980.

Goldwater 1958
Robert Goldwater. "Renoir at Wildenstein." *Art in America* 46, no. 1 (Spring 1958), pp. 60–62.

Goldwater 1966
Robert Goldwater. "The Glory that was France." *Art News,* no. 65, March 1966, pp. 40–50.

De Grada 1989
Raffaele de Grada. *Renoir.* Milan: Mondadori, 1989.

Green 1987
Christopher Green. *Cubism and its Enemies: Modern Movements and Reaction in French Art, 1916–1928.* New Haven and London: Yale University Press, 1987.

Greenberg 1950, 1993
Clement Greenberg. "Renoir and the Picturesque." *Art News,* April 1950. Revised ed. published in *Art and Culture: critical essays* (1961). Reprinted in Clement Greenberg. *The Collected Essays and Criticism.* Edited by John O'Brian. 4 vols. Chicago and London: The University of Chicago Press, 1993.

Grohmann 1926
Will Grohmann. "Die Kunst der Gegenwart auf der Internationalen Kunstausstellung, Dresden 1926." *Der Cicerone,* 1926, pp. 377–389.

Groom 1993
Gloria Groom. *Édouard Vuillard, Painter-Decorator.* New Haven: Yale University Press, 1993.

Groom 2006–07
Gloria Groom. "Vollard, the Nabis, and Odilon Redon." In exh. cat. New York, Chicago, and Paris 2006–2007, pp. 82–89 (pp. 91–109 in French ed.).

Del Guercio 2003
Antonio Del Guercio. "Roberto Longhi 1913–1919. L'orizzonte critico del suo rapporto con l'arte del Novecento." In *Da Renoir a De Staël: Roberto Longhi e il moderno.* Edited by Claudio Spadoni. Milan: Mazzotta, 2003, pp. 55–66.

Haddad 1990
Michèle Haddad. *La Divine et l'impure: le nu au XIXe siècle.* Paris: Jaguar, 1990.

Haesaerts 1947
Paul Haesaerts. *Renoir sculpteur.* Brusseles, Hermès, n. d. [1947].

Hahnloser 1973
Hans R. Hahnloser. "Künstlerfreunde um Hedy und Arthur Hahnloser-Bühler. Erinnerungen und Briefauszüge." *Künstlerfreunde um Arthur und Hedy Hahnloser-Bühler: Französische und Schweizer Kunst, 1890 bis 1940.* Exh. cat. [Winterthur, Kunstmuseum, September 23–November 11, 1973]. Winterthur, 1973.

Harris 1923
Frank Harris. "Henri Matisse and Renoir, Master Painters." *Contemporary Portraits: Fourth Series.* New York: Brentano's, 1923.

Hedström and Grate 2006
Per Hedström and Pontus Grate, eds. *French Paintings III: Nineteenth Century.* Stockholm: Nationalmuseum, 2006.

Heil and Sinzel 2000
Bettina Heil and Andrea Sinzel. *Briefe an Karl Ernst Osthaus.* Hagen: Kulturstiftung der Länder, 2000.

Héran 2003
Emmanuelle Héran [entries on Maillol]. In *Sammlung Oskar Reinhart "Am Römerholz," Winterthur: Gesamtkunstkatalog.* Edited by Mariantonia Reinhard-Felice. Basel: Schwabe, 2003, pp. 612–630.

Héran 2006a
Emmanuelle Héran. "Vollard, Publisher of Maillol's Bronzes: A Controversial Relationship." In exh. cat. New York, Chicago, and Paris 2006–07, pp. 172–181.

Héran 2006b
Emmanuelle Héran. "Les dessins de Maillol." In *Suite française: dessins de la collection Jean Bonna.* Exh. cat. [Paris, École nationale supérieure des Beaux-Arts, February 14–April 23, 2006; Geneva, Musée d'Art et d'Histoire, December 7, 2006–February 25, 2007]. Paris: École nationale supérieure des Beaux-Arts, 2006, pp. 370–375.

Herbert 1994
Robert L. Herbert. "Léger, the Renaissance and 'primitivism.'" In *Hommage à Michel Laclotte: études sur la peinture du Moyen Âge à la Renaissance.* Paris: Réunion des Musées Nationaux, 1994, pp. 462–467.

Herbert 2000
Nature's Workshop: Renoir's Writings on the Decorative Arts. Edited by Robert L. Herbert. New Haven: Yale University Press, 2000.

Hillairet 1963
Jacques Hillairet. *Dictionnaire historique des rues de Paris.* Paris: Minuit, 6th ed., 1963.

Home House Catalogue 1935
Catalogue of the Pictures and other Works of Art at Home House, 20 Portman Square, London. London: Home House Trustees, 1935.

Hoog and Guicharnaud 1984, 1990
Michel Hoog and Hélène Guicharnaud. *Musée de l'Orangerie: catalogue de la collection Jean Walter et Paul Guillaume.* Paris: Réunion des Musées Nationaux, 1984. Reprint, 1990.

Hope 1945
F. Hope. "A Late Renoir Recently Added to the Institute's Collection." *Bulletin of the Art Institute of Chicago* 39 (1945), pp. 97–102.

Hoppe 1936
Ragnar Hoppe. *Franska 1800—talsmalåre i Nationalmuseum.* Stockholm: P. A. Norstedt, 1936.

Hopper 1933
Inslee A. Hopper. "Vollard and Stieglitz." *The American Magazine of Art* 26, no. 12 (December 1933), pp. 542–545.

Hourticq 1920
Louis Hourticq. *La Galerie Médicis au Louvre.* Paris: Laurens, 1920.

House 1985a
John House. "Renoir's Worlds." In exh. cat. London, Paris, and Boston 1985–1986, pp. 11–18 (pp. 13–27 in French ed.).

House 1985b
John House. "Renoir and the Earthly Paradise." *The Oxford Art Journal* 8, no. 2 (1985), pp. 21–27.

House 1992
John House. "Renoir's 'Baigneuses' of 1887, and the Politics of Escapism." *Burlington Magazine* 134, no. 1074 (September 1992), pp. 578–586.

House 2004
John House. *Renoir.* Paris: Réunion des Musées Nationaux, 2004.

Howard 1991
Les Impressionnistes par eux-mêmes. Edited by Michael Howard. Paris: Atlas, 1991.

Hubbard 1959
Robert H. Hubbard. *The National Gallery of Canada: Catalogue of Paintings and Sculpture. II: Modern European Schools.* Ottawa and Toronto: University of Toronto Press, 1959.

Hubbard 1962
Robert H. Hubbard. *European Paintings in Canadian Collections. II: Modern European Schools.* Ottawa and Toronto: University of Toronto Press, 1962.

Huyghe 1974
René Huyghe. *La Peinture française au XIXe siècle: la relève du réel: impressionnisme, symbolisme.* Paris: Flammarion, 1974.

Huyghe and Jaccottet 1948
René Huyghe (preface) and Philippe Jaccottet. *Le Dessin français au XIXe siècle.* Lausanne: Mermod, 1948.

Imbert 1986
Daniel Imbert. "L'Hôtel de Ville de Paris: genèse républicaine d'un grand décor." *Le Triomphe des mairies: grands décors républicains à Paris 1870–1914.* Exh. cat. [Paris, Musée du Petit Palais, November 8, 1986–January 18, 1987]. Paris: Petit Palais, 1986, pp. 62–71.

Inoue and Takashina 1972
Yasushi Inoue and Shuji Takashina. *Renoir.* [No city], Toshio Nishimura, Japan Art Center (Les Grands Maîtres de la peinture moderne), 1972.

Ishibashi Collection 1996
Ishibashi Collection 1996. Tokyo, Ishibashi Foundation (Bridgestone Museum of Art, Ishibashi Museum of Art), vol. 2, 1996.

Jamot 1914
Paul Jamot. "La Collection Camondo." *Gazette des Beaux-Arts,* May 1914, pp. 387–404.

Jamot 1923
Paul Jamot, "Renoir (1841–1919)." *Gazette des Beaux-Arts,* 1923, November, 1st article, pp. 257–81; December, 2nd article, pp. 321–344.

Jamot 1929
Paul Jamot. "L'art français en Norvège. Galerie nationale d'Oslo et collections particulières." *La Renaissance,* no. 2 (12th year), February 1929, pp. 68–106.

Jamot and Guiffrey 1929
Paul Jamot and Jean Guiffrey, eds. *La Peinture au musée du Louvre: école française du XIXe siècle.* 2nd part, vol. IV. Paris: L'Illustration, 1929.

Jamot and Turner 1934
Paul Jamot and Percy Moore Turner. *Collection de tableaux français, faite à Londres, 20 Portman Square, par Samuel et Elizabeth Courtauld, 1914–31.* London: privately printed, 1934.

Jeanès 1946
J. E. S. Jeanès. *D'après nature: souvenirs et portrait: Renoir, Barrès, Rodin, Villiers de L'Isle-Adam, Erckmann sans Chatrian, Moréas, Apollinaire, Charles Cros, Theresa, et quelques autres.* Besançon: Granvelle, 1946.

Jedlicka 1947
Gotthard Jedlicka. *Renoir.* Bern: A. Scherz, 1947.

Jewell and Crane 1944
Edward Alden Jewell and Aimée Crane. *French Impressionists and Their Contemporaries Represented in American Collections.* New York: Hyperion Press, 1944.

Joannidès 1921
Alexandre Joannidès. *La Comédie française de 1860 à 1920: tableau des représentations par auteurs et par pieces.* Paris: Plon, 1921.

Joannidès 2000
Paul Joannidès. *Renoir, sa vie, son œuvre.* Courbevoie: Soline, 2000.

Joëts 1953
Jules Joëts. "Deux grands peintres au Cannet. Le dernier entretien de Pierre Bonnard avec le peintre Jules Joëts." *Art-Documents,* no. 29, February 1953, pp. 8–9.

Johnson 1944
Una E. Johnson. *Ambroise Vollard Editor.* New York: Museum of Modern Art, 1944.

Joubert and Renard 1995
Jacques Joubert and Dominique Renard. *Une partie de campagne: une nouvelle de Guy de Maupassant, un film de Jean Renoir.* Paris: Belin, 1995.

Jours de France 1959
"Dans les salons de Domenica Walter, plus d'un milliard de chefs-d'œuvre." *Jours de France,* no. 221, February 7, 1959, pp. 46–47.

Jullian 1938
René Jullian. *Lyon-Touriste,* no. 279, 1938.

Kahnweiler 1952
Daniel-Henry Kahnweiler. "Huit entretiens avec Picasso." *Le Point, revue artistique et littéraire,* XLII, October 1952.

Keller 1987
Horst Keller. *Auguste Renoir.* Munich: Bruckmann, 1987.

Kern 1996
Steven Kern. *A Passion for Renoir: Sterling and Francine Clark Collect 1916–1951.* New York: Harry N. Abrams, in association with the Sterling and Francine Clark Art Institute, 1996.

Kimmelman 1989
Michael Kimmelman. "How the Modern got the Van Gogh." *The New York Times,* October 9, 1989, Section C, p. 13.

Koella 2006
Rudolf Koella. "Vollard und die Schweiz." In exh. cat. Baden and Vevey 2006, pp. 116–137.

Koschatzky 1977
Walter Koschatzky. *Die Kunst der Zeichnung.* Salzburg: Residenz, 1977.

Kostenevich 1995
Albert Kostenevich. "Jeunes filles au piano." In exh. cat. Saint Petersburg 1995–96, pp. 112–115.

L'Amour de l'art 1926
"La collection Émile Staub. L'art français dans les collections privées en Suisse." *L'Amour de l'art.* February 1926.

L'Art Vivant 1932
L'Art Vivant 8, no. 156 (January 1932).

L'Éclair 1892
"Nos artistes. Le peintre P.-A. Renoir chez lui." *L'Éclair,* August 9, 1892, p. 1.

L'Imagier 1923
L'Imagier. "L'incident du tableau de Renoir." *L'Œuvre.* March 31, 1923.

L'Intransigeant 1913
L'Intransigeant, March 13, 1913.

L'Œuvre 1923
"Autour d'un tableau de Renoir." *L'Œuvre.* March 30, 1923.

La Chronique des arts 1912
La Chronique des arts et de la curiosité. Supplement of the *Gazette des Beaux-Arts,* no. 25, July 13, 1912.

Laporte 1948
Paul M. Laporte. "The Classic Art of Renoir." *Gazette des Beaux-Arts,* 6th series, vol. 35, March 1948, pp. 177–188.

Lauts and Zimmermann 1971
Jan Lauts and Werner Zimmermann. *Staatliche Kunsthalle Karlsruhe. Katalog Neuere Meister des 19. und 20. Jahrhunderts.* Karlsruhe: Staatliche Kunsthalle, 1971, 2 vols. (texts and reproductions).

Le Cœur 2002
Marc Le Cœur. "Le peintre, son premier modèle et ses premiers amateurs: l'histoire dont Renoir ne voulait pas parler." In exh. cat. São Paulo 2002, pp. 196–217. Revised edition, *Renoir au temps de la bohème: l'histoire que l'artiste voulait oublier.* Paris: L'Échoppe, 2009 (forthcoming).

Le Musée national 2000
Le Musée national. Paris: Gallimard, 2000.

Leclerc 1950
André Leclerc. *Renoir.* Paris: Hypérion, 1950.

Lecomte 1892
Georges Lecomte. "L'Art contemporain." *La Revue indépendante* XXIII, no. 66 (April–June 1892), pp. 1–29.

Lecomte 1943
Georges Lecomte. "Mon plus beau diner." *Voix françaises,* April 16, 1943.

Léon 1947
Paul Léon. *Du Palais-Royal au Palais-Bourbon: Souvenirs.* Paris: Albin Michel, 1947.

Les Arts à Paris 1931
Les Arts à Paris, no. 18, July 1931.

Lesné and Roquebert 2004
Claude Lesné and Anne Roquebert. *Catalogue des peintures MNR.* Paris: Réunion des Musées Nationaux, 2004.

Leymarie 1953
Jean Leymarie. *Les Pastels, dessins et aquarelles de Renoir.* Paris: Fernand Hazan, 1953.

Leymarie 1969
Jean Leymarie. *Dessins de la période impressionniste de Manet à Renoir.* Geneva: Skira, 1969.

Leymarie 1978
Jean Leymarie. *Renoir.* Paris: Hazan, 1978.

Lhote 1920
André Lhote. "Renoir." *Nouvelle Revue française* 111, no. 77 (February 1920).

Lhote 1936
André Lhote. *Parlons peinture.* Paris: Denoël, 1936.

Lhote 1947
André Lhote. *Renoir: peintures.* Paris: Chêne, 1947.

Lhote 1950
André Lhote. *Traité de la figure.* Paris: Floury, 1950.

Life Magazine 1963
"A Collector's Double-Takes: The Man who

Bought Art within Art." *Life Magazine*, April 27, 1963.

Longhi 1984
Roberto Longhi. "Giorgio Morandi" [1945]. *Scritti sull'Otto e Novecento*. Florence: Sansoni, 1984.

Los Angeles County Museum of Art 1987
European Painting and Sculpture in the Los Angeles County Museum of Art. Edited by Scott Schaefer and Peter Fusco, with the assistance of Paula-Teresa Wiens. Los Angeles: Los Angeles County Museum of Art, 1987.

Louvre 1972
Musée du Louvre: catalogue des peintures. I: École française. Paris: Musée du Louvre, 1972.

Loyrette 1991
Henri Loyrette. *Degas*. Paris: Fayard, 1991.

M. F. 1943
M. F. "Portraits at Museum of Modern Art." *Magazine of Art* 36, no. 1 (January 1943), pp. 16–18.

Madeline 2006
Laurence Madeline. *Picasso—Van Gogh*. Paris: La Martinière, 2006.

Maignan 1979
Sylvie Maignan. "Propagande artistique française en Suisse (1917)." In Sylvie Maignan. *Un critique d'art parisien: René-Jean, 1879–1951*. Dissertation, Paris, l'École du Louvre, 1979, pp. 126–137.

Mallarmé 1981
Stéphane Mallarmé. *Correspondance*. Edited by Henri Mondor and Lloyd James Austin. [Paris], Gallimard, 1981.

Mallarmé 2006
Stéphane Mallarmé. "The Future Phenomenon." *Stéphane Mallarmé: Collected Poems and Other Verse*. Translated by E. H. and A. M. Blackmore. Oxford, New York, et al.: Oxford University Press, 2006, p. 83.

Malraux 1974
André Malraux. *La Tête d'obsidiane*. Paris: Gallimard, 1974.

Manet 1979
Julie Manet. *Journal (1893–1899): sa jeunesse parmi les peintres impressionnistes et les hommes de lettres*. Paris: Klincksieck, 1979.

Manet 1987
Growing up with the Impressionists: The Diary of Julie Manet. Translated, edited, and with an introduction by Rosalind de Boland Roberts and Jane Roberts. London: Philip Wilson Publishers Ltd. for Sotheby's Publications, 1987.

Manet 1987b
Julie Manet. *Journal 1893–1899*. Paris: Scala, 1987.

Martin-Méry 1967
Gilberte Martin-Méry. "Les enrichissements du musée des Beaux-Arts de Bordeaux (1960–1966)." *La Revue des musées de Bordeaux*, 1967.

Marx 1892
Roger Marx. "Renoir." *Le Voltaire*, April 26, 1892.

Marx 1892b
Roger Marx. "Le musée de l'art contemporain." *Le Rapide*, no. 49, December 5, 1892, p. 1.

Marx 1914
Roger Marx. *Maîtres d'hier et d'aujourd'hui*. Paris: Calmann-Lévy, 1914.

Matisse 1908
Henri Matisse. "Notes d'un peintre." *La Grande Revue*, December 25, 1908.

Matisse 1952
Henri Matisse [Interview with Michel d'Amayer]. "Comment peut-on s'engager alors que pour travailler on ne s'appartient jamais assez?" *Arts*, no. 379, October 3, 1952.

Matisse 1972, 2005
Henri Matisse. *Écrits et propos sur l'art*. Edited by Dominique Fourcade. Paris: Hermann, 1972. Reprint, 2005.

Matisse on Art 1995
Matisse on Art. Edited by Jack Flam. New edition, Berkeley: University of California Press, 1995.

Mauclair 1892
Camille Mauclair. "Exposition Renoir (Durand-Ruel)." *La Revue indépendante*, no. 13, May 1892, pp. 287–288.

Mauclair 1902
Camille Mauclair. "L'Œuvre d'Auguste Renoir." *L'Art decoratif*, no. 42, March 1902.

Mauclair [1903]
Camille Mauclair. *The French Impressionists (1860-1900)*. Translated by P. G. Konody. London: Duckworth & Co., and New York: E. P. Dutton & Co., [1903].

Mauclair 1904
Camille Mauclair. *L'Impressionnisme: son histoire, son esthétique, ses maîtres*. Paris: Baranger, 2nd ed., 1904.

Mauclair 1906
Camille Mauclair. "Salon d'Automne." *Art et decoration*. November 1906.

Mauclair 1929
Camille Mauclair. *Les Musées d'Europe: Lyon (le palais Saint-Pierre)*. Paris: Nilsson, 1929.

Mauny 1940
Jacques Mauny. "Letters from Paris." *Magazine of Art* 33, no. 1 (January 1940), pp. 36–37 and 58–60.

Meier-Graefe 1904
Julius Meier-Graefe. *Entwicklungsgeschichte der modernen Kunst, vergleichende Betrachtung der bildenden Künste als Beitrag zu einer neuen Aesthetik*. Stuttgart: J. Hoffmann, 1904.

Meier-Graefe 1908
Julius Meier-Graefe. *Modern Art Being a Contribution to a New System of Aesthetics*. New York: G. P. Putnam's Sons, and London: William Heinemann, 1908.

Meier-Graefe 1911, 1920
Julius Meier-Graefe. *Auguste Renoir*. Munich: R. Piper, 1911. Reprint, 1920.

Meier-Graefe 1912
Julius Meier-Graefe. *Auguste Renoir*. Translated to French by A. S. Maillet. Paris: H. Floury, 1912.

Meier-Graefe 1925
Julius Meier-Graefe. "Die Sammlung Gangnat." *Kunst und Künstler* 23, no. 9 (June 1925), pp. 348–356.

Meier-Graefe 1929
Julius Meier-Graefe. *Renoir*. Leipzig: Klinkhardt & Biermann, 1929.

Meier-Graefe 1938
Julius Meier-Graefe. "Bonnard." *Art News*, no. 37, December 31, 1938, p. 9.

Mellerio 1891
André Mellerio. "Les artistes à l'atelier: Renoir." *L'Art dans les deux mondes*, January 31, 1891, p. 122, partially reprinted in Renoir 2002, pp. 169–170.

Mellerio 1900
André Mellerio. *L'Exposition de 1900 et l'impressionnisme*. Paris: Floury, 1900.

Metthey 1907
André Metthey. "La Renaissance de la faïence stannifère." *La Grande Revue*, no. 44, October 10, 1907, pp. 746–749.

Minervino 2003
Fiorella Minervino. "Il Novecento. Renoir e il Midi." In exh. cat. Treviso 2003–04.

Mirbeau 1913
Octave Mirbeau. *Renoir*. Special issue of *Cahiers d'aujourd'hui*, no. 3, February 1913.

Mittler and Ragans 1997
Gene Mittler and Rosalind Ragans. *Understanding Art*. New York, 1997.

Moncade 1904
C. L. de Moncade. "Le peintre Renoir et le Salon d'Automne." *La Liberté*, October 15, 1904.

Mondial Collections 1995
"Paris Revisited." *Mondial Collections*. Vol. 5, 1995.

Monneret 1990
Sophie Monneret. *Renoir*. Translated by Emily Read. New York: Henry Holt & Co., 1990.

Morice 1905
Charles Morice. "Enquête sur les tendances actuelles des arts plastiques." *Mercure de France*, August 1, 1905. See Dagen 1986.

Morisot 1987
Berthe Morisot: The Correspondence with her Family and Friends Manet, Puvis de Chavannes, Degas, Monet, Renoir and Mallarmé. Compiled and edited by Denis Rouart. Translated by Betty W. Hubbard, with a new introduction and notes by Kathleen Adler and Tamar Garb. Mt. Kisco, NY: Moyer Bell Limited, 1987.

Moskowitz 1962
Ira Moskowitz. *Great Drawings of All Time*. Vol. 3. New York: Shorewood, 1962.

Munck 2006
Jacqueline Munck. "Bonnard, par défaut." *Bonnard: l'œuvre d'art, un arrêt du temps*. Exh. cat. [Paris, Musée d'Art Moderne de la Ville de Paris, February 2–May 7, 2006]. Paris: Paris Musées, 2006, pp. 85–90.

Munson-Williams-Proctor 1952
"Picture of the Month." *Munson-Williams-Proctor Institute Bulletin*. December 1952.

Musée Picasso 1985
Musée Picasso: catalogue sommaire des collections. I: Peintures, papiers collés, tableaux reliefs, sculptures, céramiques. Paris: Réunion des Musées Nationaux, 1985.

Museum of Modern Art Bulletin 1953
"Painting and Sculpture Acquisitions, July 1, 1951–May 31, 1953." *Museum of Modern Art Bulletin* 20 (1953), pp. 42–47.

Museum of Modern Art Bulletin 1957
Museum of Modern Art Bulletin 24, no. 4 (1957).

Museum of Modern Art 1988
Painting and Sculpture in the Museum of Modern Art: Catalogue of the Collection. Edited by Alicia Legg. New York: Museum of Modern Art, 1988.

Nash 1979
Steven A. Nash et al. *Albright-Knox Art Gallery: Painting and Sculpture from Antiquity to 1942*. New York: Rizzoli, 1979.

Natanson 1896
Thadée Natanson. "Les Expositions d'art." *La Revue blanche*, March 15, 1896, p. 285.

Natanson 1900
Thadée Natanson. "De M. Renoir et de la Beauté." *La Revue blanche*, March 1900, pp. 370–377.

Natanson 1912
Thadée Natanson. "Pierre Bonnard." *La Vie*, June 5, 1912, pp. 540–542.

Natanson 1948
Thadée Natanson. *Peints à leur tour*. Paris: Albin Michel, 1948.

Natanson 1948b
Thadée Natanson. "Renoir il y a cinquante ans." In Natanson 1948, pp. 15–27. Partial reprint of the article "Renoir" published on June 15, 1896 in *La Revue blanche*.

Natanson 1951
Thadée Natanson. *Le Bonnard que je propose*. Geneva: Pierre Cailler, 1951.

National Gallery of Art 1975
European Paintings: An Illustrated Summary Catalogue. Washington, DC: National Gallery of Art, 1975.

National Gallery of Art 1985
European Paintings: An Illustrated Catalogue. Washington, DC: National Gallery of Art, 1985.

Nationalmuseum 1928
Collection des peintures du Musée national, catalogue descriptif: maîtres étrangers. Edited by Osvald Sirén. Stockholm: Nordisk Rotogravyr, 1928.

Nationalmuseum 1958
Äldre utländska målningar och skulpture = Peintures et sculptures des écoles étrangères à l'époque moderne. Stockholm, Nationalmuseum, 1958.

Nationalmuseum 1990
Illustrerad katalog över äldre udländsdkt måleri = Illustrated Catalogue: European Painting. Stockholm, Nationalmuseum, 1990.

Near 1974
Pinkney L. Near. *Treasures in the Virginia Museum*. Richmond: Virginia Museum of Fine Arts, 1974.

Near 1985a
Pinkney L. Near. "French Paintings in the Collection of M. and Mrs. Paul Mellon." *Apollo* 122, no. 286 (December 1985), pp. 456–459.

Near 1985b
Pinkney L. Near. *French Paintings from the Collection of M. and Mrs. Paul Mellon in the Virginia Museum of Fine Arts*. Richmond: Virginia Museum of Fine Arts, 1985.

Néret 2001
Gilles Néret. *Renoir, peintre du bonheur: 1841–1919*. Cologne: Taschen, 2001.

New Orleans 1995
New Orleans Museum of Art: Handbook of the Collection. Edited by Sharon E. Stearns. Works selected by E. John Bullard. New Orleans: New Orleans Museum of Art, 1995.

New York Times 1956
"First Major Renoir Enters Museum of Modern Art." *New York Times*, Arts & Leisure section, Sunday, June 24, 1956, p. X11.

Newman 1984
Sasha M. Newman. "Bonnard 1900–1920." *Bonnard: The Late Paintings*. Exh. cat. [Paris, Musée National d'Art Moderne, February 23–May 21, 1984; Washington, DC, The Phillips Collection, June 9–August 25, 1984; Dallas Museum of Art, September 13–November 11, 1984]. Paris, Washington, and Dallas, 1984.

Nochlin 2008
Linda Nochlin. "Renoir, il pittore di uomini." In exh. cat. Rome 2008, pp. 37–55.

Okamoto 1965
Kenjiro Okamoto. *Renoir*. Tokyo: SPADEM (Gendai Sekai Bijutsu Zenshu, 2), 1965.

Olson 1965
Gösta Olson. *Från Ling till Picasso: En konsthandlares minnen berättade genom Karin Jacobsson*. Stockholm: Bonniers, 1965.

Oscar Schmitz Collection 1936
The Oscar Schmitz Collection: Masterpieces of French Painting of the Nineteenth Century. [Paris], Wildenstein, 1936.

Osterman 1958
Gunhild Osterman. *Richard Bergh och Nationalmuseum: Några document*. Lunnd: Berlinska Boktr (Nationalmusei skriftserie, 4), 1958.

Osthaus 1919–20
Karl Ernst Osthaus. "Erinnerungen an Renoir." *Feuer*, 1919–20.

Osthaus 2002
Karl Ernst Osthaus. *Reden und Schriften: Folkwang, Werkbund, Arbeitsrat*. Edited by Rainer Stamm and Rainer K. Wick. Cologne: König, 2002.

Pach 1912
Walter Pach. "Pierre-Auguste Renoir." *Scribner's Magazine* 51 (May 1912), pp. 606–615, reprinted in Pach 1938, pp. 104–115.

Pach 1938, 1971
Walter Pach. *Queer Thing, Painting: Forty Years in the World of Art*. New York: Harper & Brothers

Publishers, 1938. Reprint, Freeport: Books for Libraries Press, 1971.

Pach 1950
Walter Pach. *Pierre-Auguste Renoir.* New York: Harry N. Abrams, 1950.

Pach 1951
Walter Pach. *Renoir.* Introduction by Walter Pach. London: Idehurst Press, 1951.

Pach 1958
Walter Pach. *Renoir.* Translated to French by Marie-Paule Leymarie. Paris: Nouvelles Éditions françaises, 1958.

Pach 1958b
Walter Pach. "Renoir, Rubens and the Thurneyssen Family." *Art Quarterly* 21, no. 1 (Fall 1958), pp. 278–282.

Pach 1964, 1983
Walter Pach. *Pierre-Auguste Renoir.* New York: Harry N. Abrams, 1964. Abridged reprint, 1983.

Pach 1976
Walter Pach. *Renoir: Leben und Werk.* Cologne: Dumont, 1976.

Painter and Crow 2002
Karen Painter and Thomas Crow, eds. *Late Thoughts: Reflections on Artist and Composers at Work.* Conference proceedings, Los Angeles, Getty Research Institute, 2002.

Papet 2003
Édouard Papet. "Kleine kniende Wäscherin, Grosse kniende Wäscherin." *Sammlung Oskar Reinhart "Am Römerholz," Gesamtkatalog.* Edited by Mariantonia Reinhard-Felice. Basel: Schwabe, 2003, pp. 608–611.

Parmelin 1974
Hélène Parmelin. "Picasso ou le collectionneur qui n'en est pas un." *L'Œil,* no. 230, September 1974.

Parmelin 1980
Hélène Parmelin. *Voyage en Picasso.* Paris: Robert Laffont, 1980.

Pasteau and Journiac 2004
Sophie Pasteau and Virginie Journiac. "Maurice et Philippe Gangnat, les amis collectionneurs." In exh. cat. Cagnes-sur-Mer 2008, pp. 93–95.

Patry 2005–06
Sylvie Patry. "L'Invention du modèle." In exh. cat. Paris 2005–06, pp. 26–37.

Pedrazzini 1966
Marie-Charlotte Pedrazzini. "Le legs fabuleux de Mme Walter." *Paris-Match,* January 29, 1966, pp. 38–56.

Penesco 2005
Anne Penesco. *Mounet-Sully: "L'homme aux cent cœurs d'homme."* Paris: Cerf, 2005.

Perruchi-Petri 1998
Ursula Perruchi-Petri. "Die Sammlung Hedy und Arthur Hahnloser-Bühler in Winterthur." *Die Kunst zu sammeln: Schweizer Kunstsammlungen seit 1848.* Zurich: Schweizerisches Institut für Kunstwissenschaft, 1998.

Perruchot 1964
Henri Perruchot. *La Vie de Renoir.* Paris: Hachette, 1964.

Petit-Palais 1968
L'Aube du XXe siècle: de Renoir à Chagall. Catalogue of the collection, edited by François Daulte et al. Geneva: Musée du Petit Palais, 1968, 2 vols.

Pezzi and Henry 1985
Elda Pezzi and Jacqueline Henry. *Tout l'œuvre peint de Renoir.* Paris: Flammarion, 1985.

Pharisien 1998
Bernard Pharisien. *Célébrités d'Essoyes, ce village qui a conquis Renoir.* Essoyes: Némont, 1998.

Pharisien 2009
Bernard Pharisien. *Quand Renoir vint paysanner en Champagne.* Bar-sur-Aube: Némont, 2009.

Philadelphia Museum of Art 1964
Philadelphia Museum of Art. *The Louis E. Stern Collection.* Philadelphia: George H. Buchanan Co., 1964.

Pia 1955
Pascal Pia. "Ambroise Vollard, marchand et éditeur." *L'Œil,* no. 3, 1955, pp. 18–27.

Picasso 1998
Pablo Picasso. *Propos sur l'art.* Edited by Marie-Laure Bernadac and Androula Michael. Paris: Gallimard (Art et Artistes), 1998.

Pictures on Exhibit 1958
"Renoir Again at Wildenstein." *Pictures on Exhibit* 21, no. 7 (April 1958), pp. 8–9.

Pingeot, Le Normand-Romain, and Margerie 1986
Anne Pingeot, Antoinette Le Normand-Romain, and Laure de Margerie. *Musée d'Orsay: catalogue sommaire illustré des sculptures.* Paris: Réunion des Musées Nationaux, 1986.

Pinturicchio
Pinturicchio [pseud.]. "Les Carnets des ateliers—Les derniers Renoir." *Carnet de la semaine,* June 15, 1924.

Pissarro 1989
Camille Pissarro. *Correspondance 1895–1898.* Edited by Janine Bailly-Herzberg, vol. 4. Paris: Éditions du Valhermeil, 1989.

Pointon 1990
Marcia Pointon. *Naked Authority: The Body in Western Painting 1830–1908.* Cambridge: Cambridge University Press, 1990.

Popham and Fenwick 1965
A. E. Popham and K. M. Fenwick. *Catalogue of European Drawings: The National Gallery of Canada.* Toronto: University of Toronto Press, 1965.

Pophanken 1996
Andrea Pophanken. "Privatsammler der französischen Moderne in München." In exh. cat. Berlin and Munich 1996–97.

Potron 2000
Jean-Paul Potron. *Paysages de Nice, Villefranche, Beaulieu du XVIIe au XXe siècle.* Nice, Gilletta and Nice-Matin (Voir en peinture), 2000.

Potron 2002
Jean-Paul Potron. *Paysages de Cagnes, Antibes, Juan-les-Pins, du XVIIe au XXe siècle.* Nice, Gilletta and Nice-Matin (Voir en peinture), 2002.

Prampolini 1953
Enrico Prampolini. "Incontro di Picasso con Roma." *La Biennale di Venezia.* 1953.

Preiswerk-Lösel 1992
Eva-Maria Preiswerk-Lösel. "Carl Montag als Kunstberater von Sidney und Jenny Brown." In exh. cat. Baden 1992.

Preiswerk-Lösel 2001
Ein Haus für die Impressionisten: Das Museum Langmatt, Stiftung Sidney und Jenny Brown, Baden, Gesamtkatalog. Edited by Eva-Maria Preiswerk-Lösel. Ostfildern-Ruit: Hatje Cantz, 2001.

Providence 1947
Providence Sunday Journal, May 4, 1947.

Quesada 1996
Luis Quesada. *Pintores Españoles y Extranjeros en Andalucia.* Seville: Guadalquivir, 1996.

Rapetti 1991
Rodolphe Rapetti. "René Piot et le renouveau de la fresque à l'aube du XXe siècle." *René Piot, fresquiste et décorateur.* Exh. cat. [Paris, Musée d'Orsay, February 26–May 27, 1991]. Paris: Réunion des Musées Nationaux (Les dossiers du Musée d'Orsay), pp. 6–32.

Rayfield 1998
Susan Rayfield. *First Impressions: Pierre-Auguste Renoir.* New York: Harry N. Abrams, 1998.

Reader's Digest 1971
Reader's Digest Family Treasures of Great Biographies. Vol. 10. Pleasantville, NY: Reader's Digest 1971.

Régnier 1923
Henri de Régnier. *Renoir, peintre du nu.* Paris: Bernheim-Jeune, 1923.

René 1923
Jean René. "L'art français dans une collection Suisse: la collection de M. Staub-Terlinden." *La Renaissance.* August 1923.

Renoir Paints His Family 1995
Renoir Paints His Family. Edmonton: La Fondation Renoir Pour Les Arts, 1995.

Renoir 1877
Pierre-Auguste Renoir. "L'art décoratif et contemporain." *L'Impressionniste,* April 28, 1877, no. 4, pp. 3–6.

Renoir 2002
Pierre-Auguste Renoir. *Écrits, entretiens et lettres sur l'art.* Compiled and edited by Augustin de Butler. Paris: Les Éditions de l'amateur (Regard sur l'art), 2002; new ed., Hermann 2009.

C. Renoir 1948
Claude Renoir. "Souvenirs sur mon père." *Seize aquarelles et sanguines par Renoir, accompagnées de Souvenirs sur mon père par Claude Renoir.* Paris: Quatre Chemins–Éditart, 1948.

C. Renoir 1959
Claude Renoir. "Adieu à Gabrielle de notre enfance." *Paris-Match,* no. 518, March 14, 1959, pp. 30–33.

E. Renoir 1879
Edmond Renoir. "Cinquième exposition de 'La vie moderne.'" *La Vie moderne,* no. 11, June 19, 1879.

J. Renoir 1952
Jean Renoir. "My Memories of Renoir." *Life* XXXII, no. 20 (May 19, 1952), pp. 90–99.

J. Renoir 1962
Jean Renoir. *Renoir, My Father.* Boston, Toronto, and London: Collins and Little, Brown & Company, 1962. French edition: Jean Renoir. *Pierre Auguste Renoir, mon père.* Paris: Hachette, 1962. Reprint, Paris: Gallimard (Folio), 1981 and 2005.

J. Renoir 1974
Jean Renoir. *My Life and My Films.* Translated by Norman Denny. London: Collins, 1974.

P. Renoir 1971
Paul Renoir and Stefano Pirra. *125 dessins inédits de Pierre-Auguste Renoir.* Turin: Edizioni d'Arte Pinacoteca, 1971.

P. Renoir 1991

Pointon 1990
Paul Renoir. "Si Renoir m'était conté…" Havemarkt (Belgium): Galerie Philippe Frynns, 1991.

Revers 1911
Henry Revers. "Qui sera président de la Société Nationale? Chez Auguste Rodin." *Les Nouvelles,* December 30–31, 1911.

Rewald 1939
John Rewald. *Maillol.* Paris: Hypérion, 1939.

Rewald 1946
John Rewald. *Renoir Drawings.* New York: H. Bittner & Company, 1946.

Rewald 1946b
John Rewald. *The History of Impressionism.* New York: The Museum of Modern Art, 1946.

Rewald 1948
John Rewald. "Œuvres de jeunesse de Renoir." *Arts,* September 17, 1948.

Rewald 1989
John Rewald. *Cézanne and America: Dealers, Collectors, Artists and Critics, 1891–1921.* Princeton: Princeton University Press, 1989.

Rey 1931
Robert Rey. *La Renaissance du sentiment classique: Degas, Renoir, Gauguin, Cézanne, Seurat: la peinture française à la fin du XXe siècle.* Paris: Les Beaux-Arts, 1931.

Rheims 1978
Maurice Rheims. *XIXe siècle: histoire mondiale de la sculpture.* Paris: Hachette, 1978.

Richmond Times-Dispatch 1958
Richmond Times-Dispatch. Sunday, February 11, 1958.

Riopelle 1990
Christopher Riopelle. "Renoir: The Great Bathers." *Philadelphia Museum of Art Bulletin* 86, no. 367–368 (Fall 1990).

Riout 1989
Les Écrivains devant l'impressionnisme. Textes réunis et présentés par Denys Riout. Paris: Macula, 1989.

Ritchie 1949
Andrew Carnduff Ritchie et al. *Catalogue of the Paintings and Sculpture in the Permanent Collection.* Buffalo: Buffalo Fine Arts Academy, Albright Art Gallery, 1949.

Rivière 1877
Georges Rivière. "Les intransigeants et les impressionnistes, souvenirs du Salon libre de 1877." *L'Artiste,* November 1, 1877, pp. 298–302.

Rivière 1921
Georges Rivière. *Renoir et ses amis.* Paris: H. Floury, 1921.

Robida 1959
Michel Robida. *Renoir: portraits d'enfants.* Lausanne: International Art Book, 1959.

Robinson 1985
Walter Robinson [Interview]. In "Renoir: A Symposium." *Art in America,* March 1986, pp. 103–125.

Roger-Marx 1933, 1937
Claude Roger-Marx. *Renoir.* Paris: Floury (Anciens et modernes), 1933. Reprint, 1937.

Roger-Marx 1958
Claude Roger-Marx. "Le commerce des tableaux sous l'impressionnisme à la fin du XIXe siècle." *Médecine de France,* no. 95, 1958, pp. 17–31.

Roger-Marx 1964
Claude Roger-Marx. "Trois siècles de sanguine." *Le Jardin des arts,* April 1964, p. 37.

Roque 2006
Georges Roque. *La Stratégie de Bonnard: couleur, lumière, regard.* Paris: Gallimard, 2006.

Rosand 1987
David Rosand. "Style and the Aging Artist" [introduction to the special issue "Old-Age Style"]. *Art Journal* 46, no. 2 (Summer 1987), pp. 91–94.

Rosenblum 1989
Robert Rosenblum. *Les Peintures du musée d'Orsay.* Avec une préface de Françoise Cachin. Paris: Nathan, 1989.

Rosenfeld 1991
Daniel Rosenfeld et al. *European Painting and Sculpture, ca. 1770–1937, in the Museum of Art, Rhode Island School of Design.* Providence: The Museum, 1991; paperback edition, Philadelphia: University of Pennsylvania Press, 1992.

Rouart 1954
Denis Rouart. *Renoir.* Geneva: Skira, 1954.

Rouart 1985
Denis Rouart. *Renoir.* New York: Skira/Rizzoli, 1985.

Roux-Champion 1955
Joseph-Victor Roux-Champion. "Dans l'intimité de Renoir aux Collettes." *Le Figaro littéraire,* no. 481, July 9, 1955, p. 1.

Sacs 1919
J. Sacs [Felius Elies]. "Enric Matisse." *Vell i nou,* November 1, 1919.

Said 2006
Edward W. Said. *On Late Style: Music and Literature against the Grain.* London: Bloomsbury, 2006.

Salmon 1920
André Salmon. *L'Art vivant*. Paris: Crès, 1920.

Salmon 1922
André Salmon. *Propos d'atelier*. Paris: Crès, 1922.

Salmon 1956
André Salmon. *Souvenirs sans fin*. Paris: Gallimard, 1956.

Salomon and Cogeval 2003
Antoine Salomon and Guy Cogeval, in collaboration with Mathias Chivot. *Vuillard: le regard innombrable: catalogue critique des peintures et des pastels*. Paris: Wildenstein Institute, 2003, 3 vol.

Schneider 1945
Marcel Schneider. "Lettre de Renoir sur l'Italie." *L'Âge d'or*, no. 1, 1945.

Schneider 1958, 1984
Bruno F. Schneider. *Renoir*. New York: Crown Publishers, 1958. Reprint, 1984.

Schnerb 1983
M. and Mme Froté. "Visites à Renoir et à Rodin. Extraits des carnets inédits de Jacques Félix Schnerb, 1907–1909." *Gazette des Beaux-Arts*, April 1983, pp. 175–176.

Schwarz 1998
Dieter Schwarz. "Die Sammlung Georg Reinhart, Winterthur." *Die Kunst zu sammeln: Schweizer Kunstsammlungen seit 1848*. Zurich: Schweizerisches Institut für Kunstwissenschaft, 1998, pp. 146–148.

Seckel-Klein 1998
Hélène Seckel-Klein. *Picasso collectionneur*. Paris: Réunion des Musées Nationaux, 1998.

Seize aquarelles et sanguines 1948
Seize aquarelles et sanguines par Renoir, accompagnées de Souvenir de mon père par Claude Renoir. Paris: Quatre Chemins–Éditart, 1948.

Sele Arte 1958
"Renoir a New York." *Sele Arte* 6, no. 36 (May–June 1958), pp. 20–21.

Sert 1952
Misia Sert. *Misia*. Paris: Gallimard, 1952.

Sert 1953
Misia Sert. *Misia and the Muses: The Memoirs of Misia Sert*. With an appreciation by Jean Cocteau. Translated by Moura Budberg. New York: The John Day Company, 1953.

Sérullaz 1953
Maurice Sérullaz. "Une leçon de dessin dans une galerie." *L'Illustration*, January 10, 1953.

Shapiro and Lloyd 1980–81
Barbara Stern Shapiro and Christopher Lloyd. "Ceramics." In exh. cat. London, Paris, and Boston 1980–81, pp. 238–239.

Shimada 1985
Norio Shimada. *Renoir*. Tokyo, 1985.

Shimada 2008
Hideaki Shimada. "Renoir et le Japon." In exh. cat. Cagnes-sur-Mer 2008, pp. 117–128.

Silver 1989
Kenneth E. Silver. *Esprit de Corps: the Art of the Parisian Avant-Garde and the First World War, 1914–1925*. Princeton: Princeton University Press, 1989.

Silver 1991
Kenneth E. Silver. *Vers le retour à l'ordre: l'avantgarde parisienne et la Première Guerre mondiale*. Paris: Flammarion, 1991.

Silverman 1989
Debora L. Silverman. *Art Nouveau in Fin-de-Siècle France: Politics, Psychology, and Style*. Berkeley, Los Angeles, and London: University of California Press, 1989.

Sion 1994
Georgia Sion. *Renoir: les femmes*. Translated from the English by Denis-Armand Canal. Paris: Herscher, 1994.

Slatkin 1982
Wendy Slatkin. *Aristide Maillol in the 1890s*. Ann Arbor: UMI Research Press, 1982.

Spies 1994
Werner Spies. *Picasso's World of Children*. New York and Munich: Prestel, 1994.

Spurling 2005
Hilary Spurling. *Matisse the Master: A Life of Henri Matisse. II: The Conquest of Colour, 1909–1954*. London: Hamish Hamilton, 2005.

Stein 1947, 1994
Leo Stein. *Appreciation: Painting, Poetry & Prose*. New York: Random House, 1947; 2nd ed., Lincoln and London: University of Nebraska Press, 1994.

Stein 1950
Leo Stein. *Journey into the Self, Being the Letters, Papers and Journals of Leo Stein*. Compiled and edited by Edmund Fuller. New York: Crown Publishers, 1950.

Sterling and Adhémar 1958–61
Charles Sterling and Hélène Adhémar, *La Peinture au musée du Louvre: école française XIXe siècle*. Paris: Éditions des Musées Nationaux, 1958–61.

Stix 1927
Alfred Stix. *Von Ingres bis Cézanne: 32 Handzeichnungen französischer Meister des 19.

Jahrhunderts aus der Albertina*. Vienna: Schroll, 1927.

Tapié 1952
Michel Tapié. *Impressionnistes*. Paris: P. Facchetti, 1952.

Tériade 1933
Tériade. "Renoir sans Renoir." *L'Intransigeant*, July 3, 1933.

Tériade 1996
Tériade. *Écrits sur l'art*. Paris: Adam Biro, 1996.

Terrasse 1927
Charles Terrasse. *Bonnard*. Paris: Floury, 1927.

Terrasse 1941
Charles Terrasse. *Cinquante portraits de Renoir*. Paris: Floury, 1941.

Thomas 1980
David Thomas. *Renoir*. London: The Medici Society Ltd, 1980.

Tietze 1925–26
Hans Tietze. "Französische Handzeichnungen des Neunzehnten Jahrhunderts in der Wiener Albertina." *Kunst und Künstler* 24 (1925–26), pp. 461–466.

Toutghalian 1995
Araxie Toutghalian. "Nouvelles acquisitions." *48/14. La Revue du musée d'Orsay*, no. 1, September 1995.

Turner 1991
Evan Turner. *Object Lessons: Cleveland Creates an Art Museum*. Cleveland: Cleveland Museum of Art, 1991.

Upjohn and Sedgwick 1963
Everard M. Upjohn and John P. Sedgwick Jr. *Highlights: An Illustrated History of Art*. New York: Holt, Rinehart & Winston, 1963.

Valbelle 1923
Roger Valbelle. "Les héritiers de Renoir offraient au Louvre une très belle toile de l'illustre peintre." *Excelsior*, March 31, 1923.

Van de Velde 1995
Henri van de Velde. *Récit de ma vie: Berlin, Paris, Weimar. II: 1900–1913*. Brussels: Versa, and [Paris], Flammarion, 1995.

Vauxcelles 1906
Louis Vauxcelles. "Le Salon d'Automne." *Le Gil Blas*, October 5, 1906.

Vauxcelles 1908
Louis Vauxcelles. "Collection de M. Paul Gallimard." *Les Arts*, September 1908.

Vauxcelles 1912
Louis Vauxcelles. "Dessins de Renoir." *L'Art moderne*, July 14, 1912, pp. 218–219.

Venturi 1939
Lionello Venturi. *Les Archives de l'impressionnisme: lettres de Renoir, Monet, Pissarro, Sisley et autres. Mémoires de Paul Durand-Ruel. Documents*. Paris and New York: Durand-Ruel, 1939, 2 vols.

Venturi 1942
Lionello Venturi. "Renoir—After 1900." In exh. cat. New York 1942.

Verdet 1978
André Verdet. *Entretiens, notes et écrits sur la peinture*. Paris: Galilée, 1978.

Verdet 2001
André Verdet. *Entretiens, notes et écrits sur la peinture*. Paris: Le Petit Véhicule, 2001.

Vergnet-Ruiz and Laclotte 1962
Jean Vergnet-Ruiz and Michel Laclotte. *Petits et grands musées de France: la peinture française des primitifs à nos jours*. Paris: Cercle d'art, 1962.

Vernay 1916
Jacques Vernay. "La Triennale, exposition d'art français." *Les Arts*, no. 154, April 1916, pp. 23–34.

Vincent 1956
Madeleine Vincent. *Catalogue du musée de Lyon. VII: la peinture des XIXe et XXe siècles*. Lyon: Les Éditions de Lyon, 1956.

Virginia Museum of Fine Arts 1966
European Art in the Virginia Museum of Fine Arts: A Catalogue. Richmond: Virginia Museum of Fine Arts, 1966.

Vitry [n. d.]
Paul Vitry, ed. *Catalogue de la collection Isaac de Camondo*. Paris: Gaston Braun, [n. d.].

Vitry 1914, 1922
Paul Vitry, ed. *Musée national du Louvre: catalogue de la collection Isaac de Camondo*. Paris: Éditions des Musées Nationaux, 1914; 2nd ed., 1922.

Vlaminck 1943
Maurice de Vlaminck. *Portraits avant décès*. Paris: Flammarion, 1943.

Voigt 2005
Kirsten Claudia Voigt. *Staatliche Kunsthalle Karlsruhe*. Munich: Deutscher Kunstverlag, 2005.

Vollard 1918a
Ambroise Vollard. *Tableaux, pastels et dessins de Pierre Auguste Renoir*. Paris: Éditions Vollard, 1918, 2 vols.

Vollard 1918b
Ambroise Vollard. *La Jeunesse de Renoir*. Paris: G. de Malherbe, 1918.

Vollard 1919a

Ambroise Vollard. *La Vie et l'œuvre de Pierre Auguste Renoir*. Paris: Éditions Vollard, 1919.

Vollard 1919b
Ambroise Vollard. *Auguste Renoir (1841–1919)*. Paris: Crès et Cie, 1919.

Vollard 1920
Ambroise Vollard. *Auguste Renoir (1841–1919)*. Paris: Crès (Artistes d'hier et d'aujourd'hui), 1920.

Vollard 1920b
Ambroise Vollard. "Renoir intime, ses modèles et ses bonnes." *La Renaissance de l'art français*, no. 3, March 1920, pp. 109–113.

Vollard 1921
Ambroise Vollard. "Renoir et l'impressionnisme." *L'Amour de l'art*, no. 2, February 1921, pp. 47–52.

Vollard 1924
Ambroise Vollard. *Degas*. Paris: G. Crès et Cie, 1924.

Vollard 1925, 1934
Ambroise Vollard. *Renoir: An Intimate Record*. Translated by Harold Van Doren and Randolph Weaver. New York: Knopf, 1925. Reprint, 1934.

Vollard 1936
Ambroise Vollard. *Recollections of a Picture Dealer*. London: Constable, 1936.

Vollard 1937, 1984
Ambroise Vollard. *Souvenirs d'un marchand de tableaux*. Paris: Albin Michel, 1937. Revised and expanded edition, 1984.

Vollard 1938, 1994, 2005
Ambroise Vollard. *En écoutant Cézanne, Degas, Renoir*. Paris: Grasset et Fasquelle, 1938. Reprint, Paris: Bernard Grasset, 1994 and 2005.

Vollard 1989
Ambroise Vollard. *Pierre-Auguste Renoir: Paintings, Pastels and Drawings*. San Francisco, Alan Wofsy Fine Arts, 1989 (first ed., 1918).

Von Nostitz 1933
Helene von Nostitz. *Aus dem alten Europa*. Berlin: Wolff, 1933.

Wadley 1987
Renoir: A Retrospective. Edited by Nicholas Wadley. New York: Hugh Lauter Levin Assoc., 1987.

Wadley 1989
Renoir: un peintre, une vie, une œuvre. Compiled and edited by Nicholas Wadley, with a preface by Michel Hoog. Paris: Belfond, 1989.

Waldmann 1927
Emil Waldmann. *Die Kunst des Realismus und des Impressionismus im 19. Jahrhundert*. Berlin: Propyläen, 1927.

Walker 1984
John Walker. *National Gallery of Art*. New York: Harry N. Abrams, 1984.

Warnod 1934
André Warnod. "M. Pierre Renoir évoque pour nous le souvenir de son père à propos d'une Exposition de sculptures de Renoir." *Le Figaro*, October 23, 1934, p. 8.

Washburn 1940
Gordon B. Washburn. "Buffalo's Purchases of the Season." *Art News* 38, June 8, 1940, pp. 6–7 and 17.

Washburn 1945
Gordon B. Washburn. "A Late Painting by Renoir." *Museum Notes, Rhode Island School of Design* 3, no. 6 (October 1945).

Washington, DC, 1975
European Paintings: An Illustrated Summary Catalogue. Washington, DC, National Gallery of Art, 1975.

Washington, DC, 1985
European Paintings: An Illustrated Catalogue. Washington, DC, National Gallery of Art, 1985.

Watt 1938
Alexander Watt. "Notes from Paris." *Apollo*, July 1938, pp. 32–35.

Wattenmaker 1993
Richard Wattenmaker. "Dr. Albert C. Barnes and the Barnes Foundation." In exh. cat. Washington, Paris, Tokyo, and Philadelphia 1993–94, pp. 3–27.

Wax 2007
Wendy Wax. *Renoir and the Boy with the Long Hair*. Hauppauge: Barron's Educational Series, 2007.

Weid 2006
Jean-Noël von der Weid. *Musée de l'Orangerie: guide de visite*. Versailles: Artlys, 2006.

Werner 1969
Alfred Werner. "Renoir's Daimon." *Arts Magazine* 43, no. 6 (April 1969), pp. 36–41.

Werth 1925
Léon Werth. "La collection Gangnat." *L'Amour de l'art* 6, February 1925, pp. 41–56.

Wertheimer 1953
Klára Wertheimer. "Aristide Maillol levelei Rippl-Rónai Józsefhez." *Művészettörténeti rtesitö*. 1953, pp. 110–118.

Wheldon 1975
Keith Wheldon. *Renoir and His Art*. London: Hamlyn, 1975.

White 1972
Barbara Erlich White. "Renoir's Sensuous

Women." *Women as Sex Object: Studies in Erotic Art, 1730–1970.* Edited by Thomas B. Hess and Linda Nochlin. New York: Newsweek (Art News, 38), 1972.

White 1984
Barbara Ehrlich White. *Renoir: His Life, Art, and Letters.* New York: Harry N. Abrams, 1984.

Wildenstein 1996
Daniel Wildenstein. *Monet: catalogue raisonné.* Cologne: Taschen, and Paris: Wildenstein Institute, 1996, 4 vols.

Wilenski 1931
Reginald Howard Wilenski. *French Painting.* Boston: Hale, Cushman & Flint, 1931.

Wilenski 1940
Reginald Howard Wilenski. *Modern French Painters.* New York: Reynal & Hitchcock, 1940.

Wilenski and Denvir 1954
Renoir 1841–1919. Compiled and edited by Reginald Howard Wilenski (vol. 1) et Bernard Denvir (vol. 2). London: Faber & Faber, 1954, 2 vols.

Wineapple 1996
Brenda Wineapple. *Sister/Brother: Gertrude Stein and Leo Stein.* Lincoln: University of Nebraska Press, 1996.

Worcester Telegram 1947
Worcester Telegram, May 11, 1947.

Young 1972
Mahonri Sharp Young. "The Hammer Collection: Paintings." *Apollo* 95 (June 1972), pp. 440–463.

Young 1973
Mahonri Sharp Young. "Renoir Revalued." *Apollo* 97, no. 132 (February 1973), pp. 189–192.

Zahar 1948
Marcel Zahar. *Auguste Renoir.* Paris: Somogy, 1948.

Zervos 1934
Christian Zervos. "Renoir, Cézanne, leurs contemporains et la jeune peinture anglaise." *Cahiers d'art,* 1934, no. 1–8, p. 125.

Zutter 1996
Jorg Zutter. "Les peintures de jeunesse de Maillol." In exh. cat. Berlin, Lausanne, Bremen, and Mannheim 1996–97, French ed., pp. 17–28.

Exhibitions

Amsterdam 1931
La Peinture française aux XIXe et XXe siècles. Amsterdam, E. J. Wisselingh & Co, 1931.

Antwerp 1955
IIIe Biennale de sculpture en plein air. Antwerp, Parc de Middelheim, June 3–5, 1955.

Antwerp 1958
La Sculpture dans la ville. Antwerp, June 4–November 18, 1958.

Arles 1952
Renoir. Arles, Musée Reattu, August 16–September 15, 1952.

Athens 1980
Impressionnistes et post-impressionnistes des musées français: de Manet à Matisse. Athens, Pinacothèque Nationale–Musée Alexandre Soutzos, 1980.

Athens 1992–93
From El Greco to Cézanne: Masterpieces of European Painting from the National Gallery of Art, Washington, and the Metropolitan Museum of Art, New York. Athens, National Gallery of Greece, 1992–93.

Atlanta and Birmingham 1955
French Painting: David to Rouault. Atlanta, Atlanta Art Association Galleries, September 20–October 4, 1955; Birmingham, Birmingham Museum of Art, October 16,–November 5, 1955.

Atlanta, Denver, and Seattle 2007–2008
Inspiring Impressionism: The Impressionists and the Art of the Past. Atlanta, High Museum of Art, October 16–January 13, 2008; Denver, Denver Art Museum, February 23–May 25, 2008; Seattle, Seattle Art Museum, June 19–September 21, 2008. Cat. edited by Ann Dumas, with Xavier Bray, et al.

Atlanta, Seattle, and Denver 1999
Impressionism: Paintings Collected by European Museums. Atlanta, High Museum of Art, February 23–May 16, 1999; Seattle, Seattle Art Museum, June 12–August 29, 1999; Denver, Denver Art Museum, October 2–December 12, 1999. Cat. edited by Ann Dumas and Michael E. Shapiro.

Baden 1992
Carl Montag. Baden (Switzerland), Stiftung Langmatt, June 17–October 31, 1992.

Baden and Vevey 2006
Renoir, Cézanne, Picasso und ihr Galerist Ambroise Vollard. Baden (Switzerland), Stiftung Langmatt, April 23–July 16, 2006; Vevey, Musée Jenisch, Cabinet cantonal des Estampes, August 18–November 5, 2006.

Bagnols-sur-Cèze 2004
Renoir et Albert André: une amitié (1894–1919).

Bagnols-sur-Cèze, June–September 2004. Cat. edited by Alain Girard.

Balingen 1996
Das Ewig Weibliche/L'Éternel féminin: Von Renoir bis Picasso. Balingen, Stadthalle, June 15–September 15, 1996. Cat. edited by Roland Doschka.

Baltimore 1939
Unnamed exhibition. Baltimore, Baltimore Museum of Art, Summer, 1939.

Barcelona 1984
Pintura francesa del Museu de Bordeus (Delacroix, Corot, Bouguereau, Renoir, Matisse). Barcelona, Museu d'Art Modern, 1984.

Barcelona 2002
De Renoir a Picasso: Obres mestres del Musée de l'Orangerie. Barcelona, Caixaforum, April 12–June 30, 2002.

Barcelona 2007–08
Picasso y su coleccion. Barcelona, Museu Picasso, Institut de Cultura, 13 December 2007–31 March 2008. Cat. edited by Hélène Parmelin, Jean Leymarie et Hélène Klein.

Basel 1943
Pierre Auguste Renoir. Basel, Kunsthalle, February 13–March 14, 1943.

Basel 1989–90
L'Éternel féminin. Basel, Galerie Beyeler, November 1989–February 1990.

Basel 1997
Joie de vivre. Basel, Galerie Beyeler, June–September 1997.

Beijing and Shanghai 1985
La Peinture française 1870–1920. Beijing, Museum of Fine Arts, September 9–29, 1985; Shanghai, Museum of Fine Arts, October 15–November 3, 1985.

Belgrade 1939
La Peinture française au XIXe siècle. Belgrade, Musée du Prince Paul, February 28–May 4, 1939.

Bennington 2007
Masters of Impressionism. Bennington, Bennington Museum, August 3–October 31, 2007.

Bergamo 2005
Cézanne Renoir: 30 capolavori dal Musée de l'Orangerie: i "classici" dell'Impressionismo dalla collezione Paul Guillaume. Bergamo, Accademia Carrara, March 22–July 3, 2005.

Berlin 1912
VI Ausstellung. Berlin, Cassirer, January 1912.

Berlin 1927
Erste Sonderausstellung in Berlin. Berlin, Galerie Thannhauser, January 9–mid-February 1927.

Berlin 1928
Renoir. Berlin, Galerie Alfred Flechtheim, October 7–November 9, 1928.

Berlin, Lausanne, Bremen, and Mannheim 1996–97
Aristide Maillol. Berlin, Georg-Kolbe-Museum, January 14–May 5, 1996; Lausanne, Musée cantonal des Beaux-Arts, May 15–September 22, 1996; Bremen, Gerhard-Marcks-Museum, October 6, 1996–January 13, 1997; Mannheim, Städtische Kunsthalle, January 25–March 31, 1997.

Berlin and Munich 1996–97
Manet bis Van Gogh: Hugo von Tschudi und der Kampf um die Moderne. Berlin, Nationalgalerie, September 20, 1996–January 6, 1997; Munich, Neue Pinakothek, January 24–May 11, 1997. Cat. edited by Johann Georg, Prinz von Hohenzollern, and Peter-Klaus Schuster.

Bogota 1938
Exposicion de dibujos franceses siglos XIII à XX: Dibujos, acuarelas, pasteles y grabados pertenecientes al Museo del Louvre y a otras colecciones. Bogota, Biblioteca nacional de Colombia, June–November 1938.

Bologna 2004
Il nudo: Fra ideale e realtà, dal neoclassicismo ad oggi. Bologna, Galleria d'Arte moderna, January 20–May 9, 2004. Cat. edited by Peter Weiermair.

Bonn 1998
D'Ingres à Cézanne: le XIXe siècle dans les collections du musée du Petit Palais. Bonn, Kunst- und Ausstellungshalle der Bundesrepublik Deutschland, May 27–September 27, 1998.

Bordeaux 1962
L'Art au Canada. Bordeaux, Musée de Bordeaux, May 11–July 31, 1962. Cat. edited by Gilberte Martin-Méry.

Bordeaux 1983
Hommage à Marcelle et Albert Marquet. Bordeaux, Galerie des Beaux-Arts, January–February 1983.

Bordeaux and Paris 1975–76
Albert Marquet. Bordeaux, Galerie des Beaux-Arts, May 9–September 7, 1975; Paris, Orangerie des Tuileries, October 24, 1975–January 5, 1976. Curated by Hélène Adhémar, Gilberte Martin-Méry, and Michel Hoog.

Boston 1939
The Sources of Modern Painting. Boston, Museum of Fine Arts, March 2–April 9, 1939.

Boston and London 1998–99
Monet au XXe siècle. Boston, Museum of Fine

Arts, September 20–December 27, 1998; London, Royal Academy of Arts, January 23–April 18, 1999.

Brisbane 2008
Picasso and His Collection. Brisbane, Queensland Art Gallery, June 9–September 14, 2008. Cat. edited by Anne Baldassari and Philippe Saunier.

Brisbane, Melbourne, and Sydney 1994–95
Renoir: Master Impressionist. Brisbane, Queensland Art Gallery, July 30–September 11, 1994; Melbourne, National Gallery of Victoria, September 18–October 30, 1994; Sydney, Art Gallery of New South Wales, November 5, 1994–January 15, 1995. Cat. edited by John House.

Brisbane, Sydney, and Melbourne 2001
Renoir to Picasso: Masterpieces from the Musée de l'Orangerie. Brisbane, Queensland Art Gallery, March 29–May 20, 2001; Sydney, Art Gallery of New South Wales, June 1–July 29, 2001; Melbourne, National Gallery of Victoria on Russell, August 10–September 30, 2001.

Brooklyn 1962–1963
The Louis E. Stern Collection. Brooklyn, Brooklyn Museum, September 25, 1962–March 10, 1963.

Brussels 1936–1937
Les Plus Beaux Dessins français du musée du Louvre (1350–1900). Brussels, Palais des Beaux-Arts, December 1936–February 1937.

Budapest, Warsaw, and Bucarest 2004–05
Ombres et lumières: quatre siècles de peinture française. Budapest, Mucsarnok-Kunsthalle, December 16, 2004–February 27, 2005; Warsaw, Château royal, March 18–June 19, 2005; Bucarest, Musée des Beaux-Arts, July 12–September 30, 2005.

Buenos Aires 1939
La Pintura Francesa de David a nuestros dias. Buenos Aires, Museo nacional de Bellas Artes, July 18–August 31, 1939.

Buenos Aires 1969
109 Works from the Albright-Knox Art Gallery. Buenos Aires, Museo nacional de Bellas Artes, October 23–November 30, 1969.

Cagnes-sur-Mer 1949
Hommage à Renoir. Cagnes-sur-Mer, château, December 17–January 15, 1950, no cat.

Cagnes-sur-Mer 1956–57
Hommage-souvenir à Ferdinand Deconchy. Cagnes-sur-Mer, château-musée, December 1956–February 1957.

Cagnes-sur-Mer 1969
Renoir à Cagnes et aux Collettes: exposition du cinquantenaire 1919–1969. Cagnes-sur-Mer, Maison de Renoir, Les Collettes, 1969.

Cagnes-sur-Mer 1970
Renoir. Cagnes-sur-Mer, Maison de Renoir, Les Collettes, August 9–30, 1970.

Cagnes-sur-Mer 2008
Renoir et les familiers des Collettes. Cagnes-sur-Mer, Musée Renoir, June 28–September 8, 2008. Curated by Virginie Journiac and Alain Girard.

Cannes 1970
Le Bal Renoir. Cannes, Palm Beach, Casino, August 4, 1970.

Chicago 1946
Masterpiece of the Month. Chicago, The Art Institute of Chicago, February 1946.

Chicago 1949
20th Century Art from the Louise and Walter Arensberg Collection. Chicago, The Art Institute of Chicago, October 20–December 18, 1949.

Chicago 1973
Renoir Paintings and Drawings. Chicago, The Art Institute of Chicago, February 3–April 1, 1973. Cat. edited by John Maxon.

Cincinnati 1951
Paintings: 1900–1925. Cincinnati, Cincinnati Art Museum, February 2–March 4, 1951.

Cleveland 1921
French Paintings of the Later XIXth Century. Cleveland, Cleveland Museum of Art, 1921.

Cleveland 1929
French Art since 1800. Cleveland, Cleveland Museum of Art, 1929.

Cleveland 1936
Catalogue of the Twentieth Anniversary Exhibition of the Cleveland Museum of Art. Cleveland, Cleveland Museum of Art, June 26–October 4, 1936.

Cleveland 1956
The Venetian Tradition. Cleveland, Cleveland Museum of Art, 1956.

Cleveland, New York, Forth Worth, Chicago, and Kansas City 1987–88
Impressionist & Post-Impressionist Masterpieces: The Courtauld Collection. Cleveland, Cleveland Museum of Art, January 14–March 8, 1987; New York, Metropolitan Museum of Art, April 4–June 21, 1987; Fort Worth, Kimbell Art Museum, July 11–September 27, 1987; Chicago, Art Institute of Chicago, October 17, 1987–January 3, 1988; Kansas City, Nelson-Atkins Museum, January 30–April 3, 1988.

Cologne 1962
Europäische Kunst 1912. Zum 50. Jahrestag der

Ausstellung des Sonderbundes westdeutscher Kunstfreunde und Künstler. Cologne, Wallraf-Richartz Museum, September 14–December 9, 1962.

Columbus 1991–92
Impressionism and European Modernism: The Sirak Collection. Columbus, Columbus Museum of Art, October 12, 1991–October 11, 1992. Cat. edited by Richard Brettell and Peter Selz.

Columbus 2005–06
Renoir's Women. Columbus, Columbus Museum of Art, September 23, 2005–January 8, 2006. Cat. edited by Ann Dumas and John Collins.

Dallas 1937
French Impressionists. Dallas, Dallas Museum of Fine Arts, 1937.

Detroit 1933–34
Paintings from the Ambroise Vollard Collection. Detroit, Detroit Society of Arts and Crafts, December 1933–January 1934.

Detroit 1970
A Collector's Treasure: The Tannahill Bequest. Detroit, Detroit Institute of Arts, May 13–August 13, 1970.

Detroit 1976–77
Arts and Crafts in Detroit, 1906–1976: The Movement, the Society, the School. Detroit, Detroit Art Institute, November 2, 1976–January 16, 1977.

Dresden 1926
Internationale Kunstausstellung. Dresden, 1926.

Düsseldorf 1956
Renoir: Sammlung Gangnat. Düsseldorf, Kunsthalle, January 28–April 8, 1956.

Edinburgh and London 1953
Paintings of Renoir. Edinburgh, Royal Scottish Academy, August 22–September 12, 1953; London, Tate Gallery, September 24–October 25, 1953.

Evian 2009
La Ruche, cité des artistes: 1902–2009. Évian, Palais Lumière, February 7–May 10, 2009. Catalogue entries by Sylvie Buisson.

Fort Lauderdale 1986–87
Auguste Renoir: The Complete Graphic Work. Fort Lauderdale, Museum of Art, December 10, 1986–January 31, 1987.

Fort Wayne 1953
Picture of the Month. Fort Wayne, Art School and Museum, 1953.

Fukuoka, Hiroshima, Tokyo, and Kanazawa 1983
De Rubens, Delacroix à Corot, Redon: musée de Bordeaux. Fukuoka, Hiroshima, Tokyo, and Kanazawa, 1983.

Geneva 1965
Peintres de Montmartre et de Montparnasse. Geneva, Musée Rath, Summer 1965. Cat. edited by Oscar Ghez and François Daulte, in collaboration with Ezio Gribaudio.

Geneva 1974–75
Centenaire de l'impressionnisme: hommage à Guillaumin. Geneva, Musée du Petit Palais, 1974.

Geneva 1986
La Femme, corps et âme. Geneva, Musée du Petit Palais, June 15–October 15, 1986.

Geneva 1998
Aux sources de l'art moderne: nouveau regard sur la collection. Geneva, Musée du Petit Palais, March 19–June 28, 1998.

Glasgow 1937
French Art of the 19th and 20th Centuries. Glasgow, McLellan Galleries, April 1937.

Haarlem 1936
Unnamed exhibition. Haarlem, Frans Hals Museum, 1936.

Halifax, Saint-Jean-de-Terre-Neuve, Charlottetown, Fredericton, and Québec 1971
Peinture française 1840–1924: collection de la Galerie nationale du Canada. Halifax, Dalhousie Art Gallery, February 23–March 15, 1971; Saint-Jean-de-Terre-Neuve, Memorial University of Newfoundland, March 20–April 9, 1971; Charlottetown, Confederation Art Gallery, April 15–May 6, 1971; Fredericton, Beaverbrook Art Gallery, May 10–25, 1971; Québec, Musée du Québec, May 30–June 15, 1971.

Hamburg 1970–71
Französische Impressionisten: Hommage à Durand-Ruel. Hamburg, Kunstverein Hamburg, November 28, 1970–January 24, 1971.

Hamburg 1981–82
Der Zerbrochene Kopf: Picasso zum 100. Geburtstag. Hamburg, Hamburger Kunsthalle, December 11, 1981–February 21, 1982. Cat. edited by Helmut R. Leppien.

Hamilton 1964
Fiftieth Anniversary Exhibition. Hamilton, Art Gallery of Hamilton, October 3–November 1, 1964.

Hong Kong 2005
Impressionism: Treasures from the National Collection of France. Hong Kong, Hong Kong Museum of Art, February 5–April 10, 2005.

Houston 1958

The Human Image. Houston, Museum of Fine Arts, October 10–November 23, 1958.

Iwaki, Osaka, Shimané, and Fukuoka 2000
Chefs-d'œuvre du musée des Beaux-Arts de Bordeaux: de Delacroix à Picasso. Iwaki, Musée des Beaux-Arts; Osaka, ATC Museum; Shimané, Musée départemental des Beaux-Arts; Fukuoka, Musée des Beaux-Arts, 2000.

Japan, Urban Gallery 1989
Renoir, Guino. Japan, Urban Gallery, 1989.

Jena 2008–09
Von Manet bis Renoir: Schätze französischer Malerei aus dem Musée du Petit-Palais, Genf. Jena, Städtische Museen, June 16, 2008–February 22, 2009.

Kamakura 1951
Cézanne–Renoir. Kamakura, Kanagawa Museum of Modern Art, 1951.

Krems 2005
Renoir und das Frauenbild des Impressionismus. Krems, Kunsthalle Krems, April 3–July 31, 2005.

Kurume 1963
Exposition inédite d'œuvres de peinture occidentale. Kurume, Bridgestone Museum of Art, 1963.

Kyoto and Tokyo 1999
Masterpieces from the National Gallery of Art, Washington. Kyoto, Kyoto Municipal Museum of Art; Tokyo, Tokyo Metropolitan Art Museum, 1999.

Lausanne 1963
Dessins français. Lausanne, Musée cantonal des Beaux-Arts, 1963.

Lausanne 1989
Chefs-d'œuvre du musée de Lyon. Lausanne, Fondation de l'Hermitage, June 9–September 21, 1989.

Le Cannet 2005
Bonnard illustrateur. Le Cannet, Espace Bonnard and Espace Bernardin, June 23–August 28, 2005.

Le Cateau-Cambrésis, London, and New York 2004–05
Matisse et la couleur des tissus. Le Cateau-Cambrésis, Musée départemental Matisse, 23 October 2004–25 January 2005; London, Royal Academy of Arts, 5 March–30 May 2005; New York, The Metropolitan Museum of Art, 23 June–25 September 2005. Cat. edited by Ann Dumas.

Leningrad 1966
Rodin et son temps. Leningrad, 1966.

Leningrad and Moscow 1970–71
Tableaux impressionnistes des musées français. Leningrad, Hermitage Museum, 1970; Moscow, Pushkin Museum, 1971.

Leningrad and Moscow 1986
Impressionist and Post-Impressionist Masterpieces from the National Gallery of Art, Washington. Leningrad, Hermitage Museum, 1986; Moscow, Pushkin Museum, 1986.

Lille and Martigny 2002
Berthe Morisot 1841–1895. Lille, Palais des Beaux-Arts, March 10–June 9, 2002; Martigny, Fondation Pierre Gianadda, June 20–November 19, 2002.

Limoges 1952
Hommage à Berthe Morisot et à Pierre Auguste Renoir. Limoges, Musée municipal, July 19–October 10, 1952.

Limoges 1956
De l'impressionnisme à nos jours. Limoges, Musée municipal, 1956.

Lisbon 1965
Un século de pintura francesa 1850–1950. Lisbon, Fundação Calouste Gulbenkian, 1965.

Little Rock 1963
Five Centuries of European Painting. Little Rock, Arkansas Arts Center, May 16–October 26, 1963.

Lodève 2007
Chefs-d'œuvre de la collection Oscar Ghez, musée du Petit-Palais de Genève: discernement et engouements. Lodève, Musée de Lodève, June 16–October 27, 2007. Cat. edited by Maïthé Vallès-Bled and Gilles Genty.

London 1905
Pictures by Boudin, Cézanne, Degas, Manet, Monet, Morisot, Pissarro, Renoir, Sisley. London, Grafton Galleries, January–February 1905.

London 1922
Catalogue of drawings and a few oil paintings by British and French Artists. London, Independent Gallery, September 1922.

London 1930
Renoir and the Post-Impressionists. London, Axel Reid & Lefevre Galleries, 1930.

London, French Gallery, 1930
Some French Paintings of the 19th Century. London, French Gallery, 1930.

London 1932
Commemorative Catalogue of the Exhibition of French Art, 1200–1900. London, Royal Academy, January 4–March 12, 1932. Cat. edited by W. G. Constable, in collaboration with Tranchard Cox.

London, Burlington House 1932
Exhibition of French Art. London, Burlington House, 1932.

London 1933

Commemorative Catalogue of the Exhibition of French Art. London, 1933.

London 1934
Renoir, Cézanne and Their Contemporaries. London, Axel Reid & Lefevre Galleries, June 1934.

London 1935
Fifty Years of Portraits (1885–1935). London, Leicester Galleries, May–June 1935.

London 1936
Corot to Cézanne. London, Axel Reid & Lefevre Galleries, June 1936.

London 1948
Samuel Courtauld Memorial Exhibition. London, The Tate Gallery, May–June 1948.

London 1937
Loan Exhibition of Renoir. London, Rosenberg & Helft, May 5–June 12, 1937.

London 1954
Masterpieces from the São Paulo Museum. London, Tate Gallery, June 10–August 15, 1954. Cat. edited by P. M. Bardi.

London 1956
Renoir: An Exhibition of Paintings from European Collections, in Aid of the Renoir Foundation. London, Marlborough Fine Art Ltd., May–June 1956.

London 1976
Samuel Courtauld's Collection of French 19th Century Paintings and Drawings. London, Arts Council of Great Britain, 1976.

London 1990
On Classic Ground: Picasso, Léger, De Chirico and the New Classicism 1910–1913. London, Tate Gallery, June 6–September 2, 1990. Cat. edited by Elizabeth Cowling and Jennifer Lundy.

London 1994
Impressionism for England: Samuel Courtauld as Patron and Collector. London, Courtauld Institute Galleries, 17 June–September 1994.

London 1998
Henry Moore and the National Gallery. London, National Gallery, April 3–May 31, 1998.

London 1999–2000
Art Made Modern: Roger's Fry Vision of Art. London, Courtauld Institute of Art, October 15 1999–January 23, 2000. Cat. edited by Christopher Green.

London 2009
Picasso: Challenging the Past. London, National Gallery, February 25–June 7, 2009. Cat. edited by Elizabeth Cowling.

London, Ontario 1980
The Seven Ages of Man. London (Ontario), London Regional Art Gallery, May 3–June 15, 1980. Cat. edited by William C. Forsey.

London and Chicago 1996–97
Degas: Beyond Impressionism. London, National Gallery, May 22–August 26, 1996; Chicago, Art Institute of Chicago, September 28, 1996–January 5, 1997. Cat. edited by Richard Kendall.

London and New York 2000
1900: Art at the Crossroads. London, Royal Academy of Arts, January 16–April 3, 2000; New York, Solomon R. Guggenheim Museum, May 18–September 13, 2000. Cat. edited by Robert Rosenblum, MaryAnne Stevens, and Ann Dumas.

London, Ottawa, and Philadelphia 2007–08
Renoir Landscapes, 1865–1883. London, The National Gallery, February 21–May 20, 2007; Ottawa, The National Gallery of Canada, June 8–September 9, 2007; Philadelphia, Philadelphia Museum of Art, October 4, 2007–January 6, 2008. Cat. edited by Colin B. Bailey et al.

London, Paris, and Boston 1980–81
Pissarro. London, Hayward Gallery, October 30, 1980–January 11, 1981; Paris, Galeries nationales du Grand Palais, January 30–April 27, 1981; Boston, Museum of Fine Arts, May 19–August 9, 1981. Cat. edited by Christopher Lloyd et al.

London, Paris, and Boston 1985–86
Renoir. London, Hayward Gallery, January 30–April 21, 1985; Paris, Galeries nationales du Grand Palais, May 14–September 2, 1985; Boston, Museum of Fine Arts, October 9, 1985–January 5, 1986. Cat. edited by Anne Distel, John House, and John Walsh Jr.

London, Tokyo, and Nagoya 1995–96
From Manet to Gauguin: Impressionist and Post-Impressionist Masterpieces from Swiss Private Collections. London, Royal Academy of Arts, June 30–October 8, 1995; Toyko, Musée Sezon, October 21, 1995–January 21, 1996; Nagoya, Musée Matsuzakaya, February–April 1996. Cat. edited by Dorothy Kosinski, Joachim Pissarro, and MaryAnne Stevens.

London, Washington, and New York 1999–2000
Portraits by Ingres: Image of an Epoch. London, National Gallery, January 27–April 25, 1999; Washington, DC, National Gallery of Art, May 23–August 22, 1999; New York, The Metropolitan Museum of Art, October 5, 1999–January 2, 2000.

Los Angeles 1952
Modern French Masters. Exhibition organized for the benefit of the Donald Bear Endowment Fund,

Los Angeles, Dalzell Hatfield Galleries, July 7–31, 1952.

Los Angeles 1991
Monet to Matisse: French Art from Southern California Collections. Los Angeles, Los Angeles County Museum of Art, June 9–August 11, 1991. Cat. edited by Philip Conisbee, Judi Freeman, and Richard Rand.

Los Angeles 1999
Around Impressionism: French Paintings from the National Gallery of Art. Los Angeles, Los Angeles County Museum of Art, 1999, no cat.

Los Angeles and San Francisco 1955
Pierre Auguste Renoir (1841–1919). Los Angeles, Los Angeles County Museum of Art, July 14–August 21, 1955; San Francisco, San Francisco Museum of Art, September 1–October 2, 1955.

Lyon 1938–39
Salon du Sud-Est 1938: D'Ingres à Cézanne: origines de la peinture indépendante. Lyon, Palais municipal, December 3, 1938–January 15, 1939.

Lyon 1952
Renoir. Lyon, Musée des Beaux-Arts, June 1952. Cat. edited by René Jullian.

Lyon 2003
L'Impressionnisme au musée des Beaux-Arts de Lyon: histoire de la collection. Lyon, Musée des Beaux-Arts, February 24–May 12, 2003.

Madrid 1971
Los Impresionistas Franceses. Madrid, Museo Español de Arte Contemporaneo, April 1971.

Madrid 2001–02
Forma: El ideal classico en el arte moderno. Madrid, Museo Thyssen-Bornemisza, October 9, 2001–January 13, 2002.

Marcq-en-Baroeul 1980–1981
Impressionnisme. Marcq-en-Baroeul, Septentrion, fondation Anne-Albert Prouvost, October 18, 1980–January 25, 1981.

Marseille 1955
Les Impressionnistes français. Marseille, Musée Cantini, July 1955.

Marseille 1963
Renoir, peintre et sculpteur. Marseille, Musée Cantini, June 8–September 15, 1963.

Marseille 2000
De la couleur et du feu: céramiques d'artistes de 1885 à nos jours. Marseille, Musée de la Faïence, Château Pastré, June 23–September 3, 2000.

Marseille and Paris 1995
Peintres de la couleur en Provence. Marseille, Hôtel de Région, January 28–April 28, 1995; Paris, Musée du Luxembourg, May 15–August 15, 1995. Cat. edited by Sophie Biass-Fabiani and Denis Coutagne.

Martigny 1988
De Manet à Picasso: trésors du musée d'Art de São Paulo. Martigny, Fondation Pierre Gianadda, July 2–November 6, 1988. Cat. edited by Ettore Camesasca.

Memphis 1969
Dr. Armand Hammer's Private Collection. Memphis, Brooks Memorial Art Gallery, October 2–December 30, 1969.

Mexico City 1998
La Provenza de los Pintores: Ruptura y tradicion. Mexico City, Museo del Palacio de Bellas Artes, February 18–May 3, 1998.

Minneapolis 1969
The Past Rediscovered: French Painting 1800–1900. Minneapolis, Minneapolis Institute of Arts, July 3–September 7, 1969.

Monaco 1994
Exposition vente. Monaco, Musée océanographique, September 29–November 6, 1994.

Montpellier and Grenoble 2007–08
L'Impressionnisme: de France et d'Amérique. Montpellier, Musée Fabre, June 9–September 9, 2007; Grenoble, Musée de Grenoble, October 20, 2007–January 20, 2008. Cat. edited by Sylvain Amic, Sophie Barthélémy, Ingrid Berger, and Laurence Berthon.

Montreal 1938
Paintings by French Masters: Delacroix to Dufy. Montreal, W. Scott & Sons, October 1938.

Montreal 1948
French Paintings of the XIXth and XXth Centuries: Collection of Mr. P. Eilers. Montreal, Watson Art Galleries, December 1948.

Montreal and Fort Worth 2000–01
De Renoir à Picasso: les chefs-d'œuvre du musée de l'Orangerie. Montreal, Musée des Beaux-Arts de Montreal, June 1–October 15, 2000; Fort Worth, Kimbell Art Museum, November 12, 2000–February 25, 2001. Cat. edited by Pierre Georgel and Jean-Pierre Labiau.

Moscow 1956
Peinture française du XIXe siècle. Moscow, Pushkin National Museum of Fine Arts, 1956.

Munich 1912
Renoir. Munich, Galerie Thannhauser, March 1912.

Munich 1958
Renoir. Munich, Städtische Galerie, November 5–

December 14, 1958.

Munich 1990
Französische Impressionisten und ihre Wegbereiter aus der National Gallery of Art, Washington, und dem Cincinnati Art Museum. Munich, Neue Pinakothek, 1990.

Munich 1998
Picasso und Seine Sammlung. Munich, Kunsthalle der Hypo- Kulturstiftung, April 29–August 16, 1998. Cat. edited by Hélène Seckel-Klein and Emmanuelle Chevrière.

Nagoya 1991
World Impressionism and Pleinairism. Nagoya, Matsuzakaya Art Museum, 21 March–6 May 1991.

Nagoya, Hiroshima, and Nara 1988–89
Renoir Retrospective. Nagoya, City Art Museum, October 15–December 11, 1988; Hiroshima, Hiroshima Museum of Art, December 17, 1988–February 12, 1989; Nara, Nara Prefectural Museum of Art, February 18–April 9, 1989.

Nancy 2006
Roger Marx: un critique aux côtés de Gallé, Monet, Rodin, Gauguin… Nancy, Musée des Beaux-Arts, Musée de l'École de Nancy, May 6–August 28, 2006.

Nashville 1990–91
Masterworks: Paintings from the Bridgestone Museum of Art. Nashville, Tennessee State Museum, October 14, 1990–January 20, 1991.

Nashville 2001
European Masterworks: Paintings from the Collection of the Art Gallery of Ontario. Nashville, Frist Center for the Visual Arts, April 8–July 8, 2001. Cat. with a preface by Chase W. Rynd and an introduction by Candace J. Adelson.

New Haven 1961
Paintings and Sculpture from the Albright Art Gallery. New Haven, Yale University Art Gallery, April 26–September 4, 1961.

New Orleans 1959
Early Masters of Modern Art. New Orleans, Isaac Delgado Museum of Art [now New Orleans Museum of Art], November–December 1959.

New York 1913
International Exhibition of Modern Art, Association of American Painters and Sculptors, Inc. New York, at the Armory of the Sixty-ninth Infantry, Lexington Avenue, February 17–March 15, 1913.

New York 1918
Exhibition of Paintings by Renoir. New York, Durand-Ruel Galleries, February–March 1918.

New York 1921–22
Exhibition of Paintings by the Great French Impressionists from the Collection of Monsieur Paul Rosenberg of Paris. New York, Wildenstein & Co, 1921–22.

New York 1924
Paintings by Renoir. New York, Durand-Ruel Galleries, January 5–21, 1924.

New York 1933
Exhibition of Paintings from the Ambroise Vollard Collection: XIX–XX Centuries. New York, Knoedler Galleries, November–December 1933.

New York 1934
Exhibition of Paintings by the Master Impressionists. New York, Durand-Ruel Galleries, October–November 1934.

New York 1935
Exhibition of Masterpieces by Pierre-Auguste Renoir. New York, Durand-Ruel Galleries, March 12–30, 1935.

New York 1937
Renoir: A Special Exhibition of His Paintings. New York, The Metropolitan Museum of Art, May 18–September 12, 1937.

New York 1938–39
French Impressionists. New York, French Art Galleries, December 12, 1938–January 31, 1939.

New York, Bignou Gallery, 1939
Significant Landmarks of 19th Century French Painting. New York, Bignou Gallery, February 20–March 25, 1939.

New York, Durand-Ruel, 1939
Loan Exhibition of Portraits by Renoir. New York, Durand-Ruel Galleries, March 29–April 15, 1939.

New York, MoMA 1939
Art in Our Time. New York, Museum of Modern Art, May 10–September 30, 1939.

New York 1940
Masterpieces of Art: European and American Painting 1500–1900. New York, Universal Exhibition (1939–1940), May–October 1940. Cat. edited by Walter Pach.

New York 1941
Renoir Centennial Loan Exhibition, 1841–1941. Exhibition organized for the benefit of the Caisse de Secours de la France Libre, New York, Duveen Brothers, November 8–December 6, 1941.

New York 1942
Exhibition of Masterpieces by Renoir after 1900. Exhibition organized for the benefit of the Children's Aid Society, New York, Durand-Ruel Galleries, April 1–26, 1942.

New York 1942–43
Twentieth-Century Portraits. New York, Museum of Modern Art, December 9, 1942–January 24, 1943. Cat. edited by Monroe Wheeler.

New York 1943
140th Anniversary, 1803–1943. New York, Durand-Ruel Galleries, November 15–December 4, 1943.

New York 1944
Modern Drawings. New York, Museum of Modern Art, 1944.

New York 1948
Loan Exhibition of Masterpieces by Delacroix and Renoir. Exhibition organized for the benefit of the New York Heart Association, New York, Paul Rosenberg, February 16–March 13, 1948.

New York 1950
Renoir. New York, Wildenstein & Co., March 23–April 29, 1950.

New York 1954
The Last Twenty Years of Renoir's Life. New York, Paul Rosenberg & Co., March 8–April 3, 1954.

New York 1958
Loan Exhibition Renoir. Exhibition organized for the benefit of the Citizens' Committee for Children of New York, New York, Wildenstein & Co., April 8–May 10, 1958.

New York 1959
Renoir Loan Exhibition. New York, Hammer Galleries, March 3–28, 1959.

New York 1965
Olympia's Progeny: French Impressionist and Post-Impressionist Paintings 1865–1905. New York, Wildenstein Gallery, 28 October–27 November 1965. Cat. with an introduction and notes by Kermit S. Champa.

New York 1968
Four Masters of Impressionism: Monet, Pissarro, Renoir, Sisley. Exhibition organized for the benefit of the Lenox Hill Hospital, New York, Acquavella Galleries, October 24–November 30, 1968.

New York 1969
Renoir, in Commemoration of the Fiftieth Anniversary of Renoir's Death. New York, Wildenstein & Co., March 27–May 3, 1969.

New York 1970
Four Americans in Paris: The Collections of Gertrude Stein and Her Family. New York, Museum of Modern Art, 1970. Cat. edited by Margaret Potter et al.

New York, Wildenstein, 1970
One Hundred Years of Impressionism. Exhibition organized for the benefit of the New York University Art Collection, New York, Wildenstein & Co., April 2–May 9, 1970.

New York 1972
Faces from the World of Impressionism and Post-Impressionism. New York, Wildenstein & Co., November 1–December 9, 1972.

New York 1974
Renoir: The Gentle Rebel. Exhibition organized for the benefit of the Association for Mentally Ill Children, New York, Wildenstein & Co., October 24–November 30, 1974.

New York 2002–03
A Very Private Collection: Janice H. Levin's Impressionist Pictures. New York, The Metropolitan Museum of Art, November 12, 2002–February 9, 2003.

New York, Chicago, and Paris 2006–07
From Cézanne to Picasso: Masterpieces from the Vollard Gallery. New York, The Metropolitan Museum of Art, September 13, 2006–January 7, 2007; Chicago, Art Institute of Chicago, February 17–May 12, 2007; Paris, Musée d'Orsay, June 19–September 16, 2007. Cat. edited by Anne Roquebert, in collaboration with Ann Dumas, Douglas W. Druick, Gloria Groom, Rebecca A. Rabinow, and Gary Tinterow.

New York, Cleveland, Washington, Saint Louis, and Cambridge 1952–53
French Drawings: Masterpieces from Five Centuries. New York, The Metropolitan Museum of Art–The Cloisters; Cleveland, The Cleveland Museum of Art; Washington, DC, National Gallery of Art; Saint Louis, The Saint Louis Art Museum; Cambridge, MA, Fogg Art Museum, [October 7] 1952–[May 5] 1953 for the five venues.

New York and College Park 1980
Charles Gleyre, 1806–1874. New York, Grey Art Gallery and Study Center, New York University, February 6–March 22, 1980; College Park (MD), University of Maryland Art Gallery, April 3–May 2, 1980.

New York, Houston, and Paris 1977–78
Cézanne: The Late Work. New York, The Museum of Modern Art, October 7, 1977–January 3, 1978; Houston, The Museum of Fine Arts, January 26–March 19, 1978; Paris, Grand Palais, April 20–July 23, 1978. Cat. by Theodore Reff, John Elderfield, and Michael Marrinan.

New York, Toronto, Champaign, and Toledo 1977
Ambroise Vollard, éditeur: Prints, Books, Bronzes. New York, Museum of Modern Art; Toronto, Art Gallery of Ontario; Champaign, University of

Illinois at Champaign, Krannert Art Museum; Toledo, Toledo Museum of Art, 1977. Cat. edited by Una E. Johnson.

Nice 1952
Renoir, Nice, Galerie des Ponchettes, April 1–June 15, 1952. Cat. with a preface by Germain Bazin.

Nice and Bruges 1996
La Céramique fauve: André Metthey et les peintres. Nice, Cimiez, Musée Matisse, May 17–July 21, 1996; Bruges, Fondation Saint-Jean, August 2–November 17, 1996.

Norfolk and Staunton 1958
Modern French Painting, Norfolk, VA, Norfolk Museum of Art, March 1958; Staunton, VA, Mary Baldwin College, April 1958.

Norwich 1925
Centenary of the Norwich Museum: Loan collection of pictures illustrative of the evolution of painting from the XVIIth century to the present day. Norwich Castle Museum, October 24–November 21, 1925.

Ocala 2001
19th-Century European Masterworks from the Collection of the Art Gallery of Ontario. Ocala, FL, The Appleton Art Museum, September 8–December 6, 2001.

Omaha 1951
Beginning of Modern Painting: France 1800–1910. Omaha, Joslyn Art Museum, October–November 4, 1951.

Orléans 1984
Peintures françaises du Museum of Art de La Nouvelle-Orléans. Orléans, Musée des Beaux-Arts, May 9–September 15, 1984. Cat. edited by Edward P. Caraco; English text with French translation.

Osaka 1922
Collection de peintures de Matsukata. Osaka, 1922.

Ottawa 1950
Paintings from the Vollard Collection. Ottawa, National Gallery of Canada, 1950.

Ottawa, Chicago, and Fort Worth 1997–98
Renoir's Portraits: Impressions of an Age. Ottawa, Musée des Beaux-Arts du Canada, June 27–September 14, 1997; Chicago, Art Institute of Chicago, October 17, 1997–January 4, 1998; Fort Worth, Kimbell Art Museum, February 8–April 26, 1998. Cat. edited by Colin B. Bailey, in collaboration with John B. Collins, texts by Colin B. Bailey, Linda Nochlin, and Anne Distel.

Ottawa, Victoria, and Alberta 2004–05
Dessins français du musée des Beaux-Arts du Canada. Ottawa, Musée des Beaux-Arts du Canada, May 21–August 29, 2004; Victoria, Art Gallery of Greater Victoria, December 4, 2004–February 20, 2005; Alberta, Edmonton Art Gallery, September 16–November 17, 2005. Cat. edited by Sonia Couturier.

Palermo and Milan 2002
Renoir e la luce dell'impressionismo. Palermo, Palazzo dei Normanni, June 6–July 31, 2002; Milan: Fondazione Antonio Mazzotta, September 19–November 17, 2002.

Paris 1892
Exposition A. Renoir. Paris, Galerie Durand-Ruel, May 1892.

Paris 1896
Exposition Renoir. Paris, Galerie Durand-Ruel, May 28–June 20, 1896.

Paris 1899
Exposition de tableaux de Monet, Pissarro, Renoir et Sisley. Paris, Galerie Durand-Ruel, April 1899.

Paris 1902
Tableaux par A. Renoir, Paris, Galerie Durand-Ruel, June 1902.

Paris 1905
Salon d'Automne: catalogue des ouvrages de peinture, sculpture, dessin, gravure, architecture et art décoratif. Paris, Grand Palais des Champs-Élysées, October 18–November 25, 1905.

Paris 1906
Salon d'Automne. Paris, Grand Palais, 6 October–15 November 1906.

Paris 1912
Exposition de tableaux par Renoir. Paris, Galerie Durand-Ruel, April 27–May 15, 1912.

Paris 1912b
Portraits par Renoir. Paris, Galerie Durand-Ruel, June 5–20, 1912.

Paris 1913
Exposition Renoir. Paris, Galerie Bernheim-Jeune, March 10–29, 1913.

Paris 1916
La Triennale 1916: exposition d'art français au profit de la Fraternité des artistes. Paris, salle du Jeu de Paume, March 1–April 15, 1916. Cat. with a preface by Noël Clément-Janin.

Paris 1917
Exposition d'art français du XIXe siècle. Paris, Galerie Paul Rosenberg, June 25–July 13, 1917.

Paris, Durand-Ruel, 1920
Tableaux, pastels, dessins par Renoir (1841–1919).

Paris, Galerie Durand-Ruel, November 29–December 8, 1920.

Paris, Salon d'Automne, 1920
Salon d'Automne. Paris, 1920.

Paris 1922
Paris, Galerie Barbazanges, June 1922.

Paris 1927
Cinquante Renoir choisis parmi les nus, les fleurs, les enfants. Paris, Galerie Bernheim-Jeune, February 28–March 25, 1927.

Paris 1930
Renoir: l'œuvre sculpté, l'œuvre gravé, aquarelles et dessins. Paris, Les Expositions de Beaux-Arts et de La Gazette des Beaux-Arts, October 15–November 10, 1930.

Paris 1931
Exposition coloniale internationale de Paris. May–November 1931.

Paris, Braun, 1932
Renoir. Paris, Galerie Braun and Cie, 14 November–3 December 1932.

Paris, Durand-Ruel, 1932
Quelques œuvres importantes de Manet à Van Gogh. Paris, Galerie Durand-Ruel, February–March 1932.

Paris, BN, 1933
Paris, Bibliothèque nationale, 1933. Cat. after the exchange records.

Paris, Orangerie, 1933
Renoir 1841–1919. Paris, Musée de l'Orangerie, June 26–December 12, 1933. Cat. edited by Charles Sterling, with a preface by Paul Jamot.

Paris, Beaux-Arts, 1934
Renoir: l'œuvre sculpté, l'œuvre gravé, aquarelles et dessins. Paris, Galerie des Beaux-Arts, 1934. Cat. with a preface by Raymond Cogniat.

Paris, Rosenberg, 1934
Exposition d'œuvres des dix dernières années (1909–1919) de Renoir. Paris, Galerie Paul Rosenberg, January 16–February 24, 1934.

Paris 1936
Portraits français de 1400 à 1900. Exhibition organized for the benefit of the Fondation Foch, Paris, Galerie Seligmann, June 9–July 1, 1936. Cat. edited by Claude Roger-Marx.

Paris 1938
La Peinture française du XIXe siècle en Suisse. Exhibition organized by the Gazette des Beaux-Arts, with the assistance of the Musée des Beaux-Arts de Zurich, for the benefit of the Société helvétique de bienfaisance en France, Paris, 1938. Cat. edited by G. Wildenstein and Ch. Montag, entries by A. Rubinstein.

Paris, Bernheim-Jeune, 1938
Renoir portraitiste (1841–1919). Exhibition organized for the benefit of the Société des amis du Louvre, Paris, Galerie Bernheim-Jeune, June 10–July 27, 1938.

Paris 1943
Scènes et figures parisiennes. Paris, Galerie Charpentier, 1943. Cat. with a preface by Jean Cocteau.

Paris 1944
La Vie familiale, scènes et portraits. Paris, Galerie Charpentier, 1944.

Paris 1945
Paysages d'eau douce. Paris, Galerie Charpentier, 1945.

Paris 1950
Hommage à Renoir. Paris, Galerie Pétridès, June 1950.

Paris, Bernheim-Jeune, 1952
Peintres de portraits. Paris, Galerie Bernheim-Jeune, May 17–June 28, 1952.

Paris, Bernheim-Jeune, 1952–53
150 ans de dessin (1800–1950). Paris, Galerie Bernheim-Jeune, from December 20, 1952.

Paris 1953
Un siècle d'art français, 1850–1950. Paris, Petit Palais, 1953.

Paris, Galliera, 1953
Célébrité et révélation de la peinture contemporaine. Paris, Musée Galliera, March 1953.

Paris 1953–54
Célébrités françaises. Paris, Galerie Charpentier, 1953–54.

Paris 1954
Chefs-d'œuvre de Renoir dans les collections particulières françaises. Paris, Galerie des Beaux-Arts, faubourg Saint-Honoré, June 10–27, 1954.

Paris 1955–56
Impressionnistes de la Collection Courtauld de Londres. Paris, Musée de l'Orangerie, October 1955–January 1956.

Paris, Durand-Ruel, 1955
Renoir: collection Maurice Gangnat. Paris, Galerie Durand-Ruel, July–August–September 1955.

Paris 1957
Cent chefs-d'œuvre de l'art français. Paris, Galerie Charpentier, 1957.

Paris 1958
Hommage à Renoir. Paris, Galerie Durand-Ruel, May 30–October 15, 1958.

Paris 1958–59
De Clouet à Matisse: dessins français des collections américaines. Paris, Musée de l'Orangerie, 1958–59.

Paris 1959
De Géricault à Matisse: chefs-d'œuvre français des collections suisses. Paris, Petit Palais, March–May 1959.

Paris 1960
Marquet à Bordeaux. Paris, Maison de la Pensée française, March 8–April 27, 1960.

Paris 1960–61
Les Sources du XXe siècle: les arts en Europe de 1884 à 1914. Paris, Musée national d'Art moderne, November 4, 1960–January 23, 1961. Cat. with an introduction by Jean Cassou.

Paris 1962
La Peinture française de Corot à Braque dans la collection Ishibashi de Tokyo. Paris, Musée national d'Art moderne, 1962. Cat. edited by Jeanine Fricker.

Paris 1964
Dessins de sculpteurs: de Pajou à Rodin. Paris, Musée du Louvre, Cabinet des Dessins, 1964.

Paris 1966
Collection Jean Walter et Paul Guillaume. Paris, Orangerie des Tuileries, 1966. Cat. edited by Marie-Thérèse Lemoyne de Forges, Geneviève Allemand, and Michèle Bundorf.

Paris 1967–68
Vingt ans d'acquisitions au musée du Louvre: 1947–1967. Paris, Musée de l'Orangerie, December 16, 1967–March 1968. Cat. edited by Pierre Amiet, with a preface by André Parr.

Paris 1969
Renoir intime. Paris, Galerie Durand-Ruel, January 7–February 8, 1969.

Paris 1969–70
De Raphaël à Picasso: dessins de la Galerie nationale du Canada. Paris, Musée du Louvre, 43rd exhibition of the Cabinet des Dessins, November 28, 1969–February 2, 1970.

Paris 1973
Sculptures de peintres. Paris, Musée Rodin, March 2–May 7, 1973.

Paris, Durand-Ruel, 1974
Hommage à Paul Durand-Ruel: 100 ans d'impressionnisme. Paris, Galerie Durand-Ruel, January 15–March 15, 1974.

Paris, Grand Palais, 1974
Centenaire de l'impressionnisme. Paris, Grand Palais, September 21–November 24, 1974.

Paris, Forum des arts, 1978
Paris, patrie des peintres. Paris, Forum des arts, June 1978.

Paris, Jeu de Paume, 1978
Présentation des nouvelles acquisitions: 1968–1978. Paris, Musée du Jeu de Paume, July 5–September 30, 1978.

Paris, Louvre, 1978
Donation Picasso: la collection personnelle de Picasso. Paris, Musée du Louvre, from May 1978. Cat. edited by Sylvie Béguin.

Paris 1980–81
Cinq années d'enrichissement du patrimoine national (1975–1980): donations, dations, acquisitions. Paris, Galeries nationales du Grand Palais, November 15, 1980–March 2, 1981.

Paris, Louvre, 1980–81
Donations Claude Roger-Marx. Paris, Musée du Louvre, Cabinet des Dessins, November 27, 1980–April 19, 1981.

Paris 1981
Amedeo Modigliani (1884–1920). Paris, Musée d'Art moderne, March 26–June 28, 1981.

Paris, Palais de Tokyo, 1981
Visages et portraits de Manet à Matisse. Paris, Palais de Tokyo, Musée d'art and d'essai, from November 27, 1981.

Paris 1983–84
Raphaël et l'art français. Paris, Galeries nationales du Grand Palais, November 15, 1983–February 13, 1984.

Paris 1984
"Selection One" II: tableaux modernes. Paris, Galerie Fabien Boulakia, May–July 1984.

Paris 1988
Histoire d'objets: acquérir, conserver, exposer dans les musées nationaux. Premier Salon international des musées et des expositions. Paris, Galeries nationales du Grand Palais, January 15–20, 1988.

Paris 1990–91
De Manet à Matisse: sept ans d'enrichissement au musée d'Orsay. Paris, Musée d'Orsay, November 12, 1990–March 10, 1991. Cat. edited by Françoise Cachin.

Paris 1993
1893: l'Europe des peintres. Paris, Musée d'Orsay, February 22–May 23, 1993.

Paris 1993–94
De Cézanne à Matisse: chefs-d'œuvre de la fondation Barnes. Paris, Musée d'Orsay, September 6, 1993–January 2, 1994.

Paris 1994
Sanguines du XIXe siècle de Delacroix à Maurice Denis. Paris, Musée d'Orsay, June 28–September 25, 1994.

Paris 1996–97
De l'impressionnisme à l'Art Nouveau: acquisitions du musée d'Orsay 1990–1996. Paris, Musée d'Orsay, October 16, 1996–January 5, 1997. Cat. edited by Henri Loyrette.

Paris 1996–97b
Charles Le Cœur (1830–1906), architecte et premier amateur de Renoir. Paris, Musée d'Orsay, October 16, 1996–January 5, 1997. Cat. edited by Marc Le Coeur.

Paris 2001
Maillol peintre. Paris, Fondation Dina Vierny–Musée Maillol, June 6–October 20, 2001. Cat. edited by Bertrand Lorquin.

Paris 2004
Au cœur de l'impressionnisme: la famille Rouart. Paris, Musée de la Vie romantique, February 3–June 13, 2004.

Paris 2005–06
Renoir/Renoir. Paris, La Cinémathèque française, September 26, 2005–January 9, 2006. Cat. edited by Serge Lemoine and Serge Toubiana.

Paris 2008
Monet: l'œil impressionniste. Paris, Musée Marmottan Monet, October 16, 2008–February 15, 2009.

Paris 2008–09
Picasso et les maîtres. Paris, Galeries nationales du Grand Palais, October 8, 2008–February 2, 2009. Cat. edited by Anne Baldassari and Marie-Laure Bernadac.

Paris, Brescia, Rotterdam, and Québec 2002–07
De Caillebotte à Picasso: chefs-d'œuvre de la collection Oscar Ghez. Geneva, Musée du Petit-Palais; Paris, Musée Jacquemart-André, October 15, 2002–June 15, 2003; Brescia, July 19–November 16, 2003; Rotterdam, Kunsthal, October 2, 2004–January 25, 2005; Québec, Musée national des Beaux-Arts du Québec, October 11, 2006–January 7, 2007. Cat. edited by Nicolas Sainte Fare Garnot and Gilles Genty.

Paris, Chicago, and Los Angeles 1994–95
Gustave Caillebotte (1848–1894). Paris, Grand Palais, September 12, 1994–January 9, 1995; Chicago, Art Institute of Chicago, February 15–May 28, 1995; Los Angeles, Los Angeles County Museum of Art, June 22–September 10, 1995. Cat. edited by Anne Distel and Rodolphe Rapetti.

Paris and London 1952
L'Œuvre du XXe siècle. Paris, Musée national d'Art moderne, May–June 1952; London, Tate Gallery, July 15–August 17, 1952.

Paris, Pau, and London 2007–08
La Collection La Caze: chefs-d'œuvre des peintures des XVIIe et XVIIIe siècles. Paris, Musée du Louvre, April 26–July 9, 2007; Pau, Musée des Beaux-Arts, September 20–December 10, 2007; Londres, Wallace Collection, February 14–May 18, 2008. Cat. edited by Guillaume Faroult, in collaboration with Sophie Eloy.

Paris and New York 2002–03
Manet/Velázquez: The Taste for Spanish Painting. Paris, Musée d'Orsay, September 16, 2002–January 5, 2003; New York, The Metropolitan Museum of Art, February 24–June 8, 2003. Cat. edited by Geneviève Lacambre, Deborah L. Roldán, and Gary Tinterow.

Pescara 2003
Pierre Auguste Renoir et son univers. Pescara, Museo d'Arte Moderna Vittoria Colonna, September 15–November 15, 2003.

Philadelphia 1933–34
Paintings by Manet and Renoir. Philadelphia, Pennsylvania Museum, November 29, 1933–January 1, 1934.

Philadelphia 1938
Renoir: Later Phases. Philadelphia, Philadelphia Museum of Art, April 8–June 21, 1938.

Philadelphia 1970
Exhibition Summer Loans. Philadelphia, Philadelphia Museum of Art, 1970.

Philadelphia 1990a
Figure Drawings from the Collection. Philadelphia, Philadelphia Museum of Art, January 27–April 19, 1990.

Philadelphia 1990b
Renoir: The Great Bathers. Philadelphia, Philadelphia Museum of Art, September 9–November 25, 1990.

Pittsburgh 1924
Exhibition of Paintings: Édouard Manet, Pierre Renoir, Berthe Morisot. Pittsburgh, Carnegie Institute, October 15–December 1, 1924.

Pittsburgh 1951
French Painting: 1100–1900. Pittsburgh, Carnegie Institute, October 18–December 2, 1951.

Pittsburgh 1961
Paintings from the Albright Art Gallery. Pittsburgh, Carnegie Institute, January 10–February 19, 1961.

Portland 1942–43
Fiftieth Anniversary Exhibition: 1892–1942. Portland, Portland Art Museum, December 2 1942–January 3, 1943.

Portland 1944
Eight Masterpieces of Painting. Portland, Portland Art Museum, December 1944.

Portland 1998
Impressions of the Riviera: Monet, Renoir, Matisse and Their Contemporaries. Portland, Portland Museum of Art, June 25–October 18, 1998. Cat. edited by Kenneth Silver, John House, and Kenneth Wayne.

Portland, Seattle, San Francisco, Los Angeles, Minneapolis, Saint Louis, Kansas City, Detroit, and Boston 1956–57
Paintings from the Collection of Walter F. Chrysler Jr.. Traveling exhibition, March 1956 to April 1957, Portland, Museum of Art; Seattle, Seattle Art Museum; San Francisco, California Palace of the Legion of Honor; Los Angeles, Los Angeles County Museum; Minneapolis, Minneapolis Institute of Arts; Saint Louis, Saint Louis Art Museum; Kansas City, Nelson-Atkins Gallery of Art; Detroit, Detroit Institute of Arts; Boston, Museum of Fine Arts. Cat. edited by Bertina Suida Manning.

Providence 1949
Isms in Art since 1800. Providence, Museum of Art, Rhode Island School of Design, February 3–March 9, 1949. Cat. edited by Gordon Washburn.

Richmond 1958
Untitled exhibition. Richmond, VA, Miller & Rhoads department store. February 11, 1958.

Richmond 1978
Degas. Richmond, Virginia Museum of Fine Arts, May 23–July 9, 1978.

Riehen/Basel and Vienna 2006–07
Eros in der Kunst der Moderne. Riehen/Basel, Fondation Beyeler, October 8, 2006–February 18, 2007; Vienna, Bank Austria Kunstforum, March 1–July 22, 2007.

Roanoke 1978
19th-Century French Painting from the Virginia Museum Collection. Roanoke, Roanoke Museum of Fine Arts, February 11–March 12, 1978.

Rome 1999
Renoir dall'Italia alla Costa Azzura. Rome, Museo del Risorgimento, Palazzo del Vittoriano, March 31–June 25, 1999. Cat. edited by Frédérique Verlinden, Marisa Vescovo, Alain Renoir, and Maurizio Calvesi.

Rome 2008
Renoir: la maturità tra classico e moderno. Rome, Complesso del Vittoriano, March 8–June 29, 2008. Cat. edited by Kathleen Adler.

Rome and Florence 1955
Capolavori dell'Ottocento francese. Rome, Palazzo delle Esposizioni, February–March 1955; Florence, Palazzo Strozzi, April–May 1955. Cat. edited by Albert Chatelet, with a preface by Germain Bazin.

Roslyn Harbor 1984
The Shock of Modernism in America. Roslyn Harbor, Nassau County Museum of Fine Art, April 29–July 29, 1984. Cat. edited by Constance H. Schwartz.

Saint Louis 1947
40 Masterpieces: A Loan Exhibition from American Museums. Saint Louis, City Art Museum, October 6–November 10, 1947.

Saint Petersburg 1995
Les Trésors retrouvés: chefs-d'œuvre impressionnistes et autres grandes œuvres de la peinture française, sauvegardés par le Hermitage Museum. Saint Petersburg, Hermitage Museum, 1995.

Saitama 2002
From Monet to Cézanne: Impressionists and Their Epoch. Saitama (Japan), Museum of Modern Art, 2002.

Sakura, Sendai, and Sapporo 1999
Renoir: Modern Eyes. Sakura, Kawamura Memorial Museum, April 3–May 16, 1999; Sendai, Miyagi Museum of Art, May 25–July 4, 1999; Sapporo, Hokkaido Museum of Modern Art, July 15–August 29, 1999.

Salamanca and Lisbon 2005–06
La Mirada fauve en la colección del Musée des Beaux-Arts de Bordeaux. Salamanca, Caja Duero, 2005; Lisbon, Museo do Chiado, January 13–March 19, 2006.

San Diego 1941
Exposition de peintures françaises. San Diego, Fine Arts Gallery, March 5–April 15, 1941.

San Diego and El Paso 2002–03
Idol of the Moderns: Pierre-Auguste Renoir and American Painting. San Diego, San Diego Museum of Art, June 29–September 15, 2002; El Paso, El Paso Museum of Art, November 3, 2002–February 16, 2003. Cat. edited by Anne E. Dawson.

San Francisco 1934
Exhibition of French Painting from the Fifteenth Century to the Present Day. San Francisco, California Palace of the Legion of Honor, June 8–July 8, 1934.

San Francisco 1941
French Drawings and Watercolors: Supplement to the Painting of France since the French Revolution. San Francisco, M. H. De Young Memorial Museum, summer 1941.

San Francisco 1944
Paintings by Pierre Auguste Renoir. San Francisco, California Palace of the Legion of Honor, November 1–30, 1944.

San Francisco 1947
Nineteenth Century French Drawings. San Francisco, California Palace of the Legion of Honor, March 8–April 6, 1947. Cat. text by John Rewald, preface by Thomas Carr Howe, Jr.

San Francisco 1962
Exhibition Henry P. McIlhenny Collection. San Francisco, California Palace of the Legion of Honor, June 1962.

San Francisco 1965
The Collection of Mr. and Mrs. William Coxe Wright. San Francisco, California Palace of Legion of Honor, August 28–September 26, 1965.

Santiago 1940
Exposicion de Arte Francés. Santiago, Universidad de Chile, Facultad de Bellas artes, Museo national de Bellas Artes, May–June 1940.

São Paulo 2002
Renoir: o pintor da vida. São Paulo, Museo de Arte de São Paulo, April 22–July 28, 2002.

Sapporo, Nagasaki, Kyoto, and Tokyo 1996
The Exhibition from Swiss Private Collections Coordinated by Ernst Beyeler, Basel. Sapporo, Musée de Hokkaido, May 17–June 16, 1996; Nagasaki, Musée du Huis ten Bosch, June 22–August 15, 1996; Kyoto, Musée municipal des Beaux-Arts, August 20–September 29, 1996; Tokyo, Musée Mitsukoshi, October 5–November 24, 1996.

Seattle 1951
Masterpieces of 19th Century Painting and Sculpture. Seattle, Seattle Art Museum, March 7–May 6, 1951.

Seoul 2009
Renoir: promesse du bonheur. Seoul, Seoul Museum of Art, 28 May–13 September 2009.

Shizuoka and Kobe 1986
Landscape Painting in the East and West. Shizuoka, Shizuoka Prefectural Museum of Art, April 19–June 1, 1986; Kobe, Kobe City Museum, June 7–July 13, 1986.

Stockholm and Copenhagen 2002–03
Impressionismen och Norden: Det sena 1800-talets franska avantgardekonst och konten i Norden 1870–1920. Stockholm, Nationalmuseum, September 25, 2002–January 19, 2003; Copenhagen, Statens Museum for Kunst, February 21–May 25, 2003. Cat. edited by Torsten Gunnarsson, Per Hedström, Flemming Friborg et al.

Taipei 1997
L'Âge d'or de l'impressionnisme: chefs-d'œuvre du musée d'Orsay. Taipei, National Museum of History, January 15–April 27, 1997.

Taipei and Kaoshiung 2000
Chefs-d'œuvre du musée de l'Orangerie: collection Jean Walter et Paul Guillaume. Taipei, Taipei Fine Arts Museum; Kaoshiung, Museum of Fine Arts, 2000.

Tbilisi and Leningrad 1981
Impressionnistes and post-impressionnistes des musées français: de Manet à Matisse. Leningrad, Hermitage Museum; Tbilisi, Museum of Fine Arts of Georgia, 1981.

Tel Aviv 1964
Les Trésors des musées de Bordeaux. Tel Aviv, Tel Aviv Museum of Art, 1964.

Tel Aviv 1964–65
50 peintres de Renoir à Kisling. Tel Aviv, Tel Aviv Museum of Art, December 1964–January 1965.

Tokyo 1926
Treizième exposition Kôhôkai. Tokyo, Chinretsukan Gallery, Ueno Park, 1926.

Tokyo 1931
Quatrième exposition d'art occidental: collection de Kôjirô Matsukata. Tokyo, 1931.

Tokyo 1953
Exposition de l'ancienne collection de Kôjirô Matsukata. Tokyo, Bridgestone Museum of Art, 1953.

Tokyo 1955
Deuxième exposition de l'ancienne collection de Kôjirô Matsukata. Tokyo, Bridgestone Museum of Art, 1955.

Tokyo 1957a
Premier anniversaire de l'ouverture du musée. Tokyo, Bridgestone Museum of Art, 1957.

Tokyo 1957b
Ancienne collection de Kôjirô Matsukata. Tokyo, Bridgestone Museum of Art, 1957.

Tokyo 1960
Sélection d'œuvres de la collection Matsukata.

Tokyo, National Museum of Western Art, 1960.

Tokyo 1968
Les Échanges entre Orient et Occident, Tokyo, National Museum of Modern Art, 1968.

Tokyo 1981
Hiroshima Museum of Art: Masterpieces from the Collection, Tokyo, Bridgestone Museum of Art, January–March 1981.

Tokyo, Fukuoka, and Kyoto 1954
L'Art français. Tokyo; Fukuoka; Kyoto, 1954.

Tokyo, Fukuoka, and Kobe 1971–72
Rétrospective Pierre-Auguste Renoir. Tokyo, Galeries Seibu, October 12–November 24, 1971; Fukuoka, Cultural Center, December 8–December 26, 1971; Kobe, Hyogo Prefectural Museum of Modern Art, January 5–February 6, 1972.

Tokyo and Kitakyushu 1989–90
Chefs-d'œuvre du musée des Beaux-Arts de Lyon. Tokyo, Metropolitan Art Museum, October 7–December 1, 1898; Kitakyushu, Municipal Museum of Art, December 9, 1989–January 21, 1990.

Tokyo, Kumamoto, Ishikawa, Okayama, and Osaka 1983–84
Renoir. Tokyo, October 1983; Kumamoto Museum of Art, November–December 1983; Ishikawa Museum of Art, December 1983; Okayama Prefectural Cultural Center, January 1983–December 1984; Osaka, Navio Museum of Art, January–March 1984.

Tokyo and Kyoto 1961–62
Exposition d'art français 1840–1940. Tokyo, National Museum of Modern Art, November 3 1961–January 15, 1962; Kyoto, Municipal Museum, January 25–March 15, 1962.

Tokyo and Kyoto 1979
Renoir. Tokyo, Isetan Museum, September 26–November 6, 1979; Kyoto, Municipal Museum, November 10–December 9, 1979. Cat. edited by François Daulte.

Tokyo and Kyoto 2008
Renoir/Renoir. Tokyo, Bunkamura Museum of Art, February 2–May 6, 2008; Kyoto, National Museum of Modern Art, May 20–July 21, 2008. Cat. edited by Kijima Shunsuke.

Tokyo, Kyoto, and Ibaraki 1989–90
Masterpieces from the Detroit Institute of Arts. Tokyo, Bunkamura Museum of Art; Kyoto, Kyoto Municipal Museum of Art; Ibaraki, Museum of Modern Art, 1989–90.

Tokyo, Kyoto, and Kasama 1993
Auguste Renoir (1841–1919). Tokyo, Musée d'Art Tobu, July 24–September 15, 1993; Kyoto, Kyoto Municipal Museum of Art, October 2–31, 1993; Kasama, November 3–30, 1993.

Tokyo, Kyoto, Osaka, and Canberra 1984
The Impressionists and the Post-Impressionists from the Courtauld Collection, University of London. Tokyo, Takashimaya, January 2–February 28, 1984; Kyoto, Takashimaya, March 8–April 3, 1984; Osaka, Takashimaya, April 12–May 8, 1984; Canberra, Australian National Gallery, June 2–August 5, 1984.

Tokyo and Nagoya 2001
Renoir: From Outsider to Old Master 1870–1892. Tokyo, Bridgestone Museum of Art, February 10–April 15, 2001; Nagoya, Nagoya City Art Museum, April 21–June 24, 2001.

Tokyo, Nagoya, Hiroshima, and Ibaraki 1998
Masterpieces of European Painting from the Albright-Knox Art Gallery. Tokyo, Isetan Museum of Art, April 16–June 8, 1998; Nagoya, Aichi Prefectural Museum of Art, June 19–August 2, 1998; Hiroshima, Hiroshima Museum of Art, August 8–September 13, 1998; Ibaraki, Museum of Modern Art, September 19–November 3, 1998.

Tokyo, Nagoya, Hiroshima, Niigata, and Kyoto 1998–99
Chefs-d'œuvre du musée de l'Orangerie: collection Jean Walter et Paul Guillaume. Tokyo, Bunkamura Museum of Art, November 14, 1998–February 14, 1999; Nagoya, Nagoya City Art Museum, February 23–April 7, 1999; Hiroshima, Hiroshima Prefectural Museum of Fine Arts, 17 April–27 June 1999; Niigata, Niigata Prefectural Museum of Modern Art, July 10–September 12, 1999; Kyoto, National Museum of Modern Art, September 21–November 14, 1999. Cat. edited by Masao Miyazawa.

Tokyo, Shimonoseki, Yawatahama, Hokkaido, and Yamagata 2003–2004
La Peinture française au XIXe siècle. Tokyo, Daimaru Museum, September 18–30, 2003; Shimonoseki City Art Museum, November 7–December 23, 2003; Yawatahama Citizen Gallery, February 8–April 4, 2004; Hokkaido, Hakodate Museum of Art, April 11–May 16, 2004; Yamagata Museum of Art, May 21–June 20, 2004.

Toronto 1934
Paintings by Renoir and Degas. Toronto, Art Gallery of Toronto, October 1934.

Toronto 1944
Loan Exhibition of Great Paintings. Toronto, Art Gallery of Toronto, February 4–March 5, 1944.

Toronto 1949
French Paintings of the XIXth and XXth Centuries: Collection of Mr. P. Eilers. Toronto, Laing Galleries, 1949.

Toronto 1968
Master Drawings from the Collection of the National Gallery of Canada. Toronto, Art Gallery of Ontario, January 1968.

Toronto, Ottawa, and Montreal 1954
Paintings by European Masters from Public and Private Collections in Toronto, Montreal, and Ottawa. Toronto, Art Gallery of Toronto, January 15–February 21, 1954; Ottawa, National Gallery of Canada, March 10–April 11, 1954; Montreal, Musée des Beaux-Arts de Montréal, May–June 1954.

Trento 1982
Renoir: un quadro per movimento. Trento, Palazzo delle Albere, November 20–December 15, 1982.

Treviso 2003–04
L'Oro e l'Azzurro: I colori del Sud da Cézanne a Bonnard. Treviso, Casa dei Carraresi, October 10, 2003–March 7, 2004.

Troyes 1969
Renoir et ses amis. Troyes, Musée des Beaux-Arts, June 28–September 14, 1969.

Tübingen 1996
Renoir. Tübingen, Kunsthalle Tübingen, January 20–May 27, 1996. Cat. edited by Götz Adriani.

Turin 1951
La Moda in cinque secoli di pittura. Turin, Palazzo Madama, May–June 1951.

Turin 1964
80 maîtres de Renoir à Kisling. Turin, Galleria Civica d'Arte Moderna, February 7–April 5, 1964. Cat. edited by Oscar Ghez, François Daulte et al.

Turin 2001
Da Renoir a Picasso: Un secolo d'arte dal Petit Palais di Gineva. Turin, Palazzo Brischesario, March 14–June 10, 2001. Cat. edited by Paola Gribauldo.

Turin 2003–04
Armand Guillaumin et les peintres de son temps. Turin, Fondazione Palazzo Brichesario, October 24, 2003–February 1, 2004.

Vancouver 1953
The French Impressionists, Including Works by Some Earlier Artists Who Influenced The Movement. Vancouver, Vancouver Art Gallery, March 24–April 19, 1953.

Vancouver 1966
Treasures from the Art Gallery of Toronto. Vancouver, Vancouver Art Gallery, February 3–March 27, 1966.

Vancouver 1983
Masterworks from the Collection of the National Gallery of Canada. Vancouver, Vancouver Art Gallery, October 15–December 3, 1983. Cat. edited by Peter Blackman.

Vancouver, Regina, Windsor, Halifax, and Québec 2000–02
Chefs-d'œuvre impressionnistes du musée des Beaux-Arts du Canada. Vancouver, Vancouver Art Gallery, August 30–November 5, 2000; Regina, Mackenzie Art Gallery, November 18, 2000–January 21, 2001; Windsor, Musée des Beaux-Arts de Windsor, February 9–April 29, 2001; Halifax, Musée de la Nouvelle-Écosse, October 12, 2001–January 2, 2002; Québec, Musée du Québec, February 7–May 5, 2002. Cat. edited by Stephen D. Borys.

Warsaw, Poznan, and Krakow 2001
De Manet à Gauguin: impressionnisme et postimpressionnisme dans les collections du musée d'Orsay. Warsaw, Muzeum Narodowyn, January 19–March 25, 2001; Poznan, Muzeum Narodowyn, March 31–May 13, 2001; Krakow, Muzeum Narodowyn, May 19–July 4, 2001.

Venice 1924
XVI. Biennale di Venezia. Venice, 1924.

Venice 1938
XXI. Biennale di Venezia. Venice, summer 1938.

Venice 1948
XXIV. Biennale di Venezia. Venice, May 29–September 30, 1948.

Vienna 1950
Meisterwerke aus Frankreichs Museen. Vienna, Albertina, 1950.

Vienna 1976–77
Von Ingres bis Cézanne: Aquarelle und Zeichnungen aus dem Louvre. Vienna, Graphische Sammlung Albertina, November 19, 1976–January 25, 1977.

Vienna 2005–06
Les Impressionnistes du musée d'Orsay. Vienna, Leopold Museum, September 30, 2005–January 30, 2006.

Waltham and Providence 1967
Exchange Exhibition/Exhibition Exchange: From the Collections of the Rose Art Museum/Museum of Art, Rhode Island School of Design. Waltham, Rose Art Museum, Brandeis University; Providence, Museum of Art, Rhode Island School

of Design, February 15–March 31, 1967. Cat. edited by Daniel Robbins and William Seitz.

Washington, DC, 1937
Cézanne, Gauguin, Seurat, Renoir, Van Gogh. Washington, DC, Museum of Modern Art Gallery of Washington, November 15–December 5, 1937.

Washington, DC, 1940
Emotional Design in Painting. Washington, DC, Phillips Memorial Gallery, April 17–May 5, 1940.

Washington, DC, 1965
Summary Catalogue of European Paintings and Sculpture. Washington, DC, National Gallery of Art, 1965.

Washington, DC, 1966
French Paintings from the Collections of Mr. and Mrs. Paul Mellon, and Mrs. Mellon Bruce. Washington, DC, National Gallery of Art, March 17–May 1, 1966.

Washington, DC, 1968
Paintings from the Albright-Knox Art Gallery. Washington, DC, National Gallery of Art, May 18–July 21, 1968.

Washington, DC, 1968b
European Paintings and Sculpture: illustrations. Washington, DC, National Gallery of Art, 1968.

Washington, DC, 1986–87
Henri Matisse: The Early Years in Nice, 1916–1930. Washington, DC, National Gallery of Art, November 2, 1986–March 29, 1987. Cat. edited by Jack Cowart and Dominique Fourcade.

Washington, DC, 1979
An Exhibition of Works from the Rhode Island School of Design Museum of Art. Washington, DC, Federal Reserve Board, July 23–September 14, 1979.

Washington, DC, 1996–97
Impressionists on the Seine: A Celebration of Renoir's Luncheon of the Boating Party. Washington, DC, The Phillips Collection, September 21, 1996–February 9, 1997.

Washington, Paris, Tokyo, and Philadelphia 1993–94
Great French Paintings from the Barnes Foundation: Impressionist, Postimpressionist, and Early Modern. Washington, DC, National Gallery of Art, May 2–August 15, 1993; Paris, Musée d'Orsay, September 6, 1993–January 2, 1994; Tokyo, National Museum of Western Art, January 21–April 3, 1994; Philadelphia Museum of Art.

Washington and San Francisco 1986
The New Painting: Impressionism 1874–1886. Washington DC, National Gallery of Art, January 17–April 6, 1986; San Francisco, The Fine Arts Museums of San Francisco, M.H. de Young Memorial Museum, April 19–July 6, 1986. Directed and coordinated by Charles S. Moffett with the assistance of Ruth Berson, Barbara Lee Williams, and Fronia Wissman.

Williamstown, Dallas, and Paris 2003–04
Renoir and Algeria. Williamstown, MA, Sterling and Francine Clark Art Institute, February 16–May 11, 2003; Dallas, June 8–August 31, 2003; Paris, Institut du Monde Arabe, October 7, 2003–January 18, 2004. Cat. edited by Roger Benjamin, with an essay by David Prochaska.

Winnipeg 1955
Modern European Art since Manet. Winnipeg, Winnipeg Art Gallery, October 11–30, 1955.

Winnipeg 1987
1912: Break-Up of Tradition. Winnipeg, Winnipeg Art Gallery, August 6–October 4, 1987. Cat. edited by Louise d'Argencourt.

Winterthur 1998
Die Sammlung Georg Reinhart. Winterthur, Kunstmuseum, May 24–August 23, 1998. Cat. edited by Dieter Schwarz.

Wolfsburg 1961
Französische Malerei von Delacroix bis Picasso. Wolfsburg, Rathaus Stadt Wolfsburg, April 8–May 31, 1961.

Worcester 1941
Art of the Third Republic: French Painting 1870–1940. Worcester, Worcester Art Museum, February 22–March 16, 1941.

Worcester 1947
Picture of the Month. Worcester, Worcester Art Museum, May 1947.

Wuppertal 2007–08
Auguste Renoir und die Landschaft des Impressionismus. Wuppertal, Von der Heydt-Museum, October 28, 2007–January 27, 2008.

Yokohama, Kitakyushu, Fukushima, and Fukui 2001
Treasures from The Detroit Institute of Arts: Masters of Impressionism and Modern Art. Yokohama, Sogo Museum of Art, April 7–May 27, 2001; Fukushima, Fukushima Prefectural Museum of Art, July 20–September 2, 2001; Fukui, Fukui Prefectural Museum of Art, September 10–October 8, 2001; Yawatahama, Yawatahama Shimin Gallery, October 17–November 25, 2001.

Yokohama and Kyoto 1986
Peinture française moderne. Yokohama, Sogo Museum of Art, January–February 1986; Kyoto, Kyoto Municipal Museum, June–July 1986.

Zurich 1917
Französische Kunst des XIX. und XX. Jahrhunderts. Zurich, Kunsthaus Zürich, October 5–November 14, 1917.
Zurich 1932
Sammlung d'Oscar Schmitz: Französische Malerei des XIX. Jahrhunderts. Zurich, Kunsthaus Zürich, 1932.
Zurich 1933
Französische Maler des XIX. Jahrhunderts. Zurich, Kunsthaus Zürich, May 14–August 6, 1933.

Sales

London, Sotheby's, 1989
Impressionist and Modern Paintings and Sculpture. Sotheby's London, November 28, 1989.
London, Christie's, 1990
Impressionist and Modern Paintings and Sculpture. Christie's London, April 2, 1990.
London, Christie's, 1995
Impressionist, Modern and Contemporary Paintings. Christie's London, June 26, 1995.
London, Sotheby's, 2008
Impressionist and Modern Art–Evening Sale. Sotheby's London, February 5, 2008.
New York, Anderson, 1920a
Valuable Paintings including two Whistler oils, three presentation Sargent water colors, two marble statues by Rodin, and thirty-three oil sketches by Renoir. New York, The Anderson Galleries, February 5–6, 1920.
New York, Anderson, 1920b
Ninety-six Original Drawings by Auguste Renoir (1841–1919). New York, The Anderson Galleries, 16 April 1920.
New York, Anderson, 1935
J. K. Newman Collection of Important Paintings by American and French XIX–XX Century Artists. New York, American Art Association, Anderson Galleries, December 6, 1935.
New York, Sotheby's, 1990
The Greta Garbo Collection, Impressionist and Modern Paintings and Sculpture. Sotheby's New York, November 13–15, 1990.
New York, Sotheby's, 1997
Impressionist and Modern Art. Sotheby's New York, May 14, 1997.
New York, Sotheby's, 2002
Impressionist and Modern Art, Part II. Sotheby's New York, May 9, 2002.
New York, Christie's, 2007
Impressionist and Modern Art. Christie's New York, May 10, 2007.
New York, Christie's, 2008
Impressionist and Modern Art Day Sale. Christie's New York, May 7, 2008.
Paris, Drouot, 1904
Collection Charles Gillot: estampes japonaises et livres illustrés. Paris, Hôtel Drouot, April 15–19, 1904.
Paris, Charpentier, 1907
Paris, Galerie Charpentier, April 11, 1907.
Paris, Durand-Ruel, 1907
Collection de M. George Viau: tableaux modernes, pastels et aquarelles. Paris, Galerie Durand-Ruel, March 4, 1907.
Paris, Bernheim-Jeune, 1908
Collection Thadée Natanson. Public sale, Galerie Bernheim-Jeune, June 13, 1908. Cat. edited by Henri Baudoin, with a preface by Octave Mirbeau.
Paris, Drouot, 1911
Tableaux modernes. Paris, Hôtel Drouot, June 8, 1911.
Paris, Drouot, 1925
Catalogue des tableaux composant la collection Maurice Gangnat: 160 tableaux par Renoir, œuvres importantes de Cézanne, tableaux par É. Vuillard. Paris, Hôtel Drouot, June 24–25, 1925.
Paris, Drouot, 1933
Catalogue de la vente Vautheret. Paris, Hôtel Drouot, June 16, 1933.
Paris, Charpentier, 1939
Vente Henri Canonne. Paris, Galerie Charpentier, February 18, 1939.
Paris, Charpentier, 1954
Tableaux modernes: dessins, aquarelles, gouaches. 1° Collection Pierre Bonnard. Vente après décès, en vertu d'ordonnance. Paris, Galerie Charpentier, Tuesday, February 23, 1954, "Collection Pierre Bonnard," nos. 11 to 30.
Paris, Drouot Rive-Gauche, 1979
Vente d'autographes. Paris, Drouot Rive-Gauche, February 16, 1979.
Paris, Drouot-Montaigne, 1992
Fonds Vollard. Paris, Drouot-Montaigne, May 19, 1992.
Paris, Piasa, 2003
Dessins, tableaux et sculptures des XIXe et XXe siècles. Paris, Piasa, Richelieu-Drouot, June 20, 2003.

Index of Exhibited or Illustrated Works by Renoir

Index of Names

Photo Credits

This catalogue is published in conjunction with the exhibition

Renoir au XXe siècle
Galeries Nationales (Grand Palais, Champs-Élysées), Paris
September 23, 2009–January 4, 2010

Renoir in the 20th Century
Los Angeles County Museum of Art
February 14–May 9, 2010

Late Renoir
Philadelphia Museum of Art
June 17–September 6, 2010

CATALOGUE
Edited by the Los Angeles County Museum of Art
and the Philadelphia Museum of Art

Managing editor: Claudia Einecke

Coordinating editor: Tas Skorupa, Hatje Cantz

Copyediting: Anne O'Connor

Translations: Ann Drummond and Alayne Pullen in association
with First Edition Translations, Cambridge, UK; John Lee (Cogeval)

Graphic design: Pierre-Louis Hardy, Paris

Typesetting: Weyhing Digital, Ostfildern

Typeface: Avenir

Production: Angelika Hartmann, Nadine Schmidt, Hatje Cantz

Reproductions: IGS, Angoulême

Printing: Dr. Cantz'sche Druckerei, Ostfildern

Paper: LuxoSamt, 150 g/m^2

Binding: Conzella Verlagsbuchbinderei, Urban Meister GmbH,
Aschheim-Dornach

Published by
Hatje Cantz Verlag
Zeppelinstrasse 32
73760 Ostfildern
Germany
Tel. +49 711 4405-200
Fax +49 711 4405-220
www.hatjecantz.com

Hatje Cantz books are available internationally at selected
bookstores. For more information about our distribution partners,
please visit our homepage at www.hatjecantz.com.

ISBN 978-3-7757-2539-2

Printed in Germany

Cover illustration: *Girl in a Red Ruff* (Femme à la collerette rouge)
Cat. 12